D1746945

The *Herbal* of al-Ghāfiqī

The *Herbal* of al-Ghāfiqī

A Facsimile Edition of MS 7508
in the Osler Library of the History of Medicine,
McGill University, with Critical Essays

Edited by

F. JAMIL RAGEP and FAITH WALLIS

with

PAMELA MILLER and ADAM GACEK

Published for the Osler Library of McGill University

by

McGill-Queen's University Press
Montreal & Kingston · London · Ithaca

© McGill-Queen's University Press 2014
ISBN 978-0-7735-4475-8

Legal deposit fourth quarter 2014
Bibliothèque nationale du Québec

Printed in Canada on acid-free paper

McGill-Queen's University Press acknowledges the support of the Canada Council for the Arts for our publishing program. We also acknowledge the financial support of the Government of Canada through the Canada Book Fund for our publishing activities.

Library and Archives Canada Cataloguing in Publication

Ghāfiqī, Abū Jaʿfar Aḥmad ibn Muḥammad, –1165
[Kitāb fī l-adwiya al-mufrada]

The Herbal of al-Ghāfiqī : a facsimile edition of MS 7508 in the Osler Library of the History of Medicine, McGill University, with critical essays / edited by F. Jamil Ragep and Faith Wallis with Pamela Miller and Adam Gacek.

The manuscript reproduced in this edition was purchased in 1912 by Sir William Osler and is now housed in the Osler Library of the History of Medicine at McGill University. Includes facsimile of Kitāb fī l-adwiya al-mufrada with English translation of the Prologue.

Includes bibliographical references and index.
Manuscript in Arabic; essays in English.
ISBN 978-0-7735-4475-8 (bound)

1. Herbs – Therapeutic use – Early works to 1800. 2. Ghāfiqī, Abū Jaʿfar Aḥmad ibn Muḥammad, –1165. Kitāb fī l-adwiya al-mufrada. 3. Osler Library. Manuscript. MS 7508. I. Ragep, F. J., author, editor II. Wallis, Faith, author, editor III. Miller, Pamela, 1944–, author, editor IV. Gacek, Adam, author, editor V. Osler Library. Manuscript. MS 7508 VI. Title. VII. Title: Kitāb fī l-adwiya al-mufrada

RM666.H33G53 2014 615.3'21 C2014-905027-5

This book was designed and typeset by studio oneonone in Minion 10.5/15.5

Contents

Acknowledgments vii
Contributors ix

Introduction 3
FAITH WALLIS

Al-Ghāfiqī's Prologue to the *Herbal* (*Kitāb fī l-adwiya al-mufrada*):
An English translation 12
F. JAMIL RAGEP

1
The Palaeographical and Codicological Features of the Osler Manuscript in the Context of the Manuscript Transmission of al-Ghāfiqī's *Herbal* 18
ADAM GACEK

2
The Text and Its Philological Character 35
OLIVER KAHL

3
The Historical, Scientific, and Literary Contexts of al-Ghāfiqī's *Herbal* 51
CRISTINA ÁLVAREZ MILLÁN

4
The Sources of al-Ghāfiqī's *Herbal*: A Methodological Note 72
LEIGH CHIPMAN

5
Al-Ghāfiqī's *Kitāb fī l-adwiya al-mufrada*, Dioscorides' *De materia medica*, and Mediterranean Herbal Traditions 84
ALAIN TOUWAIDE

6
The Illustrated *Herbal* of al-Ghāfiqī: An Art-Historical Introduction 121
JACLYNNE J. KERNER

Bibliography 157
Index 171

Osler Library MS 7508: A Facsimile

Acknowledgments

The editors wish to extend their sincere thanks to the many people who have contributed to realizing this facsimile edition and essays.

The Board of Curators of the Osler Library lent its support to this project from its inception, and granted permission for the reproduction of Bibliotheca Osleriana MS 7508. The Librarians who tend this remarkable collection – Pamela Miller, and following her, Christopher Lyons – have furnished energy and support at every stage of the process. The Library's staff, particularly Lily Szczygiel and the late Diane Philip, gave unflagging assistance.

The conceptual compass for the al-Ghāfiqī project was aimed in the right direction by the remarkable group of scholars who attended the consultative workshop held at McGill University on 19–20 August 2010: Leigh Chipman, Adam Gacek, Oliver Kahl, Mais Kataya, Jaclynne Kerner, Shigehisa Kuriyama, Efraim Lev, Alain Touwaide, and Raphaela Veit. Funds for the workshop came from the Canada Research Chair in the History of Science in Islamic Societies, and from an anonymous gift to the Osler Library in memory of John Mappin. Keren Abbou Herschkovits, then a Post-Doctoral Fellow at the Institute of Islamic Studies, made the workshop unfold efficiently and serenely.

The production of this volume was generously funded by the McGill University's Class of Medicine of 1961, as their fiftieth anniversary class gift. This gift was coordinated by Dr John Little, Dr Tony Ashworth, Dr Phil Gold, Dr Mort Levy, and Mrs Judy Mendelsohn, to whose generous vision and leadership we are deeply obliged. The electronic imaging of the Osler Library manuscript was carried out by Greg Houston of the McGill University Libraries, together with Pamela Miller; they used a Canon EOS-1Ds Mark II camera and a Traveller's Conservation Copy Stand, both supplied through Canada Foundation for Innovation research grants (principal investigators: Robert Wisnovsky and Jamil Ragep, Institute of Islamic Studies, McGill University). McGill-Queen's University Press took up the challenge of this unusual book with its wonted

professionalism and creativity. We are deeply indebted to the Press's Director, Philip Cercone, who encouraged us from the beginning; to Jonathan Crago, who took the helm and steered us through; to our copy-editor Kate Baltais; to Ryan Van Huijstee; and to David LeBlanc who dreamed up the cover.

We are grateful to the many libraries that have granted us permission to reproduce images from their own manuscripts: Biblioteca nazionale, Naples; Bibliotheek der Rijksuniversiteit, Leiden; Bibliothèque nationale de France, Paris; Bodleian Library of the University of Oxford; the Metropolitan Museum of Art, New York; the Morgan Library and Museum, New York; Österreichische Nationalbibliothek, Vienna; and the Süleymaniye Library, Istanbul. Special thanks go to Hasan Umut of the Institute of Islamic Studies for his invaluable assistance in securing the images from the Süleymaniye Library, and to Kendall Wallis for his help with the bibliography. Finally, for their ongoing logistical support, we salute the staff of the Institute of Islamic Studies of McGill University, particularly Zeitun Manjothi, Karen Moore, and Andrew Staples.

Contributors

CRISTINA ÁLVAREZ MILLÁN is in the Department of Medieval History at the Universidad Nacional de Educación a Distancia (UNED). She specializes in medieval Islamic medicine, with a particular focus on the study of case histories.

LEIGH CHIPMAN, Hebrew University of Jerusalem and Bar-Ilan University, researches the social and intellectual history of medicine in the pre-modern Islamicate world. Her most recent book, co-authored with Efraim Lev, is *Medical Prescriptions in the Cambridge Genizah Collections* (Leiden: Brill, 2012).

ADAM GACEK, former head of the Islamic Studies Library and faculty lecturer in Arabic manuscript studies at McGill University, is the author of numerous books and articles on Islamic manuscripts, including *The Arabic Manuscript Tradition: A Glossary of Technical Terms and Bibliography* (2001; Supplement, 2008) and *Arabic Manuscripts: A Vademecum for Readers* (2009).

OLIVER KAHL is affiliated with the Department of Semitic Studies at the University of Marburg. His research focuses on the history of Islamic science, and in particular on the transmission of "foreign" medical and pharmaceutical knowledge to the Arabs during the medieval period. He is currently finishing a book on the Sanskrit, Syriac, and Persian sources in the famous *Liber Continens* of Rhazes, to be published in 2015.

JACLYNNE J. KERNER is associate professor of art history at the State University of New York at New Paltz, where she teaches courses in the art and architecture of the Islamic world and medieval Europe. She received her BA, MA, and PhD from New York University and has held fellowships at the Metropolitan Museum of Art and the Los Angeles County Museum of Art. She recently contributed an essay, "From Margin to

Mainstream: The History of Islamic Art and Architecture in the Twenty-First Century," to *The Bloomsbury Companion to Islamic Studies* (Clinton Bennett, ed.; London: Bloomsbury Group, 2013).

PAMELA MILLER was history of medicine librarian in charge of the Osler Library from 1999 until her retirement in 2011. Previously employed as curator of archival collections (and librarian) at the McCord Museum of Canadian History, she concentrated at the Osler Library on providing access to its archival collections. Associated as well with the archives of the Montreal Neurological Institute, she continues to consult on the publication of its history, initiated by the late William Feindel.

F. JAMIL RAGEP is Canada Research Chair in the History of Science in Islamic Societies and director of the Institute of Islamic Studies at McGill University. He has written extensively on the history of astronomy, on science in Islam, on science and religion, and on the intercultural transmission of science. He is currently leading an international effort to catalogue all Islamic manuscripts in the exact sciences and is co-directing a project to study the fifteenth-century background to the Copernican revolution.

ALAIN TOUWAIDE is the scientific director of the Institute for the Preservation of Medical Traditions and a research associate at the National Museum of Natural History of the Smithsonian Institution in Washington, DC. He specializes on the history of botany, particularly medicinal plants, in the ancient Mediterranean world from antiquity to the Renaissance. He has recently published a thorough study of the manuscript Sloane 4016 of the British Library in London, which accompanies the facsimile reproduction of the codex (Barcelona: Moleiro Editorial, 2013).

FAITH WALLIS (Departments of History and Classical Studies and Social Studies of Medicine at McGill University) is a historian of medieval European science and medicine. She has published translations and studies of texts on calendar construction and time reckoning, notably by Bede (ca. 675–735). Her articles on medieval medical texts and manuscripts focus on the transmission of medical ideas and instructional techniques, and the relationship of medicine to natural philosophy. With Steven Livesey and Thomas Glick, she edited *Medieval Science, Technology and Medicine: an Encyclopedia* (Routledge, 2005); her *Medieval Medicine: A Reader* was published by the University of Toronto Press in 2010.

The *Herbal* of al-Ghāfiqī

هو اسقولوا ابن

النبات
شرب بالخل
صنفان منه
قضبان طوال
وبق صغر ونبت

انتالیس صنفان

Introduction

FAITH WALLIS

Al-Ghāfiqī, al-Andalus, and the *Herbal*

Al-Ghāfiqī, namely Abū Jaʿfar Aḥmad ibn Muḥammad ibn Aḥmad ibn al-Sayyid al-Ghāfiqī, an eminent *imām*, a knowledgeable man of wisdom, who was counted among the grandees of al-Andalus. He was the best informed among his contemporaries regarding the potency of simple medicaments – their benefits, their properties, their distinctive qualities – and the understanding of their names. His book on simple medicaments has no equal in excellence and there is nothing comparable to it in substance. In it, he has investigated in detail that which was stated by Dioscorides and the distinguished Galen [presenting it] with a precise style and complete content. After setting forth what the two of them had said, he then cited what the moderns have innovated in their writings on simple medicines, or what he has been able to gather, one by one by one, defining each afterward. His book thus became a compendium of what the learned have stated regarding simple medicaments and a resource to which one refers when needing verification for them. As for books, Ghāfiqī has the Book of Medicaments.[1]

Thus did Ibn Abī Uṣaybiʿa (d. 668 H/1270 CE) in his bio-bibliographical dictionary of famous medical writers sum up the achievements of al-Ghāfiqī, author of the *Kitāb fī l-adwiya al-mufrada* – the *Book of Simple Drugs*. This *Book of Simple Drugs* (or as we shall term it, the *Herbal*, because "simple" drugs are uncompounded *materia medica*, usually plants) is partially preserved in manuscript 7508 of the Osler Library of the History of Medicine at McGill University in Montreal. This volume, copied in 654/1256,

has the distinction of being the only known illustrated copy predating the demise of the ʿAbbāsid caliphate. Other manuscripts of the *Herbal* are preserved in Rabat (al-Khizāna al-ʿĀmma Q155), in the Bibliothèque nationale, Tunis (Fonds Ḥasan Ḥusnī ʿAbd al-Wahhāb 18177),[2] in Cairo, Museum of Islamic Art (MS 3907),[3] and in Tehran (Malik Library MS 5958 and Tehran University 7401).[4] The Osler manuscript, together with the Rabat codex, was the basis for the edition by Eleonora Di Vincenzo of the *alif* section of al-Ghāfiqī's treatise.[5] The Cairo codex, copied in 990/1582, and the Malik Library copy are, like the Osler volume, illustrated copies of the first half of the text. Others, which are now untraceable, have been reported in Cairo, Tripoli (Libya), and Istanbul.[6] But the Osler manuscript remains a witness of great significance, due to its antiquity and its illustrations. The present volume publishes a full facsimile of this manuscript; the accompanying essays aim to present a preliminary context or framework that will set the stage for future editorial and interpretive work on the *Herbal*. The authors of the essays are drawn from a group of experts who attended a workshop in August 2010 to share their insights on the significance of the manuscript, and offer advice on how best to make it available to the scholarly community. The editors wish to thank all who took part in this consultation, as well as the institutional sponsors, the Osler Library of the History of Medicine, and the Institute of Islamic Studies of McGill University. They also express their warmest appreciation to the Faculty of Medicine of McGill University's Class of 1961 whose gift has made possible the publication of this book.

Al-Ghāfiqī (d. ca. 560/1165) lived and wrote in the Arab-Islamic zone of the southern Iberian Peninsula called al-Andalus or Andalusia, probably in Cordoba.[7] His career unfolded at a time of vigorous cultural and scientific activity, and against a background of political contention and upheaval. The hegemony of the Almoravids (478–539/1086–1147) was dissolving into the second Ṭāʾifa period, which in turn set the stage for the invasion of the Almohads (540/1145). As Cristina Álvarez-Millán points out in her essay, competition between local rulers in the Iberian Peninsula was mirrored on a larger scale by cultural competition between the newly self-conscious western Islamic zone (al-Andalus and the Maghreb) and the traditional heartlands of the Islamic world in the Middle East, Mesopotamia, and Persia. The age of al-Ghāfiqī was also an encyclopedic epoch, when creative energy in the Arab-Islamic world focused on organizing, comparing, and synthesizing its vast treasury of medical learning and pharmacognosy. The core of this treasury had initially been acquired through translation, but its contents had been extended and significantly transformed by authors like Ibn Sīnā (Avicenna; d. 428/1037) and Abū Bakr al-Rāzī (Rhazes; d. 313/925). At the Cordoban court of the Umayyad caliph ʿAbd al Raḥmān III (r. 300–350/912–961), a revised version of the Arabic translation of *On Materia Medica* by the great Greek pharmacologist Dioscorides (fl. ca. 40–80) expanded the original work by interpolating references to other Greek and Eastern sources, adding entries on plants unknown to Dioscorides, and elaborating new taxonomies of plants.[8] The encyclopedic impetus was reinforced by new commentaries

on Dioscorides, notably by the Andalusī scholar Ibn Juljul (d. after 384/984), as well as by work on plant classification, particularly Abū l-Khayr al-Ishbīlī's *Kitāb ʿumdat al-ṭabīb fī maʿrifat al-nabāt li-kull labīb* (mid-10th century).⁹ This trend gained momentum in the therapeutic manual of Ibn al-Jazzār of Kairouan (d. ca. 395/1004–5), in treatise 29 of the Cordoban Abū l-Qāsim al-Zahrāwī's (d. after 400/1009) *Kitāb al-taṣrīf*, the Toledan Ibn Wāfid's (467/1075) *Book of Simples*,¹⁰ the writings of Yonah ibn Janāḥ of Saragossa (d. ca. 430/1039), and Ibn Biklārish's *Kitāb al-mustaʿīnī* (ca. 6th century/early 12th century). This Andalusī tradition was diffused outward from Spain through the writings of Maimonides (d. 601/1204), who mentions al-Ghāfiqī by name as one of his sources.¹¹ Seen in the light of two centuries of pharmacological erudition and innovation, Ibn Abī Uṣaybiʿa's claim that al-Ghāfiqī was "the best informed among his contemporaries on the matter of simple medicaments" is very high praise indeed.

As we have seen, Ibn Abī Uṣaybiʿa explains that al-Ghāfiqī's herbal "became a compendium of what the learned have stated regarding simple medicaments and a resource to which one refers when needing verification for them." Al-Ghāfiqī phrases this in analogous terms in his prologue: he aims to be concise but also comprehensive. Encyclopedic scope was certainly a hallmark of the Andalusī approach to medical botany: Abū l-Khayr al-Ishbīlī's compilation contained over 5,000 entries. The principal objective of these massive compilations was to accumulate and organize useful knowledge from pre-exiting sources in order to facilitate scientific edification by the scholar or amateur, practical consultation by the working physician, or some combination of both. The information on offer was of two kinds. First, the physical and ecological characteristics of plants were listed, and their medically useful parts were identified, along with comments on their preparation; therapeutic indications were also enumerated. Second, a lexical thesaurus furnished names of plants, sometimes with related etymological or philological information, in as many languages as the compiler could assemble or his patron and readers be presumed to find of interest. These synonym collections constituted a kind of literary genre of its own. Including such a glossary may have had the additional advantage of advertising the universal validity and usefulness of the herbal throughout the Islamic world. The two elements – descriptive and linguistic – are the essential ingredients for the Arab-Islamic herbal of the central medieval period. There could, though, be considerable formal variation based on the demands of genre: Ibn Biklārish's book, for example, is the only Andalusī herbal to be set out in synoptic tables for ready consultation, and yet this format may reach back to the Late Antique "Alexandrian Summaries" of Galen's treatises on simples. The most famous treatise in tabular form is the *Kitāb taqwīm al-ṣiḥḥa* by Ibn Buṭlān (d. 458/1066), a Christian physician of Baghdad, known in the Latin West as the *Tacuinum sanitatis* or *Table of Health*.

Though the western Islamic treatment of *materia medica* was distinctive, it was evidently not isolated from scientific and medical scholarship in the cultural heartlands of Islam; nor did Andalusī writers, even those in the employ of regional princes, write

exclusively for local audiences. This is particularly pertinent to our assessment of al-Ghāfiqī himself. His compilation is along classic lines: a botanico-pharmaco-therapeutic analysis of each plant, followed by a glossary of names in various languages, ancient and modern. However, if one lays al-Ghāfiqī's work alongside Ibn Biklarish's, al-Ghāfiqī begins to seem rather less embedded in the culture of the Iberian Peninsula than his compatriot. The Arcadian Library manuscript of Ibn Biklarish (written ca. 524/5/1130) is peppered with Latin terms throughout the text, apparently in the hand of the Arabic scribe. This scribe wrote his Latin in both Caroline and Visigothic scripts, and sometimes a hybrid of the two. Hence both the composition of the text and the production of this early manuscript speak strongly in the accents of the mixed Arabic and Latin-Romance culture of Spain.[12] Moreover, the diffusion of Ibn Biklarish's work was entirely within the confines of the western part of the Arabic world, that is, Spain and northwestern Africa.[13] By contrast, al-Ghāfiqī's *Herbal* seems less provincial, and this is reflected in its fortunes. In the century following its composition, it was used extensively by the Málagan Ibn al-Bayṭār (ca. 576–646/1180–1248) for his huge compendium *al-Jāmiʿ li-mufradāt al-adwiya wa-l-aghdhiya*; but by the time Ibn al-Bayṭār was writing, he had probably moved to Syria. The Christian scholar Bar Hebraeus (d. 1286), though originally from Asia Minor, lived and died in northern Iran, where he made an abridgement of al-Ghāfiqī's book. It is a remarkable illustration of the fluidity of intellectual exchange in the medieval world that Bar Hebraeus's abbreviation was shortly thereafter translated into Latin.[14] And by the middle decades of the 13th century, a copy of the *Herbal* was in or near Baghdad, or at least in Mesopotamia, where it served as the exemplar of the Osler Library manuscript.

The Making of the *Herbal*

Al-Ghāfiqī was not shy about advertising the excellence of his book, but he did not share a modern scientist's or scholar's concern with originality. To the contrary, like other works of the encyclopedic herbal tradition, al-Ghāfiqī's was a labour of virtuosic compilation that displayed the author's command of a fully consolidated tradition: in the words of Oliver Kahl, it is of a "scholastic" genre, in the broader sense of participating in the traditions, and employing the methods, of text-based scholarship. Al-Ghāfiqī's prologue not only vaunts the work's superiority to any book of its kind written hitherto, but is also exceptionally critical of other writers, especially Eastern authorities like al-Rāzī and Ibn Sīnā. This prickly sense of self-worth may reflect our author's personality, but it is also (though to a milder degree) a feature of Andalusī culture of the period.

In both form and content, the scaffolding of the *Herbal* is the *De materia medica* of Dioscorides. The exceptional influence of this model is the subject of Alain Touwaide's contribution to this volume. Al-Ghāfiqī's book can be fairly described as representing one

of many regional reworkings of Dioscorides; but, at the same time, its illustrations seem to link the Osler volume to a more venerable and pan-Mediterranean Dioscoridean tradition, and raise questions about whether the original *Herbal* contained pictures. Unlike Dioscorides' original text, but like most of its ancient and medieval versions, al-Ghāfiqī's *Herbal* is arranged in alphabetical order (using a form of Arabic alphabetical order called *abjad*) to enable targeted consultation, as distinct from discursive reading. There are 468 primary (i.e., pharmacognostic) entries, and around 2,200 secondary (i.e., lexical) entries in the Osler manuscript, representing about half of al-Ghāfiqī's compilation. As with Dioscorides, the entries deal overwhelmingly with plants, but also include minerals and animals or animal products.

Unlike some of his compatriots, notably, al-Ishbīlī, al-Ghāfiqī pays but slight attention to the ecology of the plant, or to uses other than medical ones. He does, however, often add personal observations or comments. By contrast, his lexical information is quite rich and rare, and this is the principal focus of Oliver Kahl's contribution to the present volume. Arabic had to create a pharmaco-botanical vocabulary *ex novo* in the process of translating works from Greek, Syriac, Persian, and Sanskrit. Hence the philological component of the *Herbal* represents an important dimension in the constitution of Arabic-Islamic medical knowledge as a whole. In Kahl's words, the multilingual glossary is "a direct outcome of the semantic intricacies posed by the source texts, and at the same time an attempt at explaining and disseminating the newly coined terminology." Al-Ghāfiqī's synonyms were thus the product of a massive labour of intellectual appropriation from many languages and cultures – a process of epistemological and scientific transformation driven by the medical imperative to match exactly the word and the thing, but shaped as well by the distinctive demands of Islamic society. In western Islam, this process was amplified by incorporating languages that were unknown in the Islamic heartlands, and that played no role in the chain of translation: Latin, Berber, and Old Spanish. The practical reference functions of the glossary were, it seems, blurred by motives of erudition. While the principal or pharmacognostic entries inventory common *materia medica*, the secondary lexical entries feature unusual plants that were less likely to be found in a doctor's study or an apothecary's shop. Indeed, al-Ghāfiqī implicitly proclaims the technical and functional distinction of pharmacognostic and linguistic information by separating the two sections within each letter – a rather unconventional arrangement. To what extent al-Ghāfiqī had any expertise in languages other than those current in al-Andalus is, of course, open to question.

As a compiler and medical scholar, al-Ghāfiqī made a virtue of displaying the many authoritative sources he consulted, or claimed to have consulted. Copious citations were read not as a sign that the work was derivative, but as an index of its scientific value. It will be recalled that Ibn Abī Uṣaybiʿa heaped praise on al-Ghāfiqī precisely because he summarized and quoted from the great proponents of ancient Greek rational medicine – Dioscorides, first and foremost, and also Galen, the source of the pharmacological theory

of qualities and degrees – and in addition mentioned everything their successors had observed that was pertinent or useful. But as Leigh Chipman observes in her essay on al-Ghāfiqī's sources, determining what works were actually used (as distinct from those that are named), and how they were exploited (e.g., whether by quotation or through paraphrase) is not a straightforward process. Al-Ghāfiqī cites sources that are no longer extant as integral texts, such as the works of the two writers known as Māsarjawayh; other works he cites have come down to us only as fragments, quotations, or abridgements. Some writings of Yūḥannā ibn Māsawayh (d. 243/857) survive, while others are lost, and this only increases the difficulty in pinning down al-Ghāfiqī's references. On occasion, a source is known only by its title, and this can lead to confusion: when al-Ghāfiqī cites *al-Filāḥa*, this could be either *al-Filāḥa al-rūmiyya* ascribed to Qusṭā b. Lūqā, or *al-Filāḥa al-nabaṭiyya*, a translation by Ibn Waḥshiyya (d. 323/935) of a translation, presumably from the Syriac, or a work on agronomy and botany. Some sources are undoubtedly quoted at second hand: references to Oribasius, for example, were very likely gleaned from al-Rāzī's *al-Ḥāwī*. On occasion, al-Ghāfiqī (and his follower, Ibn al-Bayṭār) is our only surviving witness to a lost work; as Chipman points out, this is the case with ʿAlī b. Riḍwān's *Kitāb al-mufradāt*. Finally, al-Ghāfiqī cites a number of western Islamicate writers such as Isḥāq ibn ʿImrān (ca. 292/905), Isaac Judaeus or al-Isrāʾīlī of Kairouan (d. ca. 320/932), and Ibn Juljul, but as Oliver Kahl observes, he does not rely on Andalusī writers as much as one would perhaps expect. Moreover, Abū l-Khayr al-Ishbīlī is conspicuously absent. While it is possible that al-Ghāfiqī did not know his work, this silence may signal our author's ambition to eclipse his most famous predecessor.

The Osler Library Manuscript of al-Ghāfiqī's *Herbal*

In 1912 Sir William Osler, then Regius Professor of Medicine in the University of Oxford, purchased for £25 two Arabic manuscripts from an Iranian owner.[15] One of these was the *Herbal*. Its companion was a volume containing books III–V of an Arabic translation of Dioscorides, and Osler (who read no Arabic) was given to understand that the *Herbal* was the other half of the Dioscorides. As Jaclynne Kerner observes, this pairing of two virtually contemporary manuscripts of similar format and analogous content may have been a deliberate ploy to increase the books' value on the market. It was Osler's intention to bequeath the Arabic Dioscorides to the Bodleian Library, but in the course of cataloguing his Library during the decade following Osler's death, W.W. Francis, through Arthur Cowley of the Bodleian Library, learned that one of the two volumes was, in fact, the first half of al-Ghāfiqī's *Herbal*. The Dioscorides volume, once Bibliotheca Osleriana 346, is now Oxford, Bodleian Library Arab. d. 138;[16] al-Ghāfiqī's *Herbal*, under the shelf mark Bibliotheca Osleriana 7508, came to McGill in 1929 with the remainder of Osler's collection.

Apart from the brief entry in *Bibliotheca Osleriana*, the printed catalogue of Sir William Osler's Library, and some unpublished correspondence in 1938 between Max Meyerhof and the then Osler Librarian W.W. Francis, the first thorough physical descriptions of the *Herbal* manuscript were published by Adam Gacek, then librarian of the Institute of Islamic Studies at McGill University.[17] Adam Gacek's contribution to this present volume discusses and expands upon these descriptions, with particular attention to palaeographical and codicological features that have hitherto received scant attention. Though the Osler al-Ghāfiqī dates from the earliest period of Islamic book illustration, its 397 illustrations have likewise never been the subject of thorough scientific study prior to Jaclynne Kerner's contribution to the present volume. Kerner demonstrates that the Osler manuscript and the Bodleian Dioscorides with which it was purchased were deliberately modified to look more alike so that they could be marketed as a complete Dioscorides, rather than as two partial texts by different authors. Moreover, the illustrations in the Osler manuscript are not all by a single artist, nor do they all date from the period when the book was created, though they all are executed in the typical schematic style of Byzantine and Islamic herbals. The manuscript and its images themselves cannot, as has been assumed in the past, be demonstrated to have been made in Baghdad, nor do they resemble other productions conventionally grouped on stylistic grounds as belonging to the "Baghdad School." Indeed, its affinities seem to lie with the northern Mesopotamian region of the Jazīra. Nonetheless, its iconography has clear genetic relations to those in earlier Greek and Arabic herbals. The captions for the images were not the work of the text's scribe, and some at least were added after the image was painted.

Unfortunately, there are no clear indications in either the script or the images of who might have commissioned the volume, or who owned it before it came into Osler's hands. But as Kerner observes, the fact that the Osler manuscript is illustrated at all points to a readership that was not, in the first instance, professional. Illustrated herbals are invariably deluxe productions intended for bibliophiles and scholars; their images had mnemonic value, but were certainly not designed for field identification. A physician would be interested in the text, particularly in the medical properties and therapeutic indications; even the lexical information would have been of marginal practical import. In sum, al-Ghāfiqī's book, and a fortiori the Osler copy, has the earmarks of a scholarly production, whose images added pleasure and value, if not actual information, to the text. But even if one admits a learned rather than a practical orientation, would potential readers include people outside the court, such as merchants, apothecaries, and physicians? And how would they construe the relationship between the subject matter and the form of the *Herbal*? It is our hope that this publication will help produce answers to these and other questions related to al-Ghāfiqī's remarkable work.

NOTES

1 Ibn Abī Uṣaybiʿa, *ʿUyūn al-anbāʾ fī ṭabaqāt al-aṭibbāʾ*, edited by Nizār Riḍā (Beirut: Dār maktabat al-ḥayāt, 1965), 500–1; translated by Jamil Ragep. Note that throughout this volume, all transcriptions of Arabic names follow the convention of the *Encyclopaedia of Islam*, 3rd ed. All dates in this volume are given in years of the Hijra, followed by the equivalent in the Common Era.

2 See the essay by Adam Gacek below, p. 31.

3 See the exhibition catalogue *La Médicine au temps des califes* (Paris: Institut de Monde Arabe, 1996), no. 17. Max Meyerhof described this manuscript (noting the similarity of its text to the one in the Osler codex), along with another which is no longer traceable, namely, Cairo, Royal Egyptian Library (now Dār al-kutub al-miṣriyya ʾṬalʿat 624: Max Meyerhof, "Études de pharmacologie arabe tirées de manuscrits inédits: III. Deux manuscrits illustrés du 'Livre des simples' d'Aḥmad al-Ġāfiqī," *Bulletin de l'Institut d'Égypte* 23 (1940–41): 13–29.

4 The Malik manuscript seems to be a late but nicely illustrated copy of our Osler codex.

5 *Kitāb al-ʾadwiya al-mufrada, di ʾAbū Ǧaʿfar ʾAḥmad b. Muḥammad b. ʾAḥmad b. Sayyid al-Ġāfiqī (XII sec.)* (Pisa: F. Serra, 2009).

6 E[ttore] R[ossi], "Un manoscritto del trattato di farmacologia di al-Ghafiqi scoperto del prof. Tommaso Sarnelli a Tripoli," *Oriente Moderno* 23 (1953): 67–8.

7 Essential biographical and bibliographical information is found in the following: A. Dietrich, "al-Ghāfiḳī, Abū Djaʿfar Aḥmad b. Muḥammad b. Aḥmad Ibn al-Sayyid," in *Encyclopaedia of Islam*, 2nd ed. (Leiden: Brill, 2004), 12: 313–14; I. Galán Garijo, "Al-Gāfiqī, Abū Ŷaʿfar," in Jorge Lirola Delgado and José Miguel Puerta Vílchez, eds., *Diccionario de Autores y Obras Andalusíes* (Seville: Junta de Aldalucía, Consejería de Cultura, 2002), 174–6.

8 Juan Carlos Villaverde Amieva, "Towards the Study of the Romance Languages in the *Kitāb al Mustaʿīnī*," in Charles Burnett, ed., *Ibn Baklarish's Book of Simples: Medical Remedies between Three Faiths in Twelfth-Century Spain* (London: Arcadian Library in association with Oxford University Press, 2008), 43.

9 Edited and translated into Spanish by Joaquin Bustamante Costa, Federico Corriente, and Mohamed Tilmatine, 3 vols (Madrid: CSIC, 2004–10).

10 Edited and translated into Spanish by Luisa Fernanda Aguirre de Cárcer, 2 vols, *Fuentes Arábico-Hispanas* 11 (Madrid: CSIC, AECI, 1995–97).

11 Moses Maimonides, *Šarḥ asmāʾ al-ʿuqqār (L'explication des noms des drogues): Un glossaire de matière médicale composé par Maïmonide*, edited and translated by Max Meyerhof (Cairo, 1940; reprinted Frankfurt am Main: Institute for the History of Arabic-Islamic Science, 1996), 4.

12 Burnett, "Preface," *Ibn Baklarish*, 13.

13 Joëlle Ricordel, "The Manuscript Transmission of the *Kitāb al-Mustaʿīnī* and the Contributions of the Arcadian Library Manuscript," in Burnett, *Ibn Baklarish*, 27–41. But Ana Labarta says it was known to at least one Middle Eastern bibliographer of

the 17th century: "Ibn Baklarish's *Kitāb al-Mustaʿīnī*: The Historical Context to the Discovery of a New Manuscript," in Burnett, *Ibn Baklarish*, 15.

14 On Bar Hebraeus, see Bar Hebraeus (Gregorius Abū al-Faraj, Ibn al-ʿIbrī), *The Abridged Version of "The Book of Simple Drugs" of Aḥmad ibn Muḥammad al-Ghâfiqî*, edited and translated by Max Meyerhof and G.P. Sobhy (Cairo: al-Ettemad Printing Press, 1932–40; reprinted Frankfurt am Main: Institute for the History of Arabic-Islamic Science, 1996). On the later abbreviation of the *Herbal* by Aḥmad b. ʿAlī b. Ibrāhīm b. Abī Jumhūr (fl. ca. 880/1475), see I. Garijo Galán, "La Sistematización de al-Gāfiqī," in P. Cano Ávila and I. Garijo Galán, eds., *El saber en al-Andalus, textos y estudios* (Seville: Universidad de Sevilla, 1997), 137–49. Ibn Abī Jumhūr was overwhelmingly interested in the lexical material.

15 This was not the physician and bookdealer, Dr Mirza Saʿeed, who supplied Osler with a number of Arab-Islamic manuscripts between 1910 and 1913: A. Date, "The Story of Osler's First Four Arabic Manuscript Acquisitions," *Osler Library Newsletter*, no. 106 (2006), 2, 5, correcting his earlier article "Sir William Osler's Arab and other Middle Eastern Contacts," *Ulster Medical Journal* 60 (1991): 120–8 at 125.

16 Emilie Savage-Smith, *A New Catalogue of Arabic Manuscripts in the Bodleian Library, University of Oxford*, vol. 1, *Medicine* (Oxford: Oxford University Press, 2011), 45, 64.

17 "Arabic Calligraphy and the 'Herbal' of al-Ghāfiqī: A Survey of Arabic Manuscripts at McGill University," *Fontanus* 2 (1989): 37–53; *Arabic Manuscripts in the Libraries of McGill University: Union Catalogue* (Montreal: McGill University Libraries, 1991), 95.

Prologue to the *Herbal* of al-Ghāfiqī

Translated by

F. JAMIL RAGEP[1]

[dV 3; OL 2b][2] In the name of God the beneficent, the merciful

Abū Jaʿfar Aḥmad b. Muḥammad b. Aḥmad b. Sayyid al-Ghāfiqī, may God have mercy on him, said:

I had begun to compose a book on simple drugs in order to use it as a personal aide-memoire, and I did not desire to circulate it to the public. What prevented me from that was that I realized how few people can discern, in what is written, between that which is correct from that which is not, and how little understanding they have in distinguishing between someone who derives something that is correct in what before him there had been error, and someone who errs regarding something that had been correct, thereby distorting it for those after him. Indeed, it is as if their souls were naturally inclined towards the faulty claim while shunning that which is correct. They will have a predilection for the book between their hands, prioritizing it and favouring it over others, either because its author was of high rank and closely associated with those in power or because he was a wealthy man and generally because he was a man for whom renown and fame had spread based on worldly motives. As for the content of the book, they do not understand from it either what makes it preferable to another, or another preferable to it. For this reason I did not want a book of mine to be circulated among the public because of what we stated above, namely, the lack of their discernment and because a person in so doing would subject himself to envious hearsay and the ignorant lend an ear to them; those with discernment, knowledge, and fairness are very rare indeed.

But since some comrades imposed upon me the burden of penning this book, I resolved to go ahead with it. So I [should] mention its purpose, my method in setting

it forth, and the reason that led me to [compose] it. Therefore I [start by] saying that my aims are two-fold: one of them is to collect in it the reports of insightful physicians, ancient and modern, regarding any drug from among the simples, so that he who looks up a drug may learn all that has been said about it and about its effects, without the [usual] wordiness, long-windedness, and repetitiveness of suchlike statements but rather as short and concise as is possible in a diligent compilation. The second is a commentary on unknown drug names that occur in the writings of physicians. [OL 3a] Many people have already set forth works with these two aims; however, not one of them has achieved his objective, nor brought it to completion, nor investigated thoroughly the truth of what he has laid down. Whoever examines their books finds that the inconsistencies could hardly be surpassed, so much so that he will be confused and unable to discern the true from the false. He also finds that most of these books depend upon one another, perpetuating the mistakes of their predecessors. When one of them is mistaken, you can see the community following in his mistake, each [writer] committing the same error. This indicates that they did not compose their works through research or inquiry, but some of them have merely reproduced a copy of the work of their predecessors; thus what is mistaken is followed in error, and what is correct is agreed to. Therefore, no one can blame one of them if he were mistaken, nor praise him when he is correct; rather, one should direct a single critique at all of them for their negligence in research and for not searching for the true state of affairs. And those who did do research on something were not exhaustive in their research and did not delve fully [dV 4] into what was being said; thus they might be correct in some things, but wrong about others. Were it not for my reluctance for prolixity, I would have reported the mistakes of each one of them, commenting on and explaining them so that the reader of this book would have known the extent to which we have investigated and sought the true state of affairs of the various matters so that we were able to discern, in the majority of the cases, what was correct from what was false. However, in a few exceptional cases we did not find a proper way to verify them even though we have scrutinized the matter to the best of our capacity and ability.

There are those who erred in compiling [previous] reports, such as was done by Ibn Wāfid where he gathered the words of Dioscorides on a drug, and he added them to the words of Galen on another drug, thinking them the same. This is a separate [issue] from his distortion and corruption of Galen's words, deviating from their intended meaning, abusing their interpretation, and distorting them in ways that would take some time to go into. And there are those who prevaricated, such as was done by Ibn Sīnā in many places regarding drugs where he attributes to Dioscorides and Galen things they did not say.

In general, no one has discussed the two aims mentioned in the beginning of this work without making shameful mistakes, from al-Rāzī, who was the first of them until our own days. By erring and making mistakes, none of them fulfilled his objective, nor accomplished it in his own work.

This is [OL 3b] the reason that led me to set forth a book that is a collection of the reports of the ancients and the moderns for my own usage: to spare myself from looking into other works set forth on this art that were incomplete and erroneous. I have, with the power of God most high, investigated the matter as much as I could in virtue of my knowledge and the extent of my ability and, as far as I was able, have avoided the mistakes committed by others. I did not seek through it renown and glory, but rather only benefit for myself.

I have presented fully in this [book] a report of all the drugs mentioned by Galen and Dioscorides, which none of our predecessors have assembled holistically. After their reports, we have appended for each drug they mentioned the reports of those who came after them who were on target and have ignored those reports of the later writers that were in error whose mistakes were evident to us.

For every report we have conveyed the name of its author, except those unknown to us; we have done that so that the author of every report would be known. One should follow with confidence and certainty only the reports given by Dioscorides and Galen. As for what the moderns have reported, let it be taken with suspicion and trepidation, since many of them make mistakes; they name drugs improperly, they will give the name of a drug while discussing another, and they are not knowledgeable or lie as we have mentioned. In transmitting from the ancients, they then degraded what was transmitted, distorting and corrupting it. And all of them have attested to what has neither been verified nor tested. For this reason it is appropriate to ascribe every report to its author. We have not put forth those of their reports that are similar and in agreement with the reports of the ancients, sparing ourselves from them with [instead] the reports of the ancients, even though some believe that [putting forth those reports] is fine since that counts for them as multiple witnesses. We hold that had each one of them indeed stated the tested effects of the drugs, then those who believe [in multiple reports] would be correct. However, this is not the case; rather, each of them, except in a few cases, copies the report of his predecessor. So putting down reports that are in agreement is useful only for expanding and lengthening the discussion.

Because of our wish to condense and be concise, we have replaced the names of Dioscorides and Galen with [the letters] *dāl* and *jīm*. After the letter indicating each name, we have added a letter indicating the chapter of his book in which mention of that drug occurs, so it will be easier for whoever wishes to do so to search for that report in each one of their books.

I have aimed [OL 4a] to relate fully and literally the reports of Dioscorides for each one of the drugs he mentions, since he was the pioneer and what he says is poignant, well selected, and pragmatic. I added to them [dV 5] the words of Galen that fulfil the objective and [provide] benefit; sometimes they were dispensed with if superfluous. Following that, additional comments are attached – if available from one of the moderns – regarding their two reports. In this book, I have added things that were not mentioned by the two of

them regarding simple drugs but that have been mentioned by physicians who came after them. I have also added some herbs (*al-ḥashā'ish*) found in our lands that are used by the people of our country that have not been mentioned by any of our predecessors.

I have arranged the chapters of the book according to the ABGD lettering [of the alphabet] to facilitate finding what is required. I follow the end of each chapter with an explanation of the names that occur in the book under that letter. Thus each chapter is divided into two sections: a section discussing the drugs and a section explaining the names. Of these explanations, those mentioned by al-Rāzī in his book *al-Ḥāwī* we have marked with a *ḥā'*, while those that Abū Ḥanīfa [al-Dīnawarī] reported from the Arabs we have marked with a *fā'*. We [then] follow with other names since these two are most frequently [cited]. Since this section for each chapter in which the names are explained have quite a few names, and someone seeking a particular name would [normally] need to read the entire chapter, we have employed an arrangement of names based upon the letters of the alphabet. Using this expedient for grasping them, one may then extract from any chapter he wishes any name he wishes without reading a single line or more of the chapter. This is something that no one before me has done. For this arrangement, we were guided by the shapes of the letters, not the letters themselves, since the majority of these names have undergone distortion and change, so that only the shape of the letter remains correct. Our goal in all that we have done has been accessibility and simplification.

The discussion of flavours, smells, and the division of the powers of drugs into first, second, and third [degrees] – these being outside the scope of this book – has been treated extensively by Galen and then by those coming after him who discussed these matters. Rather, we have aimed for that goal, [up to now] lacking and unfulfilled by anyone, despite the fact that this goal has little benefit for the art of medicine if the physician does not seek to test the drugs [OL 4b] that have not been used by anyone before him, but uses [only] those whose strength is known by experience.

As for knowledge of the strength of drugs and their division: even though it is thought that they are useful in the art [of medicine], I claim that they are part of the general matters of medicine that should be placed in foundational books on the science of medicine, not in discussions on the strength of individual drugs, since this pertains to particulars. For this reason we have avoided discussing it in this book, even though [previous] authors did so at length. The characteristic properties (*ḥulā*) of drugs, their selection, and the discernment of the good among them from the bad are specifically within our stated goals for this book, even though the majority of our physicians are of the opinion that they are superfluous and outside the art of medicine and that the physician need not know anything of these matters, rather entrusting that to the herbalists and apothecaries (*al-shajjārīn wa-l-ṣayādila*). I would say in reply to that: they speak the truth in their claim that this is outside the art of medicine inasmuch as the knowledge and selection of drugs is part of the art of pharmacology, not of the art of medicine. However, all those physicians of ours are pharmacologists. So whoever among them claims that he does not

need to know about drugs, this is just a disgraceful, impudent ignorance coming from him because all those physicians of ours take upon themselves the responsibility to make compound drugs as well as all pharmacological work. How shameful it would be for one of them if it came to be known that he ordered a simple drug for preparing a compound drug and he received the drug but did not know whether that was what he wanted or something else. So he would have prepared the compound and given it to his patient, trusting blindly the herbalists and the gatherers of herbs (*al-shajjārīn wa-laqqāṭī al-ḥashāʾish*), people who do not read books, have a scarce knowledge of drugs, and are mostly unreliable. What they do know about drugs is by blindly following others who lack knowledge; this is compounded by what is seen of their disagreements about [drugs] and their lack of consensus. I claim that all those physicians of ours are indeed pharmacologists, and they have no profit [dV 6] nor livelihood except from pharmacology. But they do not realize that! For them this would be comparable to the carpenter whose profit comes only from carpentry, but is ignorant of the fact that he is a carpenter and thinks his profession is something else. He who does not know himself to this extent should not talk at all!

So the physician is he who prescribes as necessary food, drugs, regimen (*tadbīr*), and so forth for the patient. [OL 5a] He is not responsible for making any of that by his own hand; he is the physician only, not a pharmacologist. He who is responsible for making drugs and compounding them is a pharmacologist. So when any of our physicians claims that "knowledge of simple drugs is not obligatory upon me," indeed this is not obligatory upon him insofar as he is a physician; but insofar as he is a pharmacologist, this is obligatory upon him so much so that there is nothing more certain for him. For there is nothing more deleterious in the art than giving a drug rather than a [correct] drug. And there is nothing more foolish than the physician who practises in this way, having taken upon himself this responsibility. But if he entrusts the matter to someone else, then the error is upon that person, not the physician. Knowledge of drugs and selecting them are at the forefront of the art of pharmacology, being like a foundation for it. As for knowledge of the strength and effect of [drugs], that is one of the parts of the medical art. Let us now begin with what we have stipulated in our book. And success is with God.

NOTES

1 The translation is generally based upon the edition of Eleonora Di Vincenzo (*Kitāb al-'adwiya al-mufrada, di 'Abū Ǧa'far 'Aḥmad b. Muḥammad b. 'Aḥmad b. Sayyid al-Ġāfiqī (XII sec.)*, Edizione del Capitolo 'Alif (Pisa-Rome: Fabrizio Serra, 2009), 3–6. I have been guided in a number of places by her translation, pp. xxxi–xxxv (translated into English by Giovanni Carrera, PhD student at the Institute of Islamic Studies, McGill University), and I have also benefited from input by Adam Gacek, Cristina Álvarez Millán, Alain Touwaide, Faith Wallis, and, especially, Oliver Kahl, none of whom should be held responsible in any way for the remaining inadequacies.

2 Numbers in brackets refer to page numbers in Di Vincenzo's edition [dV] and to folios in the Osler codex [OL].

I

The Palaeographical and Codicological Features of the Osler Manuscript in the Context of the Manuscript Transmission of al-Ghāfiqī's *Herbal*

ADAM GACEK

Al-Ghāfiqī and His Work

The Osler Library of the History of Medicine, McGill University, houses a remarkable medieval Arabic illustrated manuscript on simple drugs, *Kitāb fī l-adwiya al-mufrada* (OL 7508). The work was composed by the 12th-century Andalusian pharmacologist and botanist Abū Jaʿfar Aḥmad b. Muḥammad al-Ghāfiqī (d. ca. 560/1165).[1] Although very little is known about his life, his work quickly became very influential, both in the western and eastern parts of the Islamic world. Max Meyerhof (d. 1945) estimated that his original work consisted of 945 articles/entries of simples derived from vegetable, animal, and mineral matter.[2]

The full name of the author is given on f. 2b, after the *basmala*, as Abū Jaʿfar Aḥmad b. Muḥammad b. Sayyid al-Ghāfiqī, and the title, in a descriptive form, on the same page (f. 2b, line 3) as *Kitāb fī l-adwiya al-mufrada* (*Book of Simple Drugs*). There are two other titles given on f. 10a and f. 283a (colophon) as *Ṭibb-i Qāfiqī* (thus) (*The Medicine of al-Ghāfiqī*) and *Kitāb al-Ghāfiqī* (*The Book of al-Ghāfiqī*), respectively. The title *Ṭibb-i Qāfiqī* is written above the first line of the text with two unpointed *qāf*s and a *fāʾ*, a spelling that betrays its Persian origin whereby the letter *qāf* is sometimes written instead of *ghayn*. Other titles mentioned in various sources are *Kitāb al-adwiya al-mufrada* and *Jāmiʿ* (or *al-Jāmiʿ fī*) *al-adwiya al-mufrada*.[3]

Although the exact date of composition is not known, al-Ghāfiqī wrote his book in the 6th/12th century in Andalusia (probably Cordoba). The work was already known to the Jewish theologian and physician Moses Maimonides (Ibn Maymūn) (d. 1204), who says expressly that he used for his glossary of drug names a book of "one of the recent authors, named al-Ghāfiqī."[4]

Al-Ghāfiqī's "book of simples" was used extensively for the compilation of *al-Jāmiʿ li-mufradāt al-adwiya wa-l-aghdhiya* by his compatriot Ibn al-Bayṭār (d. 646/1248), who, according to Ibn Abī Uṣaybiʿa (d. 668/1270), always took it with him on his voyages.[5] Furthermore, Meyerhof states that Ibn al-Bayṭār quotes al-Ghāfiqī more than 200 times in his *Jāmiʿ*.[6] Al-Ghāfiqī's magnum opus must have travelled quickly from its place of origin to other parts of the Islamic world, since already within a century it was abridged by Bar Hebraeus (Gregorius Abū al-Faraj, Ibn al-ʿIbrī) (d. 1286), a famous Christian Jacobite scholar who came from Asia Minor and later settled and died in Marāgha (northern Iran).[7]

The earliest surviving copy of this abridgement is dated 684/1285, that is, one year before the death of the author and thirty years after the Osler *Herbal* was penned and illustrated. Bar Hebraeus had fashioned his extract "in a most intelligent manner, preserving all the essential material, and leaving off parts of minor importance."[8]

It was later translated into Latin of which three MSS have survived.[9]

Another abridgement of this work was made by Aḥmad b. ʿAlī b. Ibrāhīm b. Abī Jumhūr al-Aḥsāʾī (fl. ca. 880/1475), and a copy of it, under the title *Tartīb al-Ghāfiqī* (*The Re-arrangement of al-Ghāfiqī*), dated 974/1567, has survived and is now preserved in Oxford (Bodleian, Huntington 421).[10]

Writing Surface, Textblock, and Binding

Although an early brief description of this codex appeared in *Bibliotheca Osleriana*,[11] Max Meyerhof was the first scholar to examine this manuscript in quite some detail based on the "photostat" supplied to him by the Osler Library. This is what he had to say about it:

> The handwriting is wonderfully clear and legible, that of a professional calligrapher. The Ghâfiqî Ms was doubtlessly written for a person of high rank. This (*sic*) gives us the beautiful pictures of plants which seem to me better than those of most Dioscurides (*sic*) MSS. On the other hand the text is much less correct as that written by a scholar. There are very few corrections, and in the beginning many lacunae prove that the copyist did not well understand the text which he copied. It seems to me that the first nine leaves had been missing and have been supplied later by another copyist who left out the vocalisation and many (red) names of drugs.[12]

The first preliminary codicological and paleographical description of this codex was made some fifty years later when I arrived at McGill and discovered in the library system

four mostly uncatalogued collections of Islamic manuscripts.[13] The most up-to-date description is as follows:

> The original portion of the textblock is written on thick non-European glazed paper, probably Arab paper, having no visible chain or laid lines. The first quire (quaternion), however, supplied most probably in the 13th/19th century in Iran, is made of paper sprinkled with bluish ink, and is most likely of local manufacture. The fly leaves at the beginning and the end of the codex appear to be of woven European paper.
>
> The manuscript is foliated in pencil by a Western hand and numbers 284 leaves. The foliation includes the first and last folios which normally do not constitute a part of the textblock, as properly speaking they are fly leaves added at the time of rebinding. The manuscript measures 25 x 18 cm with the text area being 20.5 x 13.5 cm in dimension and each page having 23 lines. Each line of writing (except for the chapter and sub-headings) measures 7–8 mm (baseline to baseline). The lines in the first quire are frame-ruled, i.e., using a ruling board. There are no quire signatures. Catchwords (on the versos of folios) are often not supplied or visible (even in the first replacement quire). This is sometimes due to repairs of the lower margins or excessive trimming of leaves during rebinding. Some catchwords were supplied by a later hand. It is also possible that the original part of the codex (ff. 10–283) had catchwords placed at the end of each quire of ten folios only (quinions). It is difficult to establish this as the manuscript is misbound with many of its leaves out of order. The textblock, in its present arrangement of quires, consists of gatherings of ten, fourteen, sixteen, and twenty leaves.

Max Meyerhof, in one of his letters to W.W. Francis (the first Osler Librarian), tried to establish the correct sequence of folios but left out two (see his note on f. 284b). The proper sequence of folios, therefore, appears to be as follows:

> 2–11, 19, 12–18, 20–110, 120, 112–19, 111, 121–2 (one or two leaves missing), 123–41, 143, 142 (one leaf missing), 144–7, 149, 148, 150–253, 274–7, 254–67, 271–3, 279, 278, 268–70, 282, 280–1, 283.

The Osler codex is bound in red leather, without the traditional pentagonal flap. The covers are decorated with central oval medallions and pendants with designs brushed over with gilt. The decoration of the centre medallion consists of the well-known Persian motif "the rose and the nightingale" (*gul va bulbul*). The inside of the covers is decorated with blue-tinted paper. The binding, attached to the textblock upside down, is not origi-

1.1
Centre medallion (lower cover). This and subsequent images in this chapter
are substantially enlarged.

nal; like the first quire, it was supplied in the 13th/19th century. It comes from a different disbound codex as its covers do not quite fit the textblock, being a little bit larger in height and shorter in width.

The Copy and Its Date

The text of the codex begins on f. 2b, after the *basmala* (line 1), and runs as follows:

/2/ قال ابو جعفر احمد بن محمد بن سيّد الغافقي رحمه الله قد كُنت شرعت
/3/ في كتاب في الادوية المفرده اتخذه بذكره لنفسي ...

The last four lines of the first quire are inscribed vertically in the outer margin. The beginning of the original part of the codex on f. 10a is as follows: *min al-quwwa al-ghasāla* **d** (= Dīsqūrīdūs).

The Osler codex represents the first half of the original work, arranged in alphabetical order as far as the letter *kāf*, using the alpha-numerical system (*abjad*). In other words, one letter sequence represents a chapter. Here are the individual letters (11 in all) with the loci for the primary entries:[14]

alif (ff. 5a–53b), *bāʾ* (ff. 66a–99b), *jīm* (ff. 106b–120b), *dāl* (ff. 122a–134b), *hāʾ* (ff. 138b–144a), *wāw* (ff. 145b–152a), *zāy* (ff. 153b–177a), *ḥāʾ* (ff. 179a–207b), *ṭāʾ* (ff. 214b–226b), *yāʾ* (ff. 229b–239a), and *kāf* (ff. 240a–279b).

The text is arranged in such a way that each letter sequence contains descriptions of common medical drugs with references to sources, followed by a section with uncommon names and their linguistic interpretations. These subsections are termed *sharḥ* (lit. "commentary"), for example, *sharḥ mā waqaʿa fī hadhā al-bāb min al-asmāʾ* or *sharḥ al-asmāʾ al-wāqiʿa fī hadhā al-bāb* ("Commentary on the names occurring in this chapter"). They are located as follows:

alif (ff. 53b–66a), *bāʾ* (ff. 99b–106b), *jīm* (ff. 111b, 121a–122a), *dāl* (ff. 134b–138b), *hāʾ* (ff. 144a–145b), *wāw* (ff. 152a–153b), *zāy* (ff. 177a–179a), *ḥāʾ* (ff. 208a–214b), *ṭāʾ* (ff. 226b–229b), *yāʾ* (ff. 239b–240a), and *kāf* (ff. 270b, 280a–283a).

There are 468 primary entries[15] and some 2,200 secondary entries. Within a given chapter, however, an alphabetical sequence is not observed. The same applies to the secondary entries.

The primary entries deal with

1. Plants (herbs, shrubs, trees, etc.), e.g., citron (*utrujj*, f. 11a), anise (*anīsūn*, f. 28a), rice (*aruzz*, f. 14a), spinach (*isfānākh*, f. 35a), chamomile (*bābūnaj*, f. 81a), eggplant (*bādhanjān*, f. 72b), onion (*baṣal*, f. 73a), carrot (*jazar*, f. 112b), wild chicory/endive (*hindibā*, f. 139b), asparagus (*hilyūn/hilyawn*, f. 138b), ginger (*zanjabīl*, f. 160a), wheat (*ḥinṭa*, f. 182b), chickpeas (*ḥimmiṣ*, f. 184b), tarragon (*ṭarkhūn*, f. 216b), jasmine (*yāsmīn*, f. 230b), coriander (*kuzbara*, f. 259b), cabbage (*kurnub*, f. 247b), celery (*karafs*, f. 260a), leek (*karrāth*, f. 278a), and cumin (*kammūn*, f. 258a).

2. Rocks, minerals, and the like, e.g., ochre (*artakān/arīkān?*, f. 49b), white lead (*isfīdhāj*, f. 50b), onyx (*jazʿ*, f. 117b), soot/lamp-black (*dukhān*, f. 131b), pitch, asphalt (*zift*, f. 158b), talc (*ṭalq*, f. 226a), clay/argil (*ṭīn*, f. 221b), ruby (*yāqūt*, f. 239a), sulphur (*kibrīt*, f. 269a), various types of stones (*ḥajar*, ff. 203a–206b), glass (*zujāj*, f. 169b), and vitriol (*zāj*, f. 165b).

3. Animals (mammals, birds, fish, etc.), their parts and produce, e.g., weasel (*ibn ʿirs/ʿurs*, f. 53a), hare (*arnab*, f. 53b), hoopoe (*hudhud*, f. 144a), chicken (*dujāj*, f. 134a), locust (*jarād*, f. 111b), snail (*ḥalazūn*, f. 207a), lizard (*ḥirdhawn*, f. 207b), butter (*zubd*, f. 172b), rennet (*infaḥa*, f. 51b), eggs (*bīḍ*, f. 96b), urine (*bawl*, f. 98a), cheese (*jubn*, f. 118a), hides (*julūd*, f. 118b), brain (*dimāgh*, f. 134a), and blood (*dam*, f. 133a).

The explicit (f. 283a) reads:

/18/ كُولِم /19/ هُوَ الفِلِفِلِ .:. كُومِينون هو الكَمُّون .:. كُوفِيرُون هُو /20/ اَلْبُسر .:. كُوهْيان قد ذكِر مَع اصنأف الكَراْثِ فى حرف كَ هى

Below the explicit is a short colophon (f. 283a), which states that this is the end of the first volume (*juzʾ*) and the end of the letter *kāf*, gives the date (the middle of Shaʿbān 654 = September 1256), and alerts the reader to the fact that the next volume will begin with the letter *lām* while also specifying the next item, namely, *lakk*. It runs as follows:

/21/ تمّ حَرف الكَافِ وَبِتَامِه تمّ الجزء الاوّل مِنْ كِتاب /22/ الغَافقى وَالحمدُ لله حَقّ حَمِدِهِ وَذلك فى منتصف شَعبْان سَنه اربع حمس سنه(!) /23/ ويَتلوه في المجلّد الثَّأنى حَرف اَللَّام لَكّ والحمد لله رَبّ العالِمين

Features of the Osler Manuscript in Context 23

The date, 654 H, is inscribed in an unusual way and is difficult to read. It is spelled out in three words without the standard connecting *wāws* between them. Furthermore, the word *khamsīn* (fifty) is written with a contracted *yā'*, while the word *sittumi'a* (six hundred) is contracted to *sīn mu'allaqa* (i.e., without denticles), unpointed *tā'*, unpointed *yā'*, and the final *hā'*:

1.2
f. 283a (fragment).

The date 504 H is written obliquely in the lower margin (over a repair) by a European hand. The same date is inscribed on f. 1a followed by, in round brackets, (Dr Sa'eed).

An inscription by W.W. Francis on f. 1a also states that "Sir Denison Ross interpreted the difficult date of this MS as 654 A.H. = A.D. 1256. I took it to him to the Oriental School in London. W.W.F."[16] The reading of the date 504 H is unlikely, even if it referred to the date of composition, as our author died in 560 H.

The main text is written in black ink. However, red ink is used for names of authorities or sources indicated either by a proper name, for example, Ibn Māsawayh (d. 243/857), Ibn Māssa (fl. mid-3rd/mid-9th century), Ibn 'Imrān (d. ca. 292/905), al-Rāzī (d. 313/925), al-Isrā'īlī (d. ca. 320/932) (all on f. 10a) or by the title of the work, such as *Kitāb al-aḥjār* (f. 132b), *al-Aḥjār* (f. 169b), and *al-Filāḥa* (ff. 116b, 127a, 161a). The text attributed to the author (al-Ghāfiqī) is marked by *lī* or *al-mu'allif* (ff. 136b, 137b, 139b), while unknown quotations are indicated by *ghayruhu* and *majhūl*. Furthermore, red ink is used for captions of illustrations, the letter-numerals for chapters/sections referred to in the sources quoted, and abbreviations.

Rubrications for the names of plants and sources are not supplied in the replacement first quire (ff. 2b–9b). Here the missing plant names are:

asārūn (f. 5a, wild spikenard, asarum), *idhkhir* (f. 6a, aromatic rush), *ushna* (f. 6b, moss), *armāl* (f. 7a, cortex culilawan?), *ubhul* (f. 7b, juniper berries), *athl* (f. 8a, tamarisk), *arāk* (f. 8b, salvadora persica), *abanūs* (f. 8b, ebony), and *ās* (f. 9a, myrtle).

There are four abbreviations for sources used in the manuscript: the letter *dāl* for Dīsqūrīdūs (Dioscorides, fl. 2nd half of 1st century CE), unpointed *jīm* (isolated or initial forms) for Jālīnūs (Galen, d. ca. 200 CE), *fā'* for Abū Ḥanīfa al-Dīnawarī (d. ca. 281–2/894–6), and *hā'* for *al-Ḥāwī fī l-ṭibb* by Abū Bakr al-Rāzī (d. 313/925).[17] These abbreviations, in the form of *sigla*, as well as the letter-numbers following them, are marked by a superscript wavy stroke.

The ends of articles in the main entries are marked by a circle (sometimes open) with a dot inside or *hy* (initial *hā'* and final *yā'*) for *intahá* ("it is finished") or three dots arranged in a triangle. The three triangular dots are also used to separate short entries in the secondary entries (*sharḥ*).

Although not explicitly stated, the text was originally collated by the original scribe (ff. 27a, 50b, 71a, 72b, 73b). Later corrections by at least two hands are also visible (ff. 38a, 47b, 71a, 71b, 73b, 77b). Most of the corrections are for omissions. Two types of *signes de renvoi* are employed: the numeral two (٢) or a curved line. The superscript number two (often found in manuscripts of Iranian provenance) is used for variants and the curved line for omissions. The omitted passages to be inserted in the body of the text usually end with the word *ṣaḥḥa* (ff. 66b, 73b) and are sometimes followed by a crossed-out next word in the text (f. 170b), whereas the variants in the margins are indicated by ٢ and a pointed or unpointed *khā'* (خ) (for *nuskha, nuskha ukhrá*) (ff. 10a, 81b, 169b). Some words have a thin line over them (ff. 72b, 123a) signifying deletion of dittographic errors. Sometimes, however, cancellations are made by means of thin oblique strokes running through words (see, e.g., f. 161a).

Scripts and Hands

As mentioned earlier, the codex, as it has come down to us, consists of two parts: the original (dated 654 H) and the one quire at the beginning supplied in the 13th/19th century. However, in the original (older) part of the codex, some folios may have been executed by a different hand or pen (see, e.g., ff. 30a–b, 68b, 122b, 164a).

Original Quires (ff. 10a–283a)

The main entries for chapter headings (*bāb ḥarf* ..., *ḥarf* ..., and *sharḥ* ...) and plant labels are executed in black *muḥaqqaq* script, exhibiting sometimes features more common to *thuluth*, with serifs on the ascenders. The height of the *alif* in chapter headings is 10 mm and the height of *alif* in plant labels is 7–8 mm.

شرح الأسماء الواقعة في هذا الباب

1.3
f. 111b.

1.4
f. 138b.

1.5
f. 34b.

The main text, on the other hand, is penned in serifless *naskh* script, characteristic of many Mamluk manuscripts, with a contrast of thin and thick strokes. A bolder script is also used in the secondary entries (*sharḥ*) of the text. The text is mostly pointed and sometimes partly vocalized.

There are a number of characteristic individual letterforms in the main text, including the serifless *alif* with its head often thicker than its foot. There is a tail/spur on the *alif* of prolongation and a distinct bow on the final *sīn*, *shīn*, *nūn*, *qāf*, and *fāʾ*. The initial or middle *kāf* often looks like *lām*, having no oblique stroke (*shaqq/shakl*) over it. If, however, it is present, the *shakl* is usually detached and thin. The final *lām* has a flat foot that sits on the baseline or descends below it. The final *mīm* often has a short tail to the left or a long straight downward stroke, and the final *hāʾ* is sometimes joined to the preceding *rāʾ*. The letter *yāʾ*, as opposed to *hamza*, is used after the *alif* of prolongation (e.g., *māyil*, f. 28a), sometimes not pointed (*rāyiḥah*, f. 28b). The ligature *lām alif al-warrāqiyya* has a triangular base and *lām alif al-muḥaqqaqa* sometimes has a serif on the *alif*.

When vocalization is present, the *kasra* is represented by a vertical or oblique stroke and the nunation (*tanwīn*), in the indefinite nominative, by a wavy sign (like a *wāw* and a *khāʾ makhṭūfa*). Sometimes *yāʾ maqṣūra* in such words as *ilá* and *ʿalá* is pointed. The unpointed (*muhmal*) letters such as *sīn* and *rāʾ* are indicated by a v-sign, and miniature subscript forms of the letters *ḥāʾ* and *ʿayn* are employed so that they are not read as or confused with the *jīm*s/*khāʾ*s and *ghayn*s. Also, the initial form of the letter *hāʾ* (ه) is placed over the final *hāʾ* for a similar reason.

The Herbal of al-Ghāfiqī

1.6
f. 13a (fragment).

1.7
Selected words from f. 24a.

Later Supplied First Quire (ff. 2b–9b)

The *naskh* script employed in the first quire, supplied at the time of restoration of the original manuscript (most probably in the 13th/19th century), has many characteristics common to the Iranian bookhands. It is less heavy and more round than the script of the rest of the codex, and its strokes are almost of uniform thickness. Although not executed systematically, it has distinct sharp serifs sloping to the left on the shaft of the *lām*, as well as on the *alif* of the *lām alif al-warrāqiyya* and *lām alif al-mukhaffafa*. Furthermore, the foot of the final *lām* is bowed (as opposed to flat), and the partial vocalization often employs vertical *fatḥa*s and *kasra*s.

1.8
f. 3a (fragment).

1.9
Selected words from f. 3a.

Illustrations

Originally reported in *Bibliotheca Osleriana* and by Meyerhof as having 367 illustrations,[18] on careful examination the Osler codex has all together 397 illustrations, if each individual plant is counted separately.[19]

There are nine illustrations in the later replacements (ff. 2–9). In this part of the codex illustrations are mostly in the margins, while some others are located within the text. Those in the margins are often cropped, and there are no captions to identify a given illustration. The penultimate illustration (f. 279b) is not supplied, and the inscription in the blank space reads: *waqaʿa sahw fī hādhā al-ikhlāʾ* ("there is an inadvertent mistake in this empty space"). There are usually one or two, but sometimes three and even four illustrations on one page (see, e.g., f. 88a and f. 251a).

According to Max Meyerhof, about 90 of these pictures are not derived from Dioscorides. In a letter to W.W. Francis, Meyerhof writes:

> I made a list of such pictures as cannot be derived from Dioscurides MSS as they concern plants unknown to the Greeks. They are about 90 in number. This is of great

importance, as I do not know any other MS containing the pictures of these plants and drugs.[20]

Apart from full depictions of plants (with fruit or flowers), we find illustrated: two types of roots of plants (*alang*, f. 35a; and *bahman*, f. 76a), four types of mushrooms or fungi (*tarāthīth*, sg. *tarthūth*, f. 219b; *kamā*, f. 250a; and *kishna*, f. 250b), eight animals (mammals, snakes, fish), namely, viper (*afʿā*, f. 52b), weasel (*ibn ʿirs* or *ibn ʿurs*, f. 53a), hare (*arnab*, f. 53b), "marine hare" (*arnab al-baḥr*, f. 53b), three species of beaver (*jundabādastar*, *qastaryūn*, f. 119a–b), and an eel (*jirrī*, f. 111a). Furthermore, there are illustrations of a shell of an aquatic animal (*aẓfār al-ṭīb*, f. 51b), the bark of a "bunk" tree (f.68a), a wood louse (*hadaba*, f. 144a), a pot and tools for making pitch or asphalt (*zift*, f. 158b), tetter (skin eruption) (*ḥazāz al-sakhr*, f. 196a), and, mace, the dry husks of the nutmeg seed (*ṭālshafīr*, f. 214b).

1.10
f. 158b (article: *zift*).

History of the Manuscript

After its copying and illustration, the earliest documented history of the Osler *Herbal* points to the 11th/17th century, at which time the manuscript appears to have found its way to Iran. This is evidenced by three seals, two of which are dated. The earliest seal (f. 10a), of oval shape (10 x 17mm) and with the motto *wa-salām ʿalá Ibrāhīm*, is dated 1051/1641–2 and may refer to a person whose name was either Ibrāhīm or ʿAlī Ibrāhīm.[21] The second seal, this one of rectangular shape (14 x 17 mm) and found on the same page (f. 10a) (later repeated but cut off on f. 283a), bears the name Jamāl Dīn Muḥammad al-Ḥusaynī (or Muḥammad Jamāl al-Dīn al-Ḥusaynī) and the date 1080?/1669–70. There are two other seal impressions: a small, round one (13 mm in diameter) with the motto: *tawakkaltu ʿalá Allāh* ("I have put my trust in God") (ff. 119a, 127b, and 128a), and a large round seal that is now totally obliterated (f. 283a).

1.11
Seals 1 and 2, folio 10a.

1.12
Seal 3, f. 128a.

The Osler *Herbal*, originally believed to be the first volume of an Arabic translation of the work of Dioscorides, *De materia medica*, was purchased for William Osler (d. 1919) from a Persian owner in 1912.[22] It was acquired along with another illustrated manuscript that was indeed an Arabic Dioscorides and which now forms part of the holdings of the Bodleian Library.[23] A description of this manuscript on a piece of paper and in pencil, now pasted onto the front of this codex (f. 1a), gives the shelf number 346.[24]

Both manuscripts were obtained by William Osler through J.H. Bill, officer of the Indian Civil Service, for £25.[25] The new ownership is evidenced by a bookplate (on the inside of the front cover of the Osler manuscript) that reads: "FROM THE LIBRARY OF SIR WILLIAM OSLER, BART, OXFORD."[26]

State of Preservation

The Osler *Herbal* has suffered from numerous repairs of margins, sometimes with loss of text. In its present condition, it has a good number of cropped illustrations, catchwords, and captions. There are also instances of areas of the written surface (text and illustrations) damaged by dampness and peeled off (ff. 19a, 41b, 69b), cases where parts of illustrations encroach on the text (ff. 43b, 69b) or show through (f. 42a), and also instances of ink/pigment offsetting and transference.

Other Manuscripts

To date, eight other manuscripts of the *Herbal* have been reported or have come to light. They are:

1 Cairo, Dār al-āthār al-ʿarabiyya / Museum of Islamic Art (3907), dated 990/1582. According to Max Meyerhof, it is illustrated and based on the Osler codex, even to the extent of having the same mistakes and corrections.[27]
2 Cairo, Royal Egyptian Library, now Dār al-kutub al-miṣriyya (Ṭalʿat 624).[28] Just as the previous one, this illustrated manuscript represents only one half of the original composition.
3 Rabat, al-Khizāna al-ʿāmma / Bibliothèque Générale (Q155). It contains only the first half of the work (the letters *alif, bāʾ, jīm, dāl, hāʾ, wāw, zāy*), has no illustrations, and exhibits no date.[29]
4 Tripoli (Libya), private library. Copied in Maghribī script, it appears to have no illustrations and its beginning and end are wanting, although it does contain most of the original text (as far as the letter *shīn*, the last letter in the Maghribī *abjad*).[30]
5 Tunis, Bibliothèque Nationale (Fonds Ḥasan Ḥusnī ʿAbd al-Wahhāb, 18177). This witness is mutilated in places, has many gaps left by the scribe, and no illustrations.[31]
6 Tehran, Kitābkhānah-ʾi millī-i malik (5958). This manuscript, slightly incomplete at the beginning, contains only the first part of the work (*alif-kāf*, in the *abjad* sequence) and is illustrated. It was copied for Nawwāb Mīrzā Shāh Abū l-Mahdī by Muḥammad Muẓaffar ibn Muḥammad Ḥakīm, Wed. 29th of Dhū l-Ḥijja 1077/1667.[32]
7 Tehran, Dānishgāh-i Tihrān (7401). Copied in the 8th/14th century by Murtaḍā ibn Mujtabā ibn Mukhtār ibn Hādī Ḥusaynī Yazdī, this witness is incomplete at the end (as far as the beginning of the letter *ghayn*), contains only the commentary (*sharḥ*) to each letter sequence, and has no illustrations.[33]
8 Istanbul, no precise location or other details are given.[34]

It is clear from the above that the Osler codex, although representing only the first half of the original work, is the oldest illustrated witness in existence. A critical edition based on two extant MSS (that of Osler and Rabat) has recently been undertaken by Eleonora Di Vincenzo, who published the first volume, covering the letter *alif*, in 2009, on the bases of the Osler and Rabat MSS.[35]

NOTES

1 For a biography of al-Ghāfiqī see A. Dietrich, "al-Ghāfiḳī, Abū Djaʿfar Aḥmad b. Muḥammad b. Aḥmad Ibn al-Sayyid," in *Encyclopaedia of Islam*, 2nd ed., 12: 313–14. See also Ibn Abī Uṣaybiʿa, *ʿUyūn al-anbāʾ fī ṭabaqāt al-aṭibbāʾ*, edited by Nizār Riḍā, (Beirut: Dār maktabat al-ḥayāt, 1965), 500–1; C. Brockelmann, *Geschichte der arabischen Litteratur*, I: 643, SI, 891; and I. Garijo Galán, "Al-Gāfiqī, Abū Ŷaʿfar," in Jorge Lirola Delgado and José Miguel Puerta Vílchez, eds., *Enciclopedia de al-Andalus: Diccionario de Autores y Obras Andalusíes* (Seville: Junta de Andalucía, Consejería de Cultura; Granada: Fundación El Legado Andalusí, 2002), 174–6.

2 See his "Études de pharmacologie arabe tirées de manuscrits inédits: III, Deux manuscrits illustrés du 'Livre des simples' d 'Aḥmad al-Ġāfiqī," *Bulletin de l'Institut d'Égypte* 23 (1940–41): 18.

3 A. Gacek, *Arabic Manuscripts in the Libraries of McGill University: Union Catalogue* (Montreal: McGill University Libraries, 1991), 95.

4 See his *Šarḥ asmāʾ al-ʿuqqār = L'explication des noms de drogues: Un glossaire de matière médicale composé par Maïmonide*; texte publié pour la première fois d'après le manuscrit unique avec traduction, commentaires et index par ed. Max Meyerhof (Cairo: Imprimerie de l'Institut français d'archéologie orientale, 1940; reprinted Frankfurt am Main: Institute for the History of Arabic-Islamic Science at the Johann Wolfgang Goethe University, 1996), 4. See also the letter by Meyerhof to W.W. Francis dated 20 Jan. 1938; currently housed in the Osler Library.

5 See Bar Hebraeus (Gregorius Abū al-Faraj, Ibn al-ʿIbrī), *The Abridged Version of "The Book of Simple Drugs" of Aḥmad ibn Muḥammad al-Ghâfiqî*, edited and translated by Max Meyerhof and G.P. Sobhy (Cairo: al-Ettemad Printing Press, Government Printing House, 1932–40; reprinted Frankfurt am Main: Institute for the History of Arabic-Islamic Science at the Johann Wolfgang Goethe University, 1996), 33, and Meyerhof, "Études de pharmacologie arabe," 19.

6 "Études de pharmacologie arabe," 18.

7 Bar Hebraeus, *Abridged Version*. It covers the letters *alif*, *bāʾ*, *jīm*, *dāl*, *hāʾ*, and *wāw* only. There are four existing manuscripts of the abridgment: (1) Cairo, Aḥmad Taymūr Pāsha (389 Ṭibb, dated 684/1285), for which see Meyerhof, "Études de pharmacologie arabe," 14; Bar Hebraeus, *Abridged Version*, 38–9; and H. Takahashi, *Barhebraeus: A Bio-Bibliography* (Piscataway, NJ: Gorgias Press, 2005), 389; (2) Gotha (arab 1998), dated 1694 CE, for which see Meyerhof, "Études de pharmacologie arabe," 14; Bar Hebraeus, *Abridged Version*, 38–9; and Takahashi, *Barhebraeus*, 389; (3) Aleppo, private library, for which see Meyerhof, "Études de pharmacologie arabe," 15; and (4) Göttingen, no. 1998, for which see C. Peña et al., "Corpus Medicorum Arabico-Hispanorum," *Awrāq* 4 (1981): 92. The Göttingen MS edited by Peña may actually be the Gotha MS; this awaits confirmation by personal inspection.

8 Bar Hebraeus, *Abridged Version*, 588.

9 The three Latin translations of the abridgement are in Munich, Basel, and Bern (Meyerhof, "Études de pharmacologie arabe," 14, quoting Steinschneider, "Gafikis Verzeichnis").

10 The author's name as given in the colophon is Aḥmad b. Abī Jumhūr (*sic*) Ḥasāʾī (*sic*) and the MS has 146 folios; see I. Garijo Galán, "La sistematización de al-Gāfiqī," in P. Cano Avila and Ildefonso Garijo Galán, eds., *El saber en al-Andalus: Textos y estudios* (Seville: Universidad de Sevilla, 1997), 138–9. For a detailed description of this MS, see E. Savage-Smith, *A New Catalogue of Arabic Manuscripts in the Bodleian Library, University of Oxford* (Oxford: Oxford University Press 2011), 1: 518–20, 566–7, 661–5.

11 W. Osler, *Bibliotheca Osleriana: A Catalogue of Books Illustrating the History of Medicine and Science* (Montreal: McGill-Queen's University Press, 1969), 663 (a photocopy of this entry is pasted on the inside of the front cover of the Osler manuscript).

12 Letter to W.W. Francis, dated 20 Jan. 1938.

13 This is a new, extended version of my article, "Arabic Calligraphy and the 'Herbal' of al-Ghâfiqî: A Survey of Arabic Manuscripts at McGill University," *Fontanus* 2 (1989): 37–53. See also A. Gacek, "Drugs for Bodies … and Books," in Faith Wallis and Pamela Miller, eds., *75 Books from the Osler Library* (Montreal: Osler Library, McGill University, 2004), 76–7.

14 Cf. Oliver Kahl's essay in this volume, p. 42.

15 According to Meyerhof, there are 475 entries ("Études de pharmacologie arabe," 16).

16 Meyerhof also reads this date as 654 H without any qualification (see ibid.).

17 The Osler MS (f. 4a) does not give the abbreviations *fāʾ* and *ḥāʾ*. This information is supplied here from the edition by Eleonora di Vincenzo (see n35).

18 "Études de pharmacologie arabe," 16.

19 Three illustrations on f. 51b, f. 144a, and f. 158b were counted as one and two illustrations on f. 76a and f. 219b were counted as two each by the current writer.

20 A letter dated 7 June 1938; currently housed in the Osler Library.

21 The motto appears to be an adaptation of the phrase in the Qurʾan, Anbiyāʾ (21), v. 69, *qulnā yā nāru kūnī bardan wa-salāman ʿalá Ibrāhīm*.

22 Not Dr M. Sa eed; see A. Date, "The Story of Osler's First Four Arabic Manuscript Acquisitions," *Osler Library Newsletter*, no. 106 (2006): 2 and 5.

23 This volume represents Books III–V; see M. Collins, *Medieval Herbals: The Illustrative Traditions* (London: British Library, 2000), 135.

24 This MS dated at al-Madrasa al-Niẓāmiyya (probably Baghdad) in 637/1239 now bears the shelf mark, Arab. d. 138; see B.W. Robinson and B. Gray, *The Persian Art of the Book: Catalogue of an Exhibition Held at the Bodleian Library to Mark the Sixth International Congress of Iranian Art and Archaeology* (Oxford: Bodleian Library, 1972), 9–10, pl.1. A recent detailed description of this MS can be found in E. Savage-Smith, *A New Catalogue of Arabic Manuscripts*, 1: 44–65.

25 See his letter to Dr Cowley dated 7 Jan. [19]11. See also Date, "The Story of Osler's

26 First Four Arabic Manuscript Acquisitions," 1–8.

26 Above the bookplate there is a copy of the description from the *Bibliotheca Osleriana* stating that the MS has "about 367 coloured drawings of plants and 6 of animals" and that it was purchased with the Arabic Dioscorides, no. 346, from a Persian in 1912. This label also mentions that "MS. Hunt 421 (I) in the Bodleian Library appears to be abridged from this work." Furthermore, on f. 283b there is a list of historical events relating to such cities as Samarqand, Herāt, and Baghdad (all probably in the ninth/fifteenth century) and (beneath it) a chess score (ḥisāb al-shaṭranj). At the bottom of the same page there is a partly legible statement (written upside down) with a date 868?/1463–4. Finally, on f. 284b beneath a list of the correct order of leaves (copied from a letter by Meyerhof to Francis) there is a note about photographic reproductions of the Osler manuscript made for Meyerhof at Cairo, 1938, Princeton University Library, and the University of Uppsala, Sweden, Oct. 1952.

27 Meyerhof, "Études de pharmacologie arabe," 17–18, 29.

28 Preface to *Abridged Version*. See also M. Ullmann, *Die Medizin im Islam* (Leiden: Brill, 1970), 277.

29 According to Ibn Murād, it is "more perfect and more reliable"; see Ibrāhīm ibn Murād, "Abū Jaʿfar Aḥmad al-Ghāfiqī fī Kitāb 'Al-Adwiya al-mufrada': Dirāsa fī l-kitāb wa-taḥqīq li-muqaddimatih wa-namādhij li-shurūḥih," *Majallat Maʿhad al-Makhṭūṭāt al-ʿArabiyya* 30, no. 1 (1986): 166–7. See also Ullmann, *Medizin im Islam*, 277.

30 E[ttore] R[ossi], "Un manoscritto del trattato di farmacologia di al-Ghafiqi scoperto dal prof. Tommaso Sarnelli a Tripoli," *Oriente Moderno* 23 (1953): 67–8; Ibn Murād, "Abū Jaʿfar," 164, no. 200; Ullman, *Medizin*, 277.

31 I am grateful for this information to Fabian Käs, author of the recently published *Die Mineralien in der arabischen Pharmakognosie: Eine Konkordanz zur mineralischen Materia medica der klassischen arabischen Heilmittelkunde nebst überlieferungsgeschichtlichen Studien*, 2 vols. (Wiesbaden: Harrassowitz, 2010), 1: 110.

32 Īraj Afshār and Muḥammad Taqī Dānish'pazhūh, *Fihrist-i kitābhā-yi khaṭṭī-i Kitābkhāna-'i Millī-i Malik* (Tehran: [Kitābkhāna], 1352– [1973 or 1974–]), 1: 195–6.

33 Muḥammad Taqī Dānish'pazhūh, *Fihrist-i Kitābkhāna-'i Ihdā'ī-i Āqā-yi Sayyid Muḥammad Mishkāt bih Kitābkhāna-i Dānish'gā-i Tihrān* (Tehran: Muʾassasa-'i Intishārāt va Chāp-i Dānishgā-i Tihrān, 1330– [1951 or 1952–]), 16: 546.

34 I. Garijo Galán, "Radiografia de una obra inédita de Abū Ŷaʿfar al-Gāfiqī," *Revista del Instituto Egipcio de Estudios Islámicos en Madrid* 29 (1997): 283.

35 Abū Jaʿfar Aḥmad b. Muḥammad al-Ghāfiqī, *Kitāb al-'adwiya al-mufrada, di 'Abū Ǧaʿfar 'Aḥmad b. Muḥammad b. 'Aḥmad b. Sayyid al-Ġāfiqī (XII sec.)*, edited by Eleonora Di Vincenzo (Pisa and Rome: F. Serra, 2009).

2

The Text and Its Philological Character

OLIVER KAHL

Abū Jaʿfar Aḥmad b. Muḥammad al-Ghāfiqī's (d. ca. 560/1165) *Book of Simple Drugs* (*Kitāb fī l-adwiya al-mufrada*), of which the Osler manuscript represents a beautiful and important textual witness, forms part of a long and distinguished scholarly tradition within the wider framework of Arabic medico-pharmaceutical literature. Future studies of his book, which essentially is a huge compilation of botanical and pharmacognostic information, will no doubt reveal whether or not al-Ghāfiqī can be considered an "original" author, that is, to what extent he actually enhanced existing knowledge and thereby surpassed his many predecessors in the field. It is not within the scope of this essay to address the question of al-Ghāfiqī's literary sources,[1] nor where and how his own book might have been used subsequently as a source by others. I will therefore limit myself here to a few cautious, preliminary observations on that subject, insofar as it may be helpful to understand some of the philological aspects of al-Ghāfiqī's work.

Looking at both the quantity and quality of al-Ghāfiqī's compilation, it is immediately obvious that he depended on and exploited a great variety of different literary sources, and he himself, far from trying to disguise this debt, is on the contrary rather concerned with backing up relevant pieces of information by directly and explicitly referring to his textual templates: first and foremost the ubiquitous writings (in Arabic translation) of Dioscorides (fl. 2nd half of 1st century CE) and Galen (d. ca. 200 CE), but also on occasion the works of lesser known Greeks such as Paul of Aegina (fl. 7th century CE);[2] the *Saṃhitā* (again in Arabic translation) of the Indian physician Caraka (*Sharak*) (fl. 2nd century CE?); and of course a large number of authors writing in Arabic (or in some cases Syriac) from all across the Islamic world, for example, Abū Jurayj (the Monk; fl. 1st/7th century?), Māsarjawayh (fl. 2nd/8th century?), (ʿĪsā) b. Māssa (fl. mid-3rd/mid-9th century), Masīḥ (al-Dimashqī; d. after 224/839), (Yūḥannā) b. Māsawayh (d. 243/857), (ʿAlī b. Sahl Rabban) al-Ṭabarī (d. 250/864), Abū Ḥanīfa (al-Dīnawarī; d. 282/895), Ḥubaysh (al-Aʿsam; d. late 3rd/late 9th century), (Isḥāq) b. ʿImrān (d. ca. 292/905),

al-Rāzī (hereafter Rhazes; d. 313/925), (Isḥāq b. Sulaymān) al-Isrāʾīlī (d. ca. 320/932), Ibn al-Jazzār (d. 369/979), Ibn Sīnā (hereafter Avicenna; d. 428/1037), or Ibn Janāḥ (d. after 432/1040). Sometimes a source is quoted by title only, for example, the so-called Nabataean Agriculture (*al-Filāḥa al-nabaṭiyya*) of Ibn Waḥshiyya (d. 323/935); sometimes anonymously as "another" (*ghayruhu*) or simply as "unknown" (*majhūl*); and occasionally al-Ghāfiqī adds his own remarks, labelled "by me" (*lī*). When considering the descriptive (i.e., botanical) sections of al-Ghāfiqī's book in view of his occupation and environment, one would expect him to rely particularly heavily on *Andalusian* sources; this, however, is far less obvious from his explicit quotations: he does indeed quote Ibn Juljul (d. after 377/987), Ibn Samajūn (fl. 392/1002), and Ibn Wāfid (d. ca. 466/1074),³ but these authors do not seem to have carried for al-Ghāfiqī any more weight than "eastern" or "foreign" authorities; in fact, they rather fade into the background next to the likes of Dioscorides, Galen, Rhazes, and Avicenna. And to what extent did al-Ghāfiqī use the important multilingual glossary of medico-pharmaceutical terms titled *Kitāb al-mustaʿīnī*, written only two generations earlier by the Andalusian physician Ibn Biklārish (fl. 490/1097) for the then ruler of Saragossa, al-Mustaʿīn bi-Allāh? Here again, future research will have to provide answers.⁴ On the other hand, it seems clear that al-Ghāfiqī's book was itself considered important enough to be a major source of information: no less than the celebrated scientist Ibn al-Bayṭār (d. 646/1248) of Málaga incorporated a lot of material from al-Ghāfiqī into his huge *Compendium of Simple Drugs and Dietaries* (*al-Jāmiʿ li-mufradāt al-adwiya wa-l-aghdhiya*).⁵

Another question we need to address in order to contextualize al-Ghāfiqī's book properly is that of literary divisions in medieval Arabic science. According to the indigenous Arabic tradition, pharmacy is a branch of medicine or, as the great physician Rhazes once put it, "an ancillary art" (*ṣināʿa khādima*);⁶ pharmacy itself was considered by the old Arab doctors to be split into two branches, one dealing with simple drugs (*adwiya mufrada*) and another dealing with compound drugs (*adwiya murakkaba*).⁷ This classification is tangible for us only through the literature that has survived, tracing back to specific textual paradigms that were adopted mainly from the Greek tradition at a relatively early stage in Islamic history: Galen's Περὶ κράσεως καὶ δυνάμεως τῶν ἁπλῶν φαρμάκων (*On the Mixtures and Powers of Simple Drugs*) and Περὶ συνθέσεως φαρμάκων (*On the Composition of Drugs*), two conceptually separate works, were both translated into Arabic in the 3rd/9th century, and we find similar distinctions in Ayurvedic texts, some of which had also been translated into Arabic at an even earlier period of time. Al-Ghāfiqī's book, as is evident already from its title, belongs to the group of medico-pharmaceutical writings that deal with simple drugs, exploring a branch of the discipline that we call "pharmacognosy" or, since the vast majority of simples are of vegetable origin,⁸ "applied botany" as well. Within this branch of pharmacognosy, and again observing the indigenous tradition, we can perceive an interplay between two different literary genres, though they have never been explicitly categorized as such by

the old Arab doctors: the first is specific to the discipline while the second is wider in scope and also appertains to pharmacological and even purely medical literature. In more precise terms, the first genre is concerned with the description of mainly vegetable substances and the study of their medicinal properties; the second genre is strictly speaking an exponent of linguistics, for it is concerned largely with etymological correlations of "scientific" names and terms. It is important to note here that in al-Ghāfiqī's book we encounter both genres, which he organized in such a way as to create, in effect, two separate yet related textual entities or, to put it plainly, two books between one pair of covers. And because these two genres arise from practical as much as philological conventions and necessities, it is worthwhile to outline their basic structures, focusing in particular on the historical conditions, inner development, and formal manifestations of the genre that involves linguistic exercises.

The first genre, which is specific to the discipline of pharmacognosy and largely concerned with substances of vegetable origin, theoretically corresponds to what we call "botany," and practically covers much of the same ground. Pharmacognosy, generally speaking, represents the strongest exponent of applied botany. As other contributors to this volume deal with the scientific content and literary context of al-Ghāfiqī's *Herbal*, I will confine myself here to some general remarks on the subject of botany in medieval Arabic science, and focus on those aspects that are relevant to understanding the philological character of the text. Above all, we need to remember that many branches of knowledge, which in our contemporary world are defined as "scientific" and cultivated within the paradigms of science, have no absolute conceptual equivalents in the realm of medieval Islam; at the same time, some other, for us rather unscientific forms of human inquiry, such as alchemy, astrology, or magic, were pursued by the old Arab scholars with the same intellectual rigour and the same rationalistic curiosity as were, for example, mathematics or geography. There remain, to be sure, enough parallels and overlaps between historical and modern scientific concepts to justify their description under similar terms, bearing in mind that such terminological transfers are always anachronistic to a certain extent. Botany, then, as a single, isolated scientific field did not exist in early medieval Islam; the same is true for zoology and mineralogy, and even medicine as a scientific occupation must be understood differently. In epistemological terms these sciences were, not exclusively but to a high degree, a matter of book knowledge and tradition, and scientific exercises were largely conducted within the parameters of scholasticism – I will return to this point later on. And in the same way as botany was not a clearly demarcated scientific specialty, botanical knowledge was not confined to specialized literature and expressed itself just as well in the contexts of natural philosophy, agriculture, or magic, and within the wider framework of encyclopedias and cosmographies. The earliest indigenous Arabic works on botany are, in fact, onomastica, collections of plant names made by philologists on the basis of pre-Islamic poetry, the Qurʾān, and the corpus of religious traditions known as Ḥadīth, and as such were

motivated more by lexicological than strictly botanical agendas. But, even in the treatises of these inveterate philologists, we can already discern certain influences from non-Arabic quarters, notably in the form of more or less digested ideas about botanical classifications and a keen interest, well beyond the needs of lexicology, in questions of plant physiology.[9] With the translations into Arabic during the 3rd/9th century of Dioscorides' Περὶ ὕλης ἰατρικῆς (*On Medical Matters*), Galen's Περὶ κράσεως καὶ δυνάμεως τῶν ἁπλῶν φαρμάκων (*On the Mixtures and Powers of Simple Drugs*), and Caraka's *Saṃhitā*, the study of botany as practised by philologists, pharmacists, and physicians alike received a major impulse, and the nascent discipline was provided with improved and more sophisticated features; together with a vast number of new plants and plant names, the Arabs also found their practical knowledge, both in terms of plant physiology and medicinal applications, considerably enhanced and furthermore learned to organize the material according to scientific criteria and systematic functions, gradually moving away from descriptive inventories to higher and, in many ways, more comprehensive and practically minded forms of literary organization.[10] This development also led to the birth of pharmacognosy, which, though remaining an exponent of botany, soon began to distinguish itself in style and content from the cluster of writings that dealt with botanical issues from geoponic, hermetic, or metaphysical points of view. If Dioscorides furnished the Arabs first and foremost with the basic principles of plant systematics (naming, classification, life cycles, and morphology), it was Galen who gave them a theoretical superstructure; referring to Dioscorides, Galen in his aforesaid work refrained from detailed botanical descriptions and concentrated instead on the "qualities" and "degrees" of medicinal substances along the lines of humoral pathology or, as it is now known, humoralism, supplementing also the pharmaceutical observations of his famous predecessor.[11] From there the Arabs took it and raised the discipline, literally within a few decades, to new heights of scientific sophistication, surpassing in many ways their Greek and Indian teachers. Here is not the place to follow this remarkable evolution any further, so suffice it to say that al-Ghāfiqī's *Herbal* already stands near the end of a relatively long chain of medico-pharmaceutical development in the Arab world, and that it embodies and reflects the many achievements of earlier generations in an equally ingenious manner. Insofar as the purely pharmacognostic sections of al-Ghāfiqī's double-sided text are concerned, we can briefly summarize the basic structure of each entry as follows: plant morphology, habitat, species and varieties, elementary constitution (i.e., humoral qualities and degrees), medicinal properties, and forms of therapeutic application, all thoroughly backed up by quotations from relevant sources; in the rare case of animals, the descriptions tend to be briefer and more pragmatic. Yet al-Ghāfiqī's book has another "layer," composed of linguistic sections that correspond to, and are directly related with, the sections on pharmacognosy. We have already referred to these linguistic sections as representing, on a formal level, a second scientific genre, and because they lead to the core of our topic, we must now take a close look at their textual genesis and literary formation.

In order to understand the essence of this second genre, pharmaco-botanical in its contextual framework but for all intents and purposes a response to certain linguistic realities, we have to go back to the great translation movement in Baghdad, which began in the late 2nd/late 8th century and lasted for about 200 years. During that period of time, virtually all available Greek secular books (scientific and philosophical) were translated into Arabic, together with a significant number of works originally written in Syriac, Persian, and Sanskrit.[12] The translators, notably of scientific texts formulated in languages as diverse as Greek, Syriac, Persian, and Sanskrit, had to create *ex novo* a vast body of terminological symbols (i.e., words and syntagms) in order to represent items and concepts for which the Arabic language previously had no equivalents; the translators, to accomplish this feat, relied mainly on the methods of transliteration and loan-translation respectively, that is, they either converted, say, a Greek term by substituting the letters of the Greek alphabet, as well as was possible, with Arabic letters, or they rendered the semantic components of such a term literally into Arabic.[13] Parallel to this arduous process of adaptation through translation, the interpreters started to compile synonymic lists and multilingual glossaries, whose emergence was an almost logical by-product of that strife for intellectual appropriation, a direct outcome of the semantic intricacies posed by the source texts, and at the same time an attempt at explaining and disseminating the newly coined terminology. The task of translating specialized texts, of breaking them up into their terminological constituents, and of arranging and expounding this technical vocabulary adequately and systematically in the form of word lists was notoriously difficult with regard to the medico-pharmaceutical sciences, and even more complicated in the narrower realm of botany. The philological and practical problems thrown up by translating pharmaco-botanical literature were enormous and often impossible to solve, also taking into account that in those days "regular" dictionaries other than Arabic-Arabic would have been extremely hard to come by, if they existed at all. As is generally known, one of the most complex word fields in any language is that of plant names, alongside perhaps the semantics of colours and shapes. This is particularly true for Arabic because here the problems are aggravated by the fact that the "foreign" terminology for substances and drugs was more or less simultaneously adopted from a variety of languages, producing not only new lexical entries but also a ridiculously high number of synonyms and pseudo-synonyms; further by the fact that the individual names and terms congealed at varying degrees of arabicization; and also because already in the source languages these botanical designations appertained to different linguistic strata (literary, scientific, colloquial, dialectal, popular) that led, as a result of being translated (or transliterated as the case may be), to their duplication or even multiplication. Already prior to the translation movement, Arabic was a remarkably rich language in terms of vocabulary and figurative expressions, a fact that is partly due to the nature of pre-Islamic poetry and its tendency to concretism and metonymy, partly a result of the coexistence of several Arabic dialects that shared the linguistic space on the Arabian Peninsula; thus, the Bedouins in

their poems used many plant names that had currency only in the relatively small social circle of their tribe, and even within a tribal dialect one and the same plant may have been known under different names, each of which referred, for example, to the various stages in the plant's life cycle or seasonal changes of its colour. And already before the first translations were made, Arabic had borrowed a fair number of Persian and Aramaic plant names, some of which were, in turn, ultimately of Sanskrit or Akkadian origin, such that the translators of the 3rd/9th century occasionally decided to render Greek botanical terms not into Arabic but into arabicized Persian[14] or arabicized Aramaic.[15] Therefore, even when the translators began their work in the late 2nd/late 8th century, some old and genuine Arabic plant names had already been replaced and were, accordingly, translated into and explained by Persian or Aramaic terms.[16]

Unlike this rather random process of linguistic migration, the translation movement was a deliberate intellectual and cultural undertaking, a unique, fairly well-conducted, and largely successful collective attempt at implanting the scientific heritage of several "foreign" civilizations into the framework of medieval Islam, and to adjust it to the needs of that society. The procedural (i.e., linguistic) consequences of this knowledge transfer were just as dramatic as its substantive (i.e., content-related) implications: the translation movement, on a linguistic level, opened the gates to an enormous influx of "new" terms into the Arabic language, but it also created serious epistemological problems which, in turn, necessitated the implementation of hitherto uncalled-for auxiliary tools. The confluence and juxtaposition of pharmaco-botanical names and terms from Arabic, Greek, Syriac, Persian, Sanskrit, and, as we shall see later on, some other languages, were extremely confusing and soon led to the compilation of the synonymic lists and multilingual glossaries already mentioned: on the one hand, it became necessary to explain this vocabulary to physicians, pharmacists, and botanists and to clarify for them the exact meaning and correct use of those newly created and ever growing terminological clusters; on the other hand, these lists and glossaries were aides-mémoire for the compilers themselves, and thus served the double purpose of reference dictionaries for translators and interpretive manuals for practitioners. The earliest examples of this kind of "lexicography," perhaps vaguely inspired by Galen's Περὶ τῶν ἰατρικῶν ὀνομάτων (*On Medical Terms*), ran under the Syriac title *Pushshāq-shmāhē* (*Explanation of Names*), later also under the Arabic title *Thabat* (*Register*). These were multilingual glossaries containing medico-pharmaceutical names and terms in two, three, four, or five languages, arranged in tabular or diagrammatic form; the synonymic lists originally followed the same pragmatic layout, and it is therefore impossible to draw a clear line of demarcation between these two lexicographical types. The *Pushshāq-shmāhē* glossaries of the early translators were a direct response to the particular semantic intricacies of plant and drug terminology. In the beginning, these lists and glossaries must have had a purely functional design; they were probably always organized in columns according to Arabic language entries and geared

to the sequence of the Arabic alphabet.[17] Again, for obvious reasons, these "registers" initially only covered the lexical material of the source and target languages on the basis of specific texts[18] but soon developed from bilingual into multilingual compilations, as the linguistic range of translated texts widened and also because many Greek and Sanskrit works passed through Syriac or Persian intermediate translations.[19] Especially in the western regions of the Arab world, several other languages that played no role in the East had to be considered as well, most obviously Berber, Latin, and Old Spanish, regardless of whether these languages actually formed part of a chain of translation proper (which was normally not the case). As the translation movement slowed down and the Arabs increasingly turned to synthesizing, elaborating, and improving the new materials in works that were now conceived in Arabic from the start, the synonymic lists and multilingual glossaries were integrated into broader medico-pharmaceutical contexts and lost, in the process, some of their original function; they were no longer used for the purpose of translation. Whether they continued to be used by practitioners (physicians, pharmacists, and botanists) for the purpose of identification, or whether they gradually took on the features of literary conventions, is extremely hard to say – it was probably a mixture of both. From the 4th/10th century onwards, the lists and glossaries appear mainly in pharmacognostic works, or in sections on pharmacognosy that form part of general medical encyclopedias; the lexicological information is now being incorporated either into a continuous text or, if the text itself is presented in diagrammatic form, into one or more columns of a comprehensive table. We can see what happened by taking two examples from the 5th/11th century, one from the Arab East and the other from the Arab West. In the East, the Iranian polymath Abū l-Rayḥān al-Bīrūnī (d. ca. 440/1048), in his important *Kitāb al-ṣaydala fī l-ṭibb* (*Book on Medical Pharmacy*), compiled a continuous text that treats about 850 drugs, arranged according to the Arabic alphabet. Each entry commences with linguistic expositions, including synonyms in Greek, Syriac, Persian, Sanskrit, occasionally Hebrew, and also various local languages such as Khwarezmian and Sogdian. Botanical descriptions are sometimes accompanied by Arabic poems in which the plant in question is mentioned. The pharmacognostic passages deal with plant morphology, habitat, varieties, adulteration, and substitutes, including numerous excerpts and quotations mainly from authors writing in Arabic or Greek.[20] In the West, the Andalusian physician Yūsuf b. Isḥāq Ibn Biklārish (fl. 490/1097), in his equally important *Kitāb al-mustaʿīnī* (*Book [for the Ruler] al-Mustaʿīn*), compiled a multicolumn table that follows upon a general essay on the theoretical foundations of pharmacy. He treats about 700 drugs, alphabetically arranged, and organizes them in five columns of a comprehensive table: the first column contains the (Arabic) name of the drug; the second column specifies its humoral qualities and degrees; the third column lists its synonyms in Greek (Classical and Byzantine), Syriac, Persian, Berber, Latin, and Old Spanish, including regional dialects; the fourth column deals with substitutes; and the fifth column explains the

drug's medicinal benefits, sympathetic properties, and forms of application.[21] It is within the framework of these scientific and linguistic traditions that we need to interpret the philological character of al-Ghāfiqī's book, which we can now proceed to describe and exemplify in greater detail.

On the background of the foregoing explication, the compositional (i.e., formal) structure of al-Ghāfiqī's *Herbal*, at least as it appears before us in the Osler manuscript, can be described as somewhat particular, for here the pharmacognostic and linguistic information is neither presented in tabular form nor has it been merged into one textual body. In fact, al-Ghāfiqī separated these two technically disparate though conceptually related components of pharmaco-botanical knowledge, treating them each in the form of continuous texts that are jointly subordinated to a general alphabetical arrangement; the entire material runs along the sequence of the so-called *abjad* alphabet, an ancient Semitic way of organizing the letters according to their numerical value and often employed in medieval Arabic handbooks and reference works as a guiding principle. Within this overarching sequence, each alphabetical chapter contains pharmacognostic discussions of "common" medicinal drugs (primary entries), followed by linguistic interpretations of "uncommon" names and terms relevant to the field (secondary entries).[22] I estimate the total number of primary entries to be about 450 and that of secondary entries to be about 2,200 (which is a ratio of roughly 1:5); if we take into account that the Osler manuscript covers only the first half of the work, terminating as it does with the completion of the letter *kāf*, we can imagine the scope of al-Ghāfiqī's overall task. As other contributors comment on the pharmacognostic aspects of al-Ghāfiqī's *Herbal*, I will concentrate in the following on some of its linguistic features. But first, a structural summary of sections.

Osler MS 7508

Prologue ff. 2b–5a, line 10 | Primary Entries (pharmacognostic): *alif* ff. 5a, line 10 – 53b, line 17; *bā'* ff. 66a, line 2 – 99b, line 15; *jīm* ff. 106b, line 15 – 111b, line 8 and ff. 112a, line 1 – 120b, line 23; *dāl* ff. 122a, line 16 – 134b, line 13; *hā'* ff. 138b, line 3 – 144a, line 16; *wāw* ff. 145b, line 16 – 152a, line 3; *zāy* ff. 153b, line 13 – 177a, line 15; *ḥā'* ff. 179a, line 5 – 207b, line 23; *ṭā'* ff. 214b, line 9 – 226b, line 16; *yā'* ff. 229b, line 12 – 239a, line 23; *kāf* ff. 240a, line 5 – 270b, line 9 and ff. 271a, line 1 – 279b, line 23 | Secondary Entries (linguistic): *alif* ff. 53b, line 18 – 66a, line 1; *bā'* ff. 99b, line 16 – 106b, line 14; *jīm* f. 111b, lines 9–21 and ff. 121a, line 1 – 122a, line 15; *dāl* ff. 134b, line 14 – 138b, line 2; *hā'* ff. 144a, line 17 – 145b, line 15; *wāw* ff. 152a, line 4 – 153b, line 12; *zāy* ff. 177a, line 16 – 179a, line 4; *ḥā'* ff. 208a, line 1 – 214b, line 8; *ṭā'* ff. 226b, line 17 – 229b, line 11; *yā'* ff. 239b, line 1 – 240a, line 4; *kāf* f. 270b, lines 10–22 and ff. 280a, line 1 – 283a, line 23.

In his prologue, al-Ghāfiqī explains, among other things, that two reasons prompted him to the composition of his book: first, he says, "[I wanted] to collect in it the statements of insightful physicians, ancient and modern, regarding any drug from among the simples, so that he who looks up a drug may learn all that has been said about it and about its effects, without the [usual] wordiness, windiness, and repetitiveness of suchlike statements but rather as short and concise as is possible in a diligent compilation,"[23] and second, to provide "a commentary on unknown drug names that occur in the writings of physicians."[24] The first declaration refers to that part of the book that we described above as containing "primary entries"; the other declaration concerns the part we said involves "secondary entries." We need to stress here the obvious fact that not all drugs that al-Ghāfiqī deemed commonly known, and that he accordingly treated in the pharmacognostic sections of his book, are equally well known to us – there appear, in fact, certain names and terms even in the pharmacognostic sections that we would search for in vain in any Arabic dictionary, medieval or modern. That said, we can make a pretty clear distinction between the two parts of al-Ghāfiqī's *Herbal*: one part that deals with commonly known, generally used, readily available, and on the whole botanically unambiguous medicinal substances, Arabic or arabicized, most of which are already found in the works of Galen and, notably, Dioscorides, not to mention Rhazes and Avicenna; and another part that deals with what al-Ghāfiqī in his prologue refers to as "unknown" (*majhūl*) medicinal substances, which he incorporated into inventories of words of mainly non-Arabic origin, mostly transliterated but occasionally loan-translated, and including alleged synonyms and (for about 70% of terms) presumed etymologies. The semantic correlations in these linguistic sections do not at all necessarily engage the Arabic language, such that a given "foreign" term may be explained just as well by another "foreign" term, the latter having been considered more familiar than its Arabic equivalent, if there was one in the first place. As already mentioned, the linguistic sections in al-Ghāfiqī's book always follow directly upon the pharmacognostic sections, and they generally run under the heading "And here is a commentary on the names that [also] fall into this [alphabetical] chapter."[25] It is clear that the linguistic sections were of great concern to al-Ghāfiqī, and from our previous survey into the history of synonymic lists and multilingual glossaries we now also know the reason why; it is equally clear that an adequate philological treatment of these terminological inventories constitutes a major challenge. Compared with the primary entries that make up the pharmacognostic sections of the book, and that pertain to a relatively narrow range of source languages,[26] the linguistic situation is naturally far more complex when we turn to the secondary entries – here, the distribution of source languages explicitly referred to by al-Ghāfiqī is, mutatis mutandis, the following: Classical Greek, about 30%;[27] Syriac, about 15%;[28] Persian, about 15%;[29] Sanskrit, about 10%;[30] Old Spanish, about 10%;[31] Arabic, Berber, and Latin, about 15% altogether;[32] Byzantine Greek is mentioned seven times;[33] Coptic and "Nabataean" (i.e., Western Syriac) are mentioned once each;[34] sporadically, synonyms

are given in the Arabic dialects of Iraq,[35] Syria,[36] Egypt,[37] Yemen,[38] Oman,[39] and, more generally, the Arab "East" (*al-Mashriq*);[40] Romance (and possibly also Arabic) synonyms are accompanied by phrases such as "in the jargon of the people of Andalusia,"[41] or "the people in our country know it under that name,"[42] or "the common people call it [such],"[43] or "colloquially";[44] finally, there is one reference to the language of the Armenians.[45]

Looking at this impressively diverse range of source languages, and trying to assess their hermeneutical value, we have to bear in mind that in the Middle Ages scientific just as well as linguistic knowledge was acquired and transmitted largely within the framework of scholasticism – it was the result of an essentially conservative and speculative process, and deeply embedded in a received system of physical and spiritual truths which was considered in itself stable and worthy of preservation. The fixation and perpetuation of knowledge took place within structures of authority and had little to do with our concepts of innovation or originality – a mere glance at the many authorities al-Ghāfiqī explicitly relied upon in the compilation of his book immediately confirms this observation. Reliance on authoritative knowledge, handed down mainly through the medium of texts, also of course implies a potentially large-scale transfer of errors and misconceptions, especially when formulated in a "defective" script like Arabic. Book knowledge is generally transmitted with a traditionalist attitude, and to a large extent in good faith, regardless of whether the knowledge base of the transmitter (i.e., author) exceeds, or even contradicts, the content of transmission. The information provided by al-Ghāfiqī, too, in the pharmacognostic as much as in the linguistic sections of his book, is therefore primarily a reflection of his familiarity with written sources, and only then a manifestation of his own experience and reasoning. And yet al-Ghāfiqī was a critical spirit: already in his prologue he blames, in one sweeping gesture, his Andalusian predecessor Ibn Wāfid for confusing the statements of Dioscorides with those of Galen,[46] and the illustrious Avicenna for manipulating the sources;[47] besides, throughout his book, al-Ghāfiqī frequently accuses certain unnamed "commentators" (*mufassirūn*) of blunders and even lies.[48] The one thing we can safely say at this stage is that al-Ghāfiqī, in the linguistic sections of his book, relied heavily (and explicitly) on material he found in the pharmacological tables compiled some 250 years earlier in the Arab East by the great physician Rhazes, albeit for quite different purposes;[49] al-Ghāfiqī's somewhat strange choice to denote the uncommon names and terms in his linguistic sections summarily by *majhūl* "unknown" is in itself a tribute to Rhazes who applied precisely this word to problematic entries in his own tables. We cannot elaborate on this point as we are not dealing with al-Ghāfiqī's sources, so suffice it to say that large parts of the linguistic sections in his book are inconceivable without the groundwork done by Rhazes.[50] It is important to remember that not all names and terms registered by al-Ghāfiqī carry etymological attributions, but almost all of them carry semantic correlations, often supplemented by brief botanical observations and, sometimes, discriminating remarks. On the whole, I would

consider the etymological attributions specified by al-Ghāfiqī as remarkably astute, if at times only as cues in the right direction; and I would not place too much weight on borderline cases and overlaps, notably with regard to attempted distinctions between (Middle) Persian and Sanskrit or between Greek and syriacized Greek, the latter sometimes running under "Syriac." It goes without saying that in a future critical edition of al-Ghāfiqī's *Herbal* these terminological inventories are bound to pose considerable philological problems, but Eleonora di Vincenzo has recently shown, in her edition of the letter *alif*,[51] that one can make good progress also on this treacherous terrain. Whether, on the other hand, al-Ghāfiqī's semantic correlations will always stand the test of botanical scrutiny, and whether all these substances can in the end be identified scientifically, is another matter and not of our present concern.

This brings us finally to a question that is impossible to answer but nonetheless worth asking: that of al-Ghāfiqī's actual language skills. If we knew that al-Ghāfiqī was able to read, for example, Greek texts in the original, we would obviously attach greater value to his etymological attributions, and perhaps even semantic correlations, involving this language, and we could also address more confidently the thorny issue of amending or else restoring transliterated terms which do not seem to be attested in indigenous Greek lexicography; the same is true for any other literary language quoted by al-Ghāfiqī. There is, as far as I can see, no direct author communication in the Osler manuscript to demonstrate al-Ghāfiqī's language skills beyond the obvious, and we therefore will have to take a mixed approach based on circumstantial evidence and common sense. In order to place the question into a larger context and to create a referential frame, we may consider the language skills, such as they have been recorded or deduced, of three other scholar-scientists from the medieval Islamic period, who were all at some point engaged in the compilation of medico-pharmaceutical lists and glossaries. On one end of the spectrum, we have Rhazes (d. 313/925) and al-Bīrūnī (d. ca. 440/1048): the physician Rhazes, in his pharmacological tables as well as in another, now lost writing of that genre, registered synonyms in Arabic, Greek, Syriac, Persian, and Sanskrit – he actually *knew* Arabic, Persian, and Syriac, most probably Greek, had a good idea of Sanskrit, and an interest even in Chinese;[52] the polymath al-Bīrūnī, in his book on medical pharmacy, registered synonyms in Arabic, Greek, Syriac, Persian, Sanskrit, Hebrew, and several East Iranian languages – he actually *knew* Arabic, Persian, Syriac, Sanskrit, Turkish, and Khwarezmian, most probably Greek, and perhaps Hebrew.[53] On the other end of the spectrum, we have the physician Ibn Biklārish (fl. 490/1097) who, in his pharmacognostic tables, registered synonyms in Arabic, Greek (Classical and Byzantine), Syriac, Persian, Berber, Latin, Old Spanish, and various Romance dialects – he actually *knew* Arabic, Hebrew, and, being Jewish, perhaps Talmudic Aramaic (the latter two languages do not even figure in his tables), but he does not seem to have had first-hand knowledge of any of the other languages he quotes.[54] To put it differently, Rhazes and al-Bīrūnī used and transmitted information in languages they could understand and control, whereas

Ibn Biklārish had, for the most part, no control over the content and accuracy of his linguistic transmissions. Returning to al-Ghāfiqī, we can be sure that his native language was Arabic, that is to say the Arabic dialect spoken in his day in Andalusia and, for the purpose of written conveyance, Classical Arabic; it is more than likely that he was also familiar with one or another dialect of Romance, that is to say some local descendant of Vulgar Latin most probably identical with Old Spanish. Beyond that, however, we are entering uncertain territory. As already indicated, book knowledge may in principle be transmitted through the simple act of copying, and a linguistically composite text does not, by itself, imply corresponding linguistic abilities on the part of the copyist or, for that matter, author. Yet al-Ghāfiqī's case is slightly more complicated. It is true and not surprising that al-Ghāfiqī relied upon (Arabic) "translations" (*tarājim*) and "translators" (*aṣḥāb al-tarājim*),[55] often but not always with regard to Greek terms, but he also on occasion digresses into detailed philological discussions, comparing different translations and preferring one over the other in such a way as to implicate a direct understanding of the Greek original.[56] The majority of al-Ghāfiqī's etymological attributions to Sanskrit seem to be based, often explicitly, on the tables in Rhazes' *Kitāb al-ḥāwī*,[57] and I believe the same is true for his references to Persian and Syriac – it is hard to see how al-Ghāfiqī could have drawn upon these languages other than by extracting them directly from written sources he considered trustworthy. On the other hand, it is quite possible that al-Ghāfiqī had some first-hand knowledge of Berber, or could at least have sought out relevant information from among the many representatives of that ethnicity who lived in Andalusia ever since the Muslim conquest. Similarly, it would not have been impossible for him to find information about (Classical) Latin terms in the ranks of the Christian clergy, or to snatch up from travelling merchants and wandering scholars random plant names linked to Arabic dialects spoken in the eastern realm of the Islamic world; odd references to languages such as Armenian or Coptic, and even Byzantine Greek, are no doubt due to equally haphazard encounters. Thus, al-Ghāfiqī's language skills could perhaps be described as follows: Arabic (spoken and literary), Old Spanish (spoken), probably Greek (literary), and possibly Berber (spoken) – pending more detailed inquiries into the rich lexical material spread before us.

If nothing else, our excursion should have shown that any future critical edition and/or translation of al-Ghāfiqī's *Herbal* must do justice not only to the scientific but also to the linguistic content of this important book.

NOTES

1. On the question of al-Ghāfiqī's sources, see also the essays in this volume by Cristina Álvarez Millán and Leigh Chipman.

2. Dioscorides' (abbreviated د) Περὶ ὕλης ἰατρικῆς (*On Medical Matters*; Arabic title *al-Ḥashāʾish fī hayūlā l-ṭibb*); Galen's (abbreviated ج) Περὶ κράσεως καὶ δυνάμεως τῶν ἁπλῶν φαρμάκων (*On the Mixtures and Powers of Simple Drugs*; Arabic title *al-Adwiya al-mufrada*); and Paul's (*Bawlus*) Πραγματεία (*The [Medical] Handbook*; part VII on simple and compound drugs).

3. Ibn Juljul's *Explanation of the Names of Simple Drugs* (*Tafsīr asmāʾ al-adwiya al-mufrada*); Ibn Samajūn's *Compendium of Simple Drugs with Statements of Ancient and Modern Physicians and Philosophers* (*al-Jāmiʿ li-aqwāl al-qudamāʾ wa-l-muḥdathīn min al-aṭibbāʾ wa-l-mutafalsifīn fī l-adwiya al-mufrada*); and Ibn Wāfid's *Book of Simple Drugs* (*Kitāb fī l-adwiya al-mufrada*).

4. It should be noted in passing that while an edition of Ibn Biklārish's *Kitāb al-mustaʿīnī* is still in the process of being established (by Joëlle Ricordel), we do at least, for what it's worth, possess an Arabic edition and English translation of a "selection" (*muntakhab*) from al-Ghāfiqī's book, made in the 13th century by the great scholar Gregory Bar Hebraeus; see Bar Hebraeus (Gregorius Abū l-Faraj, Ibn al-ʿIbrī), *The Abridged Version of "The Book of Simple Drugs" of Aḥmad ibn Muḥammad al-Ghâfiqî by Gregorius Abu'l-Farag (Barhebraeus)*, 4 vols, edited and translated by Max Meyerhof and G.P. Sobhy (Cairo: al-Ettemad Printing Press; Government Printing House, 1932–40). Moreover, a critical Arabic edition of the first letter (*alif*) of al-Ghāfiqī's book (i.e., ca. 20% of the text as preserved in the Osler manuscript) has recently been published by an Italian colleague; see *Kitāb al-ʾadwiya al-mufrada di ʾAbū Ǧaʿfar ʾAḥmad b. Muḥammad [...] al-Ġāfiqī (XII sec.), Edizione del Capitolo ʾAlif*, edited by Eleonora di Vincenzo (Pisa-Rome: Fabrizio Serra, 2009).

5. This according to Martin Levey, *Early Arabic Pharmacology: An Introduction Based on Ancient and Medieval Sources* (Leiden: Brill, 1973), 110 and 116.

6. Abū Bakr Muḥammad b. Zakariyyāʾ al-Rāzī, *Kitāb al-ḥāwī fī l-ṭibb*, 23 vols (Hyderabad: Dāʾirat al-maʿārif al-ʿuthmāniyya, 1955–71), 22: 2.

7. Compare Manfred Ullmann, *Die Medizin im Islam* (Leiden: Brill, 1970), 257 and 295.

8. Statistical evaluations carried out on the basis of Arabic *pharmacological* writings from the medieval period show an average distribution of 75% vegetable, 13% animal, and 12% mineral substances; see Oliver Kahl, *Sābūr ibn Sahl: The Small Dispensatory* (Leiden: Brill, 2003), 16 (data for 3rd/9th century); idem, *Sābūr ibn Sahl's Dispensatory in the Recension of the ʿAḍudī Hospital* (Leiden: Brill, 2009), 10 (data for 5th/11th century); and idem, *The Dispensatory of Ibn at-Tilmīḏ* (Leiden: Brill, 2007), 28 (data for 6th/12th century).

9. For example, in the use of the terms *barrī* (i.q. ἄγριος) for "wild" plants, *ahlī* (i.q. ἥμερος) for "cultivated" plants, or *jabalī*

(i.q. ὀρεινός) for "mountain" plants, all of which coincide with Greek binary plant nomenclature; likewise, the philologist al-Dīnawarī (d. 282/895), when contemplating plant categories, appears to have taken notice of Theophrastus' (d. ca. 287 BCE) Περὶ φυτικῶν ἱστοριῶν (*Inquiries into Plants*; better known under the Latin title *De Historia Plantarum*); see Manfred Ullmann, *Die Natur- und Geheimwissenschaften im Islam* (Leiden: Brill, 1972), 70, 85, and 90–1.

10 On the nature, scope, and limits of Arabic botanical and pharmacognostic literature in general, see Ullmann, *Geheimwissenschaften*, 62–87 (botany) and idem, *Medizin*, 257–88 (pharmacognosy).

11 Books I–V contain general expositions on the subject, Books VI–VIII vegetable substances (in alphabetical order), Book IX deals with mineral substances, Book X with liquid animal products (milk, sweat, blood, bile, urine, feces), and Book XI with solid animal parts; cf. Ullmann, *Medizin*, 263.

12 On the translation movement in general, and on the Greek-Arabic track in particular, see the excellent book of Dimitri Gutas, *Greek Thought, Arabic Culture: The Graeco-Arabic Translation Movement in Baghdad and Early ʿAbbāsid Society (2nd–4th / 8th–10th Centuries)* (London: Routledge, 1998).

13 Some examples from medico-pharmaceutical literature (Greek into Arabic) are: Arabic *lītharghus* is a transliteration of λήθαργος "lethargy"; Arabic *usqūlūfindriyūn* is a transliteration of σκολόπενδριον "miltwaste" (*Asplenium ceterach*); Arabic *saraṭān*, lit. "crab," is a loan-translation of καρκίνος "carcinoma"; Arabic *lisān al-kalb*, lit. "dog's tongue," is a loan-translation of κυνόγλωσσον "greater plantain" (*Plantago major*).

14 For example, the substitution of ἀνθεμίς with (Persian) *bābūnaj* "chamomile" (*Anthemis nobilis*), or that of ἀρτεμισία with (Persian) *bilinjāsb* "mugwort" (*Artemisia vulgaris*).

15 For example, the substitution of πιστάκια with (Aramaic) *fustuq* "pistachio" (*Pistacia vera*); the fact that the Greek word itself has a Semitic etymology is of no relevance here.

16 For more details on the mechanism of this process, see Ullmann, *Geheimwissenschaften*, 87–9 (whence also some of the examples cited in nn13, 14, and 15 above).

17 It is worth noting here that the great physician Rhazes on one occasion also mentions the existence of certain lists and glossaries that ran along (transliterated?) *Greek* lemmata; see Oliver Kahl, "The Pharmacological Tables of Rhazes," *Journal of Semitic Studies* 56, no. 2 (2011): 379.

18 We know, e.g., that the famous translator Ḥunayn b. Isḥāq (d. ca. 264/ 877) established a register (*thabat*), presumably bilingual, based on Criton's (fl. 100 CE) Κοσμητικά, a now lost book on hygiene and cosmetics; see Kahl, "Tables," 388.

19 Perhaps even prior to the translation movement, the physicians in the hospital of Gondēshāpūr were in possession of a register (*thabat*), almost certainly multilingual and probably based on key texts in their medical curriculum; see Kahl, "Tables," 389.

20 See Ullmann, *Medizin*, 272–3, and the literature cited there.

21 See Ullmann, *Medizin*, 275; cf. also Emilie Savage-Smith, "Ibn Baklarish in the Arabic Tradition of Synonymatic Texts and Tabular Presentations," in Charles Burnett, ed., *Ibn*

Baklarish's Book of Simples (London: Arcadian Library in association with Oxford University Press, 2008), 113–31.

22 Within these two parts, pharmacognostic and linguistic, al-Ghāfiqī no longer observes a clear alphabetical order.

23 Osler MS 7508, f. 2b, lines 18–22:

ان اجمع فيه بين اقاويل القدماء والمحدثين [«والمحدثين» في المخطوط] من اهل البصر من الاطباء في دواء من الادوية [«الادويه» في المخطوط] المفردة حتى يكون الناظر في دواء منها قد عرف كلها قيل فيه وفي افعاله من الاقاويل من غير تطويل ولا اكثار ولا تكرار اقاويل متشابهة بل لغاية ما يكون من الايجاز والاختصار مع الجمع والاحتفال [«الاحتفال» في المخطوط]

24 Osler MS 7508, f. 2b, line 22:

شرح ما وقع في كتب الاطباء من اسماء الادوية [«الادويه» في المخطوط] المجهولة

25 Arabic: *wa-hādhā sharḥ mā waqaʿa fī hādhā l-bāb min al-asmāʾ* for the letters *bāʾ, dāl, hāʾ, wāw, zāy, ḥāʾ, ṭāʾ, yāʾ* and *kāf*; see Osler MS 7508, ff. 99b, 134b, 144a, 152a, 177a, 208a, 226b, 239b, and 270b. The heading of the secondary entries for the letter *alif* (f. 53b) is extended by the words *bi-l-yūnāniyya* "[names] in Greek," which is due to the fact that many of those names, though by no means all of them, are of Greek provenance; and the heading of the respective entries for the letter *jīm* (f. 111b) reads *sharḥ al-asmāʾ al-wāqiʿa fī hādhā l-bāb* "commentary on the names occurring in this chapter."

26 About 45% Arabic, 25% Greek, 15% Persian, 10% Syriac, and 5% Sanskrit etymologies.

27 Osler MS 7508, e.g., ff. 54a, line 1; 136b, line 11; 208a, line 4 (*yūnāniyya*).

28 Osler MS 7508, e.g., ff. 57b, line 8; 152a, line 8; 239b, line 15 (*suryāniyya*).

29 Osler MS 7508, e.g., ff. 56a, line 5; 135a, line 6; 177a, line 20 (*fārisiyya*).

30 Osler MS 7508, e.g., ff. 56a, line 12; 134b, line 16; 208a, line 15 (*hindiyya*).

31 Osler MS 7508, e.g., ff. 59a, line 4; 177a, line 18; 227a, line 1 (*ʿajamiyya*).

32 Osler MS 7508, e.g., ff. 55b, line 16; 178a, line 23 (*ʿarabiyya*); 58a, line 6; 152b, line 15 (*barbariyya*); 62a, line 6; 239b, line 4 (*laṭīniyya*).

33 Osler MS 7508, ff. 56a, line 13; 56b, line 6; 62a, line 18; 62b, line 12; 63b, line 22; 213a, line 20; 228b, line 15 (*rūmiyya*).

34 Osler MS 7508, ff. 145b, line 10 (*qibṭiyya*); 54b, line 2 (*nabaṭiyya*).

35 Osler MS 7508, ff. 177b, line 8 and 208a, lines 6–7 (*yusammīhi ahl al-ʿirāq*); cf. also 210b, line 16 (*bi-lughat ahl al-ḥīra*).

36 Osler MS 7508, f. 136b, lines 1–2 (*bi-lisān ahl al-shām*); cf. 59b, lines 18–19 (*bi-lughat ahl al-shām*), and 63b, line 15 (*yusammīhi ahl al-shām*).

37 Osler MS 7508, f. 177b, line 9 (*yusammīhi ahl miṣr*).

38 Osler MS 7508, f. 60b, line 11 (*bi-lughat ahl al-yaman*).

39 Osler MS 7508, f. 211a, line 22 (*bi-lughat ahl ʿumān*).

40 Osler MS 7508, f. 137a, lines 12–13 (*maʿrūf fī l-mashriq bi-hādhā l-ism*).

41 Osler MS 7508, f. 62a, lines 17–18 (*bi-lisān ahl al-andalus*); cf. 214b, line 8 (*bi-l-andalusī*).

42 Osler MS 7508, f. 280b, lines 8–9 (*wa-ahl baladinā hādhā yaʿrifūnahu ... bi-hādhā l-ism*); cf. 212b, line 11 (*yaʿrifuhu l-nās ʿindanā bi-*), and further 55a, line 1 (*yusammā ʿindanā bi-hādhā l-ism*).

43 Osler MS 7508, f. 229a, line 1 (*tusammīhā l-ʿāmma*); cf. 63b, line 22 (*taqūl al-ʿāmma*).

44 Osler MS 7508, f. 54a, line 14 (*min al-lugha*).
45 Osler MS 7508, f. 227b, line 9 (*ahl armīniyya*).
46 Osler MS 7508, f. 3a, lines 16–17.
47 Osler MS 7508, f. 3a, lines 19–20.
48 Osler MS 7508, ff. 59b, lines 22–3; 61b, lines 21–2; and passim.
49 On Rhazes' tabular glossaries, covering nearly 8,000 (!) medico-pharmaceutical terms and involving five languages, see Kahl, "Tables," 375–80.
50 In his prologue, al-Ghāfiqī openly acknowledges his debt to Rhazes; see Osler MS 7508, f. 4a, lines 10–11.
51 Di Vincenzo, *Kitāb al-'adwiya*.
52 See Kahl, "Tables," 392 and 394–5.
53 See Edward S. Kennedy, "Al-Bīrūnī (or Bērūnī), Abū Rayḥān (or Abu'l-Rayḥān) Muḥammad Ibn Aḥmad," in Charles Coulston Gillispie, ed., *Dictionary of Scientific Biography*, 2 (New York: Charles Scribner's Sons, 1970), 148–58. Also available in *The Complete Dictionary of Scientific Biography* at http://www.encyclopedia.com/doc/1G2-2830900460.html.
54 See Geoffrey Khan, "The Syriac Words in the *Kitāb al-Mustaʿīnī* in the Arcadian Library Manuscript," in Charles Burnett, ed., *Ibn Baklarish's Book of Simples* (London: Arcadian Library in association with Oxford University Press, 2008), 95–7.
55 Osler MS 7508, e.g., ff. 100a, line 1; 104b, line 15; 106a, line 9; 121a, line 23; 136b, line 3; 283a, lines 1–2.
56 Osler MS 7508, e.g., ff. 208b–209b (lemma *ḥāmāshwqy*, read *khāmāsūqī* < χαμαισύκη). Apparently in the 4th/10th century, during the heyday of the Western Caliphate, there was nobody, not even among the Christians of the great city of Cordoba, who could read Classical Greek; see, e.g., Manfred Ullmann, *Untersuchungen zur arabischen Überlieferung der* Materia medica *des Dioskurides* (Wiesbaden: Harrassowitz, 2009), 62. However, we must not amplify nor overstretch this long-standing scholarly notion, which originates in a story told by Ibn Juljul and set some 200 years prior to al-Ghāfiqī's time.
57 The secondary entries for the letter *wāw* are a telling example; see Osler MS 7508, ff. 152a–153b.

3

The Historical, Scientific, and Literary Contexts of al-Ghāfiqī's *Herbal*

CRISTINA ÁLVAREZ MILLÁN

Over the last ten years, the history of medieval Islamic medicine has changed beyond recognition. Although research carried out in this decade has certainly had little impact outside the small circle of specialists, the traditional (i.e., idealized) view of this crucial period of medical history is being challenged as new questions are raised, old problems reformulated, and theoretical treatises interpreted from new standpoints. Emilie Savage-Smith has led the way in deconstructing deeply rooted historical assumptions about surgery in medieval Islam, for instance, by pointing not just to the fact that Islamic treatises reproduce the Greco-Roman literary tradition with little innovation, but more importantly, to the fact that Islamic physicians themselves state in their works that they never performed the invasive surgical procedures they are describing.[1] In the same critical line, the comparison of case histories and medical theory by the 10th-century physician al-Rāzī as well as the study of case histories and medical anecdotes in literary and social contexts has shown that medical theory was rather neglected in practice. It may well be that Islamic physicians wrote medical works not only because they were motivated by love of learning and the desire to "benefit humanity," but because it was also part of the strategies they displayed for the construction of their authority and reputation as well as for self-promotion in the marketplace, namely, the court.[2]

Also, a few years ago, an article by Tzvi Langermann pointed to an Andalusī program to construct an alternative to the previous eastern medical production.[3] I would argue that, in fact, in philosophy and medicine as much as in historiographical and literary endeavours, Andalusī scholars had a determination to excel, surpass, and distinguish themselves from their Oriental predecessors and contemporaries. Research studies by Miquel Forcada and Sarah Stroumsa for the Almohad period show that politics and ideology were also at work and played a relevant role in what was intellectually going on.[4] Actually, much earlier, the Umayyad dynasty had designed Cordoba as an Andalusī

version of Damascus in order to assert its legitimacy and confront the new eastern power, while the Ṭāʾifa kingdoms had tried to emulate the Umayyad caliphate; in both instances this included cultural and scientific patronage. Likewise, Dimitri Gutas has challenged the traditional idea of western Latin scholars' admiration of Islamic culture, their desire to improve their scientific knowledge and the availability of Arabic manuscripts as pivotal criteria of the 12th-century translation movement in Spain. He argues that the choice of Islamic works basically reflected the "Andalusocentric" bias of local experts, informants, or available translating intermediaries.[5] In order to complete the revisionist picture – particularly when studying the context of al-Ghāfiqī's work – it is worth noting John Tolan's view that King Alfonso X the Learned's patronage of elite Muslim and Jewish scholars was a symbol of the submission of these social communities to his power, and the vast program of translations promoted by him was a way of appropriating a rival civilization's intellectual wealth.[6]

Yet, despite recent research, one still encounters enthusiastic judgments of – or categorical opinions on – a given work that ignores what earlier and even contemporary authors may have contributed to the discipline; eventually it turns out that the text under discussion is not that innovative and exhibits patterns that are common to an already consolidated literary tradition. Thus, bearing these opposing historiographical approaches in mind, I would like in this study to look at al-Ghāfiqī's *Herbal*, not only from a slightly sceptical perspective in harmony with recent scholarly publications, but mainly adopting a bird's-eye view of the scientific, literary, and historical contexts in which the work was written in an attempt to grasp a better understanding of the author's aim, the work's nature within the Andalusī pharmacological tradition, and the unspoken – but probable – wider agenda potentially underlying this impressive scientific composition. Unfortunately, since we know virtually nothing about the author's life or the date and place of composition of his work, it is impossible to place this pharmaco-botanical work in its exact setting. It was produced sometime in the first half of the 12th century. But was it written in Almoravid al-Andalus (478–539/1086–1145) as part of an increasingly prominent scientific literary tradition in the Islamic territories of the Iberian Peninsula in that period, perhaps in competition with the eastern intellectual production? Or was it elaborated in the context of the subsequent Almohad Caliphate's cultural project which accompanied its political expansion and which – taken as a whole – can be viewed as a precedent for King Alfonso X's political and cultural agenda?[7] On the other hand, like Ibn al-Bayṭār's extensive work on simple drugs a century later,[8] could al-Ghāfiqī's *Herbal* have been compiled outside al-Andalus while the author was working for an eastern Muslim ruler? Alternatively, could this work have sprung from a genuine interest and as a personal endeavour to improve available pharmaco-botanical knowledge far from the influence of any court?

General Survey of Scientific Development in al-Andalus

As a start, in order to place al-Ghāfiqī's *Herbal* in its scientific, literary, and historical contexts, it is relevant to provide a general overview of scientific development in al-Andalus.[9] According to Julio Samsó, by the second half of the 10th century, al-Andalus had assimilated the best of eastern scientific knowledge, both in terms of exact sciences and natural sciences. From this point on, it began to develop its own scientific tradition, which reached maturity in the first Ṭāʾifa (petty ruler) period (422–78/1031–86). Political havoc in no way resulted in a cultural crisis, but to the contrary stimulated scientific and literary endeavours on account of the number of petty kingdoms and monarchs eager to adorn their courts with scientists and poets. Thus, over the fifty-five years spanned by the first Ṭāʾifa period, Andalusī science continued to develop, and more importantly, continued to build upon its own basis and its own scientific schools, becoming progressively independent of the eastern Islamic tradition. Additionally, while the intensity of eastern scientific contact and influence on Andalusī science decreased, the literary production of al-Andalus was exported to and known in the East as well as in the Latin West. Although alchemy and magic were subjects of particular interest and development in this period, 11th-century al-Andalus is considered the Golden Age for mathematics and astronomy within the exact sciences, as well as for agronomy (studied by Ibn Wāfid, Ibn Baṣṣāl, Ibn Ḥajjāj, and al-Ṭighnarī), navigation techniques, and mechanical engineering as far as applied sciences are concerned.

With regard to pharmacology and botany, during the first Ṭāʾifa period there is a continuity of the strong tradition that took off in the previous century as a consequence of the revision of the Arabic translation of Dioscorides' *De materia medica* undertaken by the Umayyad caliph ʿAbd al-Raḥmān III (r. 300–50/912–61) at Cordoba. According to Samsó, this scientific enterprise set the agenda for later Andalusī botanists and pharmacologists. In fact, he points to a three-fold agenda involving: (1) the merging of Dioscorides' contribution with that from other Greco-Roman sources and eastern authors; (2) the extension of the list of simple drugs with the names and descriptions of new plants – either from al-Andalus or other Muslim territories – not mentioned by Dioscorides and subsequent authors; and (3) the production of progressively more elaborate classifications of known plants, a task that culminated with the first attested attempt at taxonomic classification by the Sevillian agronomist Abū l-Khayr in the first half of the 12th century.[10] Although only the treatise by Ibn Wāfid (d. 467/1075) has come down to us, to judge by later quotations or the meagre information recorded in biographical dictionaries, the contribution of scholars such as Ibn Janāḥ (d. ca. 430/1039, Zaragoza), al-Rumaylī (fl. 11th century, Almería), and Ibn al-Baghūnish (d. 444/1052, Toledo), was more medical than pharmacological, while the work of the Andalusī geographer al-Bakrī (d. 487/1094) was botanical in nature. Hence, 11th-century al-Andalus has traditionally been viewed as the Golden Age for these two disciplines.

Following the first Ṭāʾifa period,[11] Almoravid rule lasted from the invasion in 478/1086 to 539/1145 and, during the fleeting Ṭāʾifa revival (or second Ṭāʾifa period), the Almohads invaded the Iberian Peninsula in 539–40/1145–46 and ruled the conquered territories until approximately 629/1232.[12] Notwithstanding the strict religious character of the North African Almoravid and Almohad dynasties, the sciences enjoyed a particularly intense activity in al-Andalus. Al-Andalus, transformed into a province of the Maghreb, strengthened its relations with this part of the Islamic empire at the expense of contacts with the East, including in the domain of scientific exchange. Over the 12th century, while the flow of eastern medical knowledge to al-Andalus seems restricted to the – not particularly enthusiastic – reception of Ibn Sīnā's *Qānūn*, few Andalusī scholars undertook the customary trip to the East to complete their studies and, those who did – for that reason or any other, as in the case of Maimonides (d. 601/1204), Abū l-Ṣalt al-Dānī (d. 529/1134) or Abū Ḥāmid al-Gharnāṭī (d. 565/1169) – never returned. Moreover, confident and aware of its own culture, Andalusī science developed its own personality.

In Samsó's view,[13] the 12th century in al-Andalus is a period dominated intellectually by philosophy. The scientific interest in mathematics as well as astronomy declines, and though there were relevant individual contributions, production as a whole declined to such an extent that it could be said that the Golden Age was over. In the same century, pharmacology, botany, and agronomy emerged in the composition of encyclopedic works which, encompassing a high degree of new observation and experimentation and also greatly expanded with new plants, continued the line initiated two centuries earlier, that is, collecting and accumulating knowledge inherited from the past. With regard to medicine, important figures such as Abū Marwān b. Zuhr (d. 557/1162) and Ibn Rushd (d. 595/1198) lent a renewed splendour to this discipline, which, in this particular century, acquired a strong philosophical character.[14]

At this point, if only as a reference background to grasp scientific development or decline in the western and eastern lands of medieval Islam, and even if it is also restricted to well-known figures of medicine, pharmacology, or botany, as well as physicians-philosophers who wrote medical and pharmacological treatises, it is interesting to look at a basic comparative picture of medical science in al-Andalus and in the East during the 11th and 12th centuries. Bearing in mind the quantity and nature of medical works produced by these authors, 12th-century Andalusī scientific production emerges as pre-eminent in comparison with the same disciplines in the East. It is also worth noting that many 12th-century Andalusī physicians were also prolific philosophers, while for the most part the background of medical writers in the East in the same century seems to have been slightly different and their medical production smaller.

Table 3.1

5th/11th Century al-Andalus	5th/11th Century Near and Middle East
Ibn Samajūn (d. 400/1010, Cordoba?)	Ibn Sīnā (d. 428/1037)
Ṣāʿid al-Andalusī (d. 462/1070, Toledo)	al-Bīrūnī (d. 440/1048)
Ibn Wāfid (d. 467/1075, Toledo)	Ibn Buṭlān (d. 458/1066)
Ibn Janāḥ (d. ca. 430/1039, Zaragoza)	Ibn Riḍwān (d. 453/1061 or 460/1068)
al-Rumaylī (fl. 5th/11th century, Almería)	Ibn Jazla (d. 493/1100)
Ibn al-Bagūnish (d. 444/1052, Toledo)	

6th/12th Century al-Andalus	6th/12th Century Near and Middle East
Abū l-Khayr (d. first quarter 6th/12th c., Seville)	ʿAdnān b. Naṣr ʿAynzarbī (d. 547/1153)
Ibn Biklārish (d. first half 6th/12th c., Zaragoza)	Ibn al-Tilmīdh (d. 560/1165)
Abū l-Ṣalt Umayya (d. 529/1134, Valencia)	Ibn al-Maṭrān (d. 587/1191)
Abū l-ʿAlāʾ Zuhr (d. 525/1130, Seville)	Ibn Jumayʿ (d. 594/1198)
Ibn Bājja (Zaragoza, d. 533/1138, Fez)	Yaʿqūb ibn Isḥāq al-Isrāʾīlī (d. ca. 598/1202)
Abū Marwān b. Zuhr (d. 557/1162, Seville)	ʿAbd al-ʿAzīz al-Sulamī (d. 604/1208)
al-Ghāfiqī (d. 561/1165)	ʿAbd al-Laṭīf al-Baghdādī (d. 629/1231)
al-Idrīsī (Ceuta?, d. 560/1164-5, Sicily)	Ibn Abī l-Bayān (d. 634/1236)
Ibn Ṭufayl (Almería, d. 581/1185, Marrakesh)	
Ibn Rushd (Cordoba, d. 595/1198, Marrakesh)	
Maimonides (Cordoba, d. 601/1204, Egypt)	
Ibn al-Rūmiyya (d. 637/1239, Seville)	

The Literary Context of al-Ghāfiqī's *Herbal*

A more interesting point is the immediate scientific context of the work under discussion, since in a short time span of about 50 years, three voluminous works on simple drugs – halfway between pharmacology and botany, or botanical works applied to pharmacology – were written in al-Andalus. In addition to al-Ghāfiqī's *Kitāb fī l-adwiya al-mufrada*,[15] we find Abū l-Khayr al-Ishbīlī's *Kitāb ʿumdat al-ṭabīb fī maʿrifat l-nabāt li-kull labīb*,[16] as well as Ibn Biklārish's *Kitāb al-mustaʿīnī*, also written in the first half of the 12th century and dedicated to the ruler of Zaragoza.[17] Virtually nothing is known about their lives, but in terms of historical-political context, Ibn Biklārish and Abū l-Khayr were active

during the first Ṭāʾifa period and the North African Almoravid rule (478–539/1086–1145). Probably born by the end of the first Ṭāʾifa period, al-Ghāfiqī was active mainly during the Almoravid period, but like Ibn Zuhr (Avenzoar, d. 557/1162), he would have also experienced the Almohad conquest in 540/1146.

With regard to the literary context (understood as scientific literary tradition), these three works share in a striking manner several common features, the first and most visible one being their length, encyclopedic nature, and massive size which, as was the case with Ibn Sīnā's *Qānūn*, must have conferred upon them great prestige and authority. The second common element is the presumed exhaustive nature of their contents as botanical dictionaries and/or pharmacological vademecums at the time of their composition. Ibn Biklārish's *Kitāb al-mustaʿīnī* is a collection of 700 simple drugs, in which each entry starts with the plant's name and provides its humoral nature and degree, its synonyms in other languages, its substitutes, and finally, its uses, properties, and the manner in which the drug should be employed.[18] Abū l-Khayr al-Ishbīlī's *Kitāb ʿumdat al-ṭabīb*, containing over 5,000 entries, is a botanical dictionary dealing with the pharmacological uses of plants. Although a large number of entries are not developed in full in this work, a complete description includes the category and sub-category to which it belongs, the morphological description (such as the shape of its leaves, colour of its flowers, or size of its fruit), the geographical location of the plant (indicating where the author saw it personally or was informed of its existence), the type of soil in which it grows, and its pharmacological, industrial, and domestic uses. As for al-Ghāfiqī's collection of more than 900 simple drugs, for each entry he provides the morphological description of the plant, its therapeutic uses, all possible information available about it from other sources, the author's personal observations when he has something to say about it, and, in a separate section, the synonyms in other languages (see Table 3.2).

In order to complete the picture, the work by the famous geographer al-Idrīsī (d. ca. 560/1164–65) traditionally considered of Andalusī origin should also be noted in this context. Probably written between 1154 and 1165 (548–60 H), his *Kitāb al-jāmiʿ li-ṣifāt ashtāt al-nabāt wa-ḍurūb anwāʿ al-mufradāt min ashjār wa-l-thimār wa-l-uṣūl wa-l-azhār wa-ʿaḍāʾ al-ḥayawānāt wa-l-maʿādin wa-l-aṭyār* (*Compendium of the Properties of Diverse Plants and Various Kinds of Simple Drugs from Trees, Fruits, Roots, Flowers, Parts of Animals, Minerals, and Birds*) very much resembles al-Ghāfiqī's work, down to the belligerent or polemical prologue, a matter to which I will return later. Al-Idrīsī's work contains about 1,000 entries, each including the Arabic name, whether it has been cited by Dioscorides or not, synonyms in other languages, morphological description of the plant, habitat, the plant's geographical origin and dissemination, pharmacological data (such as its nature, properties, and therapeutic uses), and quotations from sources as well as his own opinion about it.[19]

Another common feature of these pharmaco-literary works is the learned display of mainly authoritative written sources, as shown in Table 3.3.

Table 3.2

Ibn Biklārish	Abū l-Khayr	Al-Ghāfiqī
Collection of simple drugs	Botanical dictionary, including pharmacological uses	Collection of simple drugs, including botanical data
(a) humoral nature and degree (b) synonyms in other languages (c) substitutes (d) uses, properties, and manner to be employed	(a) genus, species, and variety (b) morphological description (c) synonyms in other languages (d) geographical location (e) type of soil in which it grows (f) pharmacological, industrial, and domestic uses (g) personal observations	(a) morphological description (b) therapeutic uses (c) extant information extracted from available sources (d) personal observations (e) synonyms in other languages.
Number of substances: 700	Number of entries: 5,126	Number of entries: 945

Table 3.3 does not intend to be exhaustive or completely accurate. Indeed, as the contributions by Oliver Kahl and Leigh Chipman to this volume show, the question of sources remains to some degree an open one (which can only be fully resolved by a full critical edition). Nevertheless, it gives us a glimpse of the extent and type of sources considered of interest by each author.[20] In many instances, the source is not a direct one and must have been extracted mainly from Abū Ḥanīfa's work and al-Rāzī's *al-Ḥāwī*. As far as al-Ghāfiqī is concerned, two points are to be considered. On the one hand, the author often employs the expression *ghayruhu* meaning "another source says," as if avoiding the painstaking task of transcribing the exact name or as if avoiding reference to a particular source (perhaps a contemporary Andalusī one?); likewise, al-Ghāfiqī eventually resorts to what are apparently abbreviated forms for sources already quoted, so that "al-Dimashqī" can perhaps be identified with Masīḥ b. Ḥakam, and "al-Fārisī" with an author of Persian origin such as al-Rāzī or Ibn Sīnā (Avicenna). On the other hand, the copyist of the Osler manuscript often seems to misunderstand or mistakenly misrepresent the source's name, as is probably the case with "al-Fārī" in folio 275b instead of al-Fārisī, and with "Zūfun" in folio 246a for what probably must have read as "Rufus." It should be added that the Osler manuscript only preserves the first half of the work and so some sources quoted in the second half might be missing.

Sources in Table 3.3 have been roughly grouped according to Classical authors, most influential Islamic sources, lesser-known or second-tier Islamic authors, relevant Andalusī

Table 3.3

Ibn Biklārish	Abū l-Khayr	Al-Ghāfiqī
	His own botanical researches	His personal knowledge of plants in al-Andalus
Only written sources:	Written and oral sources:	Written and oral sources:
Dioscorides; Galen	Dioscorides; Galen; Hippocrates	Dioscorides; Galen
Hippocrates (preface)	Socrates; Oribasius	Socrates; Oribasius? (f. 163a)
K. al-Aḥjār = Pseudo-Aristotle	Aristotle; Hermes	*K. al-Aḥjār* = Pseudo-Aristotle
Paul of Aegina	Ahrūn; Paul of Aegina	Ahrūn; Paul of Aegina
Badīghūrash (preface)	Badīghūrash	Badīghūrash
	Rufus of Ephesus	Rufus of Ephesus
Abū Ḥanīfa al-Dīnawarī	Abū Ḥanīfa al-Dīnawarī	Abū Ḥanīfa al-Dīnawarī
Isḥāq b. ʿImrān	*al-Filāḥa al-nabaṭiyya*	*al-Filāḥa al-nabaṭiyya*
Masīḥ b. Ḥakam al-Dimashqī	*al-Filāḥa al-rūmiyya*	
ʿĪsā b. Māssa al-Baṣrī	Isṭifān [b. Basīl]	
Ibn Māsawayh; Māsarjawayh?	Isḥāq b. ʿImrān; Ibn Sarābiyūn	Isḥāq b. ʿImrān; Ibn Sarābiyūn
Sabūr b. Sahl	Masīḥ b. Ḥakam al-Dimashqī	Masīḥ b. Ḥakam al-Dimashqī
Ḥunayn b. Isḥāq	ʿĪsā b. Māssa al-Baṣrī	ʿĪsā b. Māssa al-Baṣrī
	Ibn Māsawayh; Māsarjawayh	Ibn Māsawayh; Māsarjawayh
	Ibn Bakhtīshūʿ; Sabūr b. Sahl	Qusṭā b. Lūqā
	Ḥunayn b. Isḥāq	Ḥunayn b. Isḥāq
	Thābit b. Qurra	Thābit b. Qurra
al-Kindī (preface)	al-Kindī	al-Kindī
al-Ṭabarī; al-Rāzī	al-Ṭabarī; al-Rāzī	al-Ṭabarī; al-Rāzī
	Ibn Sīnā; Ibn Buṭlān	Ibn Sīnā; Ibn Buṭlān
		al-Majūsī; Ibn Riḍwān
Ibn al-Jazzār	Ibn al-Jazzār	Ibn al-Jazzār
Isḥāq b. Sulaymān al-Isrāʾīlī	Isḥāq b. Sulaymān al-Isrāʾīlī	Isḥāq b. Sulaymān al-Isrāʾīlī
	Sindihsār	*Shandahar* (f. 182b)
	Sharak al-Hindī (Ç̌araka)	

Table 3.3 (continued)

Ibn Biklārish	Abū l-Khayr	Al-Ghāfiqī
Only written sources:	Written and oral sources:	Written and oral sources:
Yaḥyā b. al-Biṭrīq		[Yaḥyā b.] al-Biṭrīq
Ḥubaysh b. al-Ḥasan	Ḥubaysh b. al-Ḥasan	Ḥubaysh b. al-Ḥasan
Abū Jurayj	Abū Jurayj	Abū Jurayj
Kushājim		
		Kushājim
	Abū Ḥātim	Abū Ziyād [al-Kilābī?]
	Abū Ḥarshan	Ibn Haytham
	Ibn Haytham	al-Khūzī
	al-Khūzī	al-Yahūdī
	al-Yahūdī	al-Khalīl b. Aḥmad
	al-Khalīl b. Aḥmad	Ibn al-Kattānī
	Ibn al-Kattānī	[Dunāsh] Ibn Tamīm [al-Isrāʾīlī]
	Dunāsh ibn Tamīm al-Isrāʾīlī	
		Anonymous author
	Anonymous author	[Isḥāq] b. Ḥassān
	Isḥāq b. Ḥassān	
		Ḥakīm Muḥ. b. al-Ḥasan
	Abū ʿAbd Allāh al-Ṣaydalānī	Ḥakīm b. Ḥunayn (f. 242b)
	Abū l-Fatḥ al-Jurjānī	ʿAlī b. Muḥammad (f. 221a)
	Aḥmad b. Dāwūd	Thābit b. Muḥammad (f. 224a)
	Abū Ḥaddāsh al-Maghrawī	Shalmawayh ? (f. 188b)
	Abū Isḥāq al-Bakrī	Qīshāwush ? (f. 247a)
	Abū ʿĪsā; Abū ʿUbayd al-Bakrī	ʿUṭārid b. Muḥammad ? (f. 96a)
	Ibn al-Nadā	al-Laṭīnī (f. 155b)
	al-Jabalī	al-Naṣrānī (f. 202b)
	Abū ʿAlī al-Baghdādī	al-Dimashqī (= Masīḥ?)
	Aḥmad b. Ibrāhīm	al-Fārisī
	al-Qāsim b. Sallām	ʿImrān b. Isḥāq
	Abū ʿAmr ʿĀmir b. Sharāhīl al-Shaʿbī	'another [author]'
	al-Quhlumān	
	al-Iskandarāniyūn	
	al-Iskandarānī	

Table 3.3 (continued)

Ibn Biklārish	Abū l-Khayr	Al-Ghāfiqī
Only written sources:	Written and oral sources:	Written and oral sources:
al-Zahrāwī; Ibn Juljul Ibn Janāḥ Ibn Wāfid	al-Zahrāwī; Ibn Juljul Ibn Janāḥ; Ibn Samajūn Ibn Wāfid Ibn al-Baghūnish; Ibn al-Lūnquh Ibn Baṭṭāl; Ibn Baṣṣāl	al-Zahrāwī; Ibn Juljul Ibn Janāḥ; Ibn Samajūn Ibn Wāfid
Abū Ziyād al-Kilābī Abū Naṣr al-Bāhilī Abū ʿUbayda al-Farrāʾ Yaʿqūb al-Sikkīt Bedouin informants	al-Aṣmaʿī Ibn ʿAbdūn Abū ʿAlī al-Qālī Ibn Durayd References to pre-Islamic poets, historical and mythological figures	al-Aṣmaʿī Ibn ʿAbdūn al-Masʿūdī

authors, and non-scientific works. For his part, al-Idrīsī's sources are Dioscorides, Galen, Badīghūrash, Ibn Māsawayh, Māsarjawayh, Masīḥ b. al-Ḥakam, Ḥunayn b. Isḥāq, al-Ṭabarī, al-Kindī, al-Rāzī, al-Majūsī, Ibn Sīnā, Abū Ḥanīfa al-Dīnawarī, Isḥāq b. ʿImrān, Ibn al-Jazzār, Isḥāq b. Sulaymān al-Isrāʾīlī, al-Zahrāwī, Ibn Juljul, Ibn Janāḥ, Ibn Wāfid (and Abū l-Khayr once only in the preface). He innovates by quoting Ibn Jazla and Ibn Waḥshiyya, the translator of *al-Filāḥa al-nabaṭiyya*.

At first sight, this bird's-eye view fits with Samsó's description mentioned above regarding the cumulative nature of botanical and pharmacological works compiled in 12th-century al-Andalus. However, is it possible that another bias or agenda underlies the selection of sources, at least in al-Ghāfiqī, Abū l-Khayr, and al-Idrīsī's works? If we compare Ibn Biklārish and al-Idrīsī's works, the sources are virtually the same except that al-Idrīsī added four new "major" eastern authors (Ibn Sīnā, al-Majūsī, Ibn Waḥshiyya, and Ibn Jazla). He also eliminated what can be considered second-tier sources (such as Yaḥyā b. al-Biṭrīq, Ḥubaysh b. al-Ḥasan, Abū Jurayj, and Kushājim) as well as non-scientific – philological – sources (Abū Ziyād al-Kilābī, Abū Naṣr al-Bāhilī, Abū ʿUbayda, al-Farrāʾ, or Yaʿqūb al-Sikkīt). Likewise, he omitted some ancient and

Islamic medical authors – such as Paul of Aegina, Ibn Māssa, and Sabūr b. Sahl – which might not have been useful for his purposes, might not have been available to him, or which he perhaps did not consider to be authorities.

In comparison with these two, Abū l-Khayr and al-Ghāfiqī displayed a wider number of Classical sources, an impressive number of eastern and western Islamic authorities, a diverse range of Andalusī physicians and pharmacologists (to which Abū l-Khayr added a larger amount of agronomical texts), and a considerable number of second-tier authors. Moreover, they also incorporated non-scientific works by authoritative eastern writers such as al-Aṣmaʿī, al-Masʿūdī, Abū ʿAlī al-Qālī, or Ibn Durayd, and both drew information from Ibn ʿAbdūn, presumably the near-contemporary Andalusī jurist from Seville who wrote a well-known treatise on *ḥisba* or market inspection.[21] Interestingly, both authors also included sources of Sanskrit origin (to the best of my knowledge, a rare feature in Andalusī medical literature). More importantly, neither of them explicitly quote the other, nor do they mention Ibn Biklārish. There might be a chronological reason not to refer to their Andalusī counterparts, namely, that their works, even if written earlier, had not had sufficient time to be disseminated. However, we must remember that Ibn Juljul omitted al-Zahrāwī from his biographical dictionary, despite the fact that they must have been active at the same place and, possibly, at the same time. Perhaps it was common practice in al-Andalus to ignore competitors on purpose in order to market one's own work better.[22]

Seen the other way around, in terms of categories as grouped in Table 3.3, the number and variety of sources employed by Abū l-Khayr and al-Ghāfiqī, at least to some extent, could reflect their aim to be exhaustive. This would explain Abū l-Khayr's use of a relatively large number of eastern and Andalusī agronomical sources in his botanical work, but since one of al-Ghāfiqī's features is to collect all possible or available information regarding a given plant, it is worth noting that he could also have drawn information from texts other than *al-Filāḥa al-nabaṭiyya*, particularly a number of Andalusī ones. Again, we may here have a chronological clue in that the work written at a later date might have displayed a larger number and quality of sources in order to impress the audience by surpassing the immediate – and geographically close –predecessor, but it may well also be a competition between them, in both instances compatible with a desire to knock down eastern intellectual dominance.

On the whole, it seems that Ibn Biklārish had a limited number of sources at hand and al-Idrīsī deliberately restricted himself to a select group of authorities (and perhaps also of direct sources). In contrast, al-Ghāfiqī surpassed them by far in terms of Classical and eastern sources of renown as well as less prestigious authors (or indirect sources) and "exotic" references, either texts translated from Sanskrit or the sources listed in the last section of second-tier authors of Table 3.3, for the most part difficult to identify. Abū l-Khayr even went beyond expanding the number of sources to include more agronomical works and a larger number of identifiable second-tier authors. Was it by chance? Were

Table 3.4

Ibn Biklārish	Abū l-Khayr	Al-Ghāfiqī
Classical Greek (Yunāniyya)	Classical Greek	Classical Greek
Byzantine Greek (Rūmiyya)	Byzantine Greek	Byzantine Greek
Latin	Latin	Latin
Arabic	Arabic	Arabic
	Andalusī Arabic	Andalusī Arabic
Maghribī variants		Arabic dialects (Iraq, Syria, Egypt, Yemen, Oman)
Egyptian variants	Egyptian variants	
Persian synonyms	Persian	Persian
Syriac synonyms	Syriac, Coptic, Nabatean	Syriac, Coptic, Nabatean
	Sanskrit	Sanskrit
		One reference to the language of Armenians and of Khurāsān
Berber	Berber	Berber
Romance synonyms	Romance	Romance
	Iberian Romance languages and dialects from north-western Spain (Galicia), Upper Frontier (present Aragon and Catalonia, that is, north-eastern Spain), as well as French dialects	Variants of Iberian Romance languages and dialects

al-Ghāfiqī and Abū l-Khayr exclusively driven by a genuine scholarly interest to be exhaustive in order to improve the available bibliography of their time or was it intended to fulfil promotional expectations (both for themselves and for the political prestige of their patrons) with a more impressive display of sources and a massive volume? Was there an attempt to show the superiority of al-Andalus with regard to other regions of the medieval Islamic world? Or was it a genuinely Andalusī tendency to cumulate which, according to Max Meyerhof, would reach its utmost glory with Ibn al-Bayṭār's reproduction of al-Ghāfiqī's material expanded with subsequent works such as those by al-Idrīsī and Abū l-ʿAbbās al-Nabātī?[23]

A fourth interesting feature common to all these works is that they include the name equivalence in languages such as Greek, Berber, Persian, Syriac, Sanskrit, Andalusī Arabic, Latin, and Romance languages (to which al-Idrīsī apparently added Turkish and Kurdish).[24]

In the works under scrutiny, the inclusion of synonyms in all these foreign languages is not a systematic element found in every single entry of plants or simple drugs, but rather information included at random according to arbitrary availability. Although some western dialectical Arabic variants and words in Romance languages could have been collected orally, for the most part, synonyms in general, and those of Greek, Persian, Syriac, or Sanskrit origin, in particular, were extracted from written sources. Therefore, aside from the greater or lesser variety of languages and dialects – or the greater or lesser number of words in each language – to be found in the works of our Andalusī authors, a comparison of texts would probably show that the information provided by each one of them, in many instances, is exactly the same. In her pioneering article, Labarta drew attention to the striking coincidence between languages included by Ibn Biklārish and those in Ibn Janāḥ's lost work, which is said to have included Arabic, Persian, Syriac, Greek, Berber, and Romance languages.[25] However, judging by the fact that some synonyms in Persian, Syriac, Greek, etc. were also taken by Ibn Biklārish, Abū l-Khayr, and al-Ghāfiqī from previous Andalusī sources (at least from al-Zahrāwī and Ibn Juljul) and that later Andalusī authors continued to include this information in their works (at least al-Idrīsī, Maimonides, and Ibn al-Bayṭār), there seems to be a long-lasting tradition or fashion in al-Andalus for this practice. Were eastern authors as keen on this particular feature as Andalusī scholars? If so, did they care about including Andalusī, Maghribī, and Berber synonyms? To judge by E. Savage-Smith's comparison of Ibn Biklārish and two eastern authors, they did not, although it is true that the 13th-century Jewish pharmacologist al-Kūhīn al-ʿAṭṭār included names of plants in Berber and *ʿajamiyyat al-andalus*, the latter undoubtedly taken from Andalusī sources such as Maimonides and Ibn al-Bayṭār.[26] Another exception appears to be the scholar Aḥmad b. ʿAlī b. Ibrāhīm b. Abī Jumhūr (fl. ca. 880/1475) in his *Kitāb al-raḥma wa-l-ḥikma fī al-ṭibb*, an abridged and re-elaborated version of al-Ghāfiqī's text.[27] In al-Ghāfiqī's work, the pharmacological information along with synonyms predominate. In turn, if we are to follow I. Garijo, Ibn Abī Jumhūr was most interested in the synonyms. So, apart from the fact that Ibn Abī Jumhūr's concern about the corruption of plants' names in the process of transmission may have had its precedent in al-Ghāfiqī himself, he may well have been an exception among eastern scholars as far as the inclusion of Maghribī, Berber, and Andalusī synonyms is concerned.

Oliver Kahl's seminal study in this volume clearly explains the development, complexities, and aims of medieval Islamic multilingual glossaries of plant names, whose initial pragmatic purpose to serve as a translation tool was no longer valid at the time of the Andalusī authors under discussion. These synonymatic lists became a literary convention framed by the preservation of knowledge deemed authoritative within the intellectual scheme of the medieval period and one that provided additional subject-matter for rhetorical speculation. So far, so good: but did it really have a practical aim in terms of medical practice or everyday life? With regard to our four Andalusī authors, the practical utility of

including synonyms in Romance dialects of the Iberian Peninsula, Latin, Classical and Andalusī Arabic, even Berber and North African dialects, could have had an occasional practical justification on account of potential commercial purposes as much as of the circulation of people and Arabic manuscripts throughout North Africa and the Hispanic kingdoms, thus making possible the identification of a particular plant in neighbouring geographical areas. However, what was the point of including exotic words in languages such as Classical and Byzantine Greek, Persian, Syriac, Sanskrit, and even Coptic or Nabatean as in al-Ghāfiqī's and Abū l-Khayr's work? Was it just in case an Andalusī learned physician or pharmacologist would puzzle over the identification of a particular plant encountered once in a lifetime, when medieval Islamic practitioners usually prescribed basic and easily available remedies? Alternatively, were our Andalusī authors persuaded that their works would be consulted all around the Islamic world so as to make Greek, Persian, Syriac, and similar geographical synonyms useful information for inclusion? Additionally, how useful can those multilingual synonyms be when names change from one area to another and throughout time? More importantly, on the one hand, the corruption of words in the process of transmission of their own works – and the authors' awareness of it – is not a minor point. On the other hand, the possibility of our Andalusī scholars being wrong in the identification of plant names or perpetuating the mistakes of their predecessors is a matter passionately highlighted by al-Ghāfiqī in his prologue.[28] Actually, even he himself did not escape that pitfall, for the Sevillian Ibn al-Rūmiyya (d. 637/1239) wrote a commentary of Dioscorides' and Galen's works on simple drugs in which he drew attention to the mistakes made by those who translated them, particularly addressing al-Ghāfiqī's errors in the interpretation of names of simple drugs.[29] In other words, how useful can this kind of information be for medieval Islamic learned physicians, pharmacologists, botanists, and other specialized scholars such as philologists? Perhaps here we must hear Bar Hebraeus' voice, when – so it seems – "he left out from the Greek quotations many names which were useless to Arabic physicians, and suppressed several passages concerning Spanish or Latin names of drugs of no interest to Eastern scholars."[30] Nevertheless, the Andalusī synonymatic material under discussion must indeed have entailed a pragmatic aim: along with the display of one's mastery of authorities as a curricular requirement to raise one's professional status, within medieval scientific literature multilingual synonyms also constituted a highly specialized subject for scholastic thinking as much as self-marketing and political propaganda. In Tolan's perspective, perhaps it was also a way for Andalusī scientists to appropriate the eastern intellectual wealth and a symbol of their superiority.

The sole point in which these three works apparently differ is the prologue. While absent in Abū l-Khayr's work according to the two extant copies, Ibn Biklārish wrote a lengthy prologue in which, after a long passage explaining why his work is so good, necessary, original, innovative, and useful, he incorporated four preliminary chapters which

can be considered a theoretical treatise, one which – let it be said in passing – actually seems to make pharmacological theory clear (i.e., practical) to everybody in spite of the author's stated reluctance to popularize that knowledge.[31] For his part, al-Ghāfiqī wrote a more traditional kind of prologue, that is, one encompassing an explanation of why he wrote the book, how he organized the contents, and why his book is better than those of his predecessors.[32] It is a rather boastful prologue, in my view. However, al-Ghāfiqī's prologue appears to be quite original compared with previous Andalusī and later eastern prefaces on the same or similar subject matter. To begin with, to the best of my knowledge this is one of the few and one of the earliest instances where a medieval Islamic scholar states that he had the intention to write the work for himself. Although the author eventually employs the most conventional of *topoi* in this regard – that is, that he wrote it at someone's request – in order to justify the work's novelty, the original reason he put forward might have also been meant as a self-promotional innovation to set himself apart from his predecessors and contemporaries from the very beginning of his work.

A second original point to be noted is that, in contrast with Ibn Biklārish, al-Ghāfiqī not only criticizes other physicians and contemporary colleagues (a trait common to the many medieval Islamic medical writers), but also complains of people's lack of critical judgment when faced with a book's contents, their judgment being biased by the social status of the book's author or by marketing strategies as much at work in his time as in ours. In short, he criticizes people's general ignorance and their innate compulsion to choose the wrong option. Moreover, what really draws one's attention is his aggressive or radical attack on his predecessors, and more particularly on influential eastern medical authorities such as al-Rāzī and Ibn Sīnā, the latter openly accused of lying.[33] In this respect, al-Ghāfiqī's contempt towards his eastern predecessors was not new in al-Andalus, but it seems to go far beyond the usual abstract criticism by subsequent eastern medical writers such as ʿAbd al-Laṭīf al-Baghdādī (d. 629/1231) against his contemporary colleagues or al-Kūhīn al-ʿAṭṭār's specific – and indeed much rarer if not unique – criticism of his own teacher, Ibn Abī l-Bayān (d. ca. 638/1240).[34] Much earlier than ʿAbd al-Laṭīf al-Baghdādī, al-Ghāfiqī seems to claim that the sole valid knowledge is that of Greco-Roman writers. And, although he is not the first or the only Andalusī scholar to defend pharmacology as an instrumental part of medicine, he certainly does it before al-Kūhīn al-ʿAṭṭār.[35] More importantly, when reading the prologues by Andalusī physicians such as Ibn Wāfid (d. 467/1075),[36] Abū l-Ṣalt Umayya (d. 529/1134),[37] Ibn Biklārish, and al-Ghāfiqī, one cannot help but sense a growing self-confidence, assertive attitude, and polemical tone aimed at self-praise and self-aggrandizement that reached its peak with al-Ghāfiqī (and probably with al-Idrīsī, too). Criticism in varying degrees – perhaps ignoring contemporary competitors, too – was a marketing strategy known and cultivated by medieval Islamic physicians to assert one's personal credentials. In Gutas' perspective, criticism of authoritative eastern physicians such as Ibn Sīnā appears as a

somewhat "Andalusocentric" bias. In Langermann's framework, it might also be interpreted as a program to construct an alternative to eastern intellectual production – and to surpass it.

In light of this preliminary comparison, the study of al-Ghāfiqī's *Herbal* in its scientific, literary, and historical contexts may shed some light on how closely his work followed a literary tradition – simply repeating what others have said before – or whether he actually produced a more useful book than the existing ones responding to a real need. In medieval Islam, no learned scholar could escape the criterion of authority as an intellectual framework of thought and a means to gain reputation, but this is not incompatible with addressing the question of whether a pharmaco-botanical treatise is more subject to actual practical use than a theoretical medical work. A closer comparison of this work with its scientific and literary counterparts may illustrate whether the re-elaboration of available knowledge turned it into a useful tool for real practical purposes or into a rhetorical compendium with a hidden agenda – therefore, pointing to a parallel pattern common to physicians as far as the social context is concerned. In other words, it would answer the question of who were the potential readers or users of these long – and therefore, expensive – treatises, such as court physicians and scientists, audiences at court literary sessions – or also itinerant and rural practitioners, druggists in their market shops, perhaps reasonably wealthy people such as merchants or other kinds of professionals as fond of knowledge as of impressive private libraries. Likewise, a comparative study may well tell us whether the composition of three similar works in a short period of time simply responded to a fashion on account of a peculiar fondness for botany and pharmacology in al-Andalus or if it was part of the intellectual production funded by the Andalusī ruling classes as an instrument for political propaganda to attain cultural hegemony. Last, but not least, as shown by E. Savage-Smith, a close comparison of entries in the pharmacological works by the Jewish Andalusī scholars Ibn Biklārish and Maimonides reveals a common tradition among Andalusī authors as a whole that openly differs from the eastern one.[38] Going a step further, a bird's-eye view of al-Ghāfiqī's work in its scientific, literary, and historical contexts would perhaps settle the question of whether the 11th- and 12th-century Andalusī scientific strength in medicine, botany, pharmacology, and philosophy is the result of an attempt by these scholars to emulate and surpass their eastern predecessors and contemporaries and to shine in their own right in the medieval Islamic world.

NOTES

1 Emilie Savage-Smith: "The Exchange of Medical and Surgical Ideas between Europe and Islam," in John A.C. Greppin, Emilie Savage-Smith, and John L. Gueriguian, eds., *The Diffusion of Greco-Roman Medicine into the Middle East and the Caucasus* (Delmar, NY: Caravan Books, 1999), 27–55; "The Practice of Surgery in Islamic Lands: Myth and Reality," *Social History of Medicine* ("The Year 1000: Medical Practice at the End of the First Millennium," special issue edited by Peregrine Horden and Emilie Savage-Smith) 13, no. 2 (2000): 307–32; and "Tashrīḥ," in *Encyclopaedia of Islam*, 2nd ed., vol. 10 (Leiden: Brill, 2000), 354–6.

2 Cristina Álvarez Millán: "Graeco-Roman Case Histories and their Influence on Medieval Islamic Clinical Accounts," *Social History of Medicine* 12, no. 1 (1999): 19–43; "Practice *versus* Theory: Tenth-Century Case Histories from the Islamic Middle East," *Social History of Medicine* ("The Year 1000: Medical Practice at the End of the First Millennium," special issue edited by Peregrine Horden and Emilie Savage-Smith) 13, no. 2 (2000): 293–306; "The Clinical Account in Medieval Islamic Medical Literature: *Tajārib* and *Mujarrabāt* as Source," *Medical History* 54, no. 2 (2010): 195–214.

3 Y. Tzvi Langermann, "Another Andalusian Revolt? Ibn Rushd's Critique of al-Kindī's *Pharmacological Computus*," in Jan P. Hogendijk and Abdelhamid I. Sabra, eds., *The Enterprise of Science in Islam: New Perspectives* (Cambridge, MA: MIT Press, 2003), 351–72.

4 Miquel Forcada Nogués, "Síntesis y contexto de las ciencias de los antiguos en época almohade," in Patrice Cressier, Maribel Fierro, and Luis Molina, eds., *Los Almohades: Problemas y Perspectivas*, 2 vols (Madrid: Consejo Superior de Investigaciones Científicas, 2005), 2: 1091–1135; Sarah Stroumsa, "Philosophes almohades? Averroès, Maïmonide et l'idéologie almohade," in Patrice Cressier, Maribel Fierro, and Luis Molina, eds., *Los Almohades: Problemas y Perspectivas*, 2: 1137–62.

5 Dimitri Gutas, "What Was There in Arabic for the Latins to Receive? Remarks on the Modalities of the Twelfth-Century Translation Movement in Spain," in Andreas Speer and Lydia Wegener, eds., *Wissen über Grenzen Arabisches Wissen und lateinisches Mittelalter* (Berlin: de Gruyter, 2006), 3–21.

6 John V. Tolan, *Saracens: Islam in the Medieval European Imagination* (New York: Columbia University Press, 2002), 192–3.

7 For an analysis of the parallel between the "sapientalist" concept of the Almohad caliphate and Alphonse X the Learned's political and cultural agenda, see Maribel Fierro, "Alfonso X 'The Wise': The Last Almohad Caliph?," *Medieval Encounters* 15 (2009): 175–98.

8 Ibn al-Bayṭār (b. ca. 576/1180, Malaga; d. 646/1248, Damascus) was appointed as chief herbalist (*raʾīs ʿalā sāʾir al-ʿashshābīn*) in Egypt by the Ayyūbid ruler al-Malik al-Kāmil Muḥammad b. Abī Bakr, and he dedicated his most renowned works (*K. al-Jāmiʿ* and *K. al-Mughnī*) to his son. For his biography and a description of his

works, see Ana M. Cabo González, "Ibn al-Bayṭār," in Jorge Lirola Delgado and José Miguel Puerta Vilchez, eds., *Biblioteca de al-Andalus*, 7 vols (Almería: Fundación Ibn Ṭufayl, 2009–2013), 2: 619–24.

9 I have summarized here Julio Samsó's work *Las Ciencias de los Antiguos en al-Andalus*, 2nd ed., with addenda and corrigenda by J. Samsó and M. Forcada (Almería: Fundación Ibn Ṭufayl, 2011). For an English survey of Andalusī science, see Juan Vernet, "Natural and Technical Sciences in al-Andalus," and Julio Samsó, "The Exact Sciences in al-Andalus," in Salma K. Jayyusi, ed., *The Legacy of Muslim Spain*, 2 vols (Leiden: Brill, 1994), 2: 937–51 and 2: 952–73, respectively.

10 See Julio Samsó, "Un rápido recorrido por la exposición," in *El Legado científico andalusí: Museo Arqueológico Nacional, Madrid, abril–junio 1992* (Madrid: Ministerio de Cultura, Dirección General de Cooperación Cultural, 1994), 16–17.

11 The Ṭāʾifa period came to an end roughly between 478/1086 and 503/1110, as not all kingdoms fell under Almoravid rule at once. For instance, Granada fell in 482/1090, Almería and Seville in 483/1091, Badajoz in 486/1094, Valencia in 495/1102, the last one being Zaragoza in 503/1110.

12 As with the Almoravid invasion, the Almohad conquest also took place over a span of several decades: Cordoba and Seville fell under its rule in 541–2/1147–48, Badajoz in 544/1150, Granada and Almería in 551/1157, and Mallorca in 599/1203.

13 See Samsó, *Las Ciencias de los Antiguos en al-Andalus*, 312–13, 360–1, and 384–5.

14 On the shift performed within the relationship between medicine and philosophy in 12th-century al-Andalus, see the exhaustive study by Miquel Forcada Nogués, *Ética e ideología de la ciencia: El médico-filósofo en al-Andalus (siglos X–XII)* (Almería: Fundación Ibn Ṭufayl, 2011).

15 Abū Jaʿfar Aḥmad b. Muḥammad b. Aḥmad b. Sayyid al-Ghāfiqī (d. 561/1165). For his biography, see Ildefonso Garijo Galán, "Al-Gāfiqī, Abu Ŷaʿfar," in Jorge Lirola Delgado, ed., *Biblioteca de al-Andalus* (Almería: Fundación Ibn Ṭufayl de Estudios Árabes, 2012), 1: 353–5.

16 Abū l-Khayr al-Ishbīlī, also known as al-Shajjār al-Ishbīlī (second half of the 5th/11th century–first quarter of the 6th/12th century): Abulḥayr al'Išbīlī, *Kitābu ʿUmdati ṭṭabīb fī maʿrifati nnabāt likulli labīb* (Libro base del médico para el conocimiento de la botánica por todo experto), edited and translated with indices by Joaquín Bustamante Costa, Federico Corriente and Mohammed Tilmatine, 3 vols in 5 (Madrid: Consejo Superior de Investigaciones Cientificás, 2004–10). The religious expression employed by the author when mentioning one of his teachers (the physician Ibn Lūnquh, d. 498/1104) stands as internal evidence of a *post quem* date for its composition; see Julia M. Carabaza Bravo, "Al-Išbīlī, Abū l-Jayr," in Jorge Lirola Delgado, ed., *Biblioteca de al-Andalus* (Almería: Fundación Ibn Ṭufayl de Estudios Árabes, 2009), 6: 395–9.

17 Yūnus b. Isḥāq b. Biklārish al-Isrāʾīlī (second half of the 5th/11th century–first half of the 6th/12th century): The *Kitāb al-mustaʿīnī* was written in Almería (southeastern Spain), but it was dedicated to the ruler of the northeastern Ṭāʾifa kingdom of Zaragoza, al-Mustaʿīn II (r. 476–503/1110–

42). Ildefonso Garijo Galán, "Ibn Buklāriš," in Jorge Lirola Delgado, ed., *Biblioteca de al-Andalus* (Almería: Fundación Ibn Ṭufayl de Estudios Árabes, 2009), 2: 671–2.

18 See Ana Labarta, "La farmacología de Ibn Buklāriš: Sus fuentes," *Actas del IV Coloquio Hispano-Tunecino (Mallorca, 1979)* (Madrid: Instituto Hispano-Árabe de Cultura, 1983), 163–74. An updated English version of this paper can be found in "Ibn Baklārish's *Kitāb al-mustaʿīnī*: The Historical Context to the Discovery of a New Manuscript," in Charles Burnett, ed., *Ibn Baklarish's Book of Simples: Medical Remedies between Three Faiths in Twelfth-Century Spain* (Oxford: Arcadian Library in association with Oxford University Press, 2008), 15–26.

19 Al-Idrīsī, *Kitāb al-jāmiʿ li-ṣifāt ashtāt al-nabāt wa-ḍurūb anwāʿ al-mufradāt* (Compendium of the Properties of Diverse Plants and Various Kinds of Simple Drugs), facsimile edition edited by F. Sezgin, 3 vols, Publications of the Institute for the History of Arabic-Islamic Science, Series C, Facsimile editions 58, 1-3 (Frankfurt am Main: Institute for the History of Arabic-Islamic Science at the Johann Wolfgang Goethe University, 1995). For his biography and an exhaustive description of this work, see Jorge Lirola Delgado and Expiración García Sánchez, "Al-Idrīsī, Abū ʿAbd Allāh," in Jorge Lirola Delgado, ed., *Biblioteca de al-Andalus* (Almería: Fundación Ibn Ṭufayl de Estudios Árabes, 2009), 6: 371–80.

20 Sources quoted by each author have been taken from: Labarta, "La farmacología de Ibn Buklāriš: Sus fuentes," 165–7 and 170–1; Bustamante et al.'s Spanish translation and index of the *Kitāb ʿumdat al-ṭabīb*; Ghāfiqī, *Kitāb fī l-adwiya*, Osler MS 7508; and García Sánchez, "Al-Idrīsī," 380.

21 Muḥammad b. Aḥmad ibn ʿAbdūn al-Ishbīlī (fl. second half of the 5th/11th century–first half of the 6th/12th century): for his biography and a description of his work *Risāla fī l-qaḍāʾ wa-l-ḥisba*, see Pedro Cano Ávila, "Ibn ʿAbdūn al-Ishbīlī," in Jorge Lirola Delgado and José Miguel Puerta Vílchez, eds., *Biblioteca de al-Andalus* (Almería: Fundación Ibn Tufayl de Estudios Árabes, 2012), vol. 1, 647–51.

22 Ibn Juljul's biographical dictionary can be considered an illustrative example of the deliberate and careful selection of information included in an Andalusī scientific work, regarding both the choice of individuals and the data about them; see Cristina Álvarez Millán, "Medical Anecdotes in Ibn Juljul's Biographical Dictionary," *Suhayl* 4 (2004): 141–58.

23 See Max Meyerhof, "Études de pharmacologie arabe tirées de manuscrits inédits: III. Deux manuscrits illustrés du *Livre de Simples* d'Aḥmad al-Gāfiqī," *Bulletin de l'Institut d'Egypte* 23 (1940–41): 18. Abū l-ʿAbbās al-Nabātī is the name often used to refer to Ibn al-Rūmiyya (d. 637/1239).

24 Data have been taken from Labarta, "La farmacología de Ibn Buklāriš," 167–70; Carabaza Bravo, "Al-Išbīlī, Abū l-Jayr," 6: 398; Bustamante et al.'s Spanish translation and index of the *Kitāb ʿumdat al-ṭabīb*; and al-Idrīsī, *Kitāb al-jāmiʿ*, editor's introduction, viii. As for al-Ghāfiqī, the information is based on Kahl's contribution to this volume.

25 Labarta, "La farmacología de Ibn Buklāriš," 168.

26 See table in Emilie Savage-Smith, "Ibn

Baklarish in the Arabic Tradition of Synonymatic Texts and Tabular Presentations," in Charles Burnett, ed., *Ibn Baklarish's Book of Simples: Medical Remedies Between Three Faiths in Twelfth-Century Spain* (Oxford: Arcadian Library in association with Oxford University Press, 2008), 128; Leigh Chipman, *The World of Pharmacy and Pharmacists in Mamlūk Cairo* (Leiden and Boston: Brill, 2010), 85.

27 The extant copy of this work is preserved at Oxford, Bodleian Library, MS Huntington 421/1; see Emilie Savage-Smith, *A New Catalogue of Arabic Manuscripts in the Bodleian Library, University of Oxford*, vol. 1, *Medicine* (Oxford: Oxford University Press, 2011), 661–5 (entry n. 182). For an edition of the Arabic text and Spanish translation of Ibn Abī Jumhūr's preface, see Ildefonso Garijo Galán, "La sistematización de al-Gāfiqi," in Pedro Cano Ávila and I. Garijo Galán, eds., *El Saber en al-Andalus: Textos y estudios I* (Sevilla: Universidad de Sevilla, 1997), 137–49.

28 Ghāfiqī, *Kitāb fī l-adwiya*, Osler MS 7508, f. 3a, lines 3–7.

29 *Sharḥ ḥashā'ish Diyāsqūrīdūs wa-adwiyat Jālīnūs wa-l-tanbīh ʿalā awhām mutarjimīhā wa-l-tanbīh ʿalā aghlāṭ al-Ghāfiqī fī adwiyati-hi*. Ibn al-Rūmiyya was a traditionist, a botanist, the owner of a drug shop in Seville and also the author of a *Maqāla fī tarkīb al-adwiya* and *Al-Riḥla al-nabatiyya wa-l-mustadraka* (Travel account on herborization and verification). For his biography and a description of his works, see Fernando Velázquez Basanta, "Ibn al-Rūmīya, Abū l-ʿAbbās," *Biblioteca de al-Andalus,* 4: 497–504.

30 Bar Hebraeus (Gregorius Abū al-Faraj, Ibn al-ʿIbrī), *The Abridged Version of 'The Book of Simple Drugs' of Aḥmad ... Al-Ghâfiqî by Gregorius Abu'l-Farag (Barhebraeus)* [Cairo, 1932], edited and translated by Max Meyerhof and George P. Sobhy, 51: fasc. 1; 52: fasc. 2–4 (Frankfurt am Main: Institute for the History of Arabic-Islamic Science at the Johann Wolfgang Goethe University, 1996), 1: 37.

31 Ana Labarta, "El prólogo de *al-Kitāb al-Mustaʿīnī* de Ibn Buklāriš (Texto árabe y traducción anotada)," in Juan Vernet, ed., *Estudios sobre la ciencia árabe* (Barcelona: Instituto de Filología, 1981), 183–316. In this publication, the author appears to have updated or corrected some errors in Martin Levey and Safwat Souryal, "The Introduction to the *Kitāb al-Mustaʿīnī* of Ibn Biklārish (fl. 1106)," *Janus* 55 (1968): 134–66.

32 A useful synthesis of the traditional scheme followed in medieval Islamic medical prefaces is to be found in Chipman, *The World of Pharmacy*, 47–55, along with the analysis of al-Kūhīn al-ʿAṭṭār's preface in his *Minhāj al-Dukkān* (which actually bears a number of similarities with that by al-Ghāfiqī).

33 Ghāfiqī, *Kitāb fī l-adwiya*, Osler MS 7508, f. 3a, line 19.

34 See N. Peter Joosse and Peter Pormann, "Decline and Decadence in Iraq and Syria after the Age of Avicenna? ʿAbd al-Laṭīf al-Baghdadi between Myth and History," *Bulletin for the History of Medicine* 84 (2010): 21–2; and Chipman, *The World of Pharmacy*, 48–50.

35 In his influential *Kitāb al-taysīr*, Ibn Zuhr (Avenzoar, d. 557/1162) makes an impassioned defence of pharmacology as an indispensable aid for the practice of medicine stating that "[the physician] who does

not know how to extract the active principles of medicines, how these are isolated and transferred to other materials, knows nothing about medicine"; see Rosa Kuhne Brabant, Cristina Álvarez Millán, and Expiración García Sánchez, "Abū Marwān ʿAbd al-Malik b. Zuhr," in *Biblioteca de al-Andalus*, 6: 357–8.

36 Ibn Wāfid, *Kitāb al-adwiya al-mufrada* (Libro de los medicamentos simples), edited and translated with notes and glossary by Luisa Fernanda Aguirre de Cárcer, 2 vols, Fuentes Arábico-Hispanas 11 (Madrid: CSIC, AECI, 1995–97), 1: 47–99, where the preface properly speaking (47–8) is followed by a lengthy and cryptic exposition of a theoretical nature, different in content but in line with Ibn Biklārish's work. In the preface, the author starts with the need to blend Dioscorides and Galen to make their works useful, actually the reason why "he felt the effort bearable and accepted the painstaking task" of such an enterprise. He then praises his benefactor and patron, who requested the book, and explains the structure of each entry and the two sections in which he divided the book.

37 Ana Labarta, "Traducción del prólogo del *Libro de medicamentos simples* de Abū-l-Ṣalt de Denia," *Dynamis* 18 (1998): 479–87. Following a short formal praise to God, this author first explains how he has structured the contents and why, namely, that they are not in alphabetical order but according to the drug's effects and diseases so as to make finding the information one is looking for easier and faster. He then explains the basics of the *contraria contrarii* system and what has to be borne in mind when choosing a therapy. As a whole, it seems a sort of "intensive course" on practical medicine and pharmacology that closes with a table of contents. No criticism is made throughout of previous sources or colleagues. More surprisingly, boastful self-marketing statements are also missing in this text (as well as *topoi* such as being requested to write the work), so it may be described as a "low profile" preface.

38 Savage-Smith, "Ibn Baklarish in the Arabic Tradition of Synonymatic Texts," 113–29.

4

The Sources of al-Ghāfiqī's *Herbal*: A Methodological Note[1]

LEIGH CHIPMAN

The starting point of research on the sources of any pre-modern work is the assumption that the author of a given work compiled previous ones to create his own. This raises a number of questions: to begin with, what are these sources? How does the author use them? Not to mention a number of problems that will be detailed below. The whole issue of sources is related to questions of authority, originality, authorship, plagiarism, copyright, and so on. The understanding of these issues has changed over time, with changes in technology, and each could be the subject of a book in its own right.

The medical bio-bibliographer Ibn Abī Uṣaybiʿa makes the following remarks about al-Ghāfiqī's sources:

> Al-Ghāfiqī … has investigated in detail that which was stated by Dioscorides and the distinguished Galen [presenting it] with a precise style and complete content. After setting forth what the two of them had said, he then cited what the moderns have innovated in their writings on simple medicines, or what he has been able to gather, one by one, defining each afterward. His book thus became a compendium of what the learned have stated regarding simple medicaments and a resource to which one refers when needing verification for them.[2]

In other words, from very early on, it was apparent that al-Ghāfiqī made use of many sources, dating from the beginning of the study of *De materia medica* (i.e., Dioscorides) and continuing up to his own day.

The Sources

I will begin by listing some of the sources that al-Ghāfiqī quotes, building on the work done by Max Meyerhof, in his 1932–40 edition of Bar Hebraeus' *Abridged Version* of al-Ghāfiqī's book,[3] and by Cristina Álvarez Millán and Oliver Kahl, in their contributions to this volume. I have divided the sources into three categories: pre-Islamic, Mashriqī (eastern Islamic), and Maghribī/Andalusī (western Islamic). The pre-Islamic category has the fewest authors, but they are the ones most often quoted by al-Ghāfiqī:

1. Dioscorides (fl. second half of 1st century CE) – the basis of all later books of *materia medica*. Translated by Iṣṭifān b. Basīl; commentaries by Ibn Juljul, Abū l-ʿAbbās al-Nabatī, Ibn al-Bayṭār.[4] For further discussion, see Alain Touwaide's contribution to this volume.
2. Galen (d. ca. 200 CE) – The source used was presumably *De simplicium medicamentorum* = *Kitāb al-adwiya al-basīṭa* [or *al-basāʾiṭ*], but this needs to be ascertained.[5]
3. Oribasius (ca. 320–400 CE) – *Kitāb al-adwiya al-mustaʿmala*; no surviving manuscripts in Arabic, but known to have been translated from bio-bibliographical literature and citations, especially by Abū Bakr al-Rāzī in his *Kitāb al-ḥāwī*.[6]

To these authors, mentioned by Meyerhof, we should add:

4. Paul of Aegina (fl. 7th century CE) – presumably his *Kunnāsh*, is quoted.[7]
5. Caraka (*Sharak*) (fl. 2nd century CE?) – *Saṃhitā*, a classical Indian, rather than classical Greek source, this is a compendium of Ayurvedic medicine.[8] It is a prominent source of ʿAlī b. Rabbān's *Firdaws al-ḥikma* (see below), and may be an example of a source that al-Ghāfiqī knew only indirectly.
6. Abū Jurayj al-Rāhib (the Monk) (fl. 1st/7th century?) – said to have lived in Alexandria, and known today only from quotations, mainly by al-Rāzī in *Kitāb al-ḥāwī*.[9]

In the next category, Mashriqī sources, al-Ghāfiqī appears to have used at least seventeen sources from the eastern part of the Islamic world:

1. Māsarjawayh (al-Yahūdī, the Jew) (fl. 2nd/8th century?) – There are two authors of this name, one (the elder) called *al-yahūdī* and the other (the younger) with no particular *nisba*. They are confused already by those who cite them, such as al-Rāzī and al-Bīrūnī. Neither of the works attibuted to them, *Quwā al-ʿaqāqīr wa-manāfiʿihā wa-maḍarrihā* and *Quwā al-aṭʿima wa-manāfiʿihā wa-maḍarrihā*, appears to be extant.[10]

2 Bukhtīshūʿ b. Jurjis (d. 185/801) – A second-generation member of the renowned Bukhtīshūʿ medical dynasty. None of his works are extant.[11]

3 Yūḥannā b. Māsawayh (d. 243/857) – A prolific author, he wrote a number of books on *materia medica*, some of which are extant. This may make it more difficult to pinpoint which of his works al-Ghāfiqī quotes.[12]

4 ʿAlī b. Rabban al-Ṭabarī (d. 250/864) – Author of *Firdaws al-ḥikma* and *Manāfiʿ al-aṭʿima wa-l-ashriba wa-l-ʿaqāqīr*. The latter is extant only in an abridgement, but may have been al-Ghāfiqī's source rather than the *Firdaws*, which is a compendium that only deals *inter alia* with *materia medica*.[13]

5 Ḥunayn b. Isḥāq (d. ca. 264/877) – The pre-eminent translator of 3rd/9th-century Baghdad, he composed a lost book of questions and answers on simple drugs (*Kitāb al-adwiya al-mufrada*), which is an epitome of Galen's book of the same name.[14]

6 Ḥubaysh b. al-Ḥasan al-Aʿsam (d. late 3rd/late 9th century) – Ḥunayn's nephew and fellow-translator, his books on simple and compound drugs are known only through citations.[15]

7 Masīḥ b. Ḥakam al-Dimashqī (d. after 224/839) – A Judaeo-Christian alchemist and physician active at the court of Harūn al-Rashīd.[16]

8 Ibn Sarābiyūn (fl. 3rd/9th century) – Yūḥannā b. Sarābiyūn was a Syriac author, whose small and large compendia (*al-kunnāsh al-ṣaghīr*, *al-kunnāsh al-kabīr*) have survived in fragments.[17]

9 Abū Yūsuf al-Kindī (ca. 185–252/801–66) – Best known as a philosopher, al-Kindī also composed several works on pharmacology. According to Ibn Abī Uṣaybiʿa, he is the author of a commentary on Galen's *De simplicium medicamentorium*, called *Jawāmiʿ kitāb al-adwiya al-mufrada li-Jālīnūs*.[18]

10 *Al-Filāḥa al-rūmiyya* – This work is attributed to the physician and astronomer Qusṭā b. Lūqā (ca. 205–300/820–912) and is currently extant.[19]

11 Abū Ḥanīfa al-Dīnawarī (d. 282/895) – Considered the founder of Arabic botany, his *Book of Plants* (*Kitāb al-nabāt*) quotes lost predecessors extensively. This treatise is composed of six volumes, of which only two have reached us; however, the second part – an alphabetical dictionary of plants – has been completely reconstructed from later quotations.[20]

12 Abū Bakr al-Rāzī (d. 313/925) – One of the most famous physicians and philosophers of the Islamic world, al-Rāzī needs no introduction. There are sections on *materia medica* in all his compendia, but the most comprehensive is probably *Kitāb al-ḥāwī*, which includes 829 entries on *materia medica*, extensively citing earlier sources.[21]

13 ʿAlī b. al-ʿAbbās al-Majūsī (4th/10th century) – Bridging the period between al-Rāzī and Ibn Sīnā, fifty-seven chapters in the second *maqāla* of the second,

practical part of the highly influential *Kitāb al-ṣināʿa fī l-ṭibb* (*Kitāb al-malakī*) are devoted to *materia medica*.²²

14 Al-Tamīmī (fl. 4th/10th century) – Muḥammad b. Aḥmad al-Tamīmī lived in Palestine and Egypt. His *al-Murshid fī jawāhir al-aghdhiya wa-quwā al-mufradāt* is still extant.²³

15 Ibn Sīnā (d. 428/1037) – Perhaps the most celebrated of all Muslim physicians, Avicenna devoted Book 2 of the *Qānūn fī l-ṭibb* (*Canon of Medicine*) to simple drugs.²⁴

16 Ibn Jazla (d. 493/1100) – al-Ghāfiqī probably quotes the sections on diet from Ibn Jazla's book of regimen, *Minhāj al-bayān fīmā yastaʿmiluhu al-insān*.²⁵

17 ʿAlī b. Riḍwān (d. 459/1067) – According to Ullmann, this author's *Kitāb al-mufradāt* is extant only in quotations by al-Ghāfiqī and Ibn al-Bayṭār.²⁶

Finally, we have Maghribī and Andalusī sources. Al-Ghāfiqī uses at least ten sources from the Islamic West; we might expect them to be the most frequently cited of his sources, but it is not clear whether this is, in fact, so. Indeed, the pre-Islamic classical Greeks (especially Dioscorides) seem to be the most frequently cited sources. However, these western sources are important for elucidating al-Ghāfiqī's immediate intellectual environment; a thorough study of his use of such sources is beyond the scope of this note, though.

1 Isḥāq b. ʿImrān (d. ca. 292/905) – Best known for his book on melancholy, he is apparently the first Arab to compose a book on *materia medica*, which is, unfortunately, not extant.²⁷

2 Isḥāq al-Isrāʾīlī (d. ca. 320/932) – Best known as Isaac Israeli of Qayrawān, this neoplatonist philosopher also composed several medical works, including an extant *Kitāb al-aghdhiya wa-l-adwiya al-mufrada*.²⁸

3 Ibn al-Jazzār (d. 369/979) – One of the most famous books of *materia medica* of the Islamic West is his *al-Iʿtimād fī l-adwiya al-mufrada*, extant in Arabic, and in Latin, Hebrew, and Greek translations.²⁹

4 Ibn Waḥshiyya (d. 323/935) – al-Ghāfiqī's quotations are extracted from Ibn Waḥshiyya's translation of a Syriac work known as *al-Filāḥa al-nabaṭiyya*, a book of agriculture and botany rather than *materia medica* proper.³⁰

5 Ibn Juljul (d. 384/994) – This bio-bibliographer composed two books of *materia medica*: *Tafsīr asmāʾ al-adwiya al-mufrada min kitāb Diyūsqūridas*; and *Dhikr al-adwiya allatī lam yadhkurhā Diyūsqūridas fī kitābihi*.³¹

6 Ibn Samajūn (fl. 39/1002) – His book, *al-Jāmiʿ li-aqwāl al-qudamāʾ wa-l-mutaḥaddithīn min al-aṭibbāʾ wa-l-mutafalsifīn fī l-adwiya al-mufrada*, is extant. He quotes Dioscorides, Galen, Oribasius, and others, and this was the first Arabic

book of simples to use an alphabetical order rather than a division according to function or part used.[32]

7 Abū l-Qāsim al-Zahrāwī (d. ca. 400/1009) – The twenty-ninth chapter of his medical encyclopedia *Kitāb al-taṣrīf li-man ʿajiza ʿan al-taʾlīf* is devoted to *materia medica*.[33]

8 Ibn Wāfid (d. ca. 466/1074) – One of the better-known Andalusian botanists, whose *Kitāb al-adwiya al-mufrada* has survived in translations to Catalan, Hebrew, and Latin, as well as in the original Arabic.[34]

9 Abū ʿUbaydallāh al-Bakrī (d. 487/1094) – Better known as a geographer, he composed an *Aʿyān al-nabāt wa-l-shajariyyāt al-andalusiyya*, extant only in quotations.[35]

10 Ibn Janāḥ (d. after 432/1040) – R. Jonah (Marwān) b. Janāḥ, better known as a Hebrew grammarian, but trained as a physician. His *Talkhīṣ* is no longer extant, but is known from quotations.[36]

Before moving on to the problems of the literary sources, a few words about oral traditions are in order. Can we reach such traditions? Who is the *majhūl* (anonymous) cited? Is the *majhūl* an old lady or perhaps al-Ghāfiqī himself, who usually refers to himself with the terms *al-muʾallif* (the author) or *lī* (me), raising once more the issues of authorship and originality. The question of oral sources is potentially of great interest, because it can illuminate the practical use – if any – of al-Ghāfiqī's book. This raises further questions, though: Can we assume practical use? Who was the audience for this book? Maimonides (d. 1204) mentions it as one of the sources for his book on synonyms, *Sharḥ asmāʾ al-ʿuqqār*.[37]

The Problems of the Literary Sources

The first problem is the sheer number of named sources. Meyerhof mentions about 28 sources as "often quoted" by al-Ghāfiqī in the *Abridged Version* alone. Verifying these sources is a problem because just tracking down manuscripts and editions can take a long time. A serious comparison of al-Ghāfiqī and his sources would require a great deal of time, money, and manpower in order to conduct the research that might enable us to answer the next problems adequately.

The second problem relates to the survival of texts over time. How many of these named sources are extant today? Furthermore, does al-Ghāfiqī seem to be using the same texts as those we know by that name today? This question is particularly acute for the pre-Islamic sources and those that survive only in quotations.

The third, and perhaps most difficult, problem is: How did al-Ghāfiqī use these sources? Did he quote them verbatim, or did he paraphrase? Was he consistent with

regard to his use of a particular source? Can we tell how a particular source reached him – directly, or through quotation by another? Direct quotations or paraphrase can tell us in what form a source reached al-Ghāfiqī, perhaps. We would need to check consistency in order to find this out. The problem of route is again complicated by the fact that al-Ghāfiqī may have had access to complete works that we know only indirectly, or that are completely unavailable to us.

Finally, what is al-Ghafiqi's relationship with later books of *materia medica*? It may be worth looking in the opposite direction – not only al-Ghāfiqī's use of his sources, but how he is used as a source, especially by Ibn al-Bayṭār, who is usually considered the peak of Andalusī botany and study of *materia medica*. According to Meyerhof, "It is now certain that Ibn al-Baitar's pharmacology is nothing more than al-Ghafiqi's book with some enlargements and commentaries. This would be still more evident if we had the original book of the latter."[38] The Osler manuscript is, of course, a copy of the original book, and a comparison between the two books would allow us to answer the question: if Ibn al-Bayṭār quotes al-Ghāfiqī, what is he quoting?

All these questions, and more, can be answered by a comprehensive study of al-Ghāfiqī's *Herbal*. Identifying the sources more closely, comparing al-Ghāfiqī's quotations with what actually appears in those sources, and, finally, a detailed comparison of al-Ghāfiqī and Ibn al-Bayṭār – this will require painstaking work, but has the potential to transform our understanding not only of pharmacology in the Islamic world, but of the methods used by scholars of the post-formative period to select and distil the myriad sources at their disposal.

Appendix: A Source Analysis of al-Ghāfiqī's Entry on Pear (*ijjāṣ*)

The following is an example of the kind of work that could be done on al-Ghāfiqī's *Herbal* – comparing and contrasting what appears in a random entry and in the sources it quotes. The difficulties encountered while attempting to trace the sources are no doubt typical of the challenges this manuscript poses.[39]

Text: Osler MS 7508, f. 10b, line 19 – f. 11a, line 23

إجّاص هو المعروف عندنا بعيون / البقر د ١ شجرة معروفة ثمرها يوكل وهو رديئ للمعدة مليّن للبطن

فأمّا ثمرة / الإجّاص الشامي وخاصّة ماكان منه بدمشق فإنّه إذا جفّف كان جيّداً للمعدة ممسكاً / للبطن ح

د ثمرة هذه الشجرة تطلق البطن وخاصّة إذا كانت طريّة فأما إذا يبست / [طلا]قها للبطن أقلّ وأما

ديسقوريدوس فلا أدري من أين قال إنّ الإجّاص الدمشقي <11a> إذا أُكل كثيراً قد حبس البطن إذ كنّا قد نجده / يطلق البطن إطلاقاً ظاهراً ولكنّه / أقل إطلاقاً من الإجّاص المجلوب من / لميريا وهي أرمينية الداخلة أشدّ / حلاوة والشجر في كلّ واحد من هذين / البلدين على حسب الثمرة فشجرة الإجّاص / التي تكون في أرمينية الداخلة اقل قبضاً / والذي يكون بدمشق أكثر قبضاً وبالجملة / جميع الأشجار والأصول التي يوجد القبض / في ورقها وقضبانها ظاهراً فهي إذا طبخت صارت نافعة لمن تغرغر بها من ورم اللهاة(؟) / والنغانغ(؟) ابن ماسوية الإجّاص بارد رطب في الثانية يغذوا غذاءً يسيراً ويرطّب / المعدة ويسهل الصفراء ويطفئ الحرارة وفعل الأسود كما ذكرنا أكثر من فعل الأبيض / وما صغر منه كان أقل إسهالاً الاسرائيلي الأبيض منه بطئ الانهضام رديئ للمعدة / قليل الإسهال لغلظه وقلّة رطوبته وأجودها ما كان في غاية النضج مجهول ماء الإجّاص / يدرّ الطمث الفلاحة النبطية الإجّاص الجبلي شجيرة(؟) ورقها مدوّر أصغر من ورق الإجّاص / وثمرتها كالإجّاص حامضة صادقة الحموضة وهي لا يفلح في البساتين البتّة ح ثمرة / الإجّاص الصغار البرّي يقبض قبضاً بيّناً ويحبس البطن د وورق الإجّاص إذا طبخ بشراب / وتغرغر بطبخه قطع سيلان الموادّ إلى اللهاة وعضلتي اللوزتين واللثة وثمرة شجر الإجّاص / إذا نضج وجفّف فعل مثل ذلك وإذا طبخ بطلاء كان طعمه أطيب وكان إمساكه للبطن أشدّ / وصمغ شجيرة الإجّاص يلزق الجراحات وتغري(يغري؟) / وإذا شربت بشراب فنت الحصاة وإذا خلطت / بخلّ ولطخت بها القوابي العارضة للصبيان براها (أبرأها؟) ح إن كان هذا الصمغ يفعل هذا الأمر / فيه بيّن أنّه قطاع ملطّف مجهول هو شبيهه في القوّة / بالصمغ العربي إلّا أنّه أضعف / وإذا اكتحل به أحدّ البصر والله أعلم

The sources quoted are: Dioscorides (twice), Galen (three times), Ibn Māsawayh (once), Isaac Israeli (once), the *Filāḥa al-nabaṭiyya* (once), and an anonymous author/informant (*majhūl* – twice).

The entry for *ijjāṣ* in the Arabic Dioscorides is as follows:[40]

شجرة معروفة ثمرها يوكل وهو رديّ للمعدة مليّن للبطن فأما ثمرة الإجّاص الشامي وخاصّة ما كان منه بدمشق فإنه إذا جفّف كان جيّد{ا} للمعدة [مسك] {مسكناً} للبطن {إذا طبخ} وورق الإجّاص [إذا طبخ] بشراب وتغرغر بطبخة(طبخه؟) قطع سيلان المواد إلى اللهاة وعصلتي وعضلتي؟ اللوزتين واللثة وثمرة شجر الإجّاص {البرّي إذا طبخ} [إذا نضج] وجفّف فعل مثل ذلك وإذا طبخ بطلاء كان طعمه أطيب وكان إمساكه للبطن أشد وصمغ شجرة الإجّاص يلزق [الجراحات] {القروح} وتغري وإذا شرب[ت] بشراب فت فنت؟ الحصاة {في البدن} وإذا خلط[ت] بخلّ ولطخت به[ا] [القوابي العارضة] {القوافي الظاهرة} للصبيان {ا}براها

Words in braces do not appear in al-Ghāfiqī, while words in square brackets do not appear in Dioscorides. As can be clearly seen, al-Ghāfiqī quotes Dioscorides almost verbatim, with the few minor discrepancies possibly scribal errors.

As far as I have been able to find out, no edition of Galen's *al-Adwiya al-mufrada* is available, nor was it possible for me to consult any of the existing manuscripts. I attempted to overcome this with a comparison of al-Ghāfiqī's text with the quotations of Galen in the parallel entry in al-Rāzī's *al-Ḥāwī*, which read as follows (words in braces do not appear in al-Ghāfiqī):[41]

{وقال جالينوس في السابعة:} ثمرة هذه الشجرة تطلق البطن وخاصّة إذا كانت طريّة فأما إذا يبست وهو لذلك أقل ... ثمرة الإجّاص {الصغار} البرّي يقبض قبضاً بيّناً ويحبس البطن ... وأن كان هذا الصمغ يفعل هذا فالأمر بيّن فيه أنّه قطاع ملطّف.

From this comparison, it appears that al-Ghāfiqī largely quotes Galen verbatim. He also includes Galen's dispute with Dioscorides (f. 10b, line 20 – f. 11a, line 11) that al-Rāzī does not refer to.

Ibn Māsawayh's *Book of Simple Aromatic Substances* (edited by S. Gigandet) does not have an entry for *ijjāṣ*, and other extant works by Ibn Māsawayh were not available to me; thus at the moment this author is a dead end. al-Rāzī quotes him in the same entry, as follows:[42]

The Sources: A Methodological Note

الإجّاص بارد رطب في {وسط} الثانية {رطب في اخرها} يغذوا غذاءً يسيراً ويرطّب المعدة {بلزوجته ويبردها ويليّن الطبيعة بلزوجته} ويسهل الصفراء ‹ويطفئ الحرارة› وفعل الأسود {في ما} [كما] ذكرنا { أتمّ } [أكثر من فعل الأبيض وما صغر منه كان أقل إسهالاً] {والصغير منه أقل إسهالاً مما عظم منه وهو مطفئ للحرارة وخاصّته ترطيب المعدة وتبريدها}

Words in braces do not appear in al-Ghāfiqī, while words in square brackets do not appear in al-Rāzī; the difference between these two versions is greater than in the previous comparisons with Dioscorides and Galen; thus we may assume that one of the authors is paraphrasing Ibn Māsawayh.

Isaac Israeli's entry for *ijjāṣ* is much longer than al-Ghāfiqī's brief quotation here. In this case, al-Ghāfiqī is clearly paraphrasing his source. Isaac Israeli's equivalent lines open the entry, and read as follows:

الإجّاص في الجملة يغذو غذاءً يسيراً لأنه على ضربين لأنّ الأيض المعروف بالشاهلوج ومنه الأسود المعروف بالإجّاص على الحقيقة فأمّا الشاهلوج بطئ الانهضام رديئ للمعدة قليل الإسهال للبطن ذلك لغلظ بدنه وقلّة رطوبته وبعد انحداره

The entry for *ijjāṣ* in *al-Filāḥa al-nabaṭiyya* (edited by Fahd)[43] contains nothing similar to the sentence that appears under this name in al-Ghāfiqī's entry. Given Fahd's exhaustive tally of extant manuscripts upon which to base his edition, this may be a case of mistaken identity, either on the part of al-Ghāfiqī (i.e., his source was not what he thought it was) or on the part of the scribe (i.e., this may be a scribal error, perhaps some other book of *filāḥa* should appear here).

Finally, the anonymous source: obviously, at this stage of research it would be foolhardy to attempt to identify this source/informant. A large-scale and thorough source analysis would be necessary to do so; equally, it is impossible to draw conclusions at this stage about al-Ghāfiqī's use(s) of his sources and their ramifications for the learned culture of pharmacists and botanists in the Islamic West, let alone authorial culture generally.

NOTES

1 This brief chapter is based on the discussion I led at the consultative workshop on the al-Ghāfiqī *Herbal*, held at McGill University, Montreal, 19–20 August 2010; it is not meant to encompass a comprehensive listing of the sources, for which the reader should start with the tables in Cristina Álvarez Millán's contribution to this volume. I would like to thank Jamil Ragep and Faith Wallis for inviting me to take part in this project, and to thank all the participants in the workshop for their comments on the problems of al-Ghāfiqī's sources. On a personal note, I wrote this paper at a very difficult time in my life, and it would have been impossible for me to do so without the support and encouragement I received from Jamil and Faith.

2 Ibn Abī Uṣaybiʿa, ʿ*Uyūn al-anbāʾ fī ṭabaqāt al-aṭibbāʾ*, edited by Nizār Riḍā (Beirut: Dār maktabat al-ḥayāh, 1965), 500–1.

3 Bar Hebraeus (Gregorius Abū l-Faraj, Ibn al-ʿIbrī), *The Abridged Version of "The Book of Simple Drugs" of Aḥmad ibn Muḥammad al-Ghâfiqî by Gregorius Abu'l-Farag (Barhebraeus)*, edited and translated by M. Meyerhof and G.P. Sobhy, 4 vols (Cairo: Al-Ettemad Printing Press, 1932–40); reprinted, Frankfurt am Main: Institute for the History of Arabic-Islamic Science at the Johann Wolfgang Goethe University, 1996.

4 M. Ullmann, *Die Medizin im Islam* (Leiden: Brill, 1970), 257–63.

5 F. Sezgin, *Geschichte des arabischen Schrifttums* (= *GAS*), vol. 3: *Medizin-Pharmazie-Zoologie-Tierheilkunde bis ca. 430 H* (Leiden: Brill, 1970), 68–140, esp. 109–10; and Ullmann, *Medizin*, 35–68, esp. 47.

6 Ullmann, *Medizin*, 83–4, 263–4; and Sezgin, *GAS III*, 152–4.

7 Ullmann, *Medizin*, 86–7; and Sezgin, *GAS III*, 168–70.

8 Ullmann, *Medizin*, 104; and Sezgin, *GAS III*, 198.

9 Ullmann, *Medizin*, 91–2; and Sezgin, *GAS III*, 209–10.

10 Ullmann, *Medizin*, 23–4, 264; and Sezgin, *GAS III*, 206, 224–5.

11 Ullmann, *Medizin*, 109; and Sezgin, *GAS III*, 210.

12 Ullmann, *Medizin*, 112–15; and Sezgin, *GAS III*, 231–6.

13 Ullmann, *Medizin*, 119–22, 264, 300; and Sezgin, *GAS III*, 236–40.

14 Ullmann, *Medizin*, 115–19, 265; and Sezgin, *GAS III*, 247–56.

15 Ullmann, *Medizin*, 118–19, 265; and Sezgin, *GAS III*, 265–6.

16 Ullmann, *Medizin*, 112; Sezgin, *GAS III*, 227–8; Y.T. Langermann, "Masīḥ bin Ḥakam, a Jewish-Christian(?) Physician of the Early Ninth Century," *Aleph* 4 (2004): 283–97; S. Gigandet, *La risāla al-hārūniyya de Masīḥ b. Ḥakam al-Dimašqī: Médicin* (Damascus: IFAED, 2001).

17 P. Pormann, "Yūḥannā ibn Sarābiyūn: Further Studies into the Transmission of his Works," *Arabic Sciences and Philosophy* 14 (2004), 233–62.

18 Ullmann, *Medizin*, 123, 301; and Sezgin, *GAS III*, 244–7.

19 Ullmann, *Medizin*, 126–8; and Sezgin, *GAS III*, 270–4.

20 Muhammad Hamidullah, *Le dictionnaire botanique d'Abū Ḥanīfa al-Dīnawarī (Kitāb an-Nabāt, de sīn à yāʾ) reconstitué d'après

les citations des ouvrages postérieurs (Cairo: IFAO, 1973); Abū Ḥanīfa ad-Dināwarī, *The Book of Plants of Abū Ḥanīfa ad-Dīnawarī, Part of the alphabetical section (alif-zāy), edited from the unique MS in the Library of the University of Istanbul, edited with an introduction, notes, indices, and a vocabulary of selected words* by Bernhard Lewin (Uppsala: Lundequists, 1953); idem, *The Book of Plants, Part of the Monograph Section*, edited by Bernhard Lewin (Wiesbaden: F. Steiner, 1974); Bruno Silberberg, "Das Pflanzenbuch des Abû Ḥanîfa Aḥmed ibn Dâ'ûd ad-Dînawarî: Ein Beitrag zur Geschichte der Botanik bei den Arabern," *Zeitschrift für Assyriologie und verwandte Gebiete* (Strasbourg) 24 (1910): 225–65 and 25 (1911): 39–88, reprinted in Fuat Sezgin, ed., *Botany: Texts and Studies, III* (Frankfurt am Main: Institute for the History of Arabic-Islamic Science, 2001), 117–208.

21 Ullmann, *Medizin*, 128–36, 265–6.

22 Ullmann, *Medizin*, 140–6, 267–78; and Sezgin, *GAS III*, 320–2.

23 Ullmann, *Medizin*, 269–70; and Sezgin, *GAS III*, 317–18.

24 The bibliography on Ibn Sīnā is beyond counting. A convenient starting point is the section "References and Further Reading" in the entry for Avicenna in the Internet Encyclopedia of Philosophy, http://www.iep.utm.edu/avicenna/#SH10a.

25 Ullmann, *Medizin,* 160; J.S. Graziani, *Arabic Medicine in the Eleventh Century as Represented in the Works of Ibn Jazlah* (Karachi: Hamdard Academy, 1980).

26 Ullmann, *Medizin*, 273.

27 Ullmann, *Medizin*, 125, 265; Sezgin, *GAS III*, 266–7.

28 Ullmann, *Medizin*, 137–8, 200; Sezgin, *GAS III*, 295–7; Isḥāq b. Sulaymān al-Isrāʾīlī, *Kitāb al-aghdhiya* (*Book on Dietetics*), facsimile edition of MS 3604–3607, Fatih Collection, Süleymaniye Library, Istanbul, edited with an introduction by Fuat Sezgin, 3 vols (Frankfurt: Institute for the History of Arabic-Islamic Science, 1986).

29 Ullmann, *Medizin*, 147, 268–9; Sezgin, *GAS III*, 304; Idwār Qashsh, ed., *al-Iʿtimād fī l-adwiya al-mufrada: al-ʿilāj bi-l-adwiya al-ʿarabiyya* (Beirut: Sharikat al-maṭbūʿāt lil-tawzīʿ wa-l-nashr, 1998).

30 Toufic Fahd, ed., *Al-Filāḥa al-Nabaṭiyya: Al-tarjama al-manḥūla ilā Ibn Waḥshiyya*, 3 vols (Damascus: IFAED, 1995); Ullmann, *Medizin*, 265; Sezgin, *GAS III*, 294–5.

31 Ullmann, *Medizin*, 268; Sezgin, *GAS III*, 309; A. Dietrich, ed., *Die Ergänzung Ibn Ǧulǧul's zur* Materia medica *des Dioskurides: Arabischer Text nebst kommentierter deutscher Übersetzung* (Göttingen: Vandenhoeck and Ruprecht, 1993).

32 Ullmann, *Medizin*, 267; Sezgin, *GAS III*, 316–17.

33 Ullmann, *Medizin*, 149–51, 271; Sezgin, *GAS III*, 323–5; Abū l-Qāsim Khalaf al-Zahrāwī, *"A Presentation to Would-Be Authors" On Medicine – Al-Taṣrīf li-man ʿajiza ʿan al-taʾlīf*, facsimile edition of MS 502, Beşirağa Collection, Süleymaniye Library, Istanbul, introduction by Fuat Sezgin, 2 vols (Frankfurt: Institute for the History of Arabic-Islamic Science, 1986).

34 Ullmann, *Medizin*, 273; Ibn Wāfid, *Kitāb al-adwiya al-mufrada* (*Libro de los medicamentos simples*), edited and translated with notes and glossary by L.F. Aguirre de Cárcer, 2 vols (Madrid: Agencia Española de Cooperación Internacional, 1995–97

35 Ullmann, *Medizin*, 273–4.

36 Ibid., 272.

37 Moses Maimonides, *Šarḥ asmāʾ al-ʿuqqār = L'explication des noms des drogues: Un glossaire de matière médicale composé par Maïmonide*, edited and translated by M. Meyerhof (Cairo: IFAO, 1940); reprinted Frankfurt am Main: Institute for the History of Arabic-Islamic Science, 1996, 4.

38 Meyerhof, *Abridged Version*, 1: 33.

39 I would like to thank Jamil and Sally Ragep for providing me with copies of sources that would otherwise have been unavailable to me: Isaac Israeli, Ibn Māsawayh, Masīḥ b. Ḥakam.

40 *La "Materia Medica" de Dioscorides: Transmisión medieval y renacentista*, edited by César Emil Dubler, Andrés de Laguna, and Elías Terés, 6 vols (Barcelona: Tipografía Emporium, 1953–59), 2: 116.

41 Abū Bakr al-Rāzī, *Kitāb al-ḥāwī fī l-ṭibb*, 23 vols (Hyderabad: Dāʾirat al-maʿārif al-ʿuthmāniyya, 1955–71), 20 (1964): 96–7.

42 Ibid., 98.

43 T. Fahd, *al-Filāḥa al-nabaṭiyya*, 2: 1189–90.

5

Al-Ghāfiqī's *Kitāb fī l-adwiya al-mufrada*, Dioscorides' *De materia medica*, and Mediterranean Herbal Traditions

ALAIN TOUWAIDE

The *Kitāb fī l-adwiya al-mufrada* by al-Ghāfiqī and its manuscript witness Osler 7508 need to be approached in the double context of the Andalusian school of botany and *materia medica*, and the increased transcultural circulation of knowledge in the Mediterranean world from the 11th century on.

Whereas al-Ghāfiqī's text is in line with the trends that can be identified in the Andalusian botanical production – characterized by its reliance on the local reworking of Dioscorides' *De materia medica*, the further development of this body of knowledge, and, on this basis, its encyclopedic nature – the illustrative corpus of the Osler manuscript is more international, that is, pan-Mediterranean. The key element in this story is the relationship of al-Ghāfiqī's herbal to its most influential source, the *De materia medica* of Dioscorides.

Dioscorides, *De materia medica*

The encyclopedia of *materia medica* compiled by the Greek Dioscorides in the 1st century CE is a unique collection of information on over 1,000 natural substances from the three natural kingdoms (vegetable, animal, and mineral) as well as some manufactured products used for therapeutic purposes.[1] A chapter is devoted to each such substance, which presents data according to an almost standardized protocol that includes the following:[2]

- The most commonly used name of the substance
- Other frequently encountered names
- Physical description (possibly with the biota) of the entire natural element (a plant,

animal, or a mineral) from which a medicine was produced, including possible varieties
- Identification of the part(s) of this element that were used as a medicine or for the preparation of medicines, together with the method(s) of processing
- When appropriate, methods to detect adulterated products
- Major therapeutic properties of the drug
- Major indications of the drug, possibly including preparation, dosage, and any other relevant information about the medicines made out of the drug
- Other possible uses of the element or the drug, be they related to medicine *senso latu* (cosmetic or veterinary) or not (e.g., economic uses).

As an example of this method, we can cite the chapter on iris:[3]

> Iris. The Illyrian iris bears leaves like the corn flag, but larger, wider, and fatter, and flowers parallel on stems, curling, and in many colors … The roots are below ground, articulated, firm, and aromatic. After cutting them, you must dry them in the shade … Illyrian and Macedonian irises are superior … The Libyan iris is both white in color and bitter in taste … As irises age, they become worm-eaten, but it is then that they become more fragrant.
>
> All irises have warming and attenuating properties that are suitable for coughs and for thinning fluids that are hard to bring up. Seven *drachmai* in weight, drunk in hydromel, purge thick fluids and bile. They induce sleep … They are compounded into pessaries, emollients, and analgesics, and, on the whole, they are useful for many purposes.

In more than 30 manuscripts,[4] the Greek text is complemented by illustrations representing the entire plant or animal from which a *materia medica* was produced, and also the minerals and other products used as medicines.[5] In the current state of research, it is not known whether such illustrations date back to Dioscorides or were added at some later stage of the history of the work.[6] They are far from being identical in all manuscripts, but can be grouped in relatively coherent sets that can be compared with textual recensions. One such set – contained in the manuscript that is now *medicus graecus* 1 of the Österreichische Nationalbibliothek in Vienna, to which we shall return – offers images that are often considered as the most ancient form of the illustrations accompanying Dioscorides' text because of the naturalistic appearance of the plants. However tempting it is, this interpretation is not supported by any evidence and probably needs to be abandoned. It seems more probable that the most ancient iconographic apparatus of *De materia medica* was rather schematic and aimed to stress the major features of the plants mentioned in the textual descriptions to allow for identification. In this view, naturalism is a later innovation.

All the chapters of the work have been ordered in a way that Dioscorides himself described briefly in the preface to the treatise, which starts with a criticism of the authors who wrote on the same topic before him:[7]

> Niger [i.e., Sextius Niger, ca. 35 BCE–ca. 40 CE][8] and the rest of them [i.e., the earlier authors on *materia medica*] have also blundered regarding organization [of the information]: some have assembled disconnected properties, while others used an alphabetical arrangement, separating materials and their properties from those closely connected to them. The outcome of this arrangement is that it is difficult to commit to memory … I shall try both to use a different arrangement and to list the materials according to the natural properties of each one of them …

However explicit this statement is about the fact that Dioscorides created an original ordering system, it does not specify the exact nature of this system. The reference to natural properties is vague and does not provide any information on the way these properties are ordered. I have suggested that this system is an early form of *scala naturae*, that is, a hierarchical ordering proceeding by steps and going from a positively connoted group of *materia medica* to its opposite through a gradual decline of positive qualities and, conversely, a progressive increase of negative qualities.[9] Concretely, whereas the work opens with the iris, which was considered to be multicoloured, warm, drying, and thus light (something that its name already suggests since, in ancient Greek, the word "iris" also designated the rainbow), it ends with *the black [substance] used to write*, that is, soot from which ink was made[10] – black being in Antiquity the absence of any colour rather than a colour in its own right, and soot being diametrically opposed to iris because its properties are cold, humid, and heavy.

In the recension of the text traditionally supposed to be original, the whole work is divided into five books considered as thematically coherent units. In this view, Book I is mainly devoted to fragrant plants, trees, and fruits; Book II to animals and animal substances, followed by herbs; Books III and IV contain all the plants not treated in Book II; and Book V is about manufactured products and mineral substances. This interpretation is supported by the introductions that open each of the Books from II to V, which summarize the content of both the previous book and the one it introduces.

A computerized version of the treatise has shown that its five books contain almost the same number of lines and words. Interpreted in the context of the history of the ancient book – particularly the roll of papyrus – this fact suggests that the books should not be understood as thematic units of the work, but as volumes (or tomes) in the current meaning of the word. In this view, Dioscorides' *De materia medica* was made of five rolls of papyrus and its text was a long series of chapters whose sequence was not divided in the major categories above. The introductions of Books II–V are probably an expanded

version of the content of the labels attached to each of the rolls to make it possible for a reader to quickly identify the roll containing a part of the text.

At some point in time, Dioscorides' treatise was expanded with two short treatises on matters related to *materia medica*: one deals with poisons and the other with venoms.[11] Characteristically, these two works total a number of lines almost equal to that of each of the five supposed books of *De materia medica*. Judging from their contents, they correspond to 1st-century CE knowledge, which they organized by groups of toxic agents. It seems probable that they did not enter Dioscorides' corpus at the same time. The treatise on poisons may have been added first at an unknown period. The one on venoms came later and seems to reflect a teaching activity in the manner of the Alexandrian school of the 5th and 6th centuries.[12]

The Mediterranean *Fortuna* of *De materia medica*

Possibly because of its comprehensiveness and its holistic approach to *materia medica*, Dioscorides' *De materia medica* had an exceptional *fortuna* across the whole Mediterranean world.[13] Its text is currently known through more than 150 manuscripts, went through several recensions, and was translated and commented on several times in both Latin[14] and Arabic during the Middle Ages,[15] before becoming the object of intense scientific and scholarly activity during the Renaissance.[16] All this strongly contrasts with the limited diffusion of the treatise on *materia medica* (*De simplicium medicamentorum temperamentis et facultatibus*) composed by Galen (129–after 216[?] CE)[17] and currently known through three dozen Greek manuscripts.[18]

The difficulty of handling the five rolls containing *De materia medica*, together with the vastness of the work and the complexity of its structure, probably encouraged users to revise the ordering of the chapters and to reduce the length of the whole work. As early as the late 2nd/early 3rd century CE, when compiling a treatise on *materia medica*, Galen used Dioscorides' work to compile his treatise *De simplicium medicamentorum temperamentis et facultatibus*, but he divided the whole field of *materia medica* according to the three natural kingdoms and, in each of these three parts, he ordered the chapters devoted to each substance in the alphabetical order of their Greek name.

A similar principle of alphabetical ordering was applied to a selection of chapters of *De materia medica*. This is the so-called *alphabetical herbal*, which is best known through its most ancient manuscript, the codex *medicus graecus* 1 of the Österreichische Nationalbibliothek (National Library of Austria).[19] It contains approximately 300 chapters on plants, each of which is illustrated by a naturalistic representation of the whole plant. This manuscript, which is among the most ancient Greek codices currently preserved and known, has been traditionally dated to 512 CE.[20] However, a recent study established

that the body of the manuscript is anterior and that only the initial folios can be dated to this year.[21]

At an unknown time, but presumably before the 6th century, *De materia medica* was translated into Latin in a version that is no longer extant.[22] Possibly during the 6th century, its five-book recension was translated again. The locale where this translation was made is not known with certainty, but may be Northern Africa, where an intense translation activity of Greek medical works of classical antiquity took place together with the compilation of new treatises based on the ancient tradition.[23]

In chronological sequence, the next step in the history of *De materia medica* is its transmission to the Arabic world, which has been extensively studied for a long time.[24] Until fairly recently, this transmission was reduced to the activity of the famous translator Ḥunayn ibn Isḥāq (d. ca. 264/877),[25] working in Baghdad. Recent research has shown that the transmission of Dioscorides' treatise to the Arabic world was a more complex process, comprising several versions, the first of which may date to the late 8th century or early 9th century.[26] A meticulous archaeology of the Arabic text of *De materia medica* in the manuscript of Istanbul, Ayasofya MS 3704 by Manfred Ullmann has brought to light elements of an earlier Arabic version of *De materia medica* made from the Greek.[27] This translation seems to precede Ḥunayn's because it does not use the Arabic technical lexicon available in Ḥunayn's time. Instead, it often reproduces Greek terms, but transliterating them in the Arabic alphabet. Because of its possible anteriority when compared with Ḥunayn's versions, this translation has been identified by Ullmann as the *Vetus translatio*. Characteristically enough, it also contains information that does not appear in Dioscorides' Greek or in Galen's treatise on *materia medica*. They seem to be commentaries introduced into the *Vetus translatio* and witness to an early activity of study of Dioscorides' treatise not explicitly attested from other sources.

At any rate, Ḥunayn translated the work anew in several phases. He began by translating a Syriac version into Arabic, but later worked directly from Greek. In much of his activity he was assisted by Isṭifān b. Basīl, whose name reveals a Greek origin and probably a Christian faith. While one of Ḥunayn's versions was further reworked at the end of the 10th century by a certain al-Nātilī, identified by Mahmoud Sadek as one of Ibn Sīnā's (Avicenna's) teachers in Bukhārā, other translations were made afresh during the 12th century in Asia Minor. The reason for these new versions was that Ḥunayn's translations were not accurate and Arabic enough from a linguistic viewpoint. These new translations circulated widely in the Arabic world and beyond.

In most of the manuscripts containing an Arabic version of *De materia medica*, the text is complemented with representations of plants and animals. Already in the most ancient copy currently preserved (Leiden, University Library MS Or. 289, dated 475/1083), illustrations exhibit stylization, geometrization, and abstraction, even though in some cases they include naturalistic elements of the environment or instruments indicating how

the resin or other products of the plants should be collected.[28] Two manuscripts, however, do not demonstrate such a trend: the codices Istanbul, Süleymaniye Library, Ayasofya MSS 3702 and 3703 (the latter dated 612/1224), whose illustrations are iconographically closer to those of the Greek manuscripts, particularly the *Paris grec* 2179.[29] In Ayasofya MS 3703, many illustrations include additional elements (from birds and insects to doctors and pharmacists preparing drugs).[30] Some are more complex and represent individuals in such activities as loading ore into a furnace, pressing grapes to produce wine, or administering a medicine. A couple of such illustrations are even more uncommon. One of them shows a boat on a river, another illustrates a man bitten by a rabid dog, another has two men slaughtering an ox, and, finally, one has three physicians involved in a philosophico-theoretical discussion about venoms and poisons. Characteristically, such illustrations borrowed not only their iconography but also their composition from other media such as late antique Greek mosaics.[31] Also, they moved images such as philosophers' portraits from one genre of books (treatises of philosophy) to another (works of science and medicine). Similarly, they transferred scenes from literature (narratives such as the *Maqāmāt* or the tales of *Kalīla wa-Dimna*) to science.[32] The conjunction of these elements – the close similarity to Greek manuscripts and a high degree of artistic sense and maturity – suggests not only that this Ayasofya codex resulted from a commission made by a wealthy patron, possibly at the court of Baghdad, but also that Hellenism was fashionable in the Arabic world in the early 13th century.[33]

This manuscript has been dismembered and 33 of its pages, most of which were displayed in the exhibition of so-called Muhammedan art in Munich in 1910, later appeared on the antiquarian market in Paris. They were purchased by private collectors and were gradually scattered in museums across the world as a result of the changing fate of collections. Another manuscript that had the same destiny is the codex identified as the *Vignier-Densmore Dioscorides*, which has been incorrectly reported as being at the Bibliothèque nationale (now Bibliothèque nationale de France) in Paris.[34] Though of a lower quality, its iconography and style are similar to those of the Ayasofya MS 3703 codex. On this basis the codex has been dated to the same period as the Istanbul manuscript.[35]

In the West, Ḥunayn's translation reached al-Andalus.[36] In the 10th century, an otherwise unidentified Byzantine emperor named Romanos offered to the court in Cordoba a Greek codex of *De materia medica*, possibly as a deluxe art book. Since no scientist in Cordoba understood Greek, a request was made to the emperor to send a Greek speaker who would help the Andalusians to understand Dioscorides' treatise in its original language. A monk called Nikolaos arrived at Cordoba and is said to have studied *De materia medica* in collaboration with local scientists. This multi- or, probably better, transcultural group did not produce a new translation of the Greek text, contrary to what has often been affirmed in scholarly literature. This group aimed to better understand the Graeco-Arabic translation of the text and is credited with further developing botany in

al-Andalus. As early as the 7th century, the Arabs who settled in al-Andalus introduced botanical species native to their place of birth. Besides transforming the local environment, they laid down the basis for botanical, agronomical, and agricultural studies, which may account for the interest in the Greek manuscript of *De materia medica* offered by the Byzantine emperor and the request for somebody able to explain the work to local scientists. Returning to the 10th century, the result of the collaborative work carried out in Cordoba has not been preserved and can only be hypothesized on the basis of such works as those by al-Ghāfiqī and, later on, by Ibn al-Bayṭār.

Interestingly enough, after the Greek text of *De materia medica* was translated into Arabic in the East, possibly in the late 8th century and certainly in the 9th, and after interest in its Arabic version had been stimulated in the western Islamic world in the 10th century, the Greek *De materia medica* was, in turn, influenced by Arabic works in Constantinople in the 11th century. The many *materia medica* that had been eliminated to create the *Alphabetical herbal* were recovered from the complete Greek five-book recension and grouped in coherent sets according to their nature (herbs, animals, oils, trees, wine, and minerals), with each of these units being considered as a book. Characteristically, items within these five books have been ordered alphabetically as in the herbal attested by the Vienna manuscript, *medicus graecus* 1 (hence, the name of alphabetical five-book recension of this new version of *De materia medica*). However complete and accurate this recovery was, it did not include all chapters of the full text. The plants from India and South-East Asia, for example, were omitted. In the mid-11th century, some of these drugs were reintroduced, possibly via Arabic sources. On a guard leaf of the manuscript now preserved at the Lavra Monastery of Mount Athos in Greece as codex Ω 75,[37] the representation of one of these plants (*malabathron*, f. 6 recto), closely corresponds to its equivalent in Leiden University MS 1081 (f. 8a).[38] The flow of information between Byzantium and the Arabic world was inverted. It no longer went from Byzantium to Baghdad, but from Baghdad to Byzantium.[39]

A similar phenomenon took place in Sicily and southern Italy. The *Zād al-musāfir wa-qūt al-ḥāḍir*[40] by Ibn al-Jazzār (d. 369/979)[41] was translated from Arabic into Greek in Sicily (probably not at the court or at the chancellery, but by practitioners).[42] In the area of Salerno/Cassino, Constantine known as the African (d. after 1081 CE) embarked on a vast program of translation of medical texts from Arabic into Latin that included Ibn al-Jazzār's treatise under the title *Viaticum peregrinorum*. He has also been incorrectly credited with a new translation of *De materia medica* from Greek into Latin in which the chapters were ordered according to the alphabetical sequence of their titles, that is, the names of the plants and other *materia medica*.

Border-crossing exchanges of this type were increasing and are further witnessed by Simon of Genoa at the end of the 12th century and, later on, by Pietro d'Abano at the end of the 13th. Both had access to the Greek text of Dioscorides. It is highly probable that

the Fourth Crusade played a fundamental role in the development of scientific contacts between East and West.[43] The occupation of Constantinople from 1204 to 1261 by Latin troops was accompanied by a series of massacres and destructions, including the library of the imperial palace. The copy of the *Alphabetical herbal* now in Vienna, which was among the holdings of the Imperial Library, was taken out of the library and was used, possibly in Constantinople, as a source to produce a new manuscript, the codex Thott MS 190 now in the collection of the Royal Library of Copenhagen.[44] Later on, the Vienna *Alphabetical herbal* was in the library of St John's Monastery in the Petra neighbourhood of Constantinople. There it may have been used as a manual for the study of *materia medica* by the students who frequented the school adjacent to the monastery, unless it served as a practical compendium in the hospital included in the same complex, the so-called *xenodocheion tou Kralê* (Hospital of the King).[45] Whatever the exact location of the manuscript in the complex and its use, Pietro d'Abano probably saw and studied it, and reproduced some of its passages, and perhaps copied its full text for his own use. Back in Padua, he then commented on *De materia medica* in his lectures at the University.[46] In so doing, he referred to two recensions of the Greek text, one in five books and another alphabetical.[47]

The Osler Iconographic Apparatus

The illustrations of the Osler manuscript have been little studied thus far, as Jaclynne Kerner rightly stresses in her study in the present volume. The manuscript was brought to the attention of the scholarly world by the ophthalmologist and historian of Arabic medicine Max Meyerhof (1874–1945). After a first essay in 1935 on the history of pharmacology and botany among Andalusian Muslims,[48] Meyerhof devoted a specific study to al-Ghāfiqī and the Osler manuscript. According to him, its plant representations "are almost independent from those of the best Greek illustrated manuscript of Dioscorides, *De materia medica*, which is the famous codex of the National Library in Vienna," even though in very few figures there is some similarity between the two manuscripts. Furthermore, he identified a hundred plants that were, according to him, unknown to the Greeks and which are represented in the Osler manuscript with imaginary – that is, fictitious – illustrations. Furthermore, there are "multiple figures of oriental plants that have never been represented by Arabic artists" and are original.[49] In the conclusion of this second essay, he added that the plant representations in the Osler manuscript bear no similarity with those in Arabic manuscripts.[50] On the basis of these observations, Meyerhof suggested that al-Ghāfiqī's text arrived at Baghdad deprived of illustrations,[51] that it reached Baghdad possibly through "the Egyptian way,"[52] and that it was illustrated in Baghdad,[53] probably for a prince.[54] Since then, the evaluation of Ghāfiqī's treatise made by Meyerhof

has been repeated in most subsequent studies, although most of them did not discuss the Osler manuscript.[55] Recently, however, Minta Collins returned to the illustrations of the codex and proposed a new identification for one of their models.[56]

In her book *Medieval Herbals: The Illustrative Traditions*, Collins devoted two brief paragraphs to the Osler codex. Walking first in the footsteps of Meyerhof, she considered that the original manuscript of al-Ghāfiqī (probably referring to his autograph) was not illustrated and that the Osler manuscript had been commissioned in Baghdad where illustrated herbals were fashionable. According to her, the illustrations in the manuscript are typical of the "Arabic style current in Baghdad at that time" (i.e., 654/1256), which is "familiar … from Ayasofya 3703 and Oxford Arab. d. 138." Pursuing her short analysis, she then opposed Meyerhof and stated that "many of the illustrations may be corrupt versions of the Dioscorides Alphabetical Herbal Recension," that is, the recension of the Vienna manuscript *medicus graecus* 1. Further on, she repeated that the plant representations in the Osler codex are "loose copies … from a Dioscorides Herbal" to which "others in the same style [were added] when they were missing in the model."[57]

A systematic comparison of the illustrations in the Osler manuscript with those of all the Greek and Arabic manuscripts of Dioscorides' text currently known leads us in a different direction. It suggests not necessarily that al-Ghāfiqī's work was not originally illustrated, as Meyerhof and Collins surmised, but rather that, if it were illustrated, it lost its iconographic apparatus along the way from al-Andalus to the East, possibly because, at a certain point in time, its text was reproduced in an inexpensive copy that did not include the illustrations of its source. Later on, this copy with only the text was provided with a freshly constituted iconographic apparatus. Furthermore, such systematic comparison shows that the illustrative corpus of the Osler manuscript is made of different iconographic types. Plant representations from different sources were added to al-Ghāfiqī's text, be it by one artist using different models or by uncoordinated artists working in successive phases in the history of the work during its odyssey through the Mediterranean world.

The illustrative corpus of the Osler manuscript is certainly composite, as not all illustrations are of the same iconographic type and possibly not by the same artist as Jaclynne Kerner rightly points out.[58] Leafing through the whole Osler manuscript, it clearly appears that there are at least three iconographic types of illustrations that do not necessarily correspond to different types of plants: in some illustrations, the plants have a dense foliage and cover well the surface of the space, possibly with multiple intertwined twigs (e.g., *anāghālis*, f. 14b); in others, instead, the plants are linear and do not fill much of the portion of the page where they are located (e.g., *aymārūqālus*, f. 29a); and in some others the plants are represented in a highly stylized way, with a geometric composition (possibly with their constitutive parts arranged symmetrically around a central axis) and elements with very schematic forms (e.g., this is the case of *kumīnūn*, f. 258a). Although it may be the case for some illustrations, the differences in the types of illustrations are

5.1
Anāghālis: Montreal, Osler Library of the History of Medicine, MS 7508, f. 14b.

5.2
Aymārūqālus: Montreal, Osler Library of the History of Medicine, MSS 7508, f. 29a.

not necessarily determined by the fact that the plants were known and represented in Greek botanical manuscripts or not. The three plants in the illustrations quoted above (*anāghālis* = pimpernel; *aymārūqālus* = martagon lily; *kūmīnūn* = cumin) can be found in Dioscorides, *De materia medica* (pimpernel, 2.168; martagon lily, 3.122; cumin, 3.59) and are represented in the illustrated Greek copies of the work.

As will be demonstrated below, the illustrations of the first type are close to those in the Greek manuscripts of Dioscorides, *De materia medica*, whereas the others are not. In the discussion that follows, the former will be identified as *Dioscoridean* and the latter as *non-Dioscoridean*.

Starting with the illustrations of the non-Dioscoridean type, we can point, for example, to the camphor tree (*kāfūr*, Osler MS 7508, f. 241a), which does not appear in any Greek manuscript since the plant was not used to produce camphor in the Greek world. Not all the plant representations of the non-Dioscoridean type in the Osler iconographic

apparatus were unknown in the Greek, that is, the Byzantine world. Cumin, for example, which appears in the Osler codex with a non-Dioscoridean representation, is illustrated in the Greek manuscripts of Dioscorides. We should not conclude hastily that its presence among the non-Dioscoridean representations indicates that the manuscript of Dioscorides' text that was possibly used as a model for the Dioscoridean illustrations of the Osler apparatus did not contain an image of cumin, that it was lacunose, or that it contained only a part of Dioscorides' text, stopping before chapter 3.59 on cumin. Plants that come after that chapter in *De materia medica* are represented in the Osler manuscript with Dioscoridean illustrations.

The difference between the three types of illustrations I have distinguished seems to result rather from the use of three different sources to create the Osler iconographic apparatus. There could have been one model that was an illustrated manuscript of Dioscorides' text (or a Dioscorides-like model) for the Dioscoridean representations and one or more others that contained either images in the Arabic tradition (possibly from a copy of the Arabic translation of *De materia medica*) or new images created by one or more artists.

Among the illustrations for which we have *comparanda* in either Greek or Arabic manuscripts with plant representations, be they Dioscoridean or not,[59] we first must eliminate the relationship with the Arabic version of Dioscorides' work currently preserved in Oxford, Arab. MS d. 138 that has been suggested in previous literature.[60] A comparison of the illustrations of mandrake, for example, in the Osler codex (f. 232a) and in this Oxford one (f. 119b) shows substantial iconographic differences that do not allow for a relationship between the two manuscripts, nor even a stylistic similarity.

Once we have clarified these preliminary problems, we can focus on the Dioscoridean illustrations and compare the Osler codex and all the other extant illustrated copies of Dioscorides' *De materia medica* in Greek and Arabic. The two species of houseleek (Dioscorides, 4.88 and 4.89, respectively) may give the impression of a close link between the Osler illustrations and those of Ayasofya MS 3703 and the Greek Dioscorides of Vienna (illustrations 5.3–5.55 and 5.7–5.9). However, a closer relationship appears between the Osler representations and their equivalent in the Greek Dioscorides of Paris, BnF, *grec* 2179 (compare illustrations 5.6 and 5.10 with 5.3 and 5.7, respectively).

Although some other cases of such similarity between the Osler, on the one hand, and the Ayasofya and the Vienna manuscripts, on the other, do appear, they are not as significant as those between the Osler and the Paris manuscript, as many other cases make clear. Returning to mandrake, the representation in the Osler codex (f. 232a) corresponds fairly well iconographically to that in the Paris manuscript (f. 104 recto, illustration 5.11), but not to those in the Ayasofya codex (f. 38a, illustration 5.12) and the Naples manuscript *ex Vindobonensis graecus* 1 (f. 90 recto, illustration 5.13).[61]

5.3
Houseleek (greater): Montreal, Osler Library of the History of Medicine, MS 7508, f. 196b.

5.4
Houseleek (greater): Istanbul, Süleymaniye Library, Ayasofya MS 3703, f. 44a. Reproduced by permission of the Süleymaniye Library.

5.5
Houseleek (greater): Vienna, Österreichische Nationalbibliothek, MS *medicus graecus* 1, f. 12v. Reproduced by permission of the Österreichische Nationalbibliothek.

5.6
Houseleek (greater): Paris, Bibliothèque nationale de France, MS grec 2179, f. 110v. Reproduced by permission of the Bibliothèque nationale de France.

5.7
Houseleek (lesser): Montreal, Osler Library of the History of Medicine, MS 7508, f. 197a.

5.8
Houseleek (lesser): Istanbul, Süleymaniye Library, Ayasofya MS 3703, f. 45a. Reproduced by permission of the Süleymaniye Library.

5.10
Houseleek (lesser): Paris, Bibliothèque nationale de France, MS grec 2179, f. 110r. Reproduced by permission of the Bibliothèque nationale de France.

5.9
Houseleek (lesser): Vienna, Österreichische Nationalbibliothek, MS *medicus graecus* 1, f. 13v. Reproduced by permission of the Österreichische Nationalbibliothek.

5.11
Mandrake: Paris, Bibliothèque nationale de France, MS grec 2179, f. 104r. Reproduced by permission of the Bibliothèque nationale de France.

5.12
Mandrake: Istanbul, Süleymaniye Library, Ayasofya MS 3703, f. 38a. Reproduced by permission of the Süleymaniye Library.

5.13
Mandrake: Naples, Biblioteca nazionale, MS *ex Vindobonensis graecus* 1, f. 90r. Reproduced by permission of the Biblioteca nazionale di Napoli.

5.14
Lavender: Vienna, Österreichische Nationalbibliothek, MS *medicus graecus* 1, f. 319v. Reproduced by permission of the Österreichische Nationalbibliothek.

The most eloquent example of the similarity of the Osler and Paris codices is probably Greek lavender (Dioscorides, 3.26), whose representations in the Osler codex (f. 20b) and the Paris manuscript (f. 9 recto) are iconographically almost identical[62] and do not correspond to that in the Vienna manuscript (f. 319 verso, illustration 5.14). If another example were needed we could add that of cinquefoil (Dioscorides 4.42). The Osler and Paris representations (f. 85a and f. 83 verso, respectively, illustrations 5.15 and 5.16) are much closer to each other iconographically than to those of the Ayasofya and Vienna codices (f. 20a and f. 273 verso, respectively, illustrations 5.17 and 5.18). These and many other cases show that the Osler representations of plants for which a *comparandum* can be

Al-Ghāfiqī, Dioscorides, and Mediterranean Herbal Traditions

5.15
Cinquefoil: Montreal, Osler Library of the History of Medicine, MS 7508, fol. 85a.

5.16
Cinquefoil: Paris, Bibliothèque nationale de France, MS grec 2179, f. 83v. Reproduced by permission of the Bibliothèque nationale de France.

5.17
Cinquefoil: Istanbul, Süleymaniye Library, Ayasofya MS 3703, f. 20a. Reproduced by permission of the Süleymaniye Library.

5.18
Cinquefoil: Vienna, Österreichische Nationalbibliothek, MS *medicus graecus* 1, f. 273r.
Reproduced by permission of the Österreichische Nationalbibliothek.

found in Dioscorides' Greek and Arabic manuscripts are not similar to those of the Vienna tradition, that is, to what Minta Collins calls the "Alphabetical Herbal Recension," but rather to those of the recension to which the Paris manuscript grec 2179 pertains, that is, the supposedly original recension of *De materia medica*, in five books.

Pursuing our comparison between the Osler manuscript and the copies of Dioscorides' *De materia medica*, we discover that the illustrations of the third type that I have distinguished (i.e., those with a marked tendency towards stylized, geometrical representations of the plants) are very similar to their equivalent in the Ayasofya MS 3703 codex. It will suffice here to provide one example: knotgrass (Dioscorides 4.4) in the Osler and in the

Al-Ghāfiqī, Dioscorides, and Mediterranean Herbal Traditions

5.19
Knotgrass: Montreal, Osler Library of the History of Medicine, MS 7508, f. 266a.

5.20
Knotgrass: Istanbul, Süleymaniye Library, Ayasofya MS 3703, f. 5a. Reproduced by permission of the Süleymaniye Library.

Ayasofya codex (Osler MS 7508, f. 266a; Ayasofya MS 3703, f. 5a; illustrations 5.19 and 5.20, respectively).

What is remarkable with knotgrass is that this illustration after the manner of codex Ayasofya MS 3703 is the second illustration of this plant in the Osler manuscript. The first (in the order of the folios in the Osler codex; see f. 92b, illustration 5.21) is closer to its equivalent in the Paris manuscript grec 2179 (f. 72 verso; illustration 5.22) than to those of the Ayasofya and Vienna codices (f. 5a and f. 274 recto, respectively; illustrations 5.20 and 5.23). This duplication (of both the text related to the plant and the illustration) generates the impression of an originally uncoordinated work and suggests that the text of al-Ghāfiqī's treatise in the form it takes in the Osler manuscript includes later, uncoordinated additions. In both cases, however, the representation of the plant in

102 *The Herbal* of al-Ghāfiqī

5.21
Knotgrass: Montreal, Osler Library of the History of Medicine, MS 7508, f. 92b.

5.22
Knotgrass: Paris, Bibliothèque nationale de France, MS grec 2179, f. 72v. Reproduced by permission of the Bibliothèque nationale de France.

5.23
Knotgrass: Vienna, Österreichische Nationalbibliothek, MS *medicus graecus* 1, f. 274r. Reproduced by permission of the Österreichische Nationalbibliothek

the Osler manuscript appears under a specific Arabic name (*balkhiyya*) that does not correspond to the Arabic transliteration of its Greek name (*polugonon*) contrary to what we find in the Arabic version of *De materia medica,* namely, *fūlughunūn*. This might result from a standardization of the text that took place after this duplicate had been introduced.

Towards a Renewed Analysis

Before we draw any conclusion from our analysis, we need to revise the status attributed to ancient and medieval illustrated herbals in modern scholarly literature. They have indeed been granted a status of exceptionality not only because of the large size and lavish illustrative apparatus of many of them but also because of their relative rarity. A systematic search for such books has brought many more Greek illustrated Dioscorides manuscripts to light – almost three dozen – than were previously known, a number suggesting that these books were not necessarily as rare and exceptional as modern literature has claimed. These illustrated codices make up almost a quarter of the total number of manuscripts currently known that have preserved the Greek text of Dioscorides' *De materia medica* (which total around 150). The same is valid for the Arabic manuscripts of Dioscorides, which are almost two dozen, most of which are illustrated. Even for those manuscripts that apparently are of the highest quality, their exceptionality needs to be re-evaluated. A recent study of the Vienna Dioscorides has demonstrated that the book was not commissioned for the princess Anicia Juliana (b. 461 or 463; d. 527 or 529), contrary to what has been affirmed previously in Western scholarship,[63] but is an earlier codex that has been reconditioned to be offered to the princess by adding a set of front matter.[64] Although we do not know where the body of the manuscript comes from, it cannot have come from the Imperial Library, to which the inhabitants of Constantinople who offered the current *Vindobonensis* to Anicia Juliana did not have access – besides which it would have been unthinkable to recondition one of its volumes for a gift to a member of the imperial family – and it cannot be a copy of an item from the Imperial Library either, because it is highly improbable that the donors of the manuscript could have borrowed an imperial manuscript to draw a copy. It is a manuscript that was either in a private collection – and not in an institution, because this would mean that the manuscript would have been de-accessed – or on the market. In the latter case, its quality was good enough for the codex to be offered as a present to an imperial princess.

Bearing this in mind, it should not automatically be assumed that a lavishly illustrated herbal such as the Osler manuscript was made upon commission by a prince, a wealthy collector, or any other patron with interest in book collecting, culture, science, or the arts. Similarly, such books should not necessarily be viewed as deluxe products, made for prestige, representation, or gifts. Again, the analysis of the whole range of illustrated manuscripts of Dioscorides' *De materia medica*, particularly the Greek ones, leads to a

different conclusion. Books like those may have been produced to be used, be it for educational, scientific *stricto sensu*, or practical purposes. One such example may be the Dioscorides of Padua (Biblioteca del Seminario, 194) containing the illustrative corpus and the text of Dioscorides' *De materia medica*, most probably copied from the Vienna manuscript.[65] Judging from its watermark, the manuscript dates to the 1340s.[66] In the spaces of the folios not covered by the illustrations, the Greek text related to each figure has been introduced by a hand that is very similar and perhaps identical to that of Neophytos Prodromênos, who is known to have been active during the years when the manuscript was made.[67] At that time, Neophytos was active in the monastery of St John, which included a library, a school, and a hospital.[68] It is highly probable that the Padua manuscript was made to be used, because there is also ample evidence of a significant educational and medical activity in the monastery at that time.[69]

Once we have opened the path for new interpretations of illustrated herbals in this way, we can also revisit the question of the authors of their illustrations, that is, the artists responsible for the iconographic apparatus of herbals. According to scholarly tradition, artists were individuals working in collaboration (or not), and possibly using different models. Considering all the illustrated Greek manuscripts of Dioscorides' *De materia medica*, and reading the tradition of their iconographic apparatus with the tools of textual history, opens up new avenues. Such an approach clearly shows that iconographic traditions did by no means proceed in a linear way in an uninterrupted continuity, but were sometimes interrupted (the iconographic apparatus disappearing from the manuscripts of a previously illustrated text) and further recreated *ab nihilo*, thus proceeding by fits and starts in a repeated way. Furthermore, such an approach shows without any doubt that not all cases of recovery after an interruption did proceed in the same way, and that multiple strategies have been used by illustrators to reconstitute the lost iconographic apparatus of *De materia medica*. In the pages that follow, I will draw on the data of such analysis to investigate the construction of the iconographic apparatus of the Osler manuscript. We need to bear in mind that the codex is not necessarily a first-degree copy of this apparatus (i.e., its original), but may be a second- or third-degree descendant (if not a more distant one) of an original now lost that was created at a time and a place that cannot be determined. I will thus distinguish the Osler codex from its iconographic apparatus.

Such systematic analysis clearly shows that the illustrative apparatus of *De materia medica* codices should not necessarily be seen in all manuscripts as a unitary corpus made at the same time, but might be a layered collection of images gradually accumulated over time. The case of the manuscript of Paris, Bibliothèque nationale de France, grec 2183 (dating to the 1340s) is significant from this viewpoint.[70] Its iconographic apparatus presents in more than one case two or more images of the same plant side by side. Typically, these representations seem to be copies of the same model. However, the iconography of each of these images for which there is more than one representation is significantly different, suggesting that all these images were not made at the same time

by one artist reproducing representations from different models, but have been added in successive phases over time, with images added one after the other to a first one.

Another case in point is provided by the iconographic apparatus of the version of *De materia medica* identified as "the Alphabetical five-book recension." Its two most ancient manuscripts are New York, Pierpont Morgan Library, MS M652 of the late 9th or early 10th century,[71] and Athos, Megisti Lavra, Ω 75, of the mid-11th century.[72] They cannot be copies of one another, but descend from an archetype now lost,[73] which was probably not illustrated. In order to recreate an iconographic apparatus, the two manuscripts used different strategies. Whereas in the first book, which reproduces the text of an ancestor of the Vienna manuscript, the New York codex included illustrations similar to those of the *Vindobonensis*; in the others it has images created without models and without direct observation of nature either.[74] The Athos manuscript created new images afresh through the entire manuscript.[75] Their iconographic type is totally different from that of the new images in the New York manuscript and witnesses an attempt to generate a naturalistic set of plant representations. Nevertheless, for many plants, the Athos artist did not create any image, even though the copyist left blank spaces on the pages for the artist to introduce illustrations. It is highly probable that, had the manuscript been later in the hands of a reader of Dioscorides' text with a model to compensate for these iconographic lacunae, illustrations would have been introduced in these blank spaces.

Based on these premises, we can approach the illustrations of the Osler manuscript in a different, more dynamic way, which probably is also more realistic.

The similarity between many illustrations of the Osler and the Paris grec 2179 manuscripts may suggest that a codex of Dioscorides' *De materia medica* was used as the basis to create the Osler apparatus. This manuscript may have been Greek (or Arabic, but very close to Greek copies of the work), generating the images qualified as Dioscoridean, which correspond to the first type I have identified, that is, illustrations that fill a substantial portion of the ad hoc spaces on the pages. Such identification should not automatically lead to the conclusion that the Osler iconographic apparatus was created in Andalusia, since a Greek manuscript of Dioscorides' full text (which has been supposed to be close to the Vienna manuscript but without supporting evidence) was sent to Cordoba's court by the Byzantine emperor. Although this may be possible, nothing in our current state of knowledge supports such identification.

It is more probable that the textual recension of Dioscorides' text attested by the Paris manuscript (together with its iconographic apparatus) was available across the zone bounded by al-Andalus and the eastern Arabic Empire and, also, that Arabic scientists and illustrators were aware that this recension was the complete version of Dioscorides' text (contrary to the Vienna manuscript, which contains only a portion of it, i.e., a selection of chapters on herbs). This possible awareness may hint at the process by which illustrations were introduced (or reintroduced) into al-Ghāfiqī's text. They may not have been amalgamated by a fortuitous concourse of circumstances – a manuscript found by

coincidence, whose illustrations would have been transferred into a copy of al-Ghāfiqī's text. On the contrary, illustrations may have been added to al-Ghāfiqī's text as the result of a scholarly decision based on the possible examination of the different recensions of the *De materia medica*.

A closer analysis reinforces the hypothesis of possible scholarly work preceding the creation of the Osler iconographic apparatus. The transfer of illustrations from a determined text (in this case, Dioscorides' *De materia medica*) and a specific manuscript (here, a Greek codex of *De materia medica* very similar to current Paris grec 2179) to another text (here, al-Ghāfiqī's *Kitāb fī l-adwiya al-mufrada*), be it to generate a newly illustrated manuscript or to introduce illustrations in an existing manuscript, was not an easy task. The two works did not have the same content and, in any case, did not organize it in the same way. Although it is very possible that an artist illustrating al-Ghāfiqī's work by means of a copy of Dioscorides' *De materia medica* may have browsed the Dioscorides manuscript every time he needed to find a model for an illustration to be introduced into the manuscript of al-Ghāfiqī's treatise, repeating such search for each and every image, it is much more probable that, in order to have a more productive use of his time, he first established what we could call a *table of concordance* of the plants in the two manuscripts, with, in one column, the names of the plants for which an illustration was needed (i.e., the *illustranda*) and, in the other, the names of the plants in the manuscript used as a source (i.e., the *illustrata*). If no such table was generated, at least a list of available images (i.e., the *illustrata*) was necessary.

It might be that such a table of concordance did not exist as the *illustrata* correspond to the table of contents of the model(s) and the *illustranda* to the sequence of the chapters in the manuscript to be illustrated. Whatever the case, there should have been some preparatory work making it possible to combine the iconographic items of the model with the right chapter in the text to be illustrated. If some written document was prepared to this end (a table of concordance or the table of contents of the model), it was not preserved once the work was completed because it was made of handwritten notes by the artist not aimed to have any independent life beyond the production of a new illustrated manuscript.

Returning to the iconographic apparatus of the Osler manuscript, one can hypothesize that its creation went through a sequence like the following. The text of al-Ghāfiqī's *Kitāb fī l-adwiya al-mufrada* was copied with blank square spaces left for illustrations on a fraction of the width and the length of the pages. After a good manuscript had been searched (resulting in locating a codex similar to the Paris grec 2179), a list of its chapters (and, consequently, of its illustrations) was compiled if there were no table of contents in the manuscript. The illustrations in the Paris-like manuscript were put in correspondence with the chapters of al-Ghāfiqī, and Dioscoridean illustrations were added to al-Ghāfiqī's text.

Since not all chapters of al-Ghāfiqī's treatise have an equivalent in the Paris-like codex, a certain number of al-Ghāfiqī's chapters remained unillustrated. Other manuscripts needed to be located and treated in the same way as the Paris-like one. However, it is not impossible that the illustrations for which there is no *comparanda* in the Paris-like manuscript were introduced in a different way: not systematically, on the basis of one or more manuscripts carefully collated on the Osler apparatus, but randomly according to possible encounters of an ancestor of the Osler codex with one or more illustrated manuscripts – in Greek, Arabic, or other languages. In the cases for which no *comparanda* could be found at all, illustrations have been created afresh by one or more illustrators.

One such manuscript may have been an Arabic copy of Dioscorides' *De materia medica*, from which the illustrations of the third type I have distinguished were drawn, characterized by increased geometrization and stylization.

Another manuscript might have been the source of the illustrations of the second type – those with not much substance contrary to those of the first type. Given the heterogeneity of their iconography, these illustrations may come from more than one manuscript or even have been created afresh, without the help of any manuscript and not necessarily from observation of nature.

The illustration of *farikon* (in Greek; *hayūfārīqūn* and *ūfārīqūn* in the Osler MS 7508, f. 143b) may be significant and confirm the existence of a scholarly work preceding the creation of the iconographic apparatus of the Osler manuscript. This plant is present in the Greek medical literature ([Dioscorides], *Alexipharmaka*, 19),[76] but was never illustrated. Although it has not been exactly identified in modern scientific literature, it is supposed to be a member of the *Solanaceae* family, principally because of the toxic effects it is credited with.[77] Its representation in the Osler manuscript (f. 143b) closely reproduces the image of the *Solanacea* called *struchnon* in the Paris grec 2179 manuscript (f. 102 recto, illustration 5.24). The creation of an illustration for *hayūfārīqūn* and *ūfārīqūn* that is botanically correct (since it is of a *Solanacea*) hints at work done before illustrating the text, in order to properly identify the plant and to search an image of another species in the same genus. Such work was not limited to iconographic research as might be thought, but was botanical in nature in this specific case.

The plausibility of such reconstruction is confirmed by the manuscript *Vaticanus graecus* 284.[78] This copy of Galen's *De simplicium medicamentorum temperamentis et facultatibus* was produced (without illustrations) in Constantinople in the 10th century in the so-called scriptorium of Ephrem for an unknown library or private owner. In the 13th century, the codex was provided with an iconographic apparatus on the basis of the manuscript M652 of Dioscorides' *De materia medica* of the Pierpont Morgan Library in New York, most probably in the complex of St John already mentioned where the New York manuscript was preserved at that time.[79] Besides showing that an iconographic apparatus can be introduced into an aniconic manuscript at some point in its history further to its

ΔΕ ΑΥΤΟΥ ΠΟΙΕΙ ΠΡΟΣ ΕΡΥΣΙΠΕΛΑΤΑ ΚΑΙ
ΕΡΠΗΤΑΣ ΣΥΝ ΗΔΥΟΣΜΩΙ ΚΑΙ ΑΛΦΙΤΩΙ ΕΡΥ-
ΡΩΙ ΚΑΙ ΟΔΥΝΩΝ ΠΡΟΣ ΑΙΓΙΛΩΠΑΣ ΕΞ ΣΥ-
ΑΡΤΩΝ ΑΛΜΟΖΕΙ ΚΑΙ ΕΡΙΝΩΣΠΑΙΔΙΟΙΣ ΣΥ-
ΡΟΔΗΝ ΩΣ ΒΡΕΧΟΜΕΝΟΣ ΛΕΙΧΗΝΑΣ ΛΕΙΑΒ
ΚΑΙ ΚΟΛΛΟΥΡΙΟΙΣ ΑΝΤΙ ΥΔΑΤΟΣ ΕΝ ΜΟΥΣΕΩΣ
ΠΡΟΣ ΡΕΥΜΑΤΑ ΟΜΜΑ ΚΑΙ ΕΙΣ ΤΑΣ ΕΓΧΡΙ-
ΣΕΙΣ· ΩΦΕΛΕΙ ΚΑΙ ΩΤΑΛΓΙΑΣ ΕΝ ΣΤΑΦΥ-
ΙΣΧΙΑΔΕ ΚΑΙ ΡΟΗΝ ΓΥΝΑΙΚΕΙΟΝ ΕΝ ΕΡΙΩΙ
ΠΡΟΣΤΙΘΕΣΕΙΣ·
ΕΣΤΙ ΔΕ ΚΑΙ ΕΤΕΡΟΝ ΣΤΡΥΦΝΟΝ Ο ΙΔΙΩΣ ΑΛΙ-
ΚΑΚΚΑΒΟΝ ΚΑΛΟΥΣΙ ΦΥΛΛΟΙΣ ΟΜΟΙΟΝ ΤΩΙ
ΠΡΟΕΙΡΗΜΕΝΩΙ ΠΛΑΤΥΤΕΡΟΝ ΜΕΝΤΟΙ
ΚΑΥΛΟΙ ΔΕ ΑΥΤΟΥ ΜΕΤΑ ΤΟΥ ΖΗΝ ΗΝΑΓΚΑ-
ΜΙΚΑΙ ΠΙΣΤΟΝΤΑΣ ΚΑΡΠΟΝ ΔΕ ΕΧΕΙ
ΕΝ ΘΥΛΑΚΙΩΣ ΠΕΡΙΦΕΡΕΣΙΝ ΟΜΟΙΟΝ ΚΡΥ-
ΣΤΑΛΛΩ ΣΤΡΟΝ ΠΕΡΙΦΕΡΗ ΛΕΙΟΝ ΩΣΠΕΡ ΑΚΤΑ
ΦΥΛΛΗΣ ΩΣ ΚΑΙ ΟΙ ΣΤΕΦΑΝΗΠΛΟΚΟΙ ΧΡΩ-
ΤΑΙ ΚΑΤΑΠΛΕΚΟΝΤΕΣ ΤΟΙΣ ΣΤΕΦΑΝΟΙΣ.
ΔΥΝΑΜΙΝ Δ' ΕΧΕΙ
ΚΑΙ ΧΡΗΣΙΝ ΤΗΝ
ΑΥΤΗΝ ΤΩΙ ΠΡΟΕΙ-
ΡΗΜΕΝΩΙ ΟΡΚΗΝ ΕΥ-
ΤΩΙ ΤΡΥΓΙΩΝ ΧΡΟ-
ΡΙΣΤΟΥ ΒΙΒΡΩΣΚΕ-
ΣΘΑΙ ΔΥΝΑΤΑΙ ΩΣ
Ο ΚΑΡΠΟΣ ΤΕ ΓΟΥ-
Ν ΠΙΝΟΜΕΝΟΣ ΙΚΤΕ-
ΡΟΝ ΑΠΟΚΑΘΑΙΡΕΙ
ΟΥΡΗΤΙΚΟΣ ΩΝ
ΚΑΙ ΧΥΛΙΖΕΤΑΙ ΔΕ
ΑΜΦΟΤΕΡΩΝ Η
ΠΟΑ ΚΑΙ ΞΗΡΑΙΝΕ-
ΤΑΙ ΕΝ ΣΚΙΑΙ ΕΙΣ ΑΠΟ
ΘΕΣΙΝ ΠΟΙΕΙ ΔΕ ΠΡΟΣ
ΤΑ ΑΥΤΑ.

5.24
Farikon in Greek: Paris, Bibliothèque nationale de France, MS grec 2179, f. 102r. Reproduced by permission of the Bibliothèque nationale de France.

encounter with an illustrated manuscript, this *Vaticanus* is a further testimony of the necessity of a preparatory work before transferring the iconographic apparatus of a text to another one, since Galen's and Dioscorides' encyclopedias of *materia medica* do not list the several items in the same order as we have said.

Whatever its possible phasing and the places where it was created, the iconographic apparatus that accompanies Ghāfiqī's text in the Osler manuscript may result from a complex process. In this view, the Osler manuscript hints at a dynamic of medieval illustration about which we have no information, but which can possibly be discerned by an archaeology of illustrations like the one I propose here.

Given the variety of the models of the Osler iconographic apparatus and given that al-Ghāfiqī's treatise crossed the Mediterranean from west to east, it is highly improbable that all the manuscripts used to create the Osler apparatus were found at the same time at the same place (a library, a private collection, or any other assemblage of material). I thus suggest that, on a first nucleus made from an iconographic apparatus like that of the Paris grec 2179, additions have been made in several layers, most probably in different places along the journey of al-Ghāfiqī's text and possibly also at different times. The images of the second type I have distinguished may be material introduced by users of the text in the way of glosses. Rather than a unitary corpus, the Osler iconographic apparatus is a collection of illustrative material agglutinated on al-Ghāfiqī's treatise during its odyssey across the Mediterranean.

NOTES

1. On Dioscorides, with references to the previous literature, see Alain Touwaide, "Pedanius [1]: Pedanius Dioskorides," in *Brill's New Pauly: Encyclopaedia of the Ancient World*, vol. 10, edited by Hubert Cancik and Helmuth Schneider (Leiden: Brill, 2007), cols. 670–2. For the Greek text of *De materia medica*, see Dioscorides, *Pedanii Dioscuridis Anazarbei De materia medica libri quinque*, 3 vols, edited by Max Wellmann (Berlin: Weidmann, 1906–14; reprinted 1958). For a recent English translation, see Dioscorides, *Pedanius Dioscorides of Anazarbus, De materia medica*, translated by Lily Y. Beck, Altertumswissenschaftliche Texte und Studien 38 (Hildesheim: Olms-Weidmann, 2005). For an interpretation, see John M. Riddle, *Dioscorides on Pharmacy and Medicine*, History of Science Series 3 (Austin: University of Texas Press, 1985), and also Alain Touwaide, "La botanique entre science et culture au Ier siècle de notre ère," in *Geschichte der Mathematik und der Naturwissenschaften in der Antike*, vol. 1, *Biologie*, edited by G. Wöhrle (Stuttgart: F. Steiner, 1999), 219–52.

2. On this protocol, see Touwaide, "La botanique," 229–37.

3. *De materia medica*, 1.1. Greek text in Wellmann, 1: 5–7; translation by Beck, 5–6.

4. The census of these manuscripts in the literature is largely incomplete. For a fresh approach, see Alain Touwaide, "Les manuscrits illustrés du *Traité de matière médicale* de Dioscoride," in *Proceedings of the XXX International Congress of the History of Medicine (Düsseldorf, Germany, 1986)* (Leverkusen: Vicom KG, 1988), 1148–51.

5. The study of the illustrations accompanying the text of *De materia medica* has been masterfully inaugurated by the work of Joseph von Karabacek, ed., *De codicis Dioscuridei Aniciae Iulianae, nunc Vindobonensis Med. Gr. I historia, forma, scriptura, picturis* (Leiden: A.W. Sijthoff, 1906), with contributions by Antonius de Premerstein, Carolus Wessely, and Iosephus Mantuani. Later, Kurt Weitzmann frequently treated this topic in his publications, starting with his major work *Die Byzantinische Buchmalerei des 9. und 10. Jahrhunderts* (Berlin: Gebr. Mann, 1935), reprinted with addenda and an appendix under the same title in Österreichische Akademie der Wissenschaften, Philosophisch-historische Klasse, Denkschriften, 243–4 = Veröffentlichungen der Kommission für Schrift- und Buchwesen des Mittelalters, Reihe IV, Monographie, 2, 2 vols (Vienna: Österreichische Akademie der Wissenschaften, 1996). This pioneering work was followed by several others by Weitzmann, in which he studied the illustrations of many of the manuscripts discussed here. The most relevant publications are the following: *Ancient Book Illumination*, Martin Classical Lectures 16 (Cambridge, MA: Harvard University Press, 1959); *Geistige Grundlagen und Wesen der Makedonischen Renaissance*, Arbeitsgemeinschaft für Forschung des Landes Nordrhein-Westfalen, Geisteswissenschaften 107, 90, Sitzung am 18. Juli 1962 in Düsseldorf (Cologne: Westdeutscher Verlag, 1963); "The Greek Sources of Islamic Scientific Illustrations," in Georges C. Miles, ed., *Archaeologia Orientalia in Memoriam Ernst Herzfeld* (Locust

Valley, NY: J.J. Augustin, 1952, 244–66. Some of these studies have been reproduced (in English translation for the 1963 one originally published in German) in Kurt Weitzmann, *Studies in Classical and Byzantine Manuscript Illumination*, edited by Herbert L. Kessler, with an introduction by Hugo Buchthal (Chicago: University of Chicago Press, 1971). Since then, other works have been published on this topic, see, e.g., Alfred Stückelberger, *Bild und Wort: Das illustrierte Fachbuch in der antiken Naturwissenschaft, Medizin und Technik*, Kulturgeschichte der antiken Welt 62 (Mainz: Philipp von Zabern, 1994), and also Minta Collins, *Medieval Herbals: The Illustrative Traditions* (London: British Museum Library; Toronto: University of Toronto Press, 2000), the latter of which is not free of mistakes.

6 For the thesis of the later addition, see, e.g., Giulia Orofino, "Dioskurides war gegen Pflanzenbilder," *Die Waage* 30 (1991): 144–9.

7 *De materia medica*, *Preface*, §§ 3 and 5 (vol 1, pp 2 and 3, respectively, in Wellmann's edition corresponding to 2 and 3 in Beck's translation).

8 On Sextius Niger, see Umberto Capitani, "I Sesti e la medicina," in Philippe Mudry and Jackie Pigeaud, eds., *Les écoles médicales à Rome: Actes du 2ème Colloque international sur les textes médicaux latins antiques, Lausanne, Septembre 1986*), 95–123, Université de Lausanne, Publications de la Faculté des Lettres 33 (Geneva: Droz, 1991), and, more recently, John Scarborough, "Sextius Niger," in Paul T. Keyser and Georgia L. Irby-Massie, eds., *The Encyclopedia of Ancient Natural Scientists: The Greek Tradition and Its Many Heirs* (London: Routledge, 2008), 738–9.

9 Touwaide, "La botanique," 248–51.

10 See *De materia medica*, 5.162 (vol. 3, 108 in Wellmann's edition corresponding to 400–1 in Beck's translation).

11 On these two treatises, see Alain Touwaide, "L'authenticité et l'origine des deux traités de toxicologie attribués à Dioscoride: I. Historique de la question; II. Apport de l'histoire du texte," *Janus* 38 (1984): 1–53; and idem, "Les deux traités de toxicologie attribués à Dioscoride – Tradition manuscrite, établissement du texte et critique d'authenticité," in A. Garzya, ed., *Tradizione e ecdotica dei testi medici tardo-antichi e bizantini: Atti del Convegno internazionale, Anacapri, 29–31 ottobre 1990*, Collectanea 5 (Naples: D'Auria, 1992), 291–339. For their Greek text, see Alain Touwaide, "Les deux traités de toxicologie attribué à Dioscoride: La tradition manuscrite grecque; édition critique du texte grec et traduction," 5 vols, unpublished Ph.D. dissertation, Université catholique de Louvain, 1981; see esp. vol. 4.

12 On this point, see Touwaide, "L'authenticité et l'origine," 1–53.

13 For a brief overview of the *fortuna* of *De materia medica*, see John M. Riddle, "Dioscorides," in F. Edward Cranz and Paul Oskar Kristeller, eds., *Catalogus Translationum et Commentariorum: Mediaeval and Renaissance Latin Translations and Commentaries*, vol. 4, *Annotated Lists and Guides* (Washington, DC: Catholic University of America Press, 1980), 1–143.

14 A study of the medieval *fortuna* of *De materia medica* is still lacking.

15 For an overview of currently available litera-

ture on the Arabic translation of Dioscorides, *De materia medica*, see n24.

16 The Renaissance production in Latin has been exhaustively studied by Riddle, "Dioscorides."

17 On Galen, see Vivian Nutton, "Galen of Pergamum," in Hubert Cancik and Helmuth Schneider, eds., *Brill's New Pauly: Encyclopaedia of the Ancient World*, vol. 5 (Leiden: Brill, 2004), cols. 654–61.

18 For the Greek text of the work, see Karl Gottlob Kühn, *Claudii Galeni Opera Omnia*, Medicorum graecorum opera quae exstant, vols 11 and 12 (Leipzig: Karl Knobloch, 1826), 11: 379–890, and 12: 1–377. For the manuscripts of the treatise, see the list by Caroline Petit, "La tradition manuscrite du traité des *Simples* de Galien: *Editio princeps* et traduction annotée des chapitres 1 à 3 du livre I," in Véronique Boudon-Millet, Jacques Jouanna, Antonio Garzya, and Amneris Roselii, eds., *Storia della tradizione e edizione dei testi medici greci: Atti del VI Colloquio internazionale, Paris, 12–14 aprile 2008*, Collectanea 27 (Naples: D'Auria, 2010), 143–65 (esp. 146), which is not free of mistakes.

19 This manuscript has been extensively studied because of its exceptional antiquity. After the fundamental analysis in the edition by von Karabacek in 1906, one of the most authoritative studies was by Paul Buberl, *Die byzantinischen Handschriften*, vol. 1, *Der Wiener Dioskurides und die Wiener Genesis*, Beschreibendes Verzeichnis der illuminierten Handschriften in Österreich, Neue Folge, 4 (Leipzig: Karl W. Hiersemann, 1937). It has been reproduced in a magnificent facsimile edition under the title: *Dioscurides: Codex Vindobonensis med. gr. 1 der Österreichischen Nationalbibliothek*, Codices selecti phototypice impressi 12 (Graz: Akademische Druck.- u. Verlagsanstalt, 1970), together with an exhaustive study by Hans Gerstinger in the companion volume. A handy introductory study was published successively: Otto Mazal, *Pflanzen, Wurzeln, Säfte, Samen: Antike Heilkunst in Miniaturen des Wiener Dioskurides* (Graz: Akademische Druck- u. Verlagsanstalt, 1981). More recently, a small facsimile was published: *Der Wiener Dioskurides: Codex medicus graecus 1 der Österreichen Nationalbibliothek*, 2 vols, Glanzlichter der Buchkunst 8 (Graz: Akademische Druck- u. Verlagsanstalt, 1998–9).

20 This date has been recently revised by Andreas E. Müller, "Ein vermeintlich fester Anker: Das Jahr 512 als eitlicher Ansatz des *Wiener Dioskurides*," *Jahrbuch der Österreichischen Byzantinistik* 62 (2012): 103–9.

21 Ernst Gamillscheg, "Das Geschenk für Juliana Anicia: Überlegungen zu Struktur und Entstehung des Wiener Dioskurides," in Klaus Belke, Ewald Kislinger, Andreas Külzer, and Maria A. Stassinopoulou, eds., *Byzantina Mediterranea: Festschrift für Johannes Koder zum 65. Geburtstag* (Vienna: Böhlau, 2007), 187–95.

22 Arsenio Ferraces Rodríguez, *Estudios sobre testos latinos de fitoterapia entre la antigüedad tardía y la alta edad media*, Monografías 73 (Coruña: Universidade Da Coruña, Servicio de Publicacións, 1999), *passim*; and, more recently: idem, "Un corpus altomedieval de materia médica," in Alain Touwaide, ed., *Herbolarium et materia medica (Biblioteca Statale di Lucca, ms 296)*, Libro de Estudios (Lucca: Bib-

lioteca Statale di Lucca, and Madrid: AyN Ediciones, 2007), 43–53, esp. 46–7.

23 The text of this translation was published by Konrad Hofmann, Theodor M. Auracher, and Hermann Stadler in different issues of *Romanische Forschungen* at the end of the 19th century. On this translation, see mainly (with the earlier bibliography) Riddle, "Dioscorides," 6; and idem, "Pseudo-Dioscorides' *Ex herbis feminis* and Early Medieval Medical Botany," *Journal of the History of Biology* 14 (1981): 43–81; reprinted in idem, *Quid pro quo: Studies in the History of Drugs*, Collected Studies Series CS367 (Aldershot: Variorum, 1992), no. IX.

24 For an overview of the research on the work until 1996, see Alain Touwaide, "La traduction arabe du *Traité de matière médicale* de Dioscoride: Etat de recherche bibliographique," *Ethnopharmacologia* 18 (1996): 1–41. For three syntheses on the history of the translations of *De materia medica* into Arabic, see (in chronological order of publication): Mahmoud M. Sadek, *The Arabic Materia Medica of Dioscorides* (Quebec, QC: Éditions du Sphinx, 1983); Alain Touwaide, "L'intégration de la pharmacologie grecque dans le monde arabe: Une vue d'ensemble," *Medicina nei secoli* 7 (1995): 159–89; and, more recently, idem, "Pharmacology: II. The Arabo-Islamic Cultural Sphere," in Manfred Landfester, Hubert Cancik, and Helmuth Schneider, eds., *Brill's New Pauly: Encyclopedia of the Ancient World*, vol. 4, *Classical Tradition* (Leiden: Brill, 2009), cols. 362–6, with an extensive bibliography. For major philological works, see the several contributions by Albert Dietrich: *Dioscurides Triumphans: Ein anonymer arabischer Kommentar (Ende 12 Jahrh. n. Chr.) zur Materia medica; Arabischer Text nebst kommentierter deutscher Übersetzung*, 2 vols, Abhandlungen der Akademie der Wissenschaften in Göttingen, Philologisch-historische Klasse, Dritte Folge, nr. 172–3 (Göttingen: Vandenhoeck and Ruprecht, 1988); *Die Dioskurides-Erklärung des Ibn al-Baiṭār: Ein Beitrag zur arabischen Pflanzensynonymik des Mittelalters; Arabischer Text nebst kommentierter deutscher Übersetzung*, Abhandlungen der Akademie der Wissenschaften in Göttingen, Philologisch-historische Klasse, Dritte Folge, no. 191 (Göttingen: Vandenhoeck and Ruprecht, 1991); and *Die Ergänzung Ibn Ǧulǧul's zur* Materia Medica *des Dioskurides: Arabischer Text nebst kommentierter deutscher Übersetzung*, Abhandlungen der Akademie der Wissenschaften in Göttingen, Philologisch-historische Klasse, Dritte Folge, no. 202 (Göttingen: Vandenhoeck and Ruprecht, 1993).

25 For recent syntheses on Ḥunayn, see Gregg De Young, "Ḥunayn ibn Isḥāq," in Thomas Glick, Steven J. Livesey, and Faith Wallis, eds., *Medieval Science, Technology, and Medicine: An Encyclopedia* (New York: Routledge, 2005), 232–4, and Robert Morrison, "Ḥunayn ibn Isḥāq," in Josef W. Meri, ed., *Medieval Islamic Civilization: An Encyclopedia*, 2 vols (New York: Routledge, 2006), 1: 336–7; both have references to the most important literature, earlier and more recent.

26 Manfred Ullmann, *Untersuchungen zur arabischen Überlieferung der* Materia medica *des Dioskurides*, with contributions by Rainer Degen (Wiesbaden: Harrassowitz, 2009), 69–171.

27 On this manuscript, besides Ullmann, *Untersuchungen*, see also Dietrich Brandenburg, *Islamic Miniature Painting in Medical Manuscripts* (Basel: Roche, 1982), 94–7, and Sadek, *The Arabic Materia Medica*, 14.

28 For a thorough study of this translation and the Leiden manuscript, see Sadek, *The Arabic Materia Medica*, which includes several black and white reproductions of entire pages. For some other reproductions, see also Brahim Alaoui, ed., *L'Age d'or des sciences arabes: Exposition présentée à l'Institut du monde arabe, Paris, 25 octobre 2005 – 19 mars 2006* (Paris: Institut du monde arabe and Arles: Actes Sud, 2005), 180.

29 On this Paris manuscript, see the description by Brigitte Mondrain in *Byzance: L'art byzantin dans les collections publiques de France; Musée du Louvre, 3 novembre 1992 – 1er février 1993* (Paris: Musée du Louvre; Réunion des musées nationaux (France), 1992), 345–6. For the reproduction of several of its pages, see Alain Touwaide, Natale Gaspare De Santo, Guido Bellinghieri, and Vincenzo Savica, *Healing Kidney Diseases in Antiquity: Plants from Dioscorides'* De materia medica *with Illustrations from Greek and Arabic Manuscripts (A.D. 512–15th Century)* (Cosenza, Italy: Bios, 2000), 12, 39, 47, 93–4, 109, 111, 120–1, 124, 134, 140, and 167.

30 On this manuscript, see Alain Touwaide, ed., *Farmacopea araba medievale: Codice Ayasofya 3703*, 4 vols (Milan: ANTEA, 1992–93).

31 For examples of mosaics similar to the illustrations of this manuscript, see the following works by Michele Piccirillo cited here in chronological order of publication: *Chiese e mosaici della Giordania settentrionale*, Studium Biblicum Franciscanum, Collectio minor 30 (Jerusalem: Franciscan Printing Press, 1981); *I mosaici di Giordania* (Rome: Quasar, 1986); *Madaba, le chiese e i mosaici* (Cinisello Balsamo: Paoline, 1989); and, in collaboration with Eugenio Alliata, *Umm al-Rasas Mayfacah: I. Gli scavi del complesso di Santo Stefano*, Studium Biblicum Franciscanum, Collectio maior 28 (Jerusalem: Studium Biblicum Franciscanum, 1994).

32 On these characteristics of the illustrations in Ayasofya MS 3703, see Alain Touwaide, "Fluid Picture-Making across Borders, Genres, Media: Botanical Illustration from Byzantium to Baghdad, Ninth to Thirteenth Centuries," in Jaynie Anderson, ed., *Crossing Cultures: Conflict, Migration, and Convergence; The Proceedings of the 32nd International Congress in the History of Art (Comité International d'Histoire de l'Art, CIHA), University of Melbourne, 13–18 January 2008* (Carlton, Australia: Miegunyah Press, 2009), 159–63.

33 On this aspect, see Alain Touwaide, "Persistance de l'hellénisme à Baghdad au début du XIIIème siècle: Le manuscrit Ayasofya 3703 et la renaissance abbasside," *Erytheia* 18 (1997): 49–74.

34 In 1958, this manuscript contained 262 pages (= 131 folios). Folios of this manuscript can be found in several collections around the world including the University of Michigan at Ann Arbor, the Walters Art Gallery in Baltimore, the Museum of Islamic Art in Berlin, the Harvard University Museum at Cambridge, MA, the Aga Khan collection in Geneva, the Metropolitan Museum in New York, the Chrysler

35 Ernst Grube, "Materialen zum Dioskurides Arabicus," in Richard Ettinghausen, ed., *Aus der Welt der islamischen Kunst: Festschrift für Ernst Kühnel zum 75.Geburtstag am 26. 10. 1957* (Berlin: Gebr. Mann, 1959), 163–94; see esp. 179–80 with previous literature.

36 On the diffusion of Ḥunayn's translation to the West, see principally Juan Vernet, *La cultura hispanoárabe en Oriente y Occidente* (Barcelona: Arial, 1978); French translation (used here): *Ce que la culture doit aux Arabes d'Espagne*, La bibliothèque arabe, Collection L'Histoire décolonisée (Paris: Sindbad, 1985), 81–4; and, more recently, Julio Samsó, *Las ciencias de los antiguos en Al-Andalus*, Colección Al-Andalus 18, 7 (Madrid: Mapfre, 1992), 110–16.

37 Studies on this manuscript have been rare so far. See, principally, Alain Touwaide, "Un manuscrit athonite du *Traité de matière médicale* de Dioscoride: l'*Athous Magnae Laurae* Ω 75," *Scriptorium* 45 (1991): 122–7. For a reproduction of several of its illustrations, see Alain Touwaide et al., *Healing Kidney Diseases in Antiquity*, passim.

38 Reproduction in Sadek, *The Arabic Materia Medica*, 126.

39 For a first analysis of this phenomenon, see Alain Touwaide, "Arabic Medicine in Greek Translation: A Preliminary Report," *Journal of the International Society for the History of Islamic Medicine* 1 (2002): 45–53. Also, idem, "Lexica medico-botanica byzantine: Prolégomènes à une étude," in *Tês fillies tade dôra – Miscelánea léxica en memoria de Conchita Serrano*, Manuales y Anejos de "Emerita" 41 (Madrid: Consejo Superior de Investigaciones Científicas, 1999), 211–28. More recently, see Alain Touwaide and Emanuela Appetiti, "Knowledge of Eastern Materia Medica (Indian and Chinese) in Pre-modern Mediterranean Medical Traditions: A Study in Comparative Historical Ethnopharmacology," *Journal of Ethnopharmacology* 148 (2013): 361–78. For a comprehensive census and analysis of textual evidence, see Alain Touwaide, *Medicinalia Arabo-Byzantina* (Madrid: The Author, 1999).

40 Only a part of the work has been critically edited in recent times (together with an English translation): Ibn al-Jazzār, *Ibn al-Jazzār on Sexual Diseases and Their Treatment: A Critical Edition of Zād al-musāfir wa-qūt al-ḥāḍir – Provisions for the Traveler and Nourishment for the Sedentary: Book 6, The Original Arabic Text with an English Translation, Introduction and Commentary*, [by] Gerrit Bos, Sir Henry Wellcome Asian Series (London and New York: Kegan Paul International, 1997).

41 On Ibn al-Jazzār, see Sleïm Ammar, *Ibn Al Jazzar et l'école médicale de Kairouan* (Sousse: Faculté de médicine Ibn Al Jazzar de Sousse, 1994). English translation: *Ibn al Jazzar and the Medical School of Kairouan* (Tunis: n.p., 1998).

42 See Alain Touwaide, "Medicina Bizantina e Araba alla Corte di Palermo," in Natale G. De Santo and Guido Bellinghieri, eds., *Medicina, Scienza e Politica al Tempo di Federico: II. Conferenza Internazionale, Castello Utveggio, Palermo, 4–5 ottobre 2007* (Naples: Istituto Italiano per gli Studi Filosofici, 2008), 39–55.

43 On this question, see the several contributions to Isabelle Draelants, Anne Tihon, and

Baudouin van den Abeele, eds., *Occident et Proche-Orient: Contacts scientifiques au temps des Croisades; Actes du colloque de Louvain-la-Neuve, 24 et 25 mars 1997*, Réminiscences 5 (Turnhout: Brepols, 2000).

44 See Alain Touwaide, "Latin Crusaders, Byzantine Herbals," in Jean Givens, Karen M. Reeds, and Alain Touwaide, eds., *Visualizing Medieval Medicine and Natural History, 1200–1500*, AVISTA Studies in the History of Medieval Technology, Science and Art 5 (Aldershot: Ashgate, 2006), 25–50.

45 The activity in this complex was first brought to light in modern scholarship by Alain Touwaide, "Un recueil grec de pharmacologie du Xe siècle illustré au XIVe siècle: Le *Vaticanus graecus* 284," *Scriptorium* 39 (1985): 13–56 + pls. 6–8. Since then, see, e.g., Alice-Mary Talbot, "Xenon of the Kral," in Alexander P. Kazhdan, Alice-Mary Talbot, Anthony Cutler, Timothy E. Gregory, and Nancy P. Ševčenko, eds., *Oxford Dictionary of Byzantium* (New York: Oxford University Press, 1991), 3: 2209, for a brief notice with some bibliography.

46 The first printed version of the work (incunabulum) does not have a frontispiece and a title. It is usually identified by means of its colophon, which runs as follows: *explicit dyascorides quem petrus paduanensis legendo correxit et exponendo quae utiliora in lucem deduxit. Impressus Colle, per Magistrum J. Allemanum de Medemblick, mense Julio, 1478*.

47 On this question, see Alain Touwaide, "Pietro d'Abano sui veleni: Tradizione medievale e fonti greche," *Medicina nei Secoli* 20 (2008): 591–605, with a bibliography of earlier work.

48 Max Meyerhof, "Esquisse d'histoire de la pharmacologie et botanique chez les musulmans d'Espagne," *Al-Andalus* 3 (1935): 1–41 (esp. 17–20).

49 Max Meyerhof, "Études de pharmacologie arabe tirées de manuscrits inédits: III. Deux manuscrits illustrés du 'Livre des simples' d'Aḥmad al-Ġāfiqī," *Bulletin de l'Institut d'Égypte* 23 (1940–41): 13–29 (esp. 19).

50 Ibid., 29.

51 Ibid., 19.

52 Ibid., 20.

53 Ibid., 17 and 20.

54 Ibid., 16.

55 Meyerhof himself reproduced these conclusions in his article "Arabian Pharmacology in North Africa, Sicily, and the Iberian Peninsula," *Ciba Symposia* 6 (1944): 1868–76 (see 1869–71). The article was translated into French as "La pharmacologie arabe en Afrique du Nord, en Sicile et dans la péninsule Ibérique," *Revue Ciba* 48 (1945): 1698–1702 (see 1700–1). For some authors who have repeated Meyerhof's evaluation of the work, see Vernet, *La cultura hispanoárabe*, 269–70 and Samsó, *Las ciencias*, 364.

56 Comparisons are delicate because not all manuscripts have arrived to the present day in a complete form. Often, they are lacunose and do not allow for a systematic comparison.

57 Collins, *Medieval Herbals*, 138–9.

58 See Kerner's contribution to the present volume, pp. 122–3. I prefer to use the term "type" rather than "style" of illustration as the second may be subjective in nature and refer to an aesthetic evaluation. With "type" I refer to the botanical components of the illustrations such as the density of the foliage,

59 the multiplicity or, instead, the paucity of stems and roots, the complexity of the structure of the plant, and any other quantifiable element. This is not a subjective appreciation of "naturalism" (or not), but an objective description of the constitutive elements of the illustrations.

59 For a list of illustrated botanical manuscripts, see Loren MacKinney, *Medical Illustrations in Medieval Manuscripts*, Publications of the Wellcome Historical Medical Library, n.s., 5 (London: Wellcome Historical Medical Library; Berkeley: University of California Press, 1965).

60 On this point, see the contribution by Jaclynne Kerner in this volume, pp. 121–2.

61 This illustration is missing from the Vienna codex where it was present since a similar representation of mandrake appears in two other manuscripts descending from a close copy of the Vienna codex, the Naples one used here and the New York one studied below. I use here the illustration of the Naples manuscript, supposed to be a descendant from the same model as the *Vindobonensis* (or from a close ancestor of it). On the Naples codex, see the catalographic description by Elpidio Mioni, *Catalogus codicum graecorum Bibliothecae Nationalis Neapolitanae*, vol. I.1, Indici e Cataloghi, n.s., 8 (Rome: Istituto Poligrafico e Zecca dello Stato-Libreria dello Stato, 1992), 3–9. See also the facsimile reproduction and the companion volume of study respectively entitled as follows: Διοσκουρίδης: ὕλης ιατρικῆς = *Dioscurides De materia medica: Codex Neapolitanus graecus 1 of the National Library of Naples*, introductory texts by Mauro Ciancaspro, Guglielmo Cavallo, and Alain Touwaide (Athens: Miletos, [1999]).

62 For these illustrations, see the figures 6.1 and 6.2 in the essay by Jaclynne Kerner in this volume.

63 On Anicia Juliana, see Walter E. Kaegi, "Anicia Juliana," in Alexander P. Kazhdan, Alice-Mary Talbot, Anthony Cutler, Timothy E. Gregory, and Nancy P. Ševčenko, eds., *Oxford Dictionary of Byzantium* (New York: Oxford University Press, 1991), 1: 99–100, with a statement according to which the Vienna manuscript "was written" for Anicia Juliana.

64 Gamillscheg, "Das Geschenk," 187–95.

65 On this manuscript, see Elpidio Mioni, *Catalogo di Manoscritti Greci esistenti nelle Biblioteche Italiane*, Indici e Cataloghi 20 (Rome: Istituto Poligrafico dello Stato-Libreria dello Stato, 1965), 1: 244–6.

66 Filigrane: Deux cercles traversés et surmontés par une croix =/~ 3165 BR: Bologna 1329; Pisa 1330–31; Montpellier 1336.

67 On Neophytos, see, e.g., Michel Cacouros, "Le lexique des définitions relevant de la philosophie, du *Trivium* et du *Quadrivium* compilé par Néophytos Prodromènos, son activité lexicographique et le corpus de textes philosophiques et scientifiques organisés par lui au monastère de Pétra à Constantinople," in Paola Volpe-Cacciatore, ed., *La erudizione scolastico-grammaticale a Bisanzio: Atti della VII Giornata di Studi Bizantini (Università degli Studi di Salerno-Dipartimento di Scienze dell'Antichità e Associazione Italiana di Studi Bizantini, Salerno, 11–12 aprile 2002)* (Naples: Associazione di Studi Bizantini and D'Auria, 2003), 165–222.

68 On this monastery, see above p. 91 and n45.

69 On this activity, see Alain Touwaide, "The Development of Paleologan Renaissance: An Analysis Based on Dioscorides' *De materia medica*," in Michel Cacouros and Marie-Hélène Congourdeau, eds., *Philosophie et sciences à Byzance de 1204 à 1453: Actes de la Table Ronde organisée au XXe Congrès International d'Etudes Byzantines (Paris, 2001)*, Orientalia Lovaniensia Analecta 146 (Leuven, Paris, and Dudley, MA: Peeters and Department Oosterse Studies Leuven, 2006), 189–224.

70 For a description of this manuscript, together with the list of its illustrations, see Alain Touwaide, "The Salamanca Dioscorides (Salamanca, University Library 2659)," *Erytheia* 24 (2003): 125–58.

71 On this manuscript, see the recent catalographic description by Nadezha Kavrus-Hoffmann, "Catalogue of Greek Medieval and Renaissance Manuscripts in the Collections of the United States of America: Part IV.2, The Morgan Library and Museum," *Manuscripta* 52 (2008): 207–324 (see esp. 212–30).

72 On this manuscript, see above, p. 90 and note n37.

73 On the relationship between the two manuscripts, see Touwaide, *Les deux traités de toxicologie*, 2: 246–51.

74 No recent colour facsimile reproduction of the manuscript is currently available. It is still necessary to use the sepia photographic reproduction made under Henri Omont's supervision in 1935: *Pedanii Dioscuridis Anazarbei De Materia Medica Libri VII: Accedunt Nicandri et Eutecnii Opuscula Medica; Codex Constantinopolitanus saeculo X esaratus et picturis illustratus, olim Manueli Eugenici, Caroli Rinuccini Florentini, Thomae Phillipps Angli, nunc inter Thesauros Pierpont Morgan Bibliothecae asservatus*, 2 vols (Paris: n.p., 1935).

75 No facsimile reproduction of this manuscript is currently available. A substantial number of its pages have been reproduced in Touwaide, *Farmacopea araba medievale*, vol. 1, ills. 17–20, 53, 55, 81–8; and Touwaide et al., *Healing Kidney Diseases*, ills. 1, 2, 19, 21–3, 27–9, 49, 55, 56, 59, 69–72, 74, 75, 77, 78, 81–4, 86–92, 99, 101, 103–5, 107, 108, 114, 117, 119, 121, 124, 126, 128, 130, 132, 137, 140, 141, 143, 146–8, 154, 156, 158, 163, 164, 167, 169, 171, 173–6.

76 Greek text in Alain Touwaide, *Les deux traités de toxicologie*, vol. 4, Al. XXIX–XXX (= 29–30 S.).

77 The symptoms in [Dioscorides], *Alexipharmaka*, 19, correspond to those described in the same treatise for henbane (*Hyoscyamus* spp., of the *Solanaceae* family). See [Dioscorides], *Alexipharmaka*, 15 = Al. XXVI–XXVII (= 26–7 S.) in the same edition as above for the symptoms of henbane.

78 For a catalographic description of this manuscript, see Giovanni Mercati and Pio Franchi de' Cavalieri, *Codices vaticani graeci*, Tomus I, *Codices 1–329* (Rome: Typis Polyglottis Vaticanis, 1923), 39–4.

79 On this point, see Touwaide, "Un recueil grec de pharmacologie," 13–56 + pls. 6–8.

6

The Illustrated *Herbal* of al-Ghāfiqī: An Art-Historical Introduction

JACLYNNE J. KERNER

The *Kitāb fī l-adwiya al-mufrada* (*Book of Simple Drugs*) manuscript in the Osler Library of the History of Medicine at McGill University (shelf mark Osler MS 7508) has received little attention from historians of Islamic art, despite its distinction as the only extant illustrated copy of the herbal of Abū Jaʿfar Aḥmad b. Muḥammad al-Ghāfiqī (d. ca. 560/1165) datable to the pre-Mongol period.[1] This essay seeks to redress the situation by assessing the manuscript as an illustrated herbal in the medieval Greco-Arabic tradition, exploring its relationship to better-known codices, and re-evaluating its long-standing attribution to Baghdad.[2]

Art and Artifice in a Pair of 13th-Century Herbals

In 1912, the renowned Canadian-born physician, medical historian, and bibliophile William Osler outbid the British Museum to acquire a pair of profusely illustrated Arabic herbal manuscripts from an unidentified "Persian" seller.[3] The codices, which were thought to comprise an Arabic translation of the *De materia medica* of Dioscorides in two volumes, are today housed in libraries on opposite sides of the Atlantic Ocean.[4] Osler, who died in 1919, bequeathed the bulk of his library – some 8,000 volumes on the history of medicine – to McGill University. He had willed his "Dioscorides" manuscripts, however, to Oxford's Bodleian Library. It was later discovered that the first volume was not the work of the famous Greek botanist of the 1st century CE, but that of the 12th-century Andalusian physician Abū Jaʿfar Aḥmad b. Muḥammad al-Ghāfiqī.[5] The reattribution of the codex, which contains the first half of al-Ghāfiqī's *Kitāb fī l-adwiya al-mufrada*, allowed it to be claimed for the recently established Osler Library of the History of Medicine (OL 7508). The Dioscorides manuscript, comprising Books III through V of the *De materia medica*, remains part of the Bodleian's collection (Arab. d. 138).[6]

The strikingly close resemblance between the Montreal and Oxford herbals suggests that two similar, contemporary herbals were artificially "paired" to increase their value at some point before their acquisition by Osler. While extant Arabic herbals range in date from the late 11th through the 16th centuries, most are dated or datable to the 13th century.[7] Osler's ersatz two-volume "Dioscorides" is no exception. The al-Ghāfiqī codex is dated in its colophon to 654/1256.[8] The Oxford Dioscorides' scribe completed his work in 637/1240 at "al-Madrasa al-Niẓāmiyya," presumably that of Baghdad, although madrasas of the same name existed elsewhere.[9]

The Montreal and Oxford herbals are not only close in date; they also share a comparable format, a high rate of illustration, and a similar illustrative style. Their scribes interspersed text and image, aligning the text in columns and blocks to leave space for illustrations to be added later.[10] Space was reserved for illustration, relative to the manuscripts' folio size and written area, in roughly equal measure. The al-Ghāfiqī manuscript's 284 folios include 397 images of plants, animals, minerals, and other substances of therapeutic value.[11] In the Bodleian Dioscorides, which contains 210 numbered folios, 289 drawings of plants and other medicinal substances adorn nearly every page of Books III and IV; Book V is unillustrated.[12] With the exception of the heavily retouched author portrait frontispiece in the Oxford Dioscorides,[13] neither manuscript contains full-page illustrations. The quality and style of the herbals' illustrations alternate between careful, almost inorganic precision and a looser, perhaps more rapidly executed style.[14] Regardless, the herbals' illustrators conveyed their subjects visually in a manner that preserves their basic forms and displays their key attributes, which attests to the continuity of a mode of "scientific" illustration that developed in Antiquity (about which more below).

The resemblance between the Montreal and Oxford herbals extends to certain of their orthographic and codicological features, as well. The codices were copied on paper in related scribal hands, with key words of their texts highlighted in red ink.[15] At some point, perhaps in the 19th century, the Montreal and Oxford herbals' margins were trimmed to the same, fairly modest dimensions (24.6 x 17.3 cm), and the manuscripts were rebound.[16] Illustrated replacement folios, European paper flyleaves, and red leather book covers lacking an envelope flap were added to the Osler al-Ghāfiqī manuscript; the Bodleian Dioscorides was rebound in similar fashion.[17] Neither herbal retains its original pagination; modern folio numbers were added to both, in black pencil at the upper left-hand corners of their folios' "a" (recto) sides.[18]

Later additions to the Montreal herbal include marginal ink drawings of a foliate vine scroll on f. 38b and a bird in the lower left-hand margin of f. 266a. "Improvements" appear to have been made to some of the manuscript's original illustrations, as well; see, for example, the flower buds and blossoms of the plant depicted on f. 115b or the roots appended to the four plants depicted on ff. 236a–b. Alterations to the Bodleian Dioscorides include the illumination of the title page (f. 2a) and chapter headings,

scattered marginalia, and the overpainting and/or retouching of illustrations including the author portrait frontispiece of Dioscorides (f. 2b).[19] Human subjects are not found among the illustrations of the Osler Library herbal, but the book's resemblance to the Oxford Dioscorides is otherwise so striking that the pairing of the two cannot have been accidental. At least some of the later "improvements" to Osler's herbal manuscript suggest acts of commodification; a two-volume Dioscorides would have fetched a higher price on the market than two "orphan" volumes. Unfortunately, the date at which the two were paired is at present unknown.[20]

"Scientific" Illustration and the Illustrated Herbal

As described by Minta Collins, the illustrated herbal is a type of book with a "continuous line of descent from antiquity."[21] The illustrations of Arabic herbals, the Osler al-Ghāfiqī manuscript included, demonstrate the continuity and conservatism of an ancient illustrative mode for the depiction of "scientific" subjects.[22] As defined by Byzantinist Kurt Weitzmann in 1952, plants, animals, and other elements of the natural world rendered in profile view against a plain background constitute "the very essence of classical scientific illustration."[23] Framing elements, groundlines, and indicators of spatial depth are generally absent. The same norms are observable in manuscripts having zoological, astronomical, and technological content, but the overwhelming majority of extant manuscripts containing "scientific" imagery are herbals. Botanical subjects are typically rendered as mature, single specimens with their root systems showing; flowering and fruit-bearing species display buds, blooms, and ripening or ripe fruit, as appropriate.

Most extant herbals – both Greek and Arabic – are copies, translations, or variants of the *De materia medica* of Dioscorides (fl. ca. 50–70 CE). The very earliest illustrated herbal in history, however, is credited to the "father of plant illustration," Crateuas[24] of Pergamon (fl. 1st century BCE).[25] A rhizotomist who served as court physician to Mithridates VI, king of Pontus (120–63 BCE),[26] Crateuas produced an illustrated herbal that survives only in the form of quotations recorded by Dioscorides, but its form set a precedent for later herbalists, copyists, and illustrators.[27] No ancient herbals are known to have survived, but Byzantine painters are believed to have preserved the illustrative mode developed in Antiquity for scientific subjects. The earliest illustrated *De materia medica* manuscript still in existence, the "Vienna Dioscorides," is a luxury manuscript datable to the early 6th century CE.[28] Made for presentation to the Byzantine princess Anicia Juliana,[29] its Greek text was copied on large sheets of parchment (38 x 33 cm), and its 491 folios contain 383 (mostly) full-page botanical and figural illustrations. Most surviving Greek herbals, however, were not illustrated; illustrated copies were therefore special productions that appealed to patrons with expensive tastes.[30] At no point in ancient or

medieval history were illustrated herbals used as medical manuals; they were items of prestige made for wealthy, often noble, patrons or learned individuals who desired such books for the "bibliophilic pleasure" they afforded.[31]

The taste for illustrated herbals is part of medieval Islamic culture's "classical" heritage. Byzantine intermediaries (though not the Vienna Dioscorides[32]) served as conduits for the transmission of the illustrated herbal and its "scientific" illustrative idiom to the Arabic-Islamic sphere; the mechanism for the herbal's transmission was the translation movement begun in ʿAbbāsid Baghdad in the 2nd and 3rd/8th and 9th centuries.[33] More than a dozen illustrated Arabic Dioscorides manuscripts survive, as do a number of fragments scattered throughout library and museum collections worldwide.[34] On the whole, Arabic herbal imagery adheres closely to the ancient mode of "scientific" illustration, although differences in style are apparent.[35] A handful of Arabic herbals display a classicizing style that has been described as "illusionistic naturalism,"[36] but they are the exception, not the rule. More often, medieval Islamic artists – including the illustrator(s) of the Montreal al-Ghāfiqī codex – employed a formulaic, schematic, and two-dimensional style of botanical and figural representation. To modern eyes, such illustrations would appear to be superfluous or even useless, but their presence was expected in deluxe copies of learned works having medico-botanical, zoological, or technological content. The derivation of Arabic herbal illustrations from ancient archetypes is evident in the overall treatment of the subjects; as in earlier scientific illustration, the subjects were painted against the untreated paper surface of the folios, in undefined picture planes lacking groundlines and illusionistic space. In spite of their largely anti-naturalistic style, the scientific illustrations of Arabic manuscripts continued to serve as "aids to understanding and using the text."[37] Perhaps antithetically, in light of their flat, two-dimensional style, the subjects of Arabic herbals are generally recognizable. Botanical subjects retain all of the elements (roots, bulbs, stems, stalks, leaf shapes, blossoms, and often coloration) that enable a viewer to distinguish them. Medieval Arabic botanical illustration may not have allowed the identification of individual species in nature, but the images provided visual confirmation of "existing knowledge."[38] In this regard, a parallel may be drawn between the Montreal herbal's illustrations and the literary genre to which al-Ghāfiqī's text belongs. As Oliver Kahl demonstrates in his contribution to this volume, al-Ghāfiqī composed his treatise for an educated audience already familiar with the book's medical content. Arabic herbal illustrations' high degree of stylization in no way precludes their use as aides-mémoire by an informed reader/viewer.[39] Illustrated Arabic herbals, like their Greek antecedents, were essentially learned picture books whose medical texts were transformed by the addition of visually descriptive complements to the text.[40] As such, these aesthetically enhanced volumes met the expectations of the bibliophilic classes of medieval Islamic society, who desired highly erudite items of prestige.

The Osler al-Ghāfiqī Manuscript in Context

Art-historical analysis of the illustrated al-Ghāfiqī manuscript invites comparison not only with the volume with which it was once artificially paired, but with a number of other illustrated Arabic manuscripts. While a comprehensive study is outside the scope of this essay, preliminary findings confirm the manuscript's significance as a medieval Arabic herbal and suggest several rich topics for future inquiry. To that end, the discussion that follows will assess and contextualize the manuscript as an illustrated book in the medieval Greco-Arabic tradition, re-evaluate the long-standing attribution of the Montreal herbal to Baghdad, and explore possibilities for its artistic ancestry.

Nine plants, none of them labelled, are depicted in eight illustrations in the replacement folios at the beginning of the al-Ghāfiqī codex.[41] Four of the eight are marginal illustrations; for the rest, the copyist left blank space for the botanical drawings. Pencil underdrawings are visible to the naked eye in three instances (f. 6a, f. 7b, and f. 9b), and it is clear that the illustrator(s) deviated from the original designs. In the manuscript's original folios, following customary scribal practices, illustrations were added to voids left by the copyist between or alongside lines or blocks of text.[42]

Most of OL 7508's illustrations are oriented vertically, although some plants are depicted sideways and others are drawn diagonally (e.g., f. 18b and f. 40a). This type of variability is not unique to the Montreal herbal, nor is the fact that certain plants are larger than their picture planes, their root systems unfurling across adjacent lines of text (e.g., f. 17b). Other subjects, such as the eggplant illustrated on f. 73a and the red and white roots on f. 76a, are much smaller than the space allotted to them. These features raise several possibilities about the manuscript's production process. It seems nearly certain that the copyist and the illustrator(s) were not the same person; it is also possible that a variety of models were at the disposal of the illustrator(s), or that the manuscript was copied after a poorly planned exemplar or one of a different size.[43]

In terms of style, the illustrations of OL 7508 display an inconsistency that is not uncommon in Arabic herbals, and it is possible that the illustrations were the work of numerous artists, or that the entire corpus of illustrations was not completed all at once.[44] At some point after the illustrations were painted, captions were added in a red ink several shades deeper than that used for names, chapter headings, and abbreviations in the body text.[45] Like the illustrations, the orientation of the captions is inconsistent; most were written horizontally, but some are vertical. A number of captions are now missing; they must have been written outside the text area and lost when the manuscript's margins were trimmed.[46]

If the proposed reading of the date (654/1256) given in OL 7508's colophon is correct, the book is datable to the first "flowering" of manuscript illustration in Islamic history. As described by Richard Ettinghausen in his seminal 1962 book *Arab Painting*, the earliest major achievements in the arts of the Islamic book predate the Mongol invasion of

Baghdad in 656/1258.⁴⁷ Traditionally, historians of Islamic art have divided illustrated manuscripts of the period into two broad categories – scientific and literary – on the basis of their textual content. Herbals, as well as anatomical, zoological, astronomical, and technical treatises, comprise the scientific group. As in Antiquity, illustration seems to have been expected in luxury copies of Arabic texts describing medicinal plants, animals, constellations, and mechanical devices. Arabic literary works, whose texts belong to the genre of *adab* (*belles-lettres*), include poetry and artistic prose such as "mirrors for princes" and works of picaresque literature like the *Maqāmāt* (*Assemblies*) of al-Ḥarīrī.⁴⁸ Illustrations were not required in works of *adab*, but, as in scientific manuscripts, their presence seems to have made illustrated copies more valuable and desirable.⁴⁹

Manuscripts of both genres have been attributed to the so-called Baghdad School of manuscript illustration.⁵⁰ Although proof of the school's existence is negligible, historians of art have hypothesized for decades that manuscript production flourished in Baghdad as part of a broader revival of the arts during the reigns of the last ʿAbbāsid caliphs.⁵¹ "Baghdad School" was first applied as an art-historical classification in the 1930s, first by Eustache de Lorey in 1933, and five years later by the curators of an exhibition of "Iranian art" held at the Bibliothèque nationale de France.⁵² None of the manuscripts displayed in the 1938 exhibition bore proof of Baghdadi origin, and some were not even of Mesopotamian provenance; all of them were, however, datable prior to the Mongol invasion of Baghdad in 656/1258.⁵³

Both of William Osler's 13th-century herbals have long been assumed to have been copied and illustrated in Baghdad. The Montreal al-Ghāfiqī manuscript was first attributed to the ʿAbbāsid capital by Max Meyerhof (d. 1945) in the early 1940s.⁵⁴ The Oxford Dioscorides is thought to have been copied in Baghdad because its scribe recorded his workplace, the Niẓāmiyya Madrasa, in the colophon.⁵⁵ Madrasas of the same name existed in Nishapur, Merv, Herat, Balkh, Mosul, and elsewhere, but the most famous Niẓāmiyya Madrasa was that of Baghdad.⁵⁶ The powerful vizier Niẓām al-Mulk (d. 485/1092) had established the network of madrasas bearing his name throughout the Saljuq empire in the 5th/11th century.⁵⁷

When Meyerhof attributed the Osler al-Ghāfiqī to Baghdad in the early 1940s, the "Baghdad School" label was applied indiscriminately to nearly every illustrated Arabic manuscript datable to the pre-Mongol period. The art historian Hugo Buchthal published a 1942 article describing the characteristics of Baghdad School miniature painting. Buchthal's method was one of stylistic inference; his archetype was a hippiatric treatise copied, according to its colophon, in Baghdad in 605/1209.⁵⁸ As described by Buchthal and later scholars, Baghdad School miniatures are distinguished by their balanced, often bilaterally symmetrical, compositions and bright colour palettes; figures, when depicted, are "sprightly" and wear contemporary local dress.⁵⁹ Other characteristics ascribed to Baghdad School miniature painting include the adherence to Byzantine models and pronounced genre (i.e., incorporating details of everyday life) and/or narrative tendencies.⁶⁰

Meyerhof's attribution of the Osler al-Ghāfiqī manuscript to Baghdad gained wide and unquestioning acceptance. In a recent study of the Greek, Arabic, and Latin herbal traditions, Minta Collins proposed that the manuscript's illustrations were "executed in the Arabic style current in Baghdad" in the 13th century.[61] This style, Collins wrote, is "familiar to us" from the Oxford Dioscorides manuscript with which the Osler herbal was once paired, as well as the well-known but dispersed Arabic Dioscorides codex dated 621/1224.[62] The latter was one of Buchthal's "core group" of Baghdadi manuscripts. Most of the 621/1224 Dioscorides is preserved – largely devoid of its finest illustrations – in Istanbul's Süleymaniye Library (Ayasofya MS 3703).[63] The manuscript's attribution is a tautological argument devised by Buchthal based on the genre and/or narrative qualities of the illustrations, and the manuscript bears no concrete evidence of a Baghdadi origin.[64] While it stands to reason that Arabic herbals would have been produced in Baghdad if such a "school" existed,[65] none of the extant Arabic illustrated herbals has a clear Baghdadi provenance.[66]

Even if the term "Baghdad School" is understood as a designator of style rather than of provenance,[67] neither of the herbals acquired by William Osler meets the criteria for inclusion in the group of manuscripts so described.[68] In fact, nearly 30 years ago, the distinguished art historian Oleg Grabar questioned the attribution of the Oxford herbal to Baghdad, writing, "This rather strange manuscript … bears little relation to the other manuscripts attributed to Baghdad."[69] Excluding the heavily restored frontispiece, the manuscript is entirely devoid of human figures. Narrative and genre elements are therefore lacking, and the volume's botanical drawings are uninhabited by creatures of any type. For similar reasons, the Montreal herbal's attribution to Baghdad should also be treated with scepticism. Our present state of knowledge neither proves nor disproves a Baghdadi provenance; certain of the manuscript's iconographic features, however, imply a connection to the literary and illustrative traditions of the northern Mesopotamian region known to medieval geographers and historians as the Jazīra.[70]

Iconographic and Text-Image Analyses

Wherever the Montreal herbal was copied, its illustrations exhibit formal, stylistic, and iconographic affinities with a range of extant herbals and herbal fragments. A comprehensive analysis of the Osler herbal's iconography and artistic ancestry is outside the scope of the present study, but comparative analysis of a handful of its botanical and zoological subjects sheds light on the manuscript's visual character, its connection to the Greek and Arabic herbal traditions, and its possible association with manuscripts reasonably associated with the Jazīra.

The lavender (اسطوخودوس) plant illustrated on OL 7508's f. 20b is a roughly symmetrical six-branched plant bearing leaves of light and dark green. Above the foliage,

6.1
Lavender plant. Montreal, Osler Library of the History of Medicine, MS 7508, 20b.

petals of deep red project from segmented flower spikes; below, the bulk of the plant's wide, bifurcated rootstock tapers to the right. Nearly identical depictions of the same plant are found in two Dioscorides manuscripts housed in the French national library. One is the only extant Arabic copy of the *De materia medica* to have been copied on parchment rather than paper (Paris, Bibliothèque nationale de France, arabe 4947, f. 53a).[71] The manuscript's dating is uncertain, but it is usually attributed to the mid-6th/12th century.[72] The other is a Byzantine Greek Dioscorides of uncertain (and contested) provenance (Paris, Bibliothèque nationale de France, grec 2179, f. 19v). The manuscript's Greek text was probably copied in the 8th or 9th century CE in Egypt or Palestine, but the style of its illustrations is more closely related to that of Arabic herbals than Greek ones.[73] It is possible (indeed, likely) that the illustrations were added later, somewhere in the Arab-Islamic sphere.[74] The lavender plants illustrated in OL 7508, arabe 4947, and grec 2179 share the same basic, candelabrum-like form. As compared with the plants depicted in the Arabic herbals, that of grec 2179 displays a higher degree of stylization and a reverse orientation. The otherwise synoptic appearance of the trio of lavender plants suggests that their iconography derived ultimately from a common source; it is possible that one of them served as the model after which one or both of the others were copied, but a determination of exemplar and copy would likely be difficult to reach.[75]

6.2
Paris, Bibliothèque nationale de France, MS arabe 4947, f. 53a. Reproduced by permission of the Bibliothèque nationale de France.

 The striking resemblance between the Arabic herbals' lavender plants invites future research on the relationship between OL 7508 and the illustrative tradition of manuscripts attributed to the Jazīra. Medieval Arabic sources commonly referred to the region of Diyar Bakr, Mosul, Sinjar, Mayyafariqin, and Harran as the Jazīra (lit., "island," but designating the middle and upper parts of the Tigris and Euphrates valleys). In the 12th and 13th centuries, the Jazīra was transformed into "one of the liveliest regions of the Muslim world," and the artistic production of the region is widely noted for its "catholicity of taste."[76] The medieval Jazīra is also cited as a leading centre of applied science; Jazīran dynasties like the Artuqids were especially active in their support of the sciences, classical learning in general, and the arts.[77]

The Illustrated Herbal: An Art-Historical Introduction 129

6.3
Paris, Bibliothèque nationale de France, MS grec 2179, f. 19b. Reproduced by permission of the Bibliothèque nationale de France.

Paris arabe 4947's medium, parchment, "was common in the area of Diyar Bakr," and its text is a retranslation of the *De materia medica* prepared, probably in Diyar Bakr, for Fakhr al-Dīn Qara Arslān, a cousin of the Artuqid sovereign Najm al-Dīn Alpī (r. 547–72/1152–70).[78] The parchment herbal also bears a notation stating that a scribe named Biḥnām b. Mūsā b. Yūsuf al-Mawṣilī made a copy of the manuscript in 1229 CE.[79] Biḥnām's nisba, al-Mawṣilī indicates that he was probably from Mosul in modern-day northern Iraq.[80] Extant manuscripts associated with the region include at least one beautifully illuminated copy of the Qurʾān known to have been produced in Sinjar.[81] An herbal tradition is also attributable to the Jazīra.[82] The 595/1199 *Kitāb al-diryāq*, a treatise on antidotes to snakebite and the ancient physicians who compounded them, contains a representation of the lavender plant having the same basic form as those of OL 7508 and arabe 4947, but a more schematic appearance (Paris, Bibliothèque nationale de France,

130 *The Herbal* of al-Ghāfiqī

6.4
Paris, Bibliothèque nationale de France, arabe 2964, modern pagination 59. Reproduced by permission of the Bibliothèque nationale de France.

arabe 2964, modern pagination 59).[83] The Paris *Kitāb al-diryāq* was attributed by Bishr Farès to the Baghdad School shortly after the manuscript's "discovery" in the late 1940s, but it is now attributed to the Jazīra on stylistic grounds.[84]

The zoological imagery of the illustrated al-Ghāfiqī manuscript also shares its visual language and artistic ancestry with extant herbals belonging to the Byzantine and Arabic traditions. The rabbit is one of the most frequently depicted animals in all of Islamic art. The rabbit depicted on OL 7508's f. 53b, however, differs from most Islamic leporine iconography (captioned "hare" or "wild rabbit"; ارنب برّي). The creature is usually shown in an active pose with one of its forelegs raised and its head turned back or its neck bent at a sharp angle.[85] Alternatively, paired rabbits are depicted in seated poses, either confronted or addorsed.[86] Regardless of pose, the rabbit's anatomy is usually defined by dark outlines demarcating the junctions between body and legs and thin, curved lines bisecting its midsection.[87] A 12th-century paper fragment found in Egypt at Fusṭāṭ, and presumably from a bestiary, is a typical example (New York, Metropolitan Museum of Art [Rogers Fund 1954], 54.108.3).

The Illustrated *Herbal*: An Art-Historical Introduction

6.5
Montreal, Osler Library of the History of Medicine, MS 7508, 53b.

6.6.
New York, Metropolitan Museum of Art [Rogers Fund 1954], 54.108.3. Reproduced by permission of the Metropolitan Museum of Art.

The Montreal herbal's rabbit is drawn in the conventional profile view, but its head faces forward, and its standing pose is not especially active; one of its extremely long legs is raised, but only slightly, above the invisible groundline. Its mouth, nose, and whiskers are carefully rendered, but its anatomy is not otherwise defined. Iconographically, OL 7508's rabbit is congruent with a pair of earlier Dioscorides manuscript illustrations. The first is found in a Greek Dioscorides attributable to mid-10th-century Constantinople and currently housed in New York's Morgan Library (MS M.652, f. 213b).[88] The second is the earliest – and most complete – illustrated Arabic *De materia medica* in existence (Leiden, Bibliotheek der Rijksuniversiteit, Or. 289, f. 61a, dated 475/1083). The century number is missing from the manuscript's colophon, but presumably indicated the year 475/1083. The manuscript is 228 folios in length and has a folio size of 30.5 x 20.3 cm. Its text was written 26 or 27 lines to the page, and 620 illustrations of 604 subjects adorn the volume.[89] The rabbits of the Arabic herbals face left,

132 *The Herbal* of al-Ghāfiqī

while that of the Morgan Dioscorides faces right, but the three creatures are otherwise so alike that they, like the lavender plants, presuppose a common iconographic source.[90]

The illustrations of the Leiden Dioscorides seem to "descend in part from the same tradition" as those of the Greek manuscript of contested provenance (Paris, Bibliothèque nationale, grec 2179).[91] The Leiden manuscript's text, however, is a late 10th-century revision of the 9th-century Ḥunayn-Isṭifān translation of the *De materia medica*. The retranslation was the work of al-Ḥusayn b. Ibrāhīm al-Nātilī, who prepared it for a prince in the Central Asian region of Transoxiana, probably at Samarqand.[92] In a 1983 monographic study of the Leiden Dioscorides, M.M. Sadek dismissed its reliance on ancient

6.7
New York, Morgan Library and Museum MS M.652, f. 213b. Reproduced by permission of the Morgan Library and Museum.

6.8
Leiden, Bibliotheek der Rijksuniversiteit, Or. 289, f. 61a. Reproduced by permission of the Bibliotheek der Rijksuniversiteit Leiden.

Greek and/or Byzantine iconographic sources, but more recently, Minta Collins identified common archetypes for the botanical imagery of the Leiden and Morgan Dioscorides manuscripts; she also drew convincing parallels between Or. 289 and Paris grec 2179.[93] OL 7508 must now be added to the group of manuscripts that share an artistic ancestry with these herbals.[94] The relationship between OL 7508 and the other members of the group deserves a fuller art-historical treatment than this preliminary study can provide, but a comparative analysis of OL 7508's mandrake plants lends additional support to the probability of a common artistic pedigree.

6.9
Mandrake: Montreal, Osler Library of the History of Medicine, MS 7508, 232a.

6.10
Montreal, Osler Library of the History of Medicine, MS 7508, 232b.

The mandrake is illustrated three times in al-Ghāfiqī's entry for the legendary plant in the Montreal herbal (ff. 232a–b). Mandrake, with its anthropoid root, was valued for its anesthetic, hallucinogenic, and soporific properties in Greek and Arabic pharmacology.[95] The closest iconographic analogues for the mandrakes of OL 7508 are found in Paris grec 2179 (f. 104r and f. 105r) and arabe 4947 (f. 92a).[96] In another parallel with the lavender plants described above, the Greek herbal's specimen is stylized to a higher degree than those of the Arabic manuscripts. The mandrakes of arabe 4947 are nearly indistinguishable from those of OL 7508; both are dissimilar to the mandrakes represented in most extant illustrated herbals, in which the plant's rootstock has an anthropomorphic form.[97] (See, e.g., Leiden, Bibliotheek der Rijksuniversiteit, Or. 289, f. 156b and f. 157a.)

Common to the fruit-bearing specimens of OL 7508 and arabe 4947 are a roughly symmetrical arrangement of broad, ovate leaves, a tapering, non-anthropoid root structure, and bulbous fruits that rise above the foliage in a radial formation (OL 7508, f.

The Illustrated *Herbal*: An Art-Historical Introduction 135

6.11.
Paris, Bibliothèque nationale de France, MS grec 2179, f. 104r. Reproduced by permission of the Bibliothèque nationale de France.

232b, upper, and arabe 4947, f. 92a, upper left).[98] In the flowering examples, unripe and mature fruits alternate with blossoms of deep red, and a single fruit dangles from a curving stem at right (OL 7508, f. 232a, and arabe 4947, f. 92a, upper right). The plants are clustered on a single folio in the Paris herbal, while the Montreal mandrakes decorate two consecutive pages, but the manuscripts' dissimilar formats do not preclude the likelihood of a common archetype.

The foregoing comparisons, though limited in scope, demonstrate that an original cycle of botanical and zoological imagery was not invented expressly for the illustrated al-Ghāfiqī manuscript; rather, its iconography was dependent upon the Greek and the Arab-Islamic herbal traditions. Further study would likely clarify the degree of dependence on – or independence from – sources originating in Antiquity and the Byzantine

6.12
Paris, Bibliothèque nationale de France, MS grec 2179, f. 105r. Reproduced by permission of the Bibliothèque nationale de France.

6.13
Paris, Bibliothèque nationale de France, MS arabe 4947, f. 92a. Reproduced by permission of the Bibliothèque nationale de France.

sphere, and might also help localize the manuscript.[99] The manuscript's iconographic congruence with the presumably northern Mesopotamian parchment herbal merits a more thorough investigation. OL 7508's possible relationship to the herbal tradition of the Maghrib (the Islamic West) remains unstudied, but this line of inquiry might shed light on the choice to illustrate the work of its medieval Andalusian author.[100] A study of OL 7508's text-image relationships – as compared with other Arabic manuscripts with herbal content and Greek herbals to which Arabic glosses were added – might also advance our understanding of the manuscript.

In a pioneering recent study of the captioning of Arabic manuscripts, Bernard O'Kane wrote that "no text is more intimately related to an image than its caption."[101] O'Kane was referring to illustrated works of *adab*, but the same can be said of the captioning of "scientific" illustrations. Captioning was de rigueur, primarily for identification purposes, in ancient, Byzantine, and Arabic illustrated manuscripts having scientific or technical

The Illustrated *Herbal*: An Art-Historical Introduction 137

6.14
Leiden, Bibliotheek der Rijksuniversiteit, Or. 289, ff. 156b–157a.
Reproduced by permission of the Bibliotheek der Rijksuniversiteit Leiden.

content. In illustrated books of all literary genres, captions serve as intermediaries between text and image by enhancing a reader's (or viewer's) comprehension. Their presence in manuscripts like Dioscorides' *De materia medica* and al-Ghāfiqī's *Book of Simple Drugs* is a reminder that, as illustrated books, herbals were meant to be viewed *and* read.

The captions to OL 7508's illustrations have the potential to broaden our knowledge of the manuscript as an illustrated herbal, as they provide valuable information about the book's production process. Certain plants' names are spelled differently in the caption and the proximate text; these variant spellings can be understood as evidence that the captions were written by someone other than the manuscript's scribe.[102] The Montreal herbal's captions appear to have been later additions, rather than directives from the scribe to the illustrator(s). In several instances, the word spacing of the caption was

adjusted to accommodate the illustrations; the images must therefore have been painted before the captions were added.[103] Many of OL 7508's captions, like al-Ghāfiqī's text itself, provide nomenclatural variants for the plants depicted, adding a layer of meaning that surpasses mere identification.[104] The captions to the mandrake plants on ff. 232a–b form an interesting case. Al-Ghāfiqī's entry for the plant, "yabrūḥ" (يبروح), is found in his chapter on medical simples whose names begin with the letter yāʾ. The flowering mandrake plant depicted on f. 232a is captioned, "mandrāghūras, that is to say, yabrūḥ" (مندراغورس وهو اليبروح). "Mandrāghūras" is the Arabic transliteration of the plant's Greek name, "mandragoras"; "yabrūḥ," of Syriac origin, refers to the plant's unusual, humanoid root as well as the plant itself. The mandrakes depicted on the subsequent folio (f. 232b) are captioned as second and third types of "luffāḥ."[105] The Arabic term "luffāḥ" (لفّاح whence "loofah") denotes both the mandrake plant and its spongy, eggplant-like fruit. The mandrakes depicted in Paris arabe 4947 and grec 2179 are captioned as "luffāḥ," as well.[106] A more extensive analysis of OL 7508's iconographic and textual patterns may bring to light additional sources of information about the directionality of texts and their illustrations, the use of certain manuscripts as exemplars, or establish art-historical, palaeographical, and codicological links between related manuscripts and/or centres of manuscript production.

Preliminary Conclusions

As has been demonstrated by other contributors to this volume, al-Ghāfiqī's *Book of Simple Drugs* belongs to a distinguished Greco-Arabic scholarly tradition. As a written work, the herbal united an abridgement of the writings of Dioscorides and Galen with a compilation of Arab pharmacologists' commentaries. Its breadth and scope far surpassed Greek models, and established al-Ghāfiqī as the greatest authority on pharmacology in the medieval Islamic world.[107] The 7th-/13th-century medical historian Ibn Abī Uṣaybiʿa (d. 668/1270) praised al-Ghāfiqī as one of the most learned men of al-Andalus and the author of the most reliable and trustworthy of herbals, writing, "His book on simple medicaments has no equal in excellence and there is nothing comparable to it in substance. In it, he has investigated in detail that which was stated by Dioscorides and the distinguished Galen [presenting it] with a precise style and complete content."[108]

Figuratively speaking, the illustration of al-Ghāfiqī's herbal might be understood as the visual equivalent of the synthesis of ancient and medieval Arabic medico-botanical knowledge in its text. In the Arab-Islamic sphere, Dioscorides was regarded as the leading Greek source of medico-pharmacological knowledge; he was also credited with the illustration of his herbal treatise. Quoting the 7th-century philosopher Johannes Grammatikos, the renowned Baghdadi historian Ibn al-Nadīm (d. 363/973) extolled the Greek physician as "the holder of the noble soul, the most useful being to mankind, an authority

on medicinal matter, who collected valuable knowledge from the plains, islands, and seas and made priceless drawings of his findings with explanatory notes on their usefulness."[109]

The inclusion of comparable "priceless drawings" in al-Ghāfiqī's *Book of Simple Drugs* establishes a symbolic connection between the 12th-century herbalist and the greatest of the ancient physicians. Al-Ghāfiqī preserved and expanded upon the pharmacological wisdom of Antiquity, and his book was remade in the image of a Dioscoridean illustrated herbal. In illustrating OL 7058, the manuscript's anonymous artist(s) followed the compositional principles and illustrative conventions established in Greco-Roman Antiquity, principally for copies of the *De materia medica*.

That OL 7508 was later confused for an Arabic Dioscorides manuscript (conceivably through a process of intentionally deceptive commodification[110]) is understandable. This confusion might even be interpreted as a fitting tribute to the renown of its author, an intellectual heir to the Greek herbalist with whom the illustrated herbal was so closely associated. OL 7508 must have appealed to its anonymous 7th-/13th-century patron for the same reasons it attracted the interest of William Osler in the early 20th century. As an illustrated herbal, the manuscript was not intended for use in medical practice; rather, it was prized by its bibliophilic owner as a prestigious and lavishly illustrated book. As such, the al-Ghāfiqī manuscript in the Osler Library continues to fascinate scholars and students of Islamic medicine, history, literature, and art today: it is an extraordinary representative of the illustrious Greco-Arabic medical tradition and a rare survival of the arts of the medieval Islamic book.

Postscript

A Recently "Discovered" al-Ghāfiqī Manuscript in Tehran and Its Relationship to OL 7508

Shortly after the writing of the foregoing remarks, the existence of an illustrated copy of al-Ghāfiqī's herbal in Tehran's Malik Library (shelf mark MS 5958; dated 1077/1666) came to the attention of this volume's editors and contributors. From an art-historical perspective, the significance of this "discovery" is threefold. First, the availability of multiple illustrated copies of al-Ghāfiqī's treatise creates a "critical mass" of material for the future study of iconographic patterns specific to the Andalusian physician's herbal.[111] Second, the Tehran herbal is a late witness to the largely medieval Islamic phenomenon of illustrated herbal production; its 17th-century date expands the usual chronological range for illustrated Arabic herbals and evinces the continuing popularity of such books in later Islamic culture.[112] Third, the Montreal and Tehran manuscripts appear to reflect an exemplar-copy relationship that warrants further investigation. Largely synoptic in terms

of illustrative mode and iconography, the pair also shares formal, orthographic, and compositional characteristics including indented text blocks, a similar colour palette,[113] identically worded captions penned in red ink, and illustrations that frequently extend into the margins. Even the most cursory analysis of their illustrations supports an identification of the Tehran al-Ghāfiqī as a lineal descendant of the Montreal herbal.[114] While most of MS 5958's illustrations appear to have been copied directly after OL 7508, many of them (especially those representing vegetal subjects) are qualitatively and technically less accomplished than their 13th-century prototypes. Degradation of this type is consonant with copy-making; the prevalence of a lower degree of refinement in MS 5958 supports the identification of OL 7508 as the model after which the 17th-century copy was made. It appears, however, that OL 7508 was MS 5958's primary – but not only – source.[115]

The inexactitude with which MS 5958's illustrations were drawn suggests that they were copied loosely, using a freehand method rather than pounces (tracings). The illustrator(s) of the Tehran herbal sometimes "improved" upon a source image by changing a plant's orientation from horizontal to vertical, but the degree of iconographic correspondence between the Montreal and Tehran manuscripts is otherwise exceptionally high. For example, neither of the al-Ghāfiqī manuscripts' illustrators appears to have possessed direct knowledge of the sea hare's appearance (الأرنب البحري). In OL 7508, the tropical mollusk is represented as a furry, long-eared fish with a striped body (f. 53b). The Tehran herbal's sea hare is a faithful copy of the 13th-century model, with the minor exception of a more elaborate "mane" (p. 75).[116] The lavender plant depicted in MS 5958 (p. 10)[117] is also very close in appearance to that of OL 7508 (f. 20b, described above). Each displays a sexpartite, candelabrum-like form and a rootstock concentrated on the lower right-hand side. Yet the Tehran herbal's specimen is less symmetrically arranged, its stalks much longer, and its leaves more schematically rendered; these qualities also infer the use of OL 7508's illustrations as models after which untraced copies were made.

The illustrations of the Tehran herbal reveal only an infrequent use of iconographic sources other than OL 7508. The eggplant depicted in MS 5958 is a tall, bushy plant laden with blossoms and white and purple fruit (p. 111). The same plant in the Montreal manuscript, which is too small for its picture plane, bears sparsely populated branches and underdeveloped roots (f. 73a). Here, the illustrator(s) of MS 5958 must have relied on a different source image, but the vibrant colours, heavy outlines, and a high degree of schematization of the 17th-century copy are strongly reminiscent of 13th-century Arab painting style.

A handful of the Tehran herbal's illustrations simultaneously demonstrate the selective use of models independent of OL 7508 and a style reflective of the manuscript's 17th-century date. The weasel (ابن عرس) is a case in point. In the Osler al-Ghāfiqī, the creature takes the form of a brown, rat-like quadruped lacking the short legs and distinctive snout of its natural counterpart (f. 53a). Its body, a field of solid brown paint relieved

only by black dashes indicating fur, is slightly smaller than the visible underdrawing in red ink. The Tehran manuscript's weasel has a very different and far less cartoon-like appearance (p. 74). The animal occupies an otherwise blank picture plane, attesting to the longevity of the Greco-Byzantino-Islamic "scientific" illustrative tradition, but it was neither patterned after OL 7508 nor painted in a style imitative of a 13th-century exemplar. Rather, the creature was carefully rendered, almost monochromatically, in the precise line-work characteristic of Persian painting of the 17th century, when an almost calligraphic style of pen-and-ink drawing replaced the deeply saturated colours of earlier manuscript illustration.[118] A similarly analytical approach to a zoological subject and equally fine draftsmanship are evident in MS 5958's illustration of the serpent (الأفعي; p. 73). As compared with the serpent of the Montreal herbal (f. 52b), the Tehran manuscript's specimen displays a higher degree of anatomical definition and a greater sense of naturalism. The latter is heightened by the depiction of the creature in a landscape setting. Filler motifs of mounds of grass and flowering plants occupy the left-hand margin and the interstices between the serpent's sinuous curves. The fact that these, too, are consistent with later Persian painting style supports the Tehran herbal's attribution to modern-day Iran.[119] The artistic style of 17th-century Persia, however, played only a minor role in MS 5958's design. As a body of imagery, the Tehran herbal's illustrations are heavily dependent on OL 7508 and the pre-Mongol herbals to which it most closely relates.

The identification of an exemplar-copy relationship between OL 7508 and MS 5958 invites future research into the manuscripts' shared visual language, the continuing popularity of the illustrated herbal, and the longevity of the Greco-Arabic "scientific" illustrative tradition. So, too, does the Montreal herbal's "afterlife" in Iran. By the time William Osler purchased the Montreal al-Ghāfiqī and the Oxford Dioscorides manuscripts from a "Persian" seller in 1912, OL 7508 had been in Iran for more than 250 years. As Adam Gacek notes in his contribution to the present volume, the manuscript bears three seals indicating Iranian ownership; two are dated to the 17th century (1051/1641–42 and, apparently, 1080/1669–70). Persian glosses were also added (at an unknown date) to several of the Montreal herbal's illustrations, including the hare (discussed above). Scholars of Persian painting, medicine, and intellectual history may be interested in exploring the possible connection of OL 7508 and MS 5958 to the 17th-century Persian pharmacopeia of simple and compound medicines known as the *Tuḥfat al-mu'minīn*. Its compiler, Muḥammad Mu'min Tunakābunī Daylamī, belonged to a family of court physicians to the Safavid shahs. Completed in 1080/1669–70, the treatise was dedicated to Shah Sulaymān I (r. 1077–1105/1667–94). Like al-Ghāfiqī's *Book of Simple Drugs*, the *Tuḥfat al-mu'minīn* was an important work of botanical synonymy; its text was based largely on the earlier work of numerous Arabic authorities. Copies of Tunakābunī's pharmacopeia were sometimes illustrated with botanical and zoological imagery, but it remains to be seen whether the Iranian presence of al-Ghāfiqī's herbal in illustrated form was a contributing factor to their production.[120]

The Herbal of al-Ghāfiqī

Further study of OL 7508's "afterlife" in Iran might also yield a clearer understanding of the manuscript's fate as an object of desire. The role of the booksellers' market in late 19th- and early 20th-century Iran suggests a particularly rich topic of inquiry. As described above, both the Bodleian Dioscorides and the Osler al-Ghāfiqī exhibit signs of later intervention such as retouching, overpainting, and rebinding; obvious replacement folios were also added to the Montreal herbal. These restorations, as well as the artificial pairing of the Oxford and Montreal manuscripts, appear to have been deliberate acts of commodification. Similar "repairs" were made to the well-known Pierpont Morgan Library *Manāfiʿ-i ḥayavān* (*The Benefits of Animals*, MS M.500), a lavishly illustrated Persian translation of an Arabic bestiary copied at Maragha, Iran, in 1297–98 or 1299–1300. Barbara Schmitz has demonstrated that thirteen paintings were added to the manuscript, and that many of the other 103 bear signs of overpainting or inpainting.[121] The manuscript's "improvements" are datable to the very late 19th century or opening decade of the 20th century, just before the manuscript was offered for sale.[122] Iranian booksellers "restored" manuscripts like the Morgan *Manāfiʿ* to make them more attractive to Western buyers (and thus fetch higher prices). The Parisian dealer Charles Vignier purchased the Morgan *Manāfiʿ* on the Tehran art market around the year 1910. J. Pierpont Morgan bought the manuscript from the English dealer Percy Moore Turner in 1912, the same year that Osler purchased his ersatz two-volume Dioscorides. The application of Schmitz's methods to the study of the Osler al-Ghāfiqī, along with trans-historical approaches to the history of Islamic science and medicine, promise to further enrich our understanding of this remarkable witness to the medieval phenomenon of herbal manuscript illustration and its enduring appeal.

NOTES

1 A later copy, dated 990/1582, is housed in Cairo's Museum of Islamic Art (MS 3907). Like Osler MS 7508 (hereafter OL 7508), its text comprises the first half of al-Ghāfiqī's treatise. One of its illustrated folios was reproduced in the exhibition catalogue, *La Médecine au temps des califes* (Paris: Institut du Monde Arabe; Ghent: Snoeck-Ducaju and Zoon, 1996), cat. 17, but it appears to be otherwise unpublished. See also the postscript to this article, which considers the relationship between OL 7508 and a recently "discovered" al-Ghāfiqī manuscript of the 17th century in Tehran's Malek Library (MS 5958).

2 Max Meyerhof (1874–1945), a German physician, historian of medicine, and author, attributed the manuscript to Baghdad, suggesting that it had been made "for a prince." Max Meyerhof, "Études de pharmacologie arabe tirées de manuscrits inédits: III. Deux manuscrits illustrés du 'Livre des Simples' d'Aḥmad al-Ġâfiqî," *Bulletin de l'Institut d'Égypte* 23 (1940-41): 16–20.

3 Osler paid £25 for the pair. There is disagreement over whether the purchase was made through the Iranian physician, Mirza Saʿeed, who supplied Osler with a number of manuscripts. Adam Gacek recently identified the al-Ghāfiqī manuscript as having been purchased from Saʿeed, in "Some Noteworthy Arabic and Persian Manuscripts in the Osler Library, McGill University," in William Feindel, Elizabeth Maloney, and Pamela Miller, eds., *Sir William Osler: The Man and His Books* (Montreal: Osler Library of the History of Medicine, 2011), 58. Anand Date had similarly concluded that Osler must have acquired the herbal manuscripts through Saʿeed; see Anand Date, "Sir William Osler's Arab and Other Middle Eastern Contacts," *Ulster Medical Journal* 60, no. 1 (1991): 120–8, on 125. Date later offered an opposing view; Anand Date, "The Story of Osler's First Four Arabic Manuscript Acquisitions," *Osler Library Newsletter*, no. 106 (2006): 1–8, on 1–2, 5–6.

4 Minta Collins, *Medieval Herbals: The Illustrative Traditions* (London: British Library; Toronto: University of Toronto Press, 2000), 138.

5 In a letter dated 24 September 1937, Meyerhof wrote that the manuscript "was bought from a Persian who sent it to Oxford in 1912 as one of two volumes of an illustrated Arabic Dioscorides, and it was not identified as Al-G.'s work until 1920, after Osler's death, when Cowley [Bodleian head librarian Arthur Cowley] of the Bodleian catalogued it for us." Date, "The Story of Osler's First Four Arabic Manuscript Acquisitions," 5. Adam Gacek had previously credited W.W. Francis, a cataloguer of Osler's collection and the first Osler Librarian, with the discovery, in his "Arabic Calligraphy and the 'Herbal' of al-Ghâfiqî: A Survey of Arabic Manuscripts at McGill University," *Fontanus* 2 (1989): 37–53, on 49.

6 Its text is the 3rd-/9th-century Arabic translation of Isṭifān b. Basīl revised by Ḥunayn b. Isḥāq (d. ca. 264/877). The manuscript's opening flyleaf (f. 1) bears an ex libris that reads, "From the Library of Sir William Osler, Bart. Oxford," and the volume's catalogue number, "No. 346 in *Bibliotheca Osleriana*." Its colophon, on f. 210a, con-

tains the scribe's name, al-Ḥasan b. Aḥmad b. Muḥammad al-Nashawī (Nasawī?), the date 637/1240, and the information that the book was copied at "al-madrasa al-niẓāmiyya." Emilie Savage-Smith, *A New Catalogue of Arabic Manuscripts in the Bodleian Library, University of Oxford*, vol. 1, *Medicine* (Oxford: Oxford University Press, 2011), 45, 64. B.W. Robinson and Basil Gray, *The Persian Art of the Book: Catalogue of an Exhibition Held at the Bodleian Library to Mark the Sixth International Congress of Iranian Art and Archaeology* (Oxford: Bodleian Library, 1972), 9.

7 Esin Atıl, *Art of the Arab World*, exhibition catalogue (Washington, DC: Smithsonian Institution, 1975), 53.

8 See Adam Gacek's contribution to the present volume for a reading of the colophon (on f. 283a) and the unusual rendering of its date.

9 In 579/1193 the ʿAbbāsid caliph al-Nāṣir (575–622 H/1180–1225 CE) built a new library for the madrasa, and supplied it with thousands of volumes. Anna Contadini, *A World of Beasts: A Thirteenth-Century Illustrated Arabic Book on Animals (the Kitāb Naʿt al-Ḥayawān) in the Ibn Bakhtīshūʿ Tradition* (Leiden: Brill, 2012), 154, citing Ibn al-Athīr (555–630/1160–1233). See also Savage-Smith, *A New Catalogue*, 43, and Collins, *Medieval Herbals*, 135.

10 Indented arrangements of this type are not unique to OL 7508 and Bodleian Arab. d. 138. For analogous layouts, see the sole extant illustrated Dioscorides manuscript from Spain, datable to the 6th/12th or 7th/13th century (Bibliothèque nationale de France, arabe 2850) and the al-Ghāfiqī manuscript dated 990/1582 in Cairo's Museum of Islamic Art (MS 3907). For the former, see *L'Art du livre arabe: Du manuscrit au livre d'artiste*, exhibition catalogue, edited by Marie-Geneviève Guesdon and Annie Vernay-Nouri (Paris: Bibliothèque nationale de France, 2001), cat. 80. For the latter, *La médicine au temps des califes*, cat. 17. Ibid., 98, for a Greek prototype of the 9th century.

11 The manuscript's folios number 284 when counting the opening flyleaf, which is hand-numbered in pencil along with the rest of the folios. The number of illustrations was catalogued as 367 by Osler, and repeated by Meyerhof. William Osler, *Bibliotheca Osleriana: A Catalogue of Books Illustrating the History of Medicine and Science* (Montreal: McGill-Queen's University Press, 1969), 663; Meyerhof, "Études de pharmacologie arabe," 17. As Adam Gacek points out in a note to his contribution to this volume, "three illustrations on f. 51b, f. 144a, and f. 158b were counted as one and two illustrations on f. 76a and f. 219b were counted as two each."

12 The Oxford Dioscorides contains 211 folios when counting the flyleaves, both of which are modern. The title page is f. 2a. Savage-Smith, *A New Catalogue*, 45, 64; Collins, *Medieval Herbals*, 135; Robinson and Gray, *The Persian Art of the Book*, 9. On five folios, blank spaces remain for illustrations that were never completed (f. 56b, f. 70a, f. 84a, f. 103a [upper half], and f. 126a); whether some of the manuscript's illustrations are later additions is unknown.

13 Collins, *Medieval Herbals*, 135; Ernst J. Grube, "Materialien zum Dioskurides Arabicus," in Richard Ettinghausen, ed., *Aus der Welt der islamischen Kunst: Festschrift für Ernst Kühnel zum 75. Geburtstag am 27. 10.*

1957 (Berlin: Gebr. Mann, 1959), fig. 9; Robert Hillenbrand, "The Schefer Ḥarīrī: A Study in Islamic Frontispiece Design," in Anna Contadini, ed., *Arab Painting: Text and Image in Illustrated Arabic Manuscripts* (Leiden: Brill, 2007), fig. 7; Dietrich Brandenburg, *Islamic Miniature Painting in Medical Manuscripts* (Basel: Roche, 1982), fig. 89; Savage-Smith, *A New Catalogue*, pl. II.

14 Herbal illustrations "need not have been of high quality," as Michael J. Rogers has noted in his article, "Text and Illustrations: Dioscorides and the Illustrated Herbal in the Arab Tradition," in Anna Contadini, ed., *Arab Painting: Text and Image in Illustrated Arabic Manuscripts* (Leiden: Brill, 2007), 45.

15 Both manuscripts' scribes also close their entries with dotted teardrop-shaped markers. For those of OL 7508, and a description of the manuscript's orthography, see Adam Gacek's contribution to this volume.

16 The Montreal herbal's text was written 23 lines to the page, and its folios have a written area measuring 20.5 x 13.5 cm. The Oxford Dioscorides has 15 lines per page and a written area of 17.5 x 10.5 cm. Collins, *Medieval Herbals*, 146n114. Slightly different dimensions for the Oxford Dioscorides (a folio size of 24.6 x 16.6 cm, and a written area of 16.8 x 10.8 cm) are recorded by Savage-Smith, *A New Catalogue*, 45.

17 Bodleian Arab. d. 138's binding, also of dark red leather with embossed medallions, was attributed to the 17th century by Robinson and Gray, *The Persian Art of the Book*, 9. Part of a fore-edge flap remains on one of its covers; the envelope flap is missing. Savage-Smith, *A New Catalogue*, 65.

18 The modern pagination was written in Arabic numerals, rather than the Indian numerical system employed by medieval scribes.

19 The Oxford herbal's illustrations are incomplete; see n12, above. In the frontispiece (f. 2b), Dioscorides' halo was awkwardly refashioned into a turban, but the composition – a sage standing beneath an arch and reading a codex – is anchored in the Byzantine evangelist portrait tradition. The author portrait was annotated by a later hand, "Picture of the sage Dioscorides, who composed *On Simples*." The chapter heading to book 5, on f. 184b, contains a misspelling ("*maqāma*" is written instead of "*maqāla*"). Collins, *Medieval Herbals*, 135.

20 See also the postscript to this essay, below. Further study and scientific testing might determine when at least some of the alterations were made.

21 Collins, *Medieval Herbals*, 25.

22 The influence of Greek "scientific" illustration on, and its transformation by, medieval Islamic manuscript painters has been discussed at length; see: Kurt Weitzmann, "The Greek Sources of Islamic Scientific Illustrations," in George C. Miles, ed., *Archaeologica Orientalia in Memoriam Ernst Herzfeld* (Locust Valley, NY: J.J. Augustin, 1952), 244–66; Florence E. Day, "Mesopotamian Manuscripts of Dioscorides," *Metropolitan Museum of Art Bulletin* n.s., 8, no. 9 (1950): 274–80; Richard Ettinghausen, *Arab Painting* (Geneva: Skira, 1962), 67–80; and M.M. Sadek, *The Arabic Materia Medica of Dioscorides* (Quebec, QC: Éditions du Sphinx, 1983), passim.

23 Weitzmann, "The Greek Sources," 258.

See also Zoltán Kádár, *Survivals of Greek Zoological Illuminations in Byzantine Manuscripts* (Budapest: Akadémiai Kiadó, 1978).

24 Alt. Cratevas, Krateuas.

25 Charles Singer, "The Herbal in Antiquity and Its Transmission to Later Ages," *Journal of Hellenic Studies* 47 (1927): 5.

26 Sadek, *The Arabic Materia Medica*, 2.

27 C.E. Dubler, "Diyuskuridīs," in *Encyclopaedia of Islam*, 2: 349a–350a (Leiden: Brill, 1965). Dioscorides acknowledged Crateuas in the "somewhat patronizing" dedicatory letter to his benefactor and friend, Areius; an Arabic transcription and English translation of Dioscorides' dedicatory epistle, from the Arabic Dioscorides in Leiden University Library (Or. 289) appears in Sadek, *The Arabic Materia Medica*, 2–6, 42.

28 Vienna, Österreichische Nationalbibliothek, Codex Vindobonensis Medicus Graecus 1, datable to ca. 512 CE and better known as the "Vienna Dioscorides." A full-sized facsimile was published in Graz: *Codex Vindobonensis med. Gr. 1 der Österreichischen Nationalbibliothek*, 2 vols, facsimile volume, with commentary volume by Hans Gerstinger (Graz: Akademische Druck- u. Verlagsanstalt, 1965–70).

29 For a handlist of Greek Dioscorides manuscripts that predate the Arabic copy preserved in Leiden University Library (Or. 289), see Sadek, *The Arabic Materia Medica*, 61–5. See also Alain Touwaide, Natale G. De Santo, Guido Bellinghieri, and Vincenzo Savica, *Healing Kidney Diseases in Antiquity: Plants from Dioscorides'* De materia medica *with Illustrations from Greek and Arabic Manuscripts (A.D. 512–15th Century)* (Cosenza, Italy: Bios, 2000).

30 Collins, *Medieval Herbals*, ch. 2 (on Greek herbals). For a list of the dozen or so illustrated Byzantine herbals other than the Vienna Dioscorides, see Leslie Brubaker, "The Vienna Dioskorides and Anicia Juliana," in Antony Littlewood, Henry Maguire, and Joachim Wolschke-Bulmahn, eds., *Byzantine Garden Culture* (Washington, DC: Dumbarton Oaks Research Library and Collection, 2002), 204n21. They range in date from the 6th through the 15th centuries.

31 Faith Wallis, "Review of *Medieval Herbals: The Illustrative Traditions*, by Minta Collins," *Canadian Bulletin of Medical History* 19, no. 2 (2002): 527.

32 The manuscript remained in Constantinople until at least the 15th century; Brubaker, "The Vienna Dioskorides," 206.

33 On the survival of Greek "scientific" illustration, see Alfred Stückelberger, *Bild und Wort: Das illustrierte Fachbuch in der antiken Naturwissenschaft, Medizin und Technik*, Kulturgeschichte der antiken Welt 62 (Mainz: Philipp von Zabern, 1994); Kurt Weitzmann, *Late Antique and Early Christian Book Illumination* (New York: Braziller, 1977), esp. 60–1; and Kádár, *Survivals of Greek Zoological Illuminations*. The translation of medical compendia like Dioscorides' *De materia medica* was of central importance to the establishment of a "school" for the copying of manuscripts in early ʿAbbāsid Baghdad. Eva Hoffman considers Islamic manuscript illustration an outgrowth of scholarly activity in general, and of the Baghdad-based translation movement in particular; Eva R. Hoffman, "The Beginnings

of the Illustrated Arabic Book: An Intersection between Art and Scholarship," *Muqarnas* 17 (2000): 44. For an overview of Arabic translations of Dioscorides' *De materia medica*, see Sadek, *The Arabic Materia Medica*, 7–13.

34 Handlists were published by Grube, "Materialien zum Dioskurides Arabicus," and Sadek, *The Arabic Materia Medica*, 13–19. See also Collins, *Medieval Herbals*, chapter 3 (on Arabic herbals).

35 For fuller discussions of the illustration of Arabic "scientific" manuscripts, see Weitzmann, "The Greek Sources"; Eva R. Hoffman, "The Emergence of Illustration in Arabic Manuscripts: Classical Legacy and Islamic Transformation" (Ph.D. diss., Harvard University, 1982), and Hoffman, "The Beginnings of the Illustrated Arabic Book." Recent scholarship no longer supports the view expressed decades ago by Hugo Buchthal, namely, that in manuscripts like Arabic copies of Dioscorides' *De materia medica*, the text serves merely as a "pretext" for illustration. Hugo Buchthal, "Early Islamic Miniatures from Baghdad," *Journal of the Walters Art Gallery* 5 (1942): 33.

36 Ettinghausen, *Arab Painting*, 237ff.

37 Oleg Grabar, *The Illustrations of the Maqamat* (Chicago: University of Chicago Press, 1984), 3. Some medieval Islamic herbals, like the dispersed 1224 copy, did include figural imagery that went "beyond the pure scientific requirements"; Weitzmann, "The Greek Sources," 252.

38 Brubaker, "The Vienna Dioskorides," 208, in reference to the early 6th-century Greek manuscript, but equally applicable to Arabic herbals.

39 In all probability, the patrons and readers of Arabic illustrated herbals already possessed some knowledge of the botanical, zoological, and inanimate subjects depicted within. On the requirement of illustration in scientific manuscripts in the Islamic world, and the types of illustrations used, see D.S. Rice, "The Oldest Illustrated Manuscript," *Bulletin of the School of Oriental and African Studies* 2 (1959): 207–20.

40 Similarly, see Wallis, "Review of *Medieval Herbals*," 528.

41 Hand-numbered 2–9.

42 Ink is visible through the lighter shades of paint in many illustrations, making it evident that the text was copied before the images were painted. In one instance (f. 279b), space was left for an illustration that was never supplied: An inscription, probably added later than the copying of the text and written diagonally across the lacuna, reads "there is an inadvertent mistake in this empty space"; quoted in Adam Gacek's contribution to the present volume. The blank space was a scribal error; both the preceding and following entries are illustrated, so no illustration is missing (as would be the case had a model been unavailable).

43 Minta Collins theorized that the manuscript's illustrator(s) may have made "loose copies of the illustrations" from a Dioscorides manuscript and "added others in the same style when they were missing in the model." Collins, *Medieval Herbals*, 138.

44 See, e.g., the plants depicted on f. 230a. For comparison, see the grapevine and lentil plant illustrated in Ettinghausen, *Arab Painting*, 72–3. A typological study of the type Sadek undertook in his monographic study of the Leiden Dioscorides (Or. 289), *The*

Arabic Materia Medica, might clarify the manuscript's stylistic variability.

45 The captions seem to have been added by a different hand than the copyist's. The red ink used for the captions appears to have been employed in at least some of the illustrations' underdrawings (this is especially evident on f. 53b and f. 114b). Scientific testing would be required to confirm this supposition.

46 Some of the illustrations and their labels were cropped or lost as a result; a partial caption is visible on f. 32a.

47 Ettinghausen, *Arab Painting*, 59.

48 The "mirrors for princes" genre includes translations of Bidpai's Indian animal fables, known in Arabic as *Kalīla wa-Dimna*.

49 Surprisingly, there is no known illustrative tradition in the best-known work of *adab*, the *Alf Layla wa-Layla* (*One Thousand and One Nights*). Textual evidence suggests that historical treatises were illustrated, typically with serial portraiture, although no examples are known to have survived. For a reference to an "*ad hoc* compilation" of royal portraits in a chronicle of the Sasanian kings, see Rice, "The Oldest Illustrated Arabic Manuscript," 208. In illustrated copies of the *Maqāmāt*, illustrations may have been used for storytelling purposes, as well: Grabar, *The Illustrations of the Maqamat*, 22–3; Hillenbrand, "The Schefer Ḥarīrī," 131–2; Alain George, "Orality, Writing and the Image in the *Maqamat*: Arabic Illustrated Books in Context," *Art History* 35, no. 1 (2012): 10–37. On the inseparability of text and image in Arabic manuscript production, see Hoffman, "The Beginnings of the Illustrated Arabic Book," 38ff.

50 Among them are treatises on farriery and automata, copies of the Maqāmāt of al-Ḥarīrī, collections of fables, and herbals; Gaston Wiet, *Baghdad: Metropolis of the Abbasid Caliphate* (Norman, OK: University of Oklahoma Press, 1971), 159. The earliest manuscript securely attributed to Baghdad is the *Kitāb al-bayṭara* (*Book of Farriery*) now in the Egyptian National Library and dated 605/1209 (Cairo, Dār al-Kutub, Khalīl Aghā MS F8). See Buchthal, "Early Islamic Miniatures," 18–39; Ettinghausen, *Arab Painting*, 100; Contadini, *A World of Beasts*, pls. 33 and 34.

51 The Baghdad School is also alleged to have outlived the Mongol invasion of Baghdad in 656/1258 by a few decades; Ettinghausen, *Arab Painting*, 100–3, 135–42.

52 Eustache de Lorey, "La peinture musulmane: L'école de Bagdad," *Gazette des Beaux-Arts* 6, no. 10 (July 1933): 1–13; *Les arts de l'Iran: L'ancienne Perse et Bagdad*, Exhibition catalogue (Paris: Bibliothèque nationale, 1938).

53 Buchthal, "Early Islamic Miniatures," 19; *Les arts de l'Iran*, 108–31.

54 Meyerhof also speculated that the manuscript was made under princely patronage in his "Études de pharmacologie arabe," 16–20. Minta Collins (*Medieval Herbals*, 138) proposed that OL 7508 "was commissioned in Baghdad where the fashion for illustrated Herbals was at its height."

55 Savage-Smith, *A New Catalogue*, 43.

56 Ibid.

57 The Niẓāmiyya madrasas are often cited as the world's first university system, with that of Baghdad having been completed in 459/1067; Yasser Tabbaa, *Constructions of Power and Piety in Medieval Aleppo* (University Park, PA: Pennsylvania State

58 The manuscript, a copy of the *Kitāb al-bayṭara* of Ibn al-Aḥnaf (Cairo, Dār al-Kutub, Khalīl Aghā MS F8), is dated 605/1209 in its colophon. Another copy of the manuscript was made a year later, with illustrations in the same expansive style (Istanbul, Topkapı Sarayı Library, Ahmet III MS 2115); Contadini, *A World of Beasts*, pls. 33–36. Buchthal's list of "kindred works of art" includes the dispersed 621/1224 Dioscorides (Istanbul, Süleymaniye Library, Ayasofya MS 3703), the 634/1237 Maqāmāt of al-Ḥarīrī (a.k.a. the "Schefer Hariri"; Paris, Bibliothèque nationale de France, MS arabe 5847), and a zoological work on the usefulness of animals (London, British Library MS Or. 2784); Buchthal, "Early Islamic Miniatures from Baghdad," 20, and, for a transcription of the 605/1209 *Kitāb al-bayṭara* manuscript's colophon, 37n3.

59 Richard Ettinghausen, a leading 20th-century historian of Islamic art, considered the arts of the book to have reached their qualitative zenith with the Baghdad School in the late 6th/12th and 7th/13th centuries. In his estimation, "Arab painting reached its full integrating power shortly after 1200 in the capital of the ʿAbbasid caliphate, and attained its full glory there in the second quarter of the century." Ettinghausen, *Arab Painting*, 97.

60 See, e.g., the scene of grape thrashing from the 621/1224 Dioscorides, since 1956 part of the Metropolitan Museum of Art's collection (56.20). The scene illustrates the fifth book of Dioscorides' *De materia medica*, and concerns the boiling down of grape juice and the addition of this substance to wine; the miniature's subjects, however, are two men standing in a large vat and holding clubs in the air. See John M. Riddle, *Dioscorides on Pharmacy and Medicine*, History of Science Series 3 (Austin: University of Texas Press, 1985), 144; Buchthal, "Early Islamic Miniatures," 29. The most recent treatment of the Baghdad School is Contadini, *A World of Beasts*, 153–6.

61 Collins, *Medieval Herbals*, 138.

62 Ibid.

63 The 621/1224 Dioscorides was one of the most prolifically illustrated Arabic herbals ever produced, although more than two dozen of its illustrations are now scattered across the globe. Friedrich Martin, a Swedish archaeologist, removed about 30 of its "more interesting" illustrated folios in the late 19th century. Hugo Buchthal published 29 of the missing illustrations in his "Early Islamic Miniatures." A later summary was published by Grube, "Materialien zum Dioskurides Arabicus." A reproduction of the manuscript, almost in its entirety, was published with a commentary by Alain Touwaide, ed., as *Farmacopea Araba medievale: Codice Ayasofia 3703*, 4 vols, facsimile edition of Istanbul, Süleymaniye Mosque Library, MS Ayasofya 3703 (Milan: ANTEA, 1992–93). See also Collins, *Medieval Herbals*, 131.

64 Illustrations that exceed the requirements of the text include scenes of men harvesting herbs or roots, doctors preparing remedies or treating patients, and conversations between two physicians or a physician and his apprentice. See, e.g., Contadini, *A World of Beasts*, pls. 12, 20, 21, 25, 27, and 28. Similarly, several of the herbal's botanical illustrations are "inhabited" by human figures,

birds, or other animals, for which see Buchthal, "Early Islamic Miniatures," figs. 5, 7, and 8, and Contadini, *A World of Beasts*, pls. 5 and 6.

65 As Grabar noted in 1984, in reference to the "acknowledged masterpiece of the so-called Baghdad school of painting," the "Schefer Ḥarīrī" of 634/1237, "no internal evidence has so far been found to support a Baghdad origin" for the manuscript. Grabar also noted: "We have certainly been cured of the old tendency to attribute almost all Near Eastern examples of pre-Mongol painting to Baghdad, but even a more limited ascription of only four manuscripts to the Baghdad school (the Schefer *Maqamat*, the 1224 dispersed Dioscorides, the *Kitab al-Baytarah* in Cairo dated 1209, and another of the same in Istanbul) is based on the colophon in only one, the Cairo *Kitab al-Baytarah*, which was no doubt completed in Baghdad." Grabar, *The Illustrations of the Maqamat*, 10.

66 It remains difficult, if not impossible, to precisely localize pre-Mongol illustrated manuscripts.

67 For a similar suggestion, see Contadini, *A World of Beasts*, 156.

68 Grabar, *The Illustrations of the Maqamat*, 152–3.

69 Collins appears to have been unaware of Grabar's remark. More recently, Anna Contadini accepted the Bodleian Dioscorides' attribution to Baghdad, writing: "That it should be the one in Baghdad is not only signalled by the style of the paintings, but also by the fact that there is no mention of place, as might be expected if the Niẓāmiyya referred to were elsewhere." Contadini, *A World of Beasts*, 155n60.

70 The only functioning Niẓāmiyya in northern Mesopotamia at the time the manuscript was copied was the one at Mosul, but while these iconographic affinities would support the attribution of the Oxford herbal to the Jazīra, other evidence militates against unqualified ascription to Mosul. For example, manuscripts designated as belonging to the "Mosul group" tend to have framed, compartmentalized page layouts, and a characteristic figural style (evidence of which is lacking or obscured by retouching in Oxford d. 138).

71 The manuscript is in a poor state of repair; pieces of blank parchment were cut from its folios, many of which are missing, and the remainder was reassembled non-sequentially; 124 folios, measuring approximately 40 x 30 cm, are preserved. Collins, *Medieval Herbals*, 124; *La médecine au temps des califes*, cat. 191.

72 Likely 1229 CE is a *terminus ante quem*.

73 The manuscript has a folio size of 34.7 x 26.5 cm and consists of 171 folios; approximately 250 folios are missing. Touwaide et al., *Healing Kidney Diseases*, 38. On the manuscript's provenance, see Collins, *Medieval Herbals*, 84.

74 The presence of Arabic captions to the illustrations lends credibility to such a conclusion, but cannot be construed as proof. On the "orientalising style" of the Greek manuscript's illustrations, see Collins, *Medieval Herbals*, 91–3.

75 The lavender plant of OL 7508 might have been a loose copy after arabe 4947's illustration; the mirror imagery of the Greek and Arabic herbals could indicate the use of a tracing. The iconographic affinities between grec 2179 and arabe 4947 were outlined in the early 20th century by Edmond Bonnet,

who suggested a common source for their illustrations: "Étude sur les figures de plantes et d'animaux peintes dans une version arabe de la matière médicale de Dioscoride conservé à la Bibliothèque nationale de Paris," *Janus* 14 (1909): 294–303.

76 Richard Ettinghausen, Oleg Grabar, and Marilyn Jenkins-Madina, *Islamic Art and Architecture 650–1250*, 2nd ed. (New Haven and London: Yale University Press, 2001), 300.

77 Carole Hillenbrand, "The History of the Jazīra, 1100–1250: A Short Introduction," in Julian Raby, ed., *The Art of Syria and the Jazīra, 1100–1250* (Oxford: Oxford University Press, 1985), 17.

78 Sadek, *The Arabic Materia Medica*, 10–11.

79 The copy is believed to be the lavishly illustrated manuscript now in Istanbul (Topkapı Sarayi Library, Ahmet III MS 2127), which was made for Shams al-Dīn Abū l-Faḍāʾil Muḥammad, who ruled over part of Syria and Anatolia. Collins, *Medieval Herbals*, 127–8, 143n48; Sadek, *The Arabic Materia Medica*, 10, 17; Ettinghausen, *Arab Painting*, 161–2, 168, illustrated on 68–9 and 71–3.

80 For the most recent discussion of the attribution of pre-Mongol manuscripts to the "Mosul School," see Contadini, *A World of Beasts*, 149–51.

81 Ettinghausen et al., *Islamic Art and Architecture 650–1250*, 257 and fig. 428, a double-page illumination from a Qurʾan made for the library of a Zangid prince who ruled Sinjar, Khabur, and Nisibin from 1198 to 1219 CE. On Jazīran art in general, and manuscript painting in particular, see Nahla Nassar, "Saljuq or Byzantine: Two Related Styles of Jazīran Miniature Painting," 85–98, and Rachel Ward, "Evidence for a School of Painting at the Artuqid Court," 69–83, both in Julian Raby, ed., *The Art of Syria and the Jazīra, 1100–1250* (Oxford: Oxford University Press, 1985).

82 On the "northern Islamic" herbal tradition, see Collins, *Medieval Herbals*, 118ff.

83 The text of the *Kitāb al-diryāq* is not an herbal, but 12 pages of the copy in the Bibliothèque nationale de France bear herbal illustrations. A facsimile was published recently: *Kitâb al-Diryâq – Thériaque de Paris*, facsimile edition, with commentary volume, of Paris, Bibliothèque Nationale de France, MS arabe 2964 (Sansepolcro, Italy: Aboca Museum, 2009).

84 Jaclynne J. Kerner, "Art in the Name of Science: The *Kitāb al-diryāq* in Text and Image," in Anna Contadini, ed., *Arab Painting: Text and Image in Illustrated Arabic Manuscripts* (Leiden: Brill, 2007), 26. On Farès' attribution of the manuscript to the Baghdad School, see Jaclynne J. Kerner, "Art in the Name of Science: Illustrated Manuscripts of the *Kitāb al-diryāq*" (Ph.D. dissertation, New York University, 2004), 261nn4 and 5.

85 Contadini, *A World of Beasts*, 108. For rabbit/hare imagery across various media, including woodwork and textiles, see Ernst J. Grube, "Three Miniatures from Fusṭāṭ in the Metropolitan Museum of Art in New York," *Ars Orientalis* 5 (1963): 89–95.

86 See, e.g., the hares depicted on f. 75b of the Kitāb naʿt al-ḥayawān of ca. 1250 CE in the British Library in London (Or. 2784), which is attributed to the "Baghdad School"; Contadini, *A World of Beasts*, 156, fig. 47a, and cat. 21.

87 For a rabbit rendered in the usual manner

from a Dioscorides manuscript attributed to the "Baghdad School," see Brandenburg, *Islamic Miniature Painting*, 101, ill. 36.

88 Morgan M.652, which consists of 385 vellum folios measuring 39.5 x 30 cm, contains 769 illustrations. The manuscript has been attributed to Constantinople, ca. 930–70 CE, and its text comprises the *De materia medica* and a series of treatises on poisons. A photographic facsimile was published in 1935: *Pedanii Dioscuridis Anazarbei de materia medica libri VII accedunt Nicandri et Eutecnii opuscula medica*, 2 vols, facsimile edition of New York, Pierpont Morgan Library, MS M.652 (Paris: [Pierpont Morgan Library], 1935). See also Sadek, *The Arabic Materia Medica*, 63, and Collins, *Medieval Herbals*, 59–69.

89 Sadek, *The Arabic Materia Medica*, 58.

90 Both M.M. Sadek and Minta Collins reached the same conclusion; Sadek, *The Arabic Materia Medica*, 206; Collins, *Medieval Herbals*, 119. Interestingly, the lavender plants of the Arabic herbals are also mirror images of the Byzantine Greek example, as discussed above.

91 As described by Minta Collins, the ultimate source of grec 2179's illustrations is the illustrative tradition of the so-called Alphabetical Herbal Recension (in Greek) of the *De materia medica*, which appears to have been made in the 3rd or 4th century CE. Among the earliest manuscripts to contain this version of the text are the Vienna Dioscorides and a 6th- or 7th-century Greek copy in Naples (Biblioteca Nazionale, Cod. gr. 1). Collins, *Medieval Herbals*, 34–5. A comparative study of the recension's illustrative tradition might also contribute to our understanding of OL 7508.

92 In the introduction to the revision, which was completed in 380/990–91, al-Nātilī claimed to have been the book's writer and illustrator. The prince, Abū ʿAlī Simjūrī, was a member of the Samanid line. Sadek, *The Arabic Materia Medica*, 57.

93 For a comparative analysis of Morgan M. 652 and Leiden Or. 289's botanical imagery, see Collins, *Medieval Herbals*, 119–22. For the manuscripts' rose plants, see Collins' pls. II and VII, and for the mandrake, figs. 19 and 25. Collins also demonstrated the similarity between the orchids depicted in Or. 289 and Paris grec 2179, for which see her figs. 22 and 26.

94 Sadek speculated that Or. 289's illustrations might have been influenced by Iranian prototypes. At some point in the manuscript's later history, it was accessed by Persian-speakers; the rabbit of the Leiden Dioscorides is captioned with the Persian word for rabbit (خرگوش), and Persian captions exist elsewhere in the manuscript, as well. Sadek, *The Arabic Materia Medica*, 136. The possibility of Eastern Islamic or pre-Islamic Iranian inspiration for at least some of the illustrations of OL 7508 should not be ruled out, although the scarcity of evidence would make such an investigation difficult.

95 Mandrakes were also incorporated into full-page illustrations, often frontispieces, of herbal manuscripts including the Vienna Dioscorides (Vienna, Österreichische Nationalbibliothek, med. gr. 1, f. 5b) and the illustrated Arabic *De materia medica* dated 626/1229 (Istanbul, Topkapı Sarayı Library, Ahmet III MS 2127, f. 2b); for reproductions, see Collins, *Medieval Herbals*, fig. 4, and Ettinghausen, *Arab Painting*, 71.

96 In grec 2179, the first of three mandrake plants, on f. 103b, has an unusual form; it is not reproduced here, but may be viewed electronically on the Bibliothèque nationale's Website: http://mandragore.bnf.fr/html/accueil.html. In arabe 4947, the mandrake plant at the bottom of f. 92a appears to have been retouched.

97 *La Médecine au temps des califes*, 232.

98 Mandrakes of a different type, exhibiting anthropomorphic roots, are found in several Arabic herbals; compare, e.g., the mandrakes of arabe 4947 and OL 7508 with the anthropoid examples on f. 12a of the Oxford Dioscorides (Bodleian Library, Arab. d. 138) or f. 157a of the Leiden Dioscorides (Leiden, Bibliotheek der Rijksuniversiteit, Or. 289); the former was published in Brandenburg, *Islamic Miniature Painting*, ill. 18, and the latter in Collins, *Medieval Herbals*, fig. 25.

99 According to a letter Max Meyerhof wrote to Osler librarian W.W. Francis, approximately 90 of the plants depicted in the manuscript were unknown to the Greeks; see Gacek's article in the present volume. An identification of these plants, and research into their iconographic sources, might well be beneficial.

100 Parallels might eventually be drawn to al-Ghāfiqī's textual sources, which were both Mashriqī and Maghribī (the adjectival Arabic terms for the Islamic East and West) in origin; see the contributions of Leigh Chipman, Cristina Álvarez Millán, and Oliver Kahl to this volume for details. Evidence of a Maghribī herbal tradition is, however, scarce; the only illustrated Arabic herbal attributable to Spain is a 12th- or 13th-century copy in Paris (Bibliothèque nationale, arabe 2850). Collins described its illustrations as following the iconography of grec 2179 and arabe 4947, so this line of investigation may be worth pursuing, although the manuscript may have been copied by a Maghribī scribe outside the Islamic West; Collins, *Medieval Herbals*, 135–6, 303.

101 Bernard O'Kane, "The Uses of Captions in Medieval Literary Arabic Manuscripts," in Anna Contadini, ed., *Arab Painting: Text and Image in Illustrated Arabic Manuscripts* (Leiden: Brill, 2007), 144. O'Kane's essay focuses on the captioning of medieval Arabic literary manuscripts; a study of the role of captions in scientific manuscripts awaits scholarly attention.

102 See, e.g., f. 114b and f. 115a, on which the final form of the letter kāf varies between text and caption. Orthographic analysis might determine whether the captions were added when the text underwent correction, for which see Adam Gacek's contribution to this volume; Gacek suggests that the corrections were the work of at least two hands. Whether one of them was responsible for the captions would be useful to know.

103 See, e.g., the captions to the rabbit (captioned "arnab barrī," wild rabbit or hare) and sea-hare ("arnab al-baḥr," captioned "al-arnab al-baḥrī") on f. 53b. O'Kane suggests that captions may have served as substitutes for organizational features like tables of contents, which were seldom included in Arabic literary manuscripts. O'Kane, "The Uses of Captions," 143.

104 On the nomenclatural variants, see Oliver Kahl's contribution to the present volume.

105 The upper illustration is labelled "a second type of luffāḥ"; the lower, "a third type of luffāḥ."

106 Arabe 4947's f. 92a is captioned "types of luffāḥ." The caption to the mandrake plant on grec 2179's f. 103b reads, "luffāḥ, that is to say, yabrūḥ."

107 Martin Levey, *Early Arabic Pharmacology: An Introduction Based on Ancient and Medieval Sources* (Leiden: Brill, 1973), 152.

108 Full translation of the passage is in the introduction to this volume. Ibn Abī Uṣaybiʿa also wrote that Cairo's chief herbalist, Ibn al-Bayṭār (d. 646/1248), who quoted al-Ghāfiqī extensively in his own compendium of *materia medica*, always travelled with copies of Dioscorides, Galen, and al-Ghāfiqī's *Book of Simple Drugs*. Levey, *Early Arabic Pharmacology*, 152, quoting Bar Hebraeus (Gregorius Abū al-Faraj, Ibn al-ʿIbrī), *The Abridged Version of "The Book of Simple Drugs" of Aḥmad ibn Muḥammad al-Ghâfiqî by Gregorius Abu'l-Farag (Barhebraeus)*, edited and translated by Max Meyerhof and Georgy P. Sobhy (Cairo: al-Ettemad Printing Press, 1932–40), pt. 1, 33. See also Max Meyerhof, "Arabian Pharmacology in North Africa, Sicily, and the Arabian Peninsula," *Ciba Symposia* 6 (1944): nos. 5–6, 1869, and George Sarton, "Review of *The Abridged Version of "The Book of Simple Drugs" of Aḥmad ibn Muḥammad al-Ghâfiqî by Gregorius Abu'l-Farag (Barhebraeus)*, ed. Max Meyerhof and Georgy P. Sobhy," *Isis* 20, no. 2 (1934): 456.

109 Muḥammad ibn Isḥāq ibn al-Nadīm, *Kitāb al-Fihrist*, 2 vols, edited by Gustav Flügel (Leipzig: Vogel, 1871–72; reprinted Beirut: Khayyāṭ, 1964), 293, quoted in Sadek, *The Arabic Materia Medica*, 2.

110 See postscript to this essay, below.

111 See n1, above, for a reference to the late 16th-century copy in Cairo. A comparative study of the three extant illustrated al-Ghāfiqī manuscripts awaits scholarly attention. The existence of an illustrative idiom specific to the al-Ghāfiqī manuscripts (and distinct from the Dioscoridean tradition) seems unlikely, but invites further inquiry. The Montreal manuscript nevertheless remains essentially a unicum, as the only known illustrated copy of al-Ghāfiqī's treatise datable to the pre-Mongol period.

112 Most illustrated herbals from the Islamic world are dated or datable to the 11th through 16th centuries CE.

113 The preliminary conclusions drawn here rely on the use of digital photographs of the Tehran herbal, which suggest a slightly more limited range of colours than was used in the illustration of OL 7508.

114 First-hand study of the manuscript, which was not possible for the present author, would undoubtedly yield valuable information.

115 Sources other than OL 7508 are as yet unidentified.

116 The smiling, long-eared rabbit depicted on the same folio of the Tehran herbal has more in common with later Persian painting than the Osler herbal. See, e.g., the double-page illustration of Solomon and the Queen of Sheba from a *Shāhnāma* copied in Shiraz at the end of the 16th century and now in the British Library (India Office Library, MS 3540, ff. 1b–2a), published as cat. no. 179 in *L'Étrange et le Merveilleux en terres de l'Islam*, exhibition catalogue (Paris: Musée du Louvre, Réunion des musées nationaux, 2001), 266–8.

117 Tehran MS 5958 is foliated in pencil on the verso sides of folios, using Indian numerals,

but is paginated sequentially; hence, only even numbers were used.

118 In the later 16th century, following the Safavid shah Tahmasp's renunciation of painting in the 1550s and his death in 1576, the taste for illustrated manuscripts in Iran declined sharply. Single-page drawings collected in albums became the norm. The characteristic style of late 16th- and 17th-century Persian painting and drawing, with its fine draftsmanship using lines of varying thicknesses, is closely associated with, and widely credited to, Riza-yi ʿAbbāsī (d. 1635 CE), the leading artist to the Safavid shah ʿAbbas I (r. 1588–1629 CE). On Riza's career and artistry, see Sheila R. Canby, *The Rebellious Reformer: The Drawings and Paintings of Riza-yi Abbasi of Isfahan* (London: Azimuth, 1996).

119 Vegetal filler motifs are relatively common in 17th-century Iranian painting. See, e.g., the illustrations to a Persian compilation forming a "Book of Wonders of the Age" in the University of St Andrews Library [MS 32(O)]. The manuscript appears to be unpublished, but digital images of many of its illustrations appeared in "Echoes from the Vault," a blog from the Special Collections of the University of St Andrews, in January 2013: http://standrewsrarebooks.word press.com/2013/07/01/52-weeks-of-inspiring-illustrations-week-50-the-book-of-wonders/. The manuscript's cataloguing data may also be accessed online: https://pacific.st-andrews.ac.uk/dserve/dserve.exe?dsqIni=Dserve.ini&dsqApp=Archive&dsqDb=Catalog&dsqCmd=show.tcl&dsqSearch=%28RefNo==%27OM%2F32%27%29.

120 An illustrated manuscript containing numerous marginal drawings and paintings of plants and animals in the British Museum has been tentatively identified by museum staff as the *Tuḥfat al-muʾminīn* or a related dictionary of plants and animals (1998,0702,0.12). The manuscript, which is dated 1122/1711, is as yet unstudied. Basic catalogue information is available in the British Museum's online collection database: http://www.britishmuseum.org/research/collection_online/collection_object_details.aspx?objectId=265267&partId=1&searchText=1998,0702,0.12&page=1. A copy of the pharmacopoeia (dated 1080/1669) to which marginal illustrations were later added was sold on 10 April 2008 as lot 20 during the Islamic and Indian Art sale at Bonhams, London: http://www.bonhams.com/auctions/16221/lot/20/. See also Fateme Keshavarz, *A Descriptive and Analytical Catalogue of Persian Manuscripts in the Library of the Wellcome Institute for the History of Medicine* (London: Wellcome Institute for the History of Medicine, 1986), cat. no. 129, 268–74, and Lutz Richter-Bernburg, *Persian Medical Manuscripts at the University of California, Los Angeles: A Descriptive Catalogue*, Humana Civilitas 4 (Malibu: Undena, 1978), 128–31.

121 On the Morgan *Manāfiʿ*'s "improvements," see Barbara Schmitz, *Islamic and Indian Manuscripts and Paintings in the Pierpont Morgan Library* (New York: Pierpont Morgan Library, 1997), 9–23.

122 Ibid.

Bibliography

Abū Ḥanīfa ad-Dināwarī. *The Book of Plants of Abū Ḥanīfa ad-Dināwarī, Part of the alphabetical section (alif-zāy). Edited from the unique MS in the Library of the University of Istanbul, with an introduction, notes, indices, and a vocabulary of selected words.* Edited by Bernhard Lewin. Uppsala: Lundequist, 1953.

– *The Book of Plants, Part of the monograph section = Kitāb an-nabāt.* Edited by Bernhard Lewin. Wiesbaden: Franz Steiner, 1974.

Afshār, Īraj, and Muḥammad Taqī Dānish'pazhūh. *Fihrist-i kitabhā-yi khaṭṭī-i Kitābkhāna-'i Millī-i Malik.* Tehran: [Kitābkhāna], 1352– [1973 or 1974–].

L'Age d'or des sciences arabes: Exposition présentée à l'Institut du monde arabe, Paris, 25 octobre 2005 – 19 mars 2006. Edited by Brahim Alaoui. Arles: Actes Sud; Paris: Institut du monde arabe, 2005.

Álvarez Millán, Cristina. "Graeco-Roman Case Histories and Their Influence on Medieval Islamic Clinical Accounts." *Social History of Medicine* 12, no. 1 (1999): 19–43.

– "Practice *versus* Theory: Tenth-Century Case Histories from the Islamic Middle East." *Social History of Medicine* ("The Year 1000: Medical Practice at the End of the First Millennium," special issue edited by Peregrine Horden and Emilie Savage-Smith) 13, no. 2 (2000): 293–306.

– "Medical Anecdotes in Ibn Juljul's Biographical Dictionary." *Suhayl* 4 (2004): 141–58.

– "The Clinical Account in Medieval Islamic Medical Literature: *Tajārib* and *Mujarrabāt* as Source." *Medical History* 54, no. 2 (2010): 195–214.

Ammar, Sleïm. *Ibn Al Jazzar et l'école médicale de Kairouan.* Sousse: Faculté de médicine Ibn Al Jazzar de Sousse, 1994. English translation: *Ibn al Jazzar and the Medical School of Kairouan.* Tunis: n.p., 1998.

L'Art du livre arabe: Du manuscrit au livre d'artiste. Exhibition catalogue. Edited by Marie-Geneviève Guesdon and Annie Vernay-Nouri. Paris: Bibliothèque Nationale de France, 2001.

Les arts de l'Iran: L'ancienne Perse et Bagdad. Exhibition catalogue. Paris: Bibliothèque Nationale, 1938.

Atıl, Esin. *Art of the Arab World*. Exhibition catalogue. Washington, DC: Smithsonian Institution, 1975.

Bar Hebraeus (Gregorius Abū l-Faraj, Ibn al-ʿIbrī). *The Abridged Version of "The Book of Simple Drugs" of Aḥmad ibn Muḥammad al-Ghâfiqî*. Edited and translated by Max Meyerhof and G.P. Sobhy. Cairo: al-Ettemad Printing Press; Government Printing House, 1932–40. Reprint, Frankfurt am Main: Institute for the History of Arabic-Islamic Science at the Johann Wolfgang Goethe University, 1996.

Bonnet, Edmond. "Étude sur les figures de plantes et d'animaux peintes dans une version arabe de la matière médicale de Dioscoride conservé à la Bibliothèque Nationale de Paris." *Janus* 14 (1909): 294–303.

Brandenburg, Dietrich. *Islamic Miniature Painting in Medical Manuscripts*. Basel: Roche, 1982.

Brubaker, Leslie. "The Vienna Dioskorides and Anicia Juliana." In Antony Littlewood, Henry Maguire, and Joachim Wolschke-Bulmahn, eds., *Byzantine Garden Culture*, 189–214. Washington, DC: Dumbarton Oaks Research Library and Collection, 2002.

Brockelmann, Carl. *Geschichte der arabischen Litteratur*. 5 vols. Leiden: Brill, 1943. Reprinted with a new introduction by Jan Just Witkam (Leiden: Brill, 1996).

Buberl, Paul. *Die byzantinischen Handschriften*, vol. 1, *Der Wiener Dioskurides und die Wiener Genesis*. Beschreibendes Verzeichnis der illuminierten Handschriften in Österreich, Neue Folge 4. Leipzig: Karl W. Hiersemann, 1937.

Buchthal, Hugo. "Early Islamic Miniatures from Baghdad." *Journal of the Walters Art Gallery* 5 (1942): 19–39.

Byzance: L'art byzantin dans les collections publiques de France; Musée du Louvre, 3 novembre 1992 – 1er février 1993. Paris: Musée du Louvre; Réunion des musées nationaux (France), 1992.

Cabo González, Ana M. "Ibn al-Bayṭār." In Jorge Lirola Delgado, ed., *Biblioteca de al-Andalus*, 2: 619–624. Almería: Fundación Ibn Ṭufayl de Estudios Árabes, 2009.

Cacouros, Michel. "Le lexique des définitions relevant de la philosophie, du *Trivium* et du *Quadrivium* compilé par Néophytos Prodromènos, son activité lexicographique et le corpus de textes philosophiques et scientifiques organisés par lui au monastère de Pétra à Constantinople." In Paola Volpe-Cacciatore, ed., *La erudizione scolastico-grammaticale a Bisanzio: Atti della VII Giornata di Studi Bizantini (Università degli Studi di Salerno-Dipartimento di Scienze dell'Antichità e Associazione Italiana di Studi Bizantini, Salerno, 11–12 aprile 2002)*, 165–222. Naples: Associazione di Studi Bizantini and D'Auria, 2003.

Canby, Sheila R. *The Rebellious Reformer: The Drawings and Paintings of Riza-yi Abbasi of Isfahan*. London: Azimuth, 1996.

Cano Ávila, Pedro. "Ibn ʿAbdūn al-Ishbīlī." In Jorge Lirola Delgado and José Miguel Puerta Vílchez, eds., *Biblioteca de al-Andalus*. Almería: Fundación Ibn Tufayl de Estudios Árabes, 2012. vol. 1, 647–51.

Capitani, Umberto. "I Sesti e la medicina." In Philippe Mudry and Jackie Pigeaud, eds., *Les écoles médicales à Rome: Actes du 2ème Colloque international sur les textes médicaux latins antiques,*

Lausanne, Septembre 1986, 95–123. Université de Lausanne, Publications de la Faculté des Lettres 33. Geneva: Droz, 1991.

Carabaza Bravo, Julia M. "Al-Išbīlī, Abū l-Jayr." In Jorge Lirola Delgado, ed., *Biblioteca de al-Andalus*, 6: 395–9. Almería: Fundación Ibn Ṭufayl de Estudios Árabes, 2009.

Chipman, Leigh. *The World of Pharmacy and Pharmacists in Mamluk Cairo*. Leiden and Boston: Brill, 2010.

Collins, Minta. *Medieval Herbals: The Illustrative Traditions*. London: British Library; Toronto: University of Toronto Press, 2000.

Contadini, Anna. *A World of Beasts: A Thirteenth-Century Illustrated Arabic Book on Animals (the Kitāb Naʿt al-Ḥayawān) in the Ibn Bakhtīshūʿ Tradition*. Leiden: Brill, 2012.

Dānish'pazhūh, Muḥammad Taqī. *Fihrist-i Kitābkhāna-'i Ihdā'ī-i Āqā-yi Sayyid Muḥammad Mishkāt bih Kitābkhāna-i Dānish'gā-i Tihrān*. Tehran: Mu'assasa-'i Intishārāt va Chāp-i Dānishgā-i Tihrān, 1330– [1951 or 1952–].

Date, Anand. "Sir William Osler's Arab and Other Middle Eastern Contacts." *Ulster Medical Journal* 60, no. 1 (1991): 120–8.

– "The Story of Osler's First Four Arabic Manuscript Acquisitions." *Osler Library Newsletter*, no. 106 (2006): 1–8.

Day, Florence E. "Mesopotamian Manuscripts of Dioscorides." *Metropolitan Museum of Art Bulletin*, n.s. 8, no. 9 (1950): 274–80.

De Young, Gregg. "Ḥunayn ibn Isḥāq." In Thomas Glick, Steven J. Livesey, and Faith Wallis, eds., *Medieval Science, Technology, and Medicine: An Encyclopedia*, 232–4. New York: Routledge, 2005.

Dietrich, Albert. "al-Ghāfiḳī, Abū Djaʿfar Aḥmad b. Muḥammad b. Aḥmad Ibn al- Sayyid." In *Encyclopaedia of Islam*, 2nd ed., vol. 12: 313–14. Leiden: Brill, 2004.

– *Dioscurides Triumphans: Ein anonymer arabischer Kommentar (Ende 12 Jahrh. n. Chr.) zur Materia medica; Arabischer Text nebst kommentierter deutscher Übersetzung*, 2 vols. Abhandlungen der Akademie der Wissenschaften in Göttingen, Philologisch-historische Klasse, Dritte Folge, 172–3. Göttingen: Vandenhoeck and Ruprecht, 1988.

– *Die Dioskurides-Erklärung des Ibn al-Baiṭār: Ein Beitrag zur arabischen Pflanzensynonymik des Mittelalaters; Arabischer Text nebst kommentierter deutscher Übersetzung*. Abhandlungen der Akademie der Wissenschaften in Göttingen, Philologisch-historische Klasse, Dritte Folge, 191. Göttingen: Vandenhoeck and Ruprecht, 1991.

– *Die Ergänzung Ibn Ǧulǧul's zur* Materia Medica *des Dioskorides: Arabischer Text nebst kommentierter deutscher Übersetzung*. Abhandlungen der Akademie der Wissenschaften in Göttingen, Philologisch-historische Klasse, Dritte Folge, 202. Göttingen: Vandenhoeck and Ruprecht, 1993.

Dioscorides. *Pedanii Dioscuridis Anazarbei de materia medica libri VII accedunt Nicandri et Eutecnii opuscula medica*, 2 vols. Paris: [Pierpont Morgan Library], 1935.

– *Pedanii Dioscuridis Anazarbei, De materia medica libri quinque*. Edited by Max Wellmann. 3 vols. Berlin: Weidmann, 1906–14. Reprint, Berlin: Weidmann, 1958.

Dioscurides. *Codex Vindobonensis med. Gr. 1 der Österreichischen Nationalbibliothek*, 2 vols. Facsimile ed., with commentary volume by Hans Gerstinger. Codices selecti phototypice impressi 12. Graz: Akademische Druck- u. Verlagsanstalt, 1965–70.

– *De materia medica*. Translated by Lily Y. Beck. Altertumswissenschaftliche Texte und Studien 38. Hildesheim: Olms-Weidmann, 2005.

– *Διοσκουρίδης: περί ὕλης ιατρικῆς = Dioscurides De materia medica. Codex Neapolitanus graecus 1 of the National Library of Naples*. Introductory texts by Mauro Ciancaspro, Guglielmo Cavallo, and Alain Touwaide. Athens: Miletos, [1999].

Draelants, Isabelle, Anne Tihon, Baudouin van den Abeele, and Charles Burnett, eds. *Occident et Proche-Orient: Contacts scientifiques au temps des Croisades; Actes du colloque de Louvain-la-Neuve, 24 et 25 mars 1997*. Réminiscences 5. Turnhout: Brepols, 2000.

Dubler, César Emil. "Diyusḵuridīs." *Encyclopaedia of Islam*, 2nd ed., vol. 2: 349a–350a. Leiden: Brill, 1965.

L'Étrange et le merveilleux en terres de l'Islam. Exhibition catalogue. Paris: Musée du Louvre, Réunion des musées nationaux, 2001.

Ettinghausen, Richard. *Arab Painting*. Geneva: Skira, 1962.

Ettinghausen, Richard, Oleg Grabar, and Marilyn Jenkins-Madina. *Islamic Art and Architecture 650–1250*. 2nd. ed. New Haven: Yale University Press, 2001.

Fahd, Toufic, ed. *al-Filāḥa al-Nabaṭiyya: Al-tarjama al-manḥūla la ilā Ibn Waḥshiyya*. 3 vols. Damascus: Institut français d'études arabes de Damas, 1995.

Ferraces Rodríguez, Arsenio. *Estudios sobre textos latinos de fitoterapia entre la antigüedad tardía y la alta edad media*. Monografías 73. Coruña: Universidade da Coruña, Servicio de Publicacións, 1999.

– "Un corpus altomedieval de materia médica." In Alain Touwaide, ed., *Herbolarium et materia medica (Biblioteca Statale di Lucca, ms. 296)*, 43–53. Libro de Estudios. Lucca: Biblioteca Statale di Lucca; Madrid: AyN Ediciones, 2007.

Fierro, Maribel. "Alfonso X 'The Wise': The Last Almohad Caliph?" *Medieval Encounters* 15 (2009): 175–98.

Forcada Nogués, Miquel. "Síntesis y contexto de las ciencias de los antiguos en época almohade." In Patrice Cressier, Maribel Fierro, and Luis Molina, eds., *Los Almohades: Problemas y Perspectivas*, 2: 1091–1135. Madrid: Consejo Superior de Investigaciones Científicas, 2005.

– *Ética e ideología de la ciencia: El médico-filósofo en al-Andalus (siglos X-XII)*. Colección Estudios Andalusíes 5. Almería: Fundación Ibn Ṭufayl de Estudios Árabes, 2011.

Gacek, Adam. "Arabic Calligraphy and the 'Herbal' of al-Ghâfiqî: A Survey of Arabic Manuscripts at McGill University." *Fontanus: From the Collections of McGill University* 2 (1989): 37–53.

– *Arabic Manuscripts in the Libraries of McGill University: Union Catalogue*. Montreal: McGill University Libraries, 1991.

- "Drugs for Bodies … and Books." In Faith Wallis and Pamela Miller, eds., *75 Books from the Osler Library*, 76–7. Montreal: Osler Library, McGill University, 2004.

Gamillscheg, Ernst. "Das Geschenk für Juliana Anicia: Überlegungen zu Struktur und Entstehung des Wiener Dioskurides." In Klaus Belke, Ewald Kislinger, Andreas Külzer, and Maria A. Stassinopoulou, eds., *Byzantina Mediterranea: Festschrift für Johannes Koder zum 65. Geburtstag*, 187–95. Vienna: Böhlau, 2007.

Garijo, I. Galán. "Al-Gāfiqī, Abū Ŷaʿfar." In Jorge Lirola Delgado and José Miguel Puerta Vílchez, eds., *Biblioteca de al-Andalus*. Almería: Fundación Ibn Ṭufayl de Estudios Árabes, 2012. Vol. 1, 353–5.

- "Ibn Buklāriš." In Jorge Lirola Delgado, ed., *Biblioteca de al-Andalus*, 2: 671–2. Almería: Fundación Ibn Ṭufayl de Estudios Árabes, 2009.

- "Radiografia de una obra inédita de Abū Ŷaʿfar al-Gāfiqī." *Revista del Instituto Egipcio de Estudios Islámicos en Madrid* 29 (1997): 283–95.

- "La Sistematización de al-Gāfiqī." In Pedro Cano Ávila and Ildefonso Garijo Galán, eds., *El saber en al-Andalus: Textos y estudios*, 137–49. Seville: Universidad de Sevilla, 1997.

George, Alain. "Orality, Writing and the Image in the *Maqamat*: Arabic Illustrated Books in Context." *Art History* 35, no. 1 (2012): 10–37.

Al-Ghāfiqī, Abū Jaʿfar Aḥmad b. Muḥammad. *Kitāb al-ʿadwiya al-mufrada, di ʾAbu Ġaʿfar ʾAḥmad b. Muḥammad b. ʾAḥmad b. Sayyid al-Ġāfiqī (XII sec.). Edizione del Capitolo ʾAlif*. Edited by Eleonora Di Vincenzo. Pisa-Rome: Fabrizio Serra, 2009.

Gigandet, Suzanne. *La risāla al-hārūniyya de Masīḥ b. Ḥakam al-Dimašqi: Médicin*. Damascus: Institut français d'études arabes de Damas, 2001.

Grabar, Oleg. *The Illustrations of the Maqamat*. Chicago: University of Chicago Press, 1984.

Graziani, Joseph Salvatore. *Arabic Medicine in the Eleventh Century as Represented in the Works of Ibn Jazlah*. Karachi: Hamdard Academy, 1980.

Grube, Ernst J. "Materialien zum Dioskurides Arabicus." In Richard Ettinghausen, ed., *Aus der Welt der islamischen Kunst: Festschrift für Ernst Kühnel zum 75. Geburtstag am 27. 10. 1957*, 163–94. Berlin: Gebr. Mann, 1959.

Gutas, Dimitri. *Greek Thought, Arabic Culture: The Graeco-Arabic Translation Movement in Baghdad and Early ʿAbbāsid Society (2nd–4th/8th–10th Centuries)*. London: Routledge, 1998.

- "What Was There in Arabic for the Latins to Receive? Remarks on the Modalities of the Twelfth-Century Translation Movement in Spain." In Andreas Speer and Lydia Wegener, eds., *Wissen über Grenzen: Arabisches Wissen und lateinisches Mittelalter*, 3–21. Berlin: de Gruyter, 2006.

Hamidullah, Muhammad. *Le dictionnaire botanique d'Abū Ḥanīfa ad-Dīnawarī (Kitāb an-Nabāt, de sīn à yāʾ) reconstitué d'après les citations des ouvrages postérieurs*. Cairo: Institut français darchéologie orientale du Caire, 1973.

Hillenbrand, Carole. "The History of the Jazīra, 1100–1250: A Short Introduction." In Julian Raby, ed., *The Art of Syria and the Jazīra, 1100–1250*, 9–19. Oxford: Oxford University Press, 1985.

Hillenbrand, Robert. "The Schefer Ḥarīrī: A Study in Islamic Frontispiece Design." In Anna Contadini, ed., *Arab Painting: Text and Image in Illustrated Arabic Manuscripts*, 117–34. Leiden: Brill, 2007.

Hoffman, Eva R. "The Beginnings of the Illustrated Arabic Book: An Intersection between Art and Scholarship." *Muqarnas* 17 (2000): 37–52.

Hoffman, Eva R. "The Emergence of Illustration in Arabic Manuscripts: Classical Legacy and Islamic Transformation." Ph.D. dissertation, Harvard University, 1982.

Ibn Abī Uṣaybiʿa. *ʿUyūn al-anbāʾ fī ṭabaqāt al-aṭibbāʾ*. Edited by Nizār Riḍā. Beirut: Dār maktabat al-ḥayāh, 1965.

Ibn al-Jazzār. *Ibn al-Jazzār on Sexual Diseases and their Treatment: A Critical Edition of Zād al-musāfir wa-qūt al-ḥāḍir – Provisions for the Traveler and Nourishment for the Sedentary, Book 6; The Original Arabic Text with an English Translation, Introduction and Commentary*, [by] Gerrit Bos. The Sir Henry Wellcome Asian Series. London and New York: Kegan Paul International, 1997.

Ibn al-Nadīm, Muḥammad ibn Isḥāq. *Kitāb al-Fihrist*. Edited by Gustav Flügel. 2 vols. Leipzig: Vogel, 1871–72; reprinted Beirut: Khayyāṭ, 1964.

Ibn Murād, Ibrāhīm. "Abū Jaʿfar Aḥmad al-Ghāfiqī fī Kitāb 'Al-Adwiya al-Mufrada': Dirāsa fī l-kitāb wa-taḥqīq li-muqaddimatih wa-namādhij li-shurūḥih." *Majallat Maʿhad al-Makhṭūṭāt al-ʿArabiyya* 30, no.1 (1986): 157–210.

Ibn Wāfid. *Kitāb al-adwiya al-mufrada (Libro de los medicamentos simples)*. Edited and translated with notes and glossary by Luisa Fernanda Aguirre de Cárcer. 2 vols. Fuentes Arábico-Hispanas 11. Madrid: Consejo Superior de Investigaciones Científicas, AECI, 1995–97.

Al-Idrīsī. *Kitāb al-Jāmiʿ li-ṣifāt ashtāt al-nabāt wa-ḍurūb anwāʿ al-mufradāt* (Compendium of the Properties of Diverse Plants and Various Kinds of Simple Drugs). Facsimile edition edited by Fuat Sezgin. 3 vols. Publications of the Institute for the History of Arabic-Islamic Science. Series C, Facsimile editions 58, 1–3. Frankfurt am Main: Institute for the History of Arabic-Islamic Science at the Johann Wolfgang Goethe University, 1995.

al'Išbīlī, Abulḫayr. *Kitābu ʿUmdati ṭṭabīb fī maʿrifati nnabāt likulli labīb* (Libro base del médico para el conocimiento de la botánica por todo experto). Edited and translated with indices by Joaquín Bustamante Costa, Federico Corriente, and Mohamed Tilmatine. 3 vols in 5. Fuentes Arábico-Hispanas 30, 33, 34. Madrid: Consejo Superior de Investigaciones Científicas, 2004–10.

al-Isrāʾīlī, Isḥāq b. Sulaymān. *Kitāb al-aghdhiya (Book on Dietetics)*. Facsimile edition of MS 3604–3607, Fatih Collection, Süleymaniye Library, Istanbul. Edited with an introduction by Fuat Sezgin. 3 vols. Frankfurt am Main: Institute for the History of Arabic-Islamic Science at the Johann Wolfgang Goethe University, 1986.

Joosse, Peter N., and Peter E. Pormann. "Decline and Decadence in Iraq and Syria after the Age of Avicenna? ʿAbd al-Laṭīf al-Baghdādī between Myth and History." *Bulletin for the History of Medicine* 84 (2010): 1–29.

Kádár, Zoltán. *Survivals of Greek Zoological Illuminations in Byzantine Manuscripts*. Budapest: Akadémiai Kiadó, 1978.

Kaegi, Walter E. "Anicia Juliana." In *Oxford Dictionary of Byzantium*, edited by Alexander P. Kazhdan, Alice-Mary Talbot, Anthony Cutler, Timothy E. Gregory, and Nancy P. Ševčenko, vol. 1, 99–100. New York: Oxford University Press, 1991.

Kahl, Oliver. *Sābūr ibn Sahl: The Small Dispensatory*. Leiden: Brill, 2003.

– *Sābūr ibn Sahl's Dispensatory in the Recension of the ʿAḍudī Hospital*. Leiden: Brill, 2009.

– *The Dispensatory of Ibn at-Tilmīḏ*. Leiden and Boston: Brill, 2007.

– "The Pharmacological Tables of Rhazes." *Journal of Semitic Studies* 56, no. 2 (2011): 367–99.

Karabacek, Joseph von, ed. *De codicis Dioscuridei Aniciae Iulianae, nunc Vindobonensis Med. Gr. I, historia, forma, scriptura, picturis*. Leiden: A.W. Sijthoff, 1906.

Käs, Fabian. *Die Mineralien in der arabischen Pharmakognosie: Eine Konkordanz zur mineralischen Materia medica der klassischen arabischen Heilmittelkunde nebst überlieferungsgeschichtlichen Studien*. 2 vols. Wiesbaden: Harrassowitz, 2010.

Kavrus-Hoffmann, Nadezha. "Catalogue of Greek Medieval and Renaissance Manuscripts in the Collections of the United States of America: Part IV.2, The Morgan Library and Museum." *Manuscripta* 52 (2008): 207–324.

Kennedy, Edward S. "Al-Bīrūnī" (or Bērūnī), Abū Rayḥān (or Abu'l-Rayḥān) Muḥammad Ibn Aḥmad." In Charles Coulston Gillispie, ed., *Dictionary of Scientific Biography*, 2: 148–58. New York: Charles Scribner's Sons, 1970. Also available in *The Complete Dictionary of Scientific Biography* at http://www.encyclopedia.com/doc/1G2-2830900460.html.

Kerner, Jaclynne J. "Art in the Name of Science: Illustrated Manuscripts of the *Kitāb al-diryāq*." Ph.D. dissertation, New York University, 2004.

– "Art in the Name of Science: The *Kitāb al-diryāq* in Text and Image." In Anna Contadini, ed., *Arab Painting: Text and Image in Illustrated Arabic Manuscripts*, 25–39. Leiden: Brill, 2007.

Keshavarz, Fateme. *A Descriptive and Analytical Catalogue of Persian Manuscripts in the Library of the Wellcome Institute for the History of Medicine*. London: Wellcome Institute for the History of Medicine, 1986.

Khan, Geoffrey. "The Syriac Words in the *Kitāb al-Mustaʿīnī* in the Arcadian Library Manuscript." In Charles Burnett, ed., *Ibn Baklarish's Book of Simples*, 95–104. London: Arcadian Library in association with Oxford University Press, 2008.

Kitâb al-Diryâq – Thériaque de Paris. Facsimile edition of Paris, Bibliothèque Nationale de France, MS arabe 2964 with commentary volume. Sansepolcro, Italy: Aboca Museum, 2009.

Kuhne Brabant, Rosa, Cristina Álvarez Millán, and Expiración García Sánchez. "Abū Marwān ʿAbd al-Malik b. Zuhr." In Jorge Lirola Delgado, ed., *Biblioteca de al-Andalus*, 6: 352–68. Almería: Fundación Ibn Ṭufayl de Estudios Árabes, 2009.

Labarta, Ana. "La farmacología de Ibn Buklāriš: Sus fuentes." *Actas del IV Coloquio Hispano-Tunecino (Mallorca, 1979)*, 163–74. Madrid: Instituto Hispano-Árabe de Cultura, 1983.

– "El prólogo de *al-Kitāb al-Mustaʿīnī* de Ibn Buklāriš (Texto árabe y traducción anotada)." In Juan Vernet, ed., *Estudios sobre historia de la ciencia árabe*, 183–316. Barcelona: Instituto de Filología, 1981.

– "Ibn Baklarish's *Kitāb al-Mustaʿīnī*: The Historical Context to the Discovery of a New Manuscript." In Charles Burnett, ed., *Ibn Baklarish's Book of Simples: Medical Remedies between Three Faiths in Twelfth-Century Spain*, 15–26. Oxford: Arcadian Library in association with Oxford University Press, 2008.

– "Traducción del prólogo del *Libro de medicamentos simples* de Abū-l-Ṣalt de Denia." *Dynamis* 18 (1998): 479–87.

Langermann, Y. Tzvi. "Another Andalusian Revolt? Ibn Rushd's Critique of al-Kindī's *Pharmacological Computus*." In Jan P. Hogendijk and Abdelhamid I. Sabra, eds., *The Enterprise of Science in Islam: New Perspectives*, 351–72. Cambridge, MA: M.I.T. Press, 2003.

– "Masīḥ bin Ḥakam, a Jewish-Christian(?) Physician of the Early Ninth Century." *Aleph* 4 (2004): 283–97.

Levey, Martin. *Early Arabic Pharmacology: An Introduction Based on Ancient and Medieval Sources*. Leiden: Brill, 1973.

Levey, Martin, and Safwat Souryal. "The Introduction to the *Kitāb al-Mustaʿīnī* of Ibn Biklārish (fl. 1106)." *Janus* 55 (1968): 134–66.

Lirola Delgado, Jorge, and Expiración García Sánchez. "Al-Idrīsī, Abū ʿAbd Allāh." In Jorge Lirola Delgado, ed., *Biblioteca de al-Andalus*, 6: 371–80. Almería: Fundación Ibn Ṭufayl de Estudios Árabes, 2009.

Lorey, Eustache de. "La peinture musulmane: L'école de Bagdad." *Gazette des Beaux-Arts* 6, no. 10 (July 1933): 1–13.

MacKinney, Loren Carey. *Medical Illustrations in Medieval Manuscripts*. Publications of the Wellcome Historical Medical Library, n.s. 5. London: Wellcome Historical Medical Library; Berkeley: University of California Press, 1965.

Maimonides, Moses. *Šarḥ asmāʾ al-ʿuqqār = L'explication des noms de drogues: Un glossaire de matière médicale composé par Maïmonide: texte édité pour la première fois d'après le manuscrit unique avec traduction, commentaires et index par* Max Meyerhof. Cairo: Imprimerie de l'Institut français d'archéologie orientale, 1940. Reprinted, Publications of the Institute for the History of Arabic-Islamic Science. Islamic Medicine 63. Frankfurt am Main: Institute for the History of Arabic-Islamic Science at the Johann Wolfgang Goethe University, 1996.

La "Materia Medica" de Dioscorides: Transmisión medieval y renacista. Edited by César Emil Dubler, Andrés de Laguna, and Alias Terés. 6 vols. Barcelona: Tipografia Emporium, 1952–59.

Mazal, Otto. *Pflanzen, Wurzeln, Säfte, Samen: Antike Heilkunst in Miniaturen des Wiener Dioskurides*. Graz: Akademische Druck- u. Verlagsanstalt, 1981.

La Médecine au temps des califes. Exhibition catalogue. Paris: Institut du Monde Arabe; Ghent: Snoeck-Ducaju and Zoon, 1996.

Meyerhof, Max. "Arabian Pharmacology in North Africa, Sicily, and the Arabian Peninsula." *Ciba Symposia* 6 (1944): 1868–72. French translation: "La pharmacologie arabe en Afrique du Nord, en Sicile et dans la péninsule Ibérique." *Revue Ciba* 48 (1945): 1698–1702.

– "Esquisse d'histoire de la pharmacologie et botanique chez les musulmans d'Espagne." *Al-Andalus* 3 (1935): 1–41.

– "Études de pharmacologie arabe tirées de manuscrits inédits: III. Deux manuscrits illustrés du 'Livre des Simples' d'Aḥmad al-Ġāfiqī." *Bulletin de l'Institut d'Égypte* 23 (1940–41): 13–29.

Mioni, Elpidio. *Catalogo di Manoscritti Greci esistenti nelle Biblioteche Italiane*. Indici e Cataloghi 20. Rome: Istituto Poligrafico dello Stato, 1965.

– *Catalogus codicum graecorum Bibliothecae Nationalis Neapolitanae*, vol. 1.1. Indici e Cataloghi, n.s. 8. Rome: Istituto Poligrafico e Zecca dello Stato, 1992.

Morrison, Robert. "Ḥunayn ibn Isḥāq." In Josef W. Meri, ed., *Medieval Islamic Civilization: An Encyclopedia*, 1: 336–7. New York: Routledge, 2006.

Müller, Andreas E. "Ein vermeintlich fester Anker: Das Jahr 512 als eitlicher Ansatz des *Wiener Dioskurides*." *Jahrbuch der Österreichischen Byzantinistik* 62 (2012): 103–9.

Nassar, Nahla. "Saljuq or Byzantine: Two Related Styles of Jazīran Miniature Painting." In Julian Raby, ed., *The Art of Syria and the Jazīra, 1100–1250*, 85–98. Oxford: Oxford University Press, 1985.

Nutton, Vivian. "Galen of Pergamum." In *Brill's New Pauly: Encyclopaedia of the Ancient World*, vol. 5, edited by Hubert Cancik and Helmuth Schneider, cols. 654–61. Leiden: Brill, 2004.

O'Kane, Bernard. "The Uses of Captions in Medieval Literary Arabic Manuscripts." In Anna Contadini, ed., *Arab Painting: Text and Image in Illustrated Arabic Manuscripts*, 135–44. Leiden: Brill, 2007.

Orofino, Giulia. "Dioskurides war gegen Pflanzenbilder." *Die Waage* 30 (1991): 144–9.

Osler, William. *Bibliotheca Osleriana: A Catalogue of Books Illustrating the History of Medicine and Science*. Montreal: McGill-Queen's University Press, 1969.

Peña, Carmen, et al. "Corpus Medicorum Arabico-Hispanorum." *Awrāq* 4 (1981): 79–111.

Petit, Caroline. "La tradition manuscrite du traité des *Simples* de Galien: *Editio princeps* et traduction annotée des chapitres 1 à 3 du livre I." In Véronique Boudon-Millet, Jacques Jouanna, Antonio Garzya, and Amneris Roselii, eds., *Storia della traditione e edizione dei testi medici greci: Atti del VI Colloquio internazionale, Paris 12–14 aprile 2008*, 143–65. Collectanea 27. Naples: D'Auria, 2010.

Piccirillo, Michele. *Chiese e mosaici della Giordania settentrionale*. Studium Biblicum Franciscanum, Collectio minor 30. Jerusalem: Franciscan Printing Press, 1981.

– *I mosaici di Giordania*. Rome: Quasar, 1986.

– *Madaba, le chiese e i mosaici*. Cinisello Balsamo: Paoline, 1989.

Piccirillo, Michele, and Eugenio Alliata. *Umm al-Rasas Mayfa'ah I: Gli scavi del complesso di Santo Stefano*. Studium Biblicum Franciscanum, Collectio maior 28. Jerusalem: Studium Biblicum Franciscanum, 1994

Pormann, P. "Yūḥannā ibn Sarābiyūn: Further Studies into the Transmission of His Works." *Arabic Sciences and Philosophy* 14 (2004): 233–62.

Qashsh, Idwār, ed. *al-Iʿtimād fī l-adwiya al-mufrada: al-ʿilāj bi-l-adwiya al-ʿarabiyya*. Beirut: Sharikat al-maṭbūʿāt lil-tawzīʿ wa-l-nashr, 1998.

al-Rāzī, Abū Bakr Muḥammad b. Zakariyyāʾ. *Kitāb al-ḥāwī fī l-ṭibb*. 23 vols. Hyderabad: Dāʾirat al-maʿārif al-ʿuthmāniyya, 1955–70.

Rice, D.S. "The Oldest Illustrated Manuscript." *Bulletin of the School of Oriental and African Studies* 2 (1959): 207–20.

Richter-Bernburg, Lutz. *Persian Medical Manuscripts at the University of California, Los Angeles: A Descriptive Catalogue.* Humana Civilitas 4. Malibu: Undena, 1978.

Riddle, John M. "Dioscorides." In *Catalogus Translationum et Commentariorum: Mediaeval and Renaissance Latin Translations and Commentaries*, vol. 4, *Annotated Lists and Guides*, eds F. Edward Cranz and Paul Oskar Kristeller, 1–143. Washington, DC: Catholic University of America Press, 1980.

– *Dioscorides on Pharmacy and Medicine.* History of Science Series 3. Austin: University of Texas Press, 1985.

– "Pseudo-Dioscorides' *Ex herbis feminis* and Early Medieval Medical Botany." *Journal of the History of Biology* 14 (1981): 43–81. Reprinted in his *Quid pro quo: Studies in the History of Drugs.* Collected Studies Series CS367. No. IX. Aldershot: Variorum, 1992.

Robinson, B.W., and Basil Gray. *The Persian Art of the Book: Catalogue of an Exhibition Held at the Bodleian Library to Mark the Sixth International Congress of Iranian Art and Archaeology.* Oxford: Bodleian Library, 1972.

Rogers, Michael J. "Text and Illustrations: Dioscorides and the Illustrated Herbal in the Arab Tradition." In Anna Contadini, ed., *Arab Painting: Text and Image in Illustrated Arabic Manuscripts*, 41–7. Leiden: Brill, 2007.

R[ossi], E[ttore]. "Un Manoscritto del trattato di farmacologia di al-Ghafiqi scoperto dal prof. Tommaso Sarnelli a Tripoli." *Oriente Moderno* 23 (1953): 67–8.

Sadek, Mahmoud Mohamed. *The Arabic Materia Medica of Dioscorides.* Quebec, QC: Éditions du Sphinx, 1983.

Samsó, Julio. *Las Ciencias de los Antiguos en al-Andalus.* Colección Al-Andalus 18, 7. Madrid: Mapfre, 1992. 2nd ed. with addenda and corrigenda by J. Samsó and M. Forcada. Colección Estudios Andalusíes 4. Almería: Fundación Ibn Ṭufayl, 2011.

– "The Exact Sciences in al-Andalus." In Salma K. Jayyusi, ed., *The Legacy of Muslim Spain*, 2: 952–73. Leiden: Brill, 1994.

– "Un rápido recorrido por la exposición." In Juan Vernet Ginés and Julio Samsó, eds., *El Legado científico andalusí: Museo Arqueológico Nacional, Madrid, abril–junio 1992*, 9–21. Madrid: Ministerio de Cultura, Dirección General de Cooperación Cultural, 1994.

Sarton, George. "Review of *The Abridged Version of 'The Book of Simple Drugs' of Aḥmad Ibn Muḥammad al-Ghâfiqî by Gregorius Abu'l-Farag (Barhebraeus)*, ed. Max Meyerhof and Georgy P. Sobhy." *Isis* 20, no. 2 (1934): 454–7.

Savage-Smith, Emilie. "The Exchange of Medical and Surgical Ideas between Europe and Islam." In John A.C. Greppin, Emilie Savage-Smith, and John L. Gueriguian, eds., *The Diffusion of Greco-Roman Medicine into the Middle East and the Caucasus*, 27–55. Delmar, NY: Caravan Books, 1999.

– "Ibn Baklarish in the Arabic Tradition of Synonymatic Texts and Tabular Presentations." In Charles Burnett, ed., *Ibn Baklarish's Book of Simples: Medical Remedies between Three Faiths*

in Twelfth-Century Spain, 113–31. London: Arcadian Library in association with Oxford University Press, 2008.

– *A New Catalogue of Arabic Manuscripts in the Bodleian Library, University of Oxford*, vol. 1, *Medicine*. Oxford: Oxford University Press, 2011.

– "The Practice of Surgery in Islamic Lands: Myth and Reality." *Social History of Medicine* ("The Year 1000: Medical Practice at the End of the First Millennium," special issue edited by Peregrine Horden and Emilie Savage-Smith) 13, no. 2 (2000): 307–32.

– "Tashrīḥ." In *Encyclopaedia of Islam*, 2nd ed., vol. 10: 354–6. Leiden: Brill, 1960–2000.

Scarborough, John. "Sextius Niger." In *The Encyclopedia of Ancient Natural Scientists: The Greek Tradition and Its Many Heirs,* edited by Paul T. Keyser and Georgia L. Irby-Massie, 738–9. London: Routledge, 2008.

Schmitz, Barbara. *Islamic and Indian Manuscripts and Paintings in the Pierpont Morgan Library*. New York: Pierpont Morgan Library, 1997.

Sezgin, Fuat. *Geschichte des arabischen Schrifttums*. Vol. 3: *Medizin-Pharmazie-Zoologie-Tierheilkunde bis ca. 430 H.* Leiden: Brill, 1970.

Silberberg, B. "Das Pflanzenbuch des Abû Ḥanîfa Aḥmed ibn Dâ'ûd ad-Dînawarî: Ein Beitrag zur Geschichte der Botanik bei den Arabern." *Zeitschrift für Assyriologie und verwandte Gebiete* (Strasbourg) 24 (1910): 225–65 and 25 (1911): 39–88. Reprinted in Fuat Sezgin, ed., *Botany: Texts and Studies, III*, 117–208 (Frankfurt am Main: Institute for the History of Arabic-Islamic Science, 2001).

Singer, Charles. "The Herbal in Antiquity and Its Transmission to Later Ages." *Journal of Hellenic Studies* 47 (1927): 1–42.

Stroumsa, Sarah. "Philosophes almohades? Averroès, Maïmonide et l'idéologie almohade." In Patrice Cressier, Maribel Fierro, and Luis Molina, eds., *Los Almohades: Problemas y Perspectivas*, 2: 1137–62. Madrid: Consejo Superior de Investigaciones Científicas, 2005.

Stückelberger, Alfred. *Bild und Wort: Das illustrierte Fachbuch in der antiken Naturwissenschaft, Medizin und Technik*. Kulturgeschichte der antiken Welt 62. Mainz: Philipp von Zabern, 1994.

Tabbaa, Yasser. *Constructions of Power and Piety in Medieval Aleppo*. University Park, PA: Pennsylvania State University Press, 1997.

Takahashi, Hidemi. *Barhebraeus: A Bio-bibliography*. Piscataway, NJ: Gorgias Press, 2005.

Talbot, Alice-Mary. "Xenon of the Kral." In *Oxford Dictionary of Byzantium*, edited by Alexander P. Kazhdan, Alice-Mary Talbot, Anthony Cutler, Timothy E. Gregory, and Nancy P. Ševčenko, 3: 2209. New York: Oxford University Press, 1991.

Tolan, John V. *Saracens: Islam in the Medieval European Imagination*. New York: Columbia University Press, 2002.

Touwaide, Alain. "Arabic Medicine in Greek Translation: A Preliminary Report." *Journal of the International Society for the History of Islamic Medicine* 1 (2002): 45–53.

– "L'authenticité et l'origine des deux traités de toxicologie attribués à Dioscoride: I. Historique de la question; II. Apport de l'histoire du texte." *Janus* 38 (1984): 1–53.

– "La botanique entre science et culture au Ier siècle de notre ère." In *Geschichte der Mathematik*

und der Naturwissenschaften in der Antike, vol. 1, *Biologie*, edited by G. Wöhrle, 219–52. Stuttgart: F. Steiner, 1999.

– "Les deux traités de toxicologie attribués à Dioscoride – Tradition manuscrite, établissement du texte et critique d'authenticité." In A. Garzya, ed., *Tradizione e ecdotica dei testi medici tardo-antichi e bizantini: Atti del Convegno internazionale, Anacapri, 29–31 ottobre 1990*, 291–339. Collectanea 5. Naples: D'Auria, 1992.

– "Les deux traités de toxicologie attribué à Dioscoride: La tradition manuscrite grecque; Edition critique du texte grec et traduction." 5 vols. Ph.D. diss., Université catholique de Louvain, 1981.

– "The Development of Paleologan Renaissance: An Analysis based on Dioscorides' *De materia medica*." In Michel Cacouros and Marie-Hélène Congourdeau, ed., *Philosophie et sciences à Byzance de 1204 à 1453: Actes de la Table Ronde organisée au XXe Congrès International d'Etudes Byzantines (Paris, 2001)*, 189–224. Orientalia Lovaniensia Analecta 146. Leuven: Peeters, 2006.

– ed. *Farmacopea Araba medievale: Codice Ayasofia 3703*, 4 vols. Facsimile edition of Istanbul, Süleymaniye Mosque Library, MS Ayasofya 3703. Milan: ANTEA, 1992–93.

– "Fluid Picture-Making across Borders, Genres, Media: Botanical Illustration from Byzantium to Baghdad, Ninth to Thirteenth Centuries." In Jaynie Anderson, ed., *Crossing Cultures: Conflict, Migration, and Convergence; The Proceedings of the 32nd International Congress in the History of Art (Comité International d'Histoire de l'Art, CIHA), University of Melbourne, 13–18 January 2008*, 159–63. Carlton, Australia: Miegunyah Press, 2009.

– "L'intégration de la pharmacologie grecque dans le monde arabe: Une vue d'ensemble." *Medicina nei secoli* 7 (1995): 159–89.

– "Latin Crusaders, Byzantine Herbals." In Jean Ann Givens, Karen Meier Reeds, and Alain Touwaide, eds., *Visualizing Medieval Medicine and Natural History, 1200–1500*, 25–50. AVISTA Studies in the History of Medieval Technology, Science and Art 5. Aldershot: Ashgate, 2006.

– "*Lexica medico-botanica byzantina*: Prolégomènes à une étude." In *Tês filiês tade dôra – Miscelánea léxica en memoria de Conchita Serrano*, 211–28. Manuales y Anejos de "Emerita" 41. Madrid: Consejo Superior de Investigaciones Científicas, 1999.

– "Un manuscrit athonite du *Traité de matière médicale* de Dioscoride: l'*Athous Magnae Laurae* Ω 75." *Scriptorium* 45 (1991): 122–7.

– "Les manuscrits illustrés du *Traité de matière médicale* de Dioscoride." In *Proceedings of the XXX International Congress of the History of Medicine (Düsseldorf, Germany, 1986)*, 1148–51. Leverkusen: Vicom KG, 1988.

– "Medicina Bizantina e Araba alla Corte di Palermo." In Natale Gaspare De Santo and Guido Bellinghieri, eds., *Medicina, Scienza e Politica al Tempo di Federico II. Conferenza Internazionale, Castello Utveggio, Palermo, 4–5 ottobre 2007*, 39–55. Naples: Istituto Italiano per gli Studi Filosofici, 2008.

– *Medicinalia Arabo-Byzantina*. Madrid: The Author, 1999.

– "Pedanius [1]: Pedanius Dioskorides." In *Brill's New Pauly: Encyclopaedia of the Ancient World*, vol. 10, edited by Hubert Cancik and Helmuth Schneider, cols. 670–2. Leiden: Brill, 2007

– "Persistance de l'hellénisme à Baghdad au début du XIIIème siècle: Le manuscrit Ayasofya 3703 et la renaissance abbasside." *Erytheia* 18 (1997): 49–74.

– "Pharmacology: II. The Arabo-Islamic Cultural Sphere." In *Brill's New Pauly: Encyclopedia of the Ancient World*, vol. 4, *Classical Tradition*, edited by Manfred Landfester, Hubert Cancik, and Helmuth Schneider, cols. 362–6. Leiden: Brill, 2009.

– "Pietro d'Abano sui veleni: Tradizione medievale e fonti greche." *Medicina nei Secoli* 20 (2008): 591–605.

– "Un recueil grec de pharmacologie du Xe siècle illustré au XIVe siècle: Le *Vaticanus graecus* 284." *Scriptorium* 39 (1985): 13–56 + pl. 6–8.

– "The Salamanca Dioscorides (Salamanca, University Library 2659)." *Erytheia* 24 (2003): 125–58.

– "La traduction arabe du *Traité de matière médicale* de Dioscoride: État de recherche bibliographique." *Ethnopharmacologia* 18 (1996): 1–41.

Touwaide, Alain, and Emanuela Appetiti. "Knowledge of Eastern materia medica (Indian and Chinese) in Pre-modern Mediterranean Medical Traditions: A Study in Comparative Historical Ethnopharmacology." *Journal of Ethnopharmacology* 148 (2013): 361–78.

Touwaide, Alain, Natale Gaspare De Santo, Guido Bellinghieri, and Vincenzo Savica. *Healing Kidney Diseases in Antiquity: Plants from Dioscorides'* De materia medica *with Illustrations from Greek and Arabic Manuscripts (A.D. 512–15th Century)*. Cosenza, Italy: Bios, 2000.

Ullmann, Manfred. *Die Medizin im Islam*. Leiden: Brill, 1970.

– *Die Natur- und Geheimwissenschaften im Islam*. Leiden: Brill, 1972.

– *Untersuchungen zur arabischen Überlieferung der* Materia medica *des Dioskurides*. With contributions by Rainer Degen. Wiesbaden: Harrassowitz, 2009.

Velázquez Basanta, Fernando. "Ibn al-Rūmīya, Abū l-ʿAbbās." In Jorge Lirola Delgado, ed. *Biblioteca de al-Andalus*, 4: 497–504. Almería: Fundación Ibn Ṭufayl de Estudios Árabes, 2006.

Vernet, Juan. *La cultura hispanoárabe en Oriente y Occidente*. Barcelona: Arial, 1978. French translation: *Ce que la culture doit aux Arabes d'Espagne*. La bibliothèque arabe, Collection L'Histoire décolonisée. Paris: Sindbad, 1985.

– "Natural and Technical Sciences in al-Andalus." In Salma K. Jayyusi, ed., *The Legacy of Muslim Spain*, 2: 937–51. Leiden: Brill, 1994.

Wallis, Faith. "Review of *Medieval Herbals: The Illustrative Traditions*, by Minta Collins." *Canadian Bulletin of Medical History* 19, no. 2 (2002): 527–8.

Ward, Rachel. "Evidence for a School of Painting at the Artuqid Court." In Julian Raby, ed., *The Art of Syria and the Jazīra, 1100–1250*, 69–83. Oxford: Oxford University Press, 1985.

Weitzmann, Kurt. *Ancient Book Illumination*. Martin Classical Lectures 16. Cambridge, MA: Harvard University Press, 1959.

– *Die Byzantinische Buchmalerei des 9. und 10. Jahrhunderts*. Berlin: Gebr. Mann, 1935. Reprinted with Addenda and Appendix under the same title in Österreichische Akademie der Wissenschaften, Philosophisch-historische Klasse, Denkschriften 243–4 = Veröffentlichungen der Kommission für Schrift- und Buchwesen des Mittelalters, Reihe IV, Monographie 2. 2 vols. Vienna: Österreichische Akademie der Wissenschaften, 1996.

– *Geistige Grundlagen und Wesen der Makedonischen Renaissance*. Arbeitsgemeinschaft für Forschung des Landes Nordrhein-Westfalien, Geisteswissenschaften 107, Sitzung am 18. Juli 1962 in Düsseldorf. Cologne: Westdeutscher Verlag, 1963.

– "The Greek Sources of Islamic Scientific Illustrations." In George C. Miles, ed., *Archaeologica Orientalia in Memoriam Ernst Herzfeld*, 244–66. Locust Valley, NY: J.J. Augustin, 1952.

– *Late Antique and Early Christian Book Illumination*. New York: Braziller, 1977.

– *Studies in Classical and Byzantine Manuscript Illumination*, edited by Herbert L. Kessler, with an introduction by Hugo Buchthal. Chicago: University of Chicago Press, 1971.

Der Wiener Dioskurides: Codex medicus graecus 1 der Österreichen Nationalbibliothek, 2 vols. Glanzlichter der Buchkunst 8. Graz: Akademische Druck- u. Verlagsanstalt, 1998–9.

Wiet, Gaston. *Baghdad: Metropolis of the Abbasid Caliphate*. Norman, OK: University of Oklahoma Press, 1971.

al-Zahrāwī, Abū l-Qāsim Khalaf. *"A Presentation to Would-Be Authors" On Medicine – Al-Taṣrīf li-man ʿajiza ʿan al-taʾlīf*. Facsimile edition of MS 502, Beşiraǧa Collection, Süleymaniye Library, Istanbul. Publications of the Institute for the History of Arabic-Islamic Science. Series C, Facsimile editions 31. Edited with an introduction by Fuat Sezgin, 2 vols. Frankfurt: Institute for the History of Arabic-Islamic Science at the Johann Wolfgang Goethe University, 1986.

Index

Arabic personal names are listed according to *kunya* (Abū l-...) or, if lacking, first name. Exceptions are for persons better known by some other designation. The Arabic particle *al-* is ignored for alphabetization.

ʿAbd al-Laṭīf al-Baghdādī, 55, 65
ʿAbd al-Raḥmān III, Umayyad caliph, 4, 53
Abū l-ʿAbbās al-Nabaṭī (Nabātī?), 62, 73
Abū ʿAbd Allāh al-Ṣaydalānī, 59
Abū l-ʿAlāʾ Zuhr, 55
Abū ʿAlī al-Baghdādī, 59
Abū ʿAlī al-Qālī, 60–1
Abū ʿAmr ʿĀmir b. Sharāḥīl al-Shaʿbī, 59
Abū l-Fatḥ al-Jurjānī, 59
Abū Ḥaddāsh al-Maghrawī, 59
Abū Ḥāmid al-Gharnāṭī, 54
Abū Ḥanīfa al-Dīnawarī, 48n9, 60; source of al-Ghāfiqī's *Herbal*, 15, 24, 35, 57, 58, 74
Abū Harshan, 59
Abū Ḥātim, 59
Abū ʿĪsā, 59
Abū Isḥāq al-Bakrī, 59
Abū Jurayj al-Rāhib ("the Monk"), 35, 58, 60, 73
Abū l-Khayr al-Ishbīlī, 5, 7–8, 53, 55–64, 68n16
Abū Naṣr al-Bāhilī, 60
Abū l-Ṣalt Umayya al-Dānī, 54–5, 65, 71n37
Abū ʿUbayd (or ʿUbaydallāh) al-Bakrī, 53, 59, 76
Abū ʿUbayda, 60
Abū Ziyād al-Kilābī, 59–60
ʿAdnān b. Naṣr ʿAynzarbī, 55

agronomy texts as source of botanical information, 61
al-Aḥjār, Kitāb (pseudo-Aristotle), 24, 58
Aḥmad b. Dāwūd, 59
Aḥmad b. Ibrāhīm, 59
Ahrūn, 58
Alfonso X, king of Castile ("the Learned"), 52
ʿAlī b. Muḥammad, 59
ʿAlī b. Sahl Rabban al-Ṭabarī, 35, 58, 60, 74
Almohads, 4, 51–2, 54, 56, 68n12
Almoravids, 4, 52, 54, 56, 68n11
Álvarez Millán, Cristina, 4, 73
al-Andalus, 4–6, 51-5
Anicia Juliana, 105, 123
Aristotle, 58
Artuqid dynasty, 129–30
al-Aṣmaʿī, 60–1
Avicenna. *See* Ibn Sīnā
Ayurveda, 36

Baghdad: presumed place of origin of Osler MS of *Herbal*, 6, 9, 91
"Baghdad School" of manuscript illustration, 9, 126–7, 131
Badīghūrash, 58, 60
al-Bakrī. *See* Abū ʿUbayd (or ʿUbaydallāh) al-Bakrī
Bar Hebraeus (Gregorius Abū l-Faraj, Ibn al-ʿIbrī), 6, 19, 32n7, 64, 76
Bedouin sources of botanical information, 39–40, 60

Bihnām b. Mūsā b. Yūsuf al-Mawṣilī, 130
al-Bīrūnī, Abū l-Rayḥān, 41, 45, 55, 73
al-Biṭrīq, Yaḥyā b., 58, 60
botany, medical. See pharmacy and pharmacology
Buchthal, Hugo, 126
Bukhtīshūʿ b. Jurjis (Ibn Bukhtīshūʿ?), 58, 74

camphor: illustrations of, 93
Caraka (author of *Saṃhitā*), 35, 38, 58, 73
Chipman, Leigh, 8, 57
cinquefoil: illustrations of, 99–101, ills. 5.15–5.18
Collins, Minta, 92–3, 101, 123, 127, 134
Constantine the African, 90
Constantinople: Hospital of the King, 91; monastery of St John in Petra, 91, 106, 109
Cordoba, 4, 18, 51, 53, 89, 107
Cowley, Arthur, 8
Crateuas of Pergamon, 123, 147n27
Criton, 48n18
cumin: illustrations of, 93–4

Di Vincenzo, Eleonora, 4, 17, 31, 45
al-Dīnawarī. See Abū Ḥanīfa al-Dīnawarī
Dioscorides, 3–5, 8–9, 13, 30, 38, 56, 60, 84–111, 123, 138–40; form and content, 84–7, 90; illustrations, 85, 88–9, 121–3; source for al-Ghāfiqī's *Herbal*, 4, 6–7, 14, 24, 28, 35–6, 43, 58, 72–3, 78–9; translations into Arabic, 53, 88–9, 133; translations into Latin, 88; Vignier-Densmore manuscript, 89
Diyar Bakr, 129–30
Dunāsh b. Tamīm al-Isrāʾīlī, 59

eggplant: illustrations of, 141
Ettinghausen, Richard, 125

Fakhr al-Dīn Qara Arslān, 130
Farès, Bishr, 131
farikon: illustrations of, 109–10; ill. 5.24
"al-Fārisī" (unidentified source in *Herbal*), 57, 59
al-Farrāʾ, 60
Forcada, Miquel, 51
Francis, W.W., 8–9, 20, 24, 28

Gacek, Adam, 9, 142
Galen, 3, 5, 13, 15, 36, 40, 60, 87, 109; source for al-Ghāfiqī's *Herbal*, 7, 14, 24, 35, 36, 38, 43, 58, 72–3, 78–9

Garijo, Ildefonso, 63
al-Ghāfiqī, Abū Jaʿfar Aḥmad b. Muḥammad, 3, 10n7, 72; abbreviations of *Herbal*, 10n14, 63; audience of *Herbal*, 66, 105–6, 123–4; form and content of *Herbal*, 5–8, 22–3, 42; historical context of *Herbal*, 51–71; illustrations in *Herbal*, 7–9, 91–111, 121–43; knowledge of languages, 45–6; Latin translation of *Herbal*, 19; lexical entries in *Herbal*, 7, 42–6, 61–4; manuscripts of *Herbal*, 4, 31; pharmacognostic entries in *Herbal*, 37–8; philological aspects of *Herbal*, 35–50; relation of *Herbal* to contemporary works on simple drugs, 55–66; sources of *Herbal*, 6–8, 35–6, 55–61, 72–83; text of *Herbal*, 35–50. See also Osler Library MS of *Herbal* of al-Ghāfiqī
glossaries. See pharmacy and pharmacology, terminology
Grabar, Oleg, 127
Gutas, Dimitri, 52, 65

Ḥakīm b. Ḥunayn, 59
Ḥakīm Muḥammad b. al-Ḥasan, 59
herbals. See manuscripts; pharmacy and pharmacology
Hermes, 58
Hippocrates, 58
houseleek: illustrations of, 94; ills. 5.3–5.10
Ḥubaysh b. al-Ḥasan al-Aʿsam, 35, 58, 60, 74
humoralism, 38
Ḥunayn b. Isḥāq, 48n18, 58, 60, 74, 88

Ibn ʿAbdūn, 60–1
Ibn Abī l-Bayān, 55, 65
Ibn Abī Jumhūr al-Aḥsāʾī, Aḥmad b. ʿAlī b. Ibrāhīm, 10n14, 19, 63
Ibn Abī Uṣaybiʿa, 3, 5, 7, 19, 72, 74, 139
Ibn al-Baghūnish, 53, 55, 60
Ibn Bukhtīshūʿ. See Bukhtīshūʿ b. Jurjis
Ibn Bājja, 55
Ibn Baṣṣāl, 53, 60
Ibn Baṭṭāl, 60
Ibn al-Bayṭār, 6, 8, 19, 36, 52, 62–3, 67n8, 73, 75, 77, 90
Ibn Biklārish, Yūsuf b. Isḥāq, 5–6, 36, 41–2, 45–6, 55–66
Ibn Buṭlān, 5, 55, 58
Ibn Durayd, 60–1

Ibn Ḥajjāj, 53
Ibn Haytham, 59
Ibn ʿImrān. See Isḥāq b. ʿImrān
Ibn Janāḥ, Yonah, 5, 36, 53, 55, 60, 63, 76
Ibn Jazla, 55, 60, 75
Ibn al-Jazzār, Abū Jaʿfar Aḥmad b. Ibrāhīm b. Abī Khālid, 5, 36, 58, 60, 75, 90
Ibn Juljul, 5, 8, 36, 60–1, 63, 73, 75
Ibn Jumayʿ, 55
Ibn al-Kattānī, 59
Ibn al-Lūnquh, 60
Ibn Māsawayh. See Yūḥannā b. Māsawayh
Ibn Māssa. See ʿĪsā ibn Māssa
Ibn al-Maṭrān, 55
Ibn Maymūn. See Maimonides
Ibn al-Nadā, 59
Ibn al-Nadīm, 139
Ibn Riḍwān, ʿAlī, 8, 55, 58, 75
Ibn al-Rūmiyya, 55, 64
Ibn Rushd, 54–5
Ibn Samajūn, 36, 55, 60, 75
Ibn Sarābiyūn, 58, 74
Ibn Sīnā, Abū ʿAlī al-Ḥusayn b. ʿAbdallāh, 4, 54–6, 60, 88; al-Ghāfiqī critical of, 6, 13, 44, 65; source for al-Ghāfiqī's *Herbal*, 36, 43, 57–8, 75
Ibn al-Tilmīdh, 55
Ibn Ṭufayl, 55
Ibn Wāfid, 53, 55, 60, 65, 71n36; al-Ghāfiqī critical of, 13, 44; source for al-Ghāfiqī's *Herbal*, 5, 36, 60, 76
Ibn Waḥshiyya, 8, 36, 60, 75
Ibn Zuhr, Abū Marwān, 54–5, 70n35
al-Idrīsī, 55–6, 60–3, 65
illustration, botanical, 123–4. See also al-Ghāfiqī: illustrations in *Herbal*; Osler Library MS of *Herbal* of al-Ghāfiqī: illustrations
ʿImrān b. Isḥāq, 59
ʿĪsā b. Māssa al-Baṣri, 24, 35, 58, 61
Isaac Judaeus, Isaac Israeli. See Isḥāq b. Sulaymān al-Isrāʾīlī
Isḥāq b. Ḥassān, 59
Isḥāq b. ʿImrān, 8, 24, 35, 58, 60, 75
Isḥāq b. Sulaymān al-Isrāʾīlī (Isaac Judaeus, Isaac Israeli), 8, 24, 36, 58, 60, 75, 78, 80
al-Iskandarānī, 59
al-Iskandarāniyūn, 59
Isṭifān b. Basīl, 58, 73, 88

al-Jabalī, 59
Jamāl Dīn Muḥammad al-Ḥusaynī, 29

Jazīra (middle and upper Tigris-Euphrates region), 9, 127–31
Johannes Grammatikos, 139

Kahl, Oliver, 6–8, 57, 63, 73, 124
Kerner, Jaclynne, 8–9, 91–2
al-Khalīl b. Aḥmad, 59
al-Khūzī, 59
al-Kindī, Abū Yūsuf, 58, 60, 74
Kitāb al-diryāq, 130–1; ill. 6.4
Kitāb al-filāḥa, 8, 24
Kitāb al-filāḥa al-nabaṭiyya, 8, 58, 60–1, 75, 78, 80
Kitāb al-filāḥa al-rūmiyya, 8, 58, 74

knotgrass: illustrations of, 101–5; ills. 5.19–5.23
al-Kūhīn al-ʿAṭṭār, 63, 65, 70n32
Kushājim, 58–60

Labarta, Ana, 63
Langermann, Tzvi, 51, 66
al-Laṭīnī, 59
lavender: illustrations of, 99, 128, 141; ills. 5.14, 6.1

Maimonides, Moses (Ibn Maymūn), 5, 18, 54–5, 63, 66, 76
al-Majūsī, ʿAlī b. al-ʿAbbās, 58, 60, 74
mandrake: illustrations of, 94, 134–9; ills. 5.11–5.13, 6.9–6.13
manuscripts: Aleppo, private library, 32n7; Cairo, Aḥmad Taymūr Pāshā 389 Ṭibb, 32n7; Cairo, Dār al-āthār al-ʿarabiyya (Museum of Islamic Art) 3907, 4, 31; Cairo, Dār al-kutub al-miṣriyya (formerly Royal Egyptian Library) Ṭalʿat 624, 10n3, 31; Cairo, unidentified collection, 4; Copenhagen, Kongelige Bibliotek Thott 190, 91; Gotha, Universitäts- und Forschungsbibliothek Erfurt/Gotha, arab. 1998, 32n7; Göttingen, Niedersächsische Staats- und Universitätsbibliothek 1998, 32n7; Istanbul, Süleymaniye Library, Ayasofya 3702, 89; Istanbul, Süleymaniye Library, Ayasofya 3703, 89, 91, 94, 99, 101–2, 127; ills. 5.4, 5.8, 5.12, 5.17, 5.20; Istanbul, Süleymaniye Library,

Ayasofya 3704, 88; Istanbul, unidentified collection, 4, 31; Leiden, Bibliotheek der Rijksuniversiteit 1081, 90; Leiden, Bibliotheek der Rijksuniversiteit Or. 289, 88, 132–4; ills. 6.8, 6.14; Montreal, Osler Library 7508 (*see* Osler Library MS of *Herbal* of al-Ghāfiqī); Mount Athos, Megisti Lavra Ω 75, 90, 107; Naples, Biblioteca nazionale *ex Vindobonensis graecus* 1, 94; ill. 5.13; New York, Metropolitan Museum of Art [Rogers Fund] 54.108.3, 131–2; ill. 6.6; New York, Pierpont Morgan Library M.500, 143; New York, Pierpont Morgan Library M.652, 107, 109, 132, 134, 153n88; ill. 6.7; Oxford, Bodleian Library Arab. d. 138, 8–9, 92, 94, 121–3; Oxford, Bodleian Library Huntington 421, 19, 70n27; Padua, Biblioteca del Seminario 194, 106; Paris, Bibliothèque nationale de France arabe 2964, 130–1; ill. 6.4; Paris, Bibliothèque nationale de France arabe 4947, 128, 130, 135–6; ills. 6.2, 6.13; Paris, Bibliothèque nationale de France grec 2179, 89, 94, 99, 101–2, 107–9, 111, 128, 133–5; ills. 5.6, 5.10, 5.11, 5.16, 5.22, 5.24, 6.3, 6.11, 6.12; Paris, Bibliothèque nationale de France grec 2183, 106; Rabat, al Khizāna al-ʿāmma (Bibliothèque générale) Q155, 4, 31; Tehran, Kitābkhānah-'i millī malik 5958, 4, 31, 140–3; Tehran, Dānishgāh-i Tihrān (Tehran University) 7401, 4, 31; Tripoli, Private library, 4, 31; Tunis, Bibliothèque nationale, Fonds Ḥasan Ḥusnī ʿAbd al-Wahhāb 18177, 4, 31; Vatican City, Bibliotheca Apostolica Vaticana Vat. gr. 284, 109; Vienna, Österreichische Nationalbibliothek *medicus graecus* 1, 85, 87–8, 90–1, 99, 101–2, 105–7, 123; ills. 5.5, 5.9, 5.14, 5.18, 5.23; Vignier-Densmore manuscript of Dioscorides, 89

martagon lily: illustrations of, 93; ill. 5.2
Māsarjawayh, 8, 35, 58, 60, 73
Masīḥ b. Ḥakam al-Dimashqī, 35, 57–60, 74
al-Masʿūdī, 60–1
medical botany. *See* pharmacy and pharmacology
medicine, Arab-Islamic, 51–2, 54–5
Meyerhof, Max, 9, 10n3, 18–20, 28–9, 31, 62, 73, 76–7, 91–2, 126
mollusk: illustration of, 141
Morgan, J. Pierpont, 143

Mosul, 126, 129–30
al-Mustaʿīn bi-Allāh, 36

Najm al-Dīn Alpī, 130
al-Naṣrānī, 59
al-Nātilī, al-Ḥusayn b. Ibrāhīm, 88, 133
Neophytos Prodromênos, 106
Niẓāmiyya Madrasa, 122, 126

O'Kane, Bernard, 137
Oribasius of Pergamon, 8, 58, 73, 75
Osler Library MS of *Herbal* of al-Ghāfiqī (B.O. 7508), 3–4, 8–9; binding, 20–1; ill. 1.1; collation, 20; dating, 22–4, 122, 125; illustrations, 9, 28–9, 91–111, 121–43; ills. 5.1–3, 5.7, 5.15, 5.19, 5.21, 6.1, 6.5, 6.9, 6.10; origin and provenance, 9, 29–30, 122, 126–44; ills. 1.11, 1.12; palaeographical and codicological features, 18–27; preservation, 30; relationship to Oxford Bodleian Library Arab. d. 138, 121–3; scribes and scripts, 25–7; ills. 1.2–1.10
Osler, Sir William, 8, 30, 121, 140, 142–3

Paul of Aegina, 35, 58, 61, 73
pear, in the *Herbal*, 77–80
pharmacy and pharmacology, Arab-Islamic, 15–16, 36–8, 56, 87–111; in al-Andalus, 5, 53–66, 89–90; terminology, glossaries, and synonyms, 39–42, 62–4
Pietro d'Abano, 90–1
pimpernel: illustrations of, 93; ill. 5.1
poets, pre-Islamic, as sources of botanical information, 60
pseudo-Aristotle, *Kitāb al-aḥjār*, 58

al-Qāsim b. Sallām, 59
Qīshāwush, 59
al-Quhlumān, 59
Qusṭā b. Lūqā, 8, 58, 74

rabbit: illustrations of, 131–4; ills. 6.5–6.8
al-Rāzī, Abū Bakr Muḥammad b. Zakariyyāʾ, 4, 45–6, 48n17, 51, 60, 73, 79–80; al-Ghāfiqī critical of, 6, 13, 65; source for al-Ghāfiqī's *Herbal*, 8, 15, 24, 36, 43–4, 57–8, 74
Rhazes. *See* al-Rāzī
Ross, Sir Denison, 24

Rufus of Ephesus, 58
al-Rumaylī, 53, 55

Sabūr b. Sahl, 58, 61
Sadek, Mahmoud, 88, 133–4
Saʿeed, Mirza, 11n15, 33n22, 144n3
Ṣāʿid al-Andalusī, 55
Samsó, Julio, 53–4, 60
Sanskrit sources of botanical information, 61
Savage-Smith, Emilie, 51, 63, 66
science, Arab-Islamic: in al-Andalus, 53–5
Schmitz, Barbara, 143
sea-hare: illustrations of, 141
serpent: illustrations of, 142
Shalmawayh, 59
Shandahar, 58
Simon of Genoa, 90
Sindihsār, 58
Sinjar, 129–30
Socrates, 58
Stroumsa, Sarah, 51
al-Sulamī, ʿAbd al-ʿAzīz, 55

al-Ṭabarī. *See* ʿAlī b. Sahl Rabban al-Ṭabarī
Ṭāʾifa kingdoms, 52–4, 56
al-Tamīmī, 75
Thābit b. Muḥammad, 59
Theophrastus (ancient Greek botanist), 48n9
al-Ṭighnarī, 53
Tolan, John, 52, 64
Touwaide, Alain, 6–7, 73
translation movement: Arabic, 39–40, 53, 124; Latin, 52
Tunakābunī Daylamī, Muḥammad Muʾmin, 142
Turner, Percy Moore, 143

Umayyad caliphate, 4, 51–2
ʿUṭārid b. Muḥammad, 59

Vignier, Charles, 143

weasel: illustrations of, 141–2
Weitzmann, Kurt, 123

al-Yahūdī, 59
Yaʿqūb b. Isḥāq al-Isrāʾīlī, 55
Yaʿqūb al-Sikkīt, 60
Yonah b. Janāḥ. *See* Ibn Janāḥ, Yonah
Yūḥannā b. Māsawayh, 8, 24, 35, 58, 60, 74, 78–80

al-Zahrāwī, Abū l-Qāsim Khalaf, 5, 60–1, 63, 76

Back outside cover

Back inside cover

M isbound

Order of leaves (Prof. Meyerhof's letter of 7.vii.38):
2-9 (by a later copyist), 10-11, 19, 12-18, 20-41, 42-3 (seven chs. which, in the abridged version, are in different sequence; but no gap), 44-110, 120, 112-19, 111, 121-2, one or two leaves missing, 123-41, 143, 142, one leaf missing, 144-7, 149, 148, 150, 151-253, 274-7, 254-67, 271, 273, 279, 278, 268-70, 282, 280-1, 283.

He does not mention 150 or 272. W.W.T.

OR. 7.

Complete reproductions of this MS.:
1. Neg. photostats to Meyerhof at Cairo 1938
2. Bibliofilm (in []) to Princeton Univ. Lib do.
3. " , portion (by Dorothy []) to University Library, Uppsala, Sweden, Oct 1952
4. " , negative of preceding kept in E.C.

284 (alt)

لله اسلم

الدخول الى شموقطلو حامز وبيم الجمعة رابع عشر محرم ۸۷
الخروج منه باشاره السلطان اعلم في خامس عشر ذى العقد ۸۶/

الدخول هاسكوى يوم الخميس اى محرم ۸۶/

عبد بعد اوده عرب سوال ۷۹/

احمل سوار ادى في يوم السبت كس ذى القعده
۸۳/

حساب السلاح

رخ	فرس	فيل	فيل	ساه	فيل	يونش	رخ
بلش	درع ولبد	ملش	بدق	بدق	بدق	بلت	اثنين
بدو	بدو	بدو	درع	ونوب	درع	بادق	اف
درع	درع	درع	درع	وطقمه	درع	درع	درع
	ثلاثه					اربع	

ذكر أهل الحبشة بجزف آ‌. كهكم هو الباذنجان من بعض
التراجم‌: كوالف هو الباذورد‌: كوبرا هو الزوفا‌: كوبر
هو الفرفل بالهندية من الجاوى‌: كوبل هو الفلفل أيضا وجاء ببعض
النسخ الكبابل هو الفوفل وهو البندق الهندى وقيل هو اقراص الملك‌:
كونطن وكونطم هو الزنجبيل الهندية من الجاوى‌: كور هو المقل
بالهندية‌: كور الجح هو حجر البسد هو المرجان باليونانية‌: كوز
كندم هو جوز جندم‌: كوزو كبا هو لحية التيس وزعى
البفر من الجاوى قال‌: وهو ذنب الخيل‌: كور هو معا هو الطرخشقون
من الجاوى‌: كوشا هو الكاشم‌: كوشاد هو الخطبانا المعروف
بالشكة وزعم قوم انه النبل القلقطى‌: كوشه هو العطب و هو
العرشة‌: كوكب الارض بعض التراجم انه شجر يصنى بالنيل وقال
بعضهم هذا تصحيف وانما هو صنف زنى بالنيل وزعم ذلك ابراهيم بن كاشه
وبن الجاوى انه الطلق وفى كتاب امبرن انه ملح يحذنيقال لها فنوليا
وقيل هو كوكب ناموس وقال ابو خبفه كوكب الارض نبات وزعموا انه
العطر‌: كوكب ساموس صنف من الاطبان وقد ذكر مع اصناف
الطين بحرف ط‌: كوكاذر اعا تاويله بالسريانية كوكب الارض
من الجاوى قال‌: وهو الطلق‌: كوذرا هو العاقر قرحا ويقال كرار
كولس اسم فارسى ويسمى بالعربية الدمث وهو صنف من الاشنان‌: كولم
هو الفلفل‌: كومينون هو الكمون‌: كوفيزرون هو
البرع‌: كوهيان قد ذكر مع اصناف الكراث بحرف ك ع
تم حرف الكاف وبتمامه تم الجزء الاول من كتاب
الغافقى والحمد لله جق حمده وذلك فى نصف شعبان سنة اربع
ويتلوه فى المجلد الثانى حرف اللام لك‌ فالحمد لله رب العالمين

بالسرياني أنه نحل نحز وقد ذكر كل واحد في موضعه ومن الناس من يسمي
الشاعي بهذا الاسم **كثير الرؤوس** هو النبات المسمى بالیونانیة
بولوقمن وقد ذكر في حرف ب ومن الناس من يسمي الفرصعنة بهذا الاسم
كثير العدد هو وكثیر الزك . **كثیر الورق** هو المزمارون
كبودره هو كف الضبع وهو اسم لطيني . **كشاش** قيل هو
الدرسنه . **كثيله** هو البعصيد . **كنهبل** قال ابو حنيفه
هو شجر عظام وهو صنف من الكلح جعد قصار الشوك . **كبني** زعم
بعض المبرين ان اهل خراسان يسمون الهندبا بهذا الاسم . **كبحر** هو الكندر
وهو النارديه . **كندربل** هي الفلفله الهنديه من الحاوي . **كندز**
هو الخندروس . **كندهستر** هو الفرنجمشك بالهنديه من الحاوي
كنجرس هو الجاورس بالیونانیة . **كبورا** هو الهندبا من الحاوي
كبزرد وبزروت زعم بعضهم انه الشارزه واظنه الكنكرزد
والكنكرزد هو وضع الجمشف . **كنطا** هي الخطانا بالسرياني انه من
الحاوي . **كلبس** هو كامخ يصنع من الاجبان باللبن على ما زعم بعضهم
كبنسا هو الكاشم من الحاوي . **كبست** هو الجنطل بالفارسيه
كبسون من الكثوث . **كنكرزد** موضع الجمشف
والكنكر والعكوب وحوهما من الشوك يعمل للخي وهو الذي يعرفه بعض الناس
بشراب النقي . **كبدار** قيل هو الجندقوقا . **كبلامن** هو الكاشم
بالسرياني انه من الحاوي . **كبلدار** وكاید ان هو السرخس بالفارسيه
ويكتب ایضا كسدان . **كبن** هو النبق على ما زعم بعضهم . **كبه**
هو المصطلی . **كبوه** هو صنف من التوتعات وقد مضی ذكره مع انواع
الينوع في حرف ب . **كجل** هو القطران . **كحله** الناس
يعرفون عند ناس الثوث بهذا الاسم . **كجل** اذا قيل مطلقا فانما يراد به

الوثن بالسريانية من الحاوى: كاودر هو الطرخشقوق بالهندية من الحاوى: كاورن ويقال كاودران معناه بالفارسية حجر البَرّ وهو الحجر الموجود في مزاد البقر المعروف عند الناس بالورش كاول هو كبرات الادم: كاولان قيل انها العشبة المعروفة بالرعيقرا كتبا قال أبو حنيفه هو شجر مثل شجر الغبيراء سواء في ذلك الا انه لا ريح له وله ايضا ثمره صغار كثمر الغبير الا ان ثمر هى المُصطَكى: كباورن هو ورق المنّار من كتاب د نبات قيل هو ثمر الاراك اذا نضج وقبل ما لم ينضج منه عمر كبير العنقود منغير الحبّ فى وجه الكرم و في الفلاحة الكباث نبت يقرب الاراك ويشبهه في اللون والطبع وله حبّ يعقد في اسود يجتنى الكرم ينجى منه حنطة دراهم ويسف مثله سكرا او يجمع عليه من ماء بارد عذب فيسهل البطن

كيا حوارا هى الشوكة البيضاء بالسريانية من الحاوى: كادود هم اللبن من الحاوى: كناروس في كتاب الاغذية كالبنون ان الفرس يسمون بهذا الاسم الشوكة التى يسميها اليونانيسارا ويقال انها الشارية واسم الفازيه بالفارسية الكنكر: كباس هو الحمص الأسود كبامطرايا مفتاح الرمان الذى لا يعقد من الحاوى: كنّا هو نور الجنجبير: كنبار هو ليف الناجيل: كنب هو شويكة صغيرة العيدان كثيرة الشوك لها في اطرافها براعم وقد بدت من كل رعمه شوكات ثلاث منفرقه ويسمى بالفارسية حره: كبث هو صنف من العلس بحبة واحدة في علفه: كنجك هو الكذب ايضا وقد تقدم ذكره كبدانه هو حب الشمنه من الكافى للرازى: كثير الارجل هو البسباج وقال بعضهم هو النبات المسمى غافوبّا: كثير الاضلاع هو لسان الحمل: كثير الرئب هو نبات نبى باليونانية بولغوناطن

لِنَوَازَ اجمن بشرق كَرْدَانَه هوجَبُّ المثان والصحيح كَرْمِدَانَه
كَرْدَامُونَه وكَرْدَمَانَه هذا كله تصحيف وخطا والصواب كَرْم
دَانَه وهوجَبُّ المثان كَرَع اربا معناه بالسريانيه رجل الارنب
وهو النبات المسمى بالبونانيه فلبوذيون من الجادى ذكر الرازى
عن جنين كَرَفْس الجبل وكَرَفْس الفرس وهو الكَرَفْس النَّبَطى
كَرَفْس الجم هو البطراسَالِيُون كَرَفْس الماء هو قرة العين
وقد سمى ايضا هذا الاسم بان اخرفَنَال وهو البطل كَرَفْس بري
من اليابس من يسمى الكبج بهذا الاسم كَرَفْس ماقدوني هو
البطراسَالِيون كَرَفْس وحشى هو البطراسَالِيون ايضا
كَرَفْس هو القطن كَرَفْس قيل هو الرجل الاصغر دَرَش
قيل انه الشكاطراميري وقال **ابوحنيفه** الكَرَش بجير من الحنبه
تنبت فى أودية وتربع نحود زراعه ولها ورقه مدقون حرش اخضر شديد
الخضره وهى مرعى وانما قيل لها الكَرَش لانه يشبه خلها حمل الكَرَش وهى ايضا
كأنها منقوشه وهى من الذكور ومنابته السهل كَرَشام هوفشَر
البلوط عن الرازى كَرَسف هو القطن كَرَكند قيل انه
حجر يشبه الياقوت الاحمر غير انه ليس فى نصاعته ولاحسنه واذا نفخ عليه
النار انكسر والمبرد يعمل فيه علاحفنها كَرَبْرا هو الجمر بالسريانيه
كَرَكيشه هى الضائف كَرَم هو السنور الصغير الذى يعرف
بعمل قَرَش فى كتاش بانجى كَرَكون هو العافر فرجا ويقال
كَزَكُوهن كَرَطابى هو القلماطار كَرَكس هو الدردى
كَرَكب هو صنف من الكافور كَرَم هو الزعفران وهذا
الاسم انما يقع على الزعفران نيران هذا الاسم يقع على الزعفران لاداء اخر وهو
المخصوص المعروف اليوم بهذا الاسم وقد ذكرنا الكرم قبل زعم قوم ان الكذم

الإثمد :: كحل الجلاء والإثمد ايضا :: كحل السودان هي الحبة السوداء المثناة بالفارسية شبرج :: كحل خولان هو الحضض اليماني :: كحل فارس هو الزروت :: كحل الجلا هذا الإثم على السنجار وقد يقال ايضا على لسان الثور وعلى نبات آخر وهو صنف من العيون وهو المعروف بالطلبس واظن ان ابا عن ابو حنيفه يقول الجلا عشبه سهلية تنبث على ساق ولها اغصان قليله ليه وزهر كورز البجان اللطاف خضر وورده جلا ناصع وهي جنه المنظر ومنابها الغلط وهي من الدكوز :: كحلوان يقال على الجلا المذكور قبل هو الشليس ويقال ايضا على الأثمد :: كندرنا هو الفانيزى للطبيعه والبرغث بالفارسية من الحاوى :: كندروس الوس هي الحنط :: كراث الثوم وهو ايضا الثوم الكراثي وقد ذكرناه مع اصناف الكراث :: كراث الكرم هو البرى نيل هو البالي :: كراث البقل هو الكراث البابلي والنبطي وهو كراث رقوق الورق ولا اصول له ولا يوكل الا ورقه :: كراث شامي هو لائد لبي وهو كراث عريض الورق يوكل اصوله كرابا نا هو ثمر الكرم البرى بالسريانيه :: كراى هو الشكاعى بالسريانية من الحاوى :: كريا طافر هو الاذريون بالسريانية :: كرنب الدور يقال على الخاص السنا في الكبير الذي يعرفه بعض الناس الريباس وهي الكرنب الخراساني ايضا ويقال ايضا نبات يشبه الكرنب ياخذ الناس في الدور ولا يوكل :: كرنب الكلب نيل هو فل الكلب :: كرنباد هو الفربياد وهو الكراوبا :: كردمانه هو جنب السار والصواب كزمدانه :: كربسرج الأشه بالفارسية من الحاوى :: ديسان هو الكرم من الحاوى :: كرفين هو المن بالفارسية من الحاوى :: كرخا هو الطرخشقوق من الحاوى يقال الذخي :: كوبل هو نبات

الذهب ۞ كستون هو الباذنجان البري وقد نقدم القول عليه
كف الأسد يسمى بالبونانية عرطنيثا وسنذكر في بابه وزعم قوم
انه الآذريون هو خطا ۞ كف ادم زعم بعض الناس انه البهمن الأحمر
لفا خذما زعم بعضهم انه البخنكشت وزعم بعضهم انه البهمن الأحمر
وزعم قوم انه النيل الزدي وزعم آخرون انه الكرمة البيضاء ۞ كف السبع
ويقال للضبع يقال على اللخ وعلى نبات آخر يشبه الكبيج ولبريه ۞ كف
مريم هو الأصابع الصفر وقد نسمى بهذا الاسم دواء اخر يجلب من مصر ويسميه
بعض الناس ايضا كف الأسد وزعم قوم انه الماميران واهل بلدنا هذا يعرفون
البنطافلون بهذا الاسم اعني كف مريم ومن الناس من سماه البخنكشت ايضا
كف مريم يقال بالكاف والقاف وسنذكر في حرف ق وهو اثر
اليهود وانما سمي كف اليهود لانه يجلب من فلسطين الشام وما يليها وتولد يكون
فيها في الجبن الستة وهذا كانت بلاد اليهود ۞ كف هي البقلة الحمقاء
كف ادم قيل هو صنف من البهمن الأحمر ۞ كف عايشه هو الأصابع
الصفر ايضا ۞ كفرى هو وقر الطلع ۞ كساس هو المحطي من
بعض النقائس ۞ كسبني هو حشيشة الزجاج وهو العوفا واكثر
الناس يجهلها كذلك في حرف الكاف وانما اسمها باليونانية الكني والألف
واللام من نفس الاسم اعني الكني غير ذايدين كما ظن هؤلاء فينبغي ان يكتب اذا
في حرف الألف واللام والكاف وقد يسمى ايضا اللبلاب بهذا الاسم اعني الكني
كشم هو صنف من الفطر يكون ببغداد يؤكل ويسمى بالسريانية دازوبقي
واكثر ما يكون ببغداد ويقال كنك وهونبات مستطيل يخرج من
الأرض لها لولب غلظ ملا الكف في طرفه زهر احمر ۞ ابوحنيفه وذكر
ايضا ان الفلاجبة بمثل هذه الصفة وذكر بعضهم ان الكشخ هو البقلة اليمانية
ايضا والكشخ القسط بلغة اهل السواد ۞ كسبرس هو صنف من الابريسا

هو الصنف الكبير من العروق والصنف الصغير وسنذكر العروق في حرف ع. وإنما سمي هذا الدواء باسم الزعفران لأن له صبغاً أصفر كصبغ الزعفران. **كرگم هو** اسم الزعفران بالسريانية. **كرگماغا** قيل إنه الرامك وأنا أظنه ثفل دهن الزعفران الذي ذكرنا. وسماه قوم وقوم **كرگمان** يقال هذا الاسم على الزعفران وعلى العروق ويقال أيضاً على الجندقوقا. **كرگمونه** هي العروق الصفر من الجاوي. **كرگموشبه** هي العروق والصفر أيضاً. **كرگمونى** هي العروق أيضاً ويقال كزكوني. **كرزود بلوا** قيل هو الاسم. **كرم اسود** موبات ينبى باللطيني پترالله أي فريعة وبالبربرية وبجالون وقد غلط فيه كثير من الأطباء كابن عمران وابن سينا وغيرهما فظنوا أنه الهيوفاريقون ولا أدري لأي شيء زعم ابن وافد أنه البوطانيه وهو خطأ والبوطانيه هو الكرم الأسود وقد ذكرنا كل واحد من هذه فيما مضى. **كرمة شايك** هي الشع وتسمى باللطيني پهوله وهو عشبه يستعملها الصاغون في صبغ الخضر وسنذكرها في حرف ش. **كرمازج** وكرمارك وهو صنف من الطرفا بناني وقيل إنه الأثل والصحيح أنه نوع آخر غير الأثل. **كرم دانه** وكرمدانه هو حب المان وذلك صحيح. فقال علي بن محمد معناه بالفارسية حبه الدود كم هو الدود وانه هو الحب وجهال الأطباء لجهلهم بها يصحفون بها فيقولون الكردمانه وذلك خطأ. وقد ذكرها الرازي في مواضع كثيرة من الحاوي وصح أنها الحبة المسماه بالبوطانيه فوقنديوس وهي الحبة الهندية وأثبت صحة ذلك والحبة الهندية هي المنان ومما جنيت من كتاب جالينوس حب النسا. **كرهن** قيل إنه حجر يشبه الياقوت. **كرويا رومية** وكذا بالفارسية زعموا أنه الفردمانه ولست أدري ما معنى تسميتها بهذا الاسم إذ ليس بين الكرويا والفردمانا مشابهة. **كروبيز** هو العصفر. **كروسغلا** هو لزاق

وبدق ورقه وتستخرج عصارته ويشرب منه قدر أوقية فيقى فاشدًا
ونفع من عضة الكلب الكلب ومنه نوع آخر وهو العم وسنذكره في موضعه

وأما الذي ذكر
الكندي
من ازبزالكم
اذا اكتحل به
جلا الماء النازل
في العين وابراه
فما اظنه اراد
به هذا الكم
الذي نعرفه وقد
يمكن أن يكون
نوعًا آخر من الكم
ويمكن أن يكون
جبشار فانه

تومسيطومطا الاربك

شبه المنان ويستعمل كما يستعمل الكم في خضاب الشعر واصل الكم
اذا طبخ بالماء كان منه مداد يكتب به **كب** أبو خينه هي حمصه

ذات شوك
تنمو اذا اورق
لها وزعموا انها
جيدة لاستر البول
اذا كانت رطبة
اعتصر ماؤها

بالبد مزواه ويتشعب منها شعب كثير وله وورق شبيه بورق السرج
منتظم وارجه هذا النبات شبيه بارجه الجزر وله ثم مستدير قدر
الزيتون العظيم مشوك شبه بالدلب تعلو بالنبات اذا مانها قد بزد
هذا اقوته قوة محلله د وثمر هذا النبات اذا جني قبل ان ينضج جفافه ودق
ورفع في آنا من خزف ثم اخذ منه مقدار طرح ولمر زد فيه بماء فاثر
وضمد به الشعر وقد يقدم غسله بالنطرون افاد الشعر شقرة ومن
الناس من يدقه ويخلطه بشراب ثم يرفعه وقد يتمد بالثمر للاورام البلغمه

ابو حنيفه الكتم من شجر الجبال وهو بعد شب الحناء جفف
ودقه وخلط بالحناء وخضب به الشعر فنى لونه وبقوته قال وقال
بعض الاعراب من السراه الكتم نبات لا ينمو وينبت في اصلب الصخر وامنعه
فتنزل مثل بالخطاطيف الطافاوهو اخضر وورقه كورق الآس واصغر وجنتاه

صعب

لي الكتم
المعروف عندنا
ينبت في السهول
ونموا وورقه قريب
من ورق الزيتون
او ورق الختان وتعلوا
فوق القامه وله ثم
ن قد يجب الفلفل
لخلة نوا واذا
نضج اسود وقد يعتصر
منه دهن بشبه السرج
به في بعض البوادي

كَرَزَةُ الثَّعْلَب

الأرض لونها الى
الحمرة الدموية
كثيرا وعليها
ورق صغير
نصف من
جانب مستن
الجوانب نشر ينغل
متقارب الونه
بين الخضره
والسواد وله
ساق رفيعه

قائمة مدفون على طرفها زائدة قدر املة الابهام صنوبري الشكل فيه نهر
دقيق لونه الى الحمرة وزن دفق دبانة الجبال وهذا النبات اذا النقع في الماء
وشرب ماؤه عرض عنه جلا مشبه السكر مع اخنار وخشونه في الحلو
والصدر وعلاج من عرض له ذلك القى بطبيخ الشبث والرب وماءجا رد
وشيء بعد ذلك دهنا ورب الهب وعصارته بكحلها مع السكر شفى من العشا
ويكحل البصر وذهب غشاوته واذا دق وذرته باتنا وشوى كبد البير ولت
بحبسه والكنحا وفعل ذلك مرارا ابرأ العشا وينال ان هذا النبات
يشفى الخنازير كنباث هو نبات نبت في الماء
القائمة القليلة الجرى يمد وبطول لبث الماء وقضبانه طوال الكبير
تخرج من اصل واحد فيها عند كبير والوزق على العقد محط بها من كل
جانب كثيرة منكائف ورقه هدب خشن المجسه وينال انه
اذا غسل ودق ورش بماء ورد وضمد به قبله الصبيان نفع منها ه

وإن كانت بأبنه طبخ وشرب ماءها بدهن السمسم اى هذا نبات تسمّيه بعض الناس عندنا مأله :: كرّاث ابو جنبه هى شجرة جلبة لها ورق طوال دقاق وخضر ناعمه اذا قطعت هرقت لبنا والناس يسمّون لبنها بوبى بالمحذوم حتى توسّط به منبت الكرّاث فيقيم به وخلط له بطعامه وشرابه فلا يلبث ان يبرا من حرامه ويعمل منه ارشيه اى حبال من قشره ولا نعله ينبت الابدى كها وهو جل الزمران وواد من هدیل

بنا له غزوان لى أظنّه نباتا يا أيت بعض الناس يسمّيه فى بعض الوادى عشبة البلع وفيه مشابهه من نبات المثنان الا انه انعم بكثير والطول ورقا وله قشر صلب متين قوى كثيرالشان يصلح ان يتّخذ منه حبال وهو شديد المرارة وله لبن كثير الا انه ليس بابيض ولا غليظا كلبن اليتوع ورايت اهل تلك الناحيه يزعمون انه اذا اخذ من عصارته اوليه شبر فخلط برات كثيرة ومزّقه دبنه كثيرة وشرب فما بقوة ثمّ يواسهل ايضا ويتع ذلك من الجذام والمتخوليا وعضّها الكلب الكلب

كزبرة الثعلب هو نبات له خيطان له شبطة على

ثالث من كبيكج

رابع من كبيكج

غلظه طولها نحو من
ذراع واصل صغير
ابيض مر الطعم يتشعب
منه شعب مثل
شعب الخرنوب ونبت
بالقرب من المياه
الجارية ۰ ومنه
صنف اخر لونه اقرب
الى القنبرية واطول
ساقا من الاول وورقه
اكثر تشرننا ونبت
كثيرا بالبلاد التى
ينال لها سردوسا
وهو ضربت جدا ومنه
صنف ثالث صغير جدا
كريه الرائحة ولين
زهره شبيه بلون الذهب
ومنه رابع شبيه
بالثالث الا ان لون
زهره مثل لون اللبن
وانواع هذا
النبات اربعه وكلها
قوته حرّيفه

كَبيجْ

بَطْراجْيُون وهو كَبِيكَجْ وهو كَفْنِ البَرِّي

وَيُقال كَبِيكَ وهي شَجَرة الضَّفادع وَيُعرف أيضًا بكف السَّبُع

دب بَطْراجْيُون هو نبات له أصناف كثيرة وقوته جارّة معرّجة جدًا فمنه صنف ودقه شبيه بورق الكزبرة إلا أنه أعرض منه ولونه إلى البياض وفيه رطوبة لزجة وله زهر أصفر ونوا كأن لونه لون الغبرة وله ساق ليست

نوعٌ آخر منه

واخرج جماع البول دحلاً وزهم الطحال واذا احتمل اذا الطمث وقتل الجنين قتلاً قوياً واذا اصمد به مع السذاب والخل قطع الحرب المنفرح واذا طبخ بدقيق الشعير والشراب جلا لحم احات في اسدابها وقد ينفع باخلاط الشيافات المحدة للبصر ومن اخلاط المراهم وقد يحرك العطاس واذا خلط بالعسل واستعط به اخرج الفضول من الراس الى الفم ⦁ الكندس الذي يستعمله الناس عندنا هو نبات له وزق حومز ور وليس اصل لونه الى الغبر وله اصول رقاق سوداوات شعب داخلها ابيض يجمع في شهر حزيران ويوجد بآمد وميافارقين ويخرج عصارتها مطبخاً حتى يصير كالقنا الرطب وهذا هو الذي يسمى البله يستعمله الرماة في صيد الوحش وذلك انه مثل اذا اخلاط الدم وان لم يخالط الدم لمرض كبير ضر ز واما العروق والمعزاه من الجبال التي تنبت بها بجاز وبلدنا الكندس وهو احد اجزاء حداجل للعطار يجلو الكلف الغليظ والبهق وخصوصاً الاسود والبرص وينقى الاذن من الوسخ وينقح شدد المصلى بقوه ويخرج الجنين الميت وهو قوى في ذلك وقد ينفى به السهر في بقوه قويه ويسهل ايضاً وهو من الادويه القتاله اذا المرحن استعماله يمتنع ان يخرج ذمنه لاسنعده في استعمله لما ذكره له ما قبله لان هذا غير ذلك وقد وجدنا ايضاً ذلك الصنف عندنا الكن هذا اعدنا اعرف والترا استعمل واكثر نبات الصنف الاول ارض السماح ⦁

وبكثرة فيه التوابل **المجوسي** صمغ الكندر هو براب الفى وتسمى كنكرزد إذا استقى منه مع السكنجبين والماء الحار أو مع العسل فيا بسهولة **عمره** الشربة منه ثلث درهم **كندس ابن عمران** هو عرق داخله أصفر وخارجه أسود وشجرته تشبه الكندر وهو العائد ارتفاعها

الميزون بياض وخضرة **نطر وبون وهو الكندس**

د نطر وبون هذا الدوا يستعمله غسالوا الصوف لنقيته وهو معرو

ج أكثر ما يستعمل من هذا الدوا أصله خاصة وطعم هذا الاصول طعم حاد جدا يغثى فهو جار يابس المزاج كانه في الدرجة الرابعة ومن شانه ان يجلو وان ينضج ولذلك صار بمنزلة الاشياء الاخر الحارة المزاج

د اصله حريف تقتل البول اذا شرب ورب بخلط بن يهل ينفع من مرض الكبد وعسر التنفس اليرقا و؟ الانصاب والسعال والبرد فان قد يسهل البطن واذا شرب بما يشرب واصل الكبر فتت الحصاة

تكون في الكبد من البرد **الخوزي** الكبر يشفي من النواصير التي تكون في الأذن وينفع المعدة واصله جيد للبواسير اذا ادخن به **الغافقي** الكبر يقطع طيب الفم ويطرد الرياح ويزيد في الباه جيد للبواسير **الرازي** ادام صديق يأكل الكبر الطري فيهجمه ويرى انه اذا اجتف بعصير الكبر من عرق النسا كان موافقا له **البصري** هو رديء للمعدة فان صير زنجا اخل ينفع المعدة **الاسرائيلي** جبه ردي للمعدة ينعش ويضر مرة سوداء وقضبانه اجمد منه **ابن ماسه** الكبر وقضبانه وتفاحه نافعة للطحال واذا اردت اتخاذه فينبغي ان يشق ... ايسا وغسله بماء عذب يازد مرتين او ثلاث ثم خلا... لذلك الا اربعين يوما وبعد ان صب عليه زيت مغسول ... ولامخ الكبر من صلح الكواميخ السخنة للمعدة واقلها ضررا وينبغي ان يؤكل بالزيت قبل الطعام ليسرع انهضامه ولا يبطي في المعدة وهو وصبغ الرأس اذا اكثر منه :: **كنكر** هو القنارية
وهو الحرشف
البستاني
ويقال كنجر
وكنكر **الرازي**
الكنكر غليظ
الجزء مبطئ الانهضام
ينفخ ويزيد في
الباه ويسخن
الكلى والمثانة
واصلاحه ان
يهترا بالطبخ

اكبر من حده قوته واذا كان ذا ذوك كذلك فليس من العجب ان تكون
عصارته تقتل الدود التي تكون في الاذان لمكان مرارتها فاما الكبر الذي
يكون بالبلد الاكبر الخزر ان بمنزلة الكبر الذي يكون في بلاد نهاوند فهو
اشد حدة وجزاه من الكبر الذي يكون عندنا مقدار اربعة اجزاء فيه بهذا
النسب من القوة المحرفة بمقدار اليسير ٮ وقد بلغ فضاء الكبر
وثمره بالملح للاكل واذا اكل اللبن البطن وهو ردى للمعدة معطش واذا كان
مطبوخا خلا كان اطيب طعما منه نبا واذا شرب منه وزن اربعين يوما كل
يوم وزن درهمين بشراب جلا وزما الطحال وبدر البول وسهل الدم واذا
شرب نفع من عرق النسا ومن الآدا المني فوالوسر ومن وهن العضل يدر
الطمث واذا اصنع ذلع البلغم وثمره اذا طبخ باكل وتمضمض به وبطبخه
ٮكن وجع الاسنان وقشر اصل الكبر جا فا واتى الامراض الى ذكرناها
وينقى الفزروج المزمنه الوتخه كاسيه وقد سنحى ورقه نا وخلط بدقيق
الشعير ويضمد به اوزما الطحال ومن لا زبنته المرفض على اصل الكبر يسنه
الآمله نفعه من اتله واذا دق وذنا ناعما وخلط باكل واطبخ على البهى الابيض
حلاه واذا دق وزقه واصله واستعمل ي الحنار ير ولا وزم الصلبة حللها
واذا دق واخرج ماوه وقطر في الاذان قتل الدود المتولد فيها ت والكبر
النابت في البلاد التي يقال لها ينو ي المكار الذي يسكنه الامه الى
يقال لها مازمان يطبخ نفخا مفرطا والكبر النابت في البلاد التي يقال لها
اقلو با بفتح النى ث والكبر النابت في جحر الغلزم والبنى ي لوبيا جرتبف
جلا ٮفظ الفم واكل اللثه حتى سعة منه الاسنان فلذلك لا يصلح
هذا الصنف من الكبر ٮ الطبرى اصله ينفع من الفزروج الرطبة ي
الفم اذا وضع عليها من خا رج واذا طبخ وصب ماوه على الراس الذى فيه
فزروج رطبه نفعه واذا اكل مع الفلفل السذاب نفع من السد الى

جيد الحطب وينبت في أماكن خشنة وأرض ترابها قليل لغلبة الحجارة عليها
وجزائر وخرابات ٦٦ قشر أصل اكبر الغالب عليه الطعم المز وبعد
الطعم الحريف وبعدها الطعم القابض وهذا مما يدل على انه مركب من قوى
مختلفة متضادة وذلك انه بعد يجلو ويغنى وينفج ويقطع لمكان مزارته
وان يسخن ويجلل لمكان جزافته وبجمع ويشد لمكان قبضه ولذلك صار
قشر الاصل ينفع من كل دواء يعالج به الطحال الصلب اذا وضع عليه من خارج
بأن يخلط باضماده احترنا فعه للطحال الصلب واذا وردنا دخل البدن
ايضا بأن يشرب بالخل والعسل او بغير ذلك مما يشبهه او بأن جفف ويحى
ويخلط بهذا وذلك انه يقطع الاخلاط الغليظة اللزجة اذا شرب على هذه
الصفة تقطيعا بينا ويخرجها من البول ومن الغايط وقد تخرج مع الغايط شيا
دموبا يسكن الطحال ويخفف من ثقل المكان وذلك بفعله وجع الورك
وهو مع هذا يدر الطمث وبجذب المكم اذا تعذر غربه وادامضع وينفع من
الملك الذي ينغي في أثر العضلة او في وسطها واذا وضع ايضا قشر هذا
الاصل على الجراحات خبته كما يصنع الضماد فنفعها اعظم منفعه من طرق
انه سد ما احلوها وجففها جلا وجففها قوبا ولذلك ينفع من وجع الاسنان
ومن سنع اذا استعمل مطبوخا بالخل واذا استعمل مطبوخا بالتراب ومزارا
كبيرا يستعمل ايضا وجده ينفع بعض منفع عليه الانسان بمضغه وتد علم ما وصفنا
ازنه من هذه القشر قوة فقطاعه وقوة جلوا ونوة جلل وقوة شد اذا كان
جلو البنوت اذا طلى عليه بالخل وجلل الخنازير والاورام الصلبه اذا خلط مع
الادويه الاخر النافعه لذلك واما ثمر هذا النبات فقوتها على مثال
قوة قشر الاصل منه الا انها اضعف من القشر واما ورقه وقضانه فقوتها
ايضا تلك القوة واذ اعلم ان طلت في بعض الاوقات صلابه الخنازير ن ايام
يسيرة بورق الاكبر وجده وقد خلط مع الورق بعض الاشياء التي يمكن فيها

منها ولها أيضا ذكيه طيبه وفيها وقد لذ لوجهه وهو شديد الخضره وبزر
بزرا بيض ... برج والطعم ترتفع شبرا أو أرجح قليلا
وينبت في الصيف وهي ما ... للشهوه هاضمه للطعام وتؤكل نيه
ومطبوخه وقيل انها تطرد ... الدود وبزرها اذا انسحق ويمزج به مع
دهن الورد نفع من الاعيا ... فارس وهو الكبر

قا ... وهو الكبر

هي شجر مشوكه منبسطه في ارض ... وشوكه مثل السنين على شكل
شوك العليق ولها ورق شكله مثل ... السفرجل مشبه بالزبرنوع شكله
اذا انفتح ظهر منه زهر ابيض ... المنطقه الراصد لا الذي ... طنطلا
اذا انفتح ظهر في جوفه حب ... شبيه بحب الرمان صغار حمر وأمر ... باني

انا لبريا وهو الكرمة البيضاء هذا النبات له اغصان و ورق وخيوط
شبيهه باغصان و ورق وخيوط الكرم الذي يعصر منه الشراب الا انها كلها
اكثر زغبا و يلتف على ما يقرب منه من النبات و يعلق به خيوطه و له
ثمر شبيه بالعنافيد م ح خ اطرافها فى اول ما انطلع تؤكل على ما جرت به
العادة و وقت اربع من طريق انها تنفع المعدة بقبضها و فيها مع القبض
من ان تبير وجرافه و لذلك صارت تدرالبول باعتدال فاما اصل النبات
فقوته قوة تجلو و تجفف و تلطف و تحمر النجم انها معدلة و لذلك صارت
تذهب الطحال الصلب اذا شرب و اذا وضع من خارج ايضا كالضماد مع التبن
و هى فى مثال العنافيد فينفع بها الداعون ح يخلق بها شعر الجلود و قلوب
هذا النبات نى او ما ينبت نظيف و تؤكل فيدرالبول و تسهل للطمث و قوته
ورقه و ثمره و اصله و اجاده جزبيه و لذلك اذا تضمد بها مع الملح تنفع من
الشروج المتماه جرونيا و الفروج المتماه عارضا و المتماه قا غاديها نفاء و المتماه
صا رونفيا و اصله اذا اخلط بالكرسنه و الجلبه غلظ ظاهرالبدن و نقاه و صقله
و ذهب بالكلف و الثآليل المتماه اخوس و البثور اللبنيه و الاثار المتولده العارضه
من ادمال الفروج و ان طبخ بدهن حتى تصير مثل الموم تنفع من هذه الاوجاع
و يبلغ الخصف و المد و النواصيب النى فى المقعدة فان ضمد به طلا برد الورم
و نجر الاورام الحاره و جبر العظام و ان طبخ بالزيت حتى يهزاً وانفذ ذلك
ايضا وقد تذهب بكمنه الدما العارضه فيما دون العين و اذا تضمد به مع
الشراب نكر فى الداخر و قد جلل الاورام و نجر الدبله و اذا تضمد به اخرج
العظام و قد يقع فى اخلاط المراهم التى تاكل اللحم و قد يشرب منه فى كل يوم
مثقال درخى للصرع و اذا استعمل ايضا هكذا نفع من الفالج المتنى او فلسا و من
السدد و اذا شرب ادرالبول و قد جعل منه مخلوطا بالعسل لعوقا للمحنفين
و الذين قد نفسهم و الذين بهم السعال او وجع الجنب او شدخ فى العضل

الزائد بها للصداع وقد يضمد به رطبا وايبسا ويمنع الاورام الحارات
واذا اخلط وهو ممحوق بالخل والزعفران ودهن الورد والمر وضمد به نفع من
الجرب المتقرح في ابتدائه ونفع اللثة والفروج الخبيثة العارضة في
العروج وقد يبغي خلط الشياف ات التي تحمل قطع الدم وقد يضمد به مع السيفران
وهو السويق والشراب لسيلان الفضول الى العين والتهاب المعدة واذا احرق
في جرته موضوعه على جمر كان صالحا لوجاع العين وبرء مع الخل الحاذق
واظفار واللثة المنزرخه التي يسيل منها الدم والشراب الذي يتخذ من عنب
الكرم البري اسود قابض ينفع من يسيل لمعدته وامعائه فضول وانما
هذا لمن الآلم التي يحتاج فيها الى القبض **كرمة بيضاء** يسمى
جالب الشعر ويسمى بالفارسية هزارجشان والسريانيه فاشرا ويقال فشرا

أملينا الشبيه الى ورق النبات المسمى سملقس وأغصانه أيضا كذلك الا ان
ورق هذا النبات وأغصانه أكبر وقد لمس هذا النبات على ما قرب
منه من الشجر ويعلق بخيوطه بالعناقيد خضرة ابدا كونها سوادا اذا
نضجت واصلها ظاهرا اسود ولون داخله شبيه بلون الخنثى يفسر ح
وهو مثل النبات الذي ذكرناه قبل الا انه اضعف منه وقلوب
هذا النبات اذا ما انبتت يطبخ ويوكل نبول ويدر البول والطمث ويجلو الاورام من الطحال
ويوافق الصرع والفالج المسمى باورسير واصل هذا النبات له قوة شبيهة بقوة
أصل الكرنبة البضاء ويصلح لما يصلح له ذلك غير أن قوة الاصل
أضعف من قوة ذلك الاصل ورق هذا النبات اذا اضمد به مع التراب
وافق أعراب الحمى اذا انفرخت وقد يستعمل أيضا هذى لالتواء العصب ك

كسطيون ويقال أيضا كستيون وهذا النبات الذي يعرفه
الناس بالباذنجان البرى ومن الناس من سماه قصفان ومنهم من سماه
حصفان ومنهم
من سماه حولا
ودوليون ومنهم
من سماه افارى
وهو نبات ينبت
في أرضين
وغدران قد
جفت وله ساق
طولها نحو من
ذراع عليها
زغب يشبه ندف

وبعطون منه واذا اشرب منه كشين يوماً في كل يوم مدة ثلث ابولسات
اكل خلل وورم الطحال وقد يضمد به مع التين لورم الطحال فينفع به وقد يطبخ
ويجلس النسا في طبيخه فينقي ارحامهن وهذا الطبخ يخرج الجنين ايضاً وقد
يخرج عصارة الاصل في ايام الربيع ويشرب العصارة مع الشراب المتخذ بالقراطي
لما دصعنا وبهل لحما والمرصا لج للجرب المتفرج والذي لبس بمفرج واذا
لطخ بها او ضمد بها وساق هذا النبات اذا استخرجت عصارته ويخبث مع
حنطه مطبوخه ادرت اللبن غيره عصارة هذا النبات اذا اشرب منه قيأت
قيئاً جيداً مسهلاً واخرج بالقئ اخلاطاً غليظة :: **كرمة سوداء**
يسمى بالفارسية سندبار وبالسريانية فاشرشتين وهي المعروفة بالبرطانيه
انبا لس ثايا هو نبات له ورق شبيه بورق اللبلاب المتين فنوس بل هو

اثا اس بايا وماكا موكلة الكرمة السودا

وقضبانه بقوة وزرق وقضبان الكرم الذي يعنصر منه التراب وقال
وأصل هذا النبات اذا طبخ بالماء وشرب بقوانسين من التراب المعمول
بماء البحر اسهل البطن طبوخ ماءبه وقد يعطى منه المحموم وقد ينتفع بالملح
وزرع هذا النبات في اول ما ينبت ويصلح للاكل د او ثو وهو ثمره

الكرم البرى اذا كانت مرضه ينبغى ان يرفع بنى اناء من خرف غير مقير
بعد ان يجمع ويوضع في ثوب نظيف ويجفف في الظل وقد يكون منه جيد
ببلاد سوريا وليبيا وفوسنى وفحما وقوه هذه الزهرة قابضه ولذلك اذا
شرب كان جيد للمعده وبد الابوال مساكه البطن ويقطع نفث الدم وهو صالح
للمعده التى يعرض فيها الكرب ويحمض فيها الطعام وتخلط بالجلاء ودهن الورد وببل

دا قال قبضاً واثمل خروجاً ٮ‍ كَرْم بَرِّي ٮ‍ انبالس اغريا هو نبات يخرج اعصاناً طوالاً اشبه باغصان الكرم الذي يعترض منه التراب خشبه خشبيه متعلقه النشر وورق شبيه بورق عنب الثعلب البستاني الا انه اعرض منه واصغر وزهر شبيه بحب الطحلب وثمره شبيه بالعناقيد الصغار لونها احمر اذا انضجت وشكل الحب مستدير وماله ٮ‍ د ٮ‍ وهو صنفان وذلك كَرْم بَرِّي

انّ منه ما لا يعقد عناباً ابداً وانما يحمل زهراً وهو المسمى اوثنا ومنه ما يعقد حبّاً صغيراً احمر واسود فيه قبض ح‍ وعناقيده لها قوة تجلو حتى انها تذهب النمش والكلف وجميع ما هذا سبيله وفيه مع هذا دباغه

وذلك ايضاً اطرافه التي تكبس وتحفظ ٮ‍ د ٮ‍ واما العناقيد لها قوة تغسل وتنقي الكلف والدرن وتنضج ظاهر الجلد نضجاً سريعاً وما اشبه ذلك من الآثار وقال ٮ‍ د ٮ‍ وورق هذا الكرم وخيوطه

من الماء واثوا هو صنف من الطير اذا املتحت كبده وجففت وشرب منها
محلولا بالشراب المنى ادرو مالى اخرج المثيمه وفتت حصاه المثانه وقال
ابن حنا انوا هو النغر قال وكبد صورا اذا وضع على الموضع المتاكله
من الانسان نكر وجها صورا زعم جنين انه الورع وقيل هي العظايه وهو
اصح قال والقنفد البرى اذا اخذت كبده وجففت وخرفه فى سمن
 و افقت الجبن اللحمى وسايرما يوافقه وجه :: **كلى**
السقنقور يشرب لحركه الشبو وقال ان اشد الاشياد مضاده لها
بزر الحر اذا شرب بالماء وقوم اخرون يزعمون ان ماطبح العدس اذا شرب
نفعل نعاط الذكر

وهذا نشرح ما وقع فى هذا

الباب من الاسماء

كاو فى الحاوى انه عود الكادى وهاسم هندى وقال **اربسيما**
الكازو عود جلب من بلاد الهند ولا بعد ان يكون المغاث الهندى **كاربا**
هو الكهربا وقد ظن قوم ان الكاربا غير الكهربا باجلاسهم وزعموا ان
الكاربا هو صمغ الجون الرومى وقد ذكرنا الكهربا قبل **كافور** هو
من الطيب معروف وقد تقدم ذكره والكافور ايضا قشر الطلع وهو الكزرك
والكافون ايضا نبات ترنعيه ايضا القفط ويقال كافون :: **كاشر**
هو الشيح من بعض الناس :: **كاسر الحجر** هو بزر القلب :: **كاسر**
قرباي زعم قوم انه البرشاوشان :: **كاشم** هى الحيط الهندى
من الجاوى :: **كابج** هو عنب التعلب الذكر وهو المعروف
بجبل الهم وسباى ذكره مع اصناف عنب التعلب :: **كاوذر**
هو الطرخ **كاما** هو شجر المغازل من الجاوى **كاماى**

كثيراً نفعت من حريق النار جداً **كبد** اما كبد الكلب فقد ذكر قوم من اصحاب الكلب انها ان شربت او اكلت نفعت من نهشة الكلب الكلب وقد رايت قوماً كلوها وعاشوا ولكنهم لم يقصروا عليها وحدها بل استعملوا معها ادوية اخر ما نحن نرى نهشة الكلب وبلغنى ان قوماً ان قصرو واعلى كبد الكلب وحدها ونقوا بها فما ماتوا فى اخر الامر :: واما كبد الماعز فان قوماً يشووها وياخذون من الماء الذى ينظر منها فيكحلون به اصحاب العشاء وامروهم ايضاً ان يفتحوا اعينهم ويكبوا على هذه الكبد حتى يدخلها الدخان الذى يرتفع منها اذا شويت ويزعمون ايضاً انها نفع من به صرع وكثير من اذا اكلت وبثلون ان كبد البئر ايضاً يفعل ذلك :: واما كبد الورغ فقد ذكر قوم انه اذا وضع فى الاضراس المتاكلة نفع من وجعها :: واما كبد الذئب فقد فتّت انا مراراً منها كثيرًا فى الدواء المتخذ بالغافث النافع للكبد ولكن لم اجرب ان هذا الدواء ازدادوه بهذا الكبد اذ اقتنه بالذى عملوا من هذه الكبد وقال ميامن فى الميامر انى قد جرّبت كبد الذئب تجربه بالغه وذلك بان يبخوا وينسفى منها مثقال واحد مع شراب حلو وينفع من كل مزاج يحدث بالبدن من عين ان يضر الحار والبارد لان منفعته جملة جوهر فان كان العلل حمى طنّتها فالاجدار ان يسقى بماء بارد ثم كبد الحمار اذا طبخ او اذا شوى فا لطوبه السايله منه اذا اكتحل بها وافتح العشاء واذا فتح السان عينيه للدخان المصاعد منه فى الطبخ فانه نفع مثل ذلك واذا اكل مشوياً فعل ذلك وينال ان كبد الماعز اذا اكله من به صرع وليستما كبد النثر نفعه :: وكبد الخنزير الذكر رطباً كان او يابساً اذا اسحق وشرب بشراب ينفع من نهش الهوام :: وكبد الكلب القتل فيه مستفيض انه اذا شوى واكل نفع الذى عرض له الفزع

والبهق واذا اخلط مع الرانسج واكل ابرا لسعه العقرب واذا اخلط بالخل ينفع من
مضرة سم الثنين المحرى واذا اخلط بالنطرون ونعليه البدن نكن الحكة
العارضة فيه واذا اخذ مقدار فوجلادبون وشرب بالماء او بيضه حسوا نفع
من المزقان قدصلح للزكام والنزلة واذا ذرّ على البدن قطع العرق واذا
لطخ على النقرس مع النطرون بالماء بالعسل والخمر ولطخ على شقوق الاذان
ابراها ٠ كلس ح النون وهو الجير ٠ ابن سينا النون هو رماد
الاجنام الحجرية والخزفه اك ارسطو وقد يعمل على هذه الصفه يوخذ صدف
الجوار الذي ينال له دروس المحرى فيصير بنار من نور زمجى ويترك فيه ليله
فاذا اكاد ان من عند نظر اليه فان كان مضوط البياض فلمخرج من النار او من النور
والافرد ثانيه ويترك حتى يشتدّ بياضه ثم يوخذ ويغمس في ماء بارد ثم
اجعله في نخان ليله ثم تخرجه من عند وقد نفث غايه النغيث وترفع ويعمل من
اناء المحجار التي ينال لها وخلا فن وفي ما زعم قوم محجار مستندين بالطبع
مثل الفهود ويعمل ايضا من زدى الرخام والذي يعمل من الرخام نقدم على سائر الكلس
خ اما النون التي لم يصبها الماء فحره وحرا شديدا احى انها تحدث
في الموضع قشرة صلبه محرقه ثم من بعد يوم او يومين يعل اجزافها ويغل احداثها
للقشر المحترقه فاذا ذامرت عليها الايام لم يحدث قشرة محرفه اصلا الا انها
بعد جد ما ستخن ٠ ويدي بالنحر فان غنلت النون انسلخ لذلك بحرها فى الماء وصار
ما وهذا الماء المعرون ف ماء الرماد وصارت هي تحفف بلا لذع فان
غسلن مرة ثانيه او مرار اشنى صارت لا لذع فيها اصلا وصارت تحفف
تجفيفا شديدا من عير ان تلذع د قوه كل كلس ملهبه ملذعه محرفه
كوى فاذا خلط مثل الشحم او الزيت كان منضحا ملينا محلامدملاوينبغى ان
نعلم ان الكلس الحديث الذي لم يصبه الماء افوى من الكلس الحديث الذي اصابه
الماء ٠ عيبوه ٠ والنون تقطع نزف الدم من الجراحة واذا اغسلن بالماء مرارا

ابر شبنا هو صمغ كالسندن وسر مكسره الى الصفرة والباصر ولذلك يسمى كهربا اى ينالب اللبن بالنارنبيه ٥ وقد يقال ان الذي يسيل من صمغه الجوز الرومي في النهر المسمى اسطورن جنبى النهر فيكون منه هذا الدواء الذى يسمى المقطرن ومن الناس من يسميه حزوستوفورون وهو الكهربا وهو اذا فرك فاحت منه رائحة طيبة ولونه مثل لون الذهب. واذا شرب منع من المعدة والامعاء سيلان الرطوبات ·· **غبره** الكهربا بارد يابس قابص قاطع للدم من اى موضع كان اذا شرب منه نصف مثقال بماء بارد ولذلك يجبس البطن والغى ويمنع الطلب من الرأس الى الرية وينفع من الكنر والرجل وينفع من الخفقان العارض من الصفراء والدم ومن قبل المعد ومن اوجاع المعدة ·· **كبريت الحوتى** له نوعان اصفر وابيض واجودها الاصفر ٥ الينبوغى ان يعلم ان اجوده ما بقرب من النار وكان صافي اللون صلبا لبس بحجر واما ما قرب منه من النار فينبغى ان يجتاب منه الاحمر الذى فيه دهنه وقد يكون كثيرا فى المواضع التى ينالها مبلص والموضع من الجزيره التى ينالك لها يبار ط كل كبريت وفيه قوة جلاء لان مزاجه وجوهره لطيف ولذلك صار بغاوم وبضاد كل ذوات السموم من الهوام واستعماله يكون بان يسحن ويعجن بالديمونى او بزيت عتيق او علك البطم ويوضع على موضع النهسه وقد يشفى به الجرب والعله التى ينشر معها الجلد والقوابى واذا اعوجت به مع علك البطم فيبرئ بها مرارا كثيرة لانه يجلوا ويقلع هذه العلل كلها من غير ان يدفع شياً منها الى عمق البدن ٥ والصنف الاول يسحن وخلا ويصج وينفع من السعال ويخرج القيح الذى فى الصدر سريعا واذا اصير به سمنة وجبى او دخن به نفع من الربو واذا تدخنت به المراه طرحت الخنى واذا خلط بجمع البطون فلع للجرب المتفرح والقوابى والآثار البيض العارضه فى الاظفار واذا لطخ به بز ابيض مع الخل فلع ايضاً الجرب المتفرح

وبترقوه الحوراوي المنترج وما ذكر ان جالينوس من قوة الكهربا الجوز الرومي خلاف عظيم كغثوه الكهربا والكهربا صنفان منه ما يجلب من بلاد الروم والمشرق ومنه ما يوجد بالاندلس في غرناطه عند سواحل البحر بجنب الارض واكثر ما يوجد عند اصول الدوم ويزعم جمال الناس ان لذلك الموضع كانت قبور الفديم وان ملوك الروم كانوا يذيبونها ويصبونها عليهم لانها تحفظ جثه الميت وتبدي صورته بشفافها وهذا القول كذب فان المواضع التي يوجد فيها ليس فيها اثر القبور واكثر ما ينفع في القراحات وجمعها الجراحات ويوجد قطرات كالصمغ وهي اجتن واصفى واصلب من المشرقيه واقوى فعلا واخبرني الجنبياتها رطوبه تقطر من ورق الدوم وذلك ان الدوم في هده الناحيه عند طلوعه من الارض يقطر منه رطوبه شبيهه بالعسل يكون منها هذا الدواء وقد يوجد في داخلها الذباب والبر والمسامير والحجا رة

كنبات

كهربا

الناس يزعمون أنه صمغ الجوز الرومي ويغلطون في ذلك وينسبون هذا القول
الى د و ج ومن فرط ح قول ح في الجوز الرومي وفهم علما بغناءات
لا يرى أن الكهربا بصمغه الجوز الرومي وإنما قال ذلك بعد أن
ذكر الجوز الرومي ونقال إن ما يسيل من صمغه هذه الشجر في نهر اسطوس
يجمد في النهر فيكون منه الكهربا فقد بين أن الكهربا شي آخر يوجد في نهر
اسطوس ويقال أنه يكون فيما يسيل في ذلك النهر من صمغ الجوز الرومي وقد
ذكر قبل ذلك صمغ الجوز الرومي وذكر قوته ومنفعته وأخبرني
من رأى هذا النهر في بلاد الروم في داخلاد ذنبه وعند مدينة يقال
لها ابرماش وهي واقعة افريجه وعلى هذا النهر قال شجر من جوز الخلاف
ينشر اطرافه دائما وبقطر منها رطوبة دهنته وللروم فيه احاديث ويقولون
هي نبات فلان الملك سكرع اهنا نياما فأما ح في كتابه صمغه
الجوز الرومي وهي الكهربا وليست اشك أن قوله وهي الكهربا وهو قوله

وهذا الشراب يحتاج الى ان يبقى سنين كثيرة فانه ان لم يبق عليه ذلك لم يكن شرابا وتخير العنب فتختزن وتحرز وقد يعمل منه خلوطا بالمضاد للاورام الحاره والاورام الصلبه واورام المذى وطبخه اذا احتقن به نفع من قرحه الامعاء والانتهال المزمن وسيلان الرطوبه المزمنه من الرحم وقد تجلس النسا فيه وتحقن به في ارحامهن وحب العنب الذي يخرج من الخمر هو باردجيد للمعده واذا اقلى وتحو وشرب كما يشرب السويق وابر قرحه الامعاء والانتهال المزمن واستمرخا المعده حرو عجم الزبيب يجفف في الدرجه الثانيه ويبرد في الدرجه الاولى وجوهر جوهر غليظ ارضى كما قد علم من طعمه اذ كان يوجد عياصا عفص المذاق والمجنه والتجربه ايضا تدل على ذلك منه اذ كان لا نفع غا يا به المنفعه لاسطلاق البطن واما الزبيب فقوته قوه تنضج وتجلل

ل الاسود

تجليلا معتدلاً ده والابيض من الزبيب هو اشد قبضا وجرم الزبيب اذا اخرج عنه حبه واكل وانوا فضيه الريه وينفع من السعال وينفع الكلى والمثانه واذا اكل الزبيب وحل بعجمه نفع قرحه الامعاء واذا اخذ لحمه وخلط بدقيق الجاورس وبذر وفلى بعسل واكل هكذا وخلط به ايضا فلفل جذب من لغم بلغم واذا خلط بدقيق الباقلى وكمون وتضمد به سكن الاورام العارضه للانثيين واذا خلط وهو ممحوق بالشراب وتضمد به سكن ما يظهر في الجلد وتسمى استيلاس وهو الدماميل والجدرى والقروح الميناه عنقرانا والسرطان واذا تضمد بمع الجاوشير وافى النفرس واذا الزق على الاشار المنحزكه اسرع قلعها . عنب الزبيب نافع للمعد والكبد والمثانه واجوده ما كان كبارا احلوا ث علي بن محمد الكشمش بالفارسيته زبيب صغير لا نوى له جلوشد ببا حلاوه بلون ييابس وخراسانى حلو شديد الحلاوه والخراسانى اجود من الفارسى لانه اشد حمره واصدق حلاوه وعنبه طوحلا وعنا قبده طوال رقاق ومقدار الذراع ث الرازى الكشمش بشبه الزبيب الا انه النبى

من المثانه والرقه والحلاوه وغير ذلك والمتروك بعد القطف من
او ليله خير من المقطوف في يومه وهو جيد الغذا مقو للبدن وهو شبيه بالتين
في قله الرداه وكثره الغذا وان كان قل غذاء منه والمقطوف في الوقت
منضج والنضيج اقل ضررًا من الفج واذا المزمهم العنب كان غذاؤه نجائبًا وغذاؤه
حاله اكثر من غذا عصيره ولكن عصيره اسرع نفوذًا وانحدارًا **دم** واما
انفاذوز وهو عصان الجرم ينبغي ان يستخرج قبل ان يطلع نجم الكلب وتشمس
في آناء من بخاتر اجمن مغطى بثوب ولا يزال الى ان يجد كله وينبغي ان
تخلط ما جمد منه ما لم يجد بعد فاذا كان الليل يرفع الاناء من تحت السماء
فان الاندا يمنع من ان ينجم العصان فاختتم منهما كا ان اصفر بالحمره سهل
الانفراك يقبض قضا شديدًا وليمنع النار ومن الناس من يطبخ العصان وبعدها
بالطبخ وقد ثبتوا في مخلوطه بالعسل وبالشراب جلول للعضل الذي عن جنبي اللسان
واحلق واللهاه والفلاع واللثه الرخوه واللثه التي يسيل اليها الفضول والاذان التي
يسيل القيح اليها واذا اخطبت بالخل وافقت للنواصير ولقروح المزمنه والفروج
الخبيثه التي ستعتي في البدن وتنحقن بها لقرحه الامعا ولسيلان الرطوبه
المزمنه من الرحم واذا احتجر بها احدث البصر وافقت خشونه الجفن واكل
الماقي وشرب لنفث الدم العارض قد يا من اختز ان بعض العروق وينبغي ان يستعمل
وقد مزجت بالما حتى يرق وتضعف مائيته ويستعمل منها التي السير لا يها تحرف
اجزا قابضا شديدًا واما الشراب الحصرمي فانه ينتخ على هذه الصفه ، يوخذ
العنب ولم ينجز نضحه بعد وفيه من ان ثمره ثلثه ايام او اربعه
حتى يذبل ثم يعصر ويوخذ من عصارته ثلثه اجزا وملقى عليه من عسل منزوع
الرغوه جزو ويلقى في الدنان ويتمن وقوه هذا الشراب قابضه وهو مقو للمعده
بارده
نافع لمن عسر انهضام طعامه وللمعده المسترخيه وللمراه الرخا ولمزيج المفاصل
الذي يعرض فيه رطوبه ورخاوه ويقال انه ينفع الامراض التي تعرض في الوبا

بوحده أو مع سويق الشعير ينكن الورم الحار العارض للمعدة والإلتهاب العارض لها وعصارة الورق ينفع الذين بهم فرحة الأمعاء والذين يبصقون الدم والذين يشكون من معدهم والحوامل من النساء وخيوط الكرم إذا نفعت بالماء وشربت فعلت ذلك أيضا ودمعة الكرم هي شبهة بالصمغ تجمد على القضبان وإذا شربت مع الشراب أخرجت الحصاة وإذا خلطت ولطخ بها إبرات القوابي والجرب المتفرح والذي ليس متفرح وينبغي إذا أجيج إلى اللطوخ بها أن يقدم بغسل العضو بالنطرون وإذا مضغ بها ورق جفت الشعر وخاصته الدمعة الجتمعه من قضبان الكرم الطريه إذا أحرقت ونجت منها الدمعه ثم مزج العفر وهي التي إذا لطخ ليالث ليال للمنماه فرمدا ذهبت بها ورماد فضار الكرم ورماد خبر العنب إذا أضمد به مع الخل أبرا المقعد التي قد قلع منها بواسير نائته وأبرا النواء العصب وقد ينفع من شبه الافعي وإذا أضمد به مع مدر ورد وسلاف وخل نفع من الورم الحار العارض للطحال ٠ الكرم الذي يفلح نوته قوته الكرم البرى إلا أنها أضعف ٠ وأما انطوقولي وهو العنب فما كان منه جديدا فإنه كله يسهل البطن وينفخ المعدة رما كان منه شابا يرا من ذلك الا ان اكثر مافيه من الرطوبة قد جفت وهوجيد للمعدة ومنهض للشهوة ويصلح للمرضى ٠ وأما العنب الجنبى الخير والجنى الجزار فإنه طيب الطعم جيد للمعدة يعقل البطن ويضر بالمثانة والأرانب ويوافق الذين ينفثون الدم والعنب الذي يصبرى العصير شبيه به ٠٠ وأما العنب الذي يصبري الطلا الذي يسمى اكسما وينى الشراب الحلو فهو ردى للمعدة وقد تقدم ترتيب العنب تركيس بماء المطر فيكون بعده شي من قوة الشراب وهو يقطع العطش وينفع من الحميات المزمنه ٠ للرازى العنب ينفخ قليلا ويطلق البطن ويخصب البدن سريعا ويزيد في الأنعاط وهوجيد للمعدة ولا يسد فيها كما يفسد سائر الغوا له ٠ ابن سينا الابيض من العنب أحمد من الأسود إذا أنا وبابه سائر الصفات

شبيه بورق المنّ دجوش
وطعمها لزج كطعم
التّين الصغار الغض
جفّف ودقّ وشرب
بالماء نفع العقرب
فيسكن على المكان

كرم بستاني
انبالس

ابو فورس الكرم
الذي يعصر منه الشراب
وورقه
وخيوطه
اذا نعما
ونضمد
بها
سكنا
الصداع
والورم
اذ كان
باردا
فابضا
فاذا
نضمد

انبالس او بوفورس وهو الكرم البستاني

من الكما نطوس ثلاثـ... له ادل... وهو نبات له ورق دقاق يبيض عليها زغب أصفر وساق خشنة بقم... وصغير وزهر صغار على الأغصان وزراجه هذا الصنف ايضا يشبه راجه شجر... بزر الصفيز ايضا يشبه بقوة الصنف الأول والصفا... لاند... **كروان** فلاة البادي و قيل نبات آخر ثم البادي... **الصلاحه** البقله الترجه وقد نسمي بأذن جزوه وتسمى ايضا القلقله

كروا

جزانها وهي بقلة طيبة الطعم والريح وزهنا يخرج على الأرض بلا ساق وشبه أن تكون مدبرة ورأيته تدبر وفي أسفله تشريف قليل لونه ناقص الخضرة

فيضى ورائحته وطعمه رائحة قشر الأترج وطعمه مع عطرية عجيبة وهذه البقله تؤكل وهي جاز جيده لغذ المعد والقلب مطيبة للنفس سيمة للبدن تحلل تجد الدبا المحبه مضاده للسموم وخاصته سم العقرب وسنع من الخفقان البارد منفعة عظيمة واذا ما يحدث جرحه في البدن صداع على الراس

بغونس الحشيشه المسماء الفارسية كروا نسمه وخاصتها نفع الفوائد ودفع العم **كسبوا المسعودي** في كتاب السموم فانه في حشيشه نبت منبسطة على الأرض مدور يكون قطرها قدر شبر وزها

صفة الشابه

التدبير وذلك أنه من التجفيف في الدرجة الثالثة ومن التسخين في الدرجة الثانية وإذا شرب ورق هذا النبات مع الشراب الذي يقال له أذرومالي الأربعين يوما منثواليه أبرأ عرق النسا وقد نفع منه

لعلة الكبد وعسر البول ووجع الكلى المعصر وقد يبعون طبخه لضرر النيم الذي يقال له اقرسطون وقد ينال هذه العلل التي ذكرنا اسم دخنة من طبيخه وقد خلطه سوذ فينفع به واذا اذن ونحى وخطوهى ح وأخذ لبن البطن وإذا اخذ بنوا البجاتر وازنج شرب اسهل الزمن وإذا وضع على الذي الحاسية حلج حيبها واذا اصبد به مع العسل ازوالجراحيان ومنع النمله ان تسعى في البدن وقد يكون صنف اخر من الكما فطوس له اغصان طولها نحو ذراع في خلقه الاذخر دقيقة الشعب وورق زهر شبيهان بورق زهر الصنف الاول من الكما فطوس وبز راسود وراجة هذا الصنف من الكما فطوس ايضا شبيهة برايحة الصنوبر وقد يكون صنف اخر

خالانيطس وهو كانيطن

نوع ثاني منه

وبالجمله لمن يحدث في كبده السدد بـ‍هوله وهو مع هذا الجدن الطمث اذا شرب مع عسل واذا احتمل من اسفل ونفع ايضا ان ادرار البول وبعض الناس يبغي لمن به وجع الورك بعد ان يطبخه بماء العسل وما دام طريا فهو يسعد ان يلصق ويمل الجراحات الكبار وان يشفي الجراحات المتعفنه وان يحلل الصلابه التي تكون

منه

وتفشيع بلوط الأرض ح ح حاما ذروبس قد ينبت في اماكن خشنه ضيقه وفي
تخيره صغيره طولها جزمن شبر ولها وزق صغار شبيهه في شكله وترتيبه
بوزق البلوط من الطعم وزهره لونه الي الغرفين به صغار وينبغي ان يجمع هذه
العشبه وثمرها فيها بعد ح ح ن هذه الشجره الغنيه المزه وفيها يوهذ اجيده
وذلك مما يدل انه قد اجتني بتن وريبل الطحال اذا داناا بول الطمث ويقطع
الاخلاط الغليظه وينفيه السدد الحادثه في الاعضا الباطنه فلوضع الا
ن الدرجه الثالثه من درجات التجفيف والاحار على ان اتخاذه اكثر من
تجفيفه وله قوه د ولها قوه اذا اشربت طربه ومطبوخه بما ان ينفع في شدخ اطراف
العضل والسعال وجنا الطحال وعسر البول وابتدا الاستسقا و يديرا الطمث
وجدر الجنين واذا اشربت باكل حلت ورم الطحال واذا اشرب بشراب وصمك
كانت صالحه لنهش الهوام ويمكن ايضا ان تنخن وتعجن وتجفف ويستعمل للعلل
التي ذكرناها واذا اخلطت بالعسل نقت الفروج المزمنه واذا انعجف وطبت
بزيت واكتحل بها ابرات مرجحه العين التي يقال لها اطمور واذا الصح بها
استخنت ح ح ه واما شراب لكما ذروبس فصنعه مثل صنعه شراب الزوفا
وهو منحن محلل ينفع من الشيخ والبرفان ومن البغض التي تكون في الرحم ومن ابطا
الهضم ومن ابتدا الاستسقا وكل ما عنا كل راوود ** كمافيطوس**
د ح حاماطيس هو من النبات المتناثف منذ في كل عام وقد يسعي في الارض
نباته والي الاغصان ما هو وله وزق شبيه بوزق الصغير من النبات لتي ينال
لها جي العالم الا انه ادق منه ومنه رطوبه تندي باليد وعليه زغب وله
كنف على اعصانه وفيه نشيج وله اجنحه شبيهه باجنحه شجر الصنور ورءوس
دقيقه اصغر واصوله شبيهه باصول النبات التي يقال له النبال ومجدرون ح ح الطعم المز
اقوي من مذاقه هذا النبات من الطعم كاد الحرتيع وفعله ان ينبع و ينتح
الاعضا الباطنه اكثر مما يتبها لذلك مما انفع الادويه لمن به ورقان

الطمث. واذا شرب وانفع عرق النسا وسكن النفخ العارض فى المعده وبذر العرب
يحرك الجشا ويشرب خاصه للجبن واذا احتمى ددة واما الشراب المتخذ ببزر
الكرفس فمنه صفته يوخذ من بزر الكرفس الحديث متحوا وانحوا سبعون
درهما وتصير فى خرقه ويلقى فى جره من عصير وتترك تلثه اشهر ثم يروق ويعى
فى اناء اخر وهذا الشراب بقتل الشهوه وينفع المعده ويوافق من به عسر البول
وهو سريع التحلل من البدن كذلك يصنع الشراب المتخذ من بطاراسا لبون
وثوته كغوثه غبيں اذا اذى الكرسم وزق الكرفس وذلك به سى
الحكام نفع عظم من الحكه منفعه عظمه ‪:‬ كماشير المجوسى هو صمغ
يشبه الجاوشير جاز بالدرجه الرابعه بحلل الرياح من المعده والامعاء
ويدر البول والحيض ويسقط الاجنه ‪:‬ ابن ماسويه حار يابس فى الدرجه
الرابعه يطرح الولد ويسهل المأ بقوه ‪:‬ بدغورش لا مثل له فى اسقاط الجبن
واسهال الماء ‪:‬ غلطا بن وافدى هذا الدواء غلطا فتحا وهو من بعد غلطه وفحه
فانه اضاف القول فيه الى بزر الكتان ذلك ان هذا الدواء وقع فى الجاوى
عقب الكتان ‪:‬ كمادريوس اصله بالبونانيه خامادريوس

وبزره اذا اشرب بالشراب الذي يقال له انومالي اجذر الطمث واذا اشرب او تلطخ به اسخن المبرودين ونفع من تقطير البول واصله يفعل ذلك ايضا ومن الكرفس البري صنف آخر يقال له مرسون وهو الكرفس الطبري ينبت بالبرية ثمرته تشبه ساق الكرفس وفيها شعب كثير وورق اوسع من ورق الكرفس وما يلي الارض من ورقه موشح بالخارج وفي الوسط دطوبة وتدبق بالبدن وهو صلب طيب الرايحة مع حدة وطعم ورقه مثل طعم الادوية ولونه الى الصفرة ما هو وسط الساق اكليل شبيه باكليل الشبث وله بزر شبيه ببزر الارنب لونه اسود حريف رايحته كأنها رايحة المربعيناء وله اصل حريف طيب لان له ليزر كثيرالماء يندفع الحك عليه فشرح خارجه اسود وداخله اصفر الى البياض ما هو وينبت في مواضع صخرته على طلول * هذا نبات من جنس الكرفس الستاني والجبلي وهو اقوى من الكرفس البستاني واضعف من الجبلي ولذلك صار يجذب الطمث والبول ينخن ويجفف في الدرجة الثالثة فاما الذي من البلاد التي يقال لها ملفا ويسميه اهل البلد الكرفس الجبلي فهو هذا النبات الا انه افلحده من هذا او من الكرفس الجبلي فهو لذلك يمكن ان يوضع على الجراحات لانه يجففها تجفيفا لا اذى معه وهو مهذا جلل المواضع التي يحدث فيها الصلابه واما عند ذلك من جمع فونه دهني على مثل قوة الكرفس البستاني والكرفس الجبلي ولذلك صرنا نستعمل بزره في ادرار الطمث والبول ونفخ مدا واه النزول * قوة ثمره واصله وفرعه مسخنة وقد يعمل ورقه بالملح ويوكل ويعقل البطن واذا اشرب اصله وانتهش الهوام وسكن السعال وابراء عسر النفس الذي يحتاج معه الى الانتصاب وعسر البول اذا انضمد به حلل الاورام اللثمة و حسان كونها والاورام الحارة والاورام الصلبة ويصلح لعلاج الجراحات في جايها الى ان تلتثم واذا حك واجعله المرأة اسقطت الجنين وبزره يوافق وجع الكلى والطحال والمثانة وخرج المشيمة وبذر

ان ظنّ انّا وراسا سوزلا ينبت لابن الصحون ومن الكرفس صنف آخر
نبتى بالبوانته بطرا سالبون و نسبين نسين كرفس الجز وهو الذى يعرفه الاطباء
بالطرا سالبون هو الكرفس الجبلى الماقذون وهو المقدّ ونس د قد نبت فى
البلاد التى يقال لها ما قدونيا وبنت فى ما زن صخر يه فا يّه وله بزر شبيه
بالانخاه غير انه اطيب را يحه منه واشدّ جزا فه وهو عطر الرا يحه ح
انفع ما فيه هذا البزن خاصه وجمله النبات مع ورقه وقضبانه شبيه بالبزر
الا انّ فوه هذا اقل من قوه البزر وكان طعمه حريف كذلك هو فى قوه
جار قطاع وبهذا النسب صار يجدّ را البول والطمث وجلا ل النفخ و ينفى بها
وان كان كذلك فهو فى الدرجه الثالثه من درجات الاشيا المسخنه
المجففه د مدر للبول والطمث ونافق تنفخ المعده والمعا الذى يقال له قولن
والمعصر اذا اشرب ونافى ايضا وجع الجنب والكلى والمثانه وقد يقع فى اخلاط
الادويه المدره للبول والادويه المركّبه ويتّخذ منه شراب كما يتّخذ من الاذخر
وقوته كقوته ، ومن الكرفس صنف آخر يقال له افقينا بيون وبعضهم يقال
كرفس الجبل وهو الكرفس النبطى والكرفس المرّيء والكرفس المشوى
والكرفس العريض ويسمى بالبر به بحسس ويخلط فيه اطباء فظنون انه
البطرا سالبون وهو خطا د هو اعظم من الكرفس البستانى لونه الى البياض ما هو وله
ساق اجوف طويل ناعم كان فيه خطوطا وورقه اوسع من ورق الكرفس البستانى
ونحوه وورقه يميل ايسر الى الجزء الثانيه وله جمه شبيهه بجمه النبات المسمى
لاسوطوس مملوه زوسا يفتح وبطهر فيها زهر وبزر لونه اسود مستطيل مضمت
حريف فيه رايحه عطريه وله اصل ابيض طيب الرا يحه طيب الطعم لبن يغلظ
وينبت فى المواضع المظلله بالنجر وعند الآجام ويستعمل اكله كاستعمال الكرفس
البستانى وهو يوكل اصله مطبوخا ونبّا وتقطّع الورق والقضبان وتوكل
وربما طبخ مع السمك والى وقد يجعل بالملح د هو اضعف من الكرفس المستعمل

وأدوية النعال والنبات الذي ينال له اوساليس وهو الكرفس الثابت
في الماء وهو اعظم من الكرفس البستاني وقوته مثل قوته :: قسطس الارض
يهيج القيء والباه وينال لبول الدم ويجلب اليه :: مسيح ينفح سدد الكبد وبضر
من بوله اذا الصرع وما دفعت ابن ماسه يغني الدم وينفح سدده ويحلل الرياح
والنفح التي تحدث في المعده :: ابو حنج كبد البارده :: ابن زرين
يذهب جشا وينفع عصيرا وفقه من الحمى التي تكون من البلغم اذا شرب
وجل أدمع عصير وزوق الزاز اب... الزازي ينبغي أن يجتنب اكله
اذا اخيف من لدغ العقارب وقات... في لاعنيه أنه يكثر اللبن وأن
اكثار المراضع حمله اورث المرضع صرعا :: ابن عمران يوسع النفس و من
خاصته انه بتفتيح طرق والفضول يجذب الى المعده والزاير والارحام زطوبات
رديه ولذلك صار مضرا اصحاب المساو والاجنه التي في الارحام وقد
قيل إن الحامل اذا اكثرت أكله اورث الجنين شورا رديه وفروجا عفنه
الاسرائيلي زعم بعض الاوايل ان الكرفس الرعى الجبلي جميعا مضر بعل
منهوم لانها نطرف قان النمر وفصلا انه الى الغلبه بسرعه وخاصته اذا تقدم الكرفس
قبل الدواء المسموم او كان زمن يسير لأنه يفتح المجاري ويطرف السم فيوصله
الى القلب فاذا اخذ بعد ان يضعفه فربما كان له قوه تطفيه وقد فع ضرر
ومن الكرفس صنف اخر يسمى ازميون والذي يعرف عندنا سواك
العباس ويسميه اهل مصر واهل صقليه الطرخون د هو نبات له ساق طولها
نحو من شبر يخرجها من اصل دقيق وعلى الساق اغصان صغار وله زوس مثل
الفونيون الا انها اذ اكبيره ومنها ثم نستطل خريف طيب الريح يشبه
بالكمون وينبت في حجور في امكن جليه ح ج هو اقوى من الكرفس
المستعمل د وقوته ثمره و اصله اذا شرب بالشراب مدرا للبول قد يدران
الطمث وينفعان في اخلاط الادويه المركبه والادويه المسخنه ولكن ينبغي

صنف السذاب الكوهي

صنف آخر وهو الكبير

الذي الحار وإذا اكل
نيّاً أو مطبوخاً
ادّرّ البول
وإذا شرب
طبيخه مع اصوله
نفع من اوجاع
الفالج وحرّك
القي ويعقل
البطن وبزره
اشدّ ادراراً
للبول منه
وينفع من نهش
الهوامّ ويشرب
المرداسنج وجلاء
النحر وينفع
في اخلاط
الادوية المكتّبة
للاوجاع والادوية
المركّبة
لضرر ذوات
السموم والهوامّ

غالينُس الماذريوس والكلكاس

نقثا الكنس

فمنها الرومي وهو الكرفس البستاني المعروف عند جميع الناس ح خ يبلغ من اسخان الكرفس انه مدرّ للبول والطمث ويحلل الرياح والنفخ وخاصة بزره د خ سالوس اما اين هذا النبات يوافق كلما يوافقه الكرفس فاذا تضمد به مع الخبز او السيتون سكن اورام العين الحارة والتهاب المعدة وسكن اوجا م

ممزوج أو بماء الرمان وان شرب من عصير قضب أربع أواقي قتل ويزرها يمنع الرعاف واذا لُطِّخَ عنك الطرى قلع الدم واذا ذُرَّ على موضع الدم قطعه وهو يقوي القلب وينفع وخاصته المراقة وينقعه تقطع الانعاظ وان قلع اصل الكزبرة كما هي لطعا ان يُغرَس لا يزيب من عروقه شي وعُلِّقَ على فخذ امراة اسرعت ولادتها جالينوس في السابعة من الادوية المفردة الكزبرة وضفهم هاهنا بشوكران وبالبنج والادوية التي تحدثه بالبرد وكل ذلك منهم جاليندس انه ليس ممكن ان تنفع الشك في شي من الادوية المفرطة القوة كما لا يشك احد في برد الشوكران ولا في حرارة الفلفل والعاقر قرحا وانما ينفع الشك في ادوية هي قريبة من الوسط فلو كانت الكزبرة في الحرارة في مفعولها من البرد لم تنفع في امر هاشك ولا خلاف فاذا البين ما تفعله الكزبرة ما تفعله بافراط تبين بها ليس قوله حجة وذلك ان كثيرا من الادوية الحارة تفعل لحوم ما تفعله الكزبرة كالزعفران والذي يظهر من فعل الكزبرة من شرب من عصارتها انما هو جنون وفساد فكر ونوم كثير وقد يمكن ان يكون لما يصعد عنها الى الرأس من بخارات رديه فاما من زعم انها تمنع صعود البخارات فكذب وزور والحس والتجربة يشهدان بالكذب ولهم واظنهم اتى فايده واشاء على اعتقادهم الفاسد بانها في غاية البرودة والاشبه ان تكون هذه كسه كما ذكر بن سينا وان كان البرودة غالبة عليها فليس منها في الغاية وفيها مع ذلك كفيه رديه تمته وان جرم الكزبرة في موضع جارة دون مادة وفي التجربة التي تبين منها فعل الدواء المبرد لم نجد لها نفع البرد فعلا ما وقد يكون كزبرة برية هي شبيهة بالبستانيه وهي أدق ورقا وأجَلُّ وبزرها كبزرها الا انه ملصق مزدوج تنان تنان وهي اقوى من البستانية في افعالها وأزدى كفيه واكثر تمته ان خلط ماؤها بعسل وزيت ينفع من البثر الخارج بالدم الغليظ ∴ كرفس اصنافه كثيرة

التي تكون فيها لهب وإنما يشفي الجمرة التي قد خمدت وبردت وأنت تقدر
أن تعلم أن الكبريت بعيد عن أن يبرد من أنه قال د نفسه في كتابه
وذلك أنه زعم أنه يحلل الخنازير ولا لجيبه شك في أن الأدوية الباردة ليس
منها شي يحلل الخنازير د ح قودبون له موه مبرده ولذلك إذا ضمد به مع الخبز
أو النوى أبرء الجمرة والنمله وإذا ضمد به مع العسل والزيت أبرأ الشرا وورم
البيضتين الحاد والنار الفارسيه وإذا ضمد به مع دقيق الباقلى حلل الخنازير
والحركات وبزر إذا أشرب منه شي يسير يسخن أخرج الطول من الرءود وولد
المنى وإذا أشرب منه شي كثير خلط الذهن ولذلك ينبغى أن يجلد من كثـ
شربه وأدمانه وما الكبريت إذا أخلط بالاسفيداج والمرداسنج والخل ودهن
الورد ولطخ على الأورام الجار إن كان الملتهبه الظاهرة في الجلد نفع منها ابن سينا
ما نابها بإزده خالطها جوهر لطيف جاز خالطه اسرع مفارقته لها و قد
قال قوم ان جالينوس نفى البرد عن الكبريت معاند للدسقوريدس
وقد شهد ببرده روفس واصطيغانس وعيرها وعندى أن اليابسه ما بله الى
أن نضج يسيرا ولعل تحليل الكبريت للخنازير خاصيه فيه ولا ن فيها جوهرا
لطيفا غواصا ينفذ ويعوض ولا يغوص الجوهر البارد وإذا تحلل الحار
بسرعة ويبقى العل المبرد ولذلك كان الإكثار من عصارته فأنه لا
عنبر الكبريت يورث العطش ويبس النفس وورم الكبد ويمنع صعود البخار
الى الرأس ولذلك يخلط في أعينيه الادوية المصعدة الى الدماغ
ويمنع نفث الدم ويعقل البطن والسعوط بها يقطع الزكام وتسكن الجشا
الحامض إذا أكلت في آخر الطعام وتجلب النوم والإكثار منه يفسد الذهن
والفكر ويظلم البصر وهى تسكن نشر الفم والأسنان إذا الطفل مضغتها ومضمض بها
وجدا أو مع ذهن وزد وإذا ضمد بورقها منع سلان المواد إلى العين وقد ينفع
الكهام من الخفقان الحار وتطفئ حرارة الصفرا والدم وخاصه إذا أكلت بخل

السموم من الهوام والبله العارضه في المعدة واذا مضغ وخلط بزيت وعسل وتضمد به قلع آثار لون الدم العارض تحت العين واذا اضمد به مع ما وصفنا ابرا اورم الانثيين الحاره **ابن الهيثم** الكمون الاسود هو البري الشبيه بالشونيز وقد يكون زنجبيل احمر من الكمون الذي ببستاني شبيه بالبستاني ويخرج منه حبا بين غلث صغار شبيه بالفجل دون علاقه فيها البزر شبيه بالشونيز وبزنه اذا شرب كان نافعا جدا من نهش الهوام وقد ينفع به الذين به تقطير البول والحصى والذين يبولون دما معقدا وينبغي ان يشرب بعده بزر الكرفس **كزبره** هي مركبه من قوى متضاده والاكثر فيها الجوهر المر وهذا اجوهر ارضي قد تلطف وفيها ايضا رطوبه مآيه فأثره القوه ليست يسيره المقدار فيهما ايضا فمن نير

وقد زعم انها بارده وهو غير مصيب في ذلك كائنا ظن ذلك من قبل ان ضمادها مع الخبز اوسوين الشعير يشفي الحمره وهذا الضماد لم يشف قط الجمره الخالصه وهي

لها طبيعتها ودبج اما كان اخذ كثرة وله قوة متحنة مجففة قابضة واذا طبخ بالزيت
واحتشى به اوضمد به بدقيق الشعير وافى المغص والنفخ وقد ينفع بخل ممزوج
بالماء لعض النفس الذى بالانصاب وقد دبغى الثراب لهش الهوام ونفع من ورم
الاليتين اذا خلط بزيت ودقيق الباقلى اوببزروطى ووضع عليها وقد يقطع سيلان
الرطوبات المزمنة من الرحم ويقطع الرعاف اذا شرب من الرب وهو يسخى
وقد خلط بخل وبصفرة اللوز اذا اشرب او لطخ به. **ابن عمران** الكمون
الكرمانى يشبه فى طبيعته بالفوادى وهو اصغر منه الا انه على انه
وزاجته وطعم طعم الكمون الابيض. **الرازى** بعض الناس يتمون الكمون
الكرمانى كمونا اسود وكمونا ابزرنا ∴ **مسيح** الكمون الكرمانى
اقوى من البستانى فى جمع احواله ∴ **بولس** الكمون الكرمانى يعقل
البطن النبطى يسهله ∴ **ابن ماسويه** ان ولى الكمون وانفعه للحل اعقال
الطبيعه المستطلقه من الرطوبة وهو نافع من الريح الغليظه مجفف للمعده
صالح للكبد. **عبره** اذا مضغ وخلط بزيت وقطر على الطفر وكمود
الدم كثر الى العين نفع واذا مضع مع الملح وقطر بمقعه على الجرب والسبل
المكشوطه والظفر منع ازاص وهو اقوى من الكرمانى فى جلاء ايضا
والاخضر منه اقوى فعلا واذا مضغ واعتصر ماؤه وقطر فى العين التى فيها
طرفة نفعها وقطع الدم السائل منها د واما كمون ارمنى وهو الكمون
الذى لابن سينا عبث كثرا فى البلدة التى ينال لها طيفيدون من البلاد التى
ينال لها شناسا وهو نبات له ساق طوله نحو من شبر دقيق عليه اربع زوايا
او خمس دقاق مشعبة مشاور الشاهترج وعلى طرف فى روخمه او شبه
مشندبرة ناعمة فيها ثمرة ونحو الثمرة فى كالبنى او النخاله محيط بالبزر وبزرة
اشد جزافة من الكمون النبطى ينبت فى بلاد ويشرب بزرة بالماء للمغص
والنفخ واذا اشرب بالخل شكن العوان واذا اشرب بالشراب افوض ذوات

نوع اخر من الكمون

نوع اخر من الكمون

قوة كل واحد من هذه البزور التي ذكرناها وشأنه ادرار البول وطرد الرياح واذهاب النفخ وهو في الدرجة من درجات الاشياء المحخنة ٣ ت ٢ كومنون منه طيب للطعم خاصة الكرمانى الذى ينماه اغراطيس اسلفون ونصبرع الملوكى وبعده المصرى وبعد المصرى سائر الكمون قد ينبت فى البلاد التى ينال لها غلا اطيب ينبت فى البلاد التى ينال

قارواوهوكزويا

كمون نفهم الكمون

حب النفع من البطن
ويقوي المعدة
وهو جلاء للزجاج
ويعقل الطبيعة
أقل من الكمون
غيره ينفع
من الخفقان
كمون
ابن سينا منه
كرماني ومنه
فارسي ومنه شامي
ومنه نبطي فالكرماني
أسود اللون والفارسي
أصفر اللون والفارسي
أقوى من الشامي والنبطي
وهو الموجود في ساير
المواضع اكثر
ما يستعمل من هذا النبات
انما هو بزره كما يستعمل
الانيسون وبزر الرازيانج ثم
وبزر الكرويا وبزر
الكرفس الجبلي وقوة
الكمون حارة مثل

فأناس لا ان اصله وساقه شبها بالدواء الذي ينال له وما ورد ابن فلاطيون
وقوته شبيه بقوته وبنبت في الجبال الشاهقة الخشنة المطالة الاحجار
وخاصه المواضع المحموضة الشبيه بالجفر وله ورق صغير رقيقه شبيه
بورق السذب ذوعفن عليه وزن شبه يورق الكبل الملك لانه انعم منه
طيب لرايحه والورق الذي عند اعلا الساق ازن من سائر الورق واكثر شقفا
وعلى طرف الساق اكليل فيه ثمر اسود مصمف الى الطول ما هو شبيه ببزر
النارا باج حريف المذاق فيه عطريه وله اصل ابيض شبيه باصل النبات الذي
يعال له فأناس ابن فلاطيون طيب لرايحه ح اصل هذا النبات وبزره يبلغ
من اخراجهما يجدد ان الطمث ويدران البول وهما مع هذا انطرد ان الرياح وجلاء
الغثي ح وقوته بزر هذا النبات واصله تنخنه هاضمه للغذاء بوافي اوجاع
الجوف والاورام البلغميه والنفخ وخاصه العارضه في المعدة ولسع الهوام واذا
شربا درا البول والطمث واذا اجخنت لمراه اصله فعل ذلك ايضا وقد ينفع
بالبزر والاصل في اخلاط الادويه الهاضمه للطعام المسرعه في احداره
وبزره طيب جدا ولذلك اهل البلاد التي ينبت فيها يستعملونه بدل البليلج
والتوابل وينبلون به الطبيخ وقد ينغش ببزر اخر شبيه به يعرف بالمداف
لانه من ومن الناس من نعشه بان خلط معه وبزر النبات الذي ينال له ما زائش
او بزر النبات الذي ينال له ببسالوس **كرويا** ح فاز واهر

كرويا هو بزر صغير الحبه معروف عند الناس ينحن ويجفف في الدرجه
الثالثه وينضح انه معتدله فهو لذلك بطرد الرياح ويدر البول ولا بزره
فقط لكن جميعه د يدر البول طيب لرايحه يسخن جيد للمعد هضم الطعام وينفع
في اخلاط الادويه المعجونه وفي الادويه التي يسرع احداره الطعام وقوته شبيه
بقوه الانيسون واصله وايطبخ ويوكل مثل الجزر ح في اغذيه واصله اذا
اكل زدي الخلط :: **ابن ما سويه** هو اغلظ من الكمون وهو جار بابن نحرج

وهو عشب يستعمل وقود النار وله بزر مستدير مزوى كأنه طبقان طعمه إلى
الحرافة فيه عطرية ويشرب لعسر البول وادرار الطمث وعصارة ساق هذا
النبات وبزره اذا اعطرياً ويشرب منها مقدار ثلث اولوسان مسخى عشرة
ايام ابراً وجع الكلى واصل هذا النبات قوى اذا عجن بالعسل ولعق منه نفع فى اخراج
الفضول التى فى الصدر. **غيره** جاز ابن الماسة نطرد الزياج ويفتح
السدد ويهضم الطعام وكل النضج وخاصته فى المعدة ويقويها وينفع من نتوخ الهوام
وبمثل الزيدان وحتى الفرع وينفع التنفس وكثيراً ما يصدع اصحاب الرؤس
الحارة ولكن صاحبه لا يأكل شيئاً وقيل ان أصله هو اسرعاف وقيل غيره قد
ذكرنا اسرعان فى حرف أ ث **كاشم برى** ويقال

له ايضاً كاشمظى
وكاشم زدى
اد ث لنقسطقو
ن ينبت كثيراً
فى البلاد
التى يقال
لها ليغورياس
الجبل الذى
يقال له فانيس
وهو جبل مجاوز
للبلاد التى
يقال لها المغنى
واهل تلك
البلاد ينبتونه

لنقسطقون وهو الكاشم البرى

الكثيرا لها ضروب أبيض و أصفر و أحمر و هو يغتذي لمعاو يمنع ضرر
الأدوية المسهلة عنه ويعين على الحلقه و لذلك يطرح في الأدوية المسهلة
ويصلح بها حيله أدوية الأنهار بدل الصمغ وأصل شجرة الكثيرا إذا دق فانعم
وخلط بلعق اغنى البهق قيل انه النبات المسمى بالبونانيه كركودبلو

ابرجلجل هو
بزر نبات يشبه
الحلبة لشان
كالشبت وحبه
لحمه فيها بزر
كالعدس أبيض
حوله شئ فين
كالصفايح يدور
بالبزر من حواليه
يكون في قدر
خوارب النصه
اذا قطعته ادى
البدحرافه وطيب
رايحه يستعمل

الطبيخ كاجد النوابل و له اصل أصفر يسمى بالماززشه الاستر غاز وقد غلط الناس
فيه ويسمى السالوس فظنوا انها بزر الحلبه وبنباتها الآن نبات الحلم اغلظ
واحفا و نبات هذين ارق واحسن منظرا **د ح** كركودبلوا ويسمى طوربا وطورسيون
ومن الناس من يسمى هذا الدوا ابضا سيسالي ويطبقون ونشبه سساليوس
انزطى وهو ينبت في الجبل الذي يقال له ايمائس في البلاد التي يقال لها قليقيا

مجهول قشر الكندر لا هوالا دع وهوقشر احمر يقع في ادويه وفي الادويه النافعه من نفث الدم ۞ كثيرا هو صمغ العاقول دح طرا غاقنثا وهي

شجر الكثيرا
هو اصل
غليظ خشن
يظهر منه
ايضا شي على
وجه الارض
يخرج منه
اغصان
صلبة تنبط
على الارض
كثيرا ولها
زوج عنان
دقاق كثيرة

طراغاقنثا وهوالكثيرا

فيها شوك منتدب ابوزق ابيض فايم مستوى السماصلب والكثيرا يطو به من هذا الاصل اذا قطع في موضع القطع و اجوده ما يكون صافيا نقيا املس رقيقا الى الجلاء و ما هو خح و نوع الكثيرا اشبيه بقوة الصمغ وهي في فوه لج وتلزق وتغري وتكسر من حد الاشياء الحادة و هو ايضا يجفف كالجفف الصمغ ويستعمل في الاكحال و السعال و الخشونه قصبه الريه و انقطاع الصوت بان يهيا منه معجون بعسل ويوضع تحت اللسان يبلع ما يذوب منه ويحلل و ذا فا لا وقد يشرب منه وزن درخمين اذا انتفع وعجنة و خلط به شي من نزد ابل محرو مغسول تكرير من شرب ما ابي لوجع الكلى وجرح قه المثانه ۞ غيره

الأدوية

أجوده ما كان رقيقاً ما يلي لباب الحمة وهو جار بابن جنيد للمعدة مقول للأرحام وينفع أصحاب البلغم والرطوبة :: **الخوزى** معتدل في الحرارة والرطوبة يقوى المعدة ويسمن ويستعمله الشكال لذلك :: **ابن سينا** مغث يكسر حدة الحامة كالصبغ :: **كست برکست** قيل إن نبته بالناحية خط على خط وبعضهم يسميه كنت فقط يزيد عن الأخضرار ومنهم من يسميه بركست :: **مجهول** يسمى أسوة الأكراد لة وزمل ذنب العقرب وله أذرع أربع فإذا جفت انعقدت كالحبل المفتول وهي منفعة للسدد وتدخل في الأدوية الكبار **ابن سينا** هو شبه خيوط ملتف بعضها على بعض عددها في الأكثر خمسة وتلتف على أصل واحد ولونه إلى السواد والصفرة وليس له كبير طعم وقال قوم إنه البرشكان وقال بعضهم قوته قوة البرشكان وخواصه ذلك **ابن رضوان** هى عيدان رقاق مفتولة عطفة منها وعطفة شمالاً لونه أعبر وطوله عقد أجوده الهندى وهو جار بابن جنى الا ويجلو الغواري ويؤثر فيها أثراً قوياً **كندلا** **ابو حنيفة** هو نبات ببلاد الدبيل ينبت في ماء البحر ومنه هناك الجلود البيش الحم الغلاظ

<div dir="rtl">

خالیزونیورطیطاناً وهوالکرکم

هو الزعفران یشبهونه بالزعفران لأنه یصبغ به صبغاً أصفر کما یصبغ بالزعفران ویؤتی به من بعض جزائر الهند والیمن وزعم قوم أنه أصول الوزّ وقیل إن الوزّ صنف منه وی أصول غلاظ کالجزر الا ان فیها دقه تدخل فی المراهم النافعه من الجرب وینشّف وتحدّ البصر ویذهب البیاض من العین **کسیلا** عیسی بن ماسه هی عیدان بعلو هی سود وهی شبه عیدان المُقوّه ۞ **ابن عبدون** الکسیلا جبّ الجوف وعوده کعود المقوّه وللها نفع فی دواء المثانه **المجوسی**

حبّا

</div>

وأكل اللحم الغث منها وبنبت منها اللحم الصحيح ويشها وينفع الثآليل ويجوى به نوع
آخر منه يعض الناس كف الهر وهو نبات دقيق وورق مستدير مشرف
لاصق بالأرض عدده نجوم ثلث أو أربع وسوقه دقيقه مدوره تعلوا
زبيات منه وفيها زهر اصفر بزر وقط أطيب الرائحه وله أصل قد
بسوسه رقيقه شعب ونبت في اول بطن الخريف وتعرفه العامه بالملوكيه
لبرئته وملئنته
ويسمونه ابخل العفه
ويسميه بعضهم
الحوذان وأصل
هذا النبات
أيضا ينفع من
القروح الخبيثه
العفنه وينفع
الثآليل واذا
اجتمل في
فرزجه اعان
على الحبل

كزبره
فيل انه أصل النبات الذي يرعاه خ خالیدونی طوماغا وهو الصنف الكبير
عزدوق الصاعين ويى العزدوق الصغر وسببها هو الممى بنله الخطاطف
وتسمى تعرف العين والكرم المعروف عندنا عزدو وبوتيك بها من الهند
ويسمى بالهندی الفارسته ولسئله من القوه ما ذكر ح عزدوق الصاعين
ابن حسان یسمی الفارسته الهرد وأهل البصره يسمونه الكرم والكرم

شد بدجى انها ان وضعت من خارج احدث وجع وجامع فروج وجامع وجع فاما ان استعملها
الانسان بعد ان يقلع الجرب والعلة التي تنتشر معها الجلد والاظفار التي تظهر
وبها الباطن جلا الاثار ومثل الثاليل المخالفه والمدود التي تحدث فيها اذا القيت
برد الهواء وجع شديد شبيه بنخس الابر ونفع من داء الثعلب اذا وضع عليه مدة
يسيرة وكذلك انها ان ابطأت والبركة اشتطت جلد واحدث في الموضع
قرحه وهذه وهذه افعال كلها افعال ورق هذه الانواع وقضبانها ما دام طريه
اذا وضعت من خارج كالضماد فاما اصلها فان هو جفف وحفظ صار دواء
نافعا احد النجميك العطاس كمثل جمع الادويه التي يبح انخاعا قويا وبالجمله
انواع الكلج كلها مع اصولها وورقها وقضبانها وزهرها يبح وجففت انخاعا بحفف
قويا اذا اضمد بورقه واغصانه طريه فرحت واحرقت بالم ولذلك
تقلع تشق الاظفار وتشترها وتنفث الاورام والجرب والنمش والثاليل التي
يقال لها النمله والثاليل التي يقال لها قرع وحودوس واذا اضمد بها وفتاينشرا
دا الثعلب قلعه وان تركت عليه كثيرا قرحت جلد وفعلى هذا نافع الورق
والقضبان اذا كانت عضه فاذا طبخ وصب طبخه فابرا على الشارى العارض من
البرد نفعه واصله اذا جفف ودق وفاق ناعما وقرب من المحرق بكرك
العطاس واذا علا على الرقبه جفف وجع الانسان ولكنه يفتها البثه بسه

كف الضبع
ويقال قتالنع وتدسى سا الاسم الكيلج
المذكور دقل وهذا المذكور هما انواعه الا انه ليس قوته هو
نبات له ورقات مدورة مستقفه نحوه من ورق الكرور تنبسط على الارض
عليها زغب وهى فى شكل كف الكلب او النع اذا بسطها على الارض وهى على اذرع شبه
اذرع الكرفس الا انها اصغر وله زهره اصغر ذهبى وعلى قضبان دقاق ف
خوان ودور صغار وله عنصر وكبيرة تخرج من اصل واحد مثل اصل الخرنوب
ينبت بقرب المياه وفيه اصرع رطبه واصل هذا النبات ينبع من الفروج

كَنَهْبَان

خشنه شوب
مرارتها جزافة
ولذع للفم وليْت
بالكرنبة دلها
أغصان تفرع
على ساق وجذع غليظ
كالشجر الصغير
وتعروق في الأرض
عروقًا كثيرة
واذا اكثر منها
وُجد منها أجِبّة
الدخان وهي تؤكل
وتنخر الدماغ

والأذن شديدًا اذا اكثر منها وتنخر الكبد والطحال وهي في طبع الحبة
الخضراء وبذرها أسخن منها أرطب منها ودهنًا واغصانًا اذا شربت بالماء وهي
تطرد العقارب وتسكن لسعها **كهوارث الثلاثة** هي نقله جانٍ جمر بغه
وليبن لها كثير
اسخان مع جزافتها
ومرارتها ودهنا
ودون شديد
الندود وبرء نصور
نصون وزة
الخباري والطف

الى الجبال الطبيعيه. وأما الأخضر اوما ينتهي بلمه تشبه الكرات الا انها ادق وزقا منه منبت بلاد الترك في الجبال دون السهل ورضا طول مع رقه وهو حريف اشد حرافه من الكرات ينكن او يطبع لمثانه والورك والجوف والانباج الغليظه وينطع الخمار وهي بلعيه في ذلك وتنهي الطعام ويبقي الامعا ويؤكل نيه ومطبوخه. عنبر طبخ اصول الكرات النبطي استعيذ بلحه بدهن لوز واشرج نافع من القولنج وعصاره اذا بلته تنهل الدم. الفلاحه فاما المنبي قد رصا بهي وهو كرات الثوم والثوم الكراثي فنوبات له ورق فيها مشابهه من زق الكرات ومشابهه من زق الثوم وله اصل قريب من اصل الكرات الشامي ينفصل ثلثه اقسام او اربعه كانفصال الثوم الا انه ليس من فصوله قشور كالقشور التي بين اسنان الثوم بل يراه كانه شي واحد وفي طعمه شبه من طعم الكرات طيب بيبر الحرا فدا ضعف من الكرات الشامي. دب سقردون راس هو كنبات الكرات وسبيه من الثوم ولذلك قوته مركبه تفعل ما تفعله الكرات والثوم الا ان فعله اضعف وقد يطبخ لعذب ويؤكل مثل ما يؤكل الكرات الشامي. جح كما ان هذا النبات اذا فقدت رايحه وطعمه وجدت فيه كيفيه مركبه من ثوم الكرات كذلك قوته على هذا المثال. الفلاحه والماسوم كرات فنوبات له ورق مثل ورق الكرات الشامي واقل عرضا ولها في الخضر مثل لون الكرات وله اصول كاصول الكرات ينبت اصولا ملاصقه واذا عنو احمر قشره كما يحمر قشر البصل وهو رذي للمعده شديد الاختان اذا امكث في المعده جدا واذا انفق ان يخدر عنها في رمان سير لم يكن له مثل ذلك الاختان وقد ينعه رايحه البول والبرازالي التن تغيرا شديدا وبدر الطمت والبولاد اذا انشدبدا يجلل الجلد شديدا وماحذ بالجلو واذا استف بوزن شهي الطعام وينفع من نشر الهوام كنهان الفلاجه هي بصله تجليه وزقا تشبه وزق الجبه الخضرا وهي

كما إن جميع جيوش الصحر اقوى مما يزرع منه في البساتين ومن اجل ذلك صار الكراث البرى اردى للمعده وهو حريف وقطيعه وتفتيحه اكثر من تقطيع الكراث البستانى وتفتيحه للسدد ولذلك صار ان يزيد البول والطمث مرارًا اذا كان يؤكل واحد منها قد احتبس بسبب خلط بارد ومعه من الاخلاط ما يحدث بسببه قروحًا ميتى وضع على البدن من خارج وجميع الادوية التى تسخن مثل هذا الامتحان منى فى اقصى الدرجات ٠ الفلاحه ٠ الكراث النبطى اربعه اصناف فمنها الكراث النبطى المعروف ومنها الكوهان والكلكان وهما اغلظ وزفا من الكراث النبطى وينبت الكوهان بخراسان واكثر نباته بلاد الصعد والكلكان ينبت بالرى وخراسان ومنها اللسلاس وهو ينبت بابل وبزره اسود غير ممدور وكل هذه الاصناف مسخن مصبع مضر بالدماغ والمعده والقلب واللسلاس خاصه ينفع من البواسير اذا اكل واعتصر ماوه وشرب منه مع عسل او سكر واستف من بزره ممدق قائم السكر كل يوم وزن درهم وخالط جزا فيها مرآن وقبض وتصير اقلها ولخرا فقد اكثرها والاجود فان الكندر شحو وخلط بماء الكراث وسقى منه وزن عشر درا هم نفع من سيلان الدم من السفل ولذلك يقطع الرعاف اذا اشربت منه فتيله والصنت بالانف واذا قطر ماوه مع الكندر نفع من الدوى فى الاذنين وحرك شهوه الجماع ويرى احلامًا رديه ويلين البطن واما الكوهان فهو مصلح للمزاج اذا ادمن اكله مطبوخًا وهو يصلح المعده ويهضم الطعام ويقوى الظهر والبطن ويزيد فى الباه ويزيل الكسل والضعف وينير النفس وينخر الاحشا باعتدال ويقوى الكبد والطحال ويصلح المزاج والكلكان فهو خشن الجسم غليظ اللزوجه بطى الهضم وتوكل مطبوخًا وعمله فى اصلاح المعده والكبد والحشا قريب من عمل الكوهان واما اللسلاس فهو اللطف منها واسرعها هضمًا وهو يلين الطبع جيدًا ويفعل فى اصلاح المزاج والتغويه مثل فعل الكوهان وقد قيل انه يسفى العينين ويبرده

الثآليل التي ينال بها لبنه ويبرئ الشرى واذا تضمد بوقع الثلج جزء الاورام وقلع خثا الخروج واذا شرب من بزره وزن درخمين مع مثله من جلاب قطع نفث الدم المزمن من الصدر :: ابن ماسويه الكراث النبطي مصدع مولد لتخار زدي يكون به الاحلام الرديه وينفع من السدد العارضه في الكبد المتولده من البلغم وان سلق وطبخ واكل زاد في الباء للرطوبه التي التشبه بالماء :: ابن ماسه اذا اطبخ واكل وشرب ماءه نفع من البواسير البارد الدشتي يغربتفروج المثانه والكليتين اليهودي خاصه افاد الانتار والالثه الرازي يفتق شهوة الطعام ونعظ ولا يصلح اصحاب الامراج الحاره وينزع الرمد المايه والامتلا ازاله :: ابن عمران نافع من سدد الكبد والطحال واذا وجدت الامعاء بلغما اساله والان الطبيعه واذا وجد فيها من عفنها وهو غليل الغذا مذموم جدا مولد للنفاخ والنفخ مضر للمعده بلبيعه لعصبها ولد خارات مظلمه من جنس المره السودا ويحدث ظلمه في البصر واحلاما رديه مفزعه ومن كان محزورا وكان به هوسا وان كان زانفه سكره فليجذز اصلا واذا دق وعلم منه ضمادا وضمد به على موضع لسعة الافعى نفع منها :: بولس بزر الكراث يخلط مع الاداوين التي تصلح لعلل الكلي والمثانه ماسرجويه واذا دخنت المقعده ببزر الكراث قطع البواسير :: ابن ماسويه ان يطبخ بزر الكراث ويعجن بقطران ويخترث به الاضراس التي فيها الديدان تثرها واخرجها وسكن الوجع العارض فيها :: وان قطع مع الخرف نفع من البواسير وعقل الطبع وجلا الزياج التي في الامعاء :: غيره واما كراث اللازم وهو الكراث البري دب وايا الفراسن وهو كراث الكرم ازدي للمعده من الكراث وانخن وازل اللول وقد بدد الطمث واذا اكل وافق من نهش الهوام :: وان انت توهمت شبا منه وسطا بين الكراث والثوم وحدرت قوه هذا النبات كذلك اعنى الكراث البري ولذلك صار فيه حرا اشد حرا واكثر جرا من الكراث

كبأ وأطيب طعاماً من الأول وأكبر رأساً زرّ وستة زرّ وستة أمثال زرّ البصل
ملا الكف والصنف الأول هو الأندلسي وزعم أن هذا الصنف الثاني هو القلفوط
والأشبه أن القلفوط هو الأندلسي وكذلك في الفلاحة فإنه قال فيها
الكراث الشامي أصوله بيض مدورة وجبّارة وربما كبر حتى يصير وزن قدر
السليم ثم قال ... ومن الكراث الشامي صنف يقال له القلفوط لطيف
الأصول أصغر من الشامي مدوّر أبيض وهو أشدّ جزءاً من الشامي رديّ للمعدة
مضرّ بالبصر جداً وإذا أدمن أكله أحدث القلاع العين وهو أقوى
من الشامي في إدرار البول والطمث **الرازي** يسخن وينفخ ويهيج الباه
وهو غليظ جداً ومابطأ نزولاً وانهضاماً والقلفوط المخلل قريب من الكراث
يلين البطن وينفخ ويفتح سدد الكبد والطحال: **غيره** الكراث
الشامي هو الأندلسي وهو غير البلد الورق ولنبطي هو الدقيق الورق وهو كراث
البقل وكراث المايدة ورزق الكراث الشامي ينفع الرحم التي وفيها رطوبة
تلزق الدم: **علي بن محمد** الكراث النبطي هو كراث المايدة ويخرج من جنب
الأرض ذوائبه كالشار ذات أغصان ولون ورق الكراث الأندلسي وشكله إلا
أنه دونه جوداً وما يخرج من أرض من أصله قد يعقرب وأوله نصف شبر أبيض
سنبل غير مستدير **د ب** والكراث النبطي هو أشدّ جزءاً قد من الكراث الشامي
وفيه شيء من قبض ولذلك ماؤه إذا اخلط بالخل ودهاق الكندر أو الكندر
نفسه قطع الدم وخاصة النزاف ويحرّك شهوة الجماع واذا اخلط بالعسل
وعرّك كان صالحاً لنفث الدم ولأوجاع كلها العارضة في الصدر والفرجة
الربيه وإذا أكل نيئ قصبه الزبه وإذا أدمن أكله أظلم البصر وهو رديّ
للمعدة وماؤه إذا اخلط بالبقراطن نفع من نهش الهوام وإذا اضمد بالكراث
أيضاً فعل ذلك وماؤه إذا اخلط بالخل والكندر أو الكندر واللبن ودهن الورد وقطر
في الأذن نفع من أوجاعها والدوي العارض لها وإذا اضمد به مع الثمأنين قلع

قال أفلوطرخس وهو الكراث الشامي

النشا نفعه من الضمام الرحم والصلابة العارضه له وقد جلوا ان يبلغ سلقتين بماء بعد ماء ثم ينقع في ماء بارد واذا فعل به ذلك جلا طعمه وقلت نفخته

علي بن محمد

الكراث الشامي صنفان منه صنف اعناقه طويله ورؤسه صغار وصنف منه اعناقه قصيره ورؤسه

الكراث البستاني

الكمأة ازده رطبه نولده خلطا غليظا وتورث للبنو الابيض والاسود جميعا واجود
ما يوكل مطبوخه بالمري والتوابل الحارة وينبغي ان يوكل منه بوجه ولجنب شرب
الما كلها ولدعه الما الفرج بعدها ومن خواص الكماة اي ثني من دواب النموم لدعه والكماه
تفسد المعده مات ولخلصه دوا البنه وما الكماه من اصلح الادويه للعين
اذا ربي الامد واكتحل به نشوي اجفانها ويبينها الزوج الباصر قوة وجف
ويدفع عنها نزول الموا زال غبره هو ثقيله على المعده وخلطها غليظ جدا وليس
بردي وادمانها يورث القولنج وعسر البول وخوف منه الفالج والسكته
كشنه ويقال كشك ابن سينا هوشي من جنس الكماة
ملزر مجتمع في عطور الكماة الا انه
محز زجرا جدا غايل الحارة بريست في
الجبال نبات الكماة والفطر
لذيد جدا وكشربنا منها وزا
النهر وخراسان واذا فتش طعمه
الى طعم الكماة كاترب ستبرا
وبرد دون برد الكماة ولا حلوا
من رطوبه غربيه مع ليس جوهره
وهو مطفي غليظ ولم يبضي احد مفرة الفطر والكماه كراث
جنين الكراث الشامي وهو الذي له زوست علي بن محمد وهو الكراث
الاندلسي الفلاحه الكراث الشامي هو مما يوكل اصله دون فرعه واصوله
بيض ممدوده كبار داب كان الوطن وهو الكراث الشامي هو نافخ
ردي للكيموس يعرض منه احلام رديه ويدر البول ويلز الطرز ويلطف وحدت
غشاوه في العين ويدر الطمت ونصرا للمثانه المنفرجه والكلي واذا طبخ بما الشعير
او غبره اخرج الفضول التي في الصدر ودره اذا طبخ بما الجزر والخل وحلس منه

البستاني وأبين منه كما أن سائر البقول البرية هي أقوى من سائر القوى من البقول البستانية المجانسة لها ولذلك صار الكرنب البري أزيد أن يدخل إلى داخل البدن لم يسلم الإنسان من أذى لكثرة بعده عن مزاج الناس وبهذا السبب صار يجده من يذوقه أمر طعما من الكرنب البستاني أيضا وذلك أن فيه شيئا من المرار والجرا إلا أن هذين الطعمين جميعا في الكرنب البري أقوى ولذلك صار جلا وجلاء أكثر من الكرنب البستاني ܀ إذا سلق قلبه بماء مالح لم يكن ردي الطعم وإذا انضمد بورقه الرطب الخراجات وجلا الأورام البلغمية ولها أورام الحارة ܀ والكرنب الذي ينال له الجيزى هو بعيد الشبه من البستاني وورقه طوال شبيه بورق لاودندا المدحرج وأصول الورق أيضا التي بها اتصاله هي قضبان جمن صغار وموضعها من ساق النبات على مثال ما يظهر وذو النبات الذي ينال له قنوس وله لبن لبن كثير وطعمه ما يميل الملحوحة مع شيء يسير من مرارة ܀ هذا مع ما هو عليه من آلاته البطن من قبل أن طعمه ما يميل إلى الملوحة والمرارة وقد يجوز أن يستعمل أيضا من خارج البدن في الوجوه التي يحتاج فيها إلى الك الكتاب الذي ذكرناه ܀ إذا أكل مطبوخا أسهل البطن ومن الناس من يطبخه بلحم سمين بولس الكرنب الجيزى إذا أكل أسهل البطن وعالج إلى قتل الدود وإخراج حب القرع أكثر من فعل البستاني

كماة ܀ وذلك هو أصل مستدير لا ورق له ولا ساق لونه إلى الحمرة ما هو يوجد في الربيع ويؤكل نيئا ومطبوخا قوام جرم الكماة من جوهر أرضي كثير المقدار خالطه شيء يسير من الجوهر اللطيف الفلاحة

وينفع الحجاب والأحشاء لا سيما الطحال الغليظ وينقي العروق من السوداء

ابن ماسويه الكرنب الشامي هو النبيط. **الاسرائيلي** وأهل مصر يعرفونه
الاسفراج وله قلوب عظام كثير البزر نابته في وسط الورق **ابن ماسه**
النبيط أغلظ وأطاب للمعدة من الكرنب وورقه الثابت جوانبه أقل
ضررا وأصلح من جمانه النابته في وسطه للحلاق الغالبه عليه واجتنابه
كله أحمد من أكله لتوليده الدم العكر والاكثار منه يضعف البصر
وهو مطلق للبطن كثير الخازي يولد أحلاما رديه وسددا ومزه سوداء
وأصلح ما يؤكل مطبوخا باللحم وبدهن اللوز ومع زيت الأنفاق وبضه الذي
يسبج جماعه يهيج الغذاء فيه والنفخ ويزيد في الباه ويعين على المباضعه **الرازي**
العنبيط مثل الكرنب النبطي الا انه أقل حرامه وقال في موضع آخر
النبيط أكثر في تو ليد السوداء من الكرنب وخاصته إن أكل بالخل والمري
ابن عمران النبيط أفضل في ادرار البول واطلاق البطن من الكرنب
ولم به خاصه في نفع السكر **ابن ماسه** وخاصه بزره أسنادا لمني إذا احتلمه
المرأه بعد الطهر من الطمث **علي بن محمد** ومن النبيط صنف آخر يقال
له الكرنب الموصلي يسمى بالفارسيه كلم وله ورق أخضر جعد مثل ورق الكرنب
الاندلسي غير انه مبسط على وجه الارض طويل يرتفع قدرا الذراع وفيه
ورق صغير منظوم من أسفله الى أعلاه وما ثبت من أرض من أصله غليظ مدور
كأنه اللفت الا انه يطبخ كما يؤكل اللفت ولا يؤكل منه غير أصله. **الرازي**
... والهذلي فانه أجود ويجزي وزنا من
... اماثو لا اغريا وهو الكزبيل يبري
... في مواضع عاليه نواحيها الزينب
... مشبه بالكرنب البستاني غير انه أشد
بياضا منه واكثر زغبا واغلظ ورقا وهو ... هذا أحد من أجناس

الكرنب اذا دقّ ناعما وضمّد به وجده او مع سويق نفع من كلّ ورم
حارّ واحمرار جلدٍ ومن الاورام البلغميه ومن لحم وينقى البشرى والجرب المتقرح
واذا خلط بالملح قلع الثآليل الناريه وقد يسكن الشعر النساقط واذا اطبخ وخلط
به عسل وما البحر نفع اكله والمزوج الخبيثه واذا اكل الورق نائعا بالخل
نفع المطحولين واذا امضغ وتمضمض به اصلح الصوت المقطوع وطبيخ الكرنب اذا
شرب اسهل البطن وادرّ الطمث ومن اذا اعلمته فرج واحمله المرأه بعد
الجمع فعلا في بطنها وبزر الكرنب البريّ ... خلط اذا شرب فتل
الدود وقد ينفع خلاط البتر... يا فاء ونقي الوجه والبثور الخبيثه وقضبان
الكرنب الطريه اذا أجزيت مع الاصول رمادها وخلط رمادها بشحم خنزير يسكن
اوجاع الجنب المزمنه قسطس... اطعم الكرنب للصبيان مشوا سريعا وعصيره
ان شرب بالبذا ابرا ما ذهب بحمى الطحال ورماده ان خلط ببياض البيض
برى حرق النار وعصير بزرى الحمر... اكله وان خلط بالزاج والخل وطلى
به البرص والحرب نفع من ذلك واذا اكل صفى الصوت ونفع من عضّه الكلب
الكلب وجلب النوم :: **غبير** الكرنب يضرّ بالبصر وطحله لا يكون كثير
النطق به فانه ينفعه يجففه ودمه زدى سوداوى وهو ينفع من السكر
ويبطيه. اذا اكلمنه ورقات على الريق تبل الشراب وان القيت قضبانه واصوله
بخوانى لحم حمضها وافسدها استنثاوش ان ياتى الكرنب مترس ثمّ طيب
بكمون زيت وملح ودليل واغل غليه نفع اصحاب العطش... الأمعاء ثم
ابن ماسوبه يولد المرّه السوداه والدم العفن واذا طبخ باللحم اتمن قلت عاينته
الطبرى يحلل بزر داخل اذا طبخ واكل واذا طبخ ووضع على الاورام من ظاهر حللها
وذهب بها واصله وجسمه أنوى واشدّ تنعيمه منجده ونغه ث **الزراى**
الكرنب البطى حارّ يابس يولد السوداء ويفسد الاحلام غير انه يلين الجلو
والصدر ويطلق البطن وتجفف لسكن ** قنيشاوش** طبيخه تجفف الصداع

الكرنب البجرى

الاخر الشبيهه
بهذا الوجع
لان هذا
الدوا يحلل
تحليلا قويا

ذ ب

فولي مارس
وهو الكرنب
البستاني
ان تلق تلقه
خفيفه واكل
اسهل البطن
وادر البول
وان شلق

تلقا جيدا وانما ان تلق من تين اي وبعد ماء امسك البطن والكرنب الذي ينبت
في الصيف ردي للمعده واشد جرارته من غيره فالكرنب البستاني فالكرنب الذي
ينبت بمصر لا يوكل لمزاءته واذا اكل نفع من ضعف البصر والارتعاش واذا اكله
المحمور يسكر خمار وقلب الكرنب اجود للمعده وادر للبول من غيره وان عمل بالملح
والماء صار رديا للمعده ملينا للبطن وعصاره الكرنب اذا خلطت مع اصل
السوسن الذي يقال له ابريسا ونطرون بشراب اسهل البطن واذا خلطت بشراب
وشربت نفعت من لدغة الافعى واذا خلطت بدقيق الحلبه والخل تضمد به نفع
من النقرس ووجع المفاصل والقروح الوسخه العتيقه واذا استعط
بعصارته نقى الراس واذا احتملته المرأه مع دقيق الشيلم ادر الطمث ويذرق

الكرنب البستاني

أيضاً من فإن من أن
الطعم في موجود
جميع الأدوية النافعة
من الديدان وبهذه
القوة أيضاً صار
ينفع من اليرقان والكلف
الكائن في الوجه
ومن سائر العلل
التي تحتاج فيها
إلى التجفيف من
الجلاء فأما
قضبان الكرنب
إذا أحرقت فيصير
منها رماد جداً
تجفيفاً شديداً
حتى أن قوته تكون
قوته محرقة ومن
أجل ذلك صاروا
يخلطون معه شحماً
عتيقاً ويستعملونه
في مداواة وجع
الجنبين إذا عتق
وفي سائر العلل

الكرنب البري

نطع نزف الدم واذا ... رد على الشارب نوى الملح الضعيفه والمقلو منه
عقل البطن وبغى تكون اللحم و ... يوانى الخمر وزبر واذا غسل بطيخه
او بعصارته البرد والطبع من الخفقان واوجاع المفاصل **ابن ماسه** يمنح
الكشوث جيد للمعده وخاصه ان صبر معه الافسنتون او بزر الكرفس او برهما
كرنب الاندلسى الكرنب النبطى هو الكرنب الاندلسى وهو صنفان
جعد و سبط والجعد اطيب طعما واصدق حلاوة واشد رخوصه من السبط
وكلاهما تؤكل ساقه وورقه **الفلاحه** الكرنب صنفان منه النبطى والكرنب
المعروف و منه حوزى و منه غلط الورق جدا شديد الخشونه **حـ** الكرنب
الذى يؤكل قوته تجفف اذا اكل واذا وضع من خارج ولكنه ليس
بظاهر الحده واجزائه بقوته قد سلق الى ادمال الجراجات وشفا القروح
الخبيثه والاورام التى قد صلبت وماءَ اذا عجن ... حلا له والجمره التى
قضيها هذه القضيه
و بهذه القوه بعينها
يشفى الشرى والداء
وفيه مع هذا جلاء
صار يشفى العله
التى تنتشر معها
الجلد و بزر الكرنب
يقتل الدود اذا
شرب وخاصه بزر
الكرنب المصرى
من انه ابين مرارة
و من اليس ان طعمه

قولانا بزر الكرنب

كشوث

وتسميه حماض الأرنب ويختلف قوته بحسب اختلاف النبات الذي يكون عليه. **ابن ماسويه** فيه مرارة وعفوصة وهو حار في الأولى يابس آخر الثانية. **ماسرجويه** هو بارد فيه قوة قابضة وينفع من حرّ المرة ويدبغ المعدة

ويفتح السدد ويقوي الكبد ومزاجه من بلده لمكان مزاجه. **ابن ماسويه** يقوي الكبد ويفتح السدد العارض فيها وينفع الطحال مخرج للفضول العفنة من العروق ولا يردع نافع من الحميات المتقادمة ملين للطبيعة لشرب ماؤه. **الطبري** إذا شرب عصيره رطبًا مع سكر طبرزد ينفع من اليرقان. **الرازي** جيد للمعدة مدرّ للبول. **ابن عمران** وإذا شرب بسكنجبين ينفع من الحميات المتقادمة وخاصة حميات الصبيان والحميات المركبة من البلغم والصفراء. **اسرائيلي** الإكثار منه يثقل المعدة بقوة فضة. **ابن ماسويه** قوته دون قوة الأفسنتين ومن أراد أخذ طلاء خذ من مائه نصف رطل مغلي بوزن عشرة دراهم سكر. **غيره** إنّ النفع من عصارته نطبخ كان أعون للاستهال وإن طبخ كان أكثر تفتيح للسدد وقد شرب عصارته وزن ما نفعله نقيعه وطبيخه وإذا شرب بالخل سكن الفؤاق وإذا شرب بشراب سكن المغص وإذا اجتمل

الناق إلا أعلاها رهزدفني يشبه زهر الكتان أزرق اللون فيه بياض إلا أنه أصغر منه كثيراً خلفه بزر كبزر الشاهترج وطعم هذا النبات مر كذلك بزره وشربه الناس لإخراج الخام والبلغم ووجع الورك فينفعون به والشربه القويه منه د دهمان واذا طبخ هذا النبات في الزيت وحمل على القروح أبرأها وقد يكون نبات آخر يعرف بالتينية أيضاً قضبان فاي شعب من

زيتوني مجمعه حول الناق معقد جدش بلاورق ونباته في أرض قبصه جبليه وهو من نبات الصيف وهو أقوى من الصنف الأول في إخراج البلغم وإنزال الخام والشربه منه القويه دهم ونصف

كشوث *أبو حنيفه* هو شيء يعلق بالنبات مثال الخيوط يشرب من ماء النبات الذي يعلق به ولا أصل له في الأرض ولا ورق ولكنه أطراف فروعه مثل الطاف ثم يتموه في الشجر ويشبك فروعه ويكثر الكر مه والرطاب وكثيراً ما يفسد النبات ويتداوى به الناس وفيه مراره ويجعل في الشراب فيشتد ويحصله السكر ويقال الكشوث وكشوثا وكشوثا *عبره* اكثر ما يوجد بالكتان ويسميه بعض الناس الشيح الأرمني وبعضهم

واذا جلس النساء في طبيخه نفعهن من الاورام العارضة في الارحام كما ينفع طبيخ الحلبه ؞ **بوجرج** ينفع من وجع المثانه والكلى واذا شرب مقلوا انضج السعال البارد الرطب وان شرب نيا اسهل الطبيعه ؞ **زوفس** موذى للكميش ما شرجويه طبيخ بزر الكتان يضرب مع آ ويحقن به لقروح المعا فعظم نفعه ؞ **الرازى** هذا جدا يسكن الوجع واللذع ح في تدبير الاحتجاء بزر الكتان متى طبخ بالماء كان طبيخه مبردا **اسرائيلى** بزر الكتان اذا خلط بالبورق والرماد وعمل منه ضمادا قلع الثاليل **عيسى** بزر الكتان حلوا وينضج وينفع من وجع الرئة اذا شرب منه وزن ثلثه دراهم ويسكن الاوجاع قريبا من يسكن البابوبج و موذي للمعده والبصر عسر الهضم قليل الغذا مدر للبول ومقلوه يدرا البول اكثر ويعقل البطن وضمادا ينضج الاورام وجلها وينفع من الغوباء والقروح **بولس** الكتان نفسه اذا اجزوا كان له دخان لطيف ينضج سدد الزكام وبعج للنجم انى شفلس وتصير الا فوق **كتبينه** هى عشبه لها ورق طولها نحو من نصف اصبع ينشرنه على الارض فيها منا به وملاسه وخضرها تميل الى الدهمه وهى مشرفه ولها ساق رقيقه طولها نحو من ذراع فيها صلابه وهى كشار نبات الكتان وعليها ورق كورقه ومن نصف

كتبينه

قد ينبغي أن نستعمل الجديث نتعرف الحال فيهما مما وصفناه به الحظه والشعير

كتان الفلاحه هو نبات معروف يحمل حبا لطافا منه طا أحمر

وهو المستعمل ح هذا ازكا ولذ نخا وإن كان منه طا أزرق فذلك

مهو ممتلئ من

الرطوبه

الزايده الداخله

في جنس

الفضول

بسبب ذلك

وهو مع هذا

حار يابس في نحو

الدرجه الأولى

وسطه فيما

بين الدلو

والبسر

ليس يمو ازن الكتان نشبه قوة الجلبه وإذا خلط بماء العسل والزيت والماء حللا وألم الحاره ولم يمنع ظاهر هما كانت أو باطنه وإذا ضمد به مع الحلبه وأبو التين قلع الكلف وإذا خلط بما حلل الأورام العارضه في أصول الأذان وألم الصلبه وإذا شرب قلع النمله والصنف من القروح التي ينالها السعفه وإذا خلط به من أحرق أعني أسنانه والعسل نفع من شقوق الأظفار ويبرها وإذا خلط العسل والعسل يخرج الفضول التي في الصدر ويسكن السعال وإذا خلط بالعسل والفلفل يستعمل مكان الناطف وأكثر منه حرك شهوه الجماع وقد يجمع بطبخه للدغ العارض في الأمعاء والرحم وقد يخرج الفضول

الماء ثم اخرجها من الماء ثم القها
الى ان تنشف قشرها ثم اطبخها ثم اهل
دقيقها بخل صفيق واخرزه وهذا
الدقيق مسهل للبطن مدر للبول
محسن للون الوجه واذا اكثر منه
او من شربه اسهل الدم واذا طبخ بعسل
نقى القروح والبثور اللبنه والكلف
واثار الظاهره فى الجلد الكمودان
ويبرى ايضا ثائر البشره وينضج القروح
الخبيثه من انواع البدن ويلين الاورام
الخبيثه العارضه فى الثدى وغيرها من
الاعضاء ويقلع الناز الفارسى والقروح التى يقال لها الشهديه واذا عجن بشراب وضمد به اورام عضه
الكلب ونهشه الافعى وعضه الانسان نفع للكل وينفع من عسر البول وسكن الرجز والمغص واذا اقبلت
الكرسنه ثم دقت ناعما وخلطت بعسل واخذ منها مقدار الجوزه وافقت لمن يزل وما يطرح الكرسنه اذا اصاب
على الشقاق والعارض من البرد والحله والجرب العارض للبدن ابرأ اسهاله. **كميث دب**
اوليذا وهو حب محسن من الحزاره
اقل غذاء منه بتى يسر وقد
يعمل منه مخبز ويطعمونه ايضا
ملححا جريشا اخشن من
الدقيق جوهر هذه الحبه
وسط فيما بين جوهر الحنطه
والشعير على طريق الغذاء وعلى
طريق الدواء وكذلك

الكمثرى وهو لذلك يبدل ما كان من الخراجات عظم ومنع المواد من الجلب

أفيون الكمثرى أصناف كثيرة وكلها قابض ولذلك بنفع ما نه الضادات المانعة من سائر المواد إلى الأعضاء وإذا اكل أو شرب طبيخه بعد أن يجفف عقل البطن وإذا اكل الكمثرى على خلاء المعدة اضر اكله ووزن الكمثرى إذا اكل أو شرب نفع من أنواع الخراجات ولا قاعي وإذا انضمد به نفع من ذلك والمتى أحران وهو الكمثرى البرى على النضج وقوته اشد قبضا من البستاني ولذلك يوافق ما أوافقه البستاني ووزته أيضا فانه اذا فاتح رماد خشبه قوى المفعقة للذين عرض لهم خنق من اكل الفطر وقد قال قوم انه اذا طبخ الكمثرى البرى مع الفطر لم يضر اكله ووزن يخرج الكمثرى وأطرافها ينفع في النضج غيره

ما كان من الكمثرى جلو اشد الجلاوة نحو من يخرى وطيب ويلين الجلد ويغذوا غذاء جيدا ويحدد سريعا ويلين الحلو وهو جيد الخلط . وأما سائر أصناف الكمثرى فكلها قابضة حتى انه ربما احدث المغوبج اذا اكل على الصوم وهو نافع لخلقة الصفراوية والكمثرى اشد غذاء وأجد خلطا من التفاح وقال د ن هـ وقد يتخذ من الكمثرى شراب كما يتخذ بالسفرجل لأن في ذلك الكمثرى الذي يبطح منه شراب أن يكون شديد النضج وقوته فابضته جيدة للمعدة قاطعة للغئلان المواد الى الصدر والمعدة والأمعاء :

كرسنه د ت هي شجيرة صغيرة دقيقة الورق دقيقة الأعضاء أوريس
لها ثمر يعلف خ ج هذا دواء يجفف في الدرجة الثانية ممتد الى الثالثة ويسخن في الدرجة الأولى ويجنب ما فيه من المرارة كذلك بقطع وجلاء ونضج الندد وإن اكثر من أخذه ولد الدم د يطحن منه دقيق نافع في الطب وإن أكلت الكرشنه صدعت واطلقت البطن وولد الدم وإذا علفتها البقر مطبوخة اسمنتها والدقيق الذي يطحن منها على هذه الصفة خير من الكرشنه ما كان ثمره بقنة وصب عليها ما وخلا وجزها وقيل ببراثر

لقروجهما منفته للحرث فروج العين التي ينال بها فلوما طا مسكنه للورم
العارض فيها المنتمى السترا لتي قد جمع دخان المر ودخان المعة التي ينال لها
اصطرك على هذه الصفه و بوافق لما يوافقه دخان الكندر و كذلك فجمع دخان
ساير الصموع. كمثرى ح د وزن هذه الشجر واطرافها قابضه

الكمثرى البري الكمثرى و هو الكتل

فاما ثمرتها فغيها مع قبضها حلاوة ما ئيه و هذا مما يعلم به ان اجزاء هذه الشجره
ليست ببنا و بة المراج و ان منها ما هو ما ئي و منها ما هو ما ئي و ان ثبت قلت
من وجه اخر ان بعضها با زد و بعضها معدل المراج و من اجل ذلك من اكل
الكمثرى فربث بة المعه و سكن العطش و متى وضع كالضماد حفف و جلا جلا
يسيرا و هذا السبب اعلم انى قد ادخلت بوجر لبات عندما مات لا اقدر على
دواء اخر. و الكمثرى البرى اكثر قبضا و باغاء و جففا من ساير

إذا شرب كان ارفق من الكندر لمن ينفث الدم وللنساء اللواتي يسيل من ارحامهن
رطوبات من منه إذا احملته ويصلح جلاء الآثار ايضا لعلاج العين ولعلاج فروحها
التي ينال لها اسلماطا او ساخ العين وإذا كان صالحا لحكتها و تذكر وينشر
الكندر مثل ما يجز قول الكندر [...] المامردقاق الكندر هو ما يقوم من المنخل
وايضا الا [...] ما انفث منه في الاعدا الاكبار وتجعل اسم تلك الحبات
مسور الكندر [...] اىا وهو دقاق الـ[كـ]ـندر فان احدى [...] ما صار [...]
ايضا يقال دخانا وقديسه در يلطم به صنع العين [...] فلا عبار لجا وينشر
الكندر ومع ذلك [...] تابر ضي النار فانه داعش لاير بخار صاف
للكرب كدرا اسود وقوته مثل قوت كندر عبرا اضف [...] وإذا اجيب رجل
دكان لكبد فاعله هاني [...] [...]ن كيس [...] كندر رجماه وبه
ناور السراج وصبرها في الما مزج في نحدد غلفه وعطه بار [...] بخار يخوم
مثوب لوسط محلم [...] صفه الحد صير ينا سفقه انا المج من ابحى واحدو
ومن يكى للناحيين جمان وها اربع اصابع لنظر الا الكندر وعلم ارك بحرف
ولكن مكا [...] ما دظل اوا فاذ لا من حصى الكندر وقبل ان تطفى لخيا ساه التي صير نها
في الخار انطفا اما ما صاح جصاه اخرى ولا نزال نفعل ذلك حتى تعلم ان فرا جمع
من الدخان ما يكنى وه وامج خارج اما الذي من الحار يخرج جدا دايما اسنجه
مبلوله بما بارد فانك اذا فعلت ذلك لحجم الحان احنا شد بدوا وراكم الدخان
بعضه على بعض وان لم تفعل ذلك رجع الدخان من ابنا البحا بل اسفل واخلط
اجمع زماد الكندر وإذا جمعته فاجمع الدخان اولا فاذا واجمع زماد الكندر
المجز وصير ن على حده [...] واما دخان الكندر فغوه ابتر ولحن من قوه
الكندر بحى انه بعد الدرجه الثالثه وفيه مع هذا ش من الجلا لذلك يقال
انه ينقى بلا الفرح والتي تكون في العين كما يفعل دخان المر ودخان المعه [...]
وقوه دخان الكندر مبنده وزام العين الحاره قاطع لسيلان الرطوبات منها منقيه

يحدث النفس غيره جفف فروخ الرأس إذا اغتسل به وربما خلط مع القطرون
منفى الحزاز وإذا امضع حلب لطوبه والبلغم من الرأس ونفع من عرجنكه اللسان
وشد الأسنان اللثه وبلحها وشربه بطرد الريح ويقوي القلب ويذهب
النسيان والأكثار منه زمنا أورث الجذام والبرص وقد يستعمل الكندر
في النزلات ودخانه يبلغ المنفعة وقد فرض الهواء . وقد يجزون الكندر
بأن يوخذ منه حصاه ولهب في ابركار السراج ويوضع بقحان كبير يحترق
بها ه ينبغى إذا أجزوه منه ما يكفي أن يعطى منه الا أبتى إلى أن يجمد فإنه إذا فعل
به ذلك لم يصر رمادا ومن الناس من يعطي ذلك الفحار باناء من نحاس مجوف
مثقوب الوسط لبجمع ذلك الدخان ويستحيل كيف يكون ذلك في كبر الدخان الجميع
من الكندر ومن الكندر ما يبصره بعض الناس وقد طين لم نحتر بالنار ثم
يطينون فمها وبحرفونه إلى أن . ومن الناس من يبصره في نخار جديد ويقلبه
على الجمر حتى يسقط عليانه ولا يظهر منه رطوبة تغلى ولانخار وإذا لم يجزو بهون
فركه .. وأما فليشوليانى وهو فشر الكندر فاجوده ما كان رخيا لينرق
طيب لرائحه املس لحبوب الليثن رقيق وقد نغش بأن يخلط به قشر الصنوبر أو قشر
شجر النوث وهي نحجر قسم قريش ومعرفه ذلك مما يعرف بالنار بان ساير الصنور
يلتهب وقشر الكندر يدخن مع طيب لرائحه وقد بحرو قشر الكندر مثل ما
يجرو الكندر . وقشر الكندر قوته فابضه فضا بينا فهو لذلك يجفف خفيفا
شد بيا جمى انه من منهى الدرجه الثانيه مردءات الأشار المجففه وهو أغلظ
من الكندر وليست قيه حدة ولاحرافه أصلا ولما كانت له هذه الكبينات
والقوى صار الأطباء يكثرون استعماله في حبدا واه من نبقث الدم ومن يعد به
رخوه ومن به ذرب ومن به قرحه في الامعاء ولين ينصرون على خلطه في الضماد
الذي يداوى به من خارج دون أن ليقول أيضا من الأدويه التي يزداد به احمر اللون
. وقوه قشر الكندر مثل قوه الكندر غير أن القشر اقوى واشد قبضا ولذلك

وذلك ان الصمغ العربي لا يلهب بالنار وصمغ الصنوبر يدخن والكندر يلتهب
وقد يستدل ايضا على المغشوش من الراجعة. هذا بعينه في الدرجة الثانية
ويجفف في الدرجة الاولى فيه مع هذا قبض سيلان الكندر الابيض
لبن يربى فيه قبضته د والكندر يقبض ويحرو ويجلو ظلمة البصر ويملأ
القروح العميقة ويدملها ويلزق الجراحات الطرية التي بدم بها واذا شرب الكندر
نفع من نفث الدم ويقطع نزف الدم من اي موضع كان و نزف الدم من جبه الدماغ
التي يتاولها مغيس وهو نوع من الرعاف ويسكنه وينفع القروح الخبيثة التي
في المقعد وسائر الاعضاء ومن الانتشار اذا اختلط بلبن وعجنت منه فتيله واحتملت
فيها واذا اختلط الخل ولطخ به عند ابتداء الوجع الذي يسمى فرميقا قلعه وقلع الغواني واذا
خلط بشحم البط ويعجم احمر بزا برأ القروح العارضة من اجزاز النار والشفاة
العارض من البرد واذا اختلط بالعسل ابرا الداحس واذا اختلط بالزفت ابرا
شدخ الاذان واذا اختلط بلحم الحلوا وقطر في الاذن نفع من سائر اوجاعها
واذا اختلط بالطين المبني قبولا ودهن الورد وخلط به ولطخ نفع من الاورام الحارة
العارضة للثدي من الفاسر وقد خلط بالادوية النافعة لنصبة الريئة
والضمادات المحلله للاورام الاحشا واذا شرب منه شي كثير خم قتل. ابو جريج
الكندر نجار ياتي في اول الكاتبة. الدمشقي ينفع من وجع المعدة والاسطلاق
واختلاف الاغراس والدم وجلو قرح العين. النارسي يطرد الخار ويهضم الطعام
جيد للحمي. الرازي ينفع الحفقه والعى وجرو الدمار اكثر منه و بذكي الذهن
وربما احدث وسواسا و ينفع من الحفقان. حليم بن حنين اذا اكتحل به للعين
التي فيها دم محتقن نفع من ذلك وجله. ابو جريج جرو الدم والبلغم وينشف
رطوبة الصدر ويقوي المعدة الضعيفة ويحمى الكبد وان نفخ منه مثقال
بماء وشرب كل يوم نفع من البلغم وزاد في الحفظ وجلا الدمر وذهب بكثرة
النسيان الا انه يحدث لشاربه اذا اكثر منه صداعا. ابن ماسه يذهب

والزيت

المعروفه عند اليونانيين بمدينه الكندر واجود ما يكون منه هناك هو الذكر الذي ينال له نطاعونس وهو مستدير الخلقه وما كان منه على هذه الصفه وهو صلب لا

ينكسر سريعا وهو ابيض واذا انكسر كان ما داخله للرق دسما واذا ادخرته احترق سريعا وقد يكون ايضا كندر ببلاد الهند لونه الى البانوت ما هو او الى اللون الباذنجاني وقد يحتال له حتى يصير شكله مستديرا بان يأخذوه ويقطعوه قطعا مربعه ويجعلونه في جره ويحرج الجره حتى يستدير وهو بعد زمان يصير لونه الى الصفره ويقال له سفيرس والكندر الذي من البلاد التي هي بلاد العرب هو الثاني مرتبه في الجوده ثم الكندر الذي يقال له اسليوطس وتسميه بعض الناس قوسفر وهو اصغر حاصي واميلها الى اللون البانوتى ومن الكندر نوع يسمى اوسطس وهو ابيض واذا اوقدت فاحت منه رائحه المصطكى مثل وقد يغش الكندر بصمغ الصنوبر وبالصمغ العربي والمعرفه به اذا غششته

وهو ما كان من وزن الجلال وقيمته فل من قيمة الماوي وبعده كافور يقال له
الازرك وهوائم وبعده البالس وهو مخلط فيه شظايا مشاكل كافور مدسم مصنع
على قدر اللوز والحمص والفول والعدس وبصفى هذه الكوافير كلها بتصعيد
فيخرج منها كافور ابيض صافي شاصقالح الزجاج الذي يصعد فيها ويدعى المعمول
وقد يكون من البالوس وغير الكوكب ملمج من المن زطل يصعد زطل ونصف وهو
اوسط الكافور ثمنا والكافور بارد يابس في الثالثة نافع للحرور وين واصحاب
الصفراء اذا استشف ان جمة بردا ومع الورد ومع الصندل معجونا بماء الورد
وراجنه شهر اذا ادم شمه ونطف شهره الجماع واذا اشرب كان زعله في ذلك افوى
واذا اخلط منه كمية يسير مع ادوية تعقل البطن نفع منها للصفراوك
والدوام عليه سرع باطهار الشيب اذا استعط منه بوزن شعيرين مع ماء
الجبن جزان للزماغ وذهب بالصداع وقطع الرعاف واذا استعط به معجونا
مع عصير البسل الاخضر منع الرعاف وجبر الدم المفرط وقد ينفع في اخلاط
الطيب **عنبرة** تخرج الكافور زكبير نظل حلقا كثيرا والهب المور بلا
وصل اليها الا بمدة معلومة من السنه وخشب الكافور ابيض هش جدا خفيف
وربما اصيب في خلله شي من الكافور وينفع من الاورام الحارة طلا وينفع ادوية
الرمد لحار وينفع من القلاع نفعا جيدا شديدا واذا اشرب قطع الباه وبرد
الكلى والانثيين وولد الحصا فيها ما نافك **الرازي** شرب زجل سنة مثاقيل
من الكافور ثلث مرات فبطل هضم معدته حتى لا يهضم به شيا
كندر هو اللبان **ابو خنيفه** لايكون الا بالبحر محرم عمان في
تجبره شوكه لا ينمو اكثر من ذراعين ولا ينبت الا في اجبال البر والسهل
ميهابي ولها ورق مثل ورق الاس وله ثمره مثل ثمره الهاجز في المغنم وعلكه
الذي يمضغ يسمى الكندر وينظهر في امكان منه حفر يالبور ويترك فيظهر في اثار
العموس من هذا اللبان فيما يليانو وهو الكندر ويكون في بلاد العرب

اصباغهم ويصقلون بها خوص الكاذي وله منافع وليت ستأصل **الطبري**
الجذام ويقطعه **مجهول** دهن الكاذي يقوي الأعضاء الواهنة المسترخية
وتشدّها وعوده عظيم النفع في الخلع والكسر ۞ **كافور ابن جلجل**
هو صمغ شجرة تكون بالهند كالصنوبر ويطلع منها الكافور الرابح فيغلى
بالماء ويصعد فيبين
أبيض كالثلج ولونه
أولًا أصفر إلى الحمرة
والماء الذي يغلي
به يقال له ماء
الكافور وهو دهن
لذيذ طيب الرائحة
يقوم مقام دهن
البلسان الكافور
بارد يابس في الدرجة
الثالثة وله منافع
كثيرة
الجراح **ابن ماسه**

الكافور يجلب من فنصور وبلاد كله والرابح وهريج وأعظم من هريج وهي
الصين وهو صمغ شجر تكون هناك ولونه أحمر مظلم ثم يصعد منه الكافور
الأبيض والمخلوط فمن الرياحي وأعظمهن ريا حيا لأن ذلك ما وقع عليه ملك يقال
له رباح واسم الموضع الذي يوجد فيه فنصورة يسمى أيضًا الفنصوري وأجوده وأرقه
وأنقاه وأسنى بياضًا واشدّه جلاء ما يكون منه مثال الدرهم ونحوه وبعد
الفنصوري كافور يدعى الوقور وهو غليظ كمد اللون ليس له صفاء الرباحي

الصغرى
واكنة

في الاحشا وهو مدر للبول منقي للكليتين من الحصا المتولد فيها ولكن ليس له من
اللطافة ما يمكن بها الانسان ان يستعمله بدل الدارصيني كما كان يفعل فرانطس
ولجيد منها ليس داي الدارصيني في قوة لا يهودون السليخة الجيدة فضلا عن
الدارصيني وقال في الادوية المقابلة للادواء كان فرايطس بلغ من الدواء المسمى
فارفاسون في الترياق قدر الدارصيني اذا المجد وهو شبيه بالفو الا انه
اقوى منه ولمع ذلك ذائحه عطرية واكثر بانه باجل المسمى سدي
من بلاد نقوليا ولذلكشا وهو عيدان فاق شبيه فضان الدارصيني

ابن ماسه قوة اصل اصبابه شبه قوة اصل الفو الا انه الطف منه
واشد جلا واشد نفتحا للسدد لجادته الاعضا :: **منبج** الكبابه
جاز جيده لوجع الكلى ويحس البطن السل يفتح السدد ويجري مجاري البول
ويصفي الكلى ويسهل البطن :: **شبز** يقوي المعد والاعضاء الباطنه وينفع
التروج العقنه الفم وفي سائر الاعضا

كادي **ابو جنيفه**
هو من نبات بلاد العرب
بنواحي عمان وهو الذي
يطيب به الدهن الذي
ينال له دهن الكاذي
واخبرني من راه قال
هو نخله ولها طلع فاذا
الطلعت وطع ذلك
الطلع قبل ان ينشق فارع
فيه الدهن وترك حتى ياخذ
الدهن ريحه ويطيبه
والخراطون يملسون

الكاذي

بهمين هو الصمغه العظيمه من اللغه ويقال قهمن: يهق هو الأبهق أيضا وهو جربير البن: يوفاربين هو الحيوفاربيون من الجاري يوسبير هو السيكران الطنة خطا وتصحيفا وانما هو يوسبير وهو البوصبر الذي تسميه العامه سيكرانا بربا أصفر

حرف الكاف

كبابه **ابن عمران** هي حب العروس وبعضها مثل نعت الفلفل ولها اذناب في اطرافها لونها أصهب: **ابن الهيثم** هو صنفان كبير وصغير فالكبير هي حب العروس والصغير هي العلجنه: **عين الكبابه** نبات نبتي أصله الكبابه ويسمى حبه حب العروش **جبير والبطريق** وعنها من المراجه قالوا ان الكبابه تسمى باليونانيه قرفسيون والدواء الذي سماء جالينوس في كتابه في ترجمه البطريق فرفسيون نما جبن الكبابه وبأن الأدويه المقابله للأدواء ان المرفسيون عيدان رقاق تشبه قضبان الدارصيني والكبابه عندنا انما هو جبن ولم نر هذا العيدان لكن قد يمكن ان يكون هذه العيدان عيدان النبات الذي منلحنه هذا دواء تشبيه بالفوه طعمه وفي قوته الا انه الطف منها جدا ولذلك صار أكثر نفعا للسدد العارضه

وهذا شرح ما وقع في هذا الباب من الاسماء

بازا هو الابازج ٠ بافيطرد هو الفوذنج النهري وهو الصومرانـ ٠
باشيش موجر البيب بالطبني ٠ باسم هو الباسمين ٠ يامور
هو المزو ٠ بلبثون موبات من الكلح ومن زعم انه السذاب البري فقد
فقد كذب واكثر الاطباء على هذا الراي وقوم اخرون زعموا انه المشان
وكذبوا ايضا واتما هو نبات من الكلوح سمي بالبربريه ادرنيـ والبرتريروه
ويشبه به اللحم للسباع وهو كثير ببلادهم وقد ينبت ايضا بالاندلس ٠
بنو هو الانجمه ٠ بجنسليس هو الكرفس المشته بالبربريه به
واطباؤنا يغلطون فيه فيجعلونه الطرسا ليون وهو خطا ٠ يرقه من
الخان الصغير ٠ برا هو الابازج ٠ براع هو القصب ٠ يراميع
هو الهليون وهو الاسفراج وصحفه قوم فقالوا البراميع هو الاسفيداج ٠
يرنا مى الحنا ٠ بربود لون هو الطرخون ٠ بري هو الابازج ٠
يصب هو اليبب ٠ يعصيل موضف من الهندبا البري وقد
ذكرنا اصناف الهندبا ٠ بعمضا هو الزباس الزرابيه وهي فضان
لاوذوها ينبت في الكلوح ويقال لما انما يعمى ٠ يقطين من كل
شجر لا يقوم على ساق ٠ بلوثون من الكرمه البضاء البواته
ييسر زعموم انه نحث الخطمي وان عوده هو العود المعروف بعود الببر
وهو خطا وقيل هو عود الجلب وقيل هو عود لا ارك وذاك ابن حنان
عود البسر هو عود اناعر بين العرب عند كثر الناس انما يقول هو عود اسر
بالهم لا بابا ٠ وقوم بسمر كمثك حجر السر ٠ يا ذفه هو الجوز
بالجمته ٠ بلنجوج هو عود الجوز ويقال للنج ٠ يملول هو القابزك

صلب عند الإقلاع ولونه إلى السواد ومن يجلبه لحظة وعلى شكله ومن
أنواعه العشر والماهوبذانه والحليتا والسبح والوكت وغيرهما مما قد ذكرنا
بعضه وسنذكر العشر في موضعه ۞ **ياقوت** ابن جـلجـل

الياقوت حجر ينقسم إلى أربعة ألوان أبيض وأزرق وأصفر وأحمر وأجودها
وأعلاها ثمناً الأحمر والياقوت إذا سحق وشرب نفع في القلب ونفع من
الفزع والوحشة **غيره** ينفع من نفث الدم ومن تقلد منه حجرا دفع
عنه الطاعون **يسف** وما يشبه **دا** ابن النبيس زعم قوم
أنه جنس من الزبرجد ومنه ما لونه شبيه بلون الخمر ومنه ما لونه شبيه
بلون الهوا ومنه ما لونه شبيه بلون الدخان كأنه شي مدخن ومنه ما فيه
عز وقبض صقيله ويقال له اسطرونس ومعناه الكوكبى ومنه ما يقال له طبرمين
ومعناه الشبيه بلونه بالحبه الخضراء وهو شبيه أيضاً في لونه باللون الذي
يقال له نانس وقد نظر في هذه الأصناف كلها ضلح لأن تعلو على الرقبه
أو على العضد للتعويذ وعلى الفخذ لسرعة الولاد ۞ **حط** وقد شهد قوم بأن في
الحجاز أن خلصيات خاصيه مثل هذه الخاصيه التي في حجر البسد الأخضر لأنه ينفع
المرى وفم المعده إذا علق على الرقبه وقوم ينشون عليه ذلك النقش الذي
له شعاع على ما وصف باخاسيوس وقد امتحنا أنا هذا الحجر فأخبرنا
بتجربه اختباراً شافياً ولذلك أخذت محفه من حجيرات جاها من الحال
وعلقتها في العنق وجعلت طولها لا يعتد لا يبلغ إلى فم المعده فوجدته
ينفع نفعا ليس بدون ما ينفع إذا كان منفوشا عليه علما وصف باخاسيوس
إلى زعم قوم أن حجر البشت هو الدهنج وزعم قوم أنه ياقوت جبشى ملون
ويسمى أبوقلمون وقوم يصححونه فيقولون أن حجر البسد وهو خطأ ۞
فاعلم ذلك
إن شاء الله تعالى ۞

الزبرجد ومنه ما لونه
شبيه بلون

نوع الشبه من الثمونيا ومقدار الشربة منه اربعة دوانق واذا طال مكثه نقص
فعله وقل نفعه وان اصلح وقوم باخذ ونه من شجره وتخلطونه بدقيق الشعير
فاذا صنته على هذه الصفه واردت اصلاحه فامرجه بشي من الناشنج ولته بدهن
لون جلو ادهن البنفسج وان صنته على وجهه فاخلطه بالناشنج ولته بدهن
الورد واصلح ما يمزج به من الادويه كاللوز الملجوز وزيت السوسن والصبر والزبد
والهليلج والاشنين واللعافت او عصارتهما والملح الهندي والزعفران
والناشنج فاذا امزج بعض هذه اصلح المزاج ونفع من حميات الربع واسهل
الماء الاصفر انهالا قويا واذا اسعى على وجهه من غير اصلاح افسد المزاج
وهيج الوجه واعقب وجع الكبد وفساد المعدة . الوازير ومن انواع
البنوع الكبير وهو احد البنوعات لاخلو انه المزارع اجم الناس ومدبر
الورق يخرج منه لبن كثير ويقرب فعله من فعل الثمونيا الى هذا
احدا انواع البنوع فعلا وكثير من الناس عندنا ينمونها المحموده وزنه كوزن
الفلها الجمع وكوزن الصنف الاخر من البنوع الذي يقال له الناطريا
الثمر الاان على وزن هذا النبات رغب نير لذن وهي مكانته على قضبان
على قضبان حمر ممتده ون خارجه من اصل واحد ونباته بقرب انهار ومنه
نوع آخر يشبه الكاثر الفلبرين وله قضبان خمسه او ستة في غلظ الخنصر
يعلوا الجوا من ذراع لاوزن لها التي تنوع تحاذا الاطراف مرصف بعضه
على بعض وكل زجمله قضبانه شبيه بالقنابل الموجوده على نجر الصنوبر الكبير ولونها
اخضر مايل الى الغبرة فيه قليلا ويشبه بعضا خات الصغار وله اصل
ذو شعب ولونه اجمر عا برس جوف الارض واكثر ما ينبت بالرمل بالقرب
من البحر وله لبن غزير وقوته ايضا مثل قوة الثمونيا وانهاله مثل انهالها
وقد ينتي ايضا البصوص ومنه صنف آخر وهو نبات يشبه النبات المنمى صنه
الحذى الا انه اصغر والبر وقضبانه بيض وله ثمرة اطرافه ملتصق الورق

وبصير ذلك الموضع والبدن كله ان طيبه عديم الشعر وبسبب هذه القوه
التي له صار يبلغ الثاليل المعلقه والمكونه والخلان واللحم الزائد النابت
الجانب الاظافير والثوث وبجلوا النوابي والجرب لان فيه قوه تجلوا المكان
ما ازه وبسبب شده لخانه وقد يمكن ان تشفي الفروج الماكله والقروج
المعفنه متى ما استعمله الانسان في الوقت الذي ينفع به فيه وبالمقدار النافع
منه وبهذه القوه وبعينها صار لبن اللقوح يبلغ الصلابه التي تكون حول التواصير
وجميع هذه الافعال التي يفعلها ايضا كما ان لبن اللقوح كذلك يفعل وزقه وبزره
يفعل لجنسا الا انها تفعل اضعف من فعل اللبن وهذا الوزق والبزر يستعمله الناس
في صيد السمك الذي يكون في ماء قائم في آتي ماء لا زال السمك يصير بذلك
الماء اخال لكرى مسافه النصف ويطفوا فوق الماء وانواع النوع سبعه واقواها
كلها النوع المسمى بابوانثه حار افاس وهوالذي ينميه قوم احرون بنوعا
ذكرا وكذلك النوع المسمى ينوعا انثى وهو الذي ينميه البونابنون بيسسطس
ومعنى هذا الشبه بالبنت والنوع الذي يكون بين الصخور وهو انواع الحجر ومن بعد
هذه الانواع في القوه النوع الشبيه بالوصير والنوع المسمى فن فارسناس ونفرج
السوري وبعد هذا النوع المسمى بأن السوس لانه ينبت في المواضع التي تقرب من الجز
والنوع المسمى ايضا اللسوسيوس ورماد انواع البوع ورماذها فانه من كل واحد
منها فانه في القوه التي ذكرناها من الانواع ومن النوع ضعف ابن عمران
له وزوقه وزق الخطمي مرغب وقضبان واتمعنك شب وغبرته فضبان
وزق القطين تفعل واح على الارض وحود راعبن وله انوار مدور وقليل الحزم بشبه
نوار اللبلاب واصل علي ظهر حتى وعلى اطراف القضبان جمه ∴ بولس النوع
يخلف المره قريبا مما يخلفها عصان ثنا الحماز والسمونا والذي يعطي من
لبنه اربع قطرات اوخمس ينبغي ان يحرج ذلك بالسويق ويبلغ سريعا وذلك
انه ان طال اسناكه في الفم فزح اللم واللسان ما يجوله ∴ حبيش يقول

واكثرلونها الى الحمرة ومخرج الورق منها والورق شبيه وزق الصنوبر
التي يحمل قضم قريب الا انه انخص من وزق الصنوبر واطرانه وازق وباجملة فان
ورقه شبيه ورق هذا الصنف من الصنوبر نبات نباته وهذا النبات ايضا
ملان من رطوبة لبن وقوته شبيهة بقوة الاصناف من النوع التي ذكرنا واما
الصنف منه الثابت في الصخور الذي يقال له ددرودش فانه كثير الاغصان
كثير الورق ملان لبنا الا ان اغصانه الى الحمرة ما هي وعلى اغصانه ورق
شبيه بورق ابن وقيو وله ثمر شبيه بثمر الصنف من النوع الذي يقال
له حاراسار وفعل هذا الصنف والحالة فيه مثل الفعل والحالة في خرن
اصناف النوع التي ذكرنا واما الصنف منه الذي يقال له فلاطوملس
فان ورقه شبيه وزق النبات الذي يقال له فلوقوس واصله وذ قد ولبنه يسهل
كيموسا ما يا واذا ادق وطرح في الماء قتل السمك والاصناف التي ذكرنا
من النوع تفعل هذا ايضا وجميع انواع النوع وقوتها الشر
قوة جادة جان دبهاما هذا ما ان واقوى شي فيها لبنها وبعد بزرها وورقها
وبعد اصولها من هذه القوة التي ذكرنا ها هد البرد لك في الجميع بمنأ واصول
النوع اذا طبخت بالخل اذهب وجع الاسنان وشقه وليسما الوجع الحادث في
الاسنان الماكله فاما لبن النوع فانه لما كانت قوته قوة اشد واظهر
صار الناس يضعونه في جوف اللبن الماكوله واما تابرالنعم فان هو وقرب منه
اجزقه على المكان واحدث فيه فرخه ومن اجل ذلك قد ينبغي لنا حين اذا اردنا
ان ننظر في الموضع المناكل من اللبن ان نضع على اللبن من خارج كما دور شعا
لا لبن النوع والدرجة الرابعة من درجات الاشياء التي يحر وبهذه الدرجة
هي درجة الاشياء التي تحرق ولذلك صار لبن النوع اذا طلي به موضع من البدن
فيه شعر حلق الشعر ولكنه ليسه فيه جاجا الا ان خلط معه زيت فان
من على ذلك الموضع من ارابكبر طلت باصول الشعر فلا ينبت لانها تحرق

وطرح على شئ من الشراب الذي يقال له الادر ويشرب نهل البطن واذا طبخ
الجوز ومضمض ووجع من وجع الاسنان وفارزوسطر واما الصنف المعروف بالانثى و هو
الذي يسميه بعض الناس مرسنطس وفارزوسطر فان نبعته شبيهه بطبيعة
النبات الذي يقال له دفنوبدس و زرق وزغب الا انه اكبر
منه وهو متين جاد الاطراف مشوك او العدان خرجها من الاصل طولها نحو من
شبر وله ثمر باي وشه كلسنه شبيه باجزا ملع الشان و ينبت في اماكن خشنة
وقوة ان هذا الصنف واصله وثمره وزقه شبيهه بقوة الصنف الذي قبله الا
ان الصنف الذي قبله اشد سخنا للفئي منه ح واما الصنف المعروف فار البوص
ومعناه الغرب من الحجر و هو الذي يسميه بعض الناس ويسمونه ايضا
ارسر وانه ينبت في بعض السواحل وله قضبان ... نه وطولها نحو من
شبر لونها الى الحمر خرجها من الاصل وعليها ورق صغار متصقه الى الزقة ماهو
منسطيل شبيه بورق الكنان على اطراف الغصان وتكشفه ملزز مستدير
فيها ثمر شبيهه نجب الكرسنه مختلف اللون و له زهر ابيض وهذا النبات
كما هو مع اصله ملان من لبن واستعمال هذا الصنف والحال ينخز نده شبهان
استعمال جالخزن الصنفين من اليسوع اللذين يتم ذكرهما ح واما الصنف
منه الذي يقال له الميوسوس فان له ورقا شبيها بورق البقله الحمقا الا انه
ادق منه واشنا اشنان وله قضبان اربعه او خمسه خرجها من اصل واحد
طولها نحو من شبر دفاق حمر مملوه لسنا كثيرا وله راس شبيه بزاس الشبت
وثمر كانه موضوع ن روس وجهه هذا النبات يستعمل مع افعال الثمر ولذلك
يسمى المسقيوس ومعناه الناطر الى الشمس وينبت كثير ذلك في المدن والحامات
ولبنه وثمره يجعان مثل ما يجمع لبن وثمر الاصناف من اليسوع الذي ذكرنا
وقوتها مثل قوتنها الا انها ليست بقوتها لبن وثمر اصنافا اخر ح
واما الصنف منه الذي يقال له قوا قوا رسبان فان لسانا طولها نحو من شبر

بلاطوفلس وهو
البنوع العريض الورق
دعوا النابع

ينبغي ان يحب وان يطلي
الجنب بيوم او بعسل
منزوع الرغوه ثم
يشرب واما من اخذ
اللبن الذي ينظر
عليه اللبن شئين أو
ثلثا وشربت فانهما
مقدار كافٍ لما يحتاج
اليه من الاسهال
به وهذا اللبن اذا
اخذ حديثا وخلط
بالزبيب ولطخ به

الثمن حلق الشعر وصيّر النابت من بعد رقيقًا اشقر ثم اخذ بسط
الشعر كله وقد يصيره بعض اطباء العارضه من جهة انا كل ينبل وجعها
وينبغي اذا اصابت وثب الاطراس العارضه من جهة اناكل ان ينذر القب
بوم للابيل فيضمد اللبان اذا الطخ على الثآليل التي يعرض معها شبه
بثبت النمل وعلى الثآليل التي يقال لها ميرمكيا ودخوريس او على اللحم الذي
ينال له نومرا وعلى القوابي ذهب بها وقد يوافق الظفر والجدري والاكله
والورم الحبيت الذي يقال له العقربيا والواصير وقد جمع ثمر هذا النبات الذي
الخريف ويجفف في الشمس ويدق دقا خفيفا وينشف وينفع
والورق ايضا يجفف وبرفع واذا اخذ من الثمر ومن الورق مقدار نصف
السنوفرا وشرب بافعل ما يفعل اللبن ومن الناس من يحد وزنه مع الشطرج
باللبن وبالجبن الرطب واصل هذا النبات اذا اخذ منه ممحوقًا مقدار درخمى

النوع البحري وهو
فاراليومن
الثالث

وتجنبه جملة جملة
جل اكثر نشه
قشم من قطر
منه على الثرب
قطرات على رجل
ينه وتجففه واذا
جف رفعه وقد
يوجد اللبن وحد
ويستى على صلايه
وتجمع وترفع وينبغي
ان يستخرج في
وقت هبوب الرياح
وينبغي للمستخرج
له ان لا يقرب
الى عينيه وينبغي
له ايضا قبل ان
يستخرجه ان يقدم
في مسح بدنه بشحم
مذاب او زيت
مع شراب وخاصة
اذنيه والاشين
والزوفته واذا شرب
خشن الحلق فلذلك

نوع آخر وهو ابو فوبيس
ومعناه الناظر الى الشمس اي
يدور معها وهو
الرابع

قوقارسیاس وهو
البنوع السروی
وهو الخامس

دندرودیس وهی
البنوع الصغری
السادس

جبلیه واماکن
خشنه ولبن
هذا النبات
اذا شرب قدر
بدک او بولواس
بخلو مزوج
بخل و ماء ا نهل
بلغما و من واظ
شرب بالشراب
الذی یقال له
مالیقراطن انهل
و هیج القی وقد
یخرج هذا
اللبن ع الابان
اللطاف بان
یجمع القضبان
و یقطع سبی وینقی
الی یبرود و من
القضبان اذا نطبخ
ب اناء یا الیه
اللیز و من الناس
من یاخذ وینوع
الدرسنه و لی

طبيوماليَّرْ وهو البُطْم بأنواعه

وهو الاول

خارلنا منه وهو الفستق الكبار

من شينطس ومعناه الآس وهو البطم الثاني وهو الباني

في لوْنها جَمَر مملوءةٌ من لبنٍ حادٍ وزَّن هذا القضبان يُشبه وزَّن الزيتون الا انه اطولُ منه ورَقٍ واصلٍ غليظ خشنٍ و على اطرافِ القضبان جمّة من قضبانٍ دقاقٍ شبيهةٍ بقضبانِ الاذخر وعلى اطرافها زهور كالبنفسج ما هي شبيهةٌ بالصنفِ الآخر الذي يقال له مرالبون وفي هذا الدوس ثمرةٌ هذا النباتِ وينبتُ في موَاضع

منها الشراب المسمى الفقر اطن وقد يعطى من قشر الاصل مقدار اربع اولسات
مع ثلث درخميات من ميزراالنبث ويعطى من العصارة ثلث اولسات ومن
الدمعة درخم واحد ولا ان يعطى منها اكثر من ذلك اضرت بآخذها
والاسهال بها بوابوا الذين بهم السم ووجع الجنب المزمن وبعير على نبث النفول
وقد يصيبك الطعمة يعطى منها الذين يعسر عليه القئ والدمعة والقشر من
القوة على حاله المزاج اشد من قوة سائر الادويه التي يشبهها في القوة اذا اجحفا
ان يحدث لشئ من قوة سائر الادوية الموتى وهي لئلا ينقله من موضع
الى موضع اخر ولذلك الطبى الدمعة او ذلك للقشر وهى رطبة على داء
انبث فيه الشعر وقد خلطا اشر وهو ينجرو او العصارة باجزاء مساوية
من الكندر والدوم ويجعل لك لكمنة الدم والاثار البادجانية اللون
منذهبها وينبغى ان لاتركا كثر من ساعتين ولكن ينزع ثم بعد ذلك يكمد
الموضع بماجزى سخن وقد ينفع ان يكلف والعصارة اذا خلطت بالعسل قلوت
الجرب المتقرح واذا اخلطت الكبرت ولطخ على الحرات يحزها وقد ينفع به
اذا استعمل لطوخا للخنب الذى يعرض له وجع مزمن ومكنة الركبة والقدم
والمفاصل

اليتوع يتوع وانف كل ما كان للبن حاد هو اليتوع يقرح
البدن كالموبيا والشبرم والعشر واللاعية طيثوماليين هو
شبعة اصناف منه صنف يعرف بالذكر ويقال له حار اتياس ومن الناس
من يسميه قرنسطس ويسمى معطاطاليبر وينى موشس ومنه صنف اخر معروف
بالانثى ويسمى سطس وقد يسمى ايضا فاروطس ومنه صنف اخر يسمى قاالبوص
اى القريب من الجرزى من الناس من يسميه طيثوماالسن ومنهم من يسميه ميقن
ومنه صنف اخر يقال له المسفوموس ومنه صنف اخر يسمى فارسياس ومعناه
السروى ومنه صنف اخر يقال له دندريس ومنه صنف اخر يعرف بلاطوفلس
والصنف من اليتوع الذى يقال له حار اتياس قضبان طولها اكثر من الذراع

<div dir="rtl">

اسطراغالس

الأصل ان يترك وبعض لحشيشه ولوبه ويؤز ويجفف في الشمس في آناء خزف لحنين ومن الناس من يعصر الورق مع الأصل وهذه العصارة ضعيفة القوة والفرق منها ان عصارة الأصل اشد قوة

وانها ابقى لديه واما العصارة التي قد خالطها عصارة الورق ما تنفع ونفست بما يعرض لها من التأكل ويتبغى لمن راد ان يستخرج الدمعه ان لا يفعل ذلك في يوم ريح لكن في نحو هدها ومنها ان الوجه ينور مروزا شديدا وشقط ما كان من البدن مكشوفا لحدة لحرار فينبغى ان نقدم في ملطخ الوجه والمواضع المكشوفه من البدن بعنبر وطى نطبه ناله نايضه ۞ قوة هذا النبات جاز نسخ اسخا فوا معشى من نطو به ومن لذلك جنذب من عمق البدن جذبا عنيفا وجلل ما جنذب به ولكن يفعلذ لك بعد مدة طويله سبب ما فيه من الرطوبه الفضليه التى لست بالبين وبتبيب هذه الرطوبة صار البنون سريعا ۞ وقوة قشر هذا الأصل عصارته ودمعته مسهله اذا اشرب من كل من احلى

</div>

ورقه وطول الورق نحو من شبر ولونه اجر وقد هوجوا الى الاصل ليبيض طوله
اكثر من شبر بقليل وهو في غلظ الابهام ۞ بولس ولين لهذا الصنف ثمرة
وان هذا الاصل اذا طبخ حتى او اكل نيئا او في الخبز او في بعض
الطبيخ فان الانسان على ما زعموا يأكله او يشرب وببقى شبعانه
على اجاله انه كان عليها قبل ان يأكله او يشربه ولا يحتاج الى انه يحتاج من تلك
اغذيات او اربع وقد يستعمل الاطباء هذا الاصل اذا ارادوا ان يقطعوا اعضاء من
البدن ان يكودوه وقد يقال ايضا ان هذا الاصل اذا اشرب مع عنب لغلب
المعروف بالجنز كل زذى دمامته ۞ مسيح اللفاح بارد وفيه رطوبة
فضليه نافع في النهب صالح لاصحاب المره الصفراء مجرد من شمه لاذى اكله
الرازى يثقل الرأس وينيب وان اكل غثا وقيأ واسبت وربما قتل وقال
في الحاوي اخبرني بعض مشايخ الاطباء ببغداد ان جارية اكلت خمس لفاجات
فتقطعت عشيأ عليها وجربت وانا صبيت على رأسها الثلج حتى افاقت ورأيت
من اشرب من الشراب اصلته المنه فصارت جلد من جلد من لحم اوجال من اشرب
شرابا كثيرا من حمر الوجه والبدن واتفاخها ۞ بلينون
يسمى باليونانية افتبا والبربرية ادربس واد ابرس وزعم ثم انه السذاب
البري وهو خطاء ذذ استخرج هذا الدوام من اسم افتر الحزين لانه نظر ان
اول ما وجدها وهو نبات تشبه جملته النبات الذي يقال له برسش وهو الفنا
الا ان ساقه ارق وورقه شبيه يورق نبات الذي يقال له مائز وهو
الزا ربنج وعلى اطرافه في كل شعبة اكله شبيه باكله الشبت وفيها زهر
اصغر بزيله العرض ما هو شبيه ببزر النبات المسي برنسش غير انه اصغر
منه واصل ابحر كبير غليظ البشرة جريف وقد يستخرج منه دمعه بأن
يحفر حوله بشق قشره او ان يجعر فيه حفر مستند به ويغطي الحفر لبنى
يسعد فيه وفي اليوم الثاني يؤخذ ما يجمع من الرطوبة وقد يستخرج عصاره

منه عضو واحتاج الى ذلك وان شرب من اللثغة مقدار ابولسين بالشراب
الذي ينال له ما المعنى راطن قايلغها ومرّ ينوءوا ان اخذ منها مقدارا
كـ ـنا فـنا ـل وقد نفع ى ادوية الـعـ الا ا ـكنه للاوجاع والنزلات
المليـنة ىا اخذ احد منه ـا ا بنوا الـ ادر الطمث واخرج الجنين
واذا اصير المقعد ـ ـ ـكـ ا بلة ام ـسل اذا النج مع اللغاج
مقدار ست ساعات انه سهل الاـ ـ ـا ان ىكله المثـ
ووزقه اذاكـ رطرى ىضمدـ به الشريو و ـو الاوراج ا الـعا رضـه للعـىن
والقروح وقد ـجلل الا ورام آــ جانـبه والدبلات والخنازير والخراجات
واذا كاك د كل ا رفيقا البشرة ما اشبه ذلك خمسة ايام او سـة ذهب به دون
ان ىـثرح الموضع وقد جفف اـورق وىستعمل انضا لما يستعمل له وهو رطب
واذاف لـ اصلـ فا ىا عاما وخلط بالخل ىرا الحم واذا اخلط بالعسل او الزىت
كا ن صالحـا للـىع الهوام واذا اخلط بالماء ـ جلل الخنارىز والخراجات واذا اخلط
بالسوىق ـكنـ وجع المفاصل وقد ـهبا ـشراـ اـ ـيـثر الاصل ون ان ـطىح وىطرح
عليه من قـشر الاصل ثلثه اـاما وـىنع منه ـلث وا ـ اـ واـسـاـ انـ حاحـه الى
ان بفطع منه عضوا وتوى فانه اذا اشبـبه لحين لاام للـنبات لعارض له
ولغاج هذا الصنعت اذ الكلى وانشـو راحته ـرل لاـكله والمـنـسو
راحته سبات وقد ذلك ايضا ىعرض مر عصارته واذا اكـثر منه ادمن عصاد ته
عرض منه السكته وبرز الاـ الج اذا اشرب نفى الرحم واذا اخلط بكبرت لمـسه
الـنار واحمل قطـر الدم من الـرحم وقد يسـتخرح بـمـىعـة منه باـن ـفوذ الاصل
فياذا ابـنـسه بـنـج وان حمع ما ـشلـ ـلـمـا من الـرطوبات والعصار ه اقوى
من اللثغة وليس فى كل مكـان يكون للاصل دمعـ والدليل على ذلك من
الـحرى فقد يزعم بعض الناس نصفـ ـسـ ـخمن الاورىوزن انه نبت فى اماكن
طيبة ومغاـىر ولـه ـو ـق شبه ىورق الىـ الابىض الا ان ـ ورقه اصغـر من

نوع اليقطين

نوع ما الثمر من اللفاح

فأما اللفاح
وهو اللقاح
ففيه أيضا
رطوبة فنسو
لذلك يحدث
السبات وأما
قشرة أصل
اليبروح فقوية
جدا ولكن
مبردة فقط بل
هي مع ذلك
مجففة وأما
نفس الأصل
المستبطن للقشر
فهو ضعيف ومن
الناس من يأخذ الأصل
ويطبخه بشراب إلى أن
يذهب الثلث ويصفيه
ويرفعه ويأخذ منه
مقدار أواقين ويستعمله
للسهر ويسكين الأوجاع
وإذا أحب أن يطبخ
حين من يحتاج أن يقطع

الصنف من المزدوج ليس يكون له ساق والصنف الآخر يعرف بالذكر وهو أبيض ويقال له مردون وله زهر ملس كبار عراض شبيه بورق اللبلن لونه ولناحه ضعف لناح الصنف الأول ولونه شبيه بلون الزعفران طيب الرائحة مع ثقل وأكله الرعاة فيعرض لهم من ذلك شيء يسر من النبات وله أصل شبيه بأصل الصنف الأول الا انه

أكبر من أصل الصنف الأول وأشد بلازمانه وهذا الصنف ليس له ساق وقد يخرج عصارة قشر أصل هذا الصنف وهو طرى بأن يدق البشر ويصير بحت ثى يحمل وينبغي ان يخرج العصارة ثم من بعد ان تجمر ونزوع انا من خزف وقد يستخرج عصارة لناح هذا الصنف كمثل ما يستخرج عصارة قشر الاصل الا ان عصارة اللناح يكون اصغف قوة يؤخذ مشر الأصل ويشد بخيط ويعلق ويوزع ح قوة البرودة كثيرة في هذا النبات حتى انه في الدرجة الثالثة من درجات الاشياء التي يبرد ومنه منها جزاء بسيب

بارد رطب في الدرجة الثالثة دَب هذه البقلة ايضا توكل وهي ملينة للبطن لين فيها قوة الادوية ث ابن سينا هي اكثر رطوبة من الخس و المزع وغذاوها يرو نفوذها للبدن يسرع لان ما فيها لاطعم لها البته تسكن السعال والعطش الحاد و تضمد بها الاورام الحارة وعصارتها مع مودهن اوذهن دافعة للصداع العارض عن احتراق الشمس وضمدبا ڡ له الخروج السهذيه

مورد طبی عم الثانانه

يبروح دد مندراغورش موصفنا زا هم يعرف بالانثى ولونه الى السواد ويقال له يريدا قس اى الحسى لان رقه مشاكله لورق الحس الاانه ادق من ورق الحس واصغر وهو زهم معتل الرائحة منبط على وجه الارض عند الورق مثمر شبيه بالعنبرا وهو اللفاح اصفر طيب الرائحة وثمره يجب شبيه بالكمثرى وله اصول صالحة العظم اثنان او ثلثه متصل بعضها ببعض ظاهرها اسود وباطنها ابيض وعليها قشر غليظ وهذا

يابسًا و وضع على الكلف أذهبه وهو محلل ملين. لكل عضو إزد نافع للمزكومين
مصدع للمجز وزين وصلح إستعمال دهنه في الشتاء. **ابن حسان** بزر السمسم بنور
الياسمين ثم اعتصر منه دهنه نقال له الزنبق ونقال له الزارنه ينفع من أمراض
البازده: **غيره**: دهن الياسمين حار يابس نافع من الفالج والصرع واللقوه والشقيقه
البازده والصداع البارد إذا دهنت به الصدغان وقطر في الأنف منه وإذا
تمزخ به جلب المزي وجل الأعضاء وينفع ورم المفاصل وإن عمل منه مع أصفر
ضماد بدهن الخل قام مقام الزنبق بعينه. **الفلاجه** هي
شجر نحو ذراعين
ونصف عيدانها
صفر ذكيه ورقها
إستطاله ولين وإذا
دقه وطيبه الريح
كريح السعد وورد
وردا اصغار المثل
ورد الزوا الأحمر
الا انه صغير مضعف
ونبخه كزاجه
الحبري الأحمر إذا
قطف زانت رائحه
من يومه وإذا انشق
الورد عقد عند الكاس عرض الزائر زفتين الأسفل ومزاج هذه الشجره حار
حرازه خفيفه وفيها لزوجه وقبض وفي حسنه المنظر ضعفه قليله البقاء
بزبوز دلطي و هي البقله اليمانيه × وهذه بقله تؤكل ومزاجها

له الغول المذكور عن أبي حنيفه هو الصحيح وهو معروف بالعراق فأكثر الناس عندنا على أن اللبنوث هو الشوكة المنتنة للطبخ جيدة وهي شوكة شبيها هي از هره نور اذا اصفر العنب وتخرجها النحل: **ياسمين** أبو حنيفه الياسمين فارسي فمن قال

ياسمون جعل الواحد
ياسما ومن قال
ياسمين جعله واحدا
واعرب نونه وزعم
بعضهم انه بالعربيه
السجلاط: **ارجنان**
هو نبات له عيدا
ن طوال محزجا من
اصل واحد مرتفع
الى فروع وله ورق
فيها شبه من ورق
الخرزان الا انها

الين وانت خضر وله نور ابيض وأربع شربات طيبا لرائحته ويكون منه اصفر وزعم قوم انه قد يكون منه ارزق: **ابن ماسه** هو صنفان ابيض واصفر والابيض اطيبها رائحته واقواها حرارة ويبوسة **مسيح** جاء بابن آخر الثانيه والأصله الثالثه: **الدمشقي** نافع من الرطوبة والبلغم صالح للمشايخ رطبه نافع من الصداع الحادث من البلغم الريح والمرة السوداء الحادث عن احتراق البلغم ومن اللقوة والشقيقه: **الرازي** جيد نافع بالضماد لوجع الراس الذي من برد وأدهانه غليظه مقوي الدماغ: **ابن عمران** اذا دق رطبا كان او

غذاء غير النبوت

ثمر أصغر من العرعر
سودا شديد
الحلاوة ولها عجمة
توضع في الموازين
فهي بسه البنوته
لا كل شي الا انها
أصغر ثمرة وهو
على الكبير والاول
يفترش على الارض
وله شوك وقد ينتود
به الناس اذا لم
يجد واعن وقال
في موضع اخر هو

الخرنوب النبطي وهو هذا الشوك الذي ينبت قد يرتفع نحو الذراع وأفنان
وحمل أحمر خفيف كأنه نفاح يتبع لا يؤكل الا الا عجمة وينمي القرون فيه
حب صلب ولا يصلح للخرنوب الشامي الا انه أصغر **الرازى** البنوت
بارد يابس يمنع الخلفة جيد للمبرودين فان اشرب ماؤه وقال في موضع
آخر اذا دلك الاثآليل بالخرنوب النبطي الفج ذلك شديدا ذهبا البته
غيره قشر اصل البنوت اذا نبت الانسان العقنه وينفع من وجعها ويقلعها
بلا حديد **لى** فتكثر كلام الناس في البنوت واختلفت افاويلهم
وذلك ان كثيرا منهم يقول هو النبات المسمى باليونانية قوتيرا وهو الطافن
ولذلك ذكروا فيه كل ما ذكر وان الطبائخ وزعم الرازى في الكافى
انه العوسج وقال في الحاوى هو الحاج شوك ترعاه الجمال كورق

وأيضا فطر الذي طوطر يع هو التودنج من الحاوي طوطغا
هو الجذار من الحاوي طوطاق هو النابل باليونانية طوطر
مواكه الحمض ليا يعرض من طوطو هو النوشا
طوش يقول هو الشاب وبلغة البيش طوفريوس
بنات قد ذكره العود في موضعه كذلك طوفرنوس ومن الناس من
يسمي الكمأة بوسه الاكال : طوفسم هو
الانجل طوفوس هو الدوقا هو طوسارا هو النكر ومد
ش نكر: طوسبلس هو الادجر بلهدبه من الحاوي طوله
باللطيني هو الفرتكل وهو الذي يسمى بالبوتانية سيدلبون وزعم ابن جلجل
انه انطون ذلك الحل: طوماطالي هو العرطنيشا باليونانية
من الحاوي وحقيقه الاسم بنه لايطوماطالبت ع

حرف الياء

يبنوت **ابوجينه** هو ضرب ان احدهاهذا الشوك القصار الذى
يسمى الخرنوب النبطي
له ثمر كانها نفاجه
فيها حب جمر وهى
عقول للبطن يتداوى
بها والاخر شجره
عظيمه تكون مثل
شجره التفاح العظيمه
ورقها اصغر من
ورق التفاح ولها

خصبة ولا نبت بالجبال ولا بالرمال بل وهي إلى ما تنبها العامة
أم غيلان يوجد بين نجبه وصيمه شي أزرج جلو طيب الريح ينصه الناس فطيب
اللثه وتطهره و عبد الله بن شي كأصمغ لاصق بالعود لبس يسمع ينفلع فيوجد في
جوفه شي أحمر فيرمى به ويغسل ثم يبضع فيكون كأجود اللبان وأشده بياضا
وتمددا طلقوا النجدان من الجاوي: طمطم هو الماء من
الجاوي: طمسان نوع هما الذرة من الجاوي: طمسان
فلانه السوع: طهان ثل انه الكاشم وبقال الطرائن: طهيره
هو الطنخشوق والبانيته: طهف قيل هو الذرة وقيل طعام يتخذ
من الذرة وقال أبو حنيفه الطهف عشب ضعاف من المرعى شبيه
بالدوق مثل ورق الذخر وله حب رقيقه جدا طويله صفراء حمرا إذا جمعت
كما راى احد ظهرت نجم منها وإذا انفرقت خفت تولد المجده وقال
القراموثي حب من الذرة: طواكشير هوا الطباشير من الحاوي
طواره هي حشيشة نبت مع الاسله هي احد وقد ذكرناذلك
في جزء ح ط وا ليس في عصا الراعي البوانته من كتاب
د ط وبادار موخوذ من م بالسريانيه من الجاوي: طوتريون
هي الفوه بالبوانيه: طوبه انم نجي وهي شوكه معر وفه ننمي بالبوانيته
اقليون على ما رعم بعضهم وقد ذكرنا اقليون في با به وزعم كثير من
المشتربن ان الطوب هو اللبني بالبوانيته سقندولبون وغلطوا هذا هو الطوبه
فصحيحوه واما الطوب فزعم قوم انه العرتيه السبز وقوم ينمونه الفرع
وهوشوك يخذ من شوكه مسابح للناز وقم نطنون انه الباذاورد ولبس
به على الحقيقه لكنه شيه به والباذاورد اصغر من الطوب واشد بياضا
طورغولبطس هو الماء والابيض من الجاوي: طوزبي هو
الكاشم: طوز فلا هو عتر الجلود: طوط هو القطن المعروف

أنه الكاشم واظنه الأنيسون نصيفا لأن اثمامناه كـ د دليلون قال ومن الناس من يسميه طورنبي · **طورسمى** هوالطرجشقوق · **طرشقوق** وطرشقوق ايضا هوالطرجشقوق · **طرسول** هوالطرجشقوق ايضا وهوالجبن المسمى باليونانية طراغس ويقال له السكت · **طرمامال** هوالغافت من الحاوى · **طرو فلا** هوالغرا المتخذ من جلود البقر · **طروسو** هوالتكرو هى صنف من الاشربه ويقال له ايضا الكتيث · **طرى** هوالسادج بالسريانية من الحاوى · **طبطغش** هوالحيوان الذى يسميه اهل الشام الزير · **طس** هوالمسمى باليونانية اذرنى وادرنون من الحاوى وهوزبد البحر · **طرطرسوس** ويجوز رم بجر من الحاوى طغاره قيل انه الكاشم باللطينى · **طفاسى** قيل انه المزرجوش · **طفطفا** اسم هندى وهوكزكودهندى من الحاوى · **طسما** هوالبيبوت ونعم قوم انه السذاب البرى وهوخطا · **طفسيفون** هو سم يلطخ على السناب وقيل انه البيش · **طفشيل** هوكل طعام يطبخ بالقطنيه كالعدس والجلبان ويشبهها · **طفنسس** هوسمك يسميه اهل رومه بهذا الاسم · **طلافيون** هوالمشار · **طلب العدد** هوالادجر من الحاوى · **طلينا** هوصنف من الصدف صغار وبسميه اهل الشام الطبيش وسنذكرنى فى حرف ص مع الاصداف · **طلح** قيل انه الموز وهوموز برى يخرج اقناء كاقناء الموز فيها هو صغار اخضر لايطيب والطلح ايضا شجر ام غيلان قال **ابو حنيفه** الطلح اعظم العضاه واكثره ورقا واشده خضره ولبره شوك ضخام طوال وشوكته من اقل الشوك اذا وله ازهره بيضاء طيبه الريح وغلفه كبررون الباقلى كبار تاكله الابل والغنم وصمغه احمر عطيم غلط كثير ويصنع من خابيه وجفان وله خشب صلب جيد ولابنته الابارض غلطه شديد يدى

بالبونانيةِ صنعةَ الصيفِ وهو صنفٌ من الفوذنجِ الجبلي ۞ **طَرافَهْ**
هوالغافتُ من الحاوي ۞ **طَراسْنا** هو البلوطُ بالسريانيةِ من الحاوي
طَرْاوَلَسْ هو الفرنجمشكُ بالبونانيةِ ۞ **طُرْشا** هو القَظَفُ
طَرْبيلسْ هو الحنّاكُ بالبونانيةِ ۞ **طَرْهَلسْ** هو البُطْمُ
طَرْبولونْ تاويلهٔ بالبونانيةِ ذو ثلثةِ ألوانٍ وزعم قومٌ أنه
السَّبَدُ وليس بصحيحٍ ولكنّا قد ذكرناهُ مع التنبيهِ بهِ ۞ **طَرْيخ**
قيل إنه النّزر وقيلَ كلّ تمكٍ مالحٍ وقيل السردينُ وقال بعض المفسرين
الطريخُ ما يُتَّخذُ من السَّمَكِ الكِبارِ والصيرُ ما يُتَّخذُ من السّمكِ الصغارِ ۞
طَرْخوماناسْ ويقال طَرْخاماسْ يُسمّى بهذا الاسمِ نباتٌ قد
تقدّمَ عليه وهو صنفٌ من البِرْشيا وشانْ يُسمّاهُ الرازي في الحاوي
بالغارشيّه حلدا روح وطرخومانس أيضاً هو الكبرُ من كتابِ رُوفس وفي
الحاوي طرخومانسْ صنفٌ من هذا الجنسِ ۞ **طَرْعونْ** هوالشَّقَقْنِينُ
بالبونانيةِ وهو الحمامُ ۞ **طَرْعونُ البحريّ** وهو ما يمدُّ البحرَ وهو دابَّهْ
بحريّهْ شَكْلُها بشكلِ الخفّاشِ لها جناحان كجناحي الخفّاش ولون أكلونه ولها
ذنبٌ كذنبِ الفأرِ وفي أصلهِ شوكةٌ على مقدارِ الإبرةِ يلسعُ بها فتؤلمُ
المأْلوعَ ألماً شديداً ۞ **طَرْبَقلن** تاويلهُ بالبونانيةِ ثُلثٌ وزُفاتٌ وبوقعونَ
هذا الاسمِ على ثلثةِ أصنافٍ منها الحُمّانَهْ وهي المخصوصةْ بهذا الاسمِ وقد
ذكرتُ في بابِها والآخرُ هي الخندقوقا النابتُ في المروجِ والثّالثُ هو
نوعٌ من خصى الثعلبِ وهو المسمّى سابا طوزبنُونْ ۞ **طَرْبقر** هو الإسفيوسُ
من الحاوي ۞ **طَرْبقولونْ** قد ذكرناهُ في الزبدِ ۞
طَرْعوبُونْ تاويلهُ بلكْ جانْتْ وهوالغَرْزوزْ ۞ **طَرْشكهْ**
هوالمثانٰ بالعجميّهْ ۞ **طَرْثوثْ** هو واحدُ الطرائثِ ۞ **طَرْخونْ**
هو عنبُ الثعلبِ بالبونانيّةِ ۞ **طَرْدِيَلو** ويقال طَرْدِيَلوُنْ زعموا

الحروف الجبال وهي جمده :: **طخش** هو خشب من خشب الفتي بالاندلس
وزعم قوم انه املیس ولم یصح ذلك وزعم بعضهم انه المران وقیل بل هو
الشوحط وصفته بصفة الشوحط اشبه وهو شجر ورقه نجوم وذرق الحدلان
وله ثمر اخضر اذا نضج احمر ودخله نوى فيه دهنیه وفی طعمه قبض
وهذا هو الطخش المعروف عندنا وحکی ارسطو انه شجر اخر فلا اشا زل هذا
الاسم ولم نر :: **طخشیقون** ویقال طقسیقون وقیل انه
البش فال د هو سم توى فلا ما یخلص منه وقال ویسمی فسیون
وتاویله الغوى لانه نسم به السهام فال **غبیر** مود واعر ف عند
اهل ازبیته یسمون به سهامهم :: **طحما** قال **ابو حنیفة** الطحماء الحمص
وفي عریضة الوز وکثیر الماء وهو اخف لحمص سوونه على السابه حصها
خصما :: **طرائث** هو الطرائث من الحاوى وقد ذكرنا ب باب
الادویه والطرائث عندنا کثیر من اهل بلدنا نبات اخر هو صنف من
الجعفيل یغلطون فيه وزعم قوم ان الطرائث هو حبة النیل وقیل هو
ذنب الخیل وکل ذلك خطاء :: وزعم جل الاطباء والمفسرین ان
الطرائث هو المسمى بالیونانیة هو سطيذاس وهذا هو الشملا وهو قريب
من نوع الطرائث :: **طر احیطولیثو** هو الحجر الخزف
بالیونانیة :: **طر اغافتا** هو نبات شجره الکثیر بالیونانیة وتاویله
هذا الاسم شوکة البیس نحوا وزعموه على الکبیر نعنها اعنی الصغیره ة
طر اغلیس قیل انه السلك وقیل صنف اخر من الحبوب وقیل یسمی
الترمش بالعجمیه وطر اغر ایضا نبات اخر یتقدم القول علیه ة
طر اغلیس وبقال طر اغیون نبات قد تقدم ذكره وطر اغین
بالیونانیة هو اسم البیس **طر اغرنوعن** نبات یسمی بالیونانیة
قومی وسنذكره بحرف ق :: **طر اغورنعانس** تاویله

طازفه هى الماهوذانه بالعجمية ۰ طاروس هو تمليفس
طاطما هو الؤذرى بالسريانيه من الحاوى ۰ طاطس
المااورا العربيه فطاطس اسمه رومى وقد يعرف فينال الدادى وهى مصابيح
يحذ من خشب لصنو برالخفيف الكبرالدسم لانه يشعل النار وبقى يتقد مده
بمنزله مصابيح الشمع ۰ طالب هو الزنج الاصفر من الحاوى ۰
طالفاطو هوالسعط ۰ طالم هوالزنيح الاصفر ايضا ۰ طالون
هوالعزلى طبشا بالبونانيه من الحاوى واصل الاسم انما هواد وبطو طالونت
طاما سرهون هو من ماء الراعى ۰ طاملى هو الزوفرا بالهنديه
من الحاوى ۰ طاهر هوالفنكشت ۰ طبوط هو يشبه جنا شبر
عن الرازى ۰ طيثوماليبس هوالسنبج السواحلى طيثومالص
هوالسنبج بالبونانيه ۰ طيثومالس هو تمليقس ۰ طبطان
هو كراث البر ومنابته الرمل عن ابى حنيفه ۰ طبطايوس هوالزرنحان
بالبونانيه الاحمر والاصفر وقيل هوالكلس ۰ طبعا هوالسلت
بالبونانيه من الحاوى ۰ طبفنا هوالدادى ۰ طيلافيون
يعنى بالبونانيه ۰ بهذالاسم يسمى احدما يسمى بالفارسيه سارز وبنال
مشهار وسندكره فى حرف م ۰ والاخر مع اصناف جى العالم وبعض الناس
يسميه رحله برنيه ۰ طيلاون هو موضع رجل الحمامه الذى يصبغ بها الشمع
والدهن والسنحار الصعير وسندكره فى حرف ش ۰ طبلس
هوالحلبه بالبونانيه وينال الطى وطبلبيون وهن الحلبه ۰ طين اخضر
قيل هواييلج ۰ طين احمر قيل هوالحرا هوالمعروف بالاطين
طبهوج هوالقرنبر وهو طاير صعير معروف ۰ طى فاك
ابوحنيفه هى شجر تسموا احوالقامه مشوكه من اصلها شوكا غاب
لورقها ورقها صعار له نوير بيضا تحدها النحل وهى مرعى ومنابتها

النار بمدد وتأثير الصفر نكثر حتى يبرد :: **كتاب الإحجار** ان خرج بالطالون
جوان اضربه اضرارا مفرطا لتميته وان وضع صنانير لصيد السمك لربط
الجوت الحلقر واكبر وصغرت الصنانير ومن اصابته لغزه فادخله بيت
مظلم لا يدخله الضو وادمن النظر فيه مراءا من الطالون يبرى منها وان
احمى في النار وغمز في الماء لم يقرب ذلك الماء دابة وان عمل منه ملعقة وثقف
به الشعر من الجسم وادمن ذلك لم ينبت :: **طرسنوج** ويقال
برسنوج وهو حوت بحرى يسمى بأبو ثلاثة طرينلا وبالطينكه الملد ب طرنغلا
هو صنف من السمك البحرى اذا ادمن اكله اورث العين غشاوة واذا شق
وهوى ووضع على نهشتين الحزوعقربه وعنكبونه ابرأمنه ع
طرعلوديس الرازى قال ابن الكافى انه عصفور صغير
اصغر من جميع العصافير اكثر ما يظهر في الشتاء لونه متوسط بين لون
الرماد والصفرة في جناحه ريش دهبيه ومنشار دقيق ولذنبه نقط
يشبه الجزكات ثواني وهو دايم الصفير قليل الطيران له خاصية عجيبة
في تثبيت الحصا المتكون في المثانة ومنع ما لم يتكون وقال في الحاوى
انه يسمى بالاترجبه صفر اغون د ت فنائى وهو نوع من الطرسنجى بالأذ رجيته
صفراغون اذا شرب من جوفه قليلا قليلا فتت الحصاة في المثانه ع

وهذا شرح ما وقع في هذا
الباب من الأسماء

طابيا هى امر نشأ من الحاوى ۰ **طابيث** هو الفرطم من الحاوى
طاباى هو النار الإسكندرانى **طارحمس** هو الأس وهو الطرح
طاطحمس هو حيوان صغير يسميه اهل الشام الزبر وقيل انه يشبه الجراد
يصيح بالليل وصياحه صرير ۰ **طاردنا** هى نشار الخشب المتأكل ه

وهو نافع من كسر العظام اذا طلى عليها بالآناث **طلق** ابن عزان
الطلق حجر براق ينحل اذا دق الى طبقات صغار رقاق ويعمل منه مضامّ
للحمامات فيقوم مقام الزجاج ويسمى السح والحاسما بالسريانية وكوكب الأرض
وجزء والعزوسه · **الرازى** الطلق انواع يجزى ويمانى وجبلى وهوينفتح
دق صفايح دقاقا بيضا هابصبر وقال فى موضع اخر الطلق جنسان منضج
وحبلى يكون من حجاز الحمر ويكون الحجر بن قبرس ليى هذا الجنس هو الجنسين
وقوى الطلق الاندلسى **على بن محمد** الطلق ثلاثة اصناف يمانى وهندى
واندلسى واليمانى ارفعها والاندلسى اوضعها والهندى متوسط بينهما فأما اليمانى
فهو صفايح رقاق ازق ما يكون من صفايح الفضة عنبرا ازق لونها لون الصدف
والهندى مثل اليمانى فى شكله الا انه دونه فى فعله والاندلسى منضج
ايضا غير انه غليظ يجبس **على محمد** وحلى الطلق بان يجعل من جزئه مع
حبّات ويدخل فى الماء النابت يحك برفق حتى ينحل ويخرج من الحجر وهو
فى الماء ثم يصفى ذلك الماء عنه ويترك فى الشمس حتى يجف ويبقى فى اسفل
الآنا كالدقيق المطحون **الرازى** اذا طلى بالطلق عضو لم يعمل فيه النار ·
ابن سينا الطلق يازدى فى الأولى وينفى الثانيه فابض حابس للدم نافع من
اورام الثديين والمذاكير وخلف الاذنين وسائر اللحم الرخو واندمالوجع
من نفث الدم من الصدر والنزيف من الرحم والمنعد اذا اغتسل وشرب بماء
لسان الحمل وينفع من دوشنطاريا وينفى خطرا منا فمن نثت شظايا وحلها
باخل والمرى · **عنب** جيد للفروج التى تهيج اطراف الجذوم ينقيها ويحممها
طالقون **على بن محمد** الطالقون جانس ترتيبوا بالجانس المنفع فى
ابوال البقر والارهان المنفع فى ماء الاشنان الرطب فيحدث فيه شيبه وجدة
قوته · **عنب** هو صنف من الجانس الاصفر والفرق بينه وبين سائر
انواع الصفران هذا وجد اذا اجمى فى النار وضرب عندخروجه من

ن الأجال التي ينبت الأشجار وينضج الثمر وقد يلطخ به الكرم حين يندى
نبات ورقه واغصانه لئلا يمنع الدود أن يأكله ونقله :: **طين أرمني**
وأما الطين فهو طين ما لبس جدا يضرب لونه إلى الصفرة وهو ينسحق بسهوله
كما ينسحق النورة ويسير من الاستواء والملاسه وعدم الحجاز الصغار إلى مثل
ما عليه النورة والطين المعروف بكوكب الأرض وليس مثله حقيقته مثل كوكب
الأرض بل هو مكتنز وهو جفف جففا شديدا على غايه ما يكون
وذلك أنه نافع جدا للشروح الحادثه في الأمعاء ولاستطلاق البطن ونفث
الدم ونزف الطمث ونوازل الرأس والقروح المعفنه في الفم وينفع من
نجد زمن زاسه بالصدر من مادة نفعا عظيما ولذلك صار عظم المنفعه
لمن ضاق عليه نفسه من قبل هذا السبب ضعفا مسوا وينفع ايضا اصحاب
البل وذلك انه جفف الخراج الذي في رئتهم حتى لا يبعلوا الا ان نفع
تدبيرهم خطا عظيم ونغير الهواء دفعه الى حال رديه ومن شربه في وقت
الموتا انتفع به ويرى بشرعته ومن لم ينتفع به مات فدل ذلك على انما
لم ينفع منهم من لم يكن فيه أن يبرا اصلا وهذا الطين يشرب مع شراب
لطيف رقيق القوام ممن وجاع مراجا معتدلا مني ليكز العليل محموما او كان حماه
يسيره فاما متى كانت الحمى شديده فالشراب يمزج مزاجا مكسورا بالماء جدا على
ان الحميات التي تكون في وقت الموتا ان لست تكون صعبه ولا شديده فأما
الجراحات التي تحتاج إلى جفيف فلست احتاج الى ان اصف كيف قوة هذا
الطين وفعله فيها :: **ابن عمران** الطين الارمني هو طين احمر لونه سبا
السواد طيب الرائحه ولا يعلق باللسان وهو بارد يابس جدا وينفع اصحاب
الطواعين اذا اشرب منه اوطلى عليها وبدله وزنه من الطين الحجازي المسمى عندنا
بالإنجباز :: **الدمشقي** يخرج من المعقد قسو البوايس والحبز الكبر ::
عنيزه اجوده المورد الناعم والطين اللاذي قريب منه في النعل

تجفيفًا لينًا بشديد و قوته تنقي و تنتج البشرة و تجلو ظاهر البدن و تحسن
و نزق الشعر و تبلع الهوى و الجرب المتفرج و قد يستعمله المصور في الأصابع
لطول مكثها في الصور و لا يبدأ بش سريعا و قد ينفع في أخلاط الأدوية التي يقال
لها اعلوذي و ينبغي أن يجتنب من هذا الطين أيضا ما لم يكن فيه حجاز و كان قريب
العهد بالمعدن الذي اخرج منه و كان لذلك سريع التفتت و الأملاح إذا اختلط شي
من الرطوبات ⁕ و أما الطين المجلوب من أفرطش فنوشبه بهذه الأنواع من
الطين لكنه اضعف منها كثيرا و الأكثر فيه الجزء الهوائي و فيه أيضا جلاء
و لذلك صار الناس يجلون به انيه الفضة إذا اتسخت فلهذه الأسباب ينبغي أن
تستعمل هذه التربة في جميع الوجوه التي يحتاج الى ما يجلوا بلا لدع ⁕ طين
كرمي ⁕ و مما استفت خبرنا له أما الطين و هو الكرمي و من
الناس من يسميه فوما فيطش و اشفعا و هذا الاسم من قوما فن و معناه الدوا و قد
يكون هذا الطين بالمدينة المسماة سلوقيه التي البلاد التي يقال لها سورية
و ينبغي ان يختار منه ما كان أسود اللون و كان أشبهها بالغم المستطيل المتخذ من
خشب الأرز و كان أيضا أشبه من شكل الحطب المشقوق الصغار أو متناولك
الصغار له لبريطى الأملاح إذا انتحي و صب عليه شئ من الزيت فاما ما كان منه
أبيض رماديا الأملاح فينبغي أن تعلم أنه ردئ ⁕ سميت هذه التربة كرميه لا
لأنها تنضج لغير بن الكرم فيها لكنها إذا أطليت على عود الكرم فتلت الدود
الذي يتولد فيه في مبدأ الربيع عندما يورق فأكل عبر الكرم فلذلك يطلي
الفلاحون هذه التربة عند أصول تلك العيون و يتمونها تربه كرميه و تربه
دوائيه و قتلها لهذا الدود دليل على ما فيها من قوة الدوار و هي بعيد جدًا
من جميع أنواع الاخر من أنواع الارض التي يستعملها في أنواع الطب و ذلك
انها قريبة من جوهر الحجاز و انما تخلط بالأدوية في الموضع الذي ينبغي ان
تجفف فيه شئ وجل ⁕ و قوه هذا الطين فانضه مليئه مبردة و قد يستعمل

بازد منْ قوى الْمعدة وَيذهب بالقى وَيذهب بخامة الأطعمة الكارنة الدَّسمة اذا
اخذ منه بعد الطعام شياسير لاسيما اذا ان مرباً بالاشنان والورد والسعد
والاذخر والجاية والشاقلة واجتنب ان يشرب مع هذا الطين خاصة من يوُلد
النددوالحجرفى الكلى والمثانة كما مع شارب الطباز ويتما النوى المقلو
منه الذى لا ينفرك ولا يبقى من الزنوج فى الفم وينبغى ان يجتنب الطين اصحاب
الاكباد الضعيفه المجارى ومن يتولد الحصا فى كلاه وهم اكثر الا من
اصحاب الابدان الخفيفه الصفر والسمر والخضر وقال جـــــــا لينوس فى الطين
الطين الشابورى خاصته يشد قم المعدة ويَنْفع من العثا والبيضه وسيلان اللعاب
فى جال اللثوم والشهو الكلبيه مع انطلاق الطبيعه ومن بعد يريه عثى وكرب
بعقب طعامه ۞ **الطين الخناقى** د ومن اصناف الطين صنف
يقال له بسغيطين ومعنى هذا الاسم ماء البوتانى الطين الخناقى وهو طين لونه
شبيه بلون الطين الذى يقال له ارطوباس وهو عظيم القدر بازدياد المجس
اذا الزق بالنار اشتد لزاؤه فيعلق بالنار وهو مثال العلك ونوه هذا
الطين شبيه بقوة الطين الذى يقال له قموليا غى الا انه اضعف منه قليلاً
ومن الناس من يبع هذا الطين بحساب الطين الذى يقال له انطوباس على جهه
التدليس ۞ ونوه شبيه بقوة الجمولياً واما لونه فبعيد جداً من لونه اسود
مثل الطين الكرمى ولهذا للروحه مثل ما للطين شاموس اوْ اكثر د ه
لبركيلس ومعناه الطين الذى فى جبطار الاثانية الذى فذاشتد شبه ثم احمر
فوه مثل قوة خزف السور ومنها ۞ **طين بلاد فو** د صنف يقال
له فيلغى وهو طين بلاد فو وهو طين لونه شبيه بلون احد الصنفين من الطين
الذى يقال له ارطوباس الذى يشبه لونه لون الرماد وفيه خشونه واذا فركت
بالاصابع سَمع له صرير مثل ما يخرض من الفينور اذا فركت ۞ وقوته شبيه بقوه
الشب الا انها اضعف منها وقد يستدل على ذلك من البنور او قد يجعل اللسان

النوعين نخل ولطخ به الأورام العارضة في أصول الآذان سائر الجراحات جلها واذا الطخ كل واحد من النوعين على حجر والنارنج اول ما يعرض منه ومنع الموضع من النفط و تذ جللها كل واحد منها الاورام العارضة بين الاذنين والاورام الحارة العارضة في جميع اعضاء البدن والحمرة وبالجملة ما كان من هذا الطين خالصا فانه كثير المنافع :: **ابن عبدون** الطين الحر هو الطين العلك الخالص من الرمل والحجار :: **علي بن محمد** وربما خصوا بهذا الاسم طين شراف لنقائه وتداخل اجزائه وهو نحض شديد الرخوصه مشبع للخضرة كثرخضرة من الطفل حتى ان خضرته تقرب من خضرة الزنجار فاذا دخن نضوج الجوز لونه احمر لونه وطاب طعمه و قل ما يوكل عنبر متخن **ابن جلجل** طين نهولباهيمه اهل البصرة الطين الحر وهو الطفل وانواع كثيرة فمنه الارمني والمحلا س والاندلسي وهو ابيض شديد البياض صلب الجرم مكتنز الاجزاء لا ينكسر بسرعة ولا ينحل بالماء الا بعد برهم من الدهر عنه انه اذا اجل فيه من الزروجة اكثر مما في غيره والاندلسي صنفان ابيض واغبر فالابيض الشديد البياض هو الذي يستعمل في العلاج والاغبر ردي لا يصلح للعلاج ولا يصرف في شي منه :: **الطبري** الطين الحر بازد بابن باعتدال حدجمع انواع الجزاء اذا ارتفع وضع على الموضع الذي فيه الجزاء ونطلي بالخل على النبع ان ابيز فيسكن الوجع :: **الرازي** طين الاكل هو الطين المنقل به اللسابوزي :: **ثابت بن محمد** الطين النسابوري هو طين ابيض طيب الطعم يوكل نيا ومشويا :: **علي بن محمد** هو من الطين الحر ولونه ابيض شديد البياض في لون استفيداج الرصاص لين المذاق يلطخ الغم من شدة لينه نف طعمه ملوحة فاذا دخن نعمت ملوحته وطاب طعمه :: ومن الناس من نصوله ويعجنه بما الورد المنثور بشي من الكافور ويتخذ منه افراسا وطيورا وتماثيل وتوم اخرون يضعونه بين المسك والكافور وغيرهما من الطيب حتى ياخذ رائحته ويطيب فينقلون به على الشراب فيطيب الكهه وينكر ثونا المعدة :: **الرازي**

وأجوده ما كان أبيض صلباً وقوة هذا الحجر قابضة مبردة وإذا شرب نفع من
وجع المعدة وقد يخلط الجوارش وينفع من الورم والقروح العارضة في العين
إذا استعمل بالبزر وقد نظن به انه إذا علق على امرأة التي قد عسر عليها المخاض
أسرع ولادها وانه إذا علق على الحامل منها أن يسقط الجنين ومنها صنف
يقال له جالينوس وموطن حياه هو جزيرة المصطكي وهي كيوش ينبغي أن يختار منه
ما كان لونه ما يلي إلى لون الرماد شبيها بما سامي وهذا الطين رقيق وصفائح
وقطعه مختلفة الأشكال شبيه بقوة الطين الذي يقال له ساماى ويصفي الوجه
ويابس البدن قد يغسل به ينجم مكان المطرزون والطين ايضا الذي يقال
له شابلوسا فعله مثل فعل الطين الذي يقال له محبا وأجوده ما كان شديد البياض
صقيلاً سريع التفت وإذا بل بشيء من الرطوبات املس سريعا ● الطين المنسوبة
إلى اسانيا والمنسوبه إلى لوس ففيهما قوة تحلوا حلا يسيرا ولذلك صار ينبغي لها
كثير من النساء في العزم على وجوههن وهما من افضل الأدويه للقروح
الجارتوه عن حرق النار وهما صنفان عن طين ساموس من طرن وايهما الانفعان
الأورام الحارة التي تكون في الثديين والاربين والبضين مثل ذلك ● م
طين قيموليائي ﺓ ومنها طين يقال له قيموليائي أى طين قيموليائي
وهو الطين الحر وهو صنفان احدهما ابيض والآخر فيه من غيرته وهو ذم
وإذا المتروجد بإزدا لمجنسة وهو اجود النوعين ﺝ قوته قوة مركبة وذلك
إن فيه شيأ يبرد وفيه شباحلل بعض التحليل صار منى على اخرج عنه هذا
الجزء المحلل ومنى لم يغسل فإنه يعمل بالقوتين كلتيهما وإذا طلي به موضع حرق
النار من ساعته بعد أن خلط معه خل نفعه وينبغي أن لا يكون الخل ثقيفا
جيدا وإن كان ربّ على الصفه فالاجود أن خلط معه ماء قليل وكذلك يفعل
كل طين خفيف بالوزن أعني ينفع من حرق النار إذا طلي عليه من ساعته
بالخل والماء نفعه من ان يحدث في الموضع نفاخات ۰ ﺝ وإذا ديف كلي

قوتُه بجلله فان هو غُسل بعد ملح جرق سلخ جدته وترَكها في الماء و بقى في
اللطافة التى اكتسبها من الجرق وقصير اشد حَنيفًا وانفع ما كان للفروج و هو
اصلح نافع جيد للفروج التى لا يجب الى اثبات لحم فيها بهولة و بعبر اند بها لها
ح وقوه هذا الطبن قابضه مبَينه مبرده ملينه تلين ليفا ثيرا املا الفروح كما
ولرزق الجراحات في اول ما يعرض منها ۰ طين ساموس د ٓ
ومنها صنف يقال له ساسى و معناه طين ساموس و هى جزبن و ينبغى ان يختار
منه ما كان ابيض مفرط ابياض خَفيفا و اذا الزق بالنسان لزقه مثل ما يلزق
الدقيق و اذا بل بالماء امتلع سريعا و كان لينا نريح التفتت مثل الصنف الذى
يقال له قولوزبون فانه صنفان اجيمهما هو هذا الذى وصفنا و الاخرى
يقال له اصطراى الكوكب و هو كوكب الارض و كوكب ساموس وهو ذو صفايح
و مود و صفايح كَثِيف بمنزلة المسن ح لجن يستعمل النوع المُسمى من هذه التربه
كوكب ساموس مداواه نفث الدم من حيث كان مد و اه فروج الاعضاء
قبل ان يعقن ان يحقن به بعد غسل الفرجه بماء العسل الذى له فضل صرْ فِيةً
اى قليل بالماء ثم الملح بعد ذلك ثم يحقن معه بما لسان الحمل و ينفى منه
ايضا خل ممروج من حراك كثير الماء و هو نافع للاورام الحادثه فى الاعضاء
الرطبه الرخوه كالبدن والخصيين والغدد و ينبغى ان يسحق و يعجن بماء و دهن ورد
وكذلك ايضا ينفع سائر الاورام الحاره و اورام الحالبين عند ابداياها و للنزل التى
تنصب الى الجلين فى علاج النفرس و ذلك لان قوته مبرده تبريدا معتدلا د
و قوه هذا الطين و حرقه و غسله شبيه بقوه و حرف وعمل الطين الذى
يقال له اراطوماس و قد يُقطع نفث الدم و ينبغى لنا ان اتزمان الَبرى للطمث
الدايم و اذا اخلط بالماء ودهن الورد ولطخ به الثدى و الخصى الوارمه و اما
جاء السكن و نها و قد يقطع العرق و اذا اشرب بالخمر ينفع من نهش الهوام و من
الأدوية القتاله و قد يوجد فى اساميا حجر يستعمله الصاغه فى التمليس

قطعه :: ما شرحيه :: يقطع الدم من حيث خرج :: الدمشقى :: وينفع شرب
سحقه وشرب نقعه من الوبا ومن الوبا :: وطين الارض التىمنه الدتمه
نافع فىما واه جميع الاعضا المجناحه الى اليبس وقد رايت مجربين ومنتفعين
يطلون بهذا الطين على ابدانهم كلها فينتفعون به منفعه بينه ولذلك
ينفع هذا الطلا للاورام العفنه والاورام المترهله الرخوه :: واعرف
قوما رهلت ابدانهم كلها من كثره استعراق الدم من اسفل فاستعقوا به
نفعا عظيما وقوما اخرين شنوا بهذا الطين اوجا عا من منه كانت تمكنه
فى بعض الاعضا تمكنا شديدا فبرت وذهبت اصلا :: ليس رانا سر ومعناه
كل اصناف الطين التى تستعمل فى اعمال الطب لها قوه تقبض ويقوى التبريد
والتغريه وحملت كل واحد منها خاصه فى المنفعه مرىى دون
شىء اخر قد ينفع منه غير من جنسه يكون من الاستعمال منها ون بعال
له اطونايس ومعناه الارض المحرونه وهذا الصنف منه شىء اصر شديد
البياض له خطوط ومنه شىء لونه شبيه بلون الرماد وكل واحد واذا جكت
على شىء من الخاس خرج لونه شبها بلون الزجاج وقد يغل مثل ما بعل
استفيذاج الرصاص وهو على هذه الصفه يوخد منه اى مقدار كان فيذو ويسحى
ويصب عليه ما جنى يصفوا ويصب عنه الما ويوخذ الطين وجفف فى
الثمر ثم يوخذ فيسحى ويصب عليه ما فى الجى وينعا يه ذلك فى النهار كله فاذا
كان اخر النهار يترك حتى يصفوا عنه الما فاذا كان زبد الحجر صفى الما عنه وسحى
الطين فى الثمر وفعل منه افراصا ان امكن ذلك فان احتج الى ان يشوى فليوخذ
منه قطع امثال الحمص ويصير فى انا من الخار ام شقب ثقبا كبير ويشد ثمه
ويسنو ثوق منه ويصير فى جمر وتروح عليه دايما فاذا صار لون الطين شبيها
بلون الرماد الاسود رفع عن النار :: فوته قوته الا انه ليس له من زياده القوه
ما يلدع فان غلى صار لينا وقد يجزى فصير الطف واجد كثيرا جنى ينغير ويصير

فاذا رسب صبت اول ما يقوم فوقه من الماء الذي يقوم عليه واخذت ما كان من الطين ثم ثاني الرجاء تركت ما هو مجرى رملي مما قد رسب اسفل الطين وحدٍ وهو الذي لا ينتفع به ثم انها تجفف ذلك الطين الدسم جتى يصير بحد الشمع اللين ثم تاخذ منه قطعا صغارا فتحمها بالخاتم المنقوش عليه صون اطاس وتجفف تلك الخواتم في الظل جتى تجف ويصير منها هذا الطين المختوم المعروف في كل موضع فمنهم من لم يخلط فيها من الدهن هذا الطين دم التيوس او بلغمهم وذلك فضحك منجح من جهة مسلتي هذه. وهذا الطين يستعمل في وجوه شتى فتداوى به الجراح الطريه بدهنها والتروج العفنه العسرة الابدال ويستعمل في مداواة نهش الافاعي وعنز هاس من الهوام ويسقى منه شاربا ثم يغلى شربه او بعد وقد جربته فمن شرب رياقا جريا ومن شرب بالدارج فزا انهم قد تعيوا الدم كله بعد شربهم الطين المختوم المعجون مع جب العرعر ولم يعرض لهم شئ من الاعراض واذا ذيف هذا الطين بخل شنى من نهش جميع الهوام وينبغى ان يوضع فوقه اذا طلى ويرق بعض العقاقير التي فوها مضاده للعقوله وخاصه ورق الدوا المسمى استقردنون وبعده ورق المفطورٍ زبون الذنبى وبعد هذا ورق الفراسيون وقد يسقى منه شراب ممزوج لمن عضه كلب كلب واذا استعمل في مداواة الجرلجات الخبثه مدا اجل نفعها منفعه عظيمه 55 ليمنا سفر اخر وهو الطين المختوم هذه التربه نستخرج من معان ذاهبه تحت الارض شبيهه بالسرداب ويخلط بدم عنز والنار الذي هناك يطبعونها بخاتم فيها مثال عنز وتسيمونها سفر لخنين معناه علامه الخاتم في الشئ المختوم وللطين المختوم قوة اذا شرب بالخمر ضاد لادويه القتاله مضاده قويه واذا استعم في شربه وشرب الدوا القتال اخرجه بالقئ وقد يوافق لدغ ذوات السموم القتاله من الحيوان ونهشها وقد ينتفع في اخلاط بعض الادويه المركبه في اخلاط اللبن بانت الخوزى اجوده الذي نتجه ريج السبت واذا وضع على فم الجرح السايل منه الدم

العفنه من المعده وينفع من الكرب والتوحش وتقوي الاعضاء التي قد ضعفت من الخزان وينفع الادام اجازه في العين طين انواعه كثيره
منها الطين المختوم وهو اجل اصنافه المستعمله في الطب واضلها وهو خا ثم
البحيره ويقال له الطين الكى في لان اول من اخرجه امراه كاهنه في ألف
الدهر يقال لها ارطامس على ما زعم بعضهم ج ط قال انى سرت الى الجزيرة
نبوس لانظر الى هذا الطين وفي هذه الجزيرة مدينه من غربها مدينه تسمى موزنا
ومن شرقيها مدينه يقال ألقسطاس وفي هذه المدينه لا يعرف بل الكهان
وقوتل لا ينبت فيه شى وكأنه شى محبه ومكان لونه ولون هذا الطين شبه
بلون المغره وانما الخلاف بينه وبين المغره لانه لا بلط لا بد من يغسله ومنه
كما يفعل بالمغره وذلك ان ذلك التل لحمر اللون كله وليس فيه شى من
النبات ولا احجاره وانما فوقه هذه التربه وجدها وفي التربه الموجوده
هناك ثلثه اصناف احدها هذا الذي ذكرنا والمتولى لامره هي المراه
التي يقال لها بسكل ارطامس لا تغربه احد سوا تلك المراه · والصنف
الثاني مغره وهي التي يستعملها النجا زون خاصه لضرب الخطوط على الحبر
والصنف الثالث تراب ارض ذلك التل وهو تراب يجلوا ويستعمل في
كثير ممن يغسل الثياب الكتان فأما المراه ان في كتاب ج
وغيره انه يخلط هذا الطين دما النيس ناقضت نفسى لا باشر هذا الخلط لا عرف
كم مقدار ما يخلط من الدم مع التراب فسرت من اسكندريه التي في طور اله
جزيرة المنبوس وهي نحو من ميل ما بينها وبين البحر فرأيت تلك المراه بسكل
ارطامس قد اقبلت فلغت هناك عددا معلوما من الحنطه والشعير وفعلت
اشياء اخر على عاده اهل ذلك البلد يدينهم ثم حملت من تلك التربه وترجله
كما في وسارت الى المدينه فبلت ذلك التراب بالماء وعملت منه طينا
رطبا ولا زال لا نصربه ضربا شديدا ثم تدعه بعد ذلك جتى يشكل وبر سبب

العين وهو ذلك القوة الفعل الصنف الآخر شبيه بهذا الا ان خضرته تميل الى الصفرة وهو اقصر ساقا من الاول واورق واكثر اغصانا وشعبا نباتها في الآجام والمواضع الرطبة وهو من نبات الصيف وهذا الصنف يقلع من

العين ايضا وقد نسمى هذا النبات ايضا بجعفريه وعشبه العجول لانها ترعى بياض اعنها طباشير ماسنجويه هى شي يكون فى جوف القنى الهندى على بن محمد هو ما ذا اصول القنى الهندى ويجلب من ساحل الهند كله واكثر ما يكون فى موضع منه يسمى سريون من بلد كل حث يكون القلقل ويقول الهندان ان اجوده ما قال ايضا وخاصته عند وقلوسه التى فى جوف قصبه وشكلها مسند بمثل الدم واثار وجد هذا انه فيها احترق من ذانه عند حك بعضه ببعض شديدا ذهبت علته وقد يغش بعظام رؤس الضان المحرقه اذا ازائعت فيه فى صرمصعه حوزى يا بس فى الثالثه برى غوث حد يخفقان الفواد اخبار المرة والمرئ وافواه الصبيان ويشد البطن ويقوى المعدة وينفع من الغشى اذا اسقى واذا طلى به ابن عمران نافع من البواسير عنبره ينفع من الحمى الحادة اذا شرب بالماء البارد ويقطع العطش وفيه قبض ودفع وقليل حلل ويسكن الابخرة الصفراوى والقى ويشف ابله

طرابشبه هذا النبات نوعان أحدهما يشبه ورق الكرات وعليها
شيء كالغبار أبيض له ساق يعلو ذراعا سوى أعلاه شعب صغار في أطرافها
زهر أصفر كزهر
الطباق أو زهر
الخندبا وله أصل
أبيض كثير الشعب
إذا شرب عصير
هذا النبات أبرأ من
النفخ وبذا الاستسقا
ء وضعف الكبد
والطحال وعصارته
يكحل بها لبياض

أصلاح استرخاء المعدة ۰ غيره بارد يابس في الثالثة يقطع نزف الدم من
المنخرين والأرحام والمقعدة وسائر الجسد ۰ طحلب د د طاوس
الطحلب النهري والخضر
الشبيه بالعدسي في
شكلها الموجودة في
الآجام على الماء المقابلة
ح ح مزاج هذا مزاج
رطب بارد و من
الخصلتين كأنه في الدرجة
الثالثة د كذلك اذا عمد به وحده أو مع السويق وأبن الحصرم
والأورام الحارة والنقرس واذا ضمدت به فله الامعاء العارضة
للصبيان اضمرها وأما الطحلب البحري وهو شي يكون على الحجارة والجرف التي
بقرب البحر وهو وشي يشبه في قوته الشعر وليس له ساق ح ح هذا النبات
قوته مركبة من جوهر ارضي وجوهر مائي وكلاهما بارد ولذلك أن طعمه
قابض وهو يبرد واذا عمل منه ضماد نفع من جميع العلل الحارة نفعا بينا
وهو قابض جدا وصلح للأورام الحارة المحتاجة الى التبريد من النقرش غبره
يحبس البطن من أي عضو كان اذا طلى به وخاصة البحري والنهري اذا غلي في الزيت
العتق لين العصب ۰ طزخوماس د د هو نبات ينبت في
المواضع ينبت فيها شعر الخنازير وهو يشبه النبات الذي يقال له طاريس
وله ورق وطول الجدام وصفه نبت كلها الجانبين دقاق شبيه بورق العدس
محاذية بعضها بعض على قضبان دقاق صلاب صقيلة لونهما الى
السواد وقد يظن به أنه يفعل ما يفعل شعر الخنازير ح ح جميع ما يفعله
شعر الخنازير وهو البرشياوشان فهو ممكن في هذا النبات أن يفعله

نحو من عشر حبات بالشراب نفع من الإسهال المزمن وسيلان الرطوبة إلى الرحم
ومن الناس من يدق هذا الحب ويعمل منه اقراصا وتخزن ويستعمله في وقت
الحاجة. **طراثيث** **ابو حنيفة** الطرثوث بعض الأرض
سبط أعلاه نكهة وهي منه وليس
أصبع وعلية نقط حمر وهي مرة
وربما طال الطرثوث وربما قصر
وهو نقشة كالأرجوان ذكية أشبه
شي برعمة النبات الذي يسمى بستان
أبرور وينبت تحت أصول الحمض
وهو ضربان فمنه حلو يؤكل
وهو أحمر ومنه مر وهو أبيض
يجعل للأدوية ونكهة تصبغ بها
منها هو المتخذ عندنا يذرب
زاج وقد يكون بذا الاسم نبات
آخر **غيره** وأكثر ما يكون
الطراثيث في السباخ فأما النبات
المتخذ باليونانية **أبوقسطندا** اس
هو الطراثيث الذي يذكر **ح** وليس هو هذا كما زعم أكثر الناس ذلك
هو الثمار وأكثر ما يثبت تحت أصول النبس وإن لم يكن هذا هو من جنسه
وسنذكر عند ذكر لحية التيس. **الخليل** الطرثوث نبات كالفطر مستطيل
دقيق يضرب إلى الحمرة منه مر ومنه حلو يجعل في الأدوية وهو دباغ للمعدة
الطبري الطرثوث يجلب من البادية، مذاقته عفوصة وهو أزد ما به
فأنه عاقل للطبيعة إذا شرب ببعض القبض أو لبن الماعز حلبا أو مطبوخا

نوع اخر منه وهو طراغون التيني

للعلا السلانيه
اذا اكيلا او
مطبوخا نفع من
قرحة الامعاء وايجة
ورفة الحرب
مثل رابحة التيس
ولذلك يسمى طراغون
اى التيسى

طراغنيس

طراغنيس

ومن الناس من
يسميه سفريوس
ومنهم من يسميه طراغس
وهو نبت صغير على وجه
الارض طوله شبرا
او اكثر قليلا واكثر ما
ينبت فى سواحل البحر
وليس له ورق و على
اعصانه شى كانه
حبّ العنب صغار جمر
فى فنجيب الحبه
حاد الاطراف كثير
العرض يابض و ثمر هذا
النبات اذا شرب منه

خلط بسمسم خمير معجون لعين اثاجرة وتنبت في آجام وقمة

طراغيون

ورق وقضبان ثمر
شبيه بوزن وقضبان
الباذروج وثمر
النبات الذي يقال
له اخينس إلا أنها أصغر
منه أخشن وأضعف
شبيهة بالضع العربي
ورن هند
النبات وصمغه
وثمرته قوتها قوة
تحلل وهو لطيف
القوة جاء نجران
كأنها في الدرجة
الثالثة في مبداها ولذلك صار يخرج النداء ويفتت الحصاة ويدر الطمث
إذا شرب منه مقدار مثقال واحد ورق هذا النبات وثمره وصمغه إذا
ضمد بها بالشراب أحد بثور الثلاثة وما أشبهها وإذا شربت
أدرت تقطير البول ونبت الحصى المتولد في المثانة وأدرت الطمث والذي
يشرب منها مما هذه مقدار درخمي وتقدمنا أن العنز البرية اذا وقع بها
الشباب ورعت هذا النبات سقط عنها الشباب وقد يكون طراغيون
آخر وهو نبات له ورق شبيه بوزن شقولوزبون وقد يبسط أصله قريب
شبيه بالنجاسة البرية وفيه قوة مقدام ما ليس بالبين وهو موافق

العشب

هذه القوة بعينها ولذلك قد يأخذ قوم هذه الزهرة فينقعونها مع الورق
وينقونهما من الماء زادوا ما من النساء إذا إدرار الطمث بالعنف واخراج الأجنة
وقوة هذا الشراب إذا فرش بوزنه أو تدخن به إن تطرد الهوام والبق ويقتل
البراغيث وقد تضمد بورقه لنهش الهوام والجرذان فينتفع به وشرب الزهر
والعروق بالشراب لإدرار الطمث واخراج الأجنة وتطير البول والمغص
والبرفان وإذا شرب بالخل ينفع من الصرع وطبيخها إذا جلز فيه النساء أبرأ أوجاع
الرحم وإذا احتملت عصارته أسقطت الجنين وإذا لطخ بهذا النبات مع الزيت
نفع الكزاز : وأما الأصفر منه فإنه إذا اضمد به للرأس أبرأ من الصداع
وقد يكون نوع ثالث من هذا النبات أغلظ ساقا ونبا وأعظم وزنا من النوع
الصغير وأصغر من الكبير وليست فيه رطوبة ندق باليد وهو قليل الرائحة
من الأخرين بكثير والزهر وأضعف قوة وينبت في الأماكن المائية هو
أضعف قوة من النوعين الأولين ولكل النوعان الأولان كلاهما من الإسخان
والتجفيف في الدرجة الثالثة : **طيفى** فل إنه السلطان
ويسمى بالعجمية بنفاينه

طيفى ومن الناس
من يسميه اثلى هو نبات
له ورق شبيه بورق
الصعتر وله ساق
أملس وعلى طرف
الساق زهر أبيض
متكاثف شبيه
بالشعر في شكله يسميه
الناس اثلى وزهر إذا

الكبير ينفعه فيجبر له نوازل مجتمع لحرسه المحل ☙ هذا النبات نجن
انخانا نافعًا وينفع من أوجاع الكبد الباردة ويفتح سددها و يزيل النبج
والنفخ العارضين من ضعفهما و نَنوى أفعالها من هنا غلط فيه الناس
وظنوا انه الغافث جنى قدماء الاطباء فان الرازي يقول في الغافث انه
ينجن ما زعم انه وجده بالتجربة انخانا شديدا وليس هذا فعل الغافث
الحقيقي وقالوا ايضا ان الغافث انه بذر الطيث و هذا اتاهى فعل الطباق
لا الغافث وهو ينفع من سموم الهوام وخصوصا العقارب شربا وضمادا من
الاوجاع الطارئة و يسهل الاخلاط المحتبسة في الذقن فهو لذلك ينفع من
الحميات العتيقة والحرب والحكة اذا شرب طبيخه أو عصارته ۝ فاما
الطباق المنبر وهو النبات المنمى اليوناني شيئا قوشيرا منه وشذقوة واستجرارة
وأوليس منفعة الكبد والفرق بينهما بهوله الراجحة والطباق فطبيخه الراجحة
ولزك زفيها نموذج نبسنة وطعمها حلو والقوشيرا فيه حزافة ومرارة ظاهرة
وقد يستعملها كثير من الاطباء بدلا الغافث بدلا الطباق فانما غلطوا بشبهها
للطباق والغوث راهي الني يستميها الناس بشجرة البراعيث د ح من هذا النبات
ما يقال له قوشيرا الاصغر وهو أطيب زاحهة من غيره ومنه ما يقال له قوشيرا
أعظم نباتا من الاخر واوسع ورقا نفل الزاحهة وكلاهما بشبه ورقه
ورق الزيتون الا ان ليها عقبا وفيها رطوبة بندى باليد وطول ساقه أعظم
حو من ذراعين والاسمر ساقه مقدار تلع وله زهر هش اصفر إلى المرارة
ما هو يشبه بالشعير ينى شله وعرق و لا ينفع بها ۝ ح د مزاجهما وفعلهما
شبهان واحده بالاخرى وسط طعمهما حرافة ومرارة وهما ينخنان بالفعل انخانا
بليغا جدا وزقتها معجمًا اللبنة و ضع على عضو من الاعضاء وان
طبخ الورق الغيدان بالزيت واستعمل الانسان ذلك الزيت فانه يقال في هذا
الزيت انه قد جلل وينى الداء الكمينة بادواز وزهرها فوقنهما أيضا

دم و أعظم

بالبلاد التي يُنال بها قلبُها فيما يلي منها المكان الذي يقال له جنطا بابر والمكان
الذي يقال له منش ح ج قوة هذا قطاعه لطيفة ولذلك صار يشفي جَنَب
الطحال واذا أُكد ذلك لم يضعه الانسان في الدرجة الثالثة من درجات
الاشيا المجففة وفي الثانية من المسخنة د اذا اشرب طريا مع خل مسروح
آمن واذا كان يابسًا وطبخ وشُرب طبيخه فله قوة جلى وورم الطحال تحلل شديدًا
وقد يُضَمَّد به المطحن اذ نُقَع مع نبيذ وخل ويُضمد به المنهوشون من الهوام بخل
نقط • طباقُ ه العامةُ تسميهِ طبائدَة وهي بالبربرية ترهلة وزهلان
وهي التي يستعملها اكثرَ اطبانا على انها الغافث قبل ان يعرفوا الغافث

قوثبرا الاكبر قوثبرا الاصغر هو الطباق

الصحيحَ فاخذوا ان اهلَ المغرب انما يستعملون ولذلك حالُها بالغافث
قول د و ح • ابو حنيفة الطباق شجرة العامَة تنبُت نحوا من القامة ولا يكاد
ترى منه واحدةً منفردة وله طوال رقاق خضر ثلج اذا غين يصمدُ به

هو اصل الطرخون الجبلي ‧ علي بن محمد الطرخون تسمى بالفارسية الطرخي وهو نبات
طويل الورق رفيع الساق يعلو على الارض من شبر الى ذراع شبيه الشان الرخص
اول طلوعه قبل ان يصلب عوده وبغلظ ساقه وهو من بقول المائدة بعد ما
عليها الطرافه الرخصه مع النفع وغيره من البقول فيهض الشهوه ويطيب
الراحه واذا اشرب بالمعلبه طيبه وطاب به ‧ الفلاحه الطرخون صنفان
بابلي طويل الورق ودومي مدود الورق وهو من بقول الصيف وطعمه مجزرنت
لذاع ‧ مجهول الطرخون بقله ورق كورق الحماحم وهو على ساق له احمر
يعلو نحو الشبر واكثر وطعمه حار ويسير وله زمرد يشبه بذر اصغاف
الورق ‧ ابن ماسويه جار بانبت وسط الثانية يطبخ المعدة عسر الهضم ‧
الدمشقي يجفف الرطوبات وينشف البله بأطاله ‧ الطبري حبالكمون
وفيه ثقل ‧ الرازي غليظ نافخ وقال في الاغذية انه جيد للفلاح في الفم
اذا مضغ وامسك في الفم زمانا طويلا ولا ينبغي ان يكثر منه المبرز ودون
وهو يطفي حدة الدم ويقطع شهوة الباه ‧ الاسرائيلي فيه دهنه كثير جاف
لذاع عسر الانهضام يبطئ الانحدار ولذلك وجب ان يختار منه ما كان رطبا غضا
قريبا من ابتداء النبات لان ذلك اقل لدهنيته ولدوسه ويوكل مع الخل فإنه
لا يسئ هضم زرنه وسهل انحداره وانهضامه ‧

طوفوريوس دج

عشبه قضبانها نحوها
عصى في شكلها وتشبه
الذي يقال له
كما ذريوسن في
دقته الورق ورنها
شبيه بورق الحمص
وقد نبت كثيرا

بدل العفص في أدوية العين وأدوية الفم وقد يكون موافقاً لنفث الدم إذا شرب وللإسهال المزمن وللنساء اللواتي يسلن من أرحام رطوبات رمانياً طويلاً للبرقان ومن نهشته الأسلاء وإذا ضمد به الأورام البلغمية وفعل قشره مثل فعله وإذا أطبخ ثمره بما ثم مزج بشراب وشرب أذبل الطحال وإذا ضمد به نفع من وجع الأسنان وقد يسقى النساء اللواتي يسلن من أرحام رطوبات طويلاً للأدلاء طبيخه وقد نبت طبيخه على اللبن يتولد منه النمل والصبيان يسمعهم ورماد خشب الطرفا إذا أجمل قطع سيلان الرطوبات من الأرحام وقد يعمل بعض الناس من ثجر الطرفا أما شارب يستعملها المجبولون ويتزينون فيها بدلاً للأقداح ويرون أن الشرب بها نافع لهم : **الخوزي** ينفع من الأورام الباردة إذا اذخنت به ولاكثر الأورام **الطري** ينفع من انتشار اللثة ويدخن بها للذكائر الجندي فينفع وجعها **الإسرائيلي** إذا ادخن به انفعت من احدار الطمث في غير وقته **ما ترجوبه** إذا زاد ومادر الطرف ولست الزوج الرطبة تجففها وخاصة الفرج التي يكون من حرفرة البارة **طرخون** الطرخون من بقول المائدة والطرخون عند أهل مصر وأهل صقلية بقلة شبيه الكزبرة وهي من بقول المائدة وزعم قوم

أن الكرفس
البري للدقيق
الورق وهو المسمى
بألونانيه
أوزنالبون
والطرخون بالعراق
بقلة كالنعنع وقال
مسيح العافرج

به الثياب صبغًا أحمر لا ينصلح عنها ومنه صنف آخر رابع كبير وهو الأملج ج
نبة الطرفا تنفع وجلاومن عبران بحفيفا بنبا وبه مع هذا ايضن
ولكان هذه النوى هذه الوجوه صارا نافعا جدا للاطحلة الصلبه والعلل

موبغى وهو الطرفا
نوعين

ال ورقه واصله وقصبانه باخذ باشراب وينى ايضا وجع الاسنان
وثمرة الطرفا فاوه فقها ما نقص للبرد مع ان به قوة فى ذلك قريبه
من قوة العفص الاخضر الا ان العفص بابين فيه عفوصه فقط فاما ثمره
الطرفا فمزاجه من اجل غربست ولانه خالطه شى مرد لطيف ليس بسير وليس
يوجود فى العفص وقد يمكن الانسان ان يستعملها اذا لم يجد به العفص
كما يستعمل فيه العفص وكذلك ايضا الامر فى لحاء الطرفاء ورما الطرفا
اذا اجزو ويكون ثمره نبه جفيفا شديدا او الاكتر منه الخلا
والقطيع والا مليقيه القابض ثمر الطرفا البستانى ييسر الاسنان ويستعمل

هي قشور يؤتى به من بلاد ليست من بلاد البون ابير لونه الى الشقرة ما هو غليظ فابض
جدا وقد يشرب لنفث الدم و قرحه الامعاء و سيلان الفضول الى البطن ح د
هذه قشر تجلب من بلاد الهند في طعمها قبض شديد مع شئ من الحدة العطرية السيرة
و رائحتها ايضا طيبة مثل طيب رائحة خلاف او به المجلوب به من الهند و يشبه ان يكون
هذه القشر ايضا مركبة من جواهر مختلفة و الاكثر فيها الجوهر الارضي
والاقل فيها الجوهر اللطيف حار من لذلك يجفف ويقبض قبضا شديدا ولذلك
صارت تخلط في الادوية التي ينفع من الاسهال و قرح الامعاء لانها في الدرجة
الثالثة من درجات الاشياء التي تجفف واما الاسخان والتبريد فليس لهذا
الدواء و كانه واحد منهما فعل بين اللذي يبرد و من قولى د ح ني هذا
الدواء انه ليس با لبسباسه فان القبض فيها يسير والحرارة اغلب عليها كثيرا
و هو قشر رقيق ليس بغليظ كما قال د و هذه الصفة هي بالرمال اشبه ه

ابن عمران الطالسفر هو عروق دقاق قشرتها اغبر و داخلها اصفر و طعمها
عفص ولها رائحة تشبه رائحة الكرم وعفصة فيها حرافة و هي حارة يا بسه
في الدرجة الثانية و خاصتها النفع من البواسير والارواح الطاهرة والباطنه
المجوبين الطالسفر هو ذوق الزبون الهندي و هو معتدل الحرارة يا بس في
الدرجة الثانية ينفع من رائحة الانسان اذا طبخ بالخل و ماوه المطبوخ فيه ينفع
القلاع الابيض اذا امسك في الفم ه

طرفا د ا سروينى هو الطرفا شجرة
معروفة ينبت عند مياه قائمة ولها ثمر شبيه بالزهر و هو قوة شبيهة
بالطلب وقد يكون بمصر وبالشام طرفا ببنانية شبيه بالبرية في كل
شئ ما خلا الثمر فانه يشبه با لعفص و هو مضرس غين الطرفا البنانية
هو الكزمازك القلاحيد هي ثلثة اصناف منها الكزمازك مثل ليله الورق
ورد ورقه ابيض يضرب لى الحمرة و عناقيد حبة الزبيب من الجل و صغف
الث لا يورد و يعقد حتى اغصانه حبالة الشهدانج احمر يضرب الى الخضرة يصبغ

الزبان حمصاد هو الحامض ألفته من الحاوي حمونا هي الهندبا
خلصيص وحلبى هي أصول تأكلها الصبيان من الحاوي وبهى أيضا حرصانا
حومر هو النرهندى حوارى هو الدنن الأبيض وهو الدمسك حوسنا
كبرى قيل هو الخندروس بالسريانية ∴ حوا قال **أبو حنيفة** الحوا
حشيشة البروز ينها ورق الهندبا ينبسط على الأرض تأكلها الناس والدواب وبسومان
ورقها قضب رقيق نحو الشبر عليه ورق صغير ورق الأصل رأسه براعم غار
طوله فيها بزرو وهي كثيرة في الرمل حوك هو الباذروج
قيل هو النوبل بالأندلسى حولى في الماهود أنه بالسريانية من الحاوي

حرفُ الطاءِ

طالشفير هو الدار كشة وأكثر الناس على أنه السباثه ولسن أرى
ذلك صحيحا وحين يسمى الدوا المسمى بالبوثانة ما فى رنى كتاب ح بالطالشفير
وزعم **ابن جلجل** وجد ان الطالشفير هو لسان العصافير وقال **غيره**
شجرة هندية وقال بعضهم
انه عرزوف العشبة التي تعلق
بها دود الحرير وقال
المجوسى أن الطالشفير
هو ورق الزيتون الهندى
وقال **غيره** مى قشور
هندية وتسمى بالبوثانة
دار كشة ح ما في را
وتسميه اهل الشام الدار كشنه
وزعم قوم انها البسباثه

ما في س وهو طا الشفير

صقر ويجمع من اللبن وياكل الماشيه ورقه رطبا وبايسا وينبت في احواف
الجبال وتالفه الحيات كثيرا واجماها من العشب يبيس الا فانا في قيل بين
الحلم والاول اعرف واجماها ايضا مثل الصلار الا انه خشن المنبر والصليان لبن
واجماها ايضا مثل الصليان الا انه خشن المنبر والصليان لبن واجماها ايضا من الذرة
حماض الارنب قيل هوالكشوث ۞ **حماض البقر** هوالحماض البري
وهو شبيه البستاني العريض الا انه اصغر منه وبزر في غلف خشنه
بعد ناخذ اجبه برز صغير احمر مثلث الشكل ۞ **حماض السواتع**
هو حماض كبير ينه الطعم في ورقه لزوجه ويسمى سلسا برنا ۞ **جماطس**
هو الكما المطوس ۞ **جماس** قيل انه الدرويج ۞ **حماسما** قيل انه
الجنطيانا ۞ **حمصص** في الجادى انه الجنطيانا وفي موضع اخر منه انه استط العالس
جميز هوالسكمار ۞ **حمحم** زعم قوم انه اناغاليس ولبن سجين وقيل لسان
الثور وقيل هوالماميثا وقال **ابو حنيفه** الحمم وموعشبه كثير المالها
ريغب خشن يكون اقل من الذراع وهو الثفارى شبهان كلتاهما بهز تهما حمراء
وينبات في الرمل ولها ريح ذفر وحبد في طعم اللبن وهي وشفا في النعمان اذا نبتت
وعفنت اسودت سوادا اشد بيا فكانت خضابا للشعر وكذلك فشون البايلي
الرطب واجوز الصغار وقيل الحمحم مثل الشبث واطول واذا اكلها الابل وجدت
لها اريحه اذكيه ۞ **حمر** هوالنمر الهندي وهوالصاد والحمر في كثير من
التراجم نمر اليهود وقيل فقر ابهود وهوالحمر والحمر ايضا ضرب من الطير
صغار كالعصافير ۞ **حمص** هوالاشنان فاقل **الاصمعى** كلما ملح من
الشجر وكانت ورقه حبه اذا عم بها تفقات وكان زرد المتمم يتفى الثوب اذا
غسل به فهو حمض والغنم ترعاه وقد ذكرنا الاشنان في حرف آ واضافه
كثير ۞ **حمطل** هوالحنظل ۞ **حمص الامير** هوالحبك
حمصيص هوالحماض الصغير الذي يسمى بالعجمه اجطر ويقول الناس انه

على قول جميع الاطباء ومنه طيب ومنه منتن فاكلت الطيب هو صمغ الاجذار السرخسي وهو الابخر والمنتن هو صمغ الاجذار الاسود وقال **ابوحنيفه** الجلث ينبت في الرمل الذي بين رست وبين بلاد العجان وهو نبات ينبسط و يخرج قصبه بنموا رايها كعبره والجلث صمغ يخرج من اصول ورق تلك القصبه ولم يذكر انه صمغ الاجذار فان اهل تلك البلاد يطبخون نقله الحلبث ويلقون الست مما بقي على الثا ٠ جلبلب وجلباب هو اللبلاب وقال بعضهم هو اللاعبه وقال **ابوحنيفه** هو نبات ننوم محضرته في القيظ وله ورق اعرض من الكف ويلبس من عليه الظباء والغنم وهو نبات ينهش ٠ **جلجل** وجلا حل هو مصل الزبرجد على ما زعم قوم ٠ جلجلا قيل هو الشاهترج وقيل هو الكزبرن بالهندبه ٠ جلجانا وجلجينا هو صمغ الزيتون بالسريانيه من الجاوي ٠ جلزوم هو الجلزون ٠ **خلم** هو السجاد وهو رطل الحماه وقيل انه الزعفران وهي الدرما وقيل غيرها وقال **ابوحنيفه** ترتفع الحله دون الذراع ولها ورقه غلظه وافان كثيره وزهره مثل زهر شقايق النعمان الا انها اكبر واغلظ وفي كثيره البراعم كان ترا عيها جلم الضروع والفرق بينهما وبين شقايق النعمان ان نور شقايق النعمان ينبع في قصب طويل اجرد وليس من كثره البراعم الجمله ويصبغ بها الجلود ٠ جلم والجلم ايضا هو المراد ٠ جلم الشجر ٠ هو اللبلاب ٠ **حله** قال **ابوحنيفه** هي شجره شاهة اصغر من العوسج الا انها لا تنعم ولا تمر لها ولها ورق صغار دهي مرعى صدق ومنابتها غلظ الارض وهي كبيره في منابتها ٠ حلوسيا هي الكبرا حلي موسى النصي ٠ جماحم زعم انه معرفه من الاجناس وقد تقدم ذكرها ٠ حماد ربوس هو الكماد زبوس ٠ جماط هو ضرب من الجميز وقد ذكر مع الجميز وقال **ابوحنيفه** الجماط من الشجر هو الشين الجلي وهو مشبه بالتين خشبه وحناه وريحه الا ان ثمره اشد

بالحثيثة الدودة كما ذكرنا تأويل هذا الاسم بالسريانية حشجار
اجاز وكلو الطرجشقوق حشفا هو السناج ۞ حشكينا هو البزبارين
حشمو ا هو السنباج ايضا من الحاوي ۞ حلاوى موا آنيسون بالسريانية
من الحاوي ۞ حلاوى ايضا قال أبو حنيفة هى من الجنبة وهى نجم صغير
خضرا ذات شوك تقدم خضرنها ۞ حلازون هو الودع والصدف
واصنافها بالسريانية من الحاوي ۞ حلاميا هو السجار بالسريانية من الحاوي ۞
حلب قال أبو حنيفة هى نجم ينطح على الارض لاصقة بها يشبه الخضر
لها لبن كثير والنبات جين يشتد الحر وله ذرق صغار من وقضبان صغار
واصلى بعيد فى الارض و يمهلى قال المولف هو نبات يعرفه الناس يكون
اذ لا منسطحا على الارض ورفه صغار ذكور والهندبا واينما نبت اذا اشتد الحر خرج
له قضبان طوال دقاق وورق صغار متفرقة وله زهر ضعيف كالشعر اصفر
وهو ملان من لبن طعمه مر واذا اخرجت قضبانه يبزر وزفه الذى عند الارض وهب
والمعزى تاكله اذا ايبس الحشب ويعرف لذلك بالحلب ليبس عند الناس والناس ايضا
يسمون العلقى حلبا ۞ حلب والحلب ايضا بالسريانية هو اللبن ويقال حلبا ۞
حلب برورا انم سريانى راده لبن الحاوى شير ۞ حلبا هو الحلبا
حلباثا هى السجنكشت بالسريانية ۞ حلباد سقوما تأويله بالسريانية
لبن الحماس وهو الانيون ۞ حلبا قورينا هى الحلبت بالسريانية ينسب
الى قورينا وهى بلدة حلب منها ۞ حلبا شرتا هى القنه بالسريانية ۞
حلبانيا ي القنه ايضا بالسريانية وتسمى باليونانية خلبانى بالحا بجه
وبالرومية علانا بالغين المعجمه ۞ جلبا هو برز السابا ياكلنه مع
السكر وهو الجبة من الحاوى وفى موضع اخر منه انه الفوذج واظن الفوذبن
منقش لان الفوذج عند الرازى هو الجبة اوشبهة والفوذج على الحقيقة
اعنى الذى يسمى باليونانية انوسيمون فغير هذا ۞ حلبيت هو صمع الانجذان

حططا هو العويج بالسريانية من الحاوى ۞ حصص هو الورس حصاد قال أبو حنيفة هو من الحنبة نباته الرمل ويشبه السبط والنصي لو رقه حروف تحروف الجلف احر الدكا كلعنا ويقال له أيضا حصد وله اذا هبت عليه الريح جرس وذارف قال بعض المحدثين هو شبيه بالجلف لا حب كث الخطال ويسمى بالعجميه الوحي ۞ حفا هو البردى حفا يلا هو لا ذريون من الحاوى ۞ جعفرى قال أبو حنيفة هو ذات وزق و شوك صغار صعاز لا بلاد يكون الاثبى ارض غليظة وها هو بيضاء وهى يكون مثل حنة الحامة ۞ حفول هو ما له الجديد من الحاوى حفول قال أبو حنيفة هو شجر صغار مثل شجر الزمان نبج الغدر وله ثمر مدور من معترط دقاق يكون فى قدر الحاصه والناس أكلونه وفيه من راه وله عجمة شد يده قال المولف هذا شجر يعرفه الناس عندنا بالسندر وليس هو بالسدر على الحقيقة لكنه يشبهه و ثمر معترط اخضر فاذا جف احمر له معا الوق طوال يعلن من اوساطها كالنارنج شكلها او كالفطر ولحمه شوك ويبت بقرب الانها ز ۞ حسار زعم قوم انه الجرن المشرقى وقال أبو حنيفة هو اخضر شبيه بالجرف فى نباته وطعمه نبت جال ا بيت على الارض ويشبه نبات الجزر ا كله الماشيه اكلا شديدا وهو مرعى صدى و حصد وحبل جبل اكام جبل النبت ۞ حشبا هو الجرف ۞ حشيشا هو اللبم بالسريانيه حشمفا هو حب البيل بالهندية من الحاوى ۞ جشيش نبلى هو النبل الفلطى ۞ حشيشة الاسد هو الجعيل ۞ حشيشة الراجس هو السريح ۞ حشيشة الزجاج تسمى بالبونانية الكسى وبالسريانيه عوفبا حشيشة الطحال العقر بان قد يقال ايضا على البنات المسمى بالبونانيه طو ر دو نث حشيشة دودته مى العقربان حشيشة الرومية زعم بعض المعسرين ان المعقر بان هى الحبيشة الزرومية وهى نصيف وامامتى

حجر ساموس من حجر يوجد بطين ساموس وقد ذكرناه مع الطلبان
حجر سوري قيل انه الشاذنه :: حجر جزري هو البسذ
حدال قال أبو حنيفه هو شئ ينبت فى أصل الكمرة للدوم والحدال
ابضا ثيل هو البلح : حلج هو الحنطل اذا اصغر قبل ان يصفر :: حدق
الباذنجان : حذا النسج هو الزاد رخت :: حرا دوما هو جوز جندم
ومعناه بالبو نانيه جوز الجمام :: حراسيا قيل انه جز البر وهو الكمكم
حراشفا هو الحرشف بالسريانيه :: حرث قال أبو حنيفه
هو نبات يسطح على الارض له ورق طوال وبزر ذلك الورق شئ صغار وقال
الاصمعى اطيب الغنم لحما اكل الحريث فاكل غيره ومنابته السهول وقال
بعض المجدثين يسميه بعض الناس الملك وبالعجميه نمير وزو هى تجن دقيقه
الورق طيبه الراجحه طعمها طعم الفلفل ليس هو الملك المعروف :: حريفا
قيل هو البطاطل بالسريانيه :: حرمله قال أبو حنيفه هى شجرة
نحو الرمانه الصغير وورقه ادق من ورق الزمان لجمال جراد ون حرالعشره
فاذا اجفت اثنت عن البر فطرح به المحاد فكون ناعمه جدا خفيفه و ما
اقل ما يجمع سرعه البح نى نطبين :: حرنبه هو صنف من لوبخط بشبه
ورق الكراث :: حرفا هو الحرف بالسريانيه من الجاوى منه شى
حرفصى من الدقونا :: حرجون قيل هو الزاز بابح :: حرض
هو الأشنان الذى يغسل به الثياب :: حرصاتا هى اصول الهم الصبيان
من الجاوى :: حرشف الجمل هو الأنخيص وهو جر شغة القلك حرشا
قيل انه اللسان وقيل انه صنف من الحرجير الذى قد ذكرناه قال
أبو حنيفه الحرشاخرل البرمبنه ما غلظ من الأرض الأنحاف وهى من السطاح
خضرا وفيها خشونه :: حرشا رومبا هو الحور الرومى بالسريانيه من
الجاوى :: حزوا هو السجاز :: خطر الراعى هو عصا الراعى بالسريانيه

والناس يسمونه الجبة السوداء ∴ **جبة اخرى** وهى التى تسمى بالفارسية
شمخ وبالبربرية حمثك وهوجب يجلب في الكوفه معروف وزعم ابن جلجل
انه جب النبات المسمى باليونانية ملفس الاملس وهو الفشغ وقد ذكرناه في حرف
ف وزعم غيره انه جب الصنور وليس بصحيح قال **ابو حنيفة** ذهب قوم انه
القرو ولين فيه بيه ولكن فيه مشابهه ∴ **حبة حلوة** هي الانيسون حتى
هو السوس بالهندية من الجاوي ∴ **حجارة** مشوية هو الجير غير مطفى
حجارى هو المسمى باليونانية فرطسس من الجاوي وهو القصاص وسنذكره
في حرف ق ∴ **حجر رافلى** هو المغنطيس ∴ **حجر الابرزه** هو الباروذ
حجر اسيوس هو البارود ايضا ∴ **حجر البسطريط** هو المرمر
حجر الكذبذ هو الحجر الذى يجتذب الحديد وهو المغنطيس ∴ **حجر الدم**
هو الشاذنه ∴ **حجر الطور** هو الشاذنه ايضا ∴ **حجر القمر**
هو بصاق القمر ∴ **حجر الشمس** قيل انه حجر المها الذى فيه شبه قوس
قزح ∴ **حجر النسر** من الناس من يسميه حجر النسر وحجر العقاب
وهو السملك لانه لا يوجد في اوكار العقبان النسور ومنهم من يقول **حجر**
البسر لانه ييسر الولادة وقد ذكرناه في حرف أ ∴ **حجر البهت** زعم
ابن جلجل انه حجر البسر وهو السملك قال ∴ وهو حجر الحمرة اذا حركته
سمعت اطنينا كما سمع الجلجل فاذا اكثر لم يوجد في داخله شيا واذا علق على
النساء سهل عليهن الولادة ∴ **حجر الخل** هو حجر اذا طرح في الخل خرج عنه مسرعا
وكلما طرح فيه خرج لا يستقر فيه البتة وهو موجود بالاندلس ∴ **حجر**
غاغاطس هو منسوب الى وادى بالشام يقال له وادى غاغر في القديم
يعرف اليوم بوادى جهنم وهذا الحجر ايضا يوجد بالاندلس في ناحية شرنطه
ويقال له النكبج وقد ذكرناه في حرف ش ∴ **حجر العقاب** هو السملك
حجر فسقه هو قلميا الصفر وقال ∴ غيره حجر فسقه هو قلميا الفضة ∴

عيساوى

قوم انه الآذريون و زعم قوم انه الهيو فازينون قال **ابو حنيفه** الحنوة
هو الريحانة قال **ابن زياد** من العشب الحنوة هي قلبله شد بده الخضرة طيبه
الرائحه ونقرتها صفرا وليست بضخمه ٮ **حولى** هو الكمون بالهندية
من الحاوى ٮ **حبّ بوله** هو العفيج الاحمر وهو مذكور ٮ رهم مصع ٮ **حثما**
هو العنب السرياٮيه من الحاوى وغبر ٮ **حبرى** هو الجبرى ٮ **حمط**
بريه هو نوع من الماميران من الحاوى ٮ **حصكيشا** هو السونرنجان بالسرياٮيه
من الحاوى ٮ **حبق** هو الٮودح بالسرياٮيه وهو ازبعه احٮاس سٮاٮى
وٮرى و ٮهرى وحبلى فالبسٮاٮى هو ما كان مٮلا الشاهسفرم والباذروح والترحمٮك
واشباهها ذا البرى هو الذى يحضه الاطبا بايم الٮودح ومن اصٮافه المشكطرامشير
والٮهرى هو الضومران والحبلى هو الصعٮر الوزى ولهذه الاحٮاس انواع كثيره
حبق البقر هو البابوج ٮ **حبق التمساح** هو الصوصران
حبق الراعى قٮل هو البلخاسف ٮ **حبق العشاٯ** هو المرزحوش
حبق الفيل هو المرزنجوش ايضا على ما ذكر ٮ كثير من الٮراحم
ولعله ٮصٮف من حٮ الفٮا ٮ **حبق الشيوخ** هو المرزو ٮ **حبق**
الماء هو الٮودح الحبرى ٮ **حب الملوك** هو الشاهسفرم
حبق ٮٮطى هو الحم ٮ **حبق ٮرٮحاٮى** هو الباذروح ٮ **حبق**
صعٮرى هو المسما بالٮازٮٮه الشامسفرم ٮ **حبق زحاٮى**
هو الحبق الدٮو الوزى ٮ **حبق فرٮقلى** ٮسمى بانازٮٮه فرٮحمٮك
حبق كرماٮى هو الشامسفرم ايضا ٮ **حشٮوان** هو السٮد
بلغه اهل العراٯ ٮ **حبل المساكين** هو السوس وهو اللبلاب الكبٮر
حلٮلا هو اللبلاب بالسرياٮيه ٮ **حماد ماء** هو حواتم الحٮر مالسرياٮه
وهو الطٮن المحٮوم ٮ **حبق** هو الذٯ بلغه اهل عمان ٮ **حبه قندسٮه**
موحٮ لسٮان مسوٮه الحٮر ٮن قٮٮص ٮ **حبه سودا** هو الشوٮٮر

البان وهو خطأ، وزعم قوم أنه حب يشبه المحلب ولبنه، ويسمى باليونانية
فلوريا، وأظن هذا هو الصحيح، وهو الذي غلط فيه **ابن وافد** فظن أنه المحلب
وسنذكره في حرف م، وزعم قوم أنه البشام، وقال **ابن سينا** حب
مشم هو حب في مقدار الفلفل، لونه إلى الاسوداد الأكاد، يفلق عن لب
شديد البياض عطر، وقال في موضع آخر من كتابه هو أشبه شيء بالبطم
مثلث المقطع طيب للرائحة، وزعم قوم أن المشم هو الشم، وزعم قوم
أنه الأراك، وغلط **ابن سينا** فقال بعد القول الذي حكيناه عنه من شجره
نبتاني دهوه ذو ثلثة، أو رأى منه برى مضى ذكره من مر إن خبره وهذا غلط
دهن هذه الاصناف التي يجيء أصناف الحندقوقا، وأظن من قبل أن الحندقوقا
يسمى باليونانية لوطوس، يسمى بهذا الاسم أيضاً شجر الميس، وهو الشم .

حب الملوك المسمى عندنا بهذا الاسم هو المؤث بالعربية، وقيل
إنه الفراسيا، وقيل الفراسيا صنف منه يكون بالمشرق كثير الحب، وبعض
الناس يسمي حب الصنوبر الكبار حبَّ الملوك ∴ **حنا مجنون**
هو الوسمة والخطم، وقد بينا أيضاً في الرسيبة ∴ **حبان يا**
هو الجاري بالسريانية ∴ **حالعُولم** وحالعوما، هو حى العالم
بالسريانية ∴ **جاق فا** هو الحندقوقا، بلغة أهل الحرم، ويقال حاى
بالقصر ∴ **جا فاتو** هو الجوز الرومى ∴ **حياة الميت** هو القطران
حبيب ارحانا جنبر، وطاوغوس شتى بالسريانية جبيب وحاش
حجره هو حب لذلك الهندبه ∴ **حندقوقى** وحندقو فى هو الحندقوقا
حندقو فا مصرى هو الشنين، **حبّ راب** قيل إنه جزر البرى، وقال
ابو حنيفه الحزاب له زغب، عن أرض عزوق، الأرض أبيض كأنه عرق البجله
يأكله الناس بطبخونه، وهو جزر البرى، وهو شديد الحلاوة، ورفه بطيخ
وهذه الصفة تدل على أنه غير الجزر البرى المعروف ∴ **حنوه** زعم

جنبشه الكلب وقد ذكرناه أنه رتبتم الوسن وقد يبدل أنه لون ما ويله جور
الارض لان معنى اسم اجور بالونانيه البضا كأنهم سموه الشجر البيضا ولم نذكر
هذا النبات جليه وقد ذكر فيما مضى من هذا النبات ورأيت في بعض الكتب
فاطاسى هو صنف من حاملوثا وقد ذكرنا قاطاسيى بنّ موضعه ح
حبّ الدند بنّ كثير من النفاس يبرح بالدند موجبلخر وع
وأظنه خطا أن بح الجاوى جب الدند والخروع البرّى فالمفسرون وحعفر
الامم وغلطوا في المنتبر فان الدندان نجى خروع اصيتم فهى تبنى له ما يبقى
الخروع وتسميا هنديا وتسميا بريا وتبنى جالنيل نزط اهديا وقد ذكر
الدند في جرف د ح حبّ الكزلم هوالذي يعرفه الناس بلفل
السودان وليس لل السودان على الحقيقه غيره ح حبّ الصلب
وهذا الاسم قد وقع في كثير من التراجم انه جب الراس وهو تصجيف
وخطا وانما هو حب الصلب والصلب نبات وزعم قوم انه حب الراس وقيل
هو المنان وهواصح ح حبّ العروس هو الكبابه ح
حبّ القلت هو بزر نبات بنى الغلت بضم الغاف وسنذكره
موضعه واصحاب القلت باللغات المفتوحه فالناس يسمون الهنو ما رمون
بهذا الاسم لان ثمرته جمرآ صنوبريه شكل القلت ح حبّ الفلفل
من الناس من زعم انه جب الشم وهوحب المبنر ومنهم من زعم انه حب الرمان
البرّى ولا الثولين خطا وسنذكره الفلفل في جرف ف ح حبّ البنبا
اعلم ان جب البنبا المسمى بهذا الاسم في المقاله السابعه من كتاب جانيوس
وهوحب البلبان وهو الجاوى وهوحب الفريص وذلك خطا ح حبّ
السبمنته فيل انه سهدانج البرى وسنذكر اسمه في جرف س ه
حبّ اللهو الناس يسمون ثمر الكاكنج بهذا الاسم وسنذكر الكاكنج
مع انواع عنب الثعلب ح حبّ ملشم بنّ كثير من النفاس ان حب

تأليف قبل د ح وصار كلامهم في كثير من الأدوية من حيز الهذيان لاضافتهم قول لا قبل في دواء الى قول لا في دواء آخر ومن قرأ كتابنا في الأدوية المفردة وكان له ادنى معرفة رأى انه قد افسد الأدوية فيها الارجى له صلاح واخل هذا الجزء من الطب اخلالا لاغاية بعد فاما الرازي فانه خطر منه هذا الزلل الا انه لم يصف قولا يدل على انه اشياء ابتدع لكنه فرق قولا قولا واتى ما غير منظمة ولم يربط بعضها ببعض وساق الدواء الواحد في مواضع كثيرة فكان كلامه فيها منفردا متبددا غير مستقصى وكان لا بعد من اللوم الآن سنوا التأليف فنظم معا انه قد غلط في اشياء كثيرة فاما ابن رضوان فرغم انه ذكر جوا من حنين دواء ولم يذكر ها د ودل ذلك على قلة معرفته بما رام الكلام فيه ولست لمر ان ابن به من النكل في شى جهله فان ح لم يذكر د والم يذكره د الاواحدا وهو الكبابة فقط ان كان ايضا هو الكبابه كما زعم حنين من طلب سائر الأدوية التي ذكرها ح في كتاب د وجدها كلها فيه مثبته ولما سلك هذا الطريق في الجمع بين الكتابين سبب لنا خطأ من عنده نا وظهر لنا من خطأهم اشياء خفيه قد يمكن ان يخفى على كثير من الناس فلا يشعر بها من ذلك غلط اكثر الأطباء وقولهم ان ثمرد بيون هو الثوم البرى على الحقيقة وانما هى ثمر يا على طريق الاستعارة والمجاز لأنه اشبه الثوم في حده وطعمه ولكن ابن واقد لما جهل هذا اضاف قوله ج في الثوم الجبلى الى قول د في الثوم الجبلى فانه لو سلك هذا الطريق الذي ذكرنا ها لو قف على خطأ جنين كما ذكرنا قبل كذلك فعل اكثر من المزاج المذكور في كتاب د واسمها باليونانية يوجد في ترجمة البطريق قرابا وقد ذكر د في كتابه قرابا وهو غير ما نا وغير ذلك من علطم كبير. حاما لوث ذكر ابن جلجل ان تأويله بياض الأرض وهو قال نسى باللطيني الغان والغان هى الهادة وفى

وهي حشيشة لها لبن كالينوع وقد ذكرها د وحلاها وذكر ان بعض الناس
يسميها اصاسورو وهو النيبز وقد ذكر ان هذا الاسم اعني سوفا يجرد
س وقد اخطا جنيس في ترجمة الادوية كالنبوع حيث عبّر عن هذا
الاسم بشجر النيبز الجبلي وانت تحقق قولي اذا تامّل هذا الجزء الذي سمّاها جنيس بالنيبز
الجبلي في ترجمة البطريق فان رجعنا وجد يقول في آخر المقالة الثامنة ذكر شجرة
الينبز الجبلي وقال البطريق في هذا الموضع بعينه ذكرها ما سوفي و هو
نبت في الارض ثم انه ذكره فقول ح فيها مثل ما ذكر جنيس عنه في شجرة الينبز الجبلي
سوا جزءا فجزءا فاوجد د لم يسم شجرة الينبز الجبلي حا ما سوت بوجه وانما سمي
النيسورن من الناس من يسميه اربا وهو النيبز البحري وقد ذكر ان ايضا ح
الا ارجيبا ثانيا النيبز الصغار المعروف باجمرجد د وقد ذكر حا ما سوفي
في المقالة الرابعة ووصفه بانه نبات صغير له ورق مثل النبوع وذكر
فيه من المنافع ما ذكره جالينوس سوا فقد بين غلط جنيس في قوله ان حا ما سوفي
هو شجر النيبز الجبلي وعلى هذا الوجه خاصة سيح الجمع بين قوله د ح وفي الادوية
التي ذكرا ح دوا اعني ان نطلب اسماءها البونانية في الكتب النيبز جميعا اذ
كان الكتاب ان عندنا منقولين من اللسان اليوناني ولما كانت اسماء البونانيه
سية في كتاب د وكذلك في كتاب جالينوس الذي ترجمه البطريق باليونانيه
مثل ما هو سوا في كتاب د وكان جنيس قد اثبت بعضها في ترجمته باليونانية
وغير بعضها الى اسماء عربيه او فارسيه او غير ذلك من الاسماء وجب ان نطلب
الاسماء اليونانية في ترجمة البطريق ولا نلتفت الى ما عبّر عنها جنيس فان
الاسماء اليونانية التي في كتاب د اذا طلبت في ترجمة البطريق اصبت هي
باعيانها ولم يكن بينها اختلاف الا في اشياء يسيرة من الهجا وذلك لا يخفى على من
له ادنى فهم وليس يصح الجمع بينهما على غير هذه الجهة اصلا وهذا البطريق
لم يبعد الى احد ممن يعتدّ مناوا بانّ ذلك اصلا ولذلك كثر غلطهم سبب

معنى ذلك باليونانية هو الأرض وقد كذبا وخالفا ما ذكر ٥ فانه سمى
صنفي الخان جميعا افطي ونبى الصغير خاصه خامى افطي ان خمان الأرض ينذكر
الخان نے جزء الخاء وأما ابن الهيثم فانه قال نول هذه حكاية بينه
جامي افطي موضعان اجتماعا يسمى باليونانية حامى افطي وباللطيني برقه والآخر
يسمى افطي ومعناه الأرض وباللطيني شبوقه وهو حجر الخابورة وأما الذى
يعرفه الناس بالخابور فليس مومن افطي فى شىء لازعم احدانه الخابور لا
هذا ومن النسخ قوله كا بر وابد والصواب فخامى افطي باخاء وان كان المترون
للأسماء وأكثرهم قد اثبتوه فى باب الخاء فاما قوله من قال ان جامى
افطى تحرج هند به و ثمر بناه الإبل والفلفر الهدباز الذي ينبغى ان يعبر
عن ذكر ذ حاما لأنس معناه باليونانيه ملوط الأرض وهو المسمى
باليونانية ابضا ايوس وقد تقدم ذكر ة فى جزء الألف ٠ حامى
د و ى معناه غال الأرض ينذكر عند ذكر ٠ا ثم الغازة ٠ حاملاون
هى الدابه المسماه الجراب من اخاوى وغير من الرخم ومعنى هذا الاسم باليونانيه
اسد الأرض وأما من النبات فانه يسمى هذا الاسم اسخيص و هو الصعد
وانما سمى يز لك لانه قدّ يخلف لون ورق جنب خلاف الأرض التي ينبت
فيها كما يتلون الجرا بلون الموضع الذي يكون فيه وقد ذكر ذلك ومن
زعم ان حاملاون وهو الما زريون فقد كذب واخطا خطا فاحشا وانما صحف
لهم حاملا باحاملاون ٠ حاملاون لوقس هو اسخيص الابيض
حاملاون ما لس هو اسخيص الاسود ٠ خاما لبون هو حاما اول
ايضا ٠ حاما قرطم هو الخبير زان حاما قيسمس قد مضى
ذكر هذا النبات فيما مضى هذا الباب من الأدوية والصواب فى هذا
الاسم الخاء وانما اثبتنا ها هنا على ما اثبتها اكثر المفسر ين ٠ حا شاشو فى
تأويله باليونانية بين الأرض وهو بالخاء ايضا ذكرنا فى نظاير من الاسماء

وهذا أشرح ما وقع في هذا

الباب من الأسماء

حاج ذكر الحاوي أنه البنبوت قال وهو شوك يرعاه الجمال ولا يرق له
وذكر ابن سرابيون في كتابه الحاج هو العاقول ويسمى يا يونا بنبه
اربعى فال المولف واربعى هي البجر التي يعرف ما الناس با لخلبج والبنت بذ ان
شوك كما ذكر ني الحاج وقال **ابوحنيفه** عن زياد الحاج نبنه اهل
العراق العاقول وله شوك جاده وهو يجب الى المأشبه من البنبوت قال **ابوحنيفه**
والحاج عندنا مما ينقم خضرته وتذهب عروقه في الارض مدا بها بعيدا ويزاوى
بطنيخه وله ورد فاذ طوال منوه جاذ وقال **عنبزه** الحاج شجر يعلو
مندا ز فعده الرجل بيت في الرمل وها ورق طوال وهي خضرا ني الفظ شدت
الخضر ولها نوار احمر كا نه هذب يجمع من روسها واذا دوت ونضل الشاء
مازت شوكا كله ۞ **جاج رومي** هو القرطم من الحاوي ۞ **جاد**
قال **ابوحنيفه** هو من الجمض وعظم ومنا بنه النهول وهو ناجع في
الابل ويخصب عليه لحما وابنا ۞ **جاركو** هو الدودج ۞ **جارطا**
هو الزا رند بالهندية من الحاوي ۞ **جاورد** هو النمود وهو كلب البجر
جافرالمهر هو السوزبحان ۞ **جافوا** هو السباج بالهندية من
الحاوي ۞ **حاسيما** هو الطين المعزوف بكوكب الارض وزا بنه في بعض
النفاس نر با لجم ۞ **جاشى** اصله بالفارزنيه هاني وبسمى اللطيته طا له ۞
جالو الشعر هو الكرمه البضاء ۞ **جالوطا** هو اللوف الكبير
بالنز با نبه ۞ **جالوم** هو السحار ۞ **جامى افطى** هو اخان
الصعبر وهو البات لمبى بالطبنته بدقه والخاز الكرما هو اقطى وباللطبنه
شبوقه واما **ابن وافد وابن الهيثم** فزعما ان الصنف الصعبر هو اقطى وان

الجلزون البرى جيد للمعده عسر النفاد والذى منه من الجزر بر التى ينال لها
لسوى والتى ينال لها سطوف ما لها والجزر بر التى ينال لها صقله والتى ينال لها
حسن هو اجوده وما فى الجبال التى فى البلاد التى ينال لها لعودبا والتى ينال
لها افوما طبلاوسى وينال لها فوبا حلبا سى والبحرى جيد للمعده سريع البزال
واما النهرى فانه زهم الريح واما البرى اللاصق بالشوك والاعجاز الصغار الى
بيته بعض الناس ياكلين وينمونه سا سا البطن فانه يسهل البطن ويقى
ونوه اغطيها كلها اذا اجزرت ستخنه بجرته تجلو البهو والجرب والاسنان
واذا اجزرت لجمها كما هى وتحنت واستخيل بها مع عسل حلت اثار الفروح
العارضه للعين وابرات لفرجه لعارضه التى تسمى اوقوما والغشاوه واذا
صمد بها غير محرفه للاستفاخ العارض من الحرا صر نه ولا تعال الاسفاخ
حتى يعنى رطونته وسكنا اورام النترس واذا صمد بها جذبت السلا من داخل
البيم واذا تحقفت واحتلت ادرت الطمت وان صمدت لحاجات وخاصه
التى فى الاعصاب بلجومها اتجوقه وقد خلطت بم وكندر الزفتها وجوها
يبرى القروج واذا ادفت كا هى باعطبها وتحنت وشربت بحنر وستى تسى من
مر ساات اصحاب الخولنج وا وجاع المشانه واذا اخذت الزوجه التى على
لجم البرى منها بطرف برده وجعت على الشعر النابت العين الزفته عنزه
لجم الجلاز بن ذانت الاصداف يفع حراجه الكلب وازدق مع الحردل ودم وع بى
البيت قتل العقارب واذا نحى وضرب الوزه الجانى حلله وقد يحن المر والصبر
بلعاب الجلزون بان يوخذ طرفا فيتقب لجه جديد جاده الراس وتقرب من
النار حتى يسل رطونته والله اعلم

مع
جباحب

موحوان له جناحان ركن اذبابى يضى بالليل كانه نار ينال انه اذا نحى بدهن
ورد وقطوبنا اذا حقف لقم السا بم منها

حَرْدُون

طبعه فنبه من طبع الوركع

واما اخبث الجديد فان قوته شبيهه بقوه زخبار الجديد الا انها اذا ضرب
بالكبريت دفع مضرة الدوا المثال الذي يقال له افسنطون **جافر** حمآ
نعم جالينوس ان جافر الحمير قد جربنا عنها ويبادرون بها من صرع كثيرا اذا
هو واصل شربها وانهم يجللون بها الخنازير اذا عجنوها بالزيت وان كثيرا
زعموا ان هذا الرماد ان نشر وهو يابس شفى الفتح الذي يعرض في اصول
اظفار اليدين والرجلين في الشتاء **دد** جوافر الحمير يقال انها اذا اجرئت
وشربت منها ايا ما كثيرا ورن قطارتس في كل يوم نفعت المصروعين واذا
خلطت بزيت ووضعت على الخنازير بجملتها واذا اضمد بها ابرات الشفاء
العارضه من البرد **حرجول** الجراده العظيمه التي يقال لها الحرجو
وهي جرادة لبني لها جناح عظيمه للجسم اذا اخذت عشر مطبوخه ولا مملوحه
وجففت وشربت قبل ان تغشى بشراب نفعت منفعه عظيمه من لسعة العقرب
حلزون حمآ الحلزون اذا الجرف مع جثه وخلط برماده عفصا خضر
والفلفل الابيض نفع من الفروج الحادثه في الامعاء ما دامت لم نعفن منفعه
عظيمه وينفع اذا خلط هذا الذي نجعل من الفلفل حر ومن العفص حزا ان من رماد
الحلزون اربعة اجزاء ويجب جمع ذلك بحنا ناعما ويذر منه على الطعام
وينفى منه ايضا رماد الحلزون المحرق بالعفص فقوته قوه بحفف تجفيفا
شديدا وفيه مع هذا ان يجفف بسبب اجزائه ومني ما لم يحرف الحلزون فعند
بيحن معه جثه ويوضع على بطن صاحب الاستسقا وعلى الاورام الحادثه في
المفاصل من به وجع المفاصل كلا وضعها مما يعسر ولعله لكنها تجفف تجفيفا
شديدا وينفى اذا وضعت ان بحل حالها ابدا حتى تسقط من قبل نفسها وهذا
بعينه ينبغى ان يفعله في مداواة الاورام الغير الحادثه في الاذان
من رضه او صنفه وذلك ان هذا الدوا يجفف تجفيفا شديدا ولوانه
صادف فيها رطوبه غليظه لارجه ممكنه في عمق العضو **دب** فوحاسر وهو

بدل اللازورد و موازن الملمس ح ٥ ازمانها هو اللازورد و ينبغي ان يختار منه
ما كان رايناه لونه لون السما مشبعا و كان يستنوبا ليسرقته حشوته من حجاره
هذه النفت سريعا الى اجزا صغار لي هذه الصفه من ازمانها اذ ليس ع ان
ليس ما اللازورد كما زعم حنين لان اللازورد حجر صلب جدا ح ط قوه اللازورد
قوه بحلو ا معحد ه كثيره و مع قبض شديد حدا فلانه بعلم ما بصفت صار يخلط
مع الادويه التي بنفع العين و قد يحبى هو ايضا تحفا جيدا و يستعمل كما
يستعمل الذرور لدى با به الاشفار اذا كانت قد انتشرت من قله اخلاط حاره و يعنى
لا ينكبر و لا يزيد و كانت رقاقا صغارا و ذلك لان حجر اللازورد هذا في هذا
الموضع يبقي رطوبه الاخلاط الحاده فيبرد العضو الى مزاجه الاصلي الذي يكون
به نبات الاشفار و يزيد ما ما و بنوتها ح د و قوه شبيهه بقوه لزاق الذهب لا
انها اضعف منها و قد ينبت شعر الاحفان ح حجر الرحا ابن سينا يمنع
نزف الدم و يمنع الاورام الحاره و الله اعلم ح حد يد هو ملته اصناف
حديد شابر قان و برمهان و فولاد فاشابر قان هو الفولاذ الطبيعى و هو الذكر
و هو الاسطام و الفولاذ المصنوع هو المخلص من البرمهان و خبث الحد يد كز
فى باب الخبث و كذلك نوبا له مع النوبا ل س و زنخا الحديد هو صدا
الحديد و من الناس من يسميه زعفران الحديد و اذا اطفى الحديد المحمى فى
الما و فى الشراب كانت له قوه تنفع الطحا ل ح ٥ انوش سد رد و هو زنخا الحديد
هو فا بذر اذا احملته المراه قطع نزف الدم و اذا شرب منع الحبل و اذا اخلط بالخل
و لطخ على الجمره المنتشره و البثور ابرا ها سريعا و قد ينفع من الداحس و الظفر
و خشونه الجفون و البواسير النابته فى المقعد و يبدد اللك و اذا لطخ على
النقرس نفعه منه و ينبت الشعر فى المواضع التى ينتوى عليها دا الثعلب
و اما الحديد المحمى فانه اذا اطفى بالما و بالخمر و شرب ما ذلك الما و ذلك الخمر
و اقوى اتها للخمر فرحه الامعا و ورم الطحا ل و الهيضه و استرخا المعده

وشبهها من الفروج واذا استعط منه بعد ان عدسته مع ما اصول السلق
نفع من نزول الماء في العين ورعم بعضهم انه اذا اُحرق وعجن بشراب وطلي به موضع
البياض خرج الشعر اسود وقال بعضهم انما يكون ذلك في علة الثعلب
والبرص واما الشعر الابيض الطبعي فلا والله اعلم ۝ **حجر المثانه** وهو
الحصا المتولد في مثانة الانسان **ح ط** زعم قوم انه يفتت حصاه المثانه
فلما جرب ذلك لم ينتفعوا فان فتت حصاه المتولد في الكليتين فلا علم لي بذلك
لاني لم اجربه ۝ **عنبر** زعم قوم انه يزيل بياض العين اذا اُحرق واكتحل به
حجر الحامز زعم بعض الاطباء ان الحجر المتولد في الحمامات
اذا عمل منه ضمادا وحمل على السرطان عندما بدا به اذهبه وهو انوى ما يعالج
به السرطان المتولد في الرحم ۝ **حجر الحوت** بعض الاطباء هو
شبيه بالحجر في رأس حوت يقوم مقام دماغه وهو ابيض صلب يشرب فيفتت
الحصاه المتولده في الكليتين وفعله على ما ذكر الواني ذلك قوي ۝ **حجر
بحري** بعض القدماء قال هو حجر يوجد في ارض المغرب ترمي به
امواج البحر على السواحل كثيرا وهو على شكل الملك التي يغزل بها النسا مجوف
عليه حب نابت من اسفله الى اعلاه اذا شرب منه وزن دانقين وهو عشر
شعبران كسر الحصاه ومنها لي هذه صفه جثه الشقدلوق البحري وهو حجر فيه
يرمى بها الحجر وقد نبتت شوكها وذهب ما جو فها من اللحم وهي كثيرة في
ارض المغرب ۝ **حجر الافروج** جنين الافروج يكون في ارض الروم
في بلد قريب من جبل يدعى لوفين بينه وبين قسطنطينه مايد ميل ويطفوا
فوق كالقشور اذا اُكل وشرب نفع من لسعة العقارب ۝ **حجر ارمني**
اكثر الناس يعتقد وان انه اللازورد ولبس هو بالحقيقه وسماه جينى في
كتاب **ح** في الادويه اللازورد **ابن سينا** فيه اذا اللازورد ليست في
لون اللازورد ولا قوة كناية لغيه تمليه ما ينتحله الصباغون والنقاشون

الذي في المعدة وقد جرّبناه ٠ غبن ٠ ابرافيطوس حجر هندي اذا شرب
نفع من لدغ العقرب وينفع من البواسير ٠ **حجر رصاصي** لين منبسط
لينفع مع وليد وربيطو وهو الحجر الشبيه في لونه بالرصاص قوته شبيهة بقوة
حجر الرصاص وعلته كعلته ٠ **حجر مغني** لين منبسط هو حجر
يوجد بمصر المدينة التي يقال لها منف وقوته عظم حصاه وفي الحجر الواحد
منه الوان مختلفة وقد يقال انه اذا انتخو الحجر ولطخ على الاعضاء التي
يحتاج الى قطعها وكيها منع من الوجع ابطالا للحس ٠ **حجر حديدي**
بعض القدماء لون هذا الحجر لون الحديد وهو شديد صلب ويسمى بالونانية
اسوسمرن واذا حك حجر آخر خرج منه محك اسود وهو ينفع من وجع البطن
الهايج من قبل نفخه وامن قيل يشرب بالدواء المسهل ٠ **حجر اناغاطيس**
بعض القدماء هذا الحجر ينفع من الا وزامر ومن كثرة دمعة العين وذلك
ان يوخذ فيحك فيوخذ محكه بشبه الدرد في الجفن فيجلي مع لبن امراة فيعظم في
العين ٠ **حجر بولس** بعض القدماء هذا الحجر بشبه النظرون الا انه
اكثر تحللا منه وله نقط تشبه لون الذهب وتشبه الحجر الذي يدعى
سفيروس وهو ينفع من الاعيا وذلك ان يوخذ ذلك فيغلي بزيت بينه
ويوخذ ذلك الزيت فيدهن به بدن النصب فيذهب الاعيا ٠ **حجر الديك**
بعض القدماء يوجد هذا الحجر في بطون الديكة ولونه شبيه بلون المها
وعظمه مشاع عظم الباقلاء او أصغر ومن العطش الشديد اذا اغتلي بماء وشرب
ذلك الماء ويدفع اخزان النفس وهومها ٠ **حجر البقر** هو الذي يوجد
في مرارة البقر عند اسلاخ البقر وهو حجر مدور صلب لونه الى الصفرة وفيه
الباسل لون زيتي وفي البانياتس كارون زعم بعض الاطباء انه جار ياتس
جار ياتس ارابعه وقد ينفع في اجفال العين ويحد البصر وزعم بعضهم انه
اذا انتخو وطلي بما بعض البقول على الحمر والنملة نفع واظنه للنملة الساعية

المثانة ح ط فإنها قوة تجفف الا انه ليس بلغ من قوتها هذه ان يفتت
الحصاه المتولدة في المثانة والذي وصفوها بذلك في كتبهم فقد كذبوا
فاما الحصاه المتولدة في الكليتين فهذه الحجار ايضا انفعها كما قد يفعل ذلك
الحجار التي تجلب من قاذوقيا التي يوجد على ما يقولون في ارطوس وهذه الحجاره
اذا حكت خالط الماء منها شيء يصير كالعصارة ايضا ٠ حجر خرزي ح ط

ليش اسطراطوس اغمر فوم انه موجود كثيرا بمصر وهو حجر يشبه الخزف
سريع التفتت ذو صفائح وقد استعمله التماميكان الينسو ربما قلع الشعر واذا
اخذ منه مقدار درخمين وشرب باخمر قطع الطمث وان شرب منه المراه
مقدار درخمي بعد النطهير من العله في كل يوم وفعلت اربعة ايام امتنع
واذا خلط بالعسل ووضع على الثدي لازمه وعلى القروح الخبيثة سكن ورم
الثدي ومنع الفروج الخبيثة من الانتشار ح ط فقوه تجفف تجفيفا كثيرا
وهي مركبة من قبض وحدة ٠ حجر الاثاد ح ط ليش طارد وس وبعض
الحجار يجفف ويقبض ويجلو اظلم البصر واذا خلط بالماء ولطخ به الثدي والحصاه
والفروج سكن الاورام والعانصه لها ح ط ينفى الجدقه وينفي الاورام الحجار
الحادثة في الثديين وفي الاشفار اذا ديف بالماء والله اعلم ٠ حجر الحيه
د ه ليش اغمطيس هو فيما اعمر بعض الناس صنف من الحجر الذي يقال له انغنيس
اي البرنجد ومنه ما هو صلب اسود اللون ٠ ومنه مثل الحجر الفيرى ومنه ثي زمادك
اللون فيه نقط بيض ومنه ما به خطوط بيض وكل هذه
الاصناف اذا علقت على البدن نفع به من نهشة الافعى والصداع واما الصنف
الاخر الذي في كل واحد منه ثلث خطوط فانه يقال فيه خاصة انه ينفع من المرض
الذي يقال له ليثرعن وهو النسيان مع الصداع ح ط اخبرني رجل صدوق
يوثق بقوله انه ينفع من نهش الافاعي اذا هو علق ٠ حجر هندي ح ط
الحجر الهندي والحجر المني اما انا فيطين يطهر ان الدم الذي يخرجان من افواه العروق

الأقليم. **حجر الأساقفة** خ ط يعرف بالحجر الذي لابيح وهو الحجر الذي يرى الأساكنه يستعملونه وهو ينفع الماء الوارمه نفعا بينا. **حجر البحيرة** خ ط هي حجارة دفاق سود منى وصنعت على النار تولد منها لهب يسير يوجد في بلاد العوز في ذلك النيل المحيط بالصين من شرقها حيث يكون قفر اليهود استعملها اناس مداواه الاورام الى تولد عن الريح في الرقبتين اذ كان يعبرها بابزروها مع ما اهم فخذ منها نفع من هذه العله و انها قد صارت بذلك بما كانت قوه بينه و خلطت منها ايضا في المنامر المتى باربى فضائل الدواء اشد نحيفا بمقدار معلوم حتى صار تلبس انما يصلحن الجراحات الطريه بدءها فقط و هي التى قد وثق الناس منه بانه ينفعها خاصه بل يفعل ايضا بنفعه الجراحات العارضه. **حجر أوراني** بولس هذا الحجر ايضا اسود في لونه يوجد بهر صقليه يحترف بالماء و يطفئ بالزيت من منفعته لجمع لكسور المنايب و ينفع من وجع الرحم و نعلوه على المصروعين فينفعهم د ه ليس برافوس و اما الحجر الذي يقال له افراقيس فانه يكون بالبلاد التى تسمى سرما بالجزيره و يوجد في النهر التى تلك البلاد التى يقال لها بطش و قوته مثل قوة غا غاطش و قد يقال انه يلهب بالماء و يطفئ بالزيت و قد يعرض ذلك ايضا للقمر خ ط الحجر الذي اذا رش عليه الماء اشعل واذا اصب عليه النيل من الزيت انطفى ولا ينفع في الطب خلا انه يذب الجنه يطرد الهوام اذا اخربه. **حجر اعرابي** د ه ليس اذا يعتبر يشبه العاج التى عبرانه اذا اكبره كان اخشن الكبر حاد و بكم يشبه الزعفران و قوته نجفف و يخلو و يذهب الكلف خ ط فوه قوه نجفف و يخلو د و اذا اخذ ورد ربى على المواضع التى يبرز منها الدم و تضمد به نطع النزف واذا احرز كان منه سنون جلا للاسنان. **حجر الاسفنج** د ه الحصاه الموجوده في الاسفنجه اذا شرب بالخمر فتت الحصاه المتولد

ولذلك انما استعمل في المواضع المحتاج الى الجلاء التشه اذا كان في العين
اشياء احد قد فيظلم لها البصر من غير ان يكون هناك ورم جاس والاشر
القريب العهد واحد من هذه الاشياء اعني البياض الحادث قريبا فان لهذا الحجر
شانه ان يلطف ذلك ويرفعه وهو ايضا يجلو ويذهب بظفره الجاده اذا
لم يكن ملبه كثيرا ٠ **حجر يهودي** د ط ليس اردا سرا هو حجر
يكون بغلط طين الشام شبيه في شكله بالبلوط جنس الكل جدا انه خطوط
متواذيه كانها خطت بالمبرد وهو اداه الخراط ويعرف ايضا باطرون اي الخرط
وهو حجر يماع بالما لا طعم له ٠ **الزازي** ومنه صنف اخر قد زالجوز مسطوح
الشكل مخطط ايضا د واذا اخذ منه مقدار حمصه وحك على مسن بالما كما يحك
الشيافه وشرب ثلك فاتو ثلثان ماحارا نفع من عسر البول وفت الحصاه
المتولده في المثانه ح ط لما جربت هذا الحجر في ممن به حصاه في مثانته
نفع شيا ولكنه في الحصاه المتولده في الكلى قوي جدا ٠ **حجر افرسيني**
د ط ليس موعبوس هو حجر يستعمله الصاغون في فربته ويكون ايضا في بلاد
ما قذونيا واجوده ما يكون منه ما كان اصفر اللون شبيها بيض البيض وسطا
بين الخفه والثقل واجراوه مختلفه في الصلابه واللبن وفيه عروق بيض
مثل ما في الامليما وقد جرب على هذه الصفه يوخذ قبل الحم جديد بالغ
ثم يطمر في حمره ويرج الحمره دايما فاذا استحال لونه الى الحمره يخرج ويطى مثل
الحمره الذي بلديه ثم يطمر كذلك تانيه ويطنى ويجرى ايضا ثالثه وينبغى ان يجذر
لىلا يتفتت ويصبر دايما د ح ط نو ته قوه تجفف تجفيفا قويا وفيه مع
هذا شي من القبض مع تلذيع وانا استعمله ابدا هو دواي فاداوى به الخروج
المتعفنه اماواجد واما مخلوط اطلا او شراب وبعسل واحد منه للعين دا تجفف
د وهذا الحجر محرقا اوغير محرق فانه يقبض ويبنى ويكوى ويقلع الاثار واذا
خلط بسيرو طى ابرا حرق النار وقد نعفن تعفنا يسيرا وبعسل مثل ما بعسل

اضعف منه وبعدُ الحجر المعروف باللبنى واما الحجر المعروف بالعلّ ففيه
جزا موجوده وكل واحد من هذه الحجارة بعيد من قوة الشاذنا قليلا وهو
ينفع من ادوية العين كما ينفع الشاذنا الا انها ازيد من الشاذنا ونفى كل
وقت ونفى كل موضع الادويه اللتنه انفع للاعضاء التى تحدث فيها الاورام
الحارّه ما دامت الاورام فى حدّ الحدوث والكون ولكنها تضعف عن شفايها
وابرايها بجمله ::
حجر قبطى كنوفزابطس ومن الناس من يسميه موردنس
ومنهم من يسميه عالا كبيرو يسميه فنط مصراويه وهو يوجد عندهم كثيرا
ويستعملونه لتبيض الثياب وهو حجر اخضر يكمد لونه يخنيف **د ه** لبشرمويس
وهو حجر يكون بمصر ويستعمله القصارون فى تبييض الثياب وهو رخو يماع
سريعا مع الماء ويوافق نفث الدم والاسهال المزمن ووجع المثانه اذا اشرب
بالماء واذا احتملته المرأه نفع من الطمث الدايم وقد ينفع فى ادوية العين
المغربيه وذلك لانه يملا التزويج العارضه فيها ويقطع السيلان عنها
واذا اخلط مع قير وطى ينفع من انتشار التزويج الخبيثه **خ ط** هذا الحجر
ينحل سريعا مع الماء ويوجد بمصر ويستعمله الناس فى فضا ان الكتان غله
وهذا الحجر يجفف وبهذا السبب صار الاطباء يخلطونه مع القير وطى ويستعملوا
فى ادمال الجراحات الحادثه فى الابدان لزخصّة الحجر وخلطونه ايضا فى
الثياب فأت للعين كما يخلط ملك الحجاز ان الاخر الذى ذكرناها وبجنب
فضل لين هذا الحجر على ذلك الحجان من قبل انه ليس فيه قوه من القوى الشديد
لانه لا طعم له كذلك هو ليس للقبّاء البدن اكثر تسكينا للوجع منها
حجر حبشى **د ه** لبشر مروقر وهو صنف يكون من الحجاره ببلاد
الحبش لونه الى الخضره ما هو شبيه بالحجر الذى يقال له لبيس وهو صنف
من اليزدى واذا احك هذا الحجر صار لونه شبيها بلون اللبن ويلذع للذائق
له قوه منبه وقد يجلوا ظلمة البصر **خ ط** هو شبيه بالبسيس ومحكه لذاع

وان زاد شربه على الدرهم تـل حار بابن [الرابعة] مسبخ الطعم مجرف
للمعده منق جلنث ابن سينا وغير هودواء هندى شبه السوبخان
الابيض حار بابن [الثالثة] مسهل للبلغم والخام والاخلاط الغليظه انها اي
قويا ويخرج الديدان جدا نفع وينفع من النقرس وأوجاع المفاصل

جبر الخزير جار بابن [الاولى] لطيف جيد للتلبب يقويه
ويصفى دمه ويدرجه ويقوى الكبد وخصا الجسم ويجيد الذهن ويقوى
الحفظ واذا القى فى الادويه نعم بلنونه محرفا ويرون انه يزداد بذلك
لطافه وقوم لا يرون فى ذلك وينفعونه دقيقا ويخلطونه بالادويه وسهم
من يطبخه وينجى الادويه بطبخه فى ثمر جان واذا وقع فى الاكحال احد البصر

حجر لبنى [د] لبنس غالاقطش ومعناه الحجر اللبنى سمى بهذا الاسم
لانه اذا اجلك خرج منه شبيه باللبن وهو رمادى اللون حلو الطعم واذا
اكتحل به وافو سيلان الفضول الى العين والفروج العارضه فيها وينبغى اذ
اجتيح الى الاستعمال ان يسحق بالماء ونصر عصارته فى جحو من نصاى ونفع بما
فيها من الندى بنفت حجر عنسلى [د] لبنس سحنطوس ومعناه الحجر
العنسلى هو حجر شبيه فى جميع حاله بالبنى غير ان هذا الحجر اذا خرجت
منه رطوبه شديد الحلاوه جدا وقد ينفع مما ينفع منه اللبنى حجر

مشقوق [د] لبنس سحنطوس ومعناه الحجر المشقوق يكون هذا الحجر
مما يلى المغرب من البلاد التى ينال لها الربا واجوده ما يلا يا لون
الزعفران وكان يسرع النفت والشقوق اذا انفسل الى غير مرجنته وقد
تشبه الاشو فى تركيب جرأيه وانفسل بعضها ببعض قوه هذا الحجر شبيه
بقوه الشاذج الا انه اصعف منه واذا ادبف بلبن امرأه ملا الفروج العميقه
العارضه فى العين وجل علما قويا اذا اعوج به انحراق العين ونثوها والشونه
العارضه فى الجفون [ط] قوه هذا الحجر المشقوق مثل قوه الشاذى الا انه

وجع الأسنان الكائن من البلغم اذا غلي بزيت وخل وتمضمض به واذا طبخ وزقه
كما تطبخ البقل اسهل الطبيعه ايضا وكذلك نفعل بقضبانه ۞ **حمش**
واصلاح ورق الحنظل لمن اراد العلاج به ان يجتنيه من شجره اذا انضج بطبخه
واصفر ثم ابدا الهوا يبرد حتى يجف البطيخ منه ثم يجفف في الظل حتى يبقى نبيه
من الندواة فاذا احتاج اليه استعمله على نحو ما وصفنا ينجح من خلطه
بالنشا او بالصمغ العربي فانه اذا فعل به هذا كان له فعل عجيب ۞ اخراج
المره السودا اذا هو خلط مع الادويه الموافقه له مثل الايرسون والافسنتون
والملح الهندي والصبر والايارج الفيقرا ولو از شام من الادويه المسهله كان
اعماله اوجاع المره السودا منه غير از الاطبا اغفلوا ذكر وتركوا
العلاج به ۞ واما انا فقد امتحنته وسقيته اصحاب الماليخوليا والصرع
والوسواس والغلب وادا الجيه والجذام فوجدته نافعا لهم جدا وربما
نبا من نبا وله منفعه ايضا ۞ واما اصحاب الجذام فموقوف وجعم ولا يزيد
وهذا هو البرء من هذا الدا ۞ واما از يكون يبرد اوصالهم حتى يرجع محال واذا
طال مكث ورق الحنظل حتى نجا ولانه والسنبل لما الثلث نقصت قوته
فينبغي از يزاد في ورده على وزن الحديث النوى ۞ **الدمشقي** اصل الحنظل
مطبوخا نافع من الاستسقا ومن لسع الافاعي ۞ **الكدي** اصله اعظم دوا
للسع العقرب والاعراب مشهور ذلك عنهم واخبرني اعرابي انه لسعت
ابنه عقرب في اربعة مواضع فسقا هذا دهما من اصل الحنظل فسكن على المكان
كلما كان ربه وقال ۞ **البصراني** انه ان سحق وطلي عليه ايضا سكن ولا
سيما اصل الحنظل الذكر ۞ **مجهول** طبخ اصل الحنظل نافع من وجع
الاسنان وقد يوخذ عروق الحنظل وتوضع على الجمر ويجمر بها الضرس
الوجع فينفعه واذا اختمر باصله طرد النمل ۞ **ابن سينا** حد ا
هو دوا اثنى ونخل ايضا فارسي فالاوسخ هو اقوى من القرطبون

منه نضج ابو حنيفه يوخذ جب الحنظل يابسا فينقع في رميه و يصب عليه
الماء و يدلك و يداسرخن يخرج ما از نه ثم ينصب عنه ذلك الماء و يعاد عليه
ما اخر قد دق بعد صلابه فانه ينعجن ثم يوخذ بنعجن بقضعه و يصب عليه الماء
و يدلك بالكفين فيمرسونه ملث مرسات فالاولى حارث لانها الماتت و الثانيه
بيضاء بضه و الاخرى مزيج فيجعل بعضه على بعض فيجعل في قدر و يطبخ حتى ينضج
و من الناس من يطبخه وحد و من الناس من يجعل فوقه شما او دقيقا و اذا
نضج خرج فونه عدبرن من سمن ينزلونه و بالكونه اطيب طعام و ان كانوا
ضعفوا عن عمله فبقيت فيه منا ان لم يطبخوه دون سمن و لا دقيق و اكلوه صرفا اخدم
منه شرو نفخ جميعم و لكنهم يورثهم صحه و لا يبرك مذارا و لا شيا الا استخرجه
و يحدث منه شو يطيب الريح و الطعم اذا يتخ بي العسل حبش و للبين ينبغى ان
يستعمل شى من الادو سى من فشور الحنظل و لا من حبه لانها غليظان زياتان
جدا للصفاران بالمعده و الامعاء و معصان مغاصا شديد او ان يهلك منسج
الحنظل يسهل الكيموسات الماييه ٠ مجهول الحنظل ينفع من القولنج الرطب
و الرخج جين و اذا طبخ فيه الزيت كارده لك الزيت فطورا نافعا من الدوى
فى الاذن و الطنين و يسهل مع ذلك قلع الاسنان و قشر الحنظل الياير مجرفا
يدرى على المعده لوجعها و قد سحق جبه لوجع الاسنان اذا ارش اليت يطبج
الحنظل قتل البراغيث و الحنظل الذى ينبث فى المواضع المرتفعه و يشرب من
الامطار اجود من الذى ينبث بقرب المباه و الذكر منه الليى اقوى من الانثى
الرخو ٠ ابن عمران اذا اخذت حنظله فقور انها و رمى بحبها ثم ملت دهن
زنبق و سد الثقب بعين او بطين و صيرت على النار حتى يغلى غليا ثم ترك
و تدهن به الشعر فانه يسود الشعر و يمنع من انتزاع الشايبه ٠ منسج و زف
الحنظل الغض جلل الاوزام اذا اضمدت به مع الشاسح و ينفع من النقط الكاين
من حرق النار و يقطع انجار الدم و ينفع من القدر اذا انضمد به و من

صعودا الى الراس وسهل الاخلاط الرديه التي تجتمع من المره السوداء ولا ينبغي ان
يبرد شديدا ولا ينبغي ان يحر شديدا فانه اذا اشرب بقوه الحاضر بالمعده والمعكد
اضرارا شديدا ونفث الدم من افواه العروق في الحلقه واذا اشرب الحبه
بشده البرد امغص واكرب اكرابا شديدا ولم تكد الطبيعه تنحل وهو سهل
بلا دطبيعه يجيب من اهل البلاد البارده ومن يستعمل في اغذيته الالبان
والجبان فان من هذا الجنس من الناس لا يكاد طبايعهم تجيب الى الانطلاق الا
بادوي الادويه فعلاج ذلك ومن اراد اصلاحه وخلطه بالادويه فليخلص
شحمه وجده من جنبه وقشر الخارج ثم يخلطه بوزنه من الصمغ العربي او الكثيرا
والناشح مفرده او مولفه واكثر ما يخرج منه اذا دبر بهذا التدبير مع
غيره من الادويه وانا ان لا افله فينشط ولا يقوي بنصف درهم *بولس* السر
ما يوخذ من سحج الحنظل درهم نصف درهم مع ملح واقي من ماء وعسل نذاغلي
فيه شراب وينبغي ان ينقى الحنظل نايا فانه اذا كا رخشا لصق بالحشا فعقرها
ويكون منه ايضا المرج العصب *ابن ماسويه* الحنظل يورث مغسا وتطعيا
وتهيجا للامعاء واضرارا بها فاذا اراد مزيد اخذه فليتقدم قبل ذلك اصلاحه
بالكثيرا وقد يصلحه قوم بالصمغ العربي وهما ان دفع ما يجذر من ضرره في
سبيل واحد الا ان الكثيرا احمد ما يصلح به لسهولته وانه معين له على الانهال
والصمغ ما نع للانهال وينبغي ان لا يجاد تجفيفه لثلا يلصق بالامعاء فيحدثها
حبيش من احتاج ان يجعل الحنظل في شي من الحقن القاه في الطبيخ الحقنه
صحيحا غير مكسور فانه ينفع من القولنج وينزل الخام والمره السوداء وليقى منه
في الحقنه من درهم الى اربعه دراهم ولتجنب الحنظل ذفرو دهنه جاد
ليبرئ ان ذلك به ذلك باسفل الرجل من اجذم في البيت الاول من الخام ذلكا
شديدا اسهله وشفاه ونفعه ومنع علته من الزياده والاعراب ينقعونه
في ماء المطر حتى يذهب من مزاره ثم يا كلونه طبيخا فنعد وهم الا ان لا اكثار

وعسل مطبوخ وعلى حبّ اسهل البطن والثمرة كمّ هي اذا جففت ونحقّت وخلطت
ببعض الحقن نفعت من عرق النسا ومن الفالج والقولنج واسهلت بلغما وخراطه
ودما اجانا واذا اجملت قلت لجين وان ثبّت واخرج ما في جوفها وصبّر
عليها طين وتحرّ منها خل ومضمض به وافوّ وجع الاسنان وان طبخ بها احد شيا
من الثراب المنتى ما في الباطن وهو ما ينعل والثراب المنتى على نفس وجهه وتفاه
استهل كيمونا غليظا وخراطه وهي ردية للمعدة جدا وقد تجعل وتعلمه شيافات
لاسهال البطن وعصارة الثمرة اذا كان لون الثمر اخضر اذا ذلك على عرق النسا
وافضه **الدارى** الحنظل صنفان ذكر وانثى فالذكر كبير والانثى رخو
ابيض نبات **المراهب** ينبغى منّى الحنظل ان حبّته في اخر انّه اذا اصفر والبزره
وهو اخضر او فيه خضر وان خرج ثمر من بطنه نفضت نونه سريعا وضعف
وان ترك في بطنه يبقى دهرا والذي على شجرة حنظله واحدة قتّال *
ابن ماسويه ينبغى لمجتنى الحنظل ان يجدّد منه الواحدة التى الحلم تحترّ نها غير ما
فانها ضارة متلفة والمختار منه ما اصفر قشره لانّ ذلك دليل على بلوغه
ونضجه وما كان داخله ابيض قويا من الصفر فينفعلون وزن مثقال الجرم شل
مسيح الحنظل جار نفع اثاله يا بنى الثانية . **بولس** ينفع الحنظل
خلف المرة وفضولا مخاطية وليس بخلف ذلك من الدرم مثل الخربق والسقونيا
لما من العصب والاعضاء العصبيه وينبغى ان يسفى من به وجع الرائس اوى
علة الصفاق اوى الاصداغ مثل الذين يعرض لهم الصرع و السبعته واساذون
بوجع الرائس والبلسميا واصحاب الفالج ومن به لقوته من منه او يعرض له بركات
في العين ومن به عسر النفس التى يعرض منه الانتصاب واصحاب الربو والسعال
المزمن واصحاب وجع المفاصل وعرق النسا ومن به علة في الكلى المثانه *
الطبرى خامسته اسهل البلغم الغليظ اذا شرب ويقلع صفر البزوان من العيب
اذا استعط بما به * **هبيش** يسهل البلغم الذى يضب الى مفاصل البدن وله ايضا

شل يجمع ويرفع ويشوى منه مثل ما يشوى من بلس وقد يعمل ايضا بالملح والماء كما يعمل وقوته مثل قوته ح ح وهذا النبات ايضا له لبن كلبن الشوع واكثر ما ينبت في نواحى الجزر واصله لا ينتفع به ولا يصلح لشى كما لا يصلح ايضا اصل النبات المسمى بلبن فقوى مع انه ليس ينتفع به واما بزره فنافع وهو يارى مسهل مثل بزر النبات المسمى بلبن بايش

حنظل د د قولوقنثا

اغريا وهو الحنظل هو نبات يخرج اغصانا ورقا مفردا على الارض شبيها باغصان وورق القثا البستانى ووزنه مشرف وله ثمر مستدير شبيه بكرة متوسطة فى العظم منه شديد المرارة وينبغى ان يوخذ من شجره وجمع اذا ابتدا لونها يستحيل الى الصفرة

ح ح طعم هذا الدواء ممر لكنه اذا اشرب لم يعد ان يفعل افعال المرار لانه يبادر فيخرج مع الاشياء التى يخرجها بالاسهال لشدة ما هى عليه من قوة الاسهال واذا الحنظل طريا ثم دلك به الوزك ممن يوجعه انتفع به د ويشح هذه الثمرة اذا اخذ منه مقدار اربع اوولوقات بالشراب المسمى ادرومالى او خلط بنطرون

والدنيان وجب القرع واسهاله بقوه واذا شرب وجده لم ينهل الى نحو من
اربعه وعشرين ساعه وعرض لشاربه هم وكرب وقبض على فم المعده
وغثيان شديد ومغص وربما انتجح الامعاء والاسهال به ينفع من البرص و البهق
الابيض وينبغي ان نحذر منه ما لم نحد شاربا زبدا املس غير منقبض ولا يشرب
وحده اصلا بل ينبغي ان يخلط مع الهليلج والسقمونيا عند الحاجه فانهما يعينا نه
على الاسهال وبجزان عادته ويخرج انه عن البدن بسرعه فينبها جنيد البلغم
والمزا والاصفر وان خلط بالشبرم كان اسهاله اقوى والشربه وزن زهم
واقله نصف درهم الا اذا وقع مع الادويه والله اعلم. **حلبثا** د د

بتليس ومن الناس من يسميه بقله جمعقا برته واما ابقراط فانه يسميه فعلبون
وهو يمش نبت
اكثر ذلك في
السواحل وهو كثير
الاغصان كثير
الورق ملان من
لبن وله ورق شبيه
بورق البقله الحمقا
البستانيه مستدير
وفي اساقل
الورق شيء من
حمره وبحث الورق
ثم مستدير شبيه
بشيء يلتصق بحدي
الكلى وله اصل ادق قليق لا ينتفع به في الطب وقد يجفف فيرفع ويتقى منه

معلون ومخطط

مجزوفه د ان اخذ من حبه خمسه عشر حبه فدقت ونخفت وسقيت بالتراب الذي ينال له ما لبث ان نبات نموا غليظا ولبث شاربها مثل اربعه قيطا وينبغي ان ينفذ امرهم بان يسقوا اسفا منوا ترا من التراب الذي ينال له ما يعرض لهم من الاختناق ومن حراق الحلق اذا سحقت على حده وخلطت بالريح الاحمر والزيت وافقت النمل والحكه والجرب بلبن مفرج واذا مضغت اخرجت بلغما كثيرا واذا طبخت بالخل وتمضمض بطبيخها نفع من وجع الاسنان واذهب رطوبه اللثه واذا خلط بالعسل ابرا الخلاع وقد يقع في اخلاط المراهم الملينه • غيره ي سقيه خطر لانه ربما فرج المثانه واذا كان مع المصلحات له وقد عدل نفاياه واذا طلي به نفع من داء الثعلب المزمن ويقوي الشعر وبطوله ويمنع عنه الافات • حب النيل اسحق ابن عمران هو الحب وهو نبات يشبه اللبلاب ويعلق بالنباتين واللبه وهو قضبان ورقه حضر اصل كل ورقه ثلث جنبات اصغر من حب الراس املس مثلث وهذا الحب هو المستعمل وقال هو وابن عبدون وابن الهيثم وغيرهم هو حار يابس في الثالثه يسهل البلغم والصفراء والسوداء

حب النيل

النبات شديد المرارة فهى لذلك تفتح سدد الكبد وبعض الناس يستقى منه وجع الورك منه ٥د ورقته اذا شرب منه مقدار ثلث وثولثان ثلث ثواثنان من ماء ينبغى كل يوم مرة وفعل ذلك اربعين يوما او خمسين يوما وانو عرق النقل وان شرب منه هذا المقدار فى اليوم وادمن ذلك ستة ايام وسبعة ايام نقى المرة فأن: حمالوفى ٥د دادوذا قاناعما وشرب بالماء كا ينافعا لوجع الصلب ٢ج قوته هذا سايحر كا نهاية الدرجه الثالثه وتجفف كا نهاية الدرجه الاولى ش حب الراس ٥د اسطافس اعربا ومعنى هذا الاسم باليونانية الزبيب البرى المعروف بزبيب الجبل الميوذج مونبات له ورق شبيه بوزن الكرم البرى

مشرف وله اعصان قائمة سود و زهرة شبيهه بزهر النبات الذى يقال له اقاطانس وله ثمر فى غلف خشن مثل الحمص ذا ت ثلث زواياً وباد اخلا ابيض وخارجها اسود وطعما حر يحرق حرقا موجعا وهو حار فى جزأ

قوته حتى انه يجذ ز من الواس اذا مضغ او مضمض به احد بلغما كثيرا ويجلو اجلا شديدا ولذلك صار نافعا من العله التى ينتشر منها الجلد وفيه مع هذا قو

حمالوفى

اسطافس اغربا وهوحب الراس

للمزاج فيها وخاصة إيراث وجع الحلق والتهاب فمن كان يعجز ورا و يوس من
مضرته ان يوكل بعده كرين وهندباء وخسّ. **الرازي** جار مصنع طارد
للمزاج جيد لاصحاب الصرع صداع للمجرورين جدًا لا يصلح لشي وهو ينفع من
يزداد المثانة وتقطير البول واوجاع الارحام الباردة. **ابن عمران** يعقل البطن
وخاصته اذا ما كان مسلوقًا بالخل واذا استعط جاى نفع من الجنون الصرع ماء جوبه
جيد لوجع الاشنين ويبدا الاستسقاء. **الطبري** قد يتخذ من عصير الجندقوق
دهن ينفع من المزاج في الجسد. **الرازي** عنده انه علاج غير واحد لا دواء
يرمنون بيد من الجندقوق فانطلقت ارجلهم. **لي** قد ذكر كثير من الناس فيه
ما ذكره في الجومانه من انه يسكن وجع نهش الهوام اذا اصابت عليه فان اصاب
قرحه اُحدث فيها شئ مما يعرض من نهش الهوام و انه يشرب وزنه وبزر
الكتم الخامات الدائرة على الصفة المذكور فيها واطعمه علطو فيها المانربها

حما قلسطس ﺩ هو نبات له ورق شبيه بورق سنبل الحنطه
الا انه اطول منه وارق وهو كثير وله قضبان طولها نحو من شبر مملوه من
ورق الفضبان خمسه
او ستة مخرجها
من اصل واحد وله زهر
شبيه بالجيرى الا
انه اصغر منه و
شديد المزان وله
اصل ابيض دقيق
لا ينفع به في الطب
وينبت في الاجزاء ان
خ زهرة هذا

الجندقوقا البري

الجندقوقا البري فهو نبت كثير في البلاد التي ينال لها يروى ولا ساق طولها نحو من ذراع او اكبر ويتشعب منها شعب كثير وهاورق شبيه بورق الحندقوقا الذي ينبت في المروج ويقال له طرسلن وله بزر شبيه ببزر الحلبة الا انه اصغر منه كثير وهو كرّية الطعم

ج اكثر ما يكون في بلاد النوبة وبزره في الدرجة الثالثة من درجات المسخنة وفيه مع هذا شي جلو وله قوة مسخنة قابضة قبضا يسيرا منقية للآثار الحادثة العارضة في الوجه والكلف اذا خلط بالعسل ولطخ عليه واذا دق ذقا ناعما وشرب بالشراب او الطلا وخلط به بزر الملوخيا وشرب ايضا بالشراب وانا بالطلا نفع من اوجاع المثانة

ا ووه الذي بزن فيه شبيه من النبت الطويل في الماء وينبت كما ينبت الفت وهو ينبت في القيعان ومنابع المياه يسعد الانباط بالعراق ويسميه الجندقوقا ولونه ان اجدها ابيض شديد البياض نحو الجندقوقا وبزره يهيج الباه

ابن ماسوية جار اليبس يدر البول والحيض وينفع من وجع الاضلاع الحادث من البلغم اللزج ويصدع ويولد دما غليظا عكرا وهو محمود في وجع المعدة العارض من البرد نا

بحفنانيس راو هاعدان من كل طرخ احد قنوي من طرفين ان الجوهر الآتي فيهما
كثيرهما بردان بدا عظيما وها في الدرجة الثالثة من الدرجات
الستر بيده ومن اجل ذلك ها دفعار ان الورم المعروف بالجمره والاورام الحاره
الحاده تذا عن الماده المسوده والاوزام والاوزام التي يسعي ويسير في البدن وقد يكون
صنف الثاني من جهة العالم و من الناس من يسميه جعفاء بنه ومنهم من يسميه
طلاقيون اهل ذمه يسميه ابنما وهذا الصنف من جهة العالم وزقه يلي
السطح ما هي سيه يوزن العساة الجمعا وعليه زغب وينبت هذا النبات بين
الصخور وله نوه منخنه جانب مفرحه للجلد فاذا اضمد به مع النجم العنب جلل
الخنازير. حندقوقا دد لوطوس منه ما ينبت في السايس ويسميه
بعض الناس طربلس

ح ٢ قوته حلوا
جلاء معتدلا وكذلك
هوفي التخفيف
واما في تركيب
الحرا ان والبروده
فكانه وسط معتدل
المزاج د عصاره
اذا خلطت بالعسل
واستعملت نقت
القروح العارضه
في العين التي يقال
لها ارعاما والنى فال
لها قابا والاثر العارض في العين التي يقال له لوقاما وغشاوه البصر واما

الأنخوسا الأول | الأنخوسا الثاني

قوه مبرده قابضه تصلح اذا ضمد به وجد أو وجع السوق للحمرة والنملة والقروح الخبيثة والأورام الحارة مع العارضه للعينين وحرق النار والمقرس وقد خلط عصاره بدهن الورد ونطل بها الراس من الصداع وشفاء ممن عضته الرتيلا ومن كان به اسهال لرطوبة الامعاء واذا اشرب الشراب اخرجت الدود المستطيل من البطن واذا اجتملت فطعت سيلان الرطوبات التى تكون من الرحم وقد يكتحل للرمد فينفع بها. اما اجناس الصغير فينبت فى الجبال وبين الصخور وفى الساحات وخنادق ظلله وله قضبان صغار محرجة من اصل واحد وهى كثيرة مملوءة من ورق صغير مستدق طويل وفيه نطوبه يدبق بالبد جاذ الاطراف وله قضيب فى الوسط طوله نحو من شبر وعليه الكيل وزهر اصفر دقيق وقوة هذا النبات مثل قوة الأول والنوع الكبير من جنس العالم والنوع الصغير يفعان جميعا

بيّض وهي تجفّف من الوجهين جميعاً وتمنع من حدوث الأورام
البلغميّة يتولّد على الصخر النديّ وإذا ضمّد به قطع نزف الدم وسكّن الأورام
وأبرأ القوابي وإذا خلط بالعسل نفع من البرى وأن يسكن ورم اللسان

حي العالم

ابزودون الكبير ومعناه ازدون بحيى إذا أما

ابزودون وهو حيّ العالم

من النوع الذي يقال له جار أفلس وله ورق دقيق نطوف به ند في اليد يشبه عظم
الإبهام وأطرافه شبيهة بأطراف الإبر وما كان من الورق في أسفل النبات
فإنّه مستلق وما كان في أعلاه فإنّه يركب بعضه على بعض ونبته والقضبان
كأنّه كلّاغيّر وينبت في الجبال وقد ينبته الناس في منازلهم ولورق هذا النبات

وثمر اذا اشرب رطبا نفع من الحصا المتولد في الكلى والمثانة واحد الصفنين وهو الادر اذا اشرب منه مقدار درحمين وصمد به نفع من نهشة الافعى واذا شرب بالشراب واتى بادويه امثاله مطبخه اذا رش في موضع فيه براغيت قتلها والذي عند اهل الذي يسال لما سطرن موس بن لامه النبتي يقال لها نرى بعلون خلم هذا النبات اذا كان رطبا ويحلون منه من خبته لانه حلو معقد ويستعملونه بدل الخبز لعطه سد هذا حبلوج المثانه وعسر البول ابديه المنى

غبيره نفع من الاقلنج وكل ما يفعل برن يفعل عصير ورقه اذا شرب رطبا او جففت عصارته واستعملت. **ابن عمران** يستخرج عصارته كما يستخرج عصار العافت وقد يوجد ناس يتكمالهوه واخضر فيعصر ويجفف عصير في الظل وللحنك زهر اصفر خلف حكاله شوكات احرشا خله حب صغير اصغر بشبه الحلبه وكثيرا ما ينبت بقرب البحار وفي الارض الرمله. **ابن سراقيون** دهن الخلنك نفع من وجع المفاصل ويحسن اللون ويزيد في الباه ويعث على الجماع وينفع الكلى والظهر اذا اشرب منه اوقيه واحد بمطبخ او بنبد ويصب في الحقنه فنفع جدا. **حب الكلى ابن رضوان** موحث صغار في حلفه الكلى اذا اشرب منها عشرون درهما اثرت في علل الكلى اثرا حسنا. **حزاز الصخر حز** هذا هو شبيه بالطحلب ومنهم من زعم انه من جنس النبات فنداصاب واحبته ايضا يسمى حزازا لانه يشفى من العلة المسماه بهذا الاسم وهو النوبا وقوته تجلوا وتبرد شديد بلا معا الا ان تبريدها

عنزروت

وله قضبان طوال
منبسطه على الأرض
وعندالورق شوك
ململز صلب ومنه
صنف آخر ينبت
عندالانهار وقضبانه
من تفعه سبع
الارض خفي الشوك
عريض الورق
وله قضبان طوال
فيها الورق ونور
طرفها الاعلى اغلظ
من الطرف الاسفل

وعليه شيء يابس في قنته الشعر مجتمع شبيه بسفا السنبله وثمر صلب مثل
ثمر السنف الاخر ح ج هذا النبات مركب من جوهر رطب بيّر البزوده
ومن جوهر يابس ليست بونته بينة مع انه بارد والاغلب على الجنك الذي
ينبت في البر الجو هر الارضي وهو الذي بنا انه قابض والغالب على الجنك النابت
في الماء الجوهر المآئي ولذلك صار هذا النوعان من الجنك موافقين لمنع الاورام
الحادثات من الجدوث وبالجمله هو صالح في كل موضع يبتل وينصب له شيء وامّا
ثمر الجنك الذي ينبت في البر فانها اذا شربت نفت الحصاة المتولده في الكليتين
وكلا الصنفين بردان وقبضان وقد يضمد بهما الاورام الحارة واخلاط
الملتهبه اين الشراج والعضو المعارضه في الكعب واورام العضل الذي عن
جنبي الحلق ووجع اللثه وقد يخرج عصارة هذا النبات ويستعمل في الاكحال

الفُمْر وله زهر فَنفْسَجي اللون وبزر إلى الغبرة ما هو به شي من زغب وبيّن آخر طرفه شي كأنه خط وله رؤوس كطلب ح خ قوته جان يابسة على مثال فَمْر الهدهد لأن لحيته شبيهة برأس ذلك الفَمْر وهو من القوة في جعل من الدرجة الثانية ولذلك هو إذا شرب شفى وجع الأضلاع الحادث من السدد وبزر البول وبذر الطمث د وبزنه وزنه إذا شرب بالماء نفع من النهشة وعسر البول والصرع وابتدآ الاستسقآ ووجع الأرحام وقد بذر الطمث وينبغي أن يسقى من البزر ثلث درخميات ومن الورق أربع درخميات ورقه إذا شرب بالسكنجبين نفع من نهش الهوام ٠٠ وينبغي لمن أن يطبخ هذا النبات إذا أخذ بأصله وورقه وصب على موضع نهش الهوام سكن الوجع الآ أنه إن كان من نصب عليه قرحه فأصابها عرض لها شبيه بما يعرض من نهش الهوام ومن الناس من رسي وزنه للحمى المثلثة ثلث ورفعات ومن بزره ثلث جنيات بشراب وشبى للحمى الأربع أربع ورفعات وأربع جنيات لتذهب الحمى وقد ينفع أصل هذا النبات في اخلاط الأدوية المجموعة غيره حلوا وبلطف ٠ ينفع من العوارض

حسك

هو حمص الأمير وهو الكلومج بالفارسية
د د طروبيلس
وهو الجنك هو صنفان أحدهما
ينبت في الخابات
وعند النهار وزنه
شبيه بورق الفلفلة
إلّا أنه أدق منه

للمحرورين ويضمد
بورقه للاحتراق
وينفع من تعفن مغليا
لاصحاب الاسهال
المزمن بدهن ورد
وتماما بازده

حومانه

الرازى هو
انات المسمى
باليونانية طريفلن
دَه طريفلن هو
مشط طوله ذراع
او اكثر وله
قضبان دقاق
سود شبيهه
بالاذخر ومنها شعب
وفي كل شعبة
ثلث ورقات
شبيهه بورق
الشجر الذي ينقال
له اولوطن وبزر
اسود اشبه الورق
شبيه الجيحه والحبة

طريفلن وهو حومانه

للرياح جيد للمعدة وفي مسحنة اعضا نافعة اصلاح مزاج الكبد وهضم الطعام وتزيل البخارات وتصلح مزاج البدن الاحشاء وتزيل ادمانها الصفرة من الوجه وتساير البدن وتفتح سدد الكبد والطحال وشيها قبض مع عطرية وتنحي الكلى وتسمنها وتنقي المثانة ومجاري البول وتشفي الزكام وتنفع الدماغ وتحلل منه رطوبات وفي من اشد الاشياء موافقة للبواسير وتنفع من نفخ ارحامها وتسكن وجعها بالتضميد وادمان اكلها جزاه اخرى ايضا **ابو حنيفه** وهي شجرة ترتفع على ساق مقدار ذراعين او اقل لها ورقه طويلة مدججة رقيقة الاطراف على خلقه اكمام الزرع قبل ان ينفتح ولها برعمة مثل برعمة السلم وطول ورقها طول الاصبع وهي خضراء شديدة الخضرة وردادي في المحل خضر لا يبرء عاكاشي فان غلط البعير فذا اشاته **ابن عزال** اصناف اعشب قتلته على المكان ولا يشفي منها علاج **جماجم** هو صنف من الجنو غير ابو رفى ويعرف بالجبن الشامي ويبقى بالشام الجبن النبطي وله اغصان خضر ماجه خوار ونوار ابيض وبزر كبزر الجبن **منسح** هو احر وابس من الشاه فرم **غيره** جاز يابسة الثانية منفخ للسدد الدماغ جيد للزكام الرطب واصحاب البلغم مقوي للقلب واليس يوء

ورق الزاز باج في ملمسها خشونه وهي مضاد سم العقرب والأدوية القتا له بالبرد هاضمه للطعام الغليظ ونش الزباج ولانفخ البته وزيل الجشا الحامض **الرازي** ينتر المعده واصحاب الجشا الحامض وبهضم الطعام ويطرد الرياح وينفع اصحاب الزباج الغليظه والبلغم ويهيج الرمد سريعا **ابن ماسه** نافع من لسع الهوام ويدر البول ويعطش عطاشا اكبرا **ماسرجويه** هوشبيه بالسذاب في القوه واطع المتى **البصري** كانخ الحزا ندى للرأس وورث السدد وينفع لبرد المعده والخصر ولنتن الفم وبهيج المزاج ويظهر الجرب والبثر البدن

حزاه أخرى

ابو زيد الحزاه بقله ورقها مثل ورق الكرفس او ورق الجزر ولها اصل كالجزر بنظهر منه شي علي الأرض وهي تنبت منسجحه في شعب غصنه اذا استثيلت **الفلاحه** الحزاه بقله ورقها دقاق مفترق منشعب بشبه ورق الجزر بنظم كالكرفس من اصله وفي طعمه حزافه وحدة طبيه غير مكروهة

يضرب طعمها الى شبه طعم الرازباج وفي طعمها حزافه وهي هشة لنس فيها شئ من اللزوجه مستطابه ولها بزر دوني اخضر طيب الريح طارد

يتخذ منه أجود الزاد بعد المرخ والعفار ويوخذ لينها في صوف وقطن ما حمل ثم يستعمل ما لابد حتى يروي منه ثم يمهل عشرة أيام حتى ينتن ثم يحك به جرب الإنسان الأجرب حكًا شديدًا ويقام في الشمس فيدلك الجرب بذلك الصوف فيجد مضضا شديدًا فبرأ

جذا

أبو حنيفة هي النبتة التي تسمى بالفارسية الزوفا وهي تشبه النرجس وزهرها كزهره وورقها حوكى من ورق السذاب وليس في خضرته وقيل إنه سذاب البر

الطبري الجذا هو شبيه بالسذاب في صورته وقوته

الرازي الجذا يسمى بالفارسية دينارويه

الفلاحة هي بقلة جارة جريبة قليلًا شويها مائن وورقها

وَيُبَاطُ فِي الهاوَنِ بِعُودٍ وَيُصَفَّى خِرْقَةٍ صَفِيقَةٍ وَيُرْمَى شَئْلُهُ ثُمَّ يُصَبُّ عَلَى ذَلِكَ الماءِ مِنَ العَسَلِ مِثْلَهُ أَو يُزَادُ هَذَا الخَلُّ أَو قِنطَارٌ وَيُعْمَلُ فإنَّهُ يَبْقَى فِيمَا كَبِيرًا غَيْرَهُ يُبْدِلُ البَوْلَ والطَّمْتَ بِقُوَّةٍ وَيَنْفَعُ مِنَ القَولَنج شُرْبًا وَطَلاءً وَيُصَفَّى الدَّمَ مِنَ المَرَّةِ السَّوْدَاءِ وَيُحْسِنُ اللَّوْنَ وَيُحَرِّكُ الجِمَاعَ وَيُسَمِّنُ وَيَنْفَعُ بَعْضَهُمْ أَنَّهُ يَنْفَعُ أَصْحَابَ العَشْوَ وَأمَّا الجَهْلُ العَزِيزُ الأَبْيَضُ

حَرْمَلٌ وَفِيهِ شَبِيهٌ بِوَرَقِ الشَّيْلَا إِلَّا أَنَّهُ أَعْرَضُ مِنْهُ وَهُوَ مُفَنَّذُ شُعَبٍ
وَلَهُ زَهْرٌ شَبِيهٌ بِزَهْرِ العُنَّابِ وَهُوَ أَحْمَرِيٌّ
يَبْقَى اللُّونُ إِلَّا أَنَّهُ أَصْغَرُ مِنْ زَهْرِ العُنَّابِ
وَهُوَ أَرْجَى مَعَ أَقْرَبَ لَهُ القَدْرَ إِلَى الحَنْذَلِ
وَهُوَ النَّفَنْج لَهُ قَضِيبٌ أَبْيَضُ طُولُهُ أَرْبَعَةُ أَشْبَارٍ
وَعَلَى طَرَفِهِ رُؤَانٌ شَبِيهٌ بِرُؤُوسِ الثُّومِ وَلَهُ أَصْلٌ
صَغِيرٌ شَبِيهٌ بِبَصَلَةِ النَّبَاتِ الَّذِي يُقَالُ لَهُ بَلْبُوسُ

حَرْمَلَة

وَالأَصْلُ نَافِعٌ جِدًّا إِذَا اتُّخِذَ وَشَبَّرَ مَعَهُ دُهنُ الأَرْنَبَةِ واجتَمَلَتْهُ فَزَّ رَحِمَهُ مِنْ فَتْحِ فُوَّاهَا لِلأَرْحَامِ أَصْلُ هَذَا شَبِيهٌ بِأَصُولِ اليَزِيزِ الصَّغَارِ وَفِيهِ شُدَّةٌ وَجَمْعٌ وَلِذَلِكَ مَنْ يَضَعُ مِنْ أَسْفَلَ مَعَ دَقِيقِ الشَّيْلَا ضَمَادًا عَلَى مَا وَصَفَ يَنْفَعُ قَمْرَ الدَّجْمِ المَفْتُوحَ حَرْمَلَة أبو حنيفة والحَرْمَلَةُ أَيْضًا نَجْمٌ يَنْبُتُ بِقُرْبِ المَاءِ نَمَا قُضْبَانًا نَحْوَ القَامَةِ لَهَا لَبَنٌ كَثِيرٌ وَوَرَقٌ أَغْبَرُ طِوَالٌ دُونَ وَرَقِ الخِلَافِ

بالنار يشبه اسفند ه **أبو حنيفة** الحرمل نوعان له نوع له نور أبيض مثل
نور الياسمين ورقه كورق الخلاف والآخر هو الذي يبقى الله بالنار ستة
العشر **دج** النبات الذي ينبت بفاذ وفياء البلاد التي ينال لها غالبا
التي ما سايا واسمه موبى شبه بعض الناس شذا بالغير بنائي وهو ينشـ يخرجه
من أصل واحد وله أغصان كثيرة وورقه أطول من ورق التاجري بأخر بكثير
وأغلظ يقبل النابحة وله زهر أبيض ورؤس أكبر قليلا من روس النذاب البستاني
مثلته فيها بزر لولب الحمي ما هو دوثلث زوا بأم بسد يد المزاج والبزر
هو المنتفع وينضج في الحريف وإذا أخذ بالعسل والشراب ومن أنه العجاج والزعفران
وما الرايا بج وأفق من ضعف البصر ومن الناس من يشبهه وما الزابيوت
يسمونه ساسا وأهل فياد وما هم الذين يسمونه مولى لا أن فيه شبها سيرا بالنبات
الذي ينال له مولى إذ كان أصله أسود وزهره بيضا وينبت في البلاد ح ني
أرض طيبة التربة **جح** قوته لطيفه حارة في الدرجة الثالثة ولذلك
صار يقطع الأخلاط الغليظة اللزجة ويخرجها بالبول **الدمشقي** يخرج حب
القرع من البطن وينفع الغولنج وعرق النسا ووجع الورك إذا طلي بما به وجلوا
ما في الصدر والرية من البلغم اللزج ويحلل الرياح العارضة في الأمعاء
ابن عمران إن أخذ منه مقدار كفين طلاع من الشراب وطبخ حتى يذهب
ثلثه ثم يصفى المصروع منه ووزن عشر دنانير نفع من الصرع ويسقي منه
المرأة التي قدحلت من ثم انقطع عنها الحمل ثلثه أيام منوالية فنفعها أو علامه
انتفاعها إن بناه **البصري** هو غابة في منفعة المصروع وعين **الطبري**
جيد من برد **الدماغ والبدن** **الرازي** ينقى ويصدع ويسد وينضج
الأفي **جبيش** ينكر كالخمر أو قريبا منها وإصلاحه لنفي به يكون على
هذه الصفة يؤخذ من جنه حبه عشر درهما فتغسل بالماء العذب مرارا ثم
يجفف ويدق في الهاون وينخل بمنخل صفيق ويصب عليه من المغلى أربع أواقي

الأنصاب ومن أربو واخرج الدود الطوال واذر الطمث واخرج المشيمه والاجنه وهو يدر البول اذا اعجن بالعسل لعق سهل نفث الفضول التي تكون في الصدر واذا ضمد به مع الخل جلل‍لا وام البلغمه الجد بشد وهو يحلل الدم المنعقد ويقلع ما يلصق بآله البوانير والتوابل التي لا يصل لها فرحوض‍ن واذا خلط بالسويق وعجن بالشراب ووضع على عزو البسا افقه واذا اطرح في الطعام و اكل ينفع من ضعف البصر وقد يصلح استعماله في وقت الصحه في النوايل. روقش يذهب ظلمه البصر وهو اقوى من الصعتر في ذلك بالعورض ينقي المعده . الدمشقى ينفع وجع الحلو والغم ما شرح به اذا انتخ وعجن بالعسل او طبخ بالماء والعسل وشرب منه مقدار مثقالين نفع القولنج وحلل الفضول واصلح الكلى و يحيا الجماع . ابن سرافيون فعلحه يسهل المزه السوداء الا انه ضعيف ولذلك ينبغى ان يخلط معه الملح والشربه منه مثقالا ن مع خل وماء ٥ه واما الشراب الذي يتخذ من الحاشا فمن صفته يدق الدواء ويخل ويوخذ منه ما به مثقال ويصير في خرقه ويلقى في جره من عصير وهذا الشراب ينفع من سوء الهضم ومن لا وجلع التي تكون نحب الشرا اشيف ومن الاسعراز الذي يعرض في الشتاء ومن سموم الهوم التي يبرد الدم نحدل

ابن سمجون حرمل موى وهو الحرمل وهو سذاب بركي

الحرمل صنف بأن ابيض واحمر فالابيض هو الحرمل العزى ويسمى بابونا بنيه موى والاحمر هو القارسي وهو الحرمل العامي المعروف ويسمى

وماؤه ينفع طلاءً من داء الثعلب ونمل النمل إذا غلبه اعلى به الرأس ويجلل
الأورام الصلبة ويذهب القراز من الرأس **حاشي** هوصعتر
الدينون وصعتر الحمير **د** ثوُمش ن ايت يعرفه جل الناس وهو تمش صغير

في مقدار ما يصلح أن يهما من أغصانه إذا نبت عليها نزل الساذج وله ورق
صغار دقاق كثيرة وعلى أطرافه نوُرصغار وهزاها وأكثرما
ينبت في المواضع الخزنة والمواضع الرقيقة **د** الحاشي يقطع وينحن
اسخانا بينا فهو لذلك يدر الطمث والبول ويخرج الجنين وينفخ سدد
الأحشاء وينفع النفث من الصدر والرية ومن أجل ذلك قد ينبغي أن ينفعه
من التخفيف والأعيان في الدرجة الثالثة **د** إذا يشرب بالملح والخل كيموما
بلغميا وإذا عمل طبيخه بالعسل نفع من عسر النفس الذي يحتاج معه اليه

سقولومس هوالحرشف

الابطين ونبين
وراحة البدن كله
الا ان فعله هنا
بعضه جملة جوهر
من قبل ان يخرج
من البدن ما كان
على هذه من الاخلاط
فاما الافعال التي
يفعلها بكيفيانه
فندل منه على
انه جار يجاري الدرجه
الثانيه حوارها
اوبعه اول الثالثه

وانه يابس في اخر الثانيه و اذا طبخ اصله بالشراب و شرب كان صالحا لمن كان ابطاً وسائر بدنه منتنا وبول بولا كثيرا و قد يوكل هذا النبات وهو مدرى مثل الهليون **الرازي** الحرشف جائز مهيج للشهوة زائد في الباه مسخن للكلى والمثانة كاسر للرياح مخرج لما في صدر اصحاب الربو والسعال الغليظ يذر البول اكثر ما يذر الهليون وهو اسخن من الهليون والطف و اقل رطوبه وانفع للمبرودين وقال الكنكر غليظ الجرم بطي الانهضام ينفخ ويزيد في الباه وينقي الكلى والمثانه واصلاحه ان يطبخ بالطبيخ ويكثر فيه من التوابل **المجوسي** الكنكر هوتراب الغى ويسمى بالفارسيه كنكر زد اذا استفى منه مع الزبيب والماء الحار ومع العسل فانه ينفع له **غيره** الشربه منه ملبقه دراهم وان اوقع بعقار الليط وبولد السوداء اذا ادمن

حسل الرازي يشبه بالزرابنه حسنى وهو بقل يشبه الغليظه
الصعتر الطويل الورق المعروف بالبريم الا انه اعظم منه واطيب واجوده
لذلك اجود للمعده
الفلاحه اجني وهو
الجا يشبه
الصعتر البستاني
الا انه اغبر وهو
اطول ورق من الصعتر
وفيه ثم يطول حتى
ينطوي على بعض
يطبخ مع الطعام
ويؤكل نيا ويصلح
للمعده ويطيب
الجشا ويصلح للطعام
الفاسد فيها وينزع احراره الطعام ويطيب النكهه وقد يشفي من لذغة العقرب
ونهش الزنبار خرشف الجرشف منه بستاني وهو
والكنجر وهو المعروف بالقنازيه وهو اكبرها ورقا واقلها شوكا ومنه
بري كبير الزائل لا ساق له حديد الشوك ومنه بري في اخره ساق وروس
صغار يشبه الكنكر وهذا هو الذي ذكرنا ويعرف عندنا باللصف
ح سقولومس هو صنف من الشوك وورقه فيما بين ورق حامل ورق اقنيا الى
الان ورقه اشد سوادا وله ساق طويل ملوه ورقا عليها راس مشوك وله
اصل اسود غليظ ح ح اصل هذا النبات اذا بول كثيرا ثمانى ثلثه
اشار ينام وشرب ذلك الشراب ولذلك ايضا صار يذهب بالحبه

جرفومتري و يسمى ململ الصقالبه وزعم قوم انه الحصاد وقيل هو القلح

ا دار هو نبات طوله ذراع له قضبان رقاق عليها ورق ناجنين متقابلين وسوقه وورده مشابه لورق الشيطرج غير انها انعم واشد بياضا وعلى اطراف القضبان اكلة مثل اكلة النبات الذي يقال له افطى وله زهر ابيض اذا فرك يرى غليظ طيب الرائحه وقد يطبخ هذا النبات كجنس الشعير

خاصه بالبلاد التي يقال لها قبادوقيا و ثمره اذا جف يستعمل في الطعام كأن البليلي **الفلاحه** ادى انى هو قصب يعلو ذراعا و يتفرق منه عدة قضبان وجوها وزن ثبه و زق الشيطرج و ينشق القضبان و ينعطف بعضها على بعض و رقه لبن ناعم نضرة بخضرة الى بياض غير صادق الخضرة وله زهر ابيض و سطه اخضر و طبيه حرافة تلذع الفم واللسان واسمه بابل النبات البليلي و يزن حزن جدابع و يحبى و يدرع على القريص فطيبه ويلطف ويدر الطمث ويستعمل يزه و قضبانه في الطبخ المعمول بالزعفران فيكون لذيذ و دهنه قوة سخنه محلله مقويه للاعضاء والصلب طارده للرياح

طول ورقه اصبع منبسط على الارض مشرف الاطراف وفيه شي من رطوبه لزجه وله قلب في وسطه دقيق طوله شبران وفيه شعب بين وعلى كل شعبه ثمر واسع الطرف فيه بزر شبيه بالجرجير عريض شكله على شكل الفلكه كانه شي قد عصر من جانبين وله زهر لونه الى البياض وينبت في الطرق وعلى الحيطان والساحات

خط هذا بزر وقوه جاذبه تخرج الدبيلات التي تحدث في الجوف اذا شرب وهذا

ايضا بذر الطمث ويفسد الاجنه واذا احتقن به نفع من وجع اللسان بان يسهل شيا خالطه دم وهذا ايضا يخرج من فوق ومن اسفل اخلاطا مرة متى شرب منه مقدار اربعه دوانق ونصف د وزن بيت منخل اذا شرب منه مقدار اكسونا فان اخرج المرة الصفرا بالقي والاسهال وقد يحتقن به لعرق النسا وقد يسهل الدم واذا شرب فجنا الدبيلات التي في البطن وبذر الطمث ويسقط الاجنه وقد زعم قوم اطوس انه يكون منه ضرب اخر ينبته بعض الناس خردلا فارسيا وهو نبات عريض الورق كبير الاصل ينفع في اخلاط يحتقن المستعمله لعرق النسا

وله قوة تفتح وتحدر الاورام واذا اخلط بالسويق والخل تضمد به نفع من عرق
النسا والاورام الحارة واذا انضمد به مع الماء والملح انضج الدماميل ورق
الجرب يسخن ويقطع ايضا بعد ذلك الا انه اضعف فعلا. ابزراط
الجرب يسخن ويقطع ايضا بعد ذلك الا انه اضعف فعلا ويحدر رطوبة بلغمية
الى المثانة اذا اكثر من اكله وحتى حدث كثير اضطرار البول. مسيح ليس
جيدا للكلى. شلمويه ينفع من الاسترخاء في جميع الاعضاء. الغاربيي ينشف
الفج من الجوف ويزيد في الماء ويشهي الطعام. الطبري يقبل الاجنة فلا حنيا
شرابا واجمل وهو ردى للمعدة لبية وقال في كتاب جوهره له
خاصية اذهاب المواد الردية واخراجها. البصري اذا اشرب بماء حار
جلل الفولنج ويخرج الديدان وحبن المرع ومنع الشعر من السقوط اذا غسله
الراس وورقه ردى للمعدة. ابن ماسويه ان شرب منه بعد نجعه وزن
خمسة درام مع الماء اجاز اسهل الطبيعة وجلل الرياح العارضة في الامعاء ونفع
من وجع الفولنج وان شرب مقلوا اعقل الطبيعة ولاسيما اذا لم ينجو لخل الروحة
بالمء. حبيش يسخن الكبد البارده وينفع من بزر الكلين اذا اعترينا
من الثمر ومن عرق النسا اذا اشرب منه غير مقلو ويبلغ البلغم اللزج عن المعدة
ابن عمران اذا احمر وشرب ببعض الاشربة اجابته للبطن مع الاسهال
العارض من الرطوبة ونفع من الزحير وتهيج الامعاء السفلى العارضة من
البرد واذا جمل على الخروج العفنة نفاها وان يخنو وشرب نفع من البرص
وقد يلطخ عليه وعلى البهق الابيض مع الخل ان خلط بالسويق وعن بالخل جمل
على الاورام جلاها. ابن جلجل اذا اضمد به مع البصل وجمل على العلل الحلله
وان غلي منه ضمادا بالماء والملح انضج الدماميل. **حرف السطوح**
هو الجرف لا بعض وسمي اسم حرف ابغر وسميته اكثر الاطباء جرفا
بابليا ويعرفه بالا من قرن ويسمى باليوناني سيلى *** هو نبت دقيق الورق العامة

الرأس وكل واحد
من العلل الأخر
التي يحتاج
فيها إلى اللحم
كما يسخن بزر
بزر الخردل
وقد يخلط بزر
الجرجير أيضا في
أدوية شفا
أصحاب الربو من
طريق أن لا بد
فيه إلا إنه
يقطع الأخلاط

الغليظة تقطيعا قويا يطعم بزر الخردل لأنه يشبهه في كل يوم وبذر
الجرجير نفسه أيضا إذا جفف كان ثم ثلث قوة بزره فأما ما كان طريا فهو
يشبه ما يخالطه من الرطوبة المائية أنقص القوة عن البزر كثيرا وبلغ من
ضعف تلذيذه أن الإنسان يتندي بأكله مع خبزه وبزر كل حرف
متحن حريف زدي للمعده يلين البطن ويخرج الدود وحلل أورام الطحال
وينقل الأجنة ويحرك شهوة الجماع وهو شبيه بالخردل وبزر الجرجير
والجرجير قد يجلو الجرب المتقرح والثآليل وإذا ضمد به مع العسل حلل
ورم الطحال ونقى الفروج التي ينال لها الشهدية وإذا طبخ بالخل أخرج
الفضول التي في الصدر وإذا شرب نفع من نهش الهوام ولسعتها وإذا دخن به
في موضع طرد عنه الهوام ويمسك الشعر المنتاقط ويبلغ جنسا لنا الفارسية

واصلح اللثه المسترخيه واذا ادمن اكلها اتت من البرد فان

حلق ابو حنيفه وهى شجره نبات الكرم ترتقى فى الشجره ولها ورق شبيه بورق العنب خامض نفح به اللحم وله عناقيد صغار كعناقيد العنب برى يحمرثم يسودفيذبل ويؤكل فطبخ ويجعل فى العصير ويكون اجوده من ماجب الزمان فى جمادى جف فى البلاد لذلك

ومنابته جلد الارض ابن رضوان هو نوع من الاشك يعلم من حشيشه باليمن حامض جدا بارد يابس قامع للصفراء يسكن الكرب الحادث عنها نافع من الحمى قاطع للعطش

جرف الفلاحه هو صنفان احدهما برى وفيه ودته ونفريق كثير والاخر منه برى ورقه شبيه بالاسنان مع شفق وشرف ورداس هو الجرف اجوده ما ابناه منه ما يجلب من بابلى قد غلط اكثر الاطباء وظنوا ان الجرف البابلى هو الدقيق المعروف فى جرف لسطوح وقول د يدل على ان الجرف البابلى عند هذا الجرف الاجنى المعلوم ما ينبت منه فى ارض بابل بزر الجرف نوته قوه يجرف مثل بزر الخردل وذلك قد يسخن وجع الورك المعروف بالنسا واوجاع

حُمَّاضُ المَاءِ

الفلاحة هو نبات ينبت على المياه وله ورق طولها طول أصبع منغرشة على الأرض شبيه بورق الهندبا وله ساق صغيرة ورأس فيه بزر مجتمع أسود يضرب إلى الحمرة ولا نشده زهر وطعم هذا النبات طيب حامض كطعم الحماض وهو ملين للبطن إذا طبخ وأكل وإذا اتخذ بزره وشرب بخمر طيب لنفس وأزال الهموم ويشفي الوحش الخفقان الحار وهي زهرها يزيلان الغثي ويصلحان المعدة المنزحبة ويسكن الحمى إذا طبخت وصبت على العلل وإذا مضغ بزرها وزنها سكن وجع الأسنان

حمّاض الماء

حمّاض الماء

وله اصناف يحامض اذا طبخت لبنت البطن واذا اضمد بها نبتا وخلط بها دهن
ورد وزعفران علل از ام؟؟ زا؟؟ الا للدرس و؟؟ الذي يسمى الشهديه
وقد يشرب الما؟؟ ا؟؟ ؟؟ الحامض البري يسمى السولا فان و يزر الصنف
المسمى اصلين ينفع ؟؟ الم؟؟ والغثيان ولسعه العقرب
فان عدم اجب؟؟ شربه ؟؟ ؟؟ لنغما واصول هذه الاصناف التي ذكرنا من
الحامض اذا اضمد بها مع الخل مصوخه او غير مطبوخه ابرات جبر المشرح والنوابي
والنشر العارض في الاظفار والداجري ينبغي من قبل نغمد بها ان يبذل لك
المكان الذي يجاجى بلا الضماد بطرز وز؟؟ خل في الشمس وطبخها اذا ادمت على الحكه
العارضه في البدن وخلط بمازا حام واستيج به سكنها واذا اطبخ بالشراب
ويتمضمض بطبخنها اسكر وجع الاسنان واذا طبخت بالشراب وضمد بها جلت
ورما الطحال ومن الناس من يعلق اصل الحامض في رقبه من به خنا زير يرى انه
ينفعد ذلك منها واذا اجحفت واحتملها المرأه وقطعت سيلان الرطوبات السايله
من الرحم سيلا مزمنا واذا اطبخت بالشراب وشربت ابرات من بيع برقان وفتت
الحصا المتولد في المثانه وادرت الطمث ونفعت من لسعه العقرب وامّا
افولا فانن وهو حامض السوائح وهو الحامض النفه فهوا كبر من الذي وصفت
كبرا وهذه النبات تكون في الاجام وقوّه مثل قوه اصناف الحامض التي ذكرنا ها

سبيج الحامض النفه هو الثنى البري : عنبره الحامض الحامض سكن
الغثيان الصفر او ؟؟ ويذهب بالحامض وقد ينو كل شهوه الطين قسطبس از مر
بزر الحامض في خرقته وعلق على عضدا المرأه الايسر ما لم يحل ما دام عليها

حمصيص ابو حنيفه هي بقله جامضه جعل في الاقط
وهو من الذكور احمر وتسميه اهل الجبل وخزاس ان الترف و مشابه الرمل
بيّ قيل انه المسمى باليجمه اجطر ولجطبله وهو صنف من الحامض
ذنبو الوز وجعدا احمر صغير معروف عند الناس وقوّه ثنا؟؟ اصناف الحامض

الذي وصفناه وله
ساق مجدد
الطرف لبن
بعظيم وله ثمر
في شعب على ساق
أحمر حريف حامض
حاد في الحامض
البقية قليل أسير
فأما الحامض الحامض
فقوته قوة مركبة
وذلك أنه
مع القوة المجلاه
قوة رداعة مانعه
وأما بزر الحامض
ففيه قبض بين
حتى إنه يشفي
قروح الأمعاء
واستطلاق البطن
وينبت بزر الحامض
الكباز والكثير
نباته في الآجام
وقوته أضعف
من قوة هذا

انتفاخًا وتفعل فيه ما تفعل الخميرة بالعجين والخلّ في الأرض ۞ ماسَرجويه
بعذوا الزبيب أكثر من سائر الأشياء وكذلك إذا ربّيَها فروج أعضاء دينه
بالخليط وجعلناه جيدًا ويزيد في الماء وقد جعلته نجح الخيل لهذا السبب ۞
ابن ماسويه جيّد اللون ينفع لما يعرض في الرأس والبدن من الحكّة وإن انتفع
وأكلنيا وشرب ماؤه على الريق أدى إلى الانفاط وقوى الذكر ۞ الطبري
أن يقع ليلة في الخل أصلح على الريق ويبرأ عليه نصف يوم قتل الدود في
البطن وهو ينفع من وجع الظهر ۞ الرازي ماؤه يليّن البطن ويخرج الريح إذا
طبخ مع الكمّون والشبت والخلّ بالزيت والخردل وينفع من الأمراض البلغميّة ۞
ابن عمر أن الحمّص ينمّي المرّة يقوى البدن ۞ الأسرائيلي الأسود أقوى إخراج
الدود وينقّي السدد ويهيّج الجماع واسقاط الأجنّة والنفع من الاستسقاء
واليرقان وآماز باده المتى واللبن ويحسن اللون وادرّ البول فلا بيض أحسن بذلك ۞
الرازي ما الحمص الأسود يصلح للطّحال والأمراض الباردة ووجع المفاصل الرطبة ۞
عنبره هو أغذى من جميع الحبوب ويصفّي الصوت ويحسن اللون طلاء وأكلًا
ونقيعه نافع لوجع الضرس إذا طبخ مع اللحم أعان على نضجه وبزره يفرج
الكلى والمثانة ويحسن زيّ البول وإذا عقل عليه أثر الدم قلعه من الثوب ودهنه
ينفع من اللقوة والرطب منه يولّد في المعدة فضولًا رطبة د ۞ وقد يكون حمص
بريّ وقد يُشبه ورق البستاني جاف الراعيّة وثمرة مخالف لثمر الحمص البستاني
يصلح لكل ما يصلح له الحمص البستاني في كل شيء وينفع أكثر منه
بمقدار ما هو أجدّ وأحدّ منه ث ۞ **حمّاض** د ۞ لا باتٍ
منه ما يقال له الكبر كا باتٍ ينبت في الآجام وهو صلب جدا الأطراف ومنه
بستاني عريض يشبه ورق السلق لا يشبه الذي تقدّم في الشكل ومنه بريّ
ناعم شبيه بالبنات الذي يقال له لسان الحمل ومنه صنف آخر جبلي ينبت بعض
الناس يقصدان وانفلس ولا بات يرعى الحمّاض يا حمّاض البريّ وورق الحمّاض البريّ

<div dir="rtl">

الجنس آخر من الحمص
وهو المسمى حمصاً
دسياً وقوته
هذه القوة اعني
قوة جاد به مجلله
قطاعه منفشه
وهو جاز فيه
رطوبة يسيره وفيه
مع هذا شيء من
المزاز يشبه اصل
ينتفع به في سدد

اربينش وهو كاكس

والكلى ويجلو الجرب والثوبا والاورام الحادثه عند الاذنين والشعيرتين اذا طليت
وينفي ايضا الجراحات إذا استعمل مع العسل د ب اربيسس وهو الحمص السنائي يلين
الطبيعه ويدر البول ويولد المنى ويحسن اللون ويذر الطمث ويعين على اخراج
الجنين ويولد اللبن والصنف من الحمص الذي يقال له ازوينار خاصه يطبخ بماء
ويضمد به مع عسل لاورام الخصا والفروج الخبيثه والصنف آخر الذي يقال
له اوريوس وهو الحمص الاسود الصغير وكلاهما اذا شفى من طبخها مع الخشبه التي
تسمى ياوطس للبرذان والجبن نفعا منها باخراجها الفضول يدر البول ويضر
بالمثانه المتفرجه والكلى ومن الناس من زعم انه يقلع الثاليل التي يقال لها

(احد)
اوردخوديس والثاليل التي يقال لها مسمارا بان يؤخذ من الحمص حبه فتوضع
واحد على كل ثؤلول ابتدا الشهر ثم يؤخذ ذلك الحمص الذي فحرفه ويرمى به
إلى خلف بولس الحمص كثير الغذا لبن جيد الكيموس جيد في البدن

</div>

وينفع الأخلاط بالسمن من الحرق والشقاق العارض من البرد وقد خلط بادويه الكلف وبالغمر فاخترمته فاحدثا نظهرا منه رائحة الحلبه نقيا وبغى في اليد وبه طعم حلاوه مرار فان لجوده ما رابعد هذه الصفه ◊ في الاغذيه الحلبه اجود غذا من السمسم لأن اخبر عنه اخرج واذا اكلت بالخبز قل اطلاقها للبطن و نفى الاشعا من الفضول الرده به ودفع الأذى وينبغى ان يكون العسل بسيرا كما يكون لذا اعا لذا اطبختها مع ماءٍ وخلطتها بعسل يسير وطبخ حتى يسترا بعا نداول و شرب قبل وقت الطعام يسير ينفع من فصده اوجاع منه دون حمى ماشرحو به طبيخها جعدا الشعر وذهب بالحزاز وبفي الصدر ونقا الرئه بعض الغذا ◊ابن ماسويه◊ ان اكثر من اكلها غيث ودرم الجسم اذا شرب طبيخها مع حمه دراهم من الفو ومحمود لكر الاعضاء وهنا ◊ابن ماسويه◊ سن الفم والعزق بطيب رايحه النقل ◊الدمشقى◊ يسهل البلغم اللزج ويدر البول ◊الطبرى◊ يهنج الباه واذا ضعت على الطعا المشبج بطبنه ◊النازرسى◊ يبكن النعال والربو وعسر النفس جده للريح والبلغم والبواسير ◊غيزه جيد◊ لوجع الظهر وعسر الولاده وعسن اللون وينفع من اوجاع الرحم واورامها خلط زدى وقد تدخل في ادويه الكلف وينفع مع دهن اوردا للحرق النار وينفع من الشقاق البارد وخصوصا لعابها وجلو الفروج الرطبه من الراس وشقى من الطرفه وليبن الدبيلات ونضجها وهى قوته النخلل ◊البصرى◊ دهن الحلبه نافع من عسر الولاده ومن وجع الرحم اذا اجفن به ◊النارازى◊ بقل الحلبه اذا اكل كان نافعا من وجع الظهر والكبد وبرد المثانه وتقطير البول واوجاع الارحام البارده ◊حمص◊ وهذا جنس من الحبوب ينفخ ويغذوا ويلين البطن ويدر البول ويزيد في اللبن والمنى ويدر ايضا الطمث فاما الحمص الاسود منها كثير ادرارا للبول من سائر الحمص وماؤه اذا اطبخ بالما يفتت حصاه المتولد فى الكلى فاما

تهيج الاورام الملهبه فاما الاورام النلبلبه فان الصلبه فانها تحللها وتشفيها

د ب طليس وهى الجلبه الدقيق الذى يعمل منها اذا اخلط بالغرطاطن وطبخ وتضمد به
كان ملينا ودقيق الحلبه يصلح للاورام الحاره العارضه فى الجسم الطاهره منها
والباطنه واذا اخلط
دقيقها بخل ونطرون
وتضمد به حلل ورم
الطحال وقد جلس
النساء فى طبخ الحلبه
فينفعهن ذلك لوجع
الارحام العارضه من
ورم الرحم وانضمام
فيه واذا طبخت
الحلبه وعصرت
وغسل الراس بعصارها
نفعت الشعر وجلت
النخاله والفروج
الرطبه وقد يخلط بشحم او زيت ويحمل فيلين صلابه الرحم ويفتح انضمامها ۰ وقال فى
وصنعه طليثون وهو دهن الحلبه خذ من الحلبه تسعه ارطال ومن الزيت تسعه
ارطال ومن قضب الذريره رطلا ومن السعد رطلين وانقعها فى الزيت تسعه ايام
وحركه كل يوم ثلث مرات ثم اعصر واخزنه وله قوه ملينه للدبيله
منضجه ويوافق هذا الصلابه العارضه فى الرحم ويستعمل منه جنته لحم المراه
التى لم تسر ولادها اذا اجف خروج الرطوبه منه وينفع من ورم المقعده وحقن
به من النحير فينفع به وقد يحقنن به للمغص وجلوا حا له الراس وفروج الرطبه

بالمطبوخ أو بالشراب وتكمد به سكنّ ورام الثدي التي ينعقد فيها اللبن
ووافق نفع الأفعى والمعضّ ۞ وأمّا الموز وهو النشانج من الحنطة وهو لبن
الحنطة فأجوده ما عمل في الصيف من الحنطة التي ينال لها اسطا نبوس وعمله على
هذه الصفة ۞ توخذ الحنطة وتلقى في ماء عذب وتغلى به ورقاب المآء الذي
غسلت به ويصب عليها غيره ويفعل بها ذلك خمس مرات بالنهار وان امكن
فليفعل بها ذلك في الليل ايضا والآن فينبغي ان يصب مآؤها صبّا رفيقًا
ولا يحرك لئلا يخرج لبنها ويصب مع المآء فاذا فعل ذلك فندلس بالارجل ويصب
عليها ما وماطفى على المآء من نخالة نزع وما نشب بالمصفى ويستخرج ثم اميد
جودة في ثمن حانة وأنه ان بقى فيه شيء من النداوة حمض فأما النشا المتخذ من الحنطة
فهو يبرد ويجفف أكثر من الحنطة ۞ وقد يصلح النشانج لسلاس المواد الى
الأعين والفروج العارضة التي ينال لها للوطبين والسدد وج الى ينال لها
فلنطي واذا اشرب قطع نفث الدم من الصدر وخشونه الحلق وقد يخلط باللبن
وببعض الأطعمة وقد يعمل نشانج ايضًا كان ينفع بعد العمل بيومًا أو يومين
وممّن لا يأبى كما يفعل بالعجين في ثمن حانة وهذا الصنف من النشانج لا ينفع
في الطب ولكن ينتفع به في غير ذلك ۞ **عبرة** دقيق الحنطة يغنى الوجه
والبشرة والنشا علي الكلف وخاصة اذا خلط بزعفران ودقيق الحنطة كلّ ما
كان افطر كان خبزه اغذى واجوده خلطًا لكنه ابطأ انحدارًا وبالعدس والجبر المغسول
قليل الغذا وهو ابعد خبز عن توليد السدد واقلها انتفاخًا ۞ والنشا وهو اللبنا
بارد يابس يحفف الفروج التي في العين ويشف الغشا له اذا انتفخ بالخل
ووضعت على الجمر واستنشق دخانها نفع من الزكام ودهن الحنطة ينفع من الكوّ بـ
ويستخرج بأن يوضع عليها جديد مجماة وينبغي أن يدهن به الكوّ من ساعته وهو
جاف وان حكت قبل أن يدهن به شيء حتى يدمى كان اجود ۞ **حلبه**
الحلبة تسخن في الدرجة الثانيه وتجفف في الدرجة الاولى ولذلك صارت

البدن مني في الدرجة الأولى مزوج بانه لاشياء المنخنه فأما التجفيف والترطيب فليس مكن فيهما ولا واحد منهما أن يفعله فعلا ظاهرا وفيها مع هذا شيء لزج ينذوي يغري ⁃ واذا كان الخطه نيه ولدت الدود في البطن واذا ا مضغت وتضمد بها نفسها فهو يجذب وحلل من طريق ان في الحنطه وخميرا لان في الخمير قوة تجذب من عمق البدن وحلل ⁃ والخبز المتخذ من نميم الحنطه التي وصفنا اكثر غذا من الكشك ز واما الخبز المعمول من دقيق الحنطه التي يقال لها سطانيوس وانه احف وهو سريع النفوذ وقد يضمد بدقيق الحنطه مع عصاره البنج لبلان الفضول الى الاعصاب وللخ العارض لها واذا اخلط دقيق الحنطه التي يقال لها سطانيوس اذا نضمد به بالخل وبالشراب وافق منه الهواء رم واذا اطبخ بي بصير مثل الغراء لعق نفع من به سعال ونفث فيج وينفث دم من الصدر واذا اطبخ كا ز نافعا للسعال وخشونه الصدر وغبار الرجا الذي من دقيق الحنطه اذا طبخ بالشراب المنى بالبقراط او بماء وزيت حلل الاورام الحاره وخبز الحنطه ان طبخ بما بقراط او عصر من عبرا ن طبخ معه وخلط بعض الجثاش أو العصارات الموافقه وتضمد به سكن وجع الاوزام الجازه بلينه وتبريده التبز بااللبن والخبز اليابس العتيق يعقل البطن المبل ازكا ن وجيده اوخلط باشياء اخر والخبز اللبن اذا بل بماء وملح وتضمد به اما من الاوراب المزمنه وقوة الخمير لطيفه بين الجزاين ولذلك يجذب من عمق البدن بلا اذى ولا اتلذع وحلل وهو مركب من قوى متضاده مثل اشاكثير وذلك ا ن فيه حموضه بازذه وجزا ان يضام من قبل العفونه وقبه مع هذا جزاان طبيعيه من قبل الملح والدقيق ⁃ ورومى وهوالخمير الذى من دقيق الحنطه منجر جاذب بلطف خاصه الاوراض في اسفل القدم وقد ينضج شايرا لاورام واذا اخلط بالملح انضج الدمامل وفتح افواهها والنخاله اذا طبخت بخل تجفف وتضمد بها فلعت الجرب المتفرج وكا ن ضمادا نافعا من الاورام الجازه ان في ابتدايها واذا اطبخ

نفع من عضه الكلب
واما الضما ⁃ المتخذ من خبز الحط

بفعل ذلك وإن لم يطبخ بل يشرب كما هو مسحوقاً فإنه إذا شرب من ثمرته وزن مثقل وتر اسهل بلغماً مائياً ونفع من الأدوية القتالة ۝ **ماسرجويه** البلز هرج ثلثة اصناف احدهما هندى والثاني عربى وهو الذي يسمى الحضض والثالث يعمل من الأزرشك شبه للحضض الهندي هو أن يؤخذ خشب الأزرشك فيطبخ طبخاً جيداً حتى لا يبقى فيه شئ من القوة ثم يصفى ويطبخ الماجنى يجمد ۝ **يدعورش** خاصة الحضض النفع من الام وورم الزخوه الخوارات والنفاخات في الجسد وقطع الدم ۝ **ابن ماسه** صالح للسع الهوام ولأورام الحاشية الانديه في أصول الأظناب ۝ **الرازي** بنفع من الخوانيو إذا تضرع به ۝ **الطبري** البلز هرج يغزر الشعر إذا طلى عليه وينشف بلة العين إذا اكتحل به ۝ **سندماعر** البلز هرج بنفع من أوجاع العين والورم والجذام والبواسير والفروج ۝ **ماسرجويه** أقواها الهندي وخاصته في تقويه أصول الشعر وانفعها للأورام الحضض الذي يصنع من الأزرشك قوته قوه دم الأخوين الا انه دونه ۝

حنطة

د ب أجود ما يُستعمل منها في وقت الصحة الحديث الذي قد استكمل امتلاءه ولونه بلغ الصغرة وبعد هذا الصنف من الحنطة فيها بيز وقت ما يُزرع وتنبت ما بعد ثلثة اشهر وهي التي يسميها بعض الناس سنطانيوس ح ج الحنطة إذا وضعت من خارج

وقد وهو للحنطة

المحتنبه ن أصول لأظفار وذلك كان قوته قوه تجفف وهو مركب من
قوى اجناس متباينه فواحد منها لطيفه محلله حاده والاخرى ارضيه بارده ومن
قبل هذه القوه صار للحضض قبض الا ان هــ فقبله ن هذا الدواجلا فانما
الحلل والتجفيف وليس ها فضلا من به اه منها ن الدرجه الثانيه وانما
الحرارن هو منها نحو المزاج الوسط المعتدل ولذلك صار الناس يستعملون هذا
الدوا ن بمدا والاداوحر لنه فمره يستعملونه على حده انه دوا جلا شافيا
فيكون به العبر ن ما يكون ن وجه استدفه ممما يظلم البصر ومن يستعمله
على انه يجمع اجزا العضو وبشـ ه يثقون به اصحاب الاستطلاق ومن ه فوجه ن
امعائه والناس اللواتي ن يرف فهذا النوع منه يبعض يكون ن بلادنا وقتا
وبلاد نبادا وقتا كثيرا حالا وامما النوع احدمنه فهو الهندي وهو اقوى
وابلغ ن هذه الاشياء كلها من هذا ومن وة الحضض فابضه علوا ظلمه البصر وبرى
جرب العين وحكنها وبقطع عنها سيلان الرطوبه السايله سيلانا مزمنا ويوافق
الادن التى تسيل منها ماده واذا جنك به وافو وزما جلو وادا لج به وافو
الشبال المشرجه والفروج المتعفنه وشفاو المعده والسعوج واذا شرب
او احتقن ه نفع من الاسهال المزمن وفرجه الامعاء وقد سقي ما ينفث الدم والنعال
وقد ينفغ لعضه الكلب لكلب بان يمسه جب ولا يشما سه جب ولكن
يشى كما هو وقدحم الشعر و قد بشغي من الداحر والنمله والفروج الحبيثه
واذا احتقن به او اجعل قطع سيلان الرطوبات السايله من اللحم سيلانا مزمنا
وقد يقال ان الحضض الهندي يكون من الشجره التي يقال لها العطس و هذه
الشجره هي صنف من الشوك له اغصان قايمه طولها ثلثه اذرع او جمدها كثير
ومحرجها من الاصل و هي اغلظ من اصل العلتين منفلعه القشر لو نها احمر مثل لون
الدمو ولها ورق مثل ورق الزيتون وقد يقال انه اذا طبخ مع اغصانه كل نفع من
الاورام العارضه للطحال ومن به اليرقان و بث الطمث وقد يقال انه

وى اماكن اخر كثيره و نبت فى الاماكن الوعره و قد يخرج عصارة الحضض
اذا دق كما هو مع الشجره او انقع اياما كثيره و طبخ و اخرج من الطبخ و اعيد
ثانية الى الطبخ على

لوقيون و هو الحضض

النار حتى يخثر
و يصير مثل العسل
و قد يغش بعكر
الزيت خلط
فى طبخه او بعصار
الافسنتين او مرار
البقر و ينبغى ان
يجمع ما كان منه طافيا
و كان شبيها بالزعفر
و يحمر ليستعمله فى
ادويه العين
و اما الثانى

فاستعمله فى غير ذلك و قد يكون ايضا من ثمر الحضض عصاره بان
يثمر و يعصر و الجيد من الحضض هو الشهى اذا اطفى ارعى عند ذلك
رغوه لها لون شبيه بلون الدم و كان طعمه اسود و داخله بياض مثل
كبر زهرها و كان فى طعمه قبض مع مرارة و كان لونه مثل لون الزعفران و الذى يجده
فى الحضض الهندى فانه على هذه الصفة و هو اجود مما اشبهه و اقوى فى فعله

ا ص ۶ هذه شجره شوكيه منها يتخذ الحضض و هو عند الاخراج دوا رطب يستعمل
فى مداواه الكلف و مداواه الاورام و القروح الحادثه فى الفم و فى الدبر
و فى النمله و فى العفن و القروح و الاذن الى يجرى منها القيح و الرطوبه

وذلك لأن فيها قوة مجلله اكتسبتها من جوهر ماء جار معتدال وفيها
أيضاً قوة قابضة اكتسبتها من جوهرها بارد ارضى ولذلك قد نطبخ بالماء ويصب
ذلك الماء الذى نطبخ فيه على المواضع التى تحترق بالنار ونستعمل أيضاً فى
مداواة الاورام الملتهبة ومداواة الجمرة بلا لذع وهى نافعه أيضاً من
الخروج التى تكون فى الفم من غير سبب من خارج وخاصه الخروج
التى تكون من جنس القلاع وينفع أيضاً من القلاع الحادث نفسه فى أفواه الصبيان
ⓐ وقوه ورقها قابضه ولذلك اذا مضغ ابرا القلاع والخروج التى
تكون فى الفم التى تسمى الجمر واذا ضمد به نفع من الاورام الحاره وقد يصب
طبيخه على حرق النار واذا دق وانبت فيه ماء اسطروبس ولطخ على الشعر حمره
وزهرها اذا بخر وضمد به الجبهة مع خل نكن الصداع والمتوج الذى يعمل
منه منج مس لاعصاب الاشياء المسخنه التى تنفع اخلاطه وهو طيب
الرايحة ⁘ بولس خلط مع الادويه التى تنفض الطحال المشفى بفعل فى
الجراحات ما يفعله دم الاخوين البصرى فناح لحا اذا اخلط مع الشمع
المصفى ودهن الورد ينفع من اوجاع الجنب والوهن الكاين فيه وهو نافع
للسلاق العارض فى أفواه الصبيان الطبرى واذا دق ووضع على
الورم الحار الذى نفع منه ⁘ مجهول اذا اطلى بالحناء على موضع من البدن
فيه قشف ويبس اناالمها واذا شرب منه مثقال مع ماء العسل
أو لعق منجونا معجونا بالعسل نفع الدماغ منفعة بليغة وازال عنه
الاعراض الرديه من الحزازه والرطوبه ⁘ **حضض** ⓐ وهى لوقيون
شجره مشوكه لها اعصان طولها ثلثة اذرع واكثر عليها الورق وهو
شبيه بورق شجره التقس ملزز ولها ثمر شبيه بالفلفل اسود ملزز مر
المذاق املس وفشر الشجره اصفر شبيه بحضض الماء ولها اصول
كثيره ذاهبه فى جانب خشبه ويكون بالبلاد التى يقال لها لوقيا

اعنتس وأدهن من قوة الزهر واما بزرها فهو ألطف من صمغها الا انه ليس بكثير الحرارة

د ا إذا ضمد بورقه مع الخل نفع من الضربان العارض من النقرس وصمغه قد ينفع في اخلاط المراهم وقد يقال ان ثمره اذا اشرب منه صرع وقد يقال ايضا الذي ينبت من صمغه في النهر الذي يسمى ايبروا ابر حمدي النهر ويكون هو الذي يسمى المقطرن من الناس من يسميه جرموسوفورا وهو الكهربا لي

قد بينت مثل قول د ان الكهربا عندي صمغ الجوز الرومي وسنذكر الكهربا في حرف كاف

حنا ابو حنيفه شجر كبار مثل شجر السدر وله رائحة طيبة وهي نوّ ون ونوّ ون عناقيد مثل اصافه اذا انفتحت اطرافها اشبهتها بما ينفتح من الكزبرة الا انها اطيب رائحة واذا اجا نوٌ ون يقبت لها وجه اصفر اصغر من الفلفله وتوجد في العامر من بر وهو بأرض العرب كثير

د ا فيقبض ويرفع مع الحنا هي شجره وورقها على اغصانها وهو شبيه بورق الزيتون غير انه اوسع ولين واشد خضرة

ولها ازهار بيض شبيهة بالاشنة طيبة الرائحة وبزر اسود شبيه ببزر الباذنج الذي يقال لها مازريوش ح الذي يستعمل من هذه الشجرة انما هو ورقها وقضبانها خاصة وقوة هذا الورق وهذه القضبان قوة مركبة وذلك ان فيها قوة

حنا

مثقال نفع من عرق النسا وتقطير البول وبنال ايضا انه يقطع الحبال اذا اشرب
مع كل بغل وبنال ايضا ان ذقه بنعله ذلك اذا اشربته المرأة بعد طهورها وعصر
الورق اذا قطر في الاذن و نفاوا ترفع من المها و ثمر الجوز اذا اخذ منه جبن
رطب ودق ذقه وخلط بعسل والخل به ابرا عشاو العين وقد زعم قوم ان
الحوز الرومي وغيره من الجوز اذا قطع صغارا وغرس في مغارات مزبلة بين
السنه كلها فطر انه يوكل **جوز رومي** ابن جلجل هو المعروف عندنا

بالورق وشجره ادواح
وفيه مشابهه من
الحور وله قشر
اصفر بطنه في الفنا
وله ثمر يعرف بالزرد
وله سمعه ذهبيه
و قشر اذا وضع مع
عيدانه بعضها على بعض
واضرم فيها النار وخرج
قد نال منها زيت
لدن طيب لرايحه
دهن البلسان حق
وزد هذه الشجرة قوته

قوته حاره وهي في الدرجه الثالثه الله اعلم وامانى النحفيف والنرطب
فبعد زهرة هذه الشجره عزف برجحان المعتدل المزاج المنوسطه بغير سر
وهي الا اليبس اسائيلا وهي زهره من اللطافه ارى منها من العلظه وانا ورق
السجره فهو ينعلك كل شي ينعله مثلما ورق الآس الا ان الورق انفع

ملأن من بزر وهوشبيه بعناقيد صغار طيب الرائحة ليست فيه رائحة الكرج
حريف للذع اللسان لونه واحد لا يختلف وقد يغش كما بالدواء
الذي يقال له اموميس لأنه شبيه بكما غيرانه ليست له رائحة ولا يشبه
ويكون بأرمينيته وزهره شبيه بزهرة النوبج الجلي واذا اردت ان تخزن
هذا واشباهه فاجتنب القنات واختر منه ما كانت اعضأنه تامه لابد من
اصل واحد ح قوة هذه شبيهة بقوة الوج الا ان الوج اكثر تحفيفا وكما
اكثر انضاجا وقوته متخنة فايضه مبيسه ويجلب النوم ويسكن الصداع
اذا ضمدت به الجبهة وينضج الاورام الحارة ويفع من لسعة العقرب اذا ضمد به
مع الباذ ذروج والمكاز المسوع وينفع من اورام العين الكائن ومن اورام الاحشا
اذا ضمد به مع الربب وهو نافع من اوجاع الرحم اذا اعمل منه فرزجا
واذا جلست ماءه النساء واذا اشرب من طبخه كان موافقا لمن كبد عليه
ولمن كانت كلاه ايضا كذلك وللمقر شين وقد يبعث اخلاط بعض الأدوية
وينح اخلاط الطيب الشريفة ح نخرج فضولا بقسراط اكما ما جاءت لطيف
بصدع وكذلك كثراله اذا وبه نصدع لانها جارة لطيفه ▪ يربعون
خاصة النفع لطرد الرياح وتنقية المعدة وتقوية الكبد ▪ حنين ينكر
ويسوم ▪ محبوب طبخه يشرب للمقعدين وجلس فيه ايضا لذلك ح حور
ومو
الجوز

ح مزاج هذا
مركب من جوهر مائي
فاتر ومن جوهر ارضي
قد لطف ولذلك
صارت قوته منضجة لوبا
آ قشر هذه الشجرة
اذا اشرب منه وزن

روفاداز هو المعدة الياتيه‍ ۰ روفرا هي الحرا وتسمى بالفارسيه سنه
دباروديه وقد تقدم القول عليها ۰ روفورون نبات يسمى باليونانيه
ابصاطوقروس ۰ روفرفلن هو حنى العالم الكبر باليونانيه ومعنى هذا
الاسم عيون الحيوان ۰ اىهى حرف ال‍زاى والله اعلم بالصواب

حرف الحاء

حاما اً هى شجر كان اعنقود من حشب مشبك بعضه ببعض وله زهر
صغير مثل الدوا الذى ينال له لونان وله وزق يشبه وزق انبا البربر
القشرا وكذلك سنبر وجوده
ماكان من ازمينيه بلون
الذهب وله حشب الى
لون الياقوت ماهو طيب
الراىحه حدا واما الذى
من آماه فلا له ينبت فى حجار
واما كان رطبه فهو اضعف
وهو عظيم ولونه الى الحضر
ما هو لىن يحت المحنه وحشبه
كالسطا باىج والحنه شى
شبيه براىحه السذاب
واما الذى من البلاد التى
ينبا لها بيطش فان لونه الى الياقون ماهو لىن بطويل ولا عرض الارض حلقه
حلقه العقود وهو مالان من تمره وتحنه ساطعه فاحر منه ما كان حدىا
ابضر وماكان لونه الى لون الادرما هو غير منضاعط ولا سنبل متحلل ىتفرق

هو الكبح : زعبا هو الصمغ العربي وهو صمغ الشوكة القبطية من الجاوي
رغناده هو ربد الجزء السرياني انه من الجاوي ٠ زعبج قال
ابو حنيفه هو ثمر العنم وهو مثل النبق الصغار يكون اخضر ثم يبيض ثم يسود
فيحلو من مرار وله عجمه مثل عجم النبق وهو يوكل ويطبخ ايضا وهو رطب بالماء
ويصفى ماؤه ويطبخ حتى ينعقد فيكون ريا يؤتدم به ويشرب بالماء ويتداوى به
زعبر هو المر وقيل الزعبر هو المر والدقسوس الورق ٠ زعفران
الحديد هو صدا الحديد ٠ زعم باديما هو ربد الجزء بالسريانيه
من الجاوي ٠ زقيتلم هو الخطا ٠ زقزوق هو العناب ٠ زروف
هو صمغ السرو وقال له نقروف ٠ زلم هو نبات كالقصب الرقيق والدبس
لا بزر له ولا زهر وله عروق تحت الارض فيها جب مفرطح طعمه
حلاوه يوكل ويتخذ حب لازم وهو المعروف عندنا بفلفل السودان زرع عندنا
زعما واكثر بانه بلاد السودان وهو بري عندهم لا يزرع وهو عندهم صنفان
ابيض واسود ٠ زمارة الراعي هو مزمار الراعي سيذكر في حرف ميم
زمخ هو قضب الشاب ٠ زلم الحم ٠ هو جوز جندم ٠ زهره
الجاوي انه النبات المسمى بالوانس انه نجارش وقد تقدم ذكره فيما مضى من
هذا الباب وقال الطبري ان ازهر هو النبات المسمى بالوانس انه النسر وقد
ذكرنا هذا في جزب ا وزعم اخرون ان ازهر هو الوج ٠ زوان
قال ابو حنيفه الزوان هو الشيلم وهو حبه يكون في الحنطه ينتقى منه
وينكر ويسمى الزنقه وقال ابن سينا الزوان يوقعه الناس على شيين
احدهما جب شبيه بالحنطه يوكل يتخذ منه خبز والاخرى يسكر ردي وهو من
الجنب زدى وهو الجمير زوي وهو الفوه من ح ٠ زوفا هو اسم سرياني
ينفع على دواب احدهما الزوفا اليابس وهو نبات شبه الصعتر وقد تقدم ذكره
والاخر يقال له الزوفا الرطب وهو وسخ الصوف وقد مضى ذكره في حرف

طوال الورق الزيتون طلع من الأرض بلا ساق وله أصل كبير أسود ميرعرضا كثيرا
فيه عروق طيبة الرائحة وملاؤه جزاءه معتدل مع عفوصة ومرارة
كثيرة ويجفف أصله ويستعمل في الطيب والبخورات ٭ **زبد البوزق**
قد ذكر مع البوزق ٭ **زبد القمر** هو صاف الثمر وقد مضى ذكره ٭
زبرج قيل أنه الزرنيخ الأحمر ٭ **زبدى** قيل هو الجاسوس وقد
وقد تقدم ذكره ٭ **زبر** هو البلبوس ٭ **نزل الفي** هو بصل الفي
وهو صنف من البلبوس بهج الفي ٭ **زبر بالفارسية** هو الكمون
زبرماج معناه بالفارسية لون الكمون ٭ **زردنت** هو الكمون
البرى بالفارسية ٭ **زعبارى** هو الزنجبيل البوبانية ٭
زعر هو المرو ٭ قال زعير ٭ **زوسفون** هو اللب ٭
زحمول هو الكشوث ٭ **زدوار** هو الجدوار ٭ **رزاسح**
هو اللبلاب ٭ **زرنباذ** هو دوا هندى معروف وقد تقدم ذكره
وحديث فى كثير من التفاسير زرنباذ هو رنجل الغراب بالفارسية
زنبدون قيل هو الزرنباذ ٭ **زربلج** هو البأس من الجاوى
زربودى هى البقلة اليمانية وهى البرود على ما ذكر كثير من
المفسرين وقيل ان الزربودى هو رنجل الغراب ٭ **زربانج الجاوى**
قيل أنه الكشخ وقيل أنه البقلة اللينة وهو اسم سهرائى ٭ **زرجون**
هو الكرم وقيل عوده وقيل هو الماء المستنقع فى الصهريج وشبه الخمر لصفائه
وقيل الزرجون كلام فارسى ونفسيره لون الذهب نبال للخمرتم شبهه
الكرم ٭ **زردك** قيل هو نجيز العصفر وقيل هو ماؤه وهو الصحيح ٭
زرازيح هو عنب الثعلب ٭ **رطن** هو الصندل من الجاوى ٭
زرقون هو الأسرب ٭ **زرشك** هو البريس بالفارسية وهو
العدبيه الاترار ومن الناس من زعم ان الزرشك هو بزر الحماض ٭ **زروتدى**

يتخذ من عصبة الزماج وقيل انه المزان ٠ زاوق هو الزيبق
زباد حرادف هو زرعفان الجادى ٠ زيت السودان
قيل هو زيت الهوجان وهو الذي يسميه البربر ارجان وازنان لها شجر عظيمه
لها ثمر يسميه بعض الناس لوز البربر وهي نحو من شجر العاص ثمرها كالزيتون
فيه نوى وثمره كله المعزى وتلقي نواه وتسا النواه يخرج منه هذا الزيت
وهو حلو يوكل كزيت الزيتون وقيل ان زيت السودان اذا ٮسحر جدا
ينفع من الاوجاع والعلل الباردة ٠ زيت ركابي هو زيت الانفاق
وهو الزيت المتخذ من الزيتون لنج ٮسته اهل العراق لكاٮه بوتى به
من الشام على الركاب والابل وتسميه اهل مصر الزيت لفلسطني وزعم الزهراوى
ان الزيت الركابي هو الزيت ابيض المعتول وقال سمى زكابيا لانه ٮسلة
الركاب قال العزي لا دويه به لانه ساذج نني والمعروف ما ذكرناه ٠
زبيب نذكره باب اللام جٮث ذكر الكرم ٠ زبيب الجبل
هو جبل الراس زبيب برى هو جبل الراس ايضا وذكر في حرف ح
رسطوٮل هو الوزن الازمي ٠ زنبق هو دهن ال المربي بالياسمين
زنبورا وقال أبو حنيفه هى شجر عظيمه في طول الدلبه ولكن لا
عرضها ورقها مثل ورق الجوز نى منطرى ورجها وله نون مثل نون العٮس
الابيض مشرف ولهاجمل مثل الزيتون سو افاد انضج اسود سوادا شديدا وحلا
جدا ما كله الناس كالرطب وله عجمه كعجمه الغبيرا وهى ٮضع الفم كما ٮصبغه
الفرصاد وهى ٮغرس ٮرٮ عرسا ٠ زنبورا هى الحاشا السربانيه ٠ زيتون
الارض هو المازريون ٠ زيتون الحبش و زيتون الكلبه
هو الزيتون البرى وقيل انه العتم ٠ زنجبيل الكلب هى مثله قد
تقدم ذكرها وتسميها بعض الناس بالجمه فيانه وقد سمى ايضا الراسن
زنجبيل الكلب وزنجبلا شاميا وزنجبلا بلديا قيل انه نبات له ورق
يسمى

والصق على البطن نفع القولنج العارض من البلغم اللزج والرياح وأسهل
الماء الأصفر وخرء الولد ينبت الشعر في داء الثعلب وزبل الحمام اذا طبخ بالماء
وطين فنه نفع من عسر البول وجدا واذا طلي بالخل على بدن صاحب الاستسقا
نفعه وكذلك اذا استقي بالسخنين واذا طلي مع بزر الكتان مدقوقا معجونا
بالخل على الخنازير حللها وزبل الحمام الاحمر اذا شرب منه وزن درهمين مع
ثلثه درأهم دارصيني نفع من الحماء وزبل الحمام كله اذا اجزي حرقه
كتانا حتى يصير رمادا و خلط بزيت وطلي به على حرق النار أنا فعا وزبل
الابل اذا احتقن به صاحب حمى العفنة نفعه واخثا البقر حرق العلل الرطبة
كالسل ونحوه ۞ رنـد ۞ حطلس هو حيوان صغير اذا شوي وأكل
نفع من أوجاع المثانه ۞ حـمـ ۞ قد يستعمله قوم بعد أن يجففوا وبأوذن بيه من
وجع القولنج ويسقون منه عددا مع عدد مثله من الفلفل فيجعلون الشربة ثلث
حبات من هذه وخمسا أو سبعا مع فلفل عدده مثل عددها ويسقون ذلك
في وقت سكون الوجع وفراته وفي وقت صعوبته وهيجانه وقوم اخرون
يأخذون هذا الحيوان يشوونه ويطعمونه لمن به علة في مثانته فينفع بذلك
والله اعلم بالصواب

وهذا اشرح ما وقع في هذا
الباب من الأسماء

زا ا هو العلس ويسمى بالجمينه الاسفانية وهو حبة معروفة شبه الحنطه
يتخذ منها خبز ومن زعم انه السلت فقد أخطا ۞ راره هو الرز واند
من بعض التراجم ۞ رادرخت اصله بالفانيتيه أنا درنخت
وتأويله حد النجر وقد مضى ذكرة في حرف الالف وقيل انه اللبخ
زاليا هو الغار الاسكندراني من كتاب ۞ د ۞ زان هو يحـبـز

في علاج ركبه فيها ورم من باء ان امرت ان يتخذ منه ضماد امعجوناً خل
ممزوج ماء مع دقيق شعير فانفع بذلك منفعة عظيمة ٠ الطبري ويقع
مضوقاً بالشراب على لدغ الهوام وعض الكلب ينفع واذا انحى بالعسل وطلى
به البدن نفع من وجع المفاصل ومن البحر ان يطبخ بتراب صلبي حتى يصير
مثل العسل ويضع على الدبيله ايا ما جللها وقال رزل الحمام اذا اخلط بدقيق
شعير وضرب بالماء حتى يصير كالحناء وطبخ بالخل والعسل وضمدت به الدبيله
والخنازير والاورام الصلبه حلل وابرى واذا اخلط بدقيق الشعير المضروب
بالماء مع شئ من القطران ويحب حتى يصير كالمرهم ووضع على البرص في حرفة
كان وترك ثلثة ايام ثم نزع وجدد عبر نفع منه ويفعل بود الكحتى يبرى
بَوْلش زبل الدجاج قد كان بعض الناس ينبيه اصحاب النولنج ٠ بَوْلش
زبل الفلق قد ذكر بعض الناس انه اذا اشرب نفع من نفس الانفاس ب
البصرى خرو العصافير جلو وينقى ويذهب بكلف الوجه واثاره ٠ الطبرى
واذا ادنف بلعاب الانسان وطليت به الثالول قلعها ٠ البصرى زبل الفار
اذا شرب مع شراب العسل اخرج اخصاه ٠ بَوْلش زبل الوزل البرى قوة
جلاه جلو الكلف والوضح والقوبا ٠ البصرى خرو الفيل اذا عملت منه
فرزجه مع العسل واحتملته المراه لم يحل ٠ مجهول زبل الانسان اذا شرب
يابساً مع خمر او عسل نفع من جميع اذى الجمات ونهش الهوام والادويه
القتاله المتلفه وينفع من السرفان ويقطع الاسهال واذا انحى وذر على
المواضع العفنه ابراها ٠ روث احار الاهلى اذا اكتبر به الطم الذى
يكون من قطع شريان اوعرق حبسه وكذلك ان رش عليه خل واشتم قطع
الرعاف وكذلك ان عصر وقطر ماؤه في انف المرعوف وان اعصر
وهوطرى وشرب ماؤه فتت الحصاه وزبل الخيل يفعل ما يفعله زبل الحمير
وروث البرذون يخرج المتيمه ولحين الميت وبعر الغنم اذا طبخ ببول صبى

بخل او شراب وزبل الطاير المثنى والرعوش والفلوس وهو النقلوس قد يقال انه اذا اشرب
وانق من به صرع وزبل الحمر قد يقال انه اذا انخذ به طرح للجبن وخرو
الفار اذا لطخ باخل على داء الثعلب ابراه واذا اشرب بالسكنجبن والشراب
المثنى او نومالى فتت الحماه وبولها واذا اعلمت منه شيافه وجعلتها الصبيان
اسهلت بطونهم وخر والكلب اذا اخذت الصيف بعد غروب نجم الكلب وجفف
وشرب بشراب او بما عقل البطن والعدن جزاءها واذا انضمد بها منعت الحمره
من الجراحات والرضها وقد يقال انها اذا جففت وخلطت العسل وجنك
بها نفعت من الخناق وخر والجرذون يصلح للعمر ولنجير اللون وصفاء الوجه
والبشره لجودة ما يكون من خر والجرذون الشديد البياض الطين الانفراك
الذي يكون خفيفا مثل الناشج واذا اخلط برطبه اسماع سريعا واذا ادرك
فاجبت منه رائحه الى الحموضه ما هي فيها شي شبه برايحه الخمر وقد يغشه قوم
بخرو ومزادر ويكون خروها شبيها بخرو الجرذون ومن الناس من يأخذ الناشج
ويخلطه بالطين المثنى منبوبا ولونه بالخبثه التي يقال لها احشا وهو خرا الحمار
ثم يصفيه بمنخل واسع على خلج ويكون شكل الصنعه مثل الدود ويباع بجناب
خرو الجرذان في رسالة الثربا واذا اجرت احشا البقر بعد ان جفف وسقى
منها المستنقى نفعه نفعا بينا **الطبرى** وان الحرق ووضع منه في المنخرين
مع الخل قطع الرعاف وهو نافع من جميع السموم اذا اشرب او وضع على موضع اللسع
واذا دخن به طرد جميع الهوام واذا طبخ بالزبب ووضع جايا على البدن
وترك حتى يجف ثم رفع ووضع غيره وفعل ذلك مرارا اخرج الفضول
والقصب واذا اخرت به المراه سهل الولاده واخرج الجنين الميت وفعل الحي
ويوخذ ويوضع في قدر بخاير ويصب عليه ما يكفى من الزيت ويطبخ حتى يحتشى
وبضمد به اسفل الشره الى العانه والخاصرتن فينفع من القولنج والرياح الغليظه
نفعا بينا اذا فعل ذلك ابا ما **ابن سرافيون** انه قد استعملت بعد المعسر

بعض الاشربه ادر الطمث واخرج الجنين واذا دق الیابس منه دقا ناعما
وخلط بكندر واحتمله المرأه بصوفه قطع سیلان الدم المزمن واذا
خلط بخل قطع سیلان الدم من اى موضع كان من البدن واذا الحرق وخلط
او سكنجبين وطوخ علا اذا الثعلب ابرامنه واذا نضمد به مع شحم خنزیر عتیق نفع
من النقرس وقد بطبخ بالخل والشراب ویوضع علا نهش الهوام وعلا الموضع
الذى یقال له النمله والجمره المنتشره وعلا الاورام التی تعرض فا اصل الاذان
واذا لوی به نفع من عرق النسا والكیه علا هذه الجمه خصوصا و شرب به
بالزبیب و صعه على الموضع الذى فیما بین الابهام من البدن وبین الزند وهو ابل
الزند اقرب ثم خذ بعره فالهبها بالنار جی نصیر جمره ضعها على الصوف ولا
تزال تفعل ذلك الی ان نصل الحر ویتوسط العضد الی الورك وتكن اكها لم
وهذا الضرب من الكى يسمى الكى البعزى و بعر الضان اذا نضمد به مع الخل نفع
من الخنثى و ابر امن الشعر والثآلیل التى ینال لها اوحودس واللحم الزایل انی ینال
له الثوث واذا خلط بموم مذاب بدهن ورد ابرا من جرف الناز ورمل
الخنزیر البرى اذا كان حارا و شرب بما او بشراب قطع نزف الدم الذى من
الصدر و تسكن الوجع المزمن العارض للجنب واذا اشتعل بالخل نفع من وجع العضل
واذا خلط بموم مذاب بدهن ورد نفع من النواء العصب و سرجین الحمیر
و سرجین الخل اذا المجففا او المبحر فا وخلط خل قطعا قطع سیلان الدم و سرجین
الحمار الذی یرعى العشب اذا كان یابسا و خلط بشراب وصفى نفع من لسعه العقرب
منفعه عظیمه وزبل الحمام اتخن واشد احتر اقا من غیره من الزبل و قد یخلط
با وما لوسین و ینفع به فاذا خلط بخل جلل للناز بر واذا احلط بالعسل وبزرالكان
نحرا و نرم الصلب و قلع حشكر بشه الفروج التى تنمی الناز الناريه واذا اخلط
بالزبیب ابرا جنر الناز و زبل الدجاج یفعل لك غیر انه اضعف فعلا و یوافق
خاصه من اكل الفطر النابل و الادویه القانله ومن كان به قولنج اذا شرب

بذلك من الموت وبول الدجاج أقل جزءاً من بول الحمام وقد كان ذلك
الطبيب يسقي زبل الرجاج لأصحاب وجع القولنج الذين قد طال بهم الوجع وكان
يسقيه لهم بالشراب فان عدم الشراب سقاهم اياه بحل ممزوج وقد ينبغي ان نتم
على ان هذه الأجزاء الطبيه الحيوانيه والبائيه بينها اختلافات كثيره لخلاف في
الحيوان اذا كان منها الجبلي والبري والبحري والنهري والوحشي والاهلي والمروض
والمودع والتميز والمضمر فان الحيوان اذا أضمر بان اضعى صار ابين من الحيوان
الذي يغذيه الغذيه البارده الرطبه فلذلك زبل الحمام الراعيه في البيوت
اضعف من زبل الراعيه منها البراري وجدنا ايضاً وبول الدجاج التي
تعلف في البيوت وهي محبوسه بالمخاله اضعف من بول الدجاج المسيبه التي
تلقط لنفسها وبول هذه في قوته جيداً واما بول البط فليس استعملها لنصل حده
وكذلك ذرق البزاه والعقبان وقد زعم قوم انها تجلل الخنازير وزعم اخران
زبل العقعق ينفع من الربو وهو مطلن نوله وزبل الفاره زعم بعضهم انه ينفع من
داء الثعلب وكل رطب بهسامنه شيافات يحمل من اسفل لأنها لاطبيه وأما
بول الجمل اذر والعطاء يا فأن البناء قد اكثرت منها وخبرتها لانها تفضل الوجه
وتبسط جلده مع ذلك اذا اسعط ادويه كثيره وقوه هذه الابوال بأبنه جلاه
وكذلك زبل الدراريز اذا اعتلفت الأرزوجده فأنها يحلوا الكلف جلاه

باب اخثا البقر الأناث التي ترعى المرعى اذا وضع جبنروته على الأورام الحارة
العارضه عن الجراحات سكنها وقد تلف يوزق ويحبر بمااذا جار ثم يطبخ
الورق ويوضع الاحتناء على الأورام وقد ينتفع به انتفاعاً من عرق النسا
اذا وضع على هذه المواضع ومن وجع الركبه اذا اطلي مسحوقاً واذا انضمد به
مع اكل تجلل الخنازبر ومدد الأورام الصلبه والأورام التي يقال لها فوحلا
وخثا الثورخاصه اذا نجريه اصلح حال الرحم الباني واذا اختبر يطرد الألبي
وبعر المعز اذا شرب ولا سيما الجبليه منها بشراب نفع البر فأ واذا شرب

على بدنه كله فينتفعون بذلك منفعة عظيمة وكان هذا الطبيب يستعمل اختاء
البقر في الاعضاء الوارمة ولاسيما اعضاء ابدان الاكرة وكان يجمع اختاء
البقر في فصل الربيع وهي رطبة وكان ان اختار لذلك في فصل الربيع لان البقر
في ذلك الوقت ترعى العشب الرطب وبوه اختاء البقر اذا رعت العشب تكون
لينة جدا واما اختاء البقر اذا اعتلفت الحشيش اليابس فقوتها قوة يابسة
والاختاء الكائنة في فصل الربيع هي وسط بين الاختاء الكائنة من اعلاف التبن والكائنة
واختاء البقر التي تعلف الكرسنة نافعة لاصحاب الاستسقاء ولاينبغي ان تذهب
عنك ان هذه الاشياء كلها انما ينبغي ان تستعمل في ابدان الاكرة والحفارين
والحصادين وغيرهم ممن يكثر عمله وتنتشر بدنه وقد كان رد ذلك الطبيب
يستعمل اختاء البقر في الاورام الصلبة كلها وكان زعم ذلك بجمعها بالخل ويضمد
بها الاورام واما زبل الضان فقد كان رد لك الطبيب يعالج به الثاليل النملية
وهو الذي يحدث فيها بدبيب كدبيب النمل والثاليل واللحم الزايد النابت الى جانب
الاظفار وكان في وقت لاستعمال لها بجمعها بالخل ثم يطلى بها وكثيرا ما كان
يستعملها في التزويج الجادثة من حجر والنار لانها تحتم التزويج واما زبل
الحمام الطيار التي ياوي البروج والبيوت نجاس وزبل الحبلية منها والبرية
اشر وانا استعمل زبل الحمام في امراض كثيرة وربما خلطت معها بزر الجرجير
مدقوقا منخولا ومع الخردل واستعملها في الامراض الباردة التي تحتاج الى تسخين
ولاسيما الامراض المزمنة مثل النقرس والنقيقة والصداع والدوار
واوجاع الجنبين والكفين والظهر فقد نفع في الظهر اوجاع مزمنة
ويستعمل ايضا في اوجاع البطن والكليتين واوجاع المفاصل وهذه زبل بعيدة
من التبن ولاسيما اذا جفت ولذلك يكثر استعمالها في الامصار واما بول
الدجاج فقد استعمله في الخناق العارض من اكل الفطر فسقي بعد ان يخففها
ويعجنها بالخل او ماء منفعة قوية بالغة بان قيا اخلاطا بلغمية كثيرة واقلت

فكنت أعجب من منفعته إذا عولج به المرضى وكأنّا علقه على المريض نفعه منفعة
عظيمة بيّنة وكأنّ إذا أسقيناه لمن يكون منذرًا خلط معه شيئًا من الملح والفلفل
وما أشبه ذلك من الأبزور وجدناه نجع فيها أو سقيه بشراب أبيض لطيف وربما شفاه
بما وجده وربما علّق الرجل على خدّ صاحب الوجع مشدودًا بخرقة من صوف كبش
قد افترسه الذئب وذلك المعنى المنفعة إذا وجد وقوي فإن عزم هذا
الصوف ولم يقدر عليه يأخذ سيورًا من جلد أيّل ويشدّها الزبل ويعلّقها على خدّ
الرجل أما نحن فكنّا نجعل من ذلك الزبل أنبوبًا صغيرًا في مقدار أن
الباقلاء نتّخذه من فضّة بعروة ونعلّقه على الوجع ولما جرّبت ذلك في أحد
من المرضى استعملته مرّة بعد منهم فنفعهم واتّبعنا الماجرّ فقوينا أنّ محلّله
نافعة من الأورام الجاسية وغيرها من الأورام الصلبة وأورام الركبة المقاعده
إذا خلطوا بها دينيوشع وعجنوها بالخلّ والماء ووضع عليها وإنّما ينبغي أن يستعمل
في علاج الأكره والعلوج ولا يعالج به من كان رطب البدن رخصه وقد يستعمل
هذا الزبل في علاج أصحاب وجع الطحال وجساه وفي الجبر إذا أخرقت هذه الزبول
صارت ألطف وأشدّ جلاءً ممّا كانت أو لا ينفع لذلك من ذرق الثعلب ومن كلّ
داء يحتاج إليه الأدوية المنقّية الجالبة مثل الجرب والوضح والقروح الرديئة به
وأشباهها وكثيرًا ما يخلط في الضمادات المحلّلة بمنزلة الضماد النافع من
الأورام العارضة في أصول الآذان والأربيتين المتقادمة وقد كان كثير
من الأطبّاء الذين يطنّون الفترى ويعالجون أهلها يستعملون هذه الزبول الكثيرة
ما فيها من الخليل فيشفون بها من نهش الأفاعي ونهش غيرها من الهوامّ وكانوا من
تنازعوه منهم وعالجوه بها ومنهم من كان يستعمل أصحاب البزر فإن فيهم ومنهم من
كان يسكن به نزف الدم من النار وذرق البقر بأبنه محلّله وفيها قوّة جاذبة به
ولذلك ينفع من لسع النحل والزنابير ويمكن أن يكون فعلها لذلك من قبل
طبعها وقد كان رجل من أهل آسيا مشهور بالطبّ يعالج أصحاب الاستسقاء بالأحشاء

الأدوية التي تنفع من ذلك الأعراض واذا اراد ان يستعملها للدوسنطاريا خلطها باللبن الذي قد طبخ بالحجارة او الحديد المحمى وقد جربت انا هذه وتولد به بنفس بأن سقيت منه أناسا كثيرا منعم منفعة عظيمة وكذلك ينفع من الفروج المقاد منه اذا خلط بغيره من الادوية النافعة من الفروج وكان خلطه أيضا بالادوية المحللة للادرام فجد لها منفعة عجيبة واما بل الناس فإنه مرة يعالج به رجلا فانفع به وكان ان هذا الرجل الذي ينفع بهذا العلاج برملة قد شرف على الموت وبعرض له الاختناق الشديد وبصيبه ذلك مرارا في السنة وكان اذا أصاب به ذلك مستعاينه بالفصد فلما رآه هذا قال له ازدواك عندي ومتى عرض لك هذا الوجع فعزف في ذلك قبل استعمالك القصد فلما كان وقت عرض للمريض دعاه فطلاع حلقه ببعض ادوية فبرى من مرضه ذلك في اسرع مدة ثم انه بعد حين عرض له فجاءه ذلك الرجل وعالجه بمثل العلاج الاول فانفع به أيضا وانفع غيره بدوائه ممن كان يعرض له ذلك المرض وكان زبل الدواء زبل صبيا جائعا معجونا بعسل وكان يعذي ذلك الصبيا لثمس مع الخبز النوري المختم المطيب بالملح ويسقيه شرابا قليل الامزاج وكان يعذيه بذلك غذا معتدلا وسوى عليه النحم وكان يأخذ زبله بعد ما يجنيه به بذلك ثلثه أيام ثم ياخذ زبله عند اليوم الثالث شيقفه ويرفعه وانما كان يعذيه بذلك ليصرف بن الرائحة عن الزبل ولذلك كان يغذى بلحم الدجاج والدجاج المطبوخه بالماء كان نافعا وانما ينبغي ان يحمى عن غذاء كبير الطوبه فيكون زبله شبيها بزبل الكلاب في فعله وقله نتنه واما زبل الذب فقد كان بعض الاطباء يسقيه لمن كان به وجع القولنج ويسقيه في وقت هيجان الوجع وربما سقاه من قبل الوجع وخاصة اذا كان يعرض لهم بغير نخمه ورأيت بعض من شرب هذا الزبل فلم يعرض له ذلك الوجع بعد ذلك فإن عرض له يكن الشديد المؤذي وكان ذلك الطبيب يأخذ الأبيض من هذا الزبل وانما يكون ذلك اذا اعتذى الذب بالعظام

لعق منه مخلوطاً بالعسل كانت منفعته من النفث لكاين من الربو من اصحاب ذات الجنب واورام الريه عجيباً وهو مع ذلك ايضاً نضيج فمتى لعق الزبد وحده بغير عسل كانت معونته على النضج اكثر وعلى النفث اقل واضعف فعلاً واذا اكل منه مخلوطاً بعسل ولون كانت قوته من النفث اكثر وعلى النضج اقل وطوردن وهو الزبد الجيد منه يعمل من زادم ثم من اللبن مثل لبن الضان وقد يعمل ايضا زبد من لبن الماعز واخراج الزبد يكون بضرب اللبن في آنيه حتى ينفصل عنه الزبد وتنوه الزبد ملبنه هنه ولذلك اذا شرب واكثر منه اسهل البطن واذا لم يحضر زيت قام مقام الزبن في منفعه من الادويه التي تنأله واذا اخلط بالعسل ودلكت به اللثه ينفع من نبات اسنان الصبيان ومن لذغ اللثه في ذلك الوقت ومن القلاع ايضاً واذا اغتذى به غذى البدن واسمنه ولم يعرض الحيف وماكان منه لبن متن ولاعبق فهو صالح للاورام الصلبه العارضه للرجم والقرحه التي في الامعاء وقد خلط في الادويه النافعه من الجراحات العارضه في الاعصاب وحبث للدماغ وكثر المثانه وملأ الفروج وسيفها وبني اللحم فيها واذا وضع على نهشه الافعي نفع والحديث منه ينفع في صنعه بعض الاطعمه بدل الزيت وفي بعضها بدل الشحم ويجمع دخان الزبد على هذه الجهه خذ سراجا جديداً ولجعل فيه زبدا واوقد السراج وغطه باناء اعلاه اضيق من اسفله وفي اسفله ثقب مثل مافي اسفل المنانر ودع السراج يتقد واذا فني ما جعلت في السراج من الدهن ان لا فضت فيه زبدا ايضاً ولا يزال ذلك بك حتى يجتمع لك من الدخان ما تريد ثم اجمعه بريشه واستعمله في ادويه العين فانه يحفف ويقبض قبضاً رفيقاً ويقطع سيلان لمواد الى العين وبملافر وجهاً تريبا زبل حتى كلر بل محلل محفف متنى ان من معلمنا من ياخذ زبل الكلاب الذي قد اغتذى بالعظام فانه عند ذلك يكون ابيض منتن فيحققه ويخرنه واذا ارادا استعماله يحققه سحفاً ناعماً وعالج به من الخوانيق او لم الحلق خلطاً مع غيرها من

النحاس فيها من أنها إذا اشتدت عليها الأسنان انبطت ۞ ويكون زهر النحاس
على هذه الصفة اذا اذيب النحاس في البواطي المعدنية اذا اخرج الغليان وكان في
البواطي شيء من تراب وندى اسفلها وصفي بان يجري فيها مصاب بصب
بزل فان الذين يتولون تصفيته يصبون عليه ماءً باردًا من ساعته حتى ينعقد
سريعًا لأنهم يريدون من ذلك تبريده ويكون الماء صافيًا ما قد يعرض له من
سرعة تكاثفه واجتماع اجزائه بعضها الى بعض يبعث منه هذا الجوهر وزهرة
النحاس فانّ به شفصر اللحم الزائد وتحلل الاورام وكلوا عيشا النحج مع لدغ شديد
واذا شرب منها مقدار رابع او نولسات اسهل كيموسا غليظًا وقد يذيب الحم
الزائد في اطراف الانف وفي المقعدة واذا اخلطت بالخمر اذهبت البثر وما كان
من زهر النحاس ابيض يحكي ونع منخه في الاذن نفع من الصمم المزمن واذا اخلط
بالعسل ويحنك به حلّل ورم اللها والنغانع منضج ۞ زهر النحاس الطف من
النحاس هو منوع غسّال محلل لحشونه الاجفان عبرى جفف وينشف الرطوبه
من الفروح الخبيثه والفروح المتعفنه ۞ زبد ۞ الزبد يستخرج من
البان الضأن والأبل والبقر بضرب من المخض وجوه العلاج وقوته منضجه وفعله
ذلك في الابدان اللينه انوى وفيها النج واما الابدان الجاسيه ففعله فيها ضعيف
جدًا واذا كان الزبد ذو قوة على ما ذكرنا هو نافع من الأورام الكائنه في اصول
الاذن والأرنبتين والفم ومما كان ألين البدن فأما ما كان من العلط الخارج من
الطبيعه في الابدان الجاسيه الصلبه فقوته تضعف عن انضاجها و منفعتها
وربما لطفنا أو أورام ودبيلات يعرض في ابدان الغلمان والنسا وحدٍ فتفعنا هم
به وكثيرًا ما لطفنا به غلظ اللثه والعمور ويستعمله خاصه في لثات الاطفال
اذا ازدانا ان يسرع نبات اسنانهم دلكناه لثه الطفل وقد ينفع ايضا من
اورام الفم بانضاجه ويخلط ايضا ببعض الاشياء التى تعمل منها الضمادات وتوضع
على الشراسيف واورام الحالبين وغيرها من المواضع التى فيها اورام ودبيلات واذا

وبلطف ويزيل الدموع ويمنع الفروج الخبيثه من الاستاني البدن ويمنع
الجراحات من ان تنزوا واذا اخلط بالزيت والموم أدمل الفروج الوسخه
والبواسير الحاشيه وينفع من الكوى واذا اخلط بالشج وعمل منه فتايل الأذا أب
حبنا البواسير وقد ينفع أورام اللثه وانفاخها وينغص اللحم الثاني الذي يكون
في الفروج واذا خلط بالعسل والجلبه خلا جنا العارض الجفون وبعد ان
يكتحل به ينبغي ان يكمد العين باسفنجه مبلوله بما يتخن واذا اخلط بصغ البطم
او نطرون قلع الجرب المتفرح والبثر وقد يجزّر البخار على هذه الصفه بوخد
مريض وصير في مقلا من نحاس موضع المغلا على جمر ويحرك البخار الى ان يتغير
لونه ويميل الى لون التنوما ثم يوخد المقلا عن النار ويترك البخار حتى يبرد ثم
يرفع ويستعمل وقت حاجته اليه ومن الناس من يصير قدر من طين كان
المغلا ويجرده على ما وصفنا وليس ابدا اذا اجزى ينتحل لونه بالون واحد

منفع البخار اجزاء تبرن الرابعه. **غيره** ينفع جرب العين ويذهب
بالثلاث والاحتراق وينفع الاحفان التى قد استرخى عصبها اذا اخلط مع الادويه
التى ينفع العيون و اما مفردا فلا يكتحل به حكة و يبرى من البواسير اذا درش فيها
وهو يقوى الاعصاب والعضل. **ابن عمران** وقد تتخذ صلابه فهامن نحاس
احمر ويقطر عليها قطره من خل وقطرات من لبن امراه وقطره من عصاره عنب
مدخن ثم يسحو ذلك في الصلابه بالفهر حتى تسود فاذا اكتحل به العين
اجلا البصر وجلا الغشاوه وقلع البياض. **زهره النحاس** ابن وافد

هو شي يحدث من النحاس اذا اذيب واجرى في احاديث الارض ورش عليه
الماليحه فيجتمع اجزا النحاس بعضها الى بعض وينضغط الماء بينها ويحمى فيصير ذبا
طافيا على النحاس ترك له الحده اجود ما يكون منه ما كان ازهر النفش فى النحن
وكان شديد اليبس وكان شبيها في شكله بالجاورس وهوا اصغر منه وزنا
وسطانيه الصقاله فيه شى من النحاله النحاس التى بعثر بها وقد يعرف نخاله

فيما بينهم إسقولبس ومعناه الدودة فإنه صنفان أحدهما يخرج من معدن والآخر
يعمل عملًا وعمله على هذه الصفة يوضع صلابة من نحاس قبرصي لها يد يتخذ أيضًا من
النحاس النبرتي ويصب على الصلابة فوطي نصف من خل أبيض ثقيف ويدلك به
على الصلابة بيدها إلى أن يتحن الخل ثم يلقى عليه من الشب اليماني بغلوة البونابون
فيما بينهم إسطرحولي ومعناه المنديل اربع دخمات ومن الملح الغازي الصافي في
اللون ومن الحزى الشديد البياض الصلب ومن النطرون مثله ويسحق بالخل
الثمين جميع الصنف حتى يصير لونه شبيها بلون الزنجار وقوامه مشبها بقوام
الراسخ ويحز ويجب جبابا يطبع على خلقة الدود إلى البلاد التي يقال لها رودس
وبرفع فهذا الصنف من الزنجار إن عمل على هذه الصفة التي أنا مخبرك بها كان
لونه حسنا ويفعله قويا وصفته أن يؤخذ من الخل جزء ومن البول
المعتق جزء ومن ثاير الأدوية على جنب ما ذكرنا من المقادير ومن الناس من يغش
هذا الزنجار بأن يأخذ زنجارا مجرودا ويخلط به صمغا ويطبعه على شكل هذه
الدود وهذا الصنف ينبغي أن يهدف عنه لأنه ردي وقد يعمل الصانع صنفا من
الزنجار من بول صبي يسقى على صلابة متخذة من نحاس قبرصي بيد متخذة أيضا من
النحاس النبرتي وهذا الصنف من الزنجار المرقوم الذهب جـ طـ للزنجار كبنته
جاز بعد ما فيه من ذرقه وهو يحلل ويبغض اللحم ويأكله ويذيبه ولبن يفعل
ذلك باللحم الرخص فقط لكنه أيضا يفعله بالملح الصلب والزنجار لذاع
ولبن يدع الفروج فقط بل له عند مداته إنصافا فإن خلط إنسان نشاسته
بشرامع قبرصي كثيرا صار الدواء المخلوط منها جلوا جلاء لذاع معه
وقوة جميع أصناف الزنجار شبه قوة الحجاز المحرق الآن الزنجار أشد قوة من الحجاز
المحرق وأجود هذه الأصناف من الزنجار الصنف الأول والذي يقال له الدودي
لأن الحول يثلثله دعاما من غيره وأشد قبضا والذي يعمله الصانع شبه المجرود
وكل زنجار فإنه فإن نحن حللوا الآثار العارضة في العين عز الدمال القروح

تُقَفْ فِي خَابِيَةٍ أَوْ فِي آنَاءٍ آخَرَ شِبْهِ بِالْخَابِيَةِ وَيُغَطَّى الْإِنَاءُ بِغِطَاءٍ مِنْ نُحَاسٍ وَيَكُونُ الْغِطَاءُ مُثَقَّبًا فَإِنَّهُ أَصْلَحُ فَإِنْ لَمْ يَكُنْ أَنْ يَكُونَ مُثَقَّبًا فَلْيَكُنْ مَبْسُوطًا وَلْيَكُنْ مَجْلُوًّا وَلْيَكُنْ فِيهِ ثَقْبٌ وَلَا يَخْرُجُ مِنْهُ الْبُخَارُ أَصْلًا وَفِي كُلِّ عَشْرَةِ أَيَّامٍ يُجَرَّدُ عَنْ بَاطِنِ الْغِطَاءِ أَجْمَعَ فِيهِ مِنَ النُّحَاسِ وَيُرْفَعُ أَوْ يُؤْخَذُ صَفَائِحَ مِنْ نُحَاسٍ يُعَلَّقُ مِنْ آنَاءٍ الَّذِي فِيهِ الْخَلُّ دَاخِلَ الْإِنَاءِ فَوْقَ الْخَلِّ بَعْدَ نِصْفِ شِبْرٍ بِحَيْثُ لَا يَمَسُّهَا الْخَلُّ وَيُجَرَّدُ عَنْهَا أَجْمَعَ فِيهَا بِهَا فِي كُلِّ عَشْرَةِ أَيَّامٍ وَيُؤْخَذُ سَبِيكَةٌ وَأَحَدٌ مِنْ نُحَاسٍ أَوْ عِدَّةُ سَبَائِكَ فَتُحْنَى فِي الْجَبْرِ مِنْ عَصِيرِ عِنَبٍ حَدِيثٍ أَوْ فِي مَاءٍ قَدْ حَمُضَ مِنْهُ وَيُفْعَلُ بِهَا كَمَا يُفْعَلُ بِالصَّفِيحَةِ وَالْغِطَاءُ وَبَعْدُ جَبْرُ نَقْلِهِ وَقَدْ يَسْتَقِيمُ أَنْ نَعْمَلَ مِنَ الصَّفَائِحِ الْمُتَّخَذَةِ مِنَ النُّحَاسِ الَّتِي نَصِيرُ فِيمَا بَيْنَهَا الذَّهَبَ وَنَطْرَحَ إِذَا أَرَشَّ عَلَى النُّحَالَةِ أَوِ الصَّفَائِحِ خَلًّا ثَلَاثَ مَرَّاتٍ وَأَرْبَعًا فِي الْيَوْمِ وَيُحَرَّكُ فِي كُلِّ مَرٍّ وَلَمْ يَزَلْ يُفْعَلْ بِهَا ذَلِكَ إِلَى أَنْ يَسْتَحِيلَ فَيَصِيرُ زِنْجَارًا وَقَدْ يُقَالُ إِنَّهُ سُؤْلِدُ زِنْجَارٌ مِنَ الْمَعَادِنِ أَوِ الْغِيرَانِ الَّتِي يُقْرَنُ وَأَنَّ بَعْضَهُ يَظْهَرُ عَلَى بَعْضِ الْحِجَارَةِ الَّتِي فِيهَا نُحَاسٌ مِنْ بَعْضِهِ يَقْطُرُ فِي الصَّيْفِ فِي مَعَادِنِ عَنْدَ طُلُوعِ نَجْمِ الْكَلْبِ الَّذِي يَظْهَرُ مِنْهُ عَلَى الْحِجَارَةِ شَيْءٌ وَهُوَ جَيِّدٌ بَالِغٌ وَالَّذِي يَقْطُرُ مِنْهُ مِنَ الْمَغَانِ وَهُوَ كَثِيرٌ جِنْسُ اللَّوْنِ رَدِيءٌ خَبِيثٌ لِلْأَعْمَالِ لِكَثْرَةِ مَا خَالَطَهُ مِنَ الْحِجَارَةِ وَقَدْ نُغَشُّ بِأَشْيَاءَ كَثِيرَةٍ وَخَاصَّةً بِالْحِجَارَةِ الَّتِي يُنَالُ لَهَا فِيهِ شَوْرَ وَبِالرَّخَامِ وَمِنَ النَّاسِ مَنْ يَخْلِطُهُ بِالْفَلْقَنْتِ وَقَدْ يُعْرَفُ الْمَغْشُوشُ مِنْهُ بِالْفَشُّورِ أَوْ بِالرَّخَامِ بِأَنْ نَبُلَّ الْإِبْهَامَ الْأَبْيَضَ وَنَصِيرُ عَلَيْهِ شَيْءٌ مِنْ هَذَا الزِّنْجَارِ وَيُدَلَّكُ بِالْإِبْهَامِ الْأَيْمَنِ فَإِنَّهُ يَبْقَى غَيْرُ ذَائِبٍ وَبَيْنَ مَعَكَ ذَلِكَ الدَّلْكُ بِالْمَاءِ وَقَدْ يُعْرَفُ أَيْضًا بِأَنْ يُوضَعَ بَيْنَ الْأَسْنَانِ وَذَلِكَ أَنَّ الَّذِي فِيهِ مِنْ أَجْزَاءِ الْحِجَارَةِ تَنْبُو عَنْهُ الْأَسْنَانُ وَلَا نَطْحَنُ كَالَّذِي لَا يُغَشُّ وَأَمَّا كَانَ مِنْهُ مَغْشُوشًا بِالْفَلْقَنْتِ فَإِنَّهُ يُعْرَفُ بِالْمِحْنَةِ بِأَنْ يُؤْخَذَ مِنْهُ شَيْءٌ وَيُرَدُّ عَلَى صَفِيحَةٍ مِنْ نُحَاسٍ أَوْ عَلَى خَزَفَةٍ فَيُؤْخَذُ أَحَدَهُمَا فَيُوضَعُ عَلَى رَمَادٍ حَارٍّ أَوْ عَلَى جَمْرٍ فَإِنْ مَا كَانَ فِيهِ مِنَ الْفَلْقَنْتِ نَغْتَرَ وَجَمْرَ مِنْ سَاعَتِهِ لِأَنَّ الْفَلْقَنْتَ مِنْ شَأْنِهِ إِذَا أَحْرَقَ وَجَدَ أَحْمَرَ أَيْضًا. وَأَمَّا الصِّنْفُ الثَّانِي مِنَ الزِّنْجَارِ وَهُوَ الَّذِي يَعْرِفُهُ الْيُونَانِيُّونَ

أو مع الزبد فانفعت من مضرته ۞ **الرازي** الزبيب العبط إذا اشرب فلا أحسب
له كبير مضرة أكثر من وجع شديد في البطن والأمعاء وخروج كيفية لاسيما
إذا انهرك الإنسان وأما إذا أصيب في أذن فإن ذلك ما به شديده ۞ فأما المقول
منه والمصعد فانهما فلان رخاوة يعرض منها وجع شديد في البطن ومعص
وخلفه الدم ۞ **ابن جلجل** زنجفر هو صنفان مخلوق ومصنوع فالمخلوق
يسمى باليونانية ميثون وهو حجر الزبق والمصنوع يسمى باليونانية قنباري وهو القنبار
وهو يصنع من الكبريت والزبق ويؤخذ من كل واحد منهما جزء فيجعلان في انبيق ويصعدان
في قدر ويستوثق من ضمه لئلا يطير الزبق يغطي بطن الحكمة ويدفن في السرجين
يوما وليلة ۞ **د** فنباري قد ظن قوم أنه الذي يقال لها اسفاناج حجر يخلط بالرمل
الذي يقال له أرغور يطبخ وإنما استفيد هذا اللون إذا أراذ في البوطقه فإنه إذا
صار فيها حسن لونه جدا وصار في جمرة النار وليس بعرف له وجه أخرى غير هذه
الوجه التي وصفنا وإذا أعملت في المعادن فأحت منه زاجه يعرض منها للذين يشمها
إخناق ولذلك صار الذين يعملونه يسترون وجوههم بمثاله باليونانية
فوما يمكنهم النظر فيه من زاوية من غير أن يثموا الزاجه وقد يستعمله المصورون
ي الصور التي يصنعون فيها ۞ فأما القنباري فإنما يجلب من البلاد التي يقال
لها النوبي ويباع غاليا لقلته وإمتناعه ولذلك إذا أحتاج المصورون إلى استعماله
لم يبذروا على بلوغ حاجتهم منه إلا بالكد وهو عتيق اللون ولذلك طن قوم أنه
دم الثنين ۞ **ط** قوة الزنجفر قوة حارة باعتدال وفيه أيضا قبض وقوة شبيهة
بقوة الشاذنج وصلح للاكتحال لشدة قوة من الشاذنج لأنه أشد قبضا ولذلك
يقطع الدم ويؤخذ الخط بأن يروطى إذا احترن المار والبشور ۞ **غيره** جائز
يأنيس في اللاثنية بدل الجلجات وبدل لحم الخروج وينبغي من تأكل الإنسان
ويذرى على الخروج لعفنة المأكلة ۞ **زنجار** ما كان منه
يسميه اليونانيون فسنطوس ومعناه المحدد فإنه يجعل على هذه الصفة يصب خل

بأربع آيات ابن سينا منه مشتنى من معدنه ومنه ماهو مستخرج من حجاره معدنه بالنار كما ستخرج الذهب والفضه وحجاره معدنه لاتحمر وتطبخ ح و د انه مصبوع كما رايت لانه مستخرج بالنار فيجب ان يكون الذهب مصنوعا ايضا ح ط ليس هذا من الادويه التى يكون من انفسها لمن هو من الادويه التى تصنع ش د ه يصنع من الجزء من التى ينال به مسوس بالاستعان قنا بارى على هذه الصفه يوخذ طنجير ان من حديد ويصير به قدر نخار ويجعل فى اتون ويوضع فى الطرجهاره قنا بارى ويكب عليه انبيق ويطرح حوله الانبيق ويوضع القدر على لجمر فان الدخان الذى يصعد الى الانبيق اذا اجتمع يكون زنبقا وقد توجد ايضا الزببق سفوف معادن الفضه مدورا كانه قطرا لما اذا اتعلق ومن الناس من زعم انه يوجد الزبيق فى معادن له خاصه وقد يوعى الزبيق اوانى تحذ من الزجاج والرصاص لانه لاينا ان اوعى فى اى غير هذه الى كلها وافنا ها ح لم اجربه هل يفعل اذا شرب وما الذى يفعل اذا وضع من خارج البدن ش الرازى بارد رطب ماى غليظ فيه حده وقبض ويدل على ذلك بجمعه للاجساد وانه على ربحه فان اصعدا استخلا فصار جادا حربنا مجلا مقطعا والدليل على ذهابه بالجرب والحكه اذا اطلى به الجسد وتفريحه للجلد واذا اكل زحمينا خبيثا للحرب والغمل غيره فله ان يعترض بصبره كالرماده ماسر جويه تراب الزبيق ينفع من الجرب والحكه اذا اطلى عليها مع الخل الاحجار تراب الزبيق مثل الغار اذا اعجن له نفع من طعامه ودخان الزبيق ايضا يحدث اسقاما رديه مثل الفالج ورعشه الاعضاء وذهاب السمع والعثا وصفره اللون والرعد وتشنك الاعضاء ويخر الفم وينبر الدماغ ويطرد الهوام وتشلما اقلم منها بولس ومن الناس من يعرق الزبيق حتى يصير كالرماد ويسفيه اصحاب القولنج والالاوس ح اذا شرب الزبيق قتله ثقله لانه ياكل مايلقاه من الاعضاء الباطنه ثقله وقد نفع من مضره اذا شرب بالافسنتين او ببزر الكرفس او ببزر السذاب الذى ينال به ارمنى واذا شرب لحم اضاع فوذج الجبل

عليه ذبابة الأمانث والأحمر إذا نحو وغمز عصارة البنج الأخضر وطلى به نجمّ
الإبط بعد أن ينتف منه الشعر لم ينبت أبداً ۞ **غيره** الزبرجد جيد للضرب
بالعصى والسياط والحدوش ومذهب الدم الميت والقيم وطلى المتخذة منه وحصوصا
الأحمر منه لفرح الفم والأنف والأكلة فيها والزبرجد الأبيض فعال
وكذلك الزبرجد المصعد من أنها ۞ **زمرد** **كتاب الأحجار**
الزمرد والزبرجد صنفان الجنس واحد وهو حجر يوجد في معادن الذهب أخضر
شديد الخضرة شفاف والزبرجد مثله إلا أنه أقل صفاء وأميل إلى الكمد وهو
بارد يابس وكلاهما إذا شرب نفعت من الحذام وإذا شرب منها ثلاث حبات بقيت
من كل ذي حمّ وحدّ البصر ومنع عنه الكلال إذا أديم النظر فيه ۞ **ابن ماسوية**
أنه نافع من نزف الدم واسهاله إذا شرب أو علق ۞ **الرازي** إن نظرت الأفعى
إلى الزمرد الفائق سألت عيناها ۞ **زجاج** **الأحجار** منه ما هو
متحجر ومنه ما هو زمل فإذا أوقد عليه النى سمّه حجر المغنيسيا جمع جسمه بالأصالة
التى فيه وهو الزجاج وإن زاد كثرته فمنه الأبيض الشديد البياض كالبلور وهو حجر
أصنافه ومنه الأحمر والأصفر والأخضر والأتخوى وهو حجر سريع
الإنحلال بالنار سريع الرجوع إلى الحجرية مع الهواء وإذا أصابه الماء ثم أخرج إلى
الهواء من غير نار تحجر بسرعة وهو سريع القبول لكل صبغ يصبغ به وهو أيضا يجرح
اللحم مثل الحديد ۞ **خط** الزجاج ينبت الحصى المتولد فى المثانة ينشأ شدادا
إذا شرب بشراب أبيض رقيق وقال فى قاطاجانس الزجاج المحرق يجفف من
غير لذع ۞ **غيره** الزجاج المحرق ينقى نقى حصاه ۞ **الرازى** يذهب البرص
إذا غسل به الناس مدخلته لكل البص وقلع الخزاز ويبسط اللحية والشعر
كله ۞ **غيره** منع من تساقط الشعر وينبته إذا طلى به مع زنبق ۞
زنبق الطبرى أصل الزنبق من راذان نزلوا ندعى بالسعودى
وبالأندلس معدن زنبق ليس بالجيد ۞ **ابن الجزار** ويوفى بر أيضا من الأردن معدن

يوجد من الزرنيخ الأصفر صنفان أحدهما على هذه الصفة التي وصفنا والآخر
شبيه بالمدر لونه وتركيبه من لون الزرنيخ الأحمر ويوتي بهما قد ذبابا ومن قطوس
وقا أذوقيا وهذا الصنف هو مثل الصنف الاول والذي ذكرنا الا انه دون
الصنف الاخر في الجوده وقد يشوى الزرنيخ على هذه الصفه يوخذ قيصر في آناء
من خزف ويوضع على حمر ويحرك حركه دايمه فاذ احمى وتغير لونه انزل عن النار
حتى يبرد ويسحق ويرفع ۞ ط ۞ قوة هذا قوه يحرق محرق قال كان او غير محرق او متى
احرق قال لا مر فيه معلوم انه يصير الطف ممما كان والنار تستعمله في حلق
الشعر من طريق انه يحرقه واذا ابطا وطال مكته احرق البدن ايضا ۞ د ۞ وقوته
معفنه منضجه منقيه للصديد يتلذع لذعا شديدا وتقلع اللحم الرطب في الفروج
وتحلو الشعر وله حرا وعجز فه شديد ۞ واما الزرنيخ الاحمر فينبغي ان
يختار منه ما كان مشبع الحمره وكان رضفتت ويسحق سريعا وكان لونه شبيه
بلور الجوهر الذي يقال له فاناري ورايحته شبيهه برايحه الكبريت ۞ ح ۞ قوه
هذا الزرنيخ قوه يحرق وكذلك قوه الزرنيخ الاصفر واذا ركك كذلك
حتى لم يدخل في خلط في المراهم المحلله التي تحلوا ۞ د ۞ وقوه الزرنيخ الاحمر مثل قوه
الزرنيخ الاصفر وشيه مثل شيه ويحرق مثل ما يحرق واذا اخلط بالزنبج ابرا
دا الثعلب واذا اخلط بالزفت قلع آثار البثر العارضه في الاطفال واذا
خلط في الزبيب ودهن نفع من النمل واذا اخلط بشم خلل الجراحات و قد
يوافق القروح العارضه في الانف والعروح وسائر القروح واذا اخلط بدهن الورد
وافق البثور والواسيا السايه في المقعد وقد يخلط بالتراب الذي ينال
له انومالي وبشفاه من كان في صدره قيح فينفع به وقد يدخن به مع الزنبج
وبلحب دخانه بانبوب من قصب في الفم للسعال المزمن واذا العرا بالعسل
صفى الصوت وقد يخلط بالايريج ويعمل منه حب ويشفاه من كان في زبه نوع من
البول فينتفع به ۞ **ابن عمران** ۞ الزرنيخ الاصفر اذا انحى وجعل في اللبن لم يمنع

وهو السندراخ

وقد يشوى ايضا بان يوضع على الجمر وينفخ عليه حتى يصير لونه الى الصفرة او يوضع على خزف ويصير الحرف على جمر ويحرك دايما حتى يحمى ويتغير لونه واما الزاج المصري فانه في كل ما استعمل اقوى من الزاج القبرسي ما خلا اعراض العين فانه في علاجها اضعف من القبرسي بكثير واما الجوهر المتمم ما لطبوبنا فقوته مجرفه مثل قوه الزاج واجزاؤه مثل اجزاؤها وقد يبرئ وجع الضرس اذا اضيف الى الموضع الماكله منها ويشد الاضراس والاسنان المتحركه واذا احتقن به مع الخمر نفع من عرق النسا واذا اخلط بالماء ولطخت به البثور اللبنيه ذهبت بها وقد يستعمل في اخلاط الادويه المسوده للشعر واول ولا جمله ان ما كان من غير هذه الجواهر غير محرق فانه اقوى من المحرق في اكثر الاشياء خلا الملح وخبث النحاس والنطرون والكلس وما اشبهها فانها اذا احرقت كانت اقوى منها غير مجرفه وما كانت له قوه مثل هذه القوه ازداد فعله وقوت ظهورا غيبره والزاجات كلها تقطع الدم السايل من الجراحات والرعاف غير انها تسود اماكن الجراحات وتشد الاعصاب وتشد الامكان المنتخيه والزاج الاخضر اذا احرق وجمع مع السورنجان وصوعت منه اللسان نفع من القضفع والقبرطي اذا وضع فيها الزاج وخصوصا الاحمر نفع من الاكله في القبر وقروح الانف والزاج بحقف الرطبيه اذا شرب بحقيقا شدبدا حتى ربما قتل واذا ادمن الاغتسال منها الزاج اورث اجمتات الطويله ۞ **زريخ** الزارى هو لمله اصناف احمر واصفر واخضر والاحمر احدها والاصفر اعدلها الاخضر اتباها واذا اها ۞ غبره وقد يكون منه ابيض وفوادر اصنافه ده ارنابين وهو الزرنيخ الاصفر هو جوهر يكون في المعادن التي يكون منها الزرنيخ الاحمر واجوده ما كان ذي وصفاي ولا زلونه شبيها بلون الذهب وكانت صفاي سشس وكانتام ركبه بعضها على بعض ولمكن فيه خلط من جمر اخرو والتي يكون منه بالبلاد التي يقال لها اسيوقوطير هو بن على هذه الصفه وقد

الزاج الأخضر أيضا لما قد نضج نجزا زنه الطبيعيه فضل نضج على نضج العلقطار صار حقيقيا بان يكون لعشر اجلالا وذوابا من العلقطار وما البطونا وهو من الأدوية التي تفبض قبضا شديدا مع انه لطف من جميع الادوية القابضه وحلوا حلاء بشيرا ۵ العلقنت له قوة فابضه متخنه مجرقه سلعا لا شاد
واذا ابتلعنه مسدأرد زخمذرا ولعن يعمل قتل الدود المنولدين البطن الذي بيال له حب القرع فاذا شرب بالماء اجزك الغي ونفع من مضره الفطر القتال واذا أديف بالماء وشرب فيه صوفه وعصر وفطر في الانف نقى الراس وقد يحرق كما يحرق العلقطار واما النلطار فله قوة فابضه متخنه مجرقه شغي العيون
والآماقي وهو من الأدوية التي تفبض فبضا معتدلا وقد يصلح للحمره والنمله واذا ٣۰ خلط بما الكراث قطع نزف الدم من الرحم وقطع الرعاف واذا استعمل بانبا نفع من اورام اللثه والقروج اخبيثه العارضه فيها ومن ذم الغانم واذا الحرق ونخي واكتحل به مع العسل نفع من غلظ الجعون وخشونها واذا اعمل منه فتيله
وادخلت في النواصير قلعها وقد يعمل منه الدوا الذي بنال ه سوريقون على هذه الصفه خلط جزوان منه مجرء ومن الفليميا ويجوي بخل وصيرن انا من خزب وطمن في سرجين اشماء من الصيف ويرك اربعين يوما وهذا الدوا جاد ذ له قوة يفعل يها ما يفعل العلقطار ومن الناس من اخذ من العلقطار جزءا وخلط
من الفليميا مثله ويحفها الحمر ثم يفعل به كما وصفنا ۵ ط هذا الدوا يذهب الحرب وهو جفف اكثر من تحنيف العلقطار وهذا ابعد من اللذع منه واذا اركذلك فلا مزنه فيه معلوم انه الطف ۵ وقد يحرق العلقطار
على هذه الصفه يوخذ ويوضع على خزف جديد بلي ويغطى ويوضع الحزف على جمر واما اذا ان العلقطار كثير الرطوبه فالى ان ليطهر فيه نفاخات وقد يكون قد جف جفافا بالغا واما اذا اركبك فيه رطوبه كثيره فالى ان نغبر لوه منه ويحمر فاذا انغبر لونه بطنه وصار لونه شبيها بلون المغره ينبغي ان يرفع وينظف ويرفع

وبالبلاد التي يقال لها اسقابا وقبرس وينبغي ان نجنّب رَتمنه ما كان رَمضا واذا أتَ
كان رخله اسود وكان فيه خازيب وثقب كثيرة وكانت فيه دهنيّه وكان
قابضا رهما في المذاق والشمّ معنّا للمعده واما ما كان منه صقيل اللّنان قريبا
مثل الزّاج فانه جنس اخر من النوري اضعف من الجنس الاوّلح اما القلقدس
ففيه قبض شديد خالطه جرا أن ليست بالبسيرة وهذا مما يدلّ على انه يجفف
اللحم الخرّازته ويجمع جوهره وينشّفه ويفعله هذا ايضا ابضا والخرج شأمنّ ذلك الخم
وبشدّه ويُصلّب ويجمع لجوهر اللحمى وجمعه الى نفسه واما القلقطار ففيه قبض
وحدة مخلوطين وأحدهما معَ الأخر والأكثر فيه الحدّه وبلغ من شدّه جرا أنه
انه يحرق اللحم ويحدث فيه قشر محرفه واذا احرق هذا الدّواء فلذلك بعده
يكون اغلا واما يخففه فلست يفعل وقبضه ايضا سقف عندما يحرق يبقى فيما بينا
ليست بالبسيرة ولذلك صار القلقطار المحرق افضل واجودمن الذي لم يحرق في جميع
خصاله وذلك انه يصير الطف مما كان رنها يجمع الأدويه التي يحرق في جميع
خصاله وذلك انه يصير الطف مما كان رنها يجمع الأدويه التي يحرق وليس
نزداد حدّه كما نزداد حدّه كثير من الأدويه الاخر التي يحرق وجميع الأدويه
التي يحرق متي غليت بعد الحرق وصارت البن وابعد عن اللذع وهذه الثلثه
الأدويه اعني الزاج الأحمر والقلقطار والزّاج الأخضر هى من جنس واحد في
قوّتها وانها مختلفه في لطافتها وغلظها وذلك ان اغلظها الزّاج الأحمر والقَى
الزّاج الاخضر واما القلقط ففوّته وسطى بين هذين وهذه الثلثه يحرق
كلّها ويحدث في اللحم قشر صلبه بعد الاجزاء في نفس مع انها يحرق قبض ايضا والزاج
الاخضر اذا ادنى من اللحم المعذّرا كان ابلذَبعه اياه اقل من بلعِ القلقطار على انه
جاء تجزا ان ليست بدون حرا أن القلقطار ولكن انما صار هذا موجودا فيه
للطافه جوهره والزّاج الأخضر والقلقطار يذوبان ويجلّلان كلاهما اذا اطفاء
بالنّار واما الزّاج الاحمر فلا يذوب ولا ينحل لأن جوده يجزى كان

وذلك ان منه ما يكون من هذه الرطوبة وهى تنظر فطرة فطرة من غير ان فى جوف الارض ان ينجمد النظر حتى يكون له قوام ولذلك سميه جفاروا المعادن الغير شبيه المقطرة ومنها ما يكون منها وهى كبيرة شابه مغارة من المعادن يرتل ابار ان ينجمد ذلك الاباد ويبقى الجامد ومنها ما يطبخ بالبلاد التى يقال لها شابانكارة يقال له المطبوخ وهذه صفه طبخه يوخذ الصنف من القلفنت وهو منه سج اللون ضعيف القوة فيخلط بالماء ويطبخ ثم يصب فى برك وبرك ايام معلومة ليجمد فاذا انعقد لم يجد فاذا انعقد ثم يخرج وتقلع قطعا شبيه ببعوض النرد الا انها متصله بعضها ببعض كاتصال بعض العنقود ببعض واجود القلفنت ما كان لونه لون اللاورود وكان ربيا كثيفا نقيا صافيا والذى منه على هذه الصفه يقال المنظر ومن الناس من يسميه لجوطون وانشاون وهذا الاسم من الزاج اى الزاجى وبعده فى الجوده الذى يقال له الجامد ومن بعد المطبوخ فانه للصبغ والسود اصلح من الصنفين الآخرين واماء العلاج فانه اضعف منهما واما القلطار فانه ينبغى ان يحان منه ما كان لونه شبيها بلون النحاس من البث ولم يكن فيه حجارة ولم يكن عيفا وكان شطا به منشطيله هابزيق واما مليسير وهو الزاج ينبغى ان يحان منه ما كان من فبرس وكان لونه شبيها بلون الذهب وكان صلبا واذا النسر كان ميكسر شبيها بلون الذهب وكان له لمع شبيه بلمع الكواكب واما الطونا وهو صنف من الزاج فمنه ما يجد عن رودس ومن معادن الحاس منه ما يجد الملح ومنه ما يجد قوى المعادن وهو من المطونا اصفر مراجه ارضى ومنه ما توجد فى المعادن بالبلاد التى يقال لها قفلقيا ومواضع اخر كبيرة واجود هذه الاصناف ما كان منها لونه شبيها بالكبريت وكان ربيا متساوى الاجزا نقيا اذا انسحقته ما اسود سريعا واما سوزى وهو الزاج الاحمر فقد ظن انه صنف من المطونا الا انه شبيه به وله رهومه ريح ونغش وهو مهيج للقى ويوجد ببعض

حتى نصير كله فلنظار كما نصير الفلنظار زاجا وقد رأبت نفى قبرس عندما مررت بها ان الفلقنديس يجمع على هذه الصفه كان هناك بيت ليس بكبير المبنى وذام المدخل الى ذلك المعدن وفى الحائط الأسير من هذا البيت وهو الحائط الذى اذا دخل البيت كان على يمينه كان هناك سرب يمتد حتى التل الذى يقرب البيت وكان عرض هذا السرب مقدار ما يمشى بلثه انفس الواحد منهم الى جنب الاخر ويمكنه بمقدار ما يمشى فيه اطول من كان من الرجال وهو منصب القامه وكان ذلك السرب منصاو با لارض يميل الى اسفل ولكن بصاو به لم يكن كثيرا فكون منسا با العنبه وكان طوله مقدار ربيع ميل وكان فى آخره بير مملوءه ماء فان اصغر غلظا وكان فى جميع ذلك المحدد حران شبيهه بحران البيت الأول ومن بيوت الحمام وكان مقدار ما يجتمع فى ذلك البير من الماء فى كل يوم يكون ثلث جزأ من الحرار الرومية وكان ذلك الماء يستخرج وينقط قطرة قطرة فمجموعه فى كل اربع وعشرين ساعة وهو يوم وليلة هذا المقدار وكان يخرج من بعد فى ذلك التل الذى السرب تحته وكان اولبك القوم يخرجون ذلك الماء فى الجزار فيصبونه فى حياض لهم من بعده معنوله نقرا مدنة ذلك البيت وتمام السرب وكان ذلك الماء فى بين أيام بسين يجمد فيصير فلقنسا ولما زلت اناءء ذلك السرب حتى بلغت اخره الى الموضع الذى يجمع فيه ذلك الماء فان الفار بن الاصفر رأيت ان رائحه الهواء التى هناك كلها نحو من نتنها وبعثر بعز على الانسان اجتماله والصبر عليه وكانت ترتفع منه رائحه الفلنظار ورائحه الزناجار وكان طعم ذلك الماء فيه ضرب من هذه الرائحه فى ذلك الموضع فكان اوليك العبيد بهذا النبب يبادرون فى النزول والصعود عدوا واخبرنى ان هذا الماء من شأنه ان يسل ولا يزل حتى اذا قارب انقضا جفرا وانه ذلك التل وستربوا جيدا موضع الماءده فلتيس وهو فلقنديس وهو جنس واحد لانه اما هو طرد به ما ابيه بعضها بعضد وجد الا انه ينقسم الى ثلثه اصناف

غير الفلغنث وقد حط ابن جلجل من زعم ان الفلغنث هو الفلقديس وذلك على جملة بهما ويقول د و ح فيهما واما الشيزج فزعم قوم انه الزاج الاخضر المسمى باليونانية ملبس وكذلك قال ابن سينا وقال بعضهم الشيزج هو الزاج العراقي وهو المعروف بزاج الاساكفة وقال ابن جلجل زاج الاساكفة هو المسمى باليونانية مالطوحا زأيت في جزيرة قبرس المعدن الذي فيه جبل المدينة المسماه سوليا بيتا كبيرا وكان في حابط هذا الايمن وهو الحابط الذي اذا ادخلنا البيت صار يسره ثم اينا مدخلا يدخل منه الى المعدن فدخلته فرأيت فيه ثلث عروق ممتدة واحد فوق الاخر يذهب الى مسافة بعيدة وكان العرق الاسفل منها زاجا احمر والعرق الذي فوقه فلنطار والعرق الثالث الاعلى زاجا اخضر فاخذت من هذه الثلثة مقدارا كبيرا وقد مضى بهذا الحديث نحو ستين سنة ان لخذت من ذلك الزاج قطعه ملا الكف وكانت قطعه قوامها لبنا كثير المشابهة لقوام الزاج الا ان ينحل ويتفرق لاجزاء صغار منفصله فلما تعجبت من امكان على غير ما اعتدته منه وكسرت لك القطعه وجدت ان الزاج انما هو مستند بزجول القطعه كما دون طين رقيق ملبس عليه كانه زهر له وكان اخذت هذا شيء من اسر الفلنطار والزاج كانه فلنطار و استحيل فصير زاجا وكان ما هو باطن فلنطارا خالصا وذلك ان القطعه شبه او الأمر ما انما كانت قطعة فلنطار فلما رأيت ذلك فهمت ان ذلك المعدن الذي في جزيرة قبرس على هذا النوع لد الزاج فوق الفلنطار بشما يتولد الزجاج على الحجار فخطر بالى ووقع في في ظني ان عساه يمكن ان يستحيل الزاج الاحمر ايضا في مدة طويله ويصير فلنطارا وقد رأيت شيئا فلنطاريا استحال بضرب من العرض وصار فلنطارا وذلك اني قدمت قبرس ومعي من هذا الدواء شيء كثير فضاقت الصفيحه الخارجه عنده ما اتى عليها نحو من عشرين سنة فكان جوفه صار فلنطاريا فاما النقد مدة ذلك الوقت هل يصل الاستحاله الى باطنه

والاستسقا ووجع الطحال واذا احرق وخلط بالخمر ولطخ به داء الثعلب ابراه
واما الصنفان اللذان فانهما قبضان اللذان قد يستعملان فى اشيا اخر تجلو
الاسنان وتنبت الشعر اذا خلط بالملح واذا اراد احد ان يحرق صنفا من هذه
الاصناف فليأخذه ويصيّره فى قدر من طين غير مطبوخ فيها ويطين عطاها
ويدخلها فى اتون فاذا انطبخت اخرجها وحدها فيها وارفعه واستعمله فى وقت
الحاجه اليه وقد يغسل مثل ما يغسل القلميا **زبد البحره** يسمى
بالبونانيه ادرنى وادرسون واذرسين والسريانيه غاموزا **ط د** يكون بالبلاد
التى ينال لها علاطبا وهى بلاد الافرنج يجد شلما يجد الملح على نصب وحلفا
ويوخذ من القصب والحشيش فى مواضع رطبه فيها طين اذ احتمّت المواضع ولونه
شبيه بلون زهر الحجر الذى يسمى اسوس وشكله شبيه بشكر زبد البحر الرخو الخفيف
التجويف **خ ا** هو دواء حار ولذلك صار لا ينتفع به وحده فى شى من الوجوه
ولكنه يخلط مع ادويه اخر تكسر من قوته فيصير ذلك نافعا للعلل
المحتاجه الى الاخار اذا عولج به من خارج فاما ادخل البدن فليس يوجد لشده
قوته **د** يصلح لقلع الجرب المتفرج والكلف والعواريق والبثور اللبنيه وما اشبه
ذلك وبالجمله هو جاد ويبدل المزاج الردى العارض للاعبا الى المزاج الجيد وينفع
من عرق النسا **الزازى** يجلو البصر وينفع من ورم الثدين اذا اطلى به
مدقوقا مادبانا **زاج** **ابن سينا** الزاجات جواهر تقبل الخلاط
قد كانت ذنابا وانعقدت والقلقطار هو الزاج الاصفر والقلقند ليس
هو الابيض والقلقنت هو الاخضر والسورى هو احمر وهذه كلها بنجلاب الماء
والطبخ الا السورى فانه شديد التجسد والانعقاد والاخضر اشد نفعا من
الاصفر واشد انطباقا **لى** لم يذكر **د ولاح** القلقنت فى انواع الزاج وانما
ذكروا القلقديس بعينه والزاج الذى يخصى بهذا الاسم هو الزاج الاخضر الذى سماه
ابن سينا القلقنت واسمه بالبونانيه ملنيش واكثر الناس يزعمون ان القلقديس

وأقوى **زبد البحر** ☾☾ الفراسون هو زبد البحر فيما نعم كثير من
الناس ينبغي أن نعلم أن جملة أصناف أحدها أنيف الأول أن شكله شبه
الأسفنجة وهو موزر يزدهم أن الرائحة شبيه برائحة السمك وقد يوجد كثيرا
في سواحل البحر والصنف الثاني شبيه في شكله بطعمة العين أو الأسفنجة وهو
كثير كبر الجويف ورائحته شبيه برائحة الطحل البحري والثالث شبيه
في شكله بشكل الدود وفي لونه وفي برية ومن الناس من يسميه ميلسيون
والرابع شبه الصوف ولونه كثير الجويف خفيف والخامس شبيه في شكله
بالنطر وليست له رائحة وباطنه خشن فيه شبه من القشور وظاهره أملس وهو
حاد القوة وقد يكون كثيرا بالجزيرة التي يقال لها سغوسن التي بالبلاد التي
يقال لها برسطن ويسميه أهل ذلك الموضع وساحي ☾يا☽ هذا النوع الخامس
في طعمه جزا فيه وحدة لانه أحد من سائر أنواع زبد البحر حتى أنه يحرق والسبب في هذا
السبب لما كان في ذلك النوع أن ينفع من الجرب والقوابي والبهق والعلة التي
ينتشر منها الجلد ويصفي أيضا البشر لاعتدال قوتيهما صار هذا النوع الذي
ذكرناه أخيرا لا يمكن فيه أن ينفعل ذلك لانه ليس حلوا ما يحد من الوسخ وغيره
في ظاهر الجلد فقط بل يقشر الجلد نفسه ويكشطه ويغوص فيه حتى يحدث الفروج
وأما النوع الثالث فهو الطف من سائر الأنواع ولذلك إذا أحرق شفي القلب
منى خلط بالشراب الاحمر الناصع اللون الرقيق القوام ثم يطلى على داء الثعلب
وأما النوع الرابع فقوته من نوع قوة هذا ولكنه أضعف منه بمقدار كثير
بالبيت **☾** والصنف الأول والثاني من هذه الأصناف أعني الأول والثاني ينفعان
فيما يغتسل به النسا ويسفر أبدانهن وصلحان أيضا لقلع البثور اللبنية والنمش
من الوجه والكلف والقوابي والبرص والجرب المتفرح والبهق والكلف الاسود
والآثار العارضة في الوجه وفي سائر البدن وما أشبه ذلك والصنف
الثالث يصلح لمن به عسر البول وينفع من الحصا والزلاقة المثانة ووجع الكلى

كلم وهو نوع من البزيطون ومنه صغير نسمّى فاناقرحسّه ونون وهو الكلمة
فاماقرانفيليوس هو نبات يخرج سنناً فاما فقه طولهاخرجت ذات اعذاق عند ورقه شبيه
بورق النبات الذى نبتا له ماذون وهو النبات بلج غير انه ابرز واكثر عباط به الرابعة
ولهذا النبات اصل من الطعم ◌ هو ذاتل استخانا من اجا وبز ولذلك صار الناس يستعملون ورده
وثمره ان خلطوها مع العسل ويداوون بها الجراجات والخراجات والاكله ◌ زهر هذا
النبات وثمره اذااحتفا وخلط بالعسل وشج بهما وانفىضرر الهوام وامافاناقرحس وبون
مويات سبك انيتو ذلك فى الجبل الذى نبتا له فلمون ولهذا النبات شبيه بلون الذهب واصل
دقيق لبس رغاير ضاحروف ◌ هذا النبات ايضا قوته شبهه بقوة الذى
قبله ◌ واذاشرب اصل ان صاجح اضر زالهوام واذاانضمد بجمه هذا النبات
كان صاجحا ايضا لذلك. زهره الملح ◌ ◌ انسرالوص ومعناه زهر
الملح هو شئ يخرج من النل فيجمد و اضع مياه فايم سقي فى ماء النل وفى
الانهار وينبغى ان يجتار منه ما كا لوه شبها بلون العفران راجحه ننن
شبيه بنتن راجحه مرى السمك ومنه ما كون راجحه ايضا انتن من اجه مرى السمك
يلذع اللسان لذعا مفر طاجدا وفيه رطوبه و اماما كا فيه صفرة سباء
الجمره اوكا فيه رخا ارا متعقد منحبه ملتبه بعضها الى بعض فىردى ومن
اماران غير المغشوش انه يماع بالرطبت وحده والمغشوش حجتاج الى الماء ◌ هذا
دواء لطيف يحلل اطف من الملح المحرق فضلا عن غير المحرق وطعمه جاذحرف وقوته
محلله تحليلا شديدا ◌ وقد يصلح للفر وح الحبيته والاكله والفر وح التى من
شاني ان ينشر والرطوبه السائله من الاذان ولعثاوة البصر والاثار
العارضه عن ايدا النش وج العارضه فى العبر وقد ينفع فى اخلاط بعض
المراهم الادويه وينفع الادهار ليصنعها مثل ذهن الورد وقد يدرالعرق واذا
شرب باخمر والماء اشهل البطن وهوردى للمعده وقد ينفع فى ادهان الاعيا و فيما
يدلك به البدن ليرقو به الشعر وبالجمله هو فى الحده والتلذيع مثل الملح

الطيبة

بُخارِس وهو نهر

شبيه بالجزر الأسود والبنط شبيه
بزر الحماما ورقي وينبت كثيرا في
الأماكن الخشنة والمواضع المايلة واصل
هذا النبات اذا طبخ بالما نفع الذين
يبعرون من موضع عال ومن رض العضل
والطرا انها اذا عسر النفس والسعال وعسر البول
وقد يدر الطمث ويحرك الجنين وقد يتناول
منه بالشراب من نهشه الهوام فينفع به
واذا اجتمع عزقه ولحومها وطوبخ جذب
الاجنه وطبخه اذا احتس فيه النفسا
وقها وينفع به وذراره اطيب اذا كان
طيب الرايحه جدا وذرقه لاده قابض

فضمن به نفع من الصداع ومن اورام العين الحاره باشرابه ومن الناصور الذي يكون بالعين يفتح اشرابه والذي الواذم عند الوادو
من ثغث البر ولحمه نوم - **زوفرا** ثني بالبواتيه فاما وهضغان منها كبير تتمى فأ قا ن اسقلبوس والعجمه

قافاقس اسقليون وهو الزوفرا

قانو خرد بولومو

اسرفون هوبنات معرف وهو صنفان جبلي وبستاني هذا انخ وجفف ح ح
في الدرجة الثالثة وهو لطيف د قوته منخنه واذا طبخ بالماء والنبذ والعسل
والذاب وشرب نفع من اورام الزبه الحارة ومن الربو والنعال المزمن والنزلة
التي تحدر من الراس الى الصدر الحلق والصدر وعسر النفس الذي يحتاج فيه
الى الانصاب وهو يقتل الدود واذا العين بالعسل فعل ذلك واذا اشرب طبيخه
بالكمين اسهال كيموسا غلظا وقد نسخ وبوكل بالنبذ الرطب فيلين الطبيعة
وان خلط به قرمانا وايرسا والعفاص الذي يقال له ارو نمز كان اقوى لاسهاله
وقد يحسن اللون ويضمد به مع النبذ والطرون للطحال لليبن ويعمد به بالشراب
للاورام الحارة واذا انضمد به بماء معلي حلل الدم الميت الذي تحت العين واذا اخذ
مع طبيخ النبذ كان منه دواء جيد للخناق الذي يقال له سنجي واذا طبخ بالخل وتمضمض
بطبيخه سكن وجع الاسنان واذا حرث الا ذان عدان حللا لريح العارضه فيها

الازاربا الجبلي انحن انوي اقوى فعلا من البستاني كثيرا واذا اشرب بالشراب ايا ما
منافعه نفع من الاستسقاء ومن نهش الهوام واذا طبخنا بالماء وحلا على العين نفع من
نزول الماء فيها ح د واما الشراب الرازقا فينبغي ان يلقى على كل جزء من العصير رطل
من الزرواتا بعد ان يدق ويشذى خرقه كتان رقيقه ويشد بها حجر ليرسب
الصرن ثم ترقى بعد اربعين يوما ثم يوعاى الاوايي وهذا الشراب ينفع من العلل
التي تكون في الصدر والجبين والربو من النعال العتيق والربو ويدر البول
وينفع من المغص ومن الناقض ويدر الطمث

زهرة الرازي
النبات المسمي بالوتانية بحارش وهو بالعربية رهي ل الناس يعرفونها عندنا
بالترشلية ويسحقون بحازيث فيقولون لحاذش ح د بحارش عشب طيب
الرايحة ويستعمل بالليل لا لليل ل وذق حشن عظيم فيما بين وذي الجنح والنبات
الذي يقال له قلومر وساق وطوله ذراع ى الحشوته ما هو مشعب منه
شعب وله زهر بيض لونه فوق بيزره غليظ الى البياض ما هو طيب الرايحة جدا وعروق

بمنفعته من الربو والفواق والنافض وورم الطحال ووهن العضل ووجع الجنب منى يشرب بالماء ونباته اذا انضمد به اخرج السلا من اللحم والازجه ونشو العظام ويقلع حبث للفروج العفنه وينقى اوساخها واذا اخلط بالصنف من النوسس الذى يقال له ارسا والعسل ملا الفروج العميقه منها وجلا الاسنان واظن ان الصنف من الرا او ندا الذى يقال له فليماطيطس يفعل ما يفعله الطويل والمدحرج غير انه اضعف منها قوه ❊ ارباسين جميع اوصافه جا أنه في الثالثه ❊ الطبرى الرا اوند المستطيل من الصرع والكزاز ينفع اعجابا يَنْفَعُ

تولس ان شرب من الطويل وزن درهم ونصف مع شراب العسل خلف كما خلف الحنظل ❊ غيره يسهل المره الصفرا وهو نافع للاجشا ويتقى اللون وينقى الصدر والرثه واللثه والاسنان من الرطوبات ❊ زوفا ابن عمران

اسقورذيون هوالثوم البرى

هى حشيشه تنبت فى
جالست المقدس
وتنفرش اغصانها
على وجه الارض
كالذراع او اقل ولها
ورق واغصان فرخ
شبيه فى قدن ورق
المرزنجوش ويكون
اخضر ثم يصفر وقضبانها
غير انه غلظ وقضبان
المرزنجوش ولها ريح
طيبه وطعم مر ويجمع
فى ايام الربيع

الأصلين أكثر ذلك تكون شبيها بلون الخشب الذي يسميه أهل الشام نفس
وهو الشمار وطعمها مر وهما دهان ومن الزرا وند صنف ثالث يقال له
قليططس له أغصان رقاق عليها ورق كثير إلى الاستداره ما هو شبيه بورق
الصعتر الصغير من جنس العالم وزهره شبيه بزهر السذاب وأصول مفرطه
الطول ورقاق عليها قشر غليظ يستعمله العطارون في تربية الادهان ينفع
ما في هذا لما يحتاج اليه منه في الطب اصله وهو مر حريف قليلا والطف
انواع الزرا وند المدحرج منها وهو اقوى اهل في جميع الخصال فاما النوعان
الآخران من الزرا وند فالشبيه بشقض الكرم زرع الجنة اطيب خجر العطارين
يستعملونه في اخلاط الادهان الطيبة فاما في اعمال الطب فهو اضعف واما
الزرا وند الطويل وهو اقل لطافة من المدحرج الا انه ليس بالضعيف بل قوة
قوته تجلوا وتنجخ وتجلاوة وجلبله اقل فاما اتساخا انه يلبس بدون اتحانه بل اعتناء
اكثر اتساخا بامنه ولذلك متى احتجت الى ادخلوا كان الزرا وند الطويل انفع
منه لما يحتاج اليه اذا اردنا ان ينبث في النسوج بها واذا اردنا ان نداوى
توجعه يكون بروع الرحم فاما المواضع المحتاج فيها الى ان يلطف خلطا غليظا تلطفا
اشد فتحن الى الزرا وند المدحرج احوج ولذلك صار ما الوجع الحادث من قبل
شدة او من شي رخ غليظه غير نضجة انما يشفيه الزرا وند المدحرج خاصه
وهو مع هذا الخرج النلاو يذهب العفونة ويبقى الفروح الوسخه وبجلو الاسنان
واللثة وينفع اصحاب الربو واصحاب النواقص واصحاب الصرع واصحاب النقرس
اذا اشرب بالماء وهو ايضا موافق للفروح الحادثه في اطراف العضلات ومن اوساطها
منزلكا واخرا والزرا وند الطويل اذا اشرب منه مقدار درخمى بشراب
وتضمد به كان صالحا لسموم الهوام القاتله واذا اشرب بفلفل ومر نقى الفضل من
الفضول المجتسمه في الرحم واخرج الطمث واخرج الجنين واذا احتملته المرأة في
فرزج فعل ذلك يفعل الزرا وند المدحرج ما يفعله الطويل ويفضل عليه

الزراوند الطويل

زراوند مدحرج

صغيرة مخرجها من أصل واحد وأغصان طوال وزهر أبيض كأنه قز أطول وما كان منه داخل الرحم لحم فإنه مثير للزاجة وأما الزراوند الطويل فإنه يقال له باليونانية النكرو يقال له دقطر لطس وله ورق طوال أطول من ورق الزراوند المدحرج وأغصان نتنة ولها نحو ثمرة ولون زهر مثل الفرفير منتن الرائحة إذا أطهرا كأن شبها بزهر النبات الذي يقال له افيون وأصل الزراوند المدحرج منتن شبيه بالشلجمة وأصل الزراوند الطويل طوله شبراً وأكثر منه بيض أصبع وما داخل

جلا وقد يستخرج من زقاقها عصارة تجفف وتستعمل في الطبيخ وهي حريفة جدا
ونفش الراج • **زنباق اللاجه** هي بقلة تنبت بالري جادة
حريفة مصنعة تنزرع استقبال الشتاء وتوجد في البرد شديدة الخضرة
نضر بالرابس والانف كثيرا ويجد البصر وتطرد الرياح وتنشفها بقوة وتزيل
الصداع البارد اذا ادمن اكلها وقد يكون قبورد من عطشانا شديدا وان
سلوقة لم تغث • **زرنباد استخرجه ابن عمران** هي عروق
مدورة شبيهة في شكلها بالزرآوند المدور ولونها شبيه بطعم النخيل
ولونه بوني بعمل من الصين **منبح** جاز بابرج الثانية محلله جيد للرياح
الغليظة وينفع من لسع الهوام ويحبس البطن **البصرى** يثمن البدن تسمينا
صالحا ويطيب رائحة الثوم والشراب اذا اشرب او مضغ **غيره** يزيد في الباه
ويقوي القلب والكبد جدا ويمنع الغثي وحكل اورام الارحام
زرآوند منه الجبة مستورة **دح** ارسطولوخيا هو الزرآوند واشتق
هذا الاسم من ارسطو
وهو الفاضل ومن
لوخوس وهو المراه
الفاضلة ابديا لك
الفاضل المنفعة
للنفسا وهو نوعان
المدحرج وهوالذي
ورقة كورق قسوس
طيب الرائحة معي
من جدة الى الاشنان
ماهو ناعم وهود شبه

أرسطولوخيا
وهو الزرآوند
بإضافة

الزرآوند المدحرج

مخالفتها اباه بنبره ۞ واما الجزر والخردل والبتون وخر وجام البزر به
فانها لا تشعل الاشتعال التام في مده طويله ولا تزال لهبها ايضا ثابتا الى مده
طويله ۞ وقوه النخيل متخنه معينه على هضم الطعام ملينه للبطن لينا خشنا
جيده للمعده وهو حين يجدد حده البصر وينفع في اخلاط الادويه المعجونه و هو
بالجمله في قوته شبه بقوه الفلفل عبره يحلل البلغم والرطوبات من
المعده والامعاء والزاج الغلظه ويعين على الجماع عبره يحلل البلغم
والرطوبات من المعده والامعاء والزاج الغلظه ويعين على الجماع ويحبس
البطن ويحسن اللون ويخرج البلغم والمره السوداء على رفق ومهل لا على طريق
اخراج الادويه المسهله ويزيد في الحفظ وينفع من سموم الهوام ۞ زنجبيل
الكلب ابن سينا هى مثله معروفه وهى كفلفل الماء وزناها ثورد

اسلاف الانابث
صغره وقضبانها
جمّ له طعم حريف
يقتل الكلاب وطريه
مدقوقا مع بزر جلو
اثار الوجه والكلف
والنمش المتون ويحلل
الاورام الصلبه ۞
الملاحه ورقه
كورق الخلاف الا
انه اصغر وقضبانه
حمر معقد وزاجه
طيبه وهى حريفه

وزرعة اهل تلك البلاد فيه اشياء كثيرة مثل ما يستعمل من السذاب في بعض الاشربة التي يشربونها قبل الطعام و في الطبيخ والزنجبيل هو اصول صغار مثل اصول السعد لونها الى البياض وطعمها شبيه بطعم الفلفل لطيبه ان بحة وينبغي ان يخلا منهما ما يمكن مثلا و من الناس من يعله بما و ملح لسرعة عفنه و يحمله في انية خزف الى البلاد التي ينال لها انطا با يصلح للاكل و قد يوكل مع السمك الملح

د و س ختم منه ما لا زم بمجاعة غير منسوب ح و اصل هذا النبات مجلى ب

اليمن من بلاد الهند والذي ينفع به ولحاءه قوى ولكنه ليس من شانه
اولا لامر كما يفعل الفلفل ولذلك ليس ينبغى ان يوهم عليه انه فى لطا فه
الفلفل ولكنا نجد عبارا انه قد بعد ما نرجع هو لا ينضج وهذا ليس هو بارضى
بل لا يجرى ان يكون رطبا و من اجل ذلك صار الزنجبيل يا كل وينفذ سريعا بسبب
ما فيه من الرطوبة الفضلية لان هذا لا ناكل نفع يعرض له من الاشياء المحضة
البر او الرطوبة رطوبة محضه مشاكلة لجوهرها وقد عرض هذا بعينه للدار فلفل
ومن اجل ذلك صارت لجرارته لجادته عن الزنجبيل وعن الدارفلفل يبقى لا شيء
وهو طويلا اكثر من لبث لجرارة لجادته من الفلفل الابيض والاسود كما ان
النار اذا اخذت فى الحطب اليابس تشتعل وتشب على المكان وتطفى بالعجلة فكذلك
لجرارة لجادته عن الادويه التى قوتها قوة يابسة تشتعل اسرع و تلبث مدة اقل
ولجرارة لجادته عن الادويه ثم عن التى فيها رطوبة فضليه على مثال لحطب الرطب يشب
بابطا فاذا اشتعل لبث مدة طويلة و لذلك صارت منفعة كل واحد من
هذين لجنسين غير منفعة الاخر ولذلك اى متى اردنا ان نسخن البدن كله بالعجلة
فينبغى ان نعطى الاشياء التى قوى لجرارته ياتى على المكان و نسخن به البدن
ومتى اردنا ان نسخن عضوا واحدا اى عضو كان فينبغى ان نفعل خلاف ذلك اعنى ان
نعطى هذه الاشياء التى تبطى فى السخونه حتى اذا اسخنت يبقى لجرارته فيها مدة طويله
كالزنجبيل والدارفلفل وان كا ناخذ لبن الفلفل الاسود فى هذا الذى وصفت فان

النبخ لي هذا هو
الذي يعرف عندنا
بالمشتهى وبسميه بعض
العرب الينبوت
ح هذا النبات
قابض وكأنه يُني
المثل تفاح بري يخ
ثمرته عفوصة زده
يصدع الراس وذلك
لأنه يخالطها كيفيه
رديه غريبه

زنجبيل
أبو حنيفه هو
من نبات أرض العرب
يغرس غرسا وليس ثمر
شيء بري وأنما هو يعرف
ثمرى في الأرض وأخبرني
من رآه أن نباته شبيه
بنبات الراسن آد ب
زنجبار هو نبات يكون
كثيرا في موضع من
بلاد العرب يقال له
طرعلود يطبخ ويستعمل

مشتلى وهو الغرور

زنخبارى وهو النخل

كم ىطهر ما الجىرىـ ... الحىرـ ... ىحمع ىىطح الزفت ... ازعلو صو ن ىىرـ عـ الزفت
فاذا اـىـل ... الحىـرا المصاعـد ىعصرـ ىه الـىـا ... ولا ىـرى الـشعـاـ لك والزفت ىـطح
ىـىـع ما ىـىـع مىه الزفت الرطـب واذا ىصمد ىه مـد ىـمو الـشعىر اىـىـت الشعـر
ىـىـ راد الـىعـلب والفـاـر وىـالزفت ىـر ى وىـرـوح المواشى وحر ىـها اذا لـطح
عـلـىها وىـدها لـىمىـد الـحـرا ـب والاوـاـد ... ولـسـاطـر وهو عـر ق الـىسـا ... وقـد ىـحمع
الزفت الرطـب دحـاـر اىـحمع رحمه ... هكـدى حد ىـرحـا وصـىـر فـىه
ىـىله وسـىـا مـں الزفت فاوـ قـد اـــىـ وكـب على الـسـراـح احـد ـدا مرحـا وشكـله
مـىـل شكـل الـىىـور وىـكـون اعـلاـ مـسـىـدا وىاصـىـىا ودىـ اـسـمله ىـــت كالدى للـسـىـور
ودع الـسـراح ىـعـد فاد اـىـى الزفت الدى فـىه قـصـرـ زفـىـا احـر ولا ىـرـى ان ـىـعـل ذلك
حـىى ىـحـمع مـں الـدحـاـن ما ىـكـىـىـى ـىه وقوـه هـدا الـدحـاـن حاـر ـه قاىـصـه مـىل قوـه
دحـاـں الـكـىدـد وىـىـعـى ان ىـسـىعمل فى الاحـال الـى حـسـر هـد بـلـمـعـىں وىـى الـاـحـال
واللـطـوـحـاـت الـىاـفـعـه ىـــاـب الاـىـعـار المـىـاـىرـه وللعـىون مـں صـعـقـها ودمـعـىها
وقـرـ وحـها ٠ **زفـت الـسـفـں** ﮪ ـرـوـىصا مـں الـىاـس مـں قـال
اىه ىـحـرـد عـن الـسـفـں مـىـل الرواىـح المـحـلوطـ ىـالمـوـم الـدى ىـطـمـه ىعـض الـىاـسـ او حـمـا وهو
مـىدوـب لـلـفـضـول لاسـىـىـقـاـعـه ـى مـاـ الـىـحـر ومـں الـىاـس مـں ىسـمـى صـمـع الـىوـب
ىـهـدا الـاسـم ٠ **زعـرور** ﮪ مشـىـلـىں هى ىـحـره مشـوكـه
ورـقـها شـبـىـه ىـورـق الاـرـ ـه وله ىـمـر صـعـاـر شـبـىه ىالـىـفـاح ـى شـكله لـلـدـىـد
الطـعـم ىـى كـل واحـد مـىـها مـلـت حـىـاـت ولـدـلك ـسـمـاـه قـوـم طـرىـفـون هو
ذو مـلـت حـىـاـت وهـو ىاـرد ﮪ **ثـمـره الـزعـرور ىـحـىـس الـىـطـن** ﮪد ـىـد لـو ـوـكـل
ىـعـد الـدـوـں فـضـا ىـه ورـقـه عـفـوـصـه لـىـسـت ىالـىـىـں ﮪ **اـدا اـكـل رـطـبا**
للـعـده مـمـسـكا للـىـطـں وـى الـىـلاد الـىـى ـىـال ـها اـىـطاـكـىا حـىـس اـحـر مـں الزعـرور
وهو ـحـره شـبـىـه ىـسـحـر الـىـفـاح عـىـر اـں ورـقـها اـصـعـر مـىه ورـق شـحـر الـىـفـاح
وـمـر هـدـه الـشـحـره مـسـىـد ىـرـ ـى كـل واـسـا مـلـه عـرىضـه والى الـقـىـص ما هى ىـطى

وقلع الثوابى والخراجات الصلبة وصلابة الرحم والمعده واذا طبخ بدقيق
الشعير ونولى صبى فى الخنازير واذا اخلط بالكبريت او نثر الثوب اذ انما كله
ولطخ به الداء الذى يقال له النمله منعه من ان ينبعث البدن واذا اخلط بدقيق
الكندر ومن لحم العروح العتيقه واذا لطخ بمفرد على الرجل والمعده
وافو الشفاق الذى فيها واذا اخلط بالزيت والعسل قلع الخلط بشه العارضه من
العروح التى تسمى الحمر والعروج العفنه وقد ينفع به لعلل الكبد والمعده
واذا اعطى منه اوقيه واحده فعل مثل ذلك ايضا وقد ينفع به اذا خلط فى
المراهم العفنه واما كثيرا فضا وهو الرفت اليابس فانه يكون من الزفت الرطب
اذا طبخ ومنه ما هو شبيه بالدبوق لزوجته ويقال له وبقاس منه ما هو يابس
واجود ما يكون منه ما كان خالصا لازقا طيب الرائحه بانوتى اللون شبيها بالزانج
والزفت الذى من البلاد التى يقال لها لبنا والتى يقال لها بوليانا على الصفه
التى وصفناها جوهرهما قوه الزفت وقوه الزانج ح والزفت اليابس يحتج فى
الدرجه الثالثه من درجات البعد عن الاشياء المعتدله المزاج وشانه ان
يجفف كثر مما يسخن د وقوه الزفت اليابس مسخنه ملينه منضجه محلله
للخراجات التى تسمى طباوا والتى تسمى العرجلاوا سى اللحم فى العروج وقد ينفع
بوى من اهم الخراجات ح والنوعان من الزفت جميعا فيهما شى حلو وشى منضج
وشى يجلو كما عند المدا ويوجد فيهما شى من حاد جريف وكانه من ولد لك
صار كلاهما ينفعان لاظفار اذا حدث فيها البياض عندما اخلطان بشى من الشع
ودهبان ايضا القوابى وينضجان جميع الاورام الصلبه التى لا ينضح اذا وقعا فى
الاضمده وافواهنتى هذه الوجوه الزفت الرطب فاما الزفت اليابس فانه فى
هذه الخصال قليل الغنا وهو شى ادمال مواضع الضرب بلغ وانفع وهذا مما يدل
على انه يخلط الزفت شى من رطوبة جاده لبئت بالبسن د وقد يكون من
الزفت الرطب شى يقال له ماؤن وهو الزفت اذا انزعت عنه مايته

إذا طبخ إناء من نحاس مصري إلى أن ينحل ويصير مثل العسل ك؟؟؟؟ وصالحا
لما يصلح له الحضض ونفعل على الحضض؟؟؟ اذا اخلط خل او شراب ساذج الى أن ينحل
او أنومالي ولطخ به كان صالحا لوجع الاسنان والجراحات وقد ينفع بأخلاط ادوية
العين واخلاط المراهم واذا عتق كان اجود له وثمانه حقنه نافعة للمتعبد؟
والفرجه في الفرج والرحم واذا طبخ بما الحصرم الى أن ينحن ويصير مثل العسل
ولطخ به على الاسنان لم ناكل كله قلعه واذا اخلط بالدواء الذي يقال له خاملاون
مع تسع اسر؟؟ ولطخت به المواشي قلع جربها واماما كان؟ منه جديد لم يطبخ فانه
اذا انحن وصب على المقرسين والذين بهم وجع المفاصل نفعهم واذا لطخ على جلد
ووضع على بطون المجنوبين جف الانتفاخ العارض لهم ۞

زفت ۞
بصا اليغرا وهو الزفت الرطب يجمع من ادم
ما يكون من خشب الارز والتنوب واجوده ما
كان يبرق وكان صافيا نقيا املس
الزفت الرطب يسخن اكثر مما يجفف
وفيه شي من اللطا؟ فديسينها صار نافعا
للمزروبين ولمن ينقذف المرة السودا وحب
ما يعالج به ان يعلق منه مثقال قوائوس
واحد وهو اوقيه ونصف بعسل ۞ والزفت الرطب يصلح للادوية الثاثاله
واذا العزمنه اوقيه ونصف بعسل كان صالحا للمزروبين فرجه في رئته ولمن كان
به نفصدره وزبدة وللسعال قتح والربو واذا حتك به بعسل كان صالحا
لورم العضل الذي يسمى فارسما وهو عن جنبي طرسا؟ الحلقوم والمرى ولورم اللها
ولورم سبحي وهو جنبي الحلق الباطن المسمى خنائق واذا استعمل بدهن
لوز ينفع الاذان الى اذان؟؟ سبل فيها وطوبه واذا انضمد به ملح ماليوذ كان صالحا لنش
الهوام واذا اخلط به من الموم جزو مسأوي؟ وله آثار ازاله البيض العارض للاطفال

نوع السوسن المنثي ارنساو ان كان مستحكم فدعه في الثمن واعمل بهما وصفت ثم
اغزره بصدفه ۞ صفه الزيت الذي يعمل بالجزبره التي يقال لها سقور يوخد
من زيت الانفاق الجيد الابيض تسعه ارطال ونصف واطبخه بنار لينه وحركه
قليلا فاذا علي غلتين فاخرج النار من تحته ودعه حتى يبرد ثم اجمعه بصدفه وصب
عليه ما آخر واغسله وافعل ذلك ثانيه على ما فعلت به اولا واخزنه وهذا
الزيت يعمل خاصه بالجزيره التي يقال لها سقور ويقال لها السقوري وله قوه مسخنه
استحا نافعه او يوافق الحميات واوجاع الاعضاء وينعم به النساء ۞ والزيت
المتخذ من الزيتون لبري قوه مركبه حلوا وعفص معا وهو زيت بارد جدا
يدخل على قياس انواع الزيت والادهان العلاجه ان اكحل من بعض ج السبل
او اجفانه رطوبه غليطه ازده يسيرا من زيت عتيق ازال عنه ذلك وقوى
بصره وزاده نورا الى نوعه واذا اكتحل بالزيت المبيض بالطبخ والماء والنانه اللينه
من تعينه باض وادمنه اذاب ذلك البياض وازاله على طول الايام وشفاه
من جميع العلل العارضه من زياده الرطوبه وهو يقوم للعين النازل فيها الماء سقام
التي بالحديد اذا قطر فيها وحكت برائس الملح حكا كثيرا ويجب ان يكون
هذا الزيت قد عتق سنه وما زاد كان افضل مجهول مزلعته عتب
واخذ الزيت لعتق فنخنه ودهن به مجمع سكن الوجع في المكان زنبار
الرازي الزنبار هو مثل الزيت ۞ ۞ هذا التل من جوهر ارضي حار الا ان
جزاءته ليست بكبيره فخرج الى المتولد بج البر فان طبخ كما غلظ واشتد تحقيقا
فليوضع في الدرجه الثانيه من درجات التجفيف والامتحان ممده وسبب
هذا شي الفروج التي يحدث في الابدان البابنه وهتج الفروج الحاده تخرجه
عبر ها من الاوبار كلها لان فيها شيئا وعبر الكمل في الرابع والزفت
البابس والفتر فان هذه ايضا تنمل الحاجات والنواصير الحاده في الابدان
البابنه وفنح و سفد ما يحدث من الابدان الاخر لها ۞ اموز غي عكر الزيت

التي يخرج ويُسقى منه للأدوية النافعة وسفّيا ويكون ذلك دائما واذا اشرب منه
نفع واي بما ان الشعير مثله وبما جاء استهل البطن واذا الطبخ بالسراب وسقي
منه وهو سخن نفع واني نفع من به مغص واخرج الدود الذي ني البطن نفع اذا
اجتُنب من النوع العارض من ورم الأمعاء ومن شده عارضه من وجع باليبس
والعيون منه اشد انتفاعا وكحلا ويحل به لحد البصر فان لم يحضرك زيت عتيق
واحتجت به قصبه فآنا مزاج دزیت شقذ علته والطبخه حتى تسخن وتصير مثل
العسل واستعمله فان قوته مثل قوة الزيت العتيق وزيت الرتبون الني فابض
منفعته في الطب دون منفعه الزيت التي ذكرناها قبل وموافقته لمن به
صداع مثل موافقه دهن الورد وحسن العرف ومنع تساقط الشعر الفريب من
السقوط من ان ينقط وحلوا النخاله من الراس والتزوج الرطبه والجرب المتفرج
وعسر الخروج ومنع الشيب ان ينبت اذا ادهن به كل يوم واذا امضمض به للسن
التي ما كسرانفعها وثبت الاسنان المتحركه وقد هيأنامه اذ اتخوكما يطبخ
للسن التي يميل اليها الفصول وينبغي ان يوخذ صوف ويلف على ميل ويغمس في زيت
ويوضع على السن الى ان ينضج وان احببت ان ينضج الزيت فاعمل هكذا اعمد الى زيت
لونه الى البياض ما هو ما لم رأت عليه اكثر من رجل وصبه في اناء من خزف
جديد وأسع القم ويكون كيل الزيت خمسه وسبعين رطلا وصبر في الشمس
واغرفه بصدفه في كل يوم اذا انضفا لنهار واعلم يلك انك لشدحمه الزيت
اذا اخذ فينقلب بشده الحركه ويرغي والى اليوم الثامن من نصيرك كا به في
الشمس خذ حلبه منقاه وزن خمسين مثقالا وانعها ني ما جاز فاذا انت
القيتها ني الزيت قبل ان يصلى ماء وها والوني ها ايضا اتسم ما يكون من خزف البوت
مقطعا قطعا صغارا مسلما القت من الحلبه فاذا انت عملت ذلك وانت عليه
نما يه ايام فاعرف الزيت بالصدفه فان كان ينسحك فصبه ني اناء حديد مغسول
بنحمي عتيق وقد فرشت فيه من اكليل الملك وزن اثنى عشر مثقالا ومثله من ذهر

انهضامًا من الأخضر فإذا انهضم في المعدة انقلب الى المرة الصفراء ثم يعز فصار مرة سوداء ولذلك ينذر رافسًا مظلمًا للعين د واذا ضمد به منع الفروح الخبيثة من ان تسعى في البدن وفج الفروح المسماه اراقس زيت ح والزيت العذب المتخذ من الزيتون المدرك رطب ونحن انخا معدلًا واما الزيت المعتصر من الزيتون الفض وهو الانفاق هو بارد لما فيه من القبض ايضًا من البرودة واما العذب المتخذ من الزيتون العبق فهو اشد من الانفاق انخانًا واكثر تحليلًا واما الزيت العبق فهو اشد من الانفاق وفيها قبض فاما فيه قبضه فقوته مجففه حتى اذا انطلع عنه القبض شبيها بالزيت المتخذ من الزيتون العذب والذين يلقون مع الزيتون ايضًا اغصان الشجره ويعصرونها معها يجعلون يعلم هذا قربا من الزيت الانفاق وهو فوته وليس ينبغي ان يعصر على الملح عن الزيت هل فعل به هذا جير اعتصر دون ان ينزوقه فان وجد نافيه شبا من القبض فليطرا ان فيه شيًا من البرودة مثل ذلك المقدار والزيت المجلوب من انزا هو على هذه الصفه وهو المسمى ساج فان انت دفت الزيت ولم يجد فيه قبضًا اصلًا بل يجده غذبًا صادقًا والعذو به فينبغي ان تعده جارا باعتدال فان وجدته مع هذا طيبًا وما الصافي جوهره الجيد المنشف الذي اذا اخذ منه شيئًا يسيرا امتد على موضع من البدن كبير من غير ان ينقطع وبلعه البدن ويشفه فينبغي ان يظن به انه جيد جدا وان فضله الزيت لواجبه له موجود فيه وهذه صفه الزيت المسى ساسون والزيت اذا اعلا صار لا للدعته د الاورن وهو الزيت الذي يعمل من الزيتون الفض وهو الانفاق وهو او في للاضحاء وخاصه ما كان حديثًا غير لزج طيب لرايحه وقد يستعمل منه ما كان زيد على هذه الصفه في ادهان الطيب وهو جيد للمعده لما فيه من القبض ويشد اللثة ويقوي الانسان اذا امسك في الفم ومنع من العرق والزيت العبق الذي من الزيتون النضج يصلح للادويه وجميع اصنا ف الزيت جارد ملينه للبشره يمنع البزد من ان يسرى الى الابدان ويشطها للحركه ويلين الطبيعه ويضعف فوه الادويه به

البستانى اذ الهب فيه الناس اذ الطخ به اوراث الخالة النبتَ الرَّاس والحرَب والقوبا

الفلاحه اذ علق بعض عروق الزيتون علٮ مں لسعه العقرب برى واذا اُحذ عرف شجر الزيتون ووزنها وطبخ بالماء ومضمض به وهو حار مں شتكى راسه مں برد سكن الوجع واذا اصبه المزكوم علٮ راسه حلل رطوبات كثيره مں راسه واجدرَها وحفف الزكام وان انكب علٮ بخار هذا الماء وصبر علٮ ذلك حتى ینقدخ اجدرَ الرطوبه من المحرين والزاير واجراها سفلا وهو اجل المقدار لهذه العله د وصمع الزيتون البرى فيه مشابهه مں السقمونيا وفى لونه شبه مں اللاقوت الاحمر وهومركب مں قطرات صغار یلذع اللسان واما ما كان منه شبها بالصمغ عظيم القطر ان املس لیس بلذاع فانه ردى لا ينفع به والزيتون البستانى والبرى الذى بِلادنا قد یخرج صمغا علٮ انه لا ینفع به مع هذه الصفه والصفِ الاحر مں صمغ الزيتون البرى یصلح لغشاوه البصر اذا اكتحل به وجلوا والفرجه التى ٮنال لها لو قومآ النى ىكں ٯى العيں وبدَّ البول والطمث واذا وضع ٯى المواضع الماكله من الاسنان سكن وجعها و فَدْبعد مں الادویه القاله وقد یُخرج الحبں وبرى النوائب والحرب المفرج وثمر الزيتون اذا انضمد به شعى مں نَخالة الراس ومں الفروح الحبيثه وما داخل نوى الثمر اذا احُلط بشحم ودقىٯ فلع الاتار البیص العارضه للاطفار واما الزيتون الذى ىٯال له فولسادس هو زيتون الماء اذ كاں محوفآ وىصمد به لم یدع حرو الناس ان ٮتنٯط وتٮٯى الفروح الوئه **ابں عمراں** الزيتون الاحصر ردى ابر عاقل للطبیعه دابع للمعده ومقولہ وهو ىبطى ما ىنهصام ردى الغدا فاذا رٮى بالخل كان اسرع انهضاما واكثر عقلا للبطں واذا اعمل بالملح اكتسب منه جزان وكان الطف مں المنقع فى الماء واما الملح الذى كبر فيه الزيتون اذا ىمضمض به شدَّ اللثه والاسنان المىحركه والزيتون الحدىث الذى لونه الى لون الياقوت ما هو ىحبں البطن وهو حید للمعده واما الزيتون الاسود الصىح فانه سرٮع اَلىسَٯادِ ردى للمعده عبس موافق للعبں **ابں عمراں** جاز ابر وهواسْرَع

ويحوي ويضمد به منع الجمرة من ان تسعى في البدن ومنع النمله والفروج والشرا
والفروج التي تسعى اسراما وهي النار الفارسيه والفروج الخبيثه وينفع من
الداحس واذا انضمد به مع العسل قلع الحثاليثه وقد ينفي الفروج الرخصه واذا
خلط بالعسل وضمد به جلاء الورم الذي ينال له رحلا والاورام الحارة ويبرى جلد
الراس اذا انقلع واذا مضغ ابرا الفروج التي في الفم والقلاع واذا اضمد بالورق
مع دقيق الشعير كان صالحا للاسهال المزمن وعصارته وطبيخه اذا اجتملت قلعت
سيلان الرطوبات السايله من الرحم المزمنه ونفث الدم وبرد نتوا العين وينفع من
قرحة العين التي ينال لها قلغطانا ومن فروج اخر وتقطع سيلان الرطوبات اليها
ولذلك تنفع اخلاط الشياف لتاكل الاجفان ثلاثا واذا اردت ان يخرج
عصاره الورق وقد ده وتش عليه شيا من دلك ياه ماء او ماء وعصره ثم جفف
العصاره في الشمس ثم اعلها اقراصا والعصاره التي ينفع فيها شراب هي اقوى من العصاره
التي ينفع فيها الماء واصلح للحزن منها وتضع للاذان التي يسل منها القيح والاذا المتمرح
وقد تحرق الورق مع الزهر وتستعمل بدلا للتوتيا اذا لم يكن حاضرا بان يوخذ ويجعل
في قدر من طين ويطين راسه بطين ويوضع في اتون ويودع حتى يستوى ما في الاتون
ويصير خزفا ومن بعد ذلك يرش عليه شراب وبرددم يحمر يحرق ايضا ثانيه
مثل ما الجزر اولا يبدل كما يفعل باسفيذاج الرصاص ويعمل اقراصا وقد
ظن به انه اذا احرق على هذه الصفه المبس يدور التوتيا في منفعته للعين وان دونه
كمونها وقوة وذن الزيتون البستاني شبيهه بقوه وذن الزيتون البرى غير ان قوه
البستاني اضعف وهو اكثر موافقه من البرى للعين لانه اسلس واخف عليها
منها **الطبري** وذن الزيتون يقبض وينفع من اكل الاسنان اذا طبخ وامسك
العليل في فمه ماء : **غيره** وذن الزيتون يقوي اللث ويحمر الشفه واذا طبخ
فيما الجمم جني نصير كالعسل ولطخ به الانسان الماكله قلعها وان احتزن به ينفع
من فروج المقعده الباطنه والرحم **د** والرطوخ به السايله من رطب خبب الزيتون

في الطيب وهو جار بازبنى التابتة قابض محلل ملطف جابس للبطن :: **مسنج**
الزرنب سبى از جل الجزاد :: **اللطبى** الزرنـادى العطر وهو مشل ورق الطرفا
اصغرة **البصرى** الزرنب خشن دقبق طيب الرائحة بسمله العطارون لطيبه وبسبه
وبسبه زائحة الاترج وقوته جارة بابنه :: **ما سرجويه** قوته كقوه جوز الطيب
الا انه الطف منه قليلا :: **بولس** جار بابس سببه النوه بالسلخه والكبابه
ومن هنا قال **سراببون** ان لم يحضرك الدارصنى فبنبغى ان ىستعمل الزرنب
مكانه :: **غىره** يجلل الزياح وينفع الكبد والمعده البارديـن وبسعط منه
بما ودهن وزد للصداع البارد :: **زيتون** حو ورقه هذه الشجره

الالا غرىا وهو زيتون
برى

وعىذانها الطريه فيها من البز رودنه بقدار ما فيها من الخضر نها ما فبه
منها مدركا بضيحا مستكملا النضح فهو جبط انجار معتدله وما كان منها غير نضيح فهو
اشد بردا ونبضـا من الزبتون حو **الالاغرىا** وهو الزبتون البرى ورقه اىرد ادق

الزعفران وقوته مخنه منومه ولذلك كثيراً ما يوافق المبرسمين اذا ادهن به
او اشتم او دهن به المنخران وينفع الاورام ونقى الفروج الخبيثه ويوافق صلابه
الرحم وانضمامه والفروج الخبيثه العارضه فيه اذا اخلط بلبن وزعفران
وشمع وضعفه رئيساً لانه ينضج ويلين وينكز ويرطب ويسلح الزرقه اذا انحلابه والذين
لا يقلد ودن ان يستعملوا صنو الثمر واما الدواء الذى ينال له فروقوما فانه يكون
من الادهن المعمول من الزعفران اذا اعتصرت الافاويه وعلامتها اخراص والجيد منه
ما كان اطيب الرائحه قيه من المر باعتدال وكان زنما اسود ليرقبه عيدان وإذا
ديف كان لونه قريبا من لون الزعفران جدا وكان لبنائيه شيء من المرارة يصبغ
الاسنان اللسان صبغا شديدا وسقى ساعات كبير والذى من سوريا على هذه
الصفه قوته جالبه لظلمة البصر مدرا للبول مخنه منضجه وقد يشبه الزعفران
شبها يسيرا لان فيه من قوته شياً والله اعلم · **زنب** **النلاحه**

الزنب صنف من الآس الا انه اكبر منه ورقاً ناقض الخضرة الى الصفرة وهو
شجر ضعيف زخولا

ابن غبران

الزنب شجرة عظيمه
فى جبل لبنان بالشام
لا تنبت ورقها طويل
بين الخضرة والصفرة
يشبه ورق الخلاف
ولون النضبان
كلون الارز ورائحتها
كرائحه الاترج
ويدخل ورقه واغصانه

بهضم الطعام و لبن جيد للدماغ و لا الأكثار منه محمود لأنه بذهب شهوه الطعام ∴ مسيح ∴ كلواغشاوه البصر و ينبج سددا الكبد و العروق لا أنه يفسد الدماغ ∴ الرازى ردى للمعده معش مصدع ثقل الراس و جلب النوم ∴ الإسرائيلى ينفع من عسر النفس ويقوى الأعضاء الضعيفه ∴ ابن عمران ينقى المثانه والكليتين و ينفع من الشوصه اذا شم و اذا صب طبيخه على الراس نفع من النزل الكاين عن البلغم المالح و اسدر و ارقد و من خاصته ان يحس لون البشره اذا اخذ يقصد و اعتدال ∴ البصرى بدمل الخراج و يعض ينفع من الشوصه اذا شرب و استعط به و اذا اكتحل به مع المآء نفع من الزرقه اجاد ثم من مرض ∴ الاسرائيلى اذما يه مذموم جدا لانه قتيه كبيته تخلا الدماغ و العصب و نضض بهما اضرارا ابينا ∴ الطبرى ان شحى وعجن و اخذت منه خزن لها اعظم الحوايز ه و علقت على المرأه بعد الولاده اخرج المشيمه و كذلك ان علق على اناث الخيل ∴ عنبره يصلح العفونه و لا يغير طلا البته بلحفظها على السويه و يقوى آلات النفس جدا يفرح القلب و ينفع من صلابه الرحم و انضمامه و الفر وج الخبيثه فيه اذا استعمل بوم و زيت و ينفع الطحال ويشد البطن و اذما يه يملا الدماغ و العصب رطوبه و يظلم الجوايز و اذا اسعى منه وزن درخمين للمرأه البتي قد عسر بها الطلق ولدت من ساعتها د و اصله اذا شرب بالطلا ادر البول و اذا اكب صايعا دهن الزعفران و هو فرونس فبعض الريت على ما وصفنا في صنعه دهن السوسن و لكن منه مثل ازا الزيت و ما بعضه به كالمقدار الذي حددناه لك هنالك و خذ منه مثله ارطال و يصفى و يلقى عليه من الزعفران خمسين مثقالا و حركه مرارا كثيره في النهار جزكه دايمه و لكن ذلك خمسه ايام و في السادس صف الدهن من الزعفران الق عليه من الرامجبو وا اربعين مثقالا و حركه في هاون او دعه و من الناس من يستعمل في صنعه دهن الزعفران الزيت المطبب الذي يعمل منه دهن الحنا و اقوى دهن الزعفران ما كان منه مشبعا من الحنه

ليس منكرج ولا ناطع الرائحه جادها وما لم يكن على هذه الصفه فإنه إما أن
يكون عتيقًا وقد انتفع وبعد هذا الصنف الذي من وقرش التي تلك الـ د
التي تنال لها وقبا والذي من الجبل الذي ينال له او لمن الذي بلوفيا وبعد هذا
الصنف الذي من البلاد التي ينال لها اخام من البلاد التي ينال لها اطوليا وامــا
الذي من البلاد التي ينال لها مربى والذي من المدينه التي ينال لها نطوىسطس
التي بصقلبه فانهما ضعيفًا القوه وهما في جدا النقل ولكن عصارتهما اوجس
الوانهما وصبغها الصلابه التي يمتحن ان عليها بستعملها اهل انطاىيا ومن اجل
ذلك انهانها كثير واما الذي ينفع به في الادويه من هذه الاصناف فهو
الذي ذكرنا انفا وقد غشر الدواء الذي يقال له فروقوما مدفوفا بالمراىخ
او لولوليدا البنقل ويلط بطلاء النبل بلا معرفه ذلك من التي الظاهر على الزعفران
كانه عبارات وانه راجعه شيا من راحه الطلاء ح في الزعفران بىث فا بعض
فا بغرباس من هذا امنه ارضى بازدو ولكن الاغلب عليه الكيفيه اكا ن فىكون
جوهره في الامحان من الدرجه الثانيه ومن الجتف في الدرجه الاولى ولذلك
صار ينجج بعض الانضاج وممابيينه على ذلك للنبض البين الموجود فيه وذلك
لانما من الادويه التي لاينجى انجاقويا وكا ن فيه نبض فهو في قوه مضاد للادويه
التي ىغرى ولج اذاكان معها جز ان موجوده وليست بالشديد النبض في ادويه
تنجج ح وقوه الزعفران منضجه لينه فابصه مدره للبول يجتر اللون ويذهب
بالخمار اذاشرب بالمسنجىن ومىع الرطوبات التي تسيل الى العبن ان لطخ به أ ا
المجلىه يلبن امراة وقد ينفع به ابضا اذا اخطا بالادويه التي يشرب للاوجاع
الباطنه والترىىحات والصماد اسلتستعمله لاوجاع الارحام والمعقده وحر ك
شهوه الجماع ويسكن الحمره اذا طلين به وينفع من لا وزعم اجا ىه العارضه للاذان
وقد يقال انه ينقل اذاشرب منه وزن ثلثه مثاقىل بماء وينبغى أن يوضع في الثىن
او على خزف جدىدا بجاز وحرك دايما في وقت ليجف وبرن بعقده ابن ماسوبه

هو الباذنجان بالعربية من الحاوى ۰ وفعلا هو الدرنلبل بالهندبه
من الحاوى ۰ وفسا هى الفوه بالهندبه من الحاوى ۰ وفل هو ملس
المثل وعذيناك على نجرة اعنى الدوم قاله ابوحنيفه ۰ وفلافيطس
هو التبسالبوس من الحاوى ۰ ويمردل هو اظفار الطيب بالهندبه من
الحاوى ۰ وموبهشير هو الزنج الاصفر بالهندبه من الحاوى
وقور هو اظفار الطيب بالهندبه من الحاوى ۰ ومسح هو البلث
وسنن هو البزبازين بالهندبه من الحاوى ۰ وشج هو الوشق هو
الاشق ويجولا هو السندروس بالهندبه من الحاوى ۰ وسردوسا
هو الطباشير من الحاوى ۰ وسطر هو الاراك بالهندبه من الحاوى ۰ وهيك
هى اظفار الطيب بالهندبه من الحاوى ۰ ومل فسا دريس هو الاراك
بالهندبه من الحاوى ۰ وهود رنفى هو التوث بالهندبه من الحاوى ۰
وهودها هو الدادى بالهندبه من الحاوى ۰ وني هى الغبر الهندى من الحاوى

حرف الزاى

زعفران د آ نروقس اقواه خلاصه الطيب ما كان من البلاد التى ينفاك
لها قرونس وكان
جدثاً جنس اللون
وعلى شعربه بياض
يسير طويلا ضخما
ليس منفتت هشا
مملياً واذا دبف
صبغ اليد سريعاً

شلا لعاقر قرحا من الحاوي ٠ وردحريف في الحاوي انه العذروق
الصفر التي يقال لها الكركم ٠ وردحوية هو الصنف الكبير من
العذروق الصفر ايضا من الحاوي ٠ وردمثل في الحاوي قال شكله
شكل طابرحان بين الاولى هو اصفر لبني بائر الريح ٠ وردبري
هو صنف من الحلو وهو السرين ٠ وردصيني هو السرين عن ابن ماسه ٠
ورط هو الزنجبيل الهندي من الحاوي ٠ ورطا هو الراوند بالهندية
من الحاوي ٠ ورطبغى هو التمرهندي بالهندية من الحاوي ٠ ورعفو
هو التنبل بالهندية من الحاوي ايضا ٠ ورف هو الدرداز وهو يختز البق
بالفارسية ٠ ورف لسنبل هو الناذج بني بذلك لان رائحه رائحه
السنبل ومن ظن انه وزنه بالجفيفه فقد اخطا ٠ ورفم قل هو
الزعفران واظنه قرفم هو الزعفران بالرومية وقع فيه تصحيف ٠ ورقا
قال أبو حنيفه هي شجرة تنمو أفل ومها وساقها ورقها وواسع ذبق
ناعم تأكله الماشيه كلها وهي عبرة الناس خضرة الورق لها رسم شعرها اجب اعبر
مثل الشدانج ربعاة الطير وهو سهلي نبت في الأدديه وجبلها وفي الفعان ٠
ورومولا هو الجاوي شير من الحاوي ٠ ورس نبات يكون باليمن يستعمل
في الطيب وفي الصبغ وقد تقدم ذكره ٠ ورس التج عقر يوجد فيها اذا بلغت له
صبغ اصفر ٠ والورس ايضا الحجر الموجود في كردوس البقر سمي بذلك للونه
وزعم قوم ان الورس ايضا هو الكركم ٠ ورس نوس هو النكاعي
من الحاوي ٠ ورسفوى هو الجلنث من الحاوي ٠ ورسسقنا
هو المجوده من الحاوي ٠ ورسك هو الورس ٠ ورس بوطو
هو البلاذر من الحاوي ٠ وركسويه هو النكسوه وهو بالعزبية
التبشان من الحاوي ٠ ورمط هو السل بالهندية من الحاوي ٠ وهو
طراس هو البل بالهندية من الحاوي ٠ وص هو الوج ٠ وعد

ونقيس هو النفط باليونانيه ۞ وبلج هو النيلوفر بالهنديه من الحاوى
وبح قال الطبرى هو الطرخشقوق بالنارنجيه ۞ وبلغه هو اطفار
الطيب بالهنديه من الحاوى ۞ وهو سوطود هو الشبت بالهنديه من
الحاوى ۞ وبول هو المزمن الحاوى ۞ وبوقرا هو الزعفران
بالهنديه من الحاوى ۞ وحانيه هو الهليون من الحاوى ۞ وحنا هو
الهليلج من الحاوى ۞ وحقرا هو الفلفل بالهنديه من الحاوى ۞ وحان
هو الشافنا وهو السوس بالهنديه من الحاوى ۞ وحط هو اللك بالهنديه من
الحاوى ۞ ودى هو الكما باليونانيه ۞ ودنه قيل هو لبان الجمل
ودرباسر هو السكبينه من الحاوى ۞ ودركهزا هو الحسويه من الحاوى
ايضا ۞ ودرومار هو المامرد انه من الحاوى ايضا ۞ ودرد هو البلسكى
وراس هو الارز بالهنديه ۞ وريها هو المزمن الحاوى ۞ وربطى هو
هندى بالهنديه من الحاوى ۞ وربوعون هو عنب الثعلب المحير باليونانيه
ورح قال ابوحنيفه هو شجر يشبه المرخ نباته غير انه اغبر له ورق
دقاق ومثار رزق الطرخون ان اكبر قلابه الغبر ۞ ورجالون قيل هو الكره
البتاء بالبربريه ۞ وزد هو نور كل شجر ثم خص بهذا الورد المعروف
وقد مضى ذكره ۞ وزد الحب قيل هو الكبح وقيل هو نبات يتعلق بالشجر
وينبت منها دله ثمر يشبه ثمر الخرنوب ثم وطو يل وعليه زغب دنو مثل
زغب القتا الصغير لونه الى الحمره ويلزق بما ينه يجر ق مثل ما يفعل الاخبره
ويسقط الموضع ويحدث فيه حده شديده وله نور يعجب وهو الذى يعرف بوزد
الحب ۞ وزد الحمار قيل هو وزد اصفر الخارج احمر الداخل ذعم
قوم انه نوع من النرجس وقيل هو البهار واهل بلدنا يسمون القاوونيا وزد الحمار ۞
وزد الحجاز هو وزد الحجاز ۞ وزد دوا هو ثنا ئى النعمان
بالسريانيه من الحاوى ۞ وزدهس يسمى ايضا انيون واصله جار با بش

في الأسماء قبل أن نحدث فيها عنوته ۞ ورل ابن سينا هو عظيم من أشكال الوزغ وسام أبرص والطويل الذنب الصغير الذنب الرائحة جداً وبين بثوه شحمه ولحمه وخصوصاً طبقات من الآناء وفيه قوة جذب النبل والشوك مع

وهذا شرح ما وقع في هذا الباب
من الاسماء

واندرينا هي الطرفا بالهندية من الحاوي ۞ واندوه هي الجلنا بالهندية من الحاوي ۞ وانطوا هي الناليوس بالهندية ۞ وابو حبس هو جافر الحمام من الحاوي ۞ واد أقلبسا هو المازريون بالزرانية من الحاوي وادهي هو القنط بالهندية من الحاوي ۞ وارىعد هو اللك بالهندية من الحاوي ۞ وارطا هو السل بالهندية من الحاوي ۞ وارم هو اللاك بالهندية من الحاوي ۞ وارغالا هو الصأصلي واطابسنا هو الخروع بالهندية من الحاوي ۞ وارعاطا هو الطاشير من الحاوي ۞ واسفرى هو العشرق من الحاوي ۞ واسك هو السنجاذ ۞ واليه هو الطلع ۞ والكسه بالهندية هو ورد الحب ۞ واهليم هو الزعفران بالهندية من الحاوي ۞ وسجين هو يحبون من كتاب ۞ وترارة هو لا أعلم على ما وقع في بعض الكتب وأظنه كثيراً وقع فيه التصحيف ۞ ونيط هو الشيخ بالهندية من الحاوي ۞ ونطلو هو الجلنار من الحاوي ۞ ويموا هو سويق الزبيب من بعض التراجم ۞ ونير هو الحين من الورد ۞ ونوى هو الكرماذك من الحاوي ۞ ويداهي هو الدارفلفل بالهندية من الحاوي ۞ وبذرون هو التربد من الحاوي ۞ ونوسد وسطر هو الدخن بالهندية من الحاوي ۞ وردي وطر هو اطفانا الطيب بالهندية من الحاوي ۞ ونعرمدهارا هو الماهودانه

في آناءٍ من خزفٍ وليكن عملك لما وصفنا في شمرِ حارةٍ ومن الناس من يأخذ شمّ
الصوف فيغسله ويعصره ويخرج ويخه ويغلي الدهن بالماء كما ذكرنا وجمعه ويصيّره
في آناءٍ من خزفٍ قد صيّر فيه ما جاز ويعطي الآناء خزنةً من كان بصيره
في الثمن إلا أن يخرج الدهن خالصًا وبعض من الناس يزيد الماء فيها يبين
يومين وأجود هذا الدهن ما لم يفح منه رائحة اسطر وبسور وكان زبناً حنتَ الجنة
إذا امرستَ تفوح منه رائحة الصوف واذا ذيب في صدفةِ ماءٍ باردٍ لم يغرْ لم
يكن فيه شيءٌ جاسٍ ولا متعقد كالذي يغش بالموم المذاب بالزيت او بالشحم ولدسم
الصوف قوةٌ تسخنَ مليِّنةً للقرُوحِ الكائنة وخاصةً القروح العارضة في
المقعدة والرحم اذا اخلط باكليل الملك وزبد واجمل من صوفهِ اذا رُ الطمث
ويُهل خروج الجنين واذا اخلط بثمر الاس وكان صالحاً للقروح العارضة في
الآذان في القروح والنكر وما حولها وقد صلح الماء في المناكلة الجبنية
والجنون الكائنة التي نشأ فظ اشارها وتأكل الخلجنين ونفع من الشنج
[خ] الوسخ الذي يجمع على صوف الغنم الضارن واخذها ولبنما الزوق الرطب
فنضج وحلل [د] وقد يخرج وينخ الصوف في فخار جديد إلى ان يصير رمادا
وبقي دسمهُ وجمع منه دخان ينفع في اخلاط بعض ادوية العين ود ع
بعض الاطباء هو صنفٌ من المحار شبه الجلزون الا أنه اكبر منه
وخزفه اصلب وكلاهما يدخل في علاج الطب يخزف وغير يخزف وبعض الناس
ينيه سوا الهند: منسخ الودع والجلزون اذا اجزا جففا الله ونفعا
من قروج العين وقطعا الدم: البصري لحم الودع صلب عسر الانهضام
فاذا انهضم عنذا غذا جدًا ولين الطبيعة واذا الحرق الودع يتولد منه جزان
وبوسه وجلا البهن والثوابي ونفع بياض العين وجلا البصر واذا دق ناعما
واستعمل نشفَ الرطوباتِ الحادثة في الاعضاء المترهلة وهو صالح لاصحاب الجبن
ولر ماده تجفيف كثير وتحين سير فاذا اشرب بشرابٍ بعض نفع القروج الكائنة

بسخن وجلا ومثى الحمر ويوافق اشقاق الذي يكون في البواسير اذا لطخ بها موضعها
خ ح ونفع الحام بلبن لبنا معتدلا : عنبرة ونفع الحام صالح للنفط. ونفع الكور
ا ب و ا ن د هو الوسخ الاسود الموجود على ابواب وحيطان الكوائر ملطخا بها
لي الكوائر من الخلايا وفي اجاج النحل وزعم ابن سجون واكثر المنطبين ان وسخ الكور هو
العكبر وهو خطا والعكبر شي اخر وهو شي اسود شبيه بالزفت وهو اول شي يضعه
نحل الكوائر ثم يبنى عليه الشمع والعكر والعسل د ب فوقولهم ونفخ ذاب النحل ينبغى ان
تختار منه ما كان لونه الى الحمرة وكان طيبا لرائحة وكل ما بها بالصفرة من المنعقد
الذي ينبىء الاسمانرك وكان لينا لين مرط اللبن متى مدمتى مد المصطكى خ ح حلوا
حلا وليس بالكثير ولكنها يجذب جدا بالغا لا ان جوهرة جوهر لطيف ومسخن
في الدرجة الثانية في يبس لحرها وفي المالثة عند ابلاها وقوة ونفع الكوائر
مسخنة جدا جاذب يخرج السلا من باطن اللحم واذا الخبز به نفع من السعال المزمن والخط
واذا اوضع على الفوائد يحلاها ويوحدني الكوائر بشبه المومى في الطبع.. و د ح
وهو الزفت الرطب د ب استيقس وهو الودخ الموجود في الصوف يعمل
هكذا خذ صوفا نقيا وتخاولا اغسله بما ينقى فدخ فيه سطرا ويهون ما
يخرج منه من وسخ وضبن في اجانه واسعة الفم وصب عليه ما واعر قه وصب
من علوا اجانه بطرحان اوما اشبه ذلك دائما حتى يرغى وحركه بحميه
شديدا حتى يجتمع رغوته ورش عليه شيا من الماء البحر فاذا سكنت رغوته فاجمع
الدسم الصافي وصيره في انا فخرف ثم صب في الاجانة ايضا ما اخر حركه ثم صب
على رغوته شيا من ماء البحر ودعه حتى يسكن ثم اجمع ما بقى على الماء ولا يزال تفعل
ذلك الى ان ينفى رغوته ثم خذ الدسم المجتمع وامرسه بيدك فان ظهر لك فيه شي
من وسخ فاخرجه منه على المتال الذي وصفناه من صب ما اخر عليه وتحريكه
بعد ان يصب الماء الذي كان زبيه قبل ذلك وتخرجه عنه ولا يزال تفعل لك
وتصب عليه ما اخر وتباطل اليد حتى ينقى ويبيض فاذا فعلت ذلك فخزنه

وخاصه اذا اشرب اصله باللبن الحليب واذا نعته الغنم كثر نتاجها وهو معروف
مشهور ببلاد البربر: **وسخ** خ ح الوسخ يكون في ظاهر الجلد وفي باطنه
وفي الاذنين غير ان القدماء قد تركوا ذكر وسخ الاذان لنزارته وقلته
وزعموا ان وسخ الاذن يبس الاورام التي يقرب من الاطفا وانما وسخ جميع الجسد
فقد يمكن جمعه من الحمامات ومواضع المصارعه وهو ينفع مما ينفع العرق وكونه
يدل على طبيعته اذا ان مخرجه من المجارى الضيقه ولا يخرج منها الا ما لطف ورق
وبقى غليظه وكدة وقوته بأنه بغير شك وقته شى من الحزاز ز د الوسخ
المجتمع على البدن عند الصراع وخالط التراب ينفع بد من العتيدا العارضه في الرحم
اذا وضع عليها و ينفع من عرق النسا اذا وضع وهو يحن على الموضع بدل مرهم وكماد
ز ح وأما الوسخ الذى يوجد في التماثيل الموضوعه في مواضع الرياضه وهى التى
يحترق فيها الزيت كثير فهو ملين محلل وأما الوسخ الذى يجتمع على ابدان الناس وقت
الرياضه فيجتنب ما فيه من الغبار المتنفع من ذلك الموضع الذى يمر بخون بها وتكون
مشابه لوسخ التماثيل والوسخ الاول من هذين هو محلل للخراجات التى لم ينضج والبارد هو
دواء نافع للاورام الحاره الحادثه في الثديين وذلك انه يطفى لهيها ويمنع ما
ينصب اليها من الاخلاط ويحللها قد انجد ذرو فرع لانه شى مركب من غبار زوريت
ووسخ بدن الانسان وعرقه والغبار دواء ان بحلان فاما الوسخ الذى يوحد من
التماثيل فانه لما كان ليس فيه غبار ولا زايد فيه نجازيته موجوده من قبل
النحاس التى منه تلك التماثيل يحمل حوله ان يكون له احد مر ذلك الوسخ الاخر
د ا الوسخ الموجود في تماثيل النحاس من الزيت ينخر ويحلل الجراحات العسره
التحلل وأفوه البحرج والفروح العارضه للشيوخ: **عنزه** وسخ الاذان
ينفع من الداجتراح اذا لم يكن فيه فتح واذا طلى به الشقه المتفقه في ابتدا الشقاق
نفعها وينفع من نهش الافاعى ينفع ابتنا وقال ان وسخ اذان الحاز اذا استى منه ورن
ثمن درهم للصبى الذى لم يبك ز د والوسخ المجتمع فى الابدان فى الحمامات

وسنڡنايرخصالڊكلها. وخشيريڡ نلانه نبات يشبه
الاڡستىں الرومى اصفر
اللون سهك الرايحه
يوتى به من خراسان
ويعرڡ بالحشيـ
الخراسانيه يخرج
الدود وجب العرع
وهو ذلك ڡوى
الفعل. المجوـ
الحشيشه الخراسانيه
اجودها ما كـ نبـ
خضرا وطعما هامر والحيـ
نالحه وهى حيـ
بايسه يخرج الدود
وجب الڡرع جزاوها
غيره الشربه منه
وزن مثڡال ه
وطم اصله
بالبزبزيه او طلمو
وهو نبات يشبه الاذخر
يعلوذراعا وله اصل
اسود داخله ابيض
يڡوى على الجماع جدا

اذا دخلت في عابه :: **منبج** جاز بأنبس في أول الثانية وأبضله قوة صابغة صبغة
أصفر جمرة وجلوا ونفع من الكلف اذا طلى به ومن البهق الابيض اذا شرب منه
البذر اذا الطلى على المروالحدية والبثور السعفة والقوابى نفع منها :: **عبره**
من لبن يرتبع بمصبوغا بالورد ينع الابصار

ورد الحمار البصرى
ويبنى الصفر وورد الغفار وهو ورد احمر الداخل اصفر الخارج ومزاجه بارد يابس في
الثالث **ابن رضوان** توى لاعضاء ويسكن اللهب العارض في الراس من الخزه
الحار وماوه نافع للصداع الحادث من ذلك :: **وسمه** منها العظم
واليلح وسندكره ومنها يحرف ثون منها الخطى ومنها البريدة ومنها الوسمه المخصوصة
بهذا الاسم وهى المعترف به بالحا المحرز عندنا وهى صفان منها صنف ورقة نحو
ورق الحماض الا انها اصغر :: وورق المرج يكون ثلث ورقات كثرذلك

وسمه نوعان

الأقراص أيضاً ويستعملها بعد إحكام فيما يبد زغب البدن وفيما ينبع به واذا اجتمعن عليك منها بماء بارد **ورس** ابن ماسه هو شي أحمر قاني شبيه بالزعفران المسحوق حلب من اليمن **ابو حنيفه** يزرع باليمن زرعاً ولا يكون منه شي بري ولا يكون بغير اليمن وساقه مثل نبات السمسم فاذا جف عند ذلك تنفتق سنفته فينتفض منه الورس ويزرع فيقيم في الأرض عشرين سنة في كل سنة يثمر وأجوده حديثه ويسمى الباذن وهي التي لم يسع تجرها والعينة منه ما نافه متحرمه ومنه صنف يسمى الحبشي وفيه سواد وهو إذا الورس وللعرعر ورس لا يكون البي عن عتيق جفت من ذا أنها توجد بين ذاباها والنسيم قديس إذا فرك أنترك ولا خير فيه ولكنه يعش به الورس والرب زوت وذلك في آخر الصيف إذا انتهى منها اصمر صفرة شديد حتى يصفر منه ملابسه **ابن عمران** الورس صنفان حبشي وهندي فالحبشي أسود وهو مردد والهندي أحمر قاني ويقال إن أنكر كم عرفه يون بها من الصين ومن بلاد اليمن ولحب كحب الماش وأجود الورس الأحمر اللين القليل النخالة لين البز الجيد القليل النخالة ودبا أن على لون النضج الجيد الخارج عن الحجم القليل سمه والسم ببلبل دقيق لبن يتعلق بالبد

حريف حاد مر وهو في الدرجة الثالثة من درجات الأشياء المسخنة ولذلك
صار يدر البول والطمث وينفع مع ذلك الأجنة ويجذب المشيمة ويخرجها ولقوة
مسخنة حارة ولذلك اذا شرب مطبوخاً زيته ادر الطمث واخرج المشيمة · غيره
اذا انضاف به الملح نفع من عضة الكلب الكلب · ولـ دد
بالعصر والناس يجنبه سوساً وسمهُ مريمَسْهُ بعد افرازه وهو نبت صغير ملآن
لبّاً وهو ورق
شبيه بورق السذاب
الأنداء وضرسه
وجه هذا النبات
مستدير مبسط
على وجه الأرض
وقد ربما يكون
نجوس نبره و يجنـ
الحية ثم مستدير
صغاراً صغر من
ثمر الخشخاش البري
وهذا النبات كثير
الثمرة وله أصل واحد
لا ينتفع به في الطب ويخرج من هذا النبات كله منه ونبت في البساتين وفي الكروم
ويجمع في أيام الحصاد ويجفف في ظل ويقلب دائماً وأما ثمرة فانها تدق وتنشف
ثم يرفع واذا شرب منه مقدار دِكِشُوبَى بقوانس من الشراب الذي يقال له اذ ومالي
اسهل بلغماً ومرّة وقد تخلط بالطبيخ واذا اكل اسهل وقد يجعل بالماء والملح ح ح هو نوع
من انواع النبات التي لها لبن وهو في ذلك شبيه باليتوع اذ يسهل في مثل ما به

أو أربع ينتثر على الأرض يلصق بها ولون ظاهر الورق أخضر إلى السواد أدهم وباطنها
أبيض إلى الغبرة أزغب وله ساق غبرا جوفا مدورة نحو الذراع عليها ورق
وتطلع في آخر الربيع زأنا صنوبرية الشكل عليه قشور هفاف شفعة لونها بين البياض
والصفرة وله زهر لطيف قنبري وفي زوسه عندنهايتها يعني شيء شبيه الصوف
كالذي يخرج من دن الحشف وله برز مزوى كالقرطم وأصله غلظ أصبع مستطيل
ومنابته الجبال والضنف الثاني ورقه أعرض وأقصر من ورق الأول وهي مشرفة
وفيها شوك دقيق وناسه في قدر زبد قه إلى الطول للمشوك وعليه زهر شبيه
الشعر لونه قنبري يستعمل ورقه في صبغ الشعر مع الخاي وهو أحسن من الأول وأقوى
صبغا وإذا فرك ورقه بالبد وردها كما يفعل قشر الجوز الأخضر **الرازي** جازه
فأبضه ينضو الشعر **الجوينى** يسود الشعر وفيه قوة مجللة وهي معتدلة إلى الحرارة

أمك **ورطورى** يسمى باليونانية يطاخيسو بالعجمية مزويه بلنوشته

هو نبت شبيه
ببراسيون إلا أنه
أطول منه وله ورق
صغار كثيرة مشين
طيب الرائحة أبيض
عليه زغب يسير وله
قضبان كثيرة مخرجها
من أصل واحد أشد
بياضا من قضبان
البراسيون ينبت في
أماكن جبلية ومواضع
خشنة طعم هذا

في زيت ثالثة واعصرها وارابعه فانه يجيك في المرة الأولى الدلالة القوه وفي
الثانية ثانيا وفي الثالثة ثالثا وفي الرابعة رابعا والطح الاناء علی كل مرة يريد
ان تعمل وان احبت ان تنتفع الورد ذلك في الدهن الذي عصرته اولا فاطرح عليه من
الورد الطري الذي لم يمسه الماء علی عددا ولوحركه بيدك وقد لطخت يديها بعسل
واعصره واعمل بالثاني والثالث والرابع علی ما وصفت انفا وان احببت ايضا
ان تلح علی الدهن الاول وردا فافعل ولكن اعلم انك كلما جددت الورد فيه قوّيته
وانما يحتمل ان تكثر عليه الورد سبع مرات فاما اكثر من ذلك فليس يحتمل
وللطخ المعصره بعسل وينبغي ان تنفضي بنت الدهن من عصارة الورد فانه ان ثبت
منه بقيه افسدت الدهن وان كانت قليله ومن الناس من ينقل الورد وينقعه
في الزيت وبدله في كل سبعة ايام ويفعل ذلك مرات ثم يعتركه بيدك ثم يخزنه ومن
الناس من يعصر الزيت بقصب الذريره ويشتغال ومنهم من يلقي فيه
ختم احمر بحمزة وللحال للافسد وله قوّة قابضه مبرده وصلح للادهان وللخلاط
بالضمادات ويسهل البطن اذا شرب ويطفئ التهاب المعده وينبت اللحم في الفروج
العميقة ويبكر رداءة الفروج الرديه ومدهن به الرأس للصداع في ابدايه
ومضمض به لوجع الاسنان ويصلح للجبرن التي فيها غلظ اذا الخليه واذا احتقن
به نفع من وجعه الامعاء والنجم واما الامراص التي يقال لها وردبيدس فانها تعمل
ملكی خذ من الورد الطري ما الم يبصه ماء وقد ضمر وزن اربعين مثقالا
ومن الناردين الهندي خمسة مثاقيل ومن المستكه مثاقيل تدق جميعا منه اقراص
وزن كل قرص ثلث او نولثان وجفف في الظل وتخزن في اناء من فخار للسبن يقير
ويشد رأسه ومن الناس من يزيد في نسخه هذه الاقراص من القسط وزن
درخمين ومن السوس الذي يمالا ابنا من البلاد التي يقال لها الوزن مثله
وتخلطون لكل يعنار شراب من البلدا المنی اخونس وسنعمل هذه الاقراص اذا
ازدن قطع من العرف ويعمل منها محاجن وعطاره وتعلنها في رفابن وقد تستحت

يهيج العطاس ممن كان به نزلة الدماغ والمعده :: ابن عمران جيد للمعده والكبد منقح
المعده الكائنه به يبرد الكبد من الحراره جيد لعليل اذا طبخ مع العسل و تغرغر به :: الرازي
يسكن الخمار ويهيج الزكام بماؤه بارد لطيف ينفع الصداع الحار والخمار والغثيان والاكار
منه يضر البعض الشعر :: الطبري اجودها الورد ما اخذ من الورد الابيض لانه انقاه :: غيره
ماء الورد نافع لاصحاب المواد الحاره نافع لما قد حصل فيها من الخلل والاكثار منه
صبه على الرأس يصدع بالشيب :: الرازي اذا شرب ماء الورد الطري عشره
دراهم مع عشره مثاقيل ماء الزرد والدوم عليه قطع القيء وسهل اسهالا كثيرا :: غيره
الورد منفع جدا ويكون حاده كانه اصفرا و فيه خليل واذا انتبت على الغروج حففها وانبت
اللحم في القروج العميقه وينفع من القلاع والتربيه النمو وقد زعم قوم ان فيه
قوه جذب السلاء والشوك وانه بلع الثاليل اذا استعمل نخوتا وطبخه صلح لغلط الابدان
اذا اكتحل به :: مسبح واذا ضرب بالعسل جلا ماء المعده من البلغم واذهب العفونات
من المعده والاحشاء والاربا الذكر فعل فعلا دون ذلك :: الرازي الجلنجبين
صالح للمعده والذي فيها رطوبه اذا اخذ على الريق واجيد مضغه وشرب عليه الماء الحار
ولا ينبغي ان يأخذه من جد مجدبا والبابا وخاصته في البط فانه ينفخ ويعطش الا
ان يكون سكر يادا واما البزر الذي في وسط الورد فانه اذاذن وهو علي الله
التي يصبها عليها المواد كاصبا جاها واما اقماع الورد اذا شرب قطع الاسهال ونشف
اللثم :: وهي ده صنعه رودبون وهو من الورد :: خذ من الاذخر
خمسه اطال وثمان اواقي ومن الزبيب عشرين رطلا وحمل لأذخر والعجبه
بماء ترد نيهم من الماء قدر ما تعمره واطبخه بالزبيب وحركه في طبخك الماء ثم صفه
ثم اطرح فيه الف ورد منقاه من اقماعها لم يصبها الماء واطح بك بعشل طيب اربعه
وجزله كثيرا ونجرنيك ما اناء عصره رفعناه عنه ينقع ليله ثم اعصر
فاذا شب عصره وصب في اجانه ملطخه بعسل ثم صب ثقل الورد في اناء ثم صب عليه
عشرين رطلا ولث اواقي مثل ذلك وقد عصر واعصر ثانيه وان اجبت فضع العصاره

روذا وهو الورد

المذيج اوراق الزهر
هو مركب
من جوهرماىي جاٍر
مع طعمين اخرين
يعنى القابض وهو
ارضى غليظ بارد والمر
وهو لطيف جاٍر
فأما بزر الورد فهو
اشد قبضا من نفس
الورد فمن لذلك
يجفف كا زوذا
هو الورد وهو بارد
يابس واليابس اقل
قبضا من الطرى وينبغى
ان يوخذ منه الطرى ويقص اطرافه البيض ويدق الباقى ويعصر ويجفى
عصارته فى الظل على صلابه الى ان يبخن ويخزن ليطلخ به العبر وقد يجفف الورد
فى الظل ويدرك كثيرا للاينكرج وعصارة الورد اليابس اذا طبخ بشراب كان نافعا
لوجع الراس والعين والاذن واللثه اذا امضمض به وللمقعده اذا لطخ عليها يابسه
وللرحم والمعا المستقيم وان طبخ ودق ولم يعصر وتضمد به نفع من الاورام الحارة
العارضه فى المراق ومزج بلة المعدة ومن الحمرة وقد سحق اليابس اخلاط النفح والدواء
وادويه الجراحات والمعجونات وقد يدخن ويستعمل فى الحال المحتاجه لتطيب العين

ابن ماسه يقوى الاعضاء هو وماؤه ودهنه ويبرد الملهب اليابس من الزائين لانها
الاحمر منه فأما الابيض فدون ذلك فى الفعل وان كان الطف ذكيا ابن ماسويه

حق هذا لنبات انما يستعمل منه اصله فقط وهو جاذب جذب في طعمه مر ان يتبين
وليست زاجته بالرديه وكذلك فعله وقد يعلم منه ان قوته جاذه جزئيه
وجوهرهن جوهر لطيف ومما يشهد على ذلك انه يدر البول وينفع من صلابه
الطحال ويجلوا ويلطف ما يجتمع من الغلظ في الطبقه القرنيه من طبقات العين
وانفع ما يكون منه لهذا عصار اصله ومن المبين انه يجفف لا محاله فليوضع ايضا
في الدرجه الثالثه من الامرين جميعا اعني من الاسخان التجفيف د وقوه اصله
حاره واذا سلق وشرب ما ادر البول ونفع من اوجاع الجنب والصدر والكبد
والمعص شدخ العضل وجلو ورم الطحال ينفع من عظم البول ومن نهش الهوام
وجلس فيه مثل ما يجلس في ما الابرسا لاوجاع الارحام واما عصار اصل الرجل
فانه يجلوا ظلمه البصر واصل
الرج قد ينفع به سوء اخلاط
الادويه المعجونه غبره
نصفي اللون وينفع من البرص
والبهق وبياض العين وينفع
من وجع الاسنان جدا
ومن نثل اللسان ويقوي
المعده ويطرد الريح وينفع
من وجع الامعا ويسخنها
العارضين من البرد ومن
تقطير البول يحرك شهوه
الجماع ورد شا اسحق ابن عمران الورد صنفان ابيض واحمر
ابن ماسويه وقد يكون منه اصفر وبلغني انه يكون ورد اسود بالعراق واجود
الورد الفارسي ويقال انه لا ينضج والمختار من الورد القوي الرائحه الشديد الحمره

الكتب بهذا المجا اغني هشت دهان ديني بعضها السندهان وهو عود هندي بنفع من القرش: هلاورص هو الخرنق باليونانيه: **هلاطيني** هو حرف للاطيني وقد ذكرت حرف لألف: **هلسا** هو الخطمى **هليبوس** هو الدخن **هلسكاس** ني الجاوي انه الكشوت واظنه ملكسني وهو اللبلاب وقع فيه تصحيف وخطا **هلسكيني** ني الجاوي انه الكشوث وهو خطا واما هو ملكسني وهو اللبلاب: **هلكسيني** وهلسني هو اللبلاب باليونانيه وهو البرطال: **هلك** هي العروق الصفر من الجاوى: **همند** هو الحمص: **هميسفريس** قال الرازى موخى العالم بالفارسيه وهو نبات يشبه نبات الجاوز احضر كان الماء يسقط منه واكثر نباته ببغداد: **هموبا** هو الثيل البطيه: **هوازى** هو الكماة من الجاوى: **هو فنوس** هو اواقيتوس وقد ذكر في حرف لألف: **هواله** هو الهرنون: **هونه** هو الجعده بالفارسيه: **هو بوطوريوس** هو الفاوت: **هوداه** هو الطباشير من الجاوى: **هوديسمون** هو النعنع: **هودرافاقازى** هو فلنل الماء: **هوطا** هو الماش بالهنديه من الجاوى: **هموم قمل** هو المنك بالهنديه من الجاوى

باب حرف الواو

وج آقورون: ورقه يشبه ورق الايرس غير انه ادق منه واطول اصوله اعيد الشبه اصوله غير انها مشتبكه بعضها ببعض وليست بمثقبه ولكنها معوجه وفي ظاهرها كعقد لولو نهايه البياض ما خرنبه ليست بكريهه الرائحه واجود الوج ما كان ابيض كثيفا غير مختلج كانه كالملح طيب الرائحه والذي من البلاد التي يقال لها غالاطيا ويقال لها اسطوطليون هو ايضا على هذه الصفه:

على ما زعم بعض المفسرين ۞ هرانة وهراوية هو الشبث هزارجشان وبقال هزارذشان هو الكرمة البيضاء التي تنمي بالزبانيه فأشرا وقال بعضهم هو أصل يشبه الجلنمي وأنه عشكة أي الخل الجليل والصحيح ما قدمناه ۞ هراطان هرطان وبقال أيضا هرطان وهو صنف من الحبوب وهو الخرطال ۞ هراول هو الحلبان مز الجاوى ۞ مزاس زعم بعض المفسرين أنه المرار وهو أقبر وقال أبو حنيفه المزاس ىشبه القطب إلا أنه أكبر منه شوكا وأصغر وهي مقنبة ۞ هرنيك هو الهليلج الهندية من الجاوى وبى موضع آخر من الجاوى هرنيك عناب ۞ هرطن هو دفن البزر ۞ هريعي هو الخلنج وقيل هو العائول ۞ هردهي العروف المعرفة بالذكر وفيه الذي زعم قوم أنها عروق الورس ۞ هردوا هو الوج بالهندية من الجاوى ۞ هردوس هو الدفلى ۞ هزدوسطوں هو الخلاف ۞ هزقلما هو الجاتوس وبعرف بالخشاش الزدي ۞ هرقلوس هو النغاف وهى البقلة اليهودية وسميه بعض الناس نخن الحاز وهو صنف من الهندبا البزى ۞ هرقلس وهرقلوس بالبونانيه وهو التمام اللبناني وهو غير هرقلت المذكور قبل و اسم النغاف بالبونانية صنحبس ۞ هرسوا هو الهليلج من الجاوى ۞ هر ويدى هو العروق الصفر بالهندية من الجاوى ۞ مزرونه هو الثل وهو النجم مزوبسمون هو النودرى ۞ هلطا وهطط ا و هطما هو العويج بالسريانية ۞ هطوزافا هو عصا الراعي ۞ هقتبرح هو المازربون بالفارسية ۞ هفيثمون من الأفثيمون ۞ هفندورى هو الكرما البرى من الحاوى ۞ هقمارن هو السوسن الأصفر ۞ هصيلون هو صنف من الزعرور ۞ هقسىبى هو الثبلاب ۞ هسيتوس هو أجنص وقد ذكر في حرف الألف وبقال أيضا أخينوس هشت دهان هكذى وجدت اسمه ى بعض

بالهندية من الحاوى: **هادزما** هو النعنع: **هازرى** هو الهليلج:
هاربيون هو الهليلج أيضا: **هاروط** هو الهليلج أيضا من الحاوى:
هال هى القاقلة الصغيرة: **هالا** هو ثجر الزيتون: **هالابيون**
هو الزانت: **هالاقوس** مذبحى الابل: **هالاسفاقس** هو
الاسنافث: **هالاون** هو الزيت: **هالاومالى** هو عسل داود:
هاماطيس قال الرازى هو الرمرام وأظن أنه أراد الشاذنه:
هاه هو الأبلج على ما زعم بعضهم فال تأويل هذا الاسم المشتق: **هانا**
هو زهر الحنا: **هاناى** هو الورك بالسريانيه من الحاوى: **هازكشوى**
هو القرطم من الحاوى: **هبيند** هو حب الخطمى: **هجروسوسن**
زعم الرازى فى الحاوى انه الكشوث: **هنديوا** قيل انه الخروع: **هدليه**
هو الحلتيث بالهندية: **هز** من مصنف من المزد ورقه عجر حدث يحذ
نى الدور: **هزويا** هو زهر الحنا: **هتروما** هو النعنع: **هيضمان**
هو الخل البرى: **هلسقيا موس** هو الفطر: **هلسنم** هو التوت من الحاوى:
هسوبون هو الزوفا: **هسل** هى القاقلة الصغيرة: **هلبوا**
هى القاقلة الكبيرة: **هنك** هو الخيرى بالسريانيه وهو الفار شيه
ما زاه مى من الحاوى: **هبوكوفيطس** هو القلقاس ويسمى بالبونانيه مباروزن
هيومن قناموس هو البيح: **هوساموس** هو المرزنجوش: **هوطى**
هو الاجار بالهندية من الحاوى: **هدال** قيل أنها البنومة وقال ابوحنيفه
الهدال شجر ينبت والسهم ليست منه وثمرته بيضاء وتنبت فى اللوز والرمان وفى كل
شجرة وقيل هو شجر ينبت فى الحجاز يلبس بالشجر له ورق عراض أمثال الدراهم الضخام
ولا تنبت الهدال لا وحدها ولا ينوجد لامع شجرة واهل اليمن يطبخون ورقه وزعم
قوم أن الهدال ثمرة بيضاء تنبت على الأشجار ليست منها وقال ابو زياد الهدال
هو شجر بنبته الخلاف: **هدما وهدمان وهذان** هو الصومران

يكون في جماعة مثل الخشخاش لأنها صلبة ذات شعب ثقال وتوكل للجماع ويكون في جالـ يـلغم . هنت **الناري** وحبثـه معروفه : **ماسرجويه** بارد يابس في الثالثة وحبس البطن **هذهل** زعم بعض الأطباء انه اذا الطبخ بماء وشرب وغنى من مايه والطعم من لحمه نفع من القولنج : **هديه**

أو بي اعوطاس اندر السر

هي دويبة توجد تحت الجزاز والحباب كثير الرجلـ شديد عندما ئلمسـ بالمبد اذا شرب بشرابـ نفع من عسر البول والبرفان

أو بي اعوطاس امدا السر وهو الهديه

واذا اختك بجل وطلى بـنه نفع من
الاحتا ق وسقوط الحلق اذا اتـنى وصير في
قشر رمان مع دهن ورد ونحن وفطري في الاذن
وافن من وجما حـا موجوا انجمع نفسه

وبستنديز ولونه الى الخضره والدكنه وانت تجدمنه في القرى مقدارا كثيرا
ممن توكلـ تحـت الجزاز التي يملوها اهل القرى بالماء من العذاران وضعوها عند المستوقد
وبستعمل ثوم من المعاج البن في الثرى الري الري الذي بطبخ قيه مداوا و وجع
الاذن من غيران يحد وأسبب رجوع من أجلا ذلك حتى يكوا ازما ارزوا
وزيما اضروا **عبره** : واذا احرق ورفـ روخلط زماده بعسل لحدمنه
كـو بنوم ملعقه نفع من عسر النفس

وهذا أشرح ما وقع في هذا

الباب من الأسماء

هاما هوزهر الختـى ها بانوس هو الابنوس هابادراما
شراج القطرب من الحاوى ها فقـى هو الكبر الهندي من الحاوى
هاذاتـ قيل هو الموذج الجبلى هادرا مى العزروا الصفر

طولها دون أعان ملئ ناعم غلظ فيما يلي الساق الأعلى ورقه صغار شبيهة بأصغر من
ورق النبات الذي يقال له فسوس مستطيل لونه شبيه بلون هذا النبات المسمى
بوقيسس يخرج فيما بينها زهر أبيض وله ثمر مستطيل أصفر اللون في طرفه زائش
كرأس الدبور وأصوله أزجة فيها شيء شبيه بالمخاط وبلونها حمرة النار طوال
د ق وورق هذا النبات قوته تحلل باعتدال وأما أصله فجفف وينضج
الأخلاط الغلظة بعد النضج وهو لطيف د إذا ضمدت بها وافقت حرق النار
والنوا العصب وإذا شرب أدرت البول وعقلت البطن ونفعت من وجع الربو
وحضرت مع العسل وحصر اطرافه و قد يكون من هذا النبات بري شبيه بالشوكة
التي يقال لها اقنثولومس وهو نبات مشوك اقصر من البستاني وقوة أصل البري مثل
قوة أصل البستاني

هيوفاريقون

هو أربعة أصناف فمنه الهيوفاريقون
المطلق المخصوص بهذا
الاسم والثاني يسمى
اسفيرن وهو الصنف
المعروف عندنا يسمى
الميتة والثالث
اندروسامن والرابع
قورس فأما اسحق
ابن عمران فزعم ان
الهيوفاريقون هي الكمه
البيضاء وهي الهزارجشان
وصفها بصفتها وسماها
بأسمها وتابعه على ذلك ابن الجزار وابن سينا وقد غلط هؤلاء غلطا عظيما حادا
وبعدوا غايه البعد د ح اوفاريقون ومن الناس من سماها حاما نبطن لمشاكله

ابن ماسويه الشبه من جرمه ما بين درهمين إلى خمسة دنانير ومن شعبه وطبيخه ما بين خمسة دنانير إلى أربعة عشر درهما ۔ الرازي الهليلج الأسود المربى يقوى المعدة وينقيها ويدبغها ويعصرها فضول الرطوبات الباقية من الغذاء والمتولدة فيها وإذا أدمن جش اللون ومنع الشيب أن ينزع ۔ البصري الهليلج الصيني صنف من الهليلجات خشب دقيق أسود يجلو الوجه ويشبه الزيتون في شكله ومنفعته أقل منفعة سائر أصنافه وإذا ربى يقوي المعدة تقوية ضعيفة

عنبره إذا شرب الهليلج منجوفا فإنه يعقب بعد ذلك لأنه ليس في الطبيعة والأصفر إذا طبخ ضعفت قوته وجميع الهليلجات تنقي المرة وتنفع منها وتنفع من الجذام والأسود ينزل خاصة المرة السوداء المتولدة عن احتراق الصفراء وكلها تنفع من الخفقان والتوحش ووجع الطحال وتنفع الآن الغذاء والكابلي يجدد الحواس وينفع للحفظ والعقل وتنفع من الصداع والاستسقاء والفولنج والحميات العتيقة وإذا ربى في الزيت عقل البطن وكذلك الهندي ومن أخذ كل يوم من الهليلج الكابلي منزوعة النوى فلاكها حتى تذوب وأبلعها وأدمن ذلك لم يشب وهو مع ذلك يشد الله ويقوي الأسنان جدا ويقوي الدماغ والحواس ويزيل الحفظ ويزيل ضرر كبير يشرب الماء البارد وهو من أكبر أدويته ۔

هليش د ح القوس من الناس

القنس

الأقيس وهو الهلشير

من ينبته يا قراس وهو صنف من الشوك ينبت في البساتين والمواضع الصخرية التي فيها مياه وله ورق أعرض يشرب ...مثل نشر في الجزجين ...عليه رطوبة تدنو باليد أملس إلى السواد وشاق

مقسمة الأطراف عليها زهر أصغر صغار وبزر في غلف شبيه بغلف الخشخاش
كأن عليها خطوطاً واذا اخذ من هذا النبات فاجتن منه زاجه الزانيج وبزر هذا
النبات اذا انحق وشرب منه مقدار درخمى اسهل اخراعاً نما واذا اضمد بهذا النبات
ابرى حرق النار ح و ثمرة النوعين جمعا يسهل البطن واما ورقها فقوتها
تجفف وتحلوا اخلاط لذلك قد وثق الناس منه بانه يشفي حرق النار واذا طبخ
بشراب قابض صار لذلك الشراب قوة تندمل الجراحات العظيمة ح واما فورس و من
تسيه وفارلين فلد ورق شبيه بورق النجرة التي يقال لها اريغى الا انه اصغر منه
وفيه شئ من طولة يدق بالبد ولونه احمر وحمرته شبيهه بالدم وطول هذا النبات
نحو من شبر وهو طيب الطعم حريف طيب الرائحة وله بزر اذا شرب ادر البول واذا
شرب بالشراب نفع من نهش الافاعي والصنف من الفلج الذي يعرض منه ميل الرقبة
الى خلف وعرق النسا ٠ هديلية هو نبات يبت في مواضع رطبة
وله ورق يخرج من ورق
الكرفس وله عروق
مخرة تشبه عروق
الساج ليته فيها حرافة
شديدة ومزاجه بغرب
من طعم الموبرج يستعمل
لوجع الاسنان ويزيد في
الباه وهو شديد الحرارة
وينبغي ان يحذر من قوته لانها
شديدة جداً ويقال ان ورقه
اذا دلكت بها طهور البقر
دواها على الطرد ٠ همقان ابو جبيه حب يشبه حب القطن

زابجة بزر لزابجة الرابنج الذي هو صمغ الصنوبر وسطس هو الصنوبر هو مثل يستعمل
في وقود النار له ورق شبيه بورق السذاب وطوله نحو من شبر ولونه احمر
وجمره بالحمرة الدم وله زهر ابيض شبيه بالحمى الابيض وبزر في علف مستطيل
ممدود وعظمه في عظم حب الشعير ولون البزر اسود وله زابجة شبيهة بزابجة
الرابنج وينبت في اماكن خشنة واماكن وعرة ج ح هذا يسخن وينشف وجوهره
جوهر لطيف حتى انه يدر الطمث والبول وينبغي لنا اذا اردنا ان نستخرج منه
ما هي ولا ينقض على بزره ان نجده مع انه اذا انخذ من ورقه صمادت به مواضع
حرق النار والقروح اصارها كالالحام والالتيام فاذا جفف ودق وهو يشفي
القروح المترهلة والمتعفنة وقد يشوي به وجع الورك ح د اذا احتبس اذا الطمث
والبول واذا شرب بزره بالشراب ذهب جمى الربع واذا شرب اربعين يوما منه
ابرا عرق النسا واذا انضمد بورقه و بزر ابرا جرق النار : مسيج جات بابنين
الثالثة :. بدعورس خاصته الاذابه والتحليل : الرازي ينقي السدد : الطبري
اذا شرب بما ورقه ينفع من النقرس نفعا بينا : د واما الاسفيرنج من الناس من
يسميه اسفور بداس وهو صنف من ا وفارقض حاله الصفا الاول في العظم وذلك ان
هذا اعظم من الاول اكثر اغصانا وهو اصلح منه لوقود النار ولونه احمر فاز وله
زهر وبزر شبيه بزر او فازبين واجنه شبيهة بزابجة الرابنج اذا ورك يمين الاصابع
واذا شرب بشي من بزر هذا النبات بوطولين من الشراب النى بخاله ادرومالى
نفع من عرق النسا واسهل البطن واخرج المرة وينبغي ان يتمر اخذه من كل زبه عرق
النسا الى ان يخرج من الاعله واذا انضمد بهذا النبات كان صالحا لحرق النار
واما الدد وينامن ومن الناس من يسميه بيتمه دبو سامن ومنهم من يسميه ايضا اسفيرن
وبينه وبين اسفيرن وبينه وبين افا زبين وهو ممبس ويستعمل في وقود النار وله ورق
دقيق واعصان احمر نها قانيه و وزن كذب كم قريب كله اصعاف ورق السذاب
في العظم اذا فرك هذا الورق خرجت منه رطوبة شبيهة بالشراب وله شعب كثيرة

أسود من الهليلج الأصفر على أنه الهليلج الأسود والأجود به الحبشنه وهو الهندي
كما اسماه قوم واذا اجتني الاصفر وبه بعد نجاحه كان لونه اصفر والاسود منه
اثمر واكثر لحما من الاصفر لانه بلغ في خزنه ونضج وكذلك ايضا قد يصاب
في الهليلج الكابلي اصفر اللون واسود واثما اسود هذا وذلك على قدر نضج ما بلغ
شجره :: الرازي اجود الهليلج ما رسب في الماء :: مسيح الاسود بارد يابس
في الاولى اجذا بغ للمعده والمنعده منقوها جابر للطبيعه بعينه :: الرازي ينفع
من البواسير :: ابن عمران خاصه اسهالها للمره السوداء المتولده عن احتراق
الصفراء ويسهل المزتين :: ابن ماسويه الشربه منه من درمه ما بين درهمين الى احمه
دراهم ومن نقيعه او طبيخه ما بين خمسه دراهم الى احد عشر :: ابن عمران
الكابلي يوتى به من كابل وهو افضل الهليلجات وهو اسود ودسم اطيب طعما من غيره
:: ابن ماسويه المختار منه ما قرب لونه الى الحمره وكان رزينا ممتلئا ليس
بخور :: مسيح بارد يابس في الاولى صالح للمعده نفع بطبعه من المره السوداء
فيخرج الاخلاط الرديه منها :: البصري يسهل ايضا ايسيرا ويخرج السوداء وهو
نافع من نزح البواسير :: جبيش يقرب من البزوده مع انه يسير ممتزجه
واتما صارت البزوده ذايده في الحموضه الغالبه على طعمه فأنك اذا ذقته
اصبت فيه شيئا من الحموضه خفيه وله خاصيه بقيه اصلاح المره السوداء ويشف
ما يتولد من احتراق المعلي وهو يشف البلغم ايضا ويفعل في اخراج الصفراء
وليس كنعله المره السوداء واما الهندي فيقرب من ميعه الا انه ليس
له نوه الكابلي مقدار الشربه منه مدقوقا من مثقال الى مثقالين ومن طبيخه
من خمسه دراهم الى عشر دراهم :: ابن مزرافيون يسهل السوداء بقوه ويزك
المعده والبطن يجبه ايضا وينفع ابضا من البواسير من السوداء وهو ينفع الاعضاء العصبيه
والبطن والشربه منه ان اخذ منقوعا او مطبوخا من خمسه دراهم الى سبعه دراهم
فأن اخذ متحوا فان من درهم الى خمسه دراهم ولا بئن بالدهن فانه لا ينقص كالاصفر

وحتى فانه يخلص من الأدوية النتن له كلها ويعقب صلاحا تاما واذا اشرب ماء أصله نفع من نهش الأفاعي ولسع العقارب والزنبور ولينه بجلو بياض العين ∴

هليلج البستي هو اربعة اصناف فصنف اصفر وصنف اسود كابلي كبار وصنف حشف دفاق يعرف بالصيني ∴ ا**بن ماسويه** المختار من الهليلج الاصفر ما اصفر لونه وقرب من الحمرة وكان رزينا مثل يا لا بحر ولا ينقض

ال**رازي** الاصفر منه يسهل الصفراء والاسود الهندي يسهل السوداء فاما الذي فيه عفوصة فلا يصلح للاسهال بل يدبغ المعدة ولا ينبغي ان يشرب للاسهال لكن ما ان مع السكر فقط انها له صمغية موجودة فيه وما لم تظهر منه هذه الصمغة اذا كسر كان فعله ضعيفا ومن الدليل على ذلك انه اذا انقع في الماء كان اسهاله اقوى واذا اشرب مطبوخا قل اسهاله لان النار تفوته الخاصية في جوهره ∴ منضج الاصفر بارد يابس في الاولى يابس في الثالثة يدبغ المعدة ويقويها وينفع من استرخائها ∴ **مارجويه** الاصفر يسهل المرة الحمراء وهي دقيق مع ما فيه من القوة القابضة والاسود يقبض ويدبغ المعدة وفيه شي من برد مع شي من حدة ولطافة ∴ جيش الاصفر اقل بردا من الكابلي ∴ **ابن ماسه** يسهل الصفراء من البدن ∴ **ابن ماسويه** الشربة من جرمه ما بين ثلثه دراهم الى عشر دراهم ∴ **حبيش** اصلاحه اذا اشرب صرفا مدو قامع الماء اجاز ان يخلط بالسكر وبالترنجبين يمنع من شدة قبضه فاذا طبخ مع الاجاص والعناب والبسفايج وشرب كان اصلح لان طبخ الادوية لزوجات مغرية بكبر من قبضه ويكبر هذا من لزوجتها فيعند لقبضه ويكون دواء نافعا ومقدار ما يشرب منه مدقوقا مخلوطا طعم السكر ما ينا بدهن اللوز الحلو من خمسة دراهم الى خمسة عشر درهما ∴ **ابو جريح** قد يبيع الصياد له ما اسود من الهليلج الاصفر على انه اسود وليس هو كذلك وانما اسوداده على قد رنضجه من شجرة والاصفر غير نضيج ∴ **حبيش** وقد يغالط الصياد له من يبيع منه او يكون ذلك عن غلط منهم بان يبيعوا ما

عند تحوّنه. واذا اخّر زادت مرازته وهوجاً قليل الخراءة قريب من الاعدال
واذا عصر ماءه وغلا وصفى نفع من الاوارم وفتى المعده وفتح السدد وماءه يبرد
الاورام الظاهره ❉ البصرى الهندبا الشامي المتى انطولبا بارد رطب فى الدرجه
الاولى ❉ مسيح هو بين الحر والهندبا ❉ الاسترابلى هو اعدل من الهندبا واجود
كيموسا ❉ الطبرى الطف من الحر واقل عذا واذا ادق ورقه ووضع على الاورام
الحاره بردها وحللها ❉ غيره حلل الاورام الظاهره والباطنه شربا وطلا ولذلك
اورام الحلق اذا تمضمض به ويسكن الغثى وهيجان الصفراء وهو افضل دواء للمعده
الحاره وينقى الكبد ويعينها على افعالها الخاصيه من غير امتحان او تبريد ظاهر
وينفع من لسع العقارب والحيات الباردة واذا انضمد به مع اصوله نفع من
لسع العقرب والهوام والزنابير والحيات وسام ابرص ❉ الطبرى الهندبا
البرى هو الطرخشقون وينمى بالفارسيه وسج ❉ غيره يقال طرخشقوق
وطرسقون ولجتوك وهو الفلت وهو الامبرون ❉ انحن بن عمران ورقه يشبه
ورق صغير الهندبا البستانى وله عساليج دقاق مقدار شبرين وقل فيها نوار
صغير لونه اسما جورى ويسقط وخلفه حب دقيق ❉ ابن ماسه البحتوك
مقوٍ للمعده نافع لها واذا دق ووضمد به لسعه العقرب او اكل او شرب نفع
من ذلك وما بت منه فى البساتين والمواضع الكثيره المياه كان يلزمه اكل
ويسيه اقل وخاصه النفع من لسع الهوام اذا اكل او شرب ماءه ويحلى
كل ما يظرفيه الهندبا من الادويه ❉ الطبرى اذا اكتحل بماء ورقه نفع
من العشا وقد يدخل ورقه فى الترياقات وينفع ايضا اذا اتحى وشرب من
الحميات ولاسيما الذى يلى شربه الماء ❉ الرازى الطرخشقوق اقوى من الهندبا
فى جمع افعاله ❉ ابن عمران ينفع من نفث الدم ويقطع العطش وهو مقوٍ للمعده
نافع لها مشهٍ للاكل ❉ غيره لطيف مفتح نافع من حمى الربع ومن الاستسقاء
والحرارات وبقاوم اكثره السموم وخاصته اذا اعتصر ماءه وصب عليه الزيت

وكسر

صنفان آخران وهو البعيد ويسمى باليونانية خدرىلى وسنذكره بعد هذا

ح خ هذا نوع من البقول يميل إلى المرار خاصه ولذلك يسمى قوم الهند با البرى البتله المرّه ومزاج الهندبا البرى بارد يابس وهو من البرودة والبوسة جميعا في الدرجة الاولى فاما الهندبا البستانى فبرده اكثر ثم يريد البرى ولكنه بسبب ما قد خالطه من الرطوبة العذبة الكبيرة فيه ذهب عنه اليبس والبوعاز وكلا عام ان الهندبا اعنى البرى والبستانى طعمها طعم قابض وكذلك طعم الثالث من انواعه المسمى باليونانية خدريلى وكل هذه الاصناف فابضه مبرده جيده للمعده وا... طبخت واكلت بالخل عقلت البطن وخاصة البرى منها فانها اشد عقلا للطبيعة واذا انعنت مرضخ للمعده والمقل واذا انضمد بها وجدها او مع السويق نفعت الالتهاب العارض في المعده وقد يستعمل منها ضماد الخفقان وقد ينفع من النفس ومن اورام العين الحارة اذا خلطت مع السويق والخل واذا انضمد بها مع اصولها نفعت من لسعة العقرب واذا اخلطت بالسويق نفعت من الجمره ومآؤها اذا خلطت باسفيذاج الرصاص كان منه لطوخ لمن أحتاج إلى التبريد

منبج بارد يابس في الاولى يقوى المعده ويفتح السدد في الكبد ويجلوا ماء المعده ويفتح سدد الطحال ويطفى حران الدم والصفراء

الرازي صالح للمعده والكبد الملتهبين وليس معه شيء من العفيفة والرطب وتسكين العطش الحسن مانع من اوجاع الكبد حارها وباردها والبرى وافق لاصحاب الاستعمال الا للمبرودين من البقول لان اكثرها مبرد نافخ وما لا ان مر من هذه البقول كثرت فيه الرطوبة والنفخ وكان من المعنى ازداد **الاسترابلى** اذا عصر ماؤه واغلى ونزعت رغوته وشرب بلكجين فتح السدد ونقى الرطوبات العفنه ونفع من اجحاف المنظاوله **ابن ماسة** جيد الكيمون نفع في المعده واصله ينفع من لسعة العقرب وان قال ... فا ... ل ان في قبه جزاز الموضع ما زنته في الصيف لم يعد لم ينزل في البقول . **جبيش** الهندبا استحلى مع الهواء ويكون خشنا

أكلت

بنج الأوجاع كلها واذا اسحق ووضع في أصل الضرس الوجع فانه ان كان فاسداً قلعه وان كان متأكلاً سكن وجعه ثم **هندبا** موصفان برى وبستانى

سادس

نات برى وهو كالبنيا

والبرى ينال له لوروفخوريون وهو أعرض ورغا من البستانى واجود للمعدة منه والبستانى صنفان أجمها قريب من الجرجير عريض الورق والاخر ذو ورق في طعمه مرارة **ابن سمحون** البستانى منه صنفان أحدهما طويل الورق اجماجونى الزهر كثيره الطعم مر وخاصته في آخر الصنف اذا ومن هذا الصنف برى يشبه به في صورته وزهرته الا انه اقوى مرارة واشد كثرا همنه ويسمى المبرزون والصنف الثانى من البستانى عريض الورق ابيض الزهر رتبه الطعم عديم المرار وخاصته في اول الربيع ويسمى بالرومية انطوبيا ويعرف بالهندبا الشامى والهاشمى ورقه قريب منه في شكل ورقه وقله مرارته بعد منه في شكل زهرة وكثرة زغبه وهو الشراليه بالعجمية وزعم انه الطرخشقوق فأن **المولف** الطرخشقوق هو الصنف الاول البرى التى ذكرت ثماوى صغرى والثراليه زهرة اصفر كبير كالشعر ومن البرى

عنبج

قوم

قوه تجلو او ليس لها امتحان ولا تبريد ظاهر ان وضعت من خارج ولذلك صارت تفتح
سدد الكبد والكليتين وخاصته اصلها وبزرها وتغني ايضاً من وجع الاسنان لانها
لانها تجفف من غير ان تعفن وهذا هو كيفية حاجة اليه الاشفار خاصة **ذب** اذا
شق سلقه حفقفه واكل لبن البطن وادر البول واذا طبخ اصوله وشرب من ربه عشر
البول ويرقان او عسر النسا او وجع الامعاء واذا طبخت بالشراب نفع طبيخها
من نهش الانثى واذا مضمض بطبيخها على موضع السن الآكله نفع من المها وبزره اذا
شرب طبخه قبلها ومن الناس من يزعم انه اذا اخذت فزون الكباش وقطعت
ودفنت في التراب نبت فيه هليون **ابن ماسة** جات رطب في الخرا اولى وأول
الثانيه يدر البول وبعبز لحمه كما يفعل الأجزا يزيد في الباه مفتح لسدد
الكبد ينفع وجع الظهر العارض من الريح والبلغم وينفع من وجع القولنج واذا
اكل بعد الطعام غذا اكثر مما قبل الطعام ا**لرازي** يتخذ الكل والمشا انه
ينفع من تعطر البول التي من بزروده والمشائخ المبزودين ولوجع الظهر والورك
العتيق صالح للصدر والريه وليس جيد للمعده لا ماغنى ولا سيما اذا ملون
ابن مركوين الغذيه بهضم سريعاً ا**لاسرائيلي** البستاني علها رطوبه وأكثرها
غذا لانه اذا انهضم واستحكم نجده اكثر من غذا سائر البقول ولذلك
صار ايما ان المني البري اكثر يبسا وجفافا والصحراوي اقلها رطوبه واقواها
جلاء من عجر امتحان شت م**سيح** بزر يفتت الحصاه التي في المثانه والكليتين
اذا شرب مع العسل وشي من دهن البلسان ا**لطبري** ان علق اصل الهليون وهو
يابس على الضرس الوجع قلعه بلا وجع : **مجهول** طبيخ اصوله يزيد في الباه
وينفع من عسر البول بالخل ينفع لوجع الاسنان وبزره اذا اجتمل ادر الطمث واذا
شرب فتح سدد الطحال والهليون نفسه ان اكل نيا على الريق فتت الحصاه ونفع
من علل المثانه والكلى كلها وادمان اكل الهليون يفتح وجع المفاصل ث
ا**لفلاحه** اكله بعد البصر وينفع من ابتدا نزول الما في العين وادمان اكله

لريو وسماها د سملش دُومَانَا هو الرَّارَبَابح بالسُرَيَّانِيَّة :: دُومَيَاطِان
هو الرُومِيَا المُقَدَّم ذِكرُها شـ

باب حرف الهاء

هرنوه وقال فرنوه :: ابن ماسه هو حَبّ ضَعِيف أصغَر مِن الفُلفُل عَلوه
صُفرَة فُلفُلِيَّة وَشَمّ مِنهُ رَائِحَةُ العُود :: ابن عمران قِلاعُ الفُلفُل وَهِيَ فِي
صُورَة الفلفل الصَّغِير الا انَّ لونها الصَهوبه وفيها قوَّتان مُتضادان مِن الحَرارَة
والبُرودَة وَهِيَ جَيِّدَة لِوَجَع الحَلق وحُسن البَطن :: ابن ماسه هي حارَّة رَطبَة وفيها
جلاسته **هليون** هو الاسفرَاخ هو صِنفَان مِن صِنفٍ يتَّخِذ بالسَّاسِين
بالمَشرِق ورقه كَوَرَق السَّبت لا شَوكَ لَهُ ومنه بَرِّي وَهو شَوكَ كُلّه مِثل الحَولِ

اسمار الغش يقَال ادهما هليون

وَهُوَ كَثِير بالاندلس مَعرُوف وَهَذَا هُوَ المُستَعمَل فِي الطِبّ خ وقوَّة مَدَّه الحَشِيشَة

دُهْن مُوَنْجَر سُوفَ قَالَ لِلْجَوَّارَ بِالذَّنْبِ. دُهْنُ الْحُلِّ هُوَ دُهْنُ السِّمْسِمِ الَّذِي لَمْ يَغْشِ. دُهْنُ الْبَزْرِ هُوَ دُهْنُ بَزْرِ الْكَتَّانِ خَاصَّةً. دُهْنُ الْعَسَلِ هُوَ شَيْءٌ يُسَمِّيهِ أَهْلُ الشَّامِ عَسَلًا وَقَدْ ذَكَرْنَاهُ فِي حَرْفِ الْعَيْنِ. دُهْنُ السِّرَاجِ هُوَ دُهْنُ الْبَزْرِ. دُهْنٌ صِينِيٌّ وَدُهْنٌ لَهَنْدِي هُوَ الْمُتَّخَذُ مِنَ السَّنْدَرُوسِ وَدُهْنُ الْبَزْرِ. دُوَ الْحَيَّةِ هُوَ الْحَطَاطَا. دَوَافَا قِيلَ الْخَرُّوبُ. دَوَادِمٌ وَيُقَالُ الدُّودَمُ وَهُوَ شَيْءٌ يَخْرُجُ مِنْ أَجْوَافِ الْخَشْبِ مِثْلَ الصَّمْغِ أَسْوَدَ فِيهِ حُمْرَةٌ نِشِبَهُ الدَّمَ وَأَكْثَرُ مَا يَخْرُجُ مِنَ الشَّمْمِ. دَوَاسِنَةٌ هُوَ الزَّعْرُورُ. دَوْبٌ وَدَوِيطٌ الشَّطْرَنْج بِالْهِنْدِيَّةِ مِنَ الْحَاوِي. دُودُ الصَّنَوْبَرِ يَنْكُرُ مَعَ الدَّرَانِجِ. دُودُ الصَّبَّاغِينَ هُوَ دُودُ الْقِرْمِزِ. دُودُودٌ قِيلَ هُوَ بَزْرُ الْجَحْجِيرِ. دُورِسُ اسْمٌ يُونَانِيٌّ وَيُسَمُّونَهُ أَيْضًا خَبُوزَ وَقَدْ ذَكَرْنَاهُ أَيْضًا فِي حَرْفِ الْأَلِفِ. دَرُوفَا هُوَ الْمِلْحُ بِالْهِنْدِيَّةِ مِنَ الْحَاوِي. دُوصٌ هُوَ مَاءُ الْحَدِيدِ وَزَعَمَ قَوْمٌ أَنَّهُ خَبَثُهُ. دُوعٌ هُوَ مَخِيضُ الْبَقَرِ عَنْ مَسِيحٍ وَعَنِ الْإِسْرَائِيلِيِّ أَنَّهُ التُّرَابُ. دُوعَرْنِ هِيَ الْأَشْنَةُ. دُوقِسُ هُوَ الدَّوْقُ بِالرُّومِيَّةِ وَقَدْ يُسَمُّونَ الْجَزَرَ الْبُسْتَانِيَّ أَيْضًا بِهَذَا الِاسْمِ. دُوقَصٌ هُوَ الْبَصَلُ. دُوقَرَا بَارْسُ مَعْنَاهُ جَزَرٌ بُسْتَانِيٌّ. دُوقَسَ اعْرَيَا مَعْنَاهُ جَزَرٌ بُرِّيٌّ وَدُوقَرْبَرِيٌّ يُسَمَّوْنَ بِهَذَا الِاسْمِ الْبَانَ الْمُسَمَّى فُوقَالِسَ وَهُوَ ضَرْبٌ مِنَ الْأَنْطِ. دُوقُوا أَصْلُ هَذِهِ الْكَلِمَةِ بِالْيُونَانِيَّةِ دُوقَسَ وَالَّذِي يَخُصُّ بِهَذَا الِاسْمِ صِنْفٌ مِنَ الْجَزَرِ الْبُرِّيِّ وَقَدْ تَقَدَّمَ ذِكْرُهُ وَكَثِيرٌ مِنَ الْأَطِبَّاءِ يَسْتَعْمِلُونَ عِنْدَنَا الْجَزَرَ الْبُرِّيَّ نَفْسَهُ بَدَلَ الدُّوقُوا وَلَيْسَ بِعَيْنِهِ وَمِنْهُمْ مَنْ يَسْتَعْمِلُ لَعَرْبَا بَدَلَ الدَّوْقُوا. دُوقَبَرِيٌّ ضَرْبٌ مِنَ الْبَسَطِ وَيُسَمَّى بِالْيُونَانِيَّةِ فُوقَالِسَ. دُوشَابٌ هُوَ مَيْثُ النَّمِرِ. دُوسَنَا قِيلَ إِنَّهُ صَغَارُ الزَّيْتُونِ. دُوسُونٌ هُوَ الْفَنَابَرِيُّ وَيُسَمَّى بِالْفَارِسِيَّةِ بَرْغَشْتَ. دُولَنْجُوا هُوَ اللُّوبِيَا بِالْيُونَانِيَّةِ مِنْ كِتَابِ الْأَغْذِيَةِ لِجَالِينُوسَ وَيُسَمَّوْنَهَا أَيْضًا

ويقل وبقال له الشنيان قال **المولف** قد اختلف فيه فمنهم من زعم أنه عصيان
كما زعم أبو حنيفه وزعم كثير من المترجمين أنه النبات المسمى بالوناتيه اخيلوس
وهو صنف من شيذ ريطرس وزعم قوم أنه صمغ يذكر الشان في جزف لشيئ
دم التنين ودم الثعبان وهو دم الاخوين وزعم قوم أنه اللوف الكبير
وكذبوا وأنما هي اللوف الكبير يجز الشين **دم الغزال** قال
ابو حنيفه نبات شبيه البقله التي تسمى الطرخون وكل وله حروفه وهذا اخضر
وله عذروق مثل عذروق الرطاة ويخطط الحواري بها مسك في أيديهن حمرا
دم لحم قال **ابن رضوان** أنه حب شبيه باللوبيا الاحمر غير أنه اصغر
منها واصفر ونا جاز قاطع للعاب الصبيان منفول ادمتهم إذا اسقوا منه نصف
دانق **دمامري** هو القنابري ۞ **دميا** هو سرطان البحر عن
مسيح ويوجد في الكتب المسا بالروائن كتاب جاليونس في الادويه المفرده
الدميا هو السرطان البحري والذي تناه جاليونس في هذا الموضع بهذا الاسم
فشرحنه بالدميا وهو السرطان ۞ شبيها وهو المعروف بالشبيا المعروف
بهذا الاسم عندنا بالدميا اما هي الشبيا وتسمى سرطان البحر وسرطان البحر ايضا غيرها
دم ادمه قال **ابو حنيفه** هي ينضج لها وزفه خضرا مدورة رء
صغين ولها عذروق مثل الجزر ابيض شديد الحلاوه بالكله الناس ويرفع الكاس
وسطها قصبه قد ذال الشبر في ذا ينها يرى عمه الصلب فيها يجب ۞ **دها و دها نا**
و دها نفا هي اسما الكرنبه الهنديه من الحاوي ۞ **دها نفس** هو
عنب الثعلب بالهنديه من الحاوي ۞ **دهاي** هو الفيروزج من الحاوي
دها طو هي المغره بالهنديه من الحاوي ۞ **دهما** هي الدارين من الحاوي
دهنش وقيل هو صمغ الذاب ۞ **دهيما سو** هو الشكاعي من الحاوي
دهرب هو الزعفران بالهنديه ۞ **دهما** هي عشبه خضرا عريضه
الورق يدبغ بها عن **ابي حنيفه** ۞ **دهمست** هو الغار بالفارسيه

درواليس مولطباشير من الحاوي: درنفسوج السبانه من الحاوي: دروري هوالنافله بالهندبه من الحاوي: د عياع
قال أبوحنيفه هي بقله منسطحه على الأرض سطحا لا تذهب صعدا والها ورقات قريبه من ورق الهندبا ويظهر البرعمه من وسطها بيضا أو لبنا فاذاحفت دقت ودرست واستخرج منها حب سود كالسون بخت منه خبز وزعم قوم انه شونيز النبطي وهو معروف: دعلول قيل هو البعبوب: دقاق الكندر هو ما يقع تحت المنخل اذا نخل الكندر وغير ذلك: د فو يدا س بعناه الشبيه بالغار وهو ضرب من الغار الجلي وسنذكر مع أصناف النبوع بهذا الاسم أعنى دميو بدإنيا: دفراق قيل هوالعرعر ويقال أيضا دفرانا: دقطبس هوالشكطرامشير: دقطوليطوس هوالرز أوهو الطويل: دفلا هوالعنصل السرياني انه من الجاوي: د قه هي الكزبره بالهندبه: دسنبنويه قيل هو ضرب من اللفاح طيب الرائحه والطعم معروف في المشرق بهذا الاسم وزعم قوم انه ضرب من الخوخ وقال ابن رضوان أن الدسنبنويه مركب قشره جار لطيف يهضم الطعام ويقوي المعده ويطرد الرياح منها واللحمه بطيئة الانهضام عنها: دسليسا هو ذنب الخيل بالسريانيه: دستي هوالنقاث: دسنطرفا هو المازريون من الحاوي: دسقس هو نبات انصابيني باليونانيه لبس يذكر في حرف لام: دسم المر هوالمقعه النايله: د لب وقد تقدم القول عليه وكان اطباء الاندلس قبل يستعلون بدله الصنبرا ثم انهم اليوم ويقعون اسم الصنبرا على ثلثة أشجار متباينه وكل واحد يوقع اسم الدلب على واحد منها أيضا اتقول له ولبس واحد منها بالدلب على الحقيقه: د ليك هو ثمر الورد الذي يخلفه بعد الورد وهو ثمر احمر اذا انضج وفيه حلاوه وداخله بزر كالزعروره: دم الاخوين قال أبوحنيفه يؤتى به من سقطرى وهو نبات يدق

دَازْقِطُون وصوابه دَانْقِطْيون بِالْمُعجمة :: **دَرَاقِن** هو الْخَوخ بِلسَان أَهل الشَّام وَهي وَزنّبه معرَّبه :: **درَاقْوا** هو الْحَزن الْمشرقي :: **دَازْسِبَا** هو الْكَشم بِالسِّرْيَانيَه :: **درَاسك** هو الْجَبلي عَلى مَا في كَثير مِن الترَاجِم والْاسم مُصَحّف وإنّما هو وَزرشك والزرْشك على بَعضه هو الاميرْبَارِيس وقيل إنه الحَمَاض الْجَبَلي وَهو حَظأ :: **درَاسي** قِيل هو الْعَصيْد وَقيل هو صِنْفٌ لِلّبَاب صَغير لَه فضلًا مُنْبت على الْأَرض كحمرَة درَاع وَدهن أرزوَرَهن مِثل رَجب النِّيل وَلَه ثَمَر كَثِير أنَا عَايِن فهَذا النبَات أكلَه الضَان فطلقَت بطونَها وَزعم قوم أنه أبرح وَهو حَظأ :: **دَازْمَك** هو المَرو والْأبيَض مِن الْحاوي :: **دَزَلْط** قِيل هو عَصَا الرَّاعِي :: **درب** هو الجلفَا مِن الْحاوي :: **دَرَلّت** هو الاشنه مِن الحاوي :: **دَرَيْط** هو الارَادَزَخت مِن الحاوي :: **دَرُورَقُ** هي الكرَشنة مِن الحاوي :: **دَرْسْ** وَدَرْبيس وَدَرْبوس هو الْبَلُوط بِالْيونَانِيَه :: **دَزْخُولَى** الناسُ يعرِفون عِنْدنَا سَيْفَا لِغرَاب بِهَذا الْاسم وَهو الدلْبُوث :: **دَزْحوِيَه** هو الصِنْف الْكبير مِن الْعرْوز وَهو الْكَزَم مِن الحاوي :: فَهو أضعَف مِنه دَزْحويه :: **دَرْدَرَه** قِيل الْمعْرُوف عِنْدَنا بِالنَاك وَهو مِن الْبِيش :: **دَرْفَا** هو الْعرق بِالْيونَانِيَه وَقَد يُسَمى أيضاً الْبيرْزَوج بهَذا الْاسم :: **دَرْفَاس** هو الْبَسْبَاسَه بِالْهِنْدِيَه مِن الحاوي :: **دَرْفِه** هو فَمَلة السْنَرْ بالسِّرْيَانِيَه :: **دَرْسْيَان** قِيل هُو عَصَا الرَاعِي :: **درله** هو الإرَادَزَخت مِن الحاوي :: **دَرْمَا** قَالَ أبو حَنِيفَه الدمَا يَنْفَع كلَ نَاجِيَة ولهَانَا أَحْمَر وَرَقهَا أَخْضَر وَهي شبِيه الحمَة الآرّ الحَمَه غَبرَا أخْشَنه ونُورهَا مثل نَوْر الحَلْمَه وَهي مِن نَبَات السّهل وَرَقهَا خضَب بِه الصَبيَان قَالَ الْمُؤَلف أظنهَا المَعْرُوفَه عِنْدَنَا بِالزعيْفرَا :: **دَرْمَسه** وَدَرْمَوا هو المَرَا الْأَبيَض وَهو الْمَزمَاجُوز مِن الحاوي :: **دَزَكْ** هي فَمَلة السْنَرْ الْهِنْدِيَه :: **دَزْعَرَلْ** بِالْهِنْدِيَه هو النَبَات الْمَعْروف بِالْيونَانِيَه أعرَاطِرن مِن الحاوي :: **دَرْوَا** قِيل هو الدَّرْدَانْ ۞

بالهندية من الحاوي ٠٠ **دسدار** هو صنف ثمر الأهل ٠٠ **دسافوس**
تأويل هذا الاسم باليونانية العطشان وهو صنف من النوك يسمى مشط الراعي ٠٠
دبك هو اللاك بالهندية من الحاوي ٠٠ **دندردوس** هو صنف
من البتوع ٠٠ **دنرخموا** هو الفوه من الحاوي ٠٠ **درحون** هو
الكرفس الجبلي من الحاوي ٠٠ **دبق** هو العلك الذي يعرفه الناس بعلك
السبيبط وهو الذي يستعمله الصيادون لصيد العصافير والدبق ايضا هو الاخيص
الاسود وهذا هو الذي يقول فيه الشاعر
كالدبق يمثل من تعرض اكله وشكا وبلم اكل الغثان ٠٠ فالدبق
اصل الشكران والغثان سافه وفرعه وذلك ان اصل اللبان ثمة لست
في فرعه وزعم قوم ان الدبق هو الطوان والغثان هو الاشلة ولبس هذا الاول
بصحيح وزعم ابحيى ابن عمر ان زبج الحظا ينبني ثمر الدبق ٠٠ **دبقه** هو الزوان
الذي يكون في الحطة وينفى منه ٠٠ **دبقيطين** مثل ماشبه ٠٠ **دبقسا**
هو ذنب الخيل من الحاوي ٠٠ **دبس** هو عسل التمر ٠٠ **دبس** هو الاتل وقد
مضى ذكره في جزء الالف ٠٠ **دبكا** هو الجنك بالترنانيه ٠٠ **دبك**
اعور هو الجنك ايضا ٠٠ **دنوسناس** هو صنف من الهو فارنيون
دوسنالايوا هو الشاه بلوط باليونانيه ٠٠ **دوسقرون**
هو الملب ٠٠ **دج** هو كزبرة النحام ٠٠ **دجا** هو الزاج بالهندية من الحاوي
دحا هو الزعفران ٠٠ **دجر** هو اللوبيا ٠٠ **دجنيسا** اسم يقع
على البلك وبيع ايضا على دهن البلسان من الحاوي ٠٠ **دجودا** وفوع هذا
الاسم في جداول الحاوي وكتب ازايه اسفنغو زورك جزء مناج ٠٠ **دحوانا**
الغراب ٠٠ **در** بذكر في ثم لولو ٠٠ **درابن** هو فلفل الصقالبه وهو
الجزء المشربي ٠٠ **دراجن** قتل هو الرابل وهو عتر الحروف ويقال له ايضا
المداهني ٠٠ **درافيطون** هو اللوف الكبير وقوم يصحفونه ويقولون

وغيره من القدماء وأما وشّ ابن نميم فانه قال ان الدارشيشغان عند عبّاد له أهل
العراق وهو ثمر الرمان البرّي وله خشب أصفر صلب فيه عطر به وله ثمر يقال
له انلو وما داخله لحمه يقال لها الكمنه وهو دواء يحبس الطبيعه وينفع من الحمّات

دار سوانر قبل هو عرق الكرم. **دار كسه** ويقال دار كنه
قيل انه البسباسه وقيل هو الطاشمير. **دارم** نجز نشبه الغضا له هدب
ولونه اسود ومنابته الرمل نواحي البحر ويتخذ منه المساويك وطعمه حريف واذا
استيك حمّر اللثه والشفه ذكره ابو حنيفه. **دارما** هو المرّ والأبيض
وهو المرّ ماجور. **دارويقي** هو الشاع من الحاوي. **داروح** قيل
هو الراعي. **دلسيقي** هو النبيج. **داري** هو الطرفا بالهنديه من
الحاوي. **دا قدس** هو جل الغار بالبونانيه. **دا فونداس**
معناه الشبه بالغار وهو ضرب من الغار الجبلي وسنذكر مع اصناف الغار
وقد سمّي ايضا البان المسمّى للمباطن بهذا الاسم. **دافني** هو الغار بالبونانيه
دا في الاسكندراي هو الغار الاسكندراني. **داوور** هو صمغ
الكرم بالهنديه من الحاوي. **دافولا ولا** بالسرنانيه هو صمغ
زيتون الحبش وهو الزيتون البرّي من الحاوي. **داماسايون** هو من ماد
الراعي. **دامفتري** هو المرّ والأبيض. **دامقر** هو الدادي
بالهنديه من الحاوي. **ديا** هو الفرع. **دباب** هو النمام البستاني
دباد ازي صنف من الآ‍هل يقال له الصنوبر الهندي وقد ذكر مع الابهل.
دماسيوس ملكى وقع هذا الاسم كثير من التراجم وزعموا انه العوسج
والاسم مصحف وانما هو اسيوس. **دياميرون** هو مركب اللون بالبونانيه
دياقود هو شراب الخشخاش يسمّى بالرّوميه وبالبونانيه دافرديوس
وبالسريانيه دياقودا. **دنا روبه** هي البقله التي يقال لها الحزاه
بالعلز يانه ذكر ذلك الرازي في المنصوري. **دينو** هو النخواه

والمصابح فتسمّى هذه المصابح الدادى وأصل هذه الكلمة بالدرّ ومنه طاطس
والدادى أيضًا هو القطران الصافى ۞ دارزبو ا هو النظر أن الصافى أيضًا
الذى ينال له الدادى دارى هو الأهل ۞ دارصوص موصّف من
الدارصنى وقد ذكرمعه ۞ دارفلفل نذكر مع الفلفل ۞ دارفل
هو جنسٌ من الحاوى ۞ دارسليسان هو البخنكشت ۞ دارشيغان
اسم فارسيّ ويسمّى بالفارسيّة ربانسان وتسمّيه أهل الشام فليسيد ازدبز ومعناه
بلسانهم عود السنبل وأمّا يزيدون به عود ىشبه رائحه السنبل لأنه عود السنبل
على الحقيقة والناس يستعملون بدله عند ابخاب جولا لأنه زهر والصحيح أنه
نوع من الجوز وكان الجولا صنف منه زدى وأحلى به أن يكون الصنف الذى ذكر
منه أنه ليست له رائحه والجولاشجرلها أصناف كثير منه كبير وصغير
ومنه ما يقوم على ساق ومالا ساق وله وجميعها شوك كبيرا وأكثرها
لا ورق لها ومن أصنافه يكون له ورق لطاف صغار فيما يكون كصغار ۞ ورق
الآس ولجميعها زهر أصفر ومنها ما لزهرة رائحه طيبه ومنها مالا رائحه له ومنها ما
يخلف حرارب صغار فيها بزر ومنها ما يعقد حبا جب العرعر ويمتلى منه
والدار شيشعان من هذه الأصناف منه ما هو شوك كله بلا ورق واغصانه
كثيره فصارتخرج من أصل واحد وهو متندوح كأنه قفّة شوك أفرعت على الأرض
أخضرحصن وزوق الارنب ولون اغصانه حمراء لون الفرفرته وفيه عطريه
ومنه ما يقوم على ساق وله خشب غلط طلب صفر وداخله احمر عطر الرائحه
وشوكه دقيق كثيف وقضبانه دقاق مندوحه ن اعلى ساقه ويعلوا شجره
دون القامة وبز اصعاف الشوك وزود منوجدا وزهر أصفر ذهبى وحراب
صغار فيها ملث حبّات لطيفة لون ها أصفر ونبت فى جبال مظللة بالشجر
وخشبه عطرته عجيبة وهو ألطف من الصنف الذى ذكر أنه واكثر
نبات هذا الصنفين فى السواحل فهو الذى يعرفه وهو أفون الما وصف

وهو الذي يطبخ عند الطبخ وقد جفت ويحتج ويشرب بشراب وانفع من كانت معدته
وجعه :: ومرق الفراريج اذا كان ساذجاً واستعمل نفعه خاصه لتعديل الابدان
النحيفه والذين يعرض لهم التهاب في المعده ومرق الديوك العتيقه نستعمل
لأنها تلطف البطن وينبغي ان تخرج اجوافها وتصير مكانها ملح وتخلط بطونها وتطبخ بعشر من
اوطالها من الما حتى ينضج ثم تؤخذ ويطبخ ويشرب وينجح ومن الناس من يطبخ معها كرنبا
جزلا والنبات الذي ينال له ليون يسطرل وقطماً وتنبأخ فنبهل كيمونا زحجا
غلظا نابا اسود ونافع الحمات لمن به التي ينال لها دوا والادوا والازنعاس
والزبوو وجع المفاصل ونفخ المعده والرهل الفاسد :: عنبر هذا المرق المذكور
نفع التوبيخ جدا ولحم الدجاج المتي ينفع العقل ويصفي الصوت :: دود القرم
دد ويوجد في شجر البلوط في البلاد التي ينال لها قلبفاشي صدي وصغر بشبه
بأكلرون وجمعه ناس اهل البلده ويسمونه بقبر حج اذا اخذ هذا من البحر وهو
رطب طري فهو يبرد وجفف في الدرجه لان بيه شي يقبض قبضا معتدلا :: ه

الثالثه
تيفا

دود البقل دب ينال انه اذا يلطخ به الازب منع من نشر الدوا والسم

وهذا شرح ما وقع في هذا
الباب من الاسماء

دانق موجب العزعز :: دانغای هو السعد الهندیة من الحاوی ::
دابوتنا هو الدنق بالسریانیه :: دادی شجر له نوار احمر وقد تقدم
ذکره وایضا النبات التي بالیونانیه انغزا وقد مضی ذکره ایضا واصله
بالبربریه اداد وقالت ایضا جنس الهو فان یغون هو الدادی الرومي والدادی
ایضا هو المعاور دهی مصابح تتخذ من الخشب الدسم الکثیر الدهن الخفیف
کخشب بعض اصناف الصنوبر فانه لدسمه سندونه الناس ویکون بمنزله الشمع

نهش الهوام ومن شرب الحيوان الذي ينال له فروبوس ودم السلحفاة البرية اذا اشرب
وافىق من به صرع ودم الثور اذا ضمد به جراح مع النوبة حللها ولبن الاتن وام الصبيه
ودم الخل المحصه ينفع ج اخلاط المرا هم المعفنه ودم الحيوان الذى ينال له
حاملا و هو الجربا سبل انه اذا انبت الشعر النابت في العين وجعل ج اصوله
يتركه ان ينبت ودم الضفادع الخضر النهاليه يفعل ذلك ايضا وقد يبط بدم
الحيضه انه اذا انتج به و يعدى فيه الباوس منع من الحمل واذا الطخ على النفرس
خفف وجعه وكذلك اذا لطخ على الجمره وقال فى الارانب انه ان يلطخ بدمه
وهو جارىا رئنا الكلف والبهق والبثور اللبنيه وقال فى ابن عرس ان دمه اذا
لطخ على الحنازير ىفع منها : **غيره** دم النيس المحفف ينفت حما الكلبين
ودم البقر اذا صب على الحراحه حبس الدم . **دماغ** دب دماغ الارنب
اذا شوى واكل نفع من الارتعاش العارض من مرض واذا دلكت به لثه الاطفال
او اطعمه الاطفال نفع من الاوجاع العارضه لهم من نبات الاسنان : دماغ الدجاج
اذا شرب بشراب نفع من نهش الهوام الخبيثه وىقطع نزف الدم العارض من حجب
الدماغ ح ى دماغ الضفادع المجزى ينال انه ىقطع انفجار الدم اذا اشرب عليه
واذا اعوج به : زعموا اذا التعلب مع الرفت شفاه ودماغ الارنب مشوبا ىوافق ىبات
الاسنان الاطفال كما ىوافقها الزبد و شبهه وىنال ايضا انه نافع لاصحاب
الرعشه : **غيره** دماغ ابن عرس اذا جفف وشرب مع الخل نفع من الصرع ودماغ
البط من ادوىه اورام المعدده وزعم قوم ان لادمغه صاحبه من شئ النوم ونش
الحيوانات اذا اكل : **دجاج** ح ب مرق الدجاج المطبوخ استفيد باجا مطروديوس
قوته فوته مصلحه للمزاج واما مرق الدىوك العنىقه يطلق البطن وىنبغى لمن
اراد ان ىعالج به ان يطبخ الدىوك بالما طبخا كثيرا و هذه اشيا قد جربت بها
وصحت د ب الدجاج اذا اشفت ووضعت و هى ىخنه على نهش الهوام نفعت
منه وىنبغى ان ىبدل كلوقت والدىك اذا الحزى و اطا الحجاب من باطن حوصلته

الناس من شئ دم المعز مخلوطا بغلا اصحاب الحبن و منهم من شوى الاكرو سقاه لمن
به انطلاق البطن و اختلاف الاشيا الزرجه المحالطه التى خلط الدم فانتفعوا بذلك
و من الاطبا من زعم ان دم الديوك و الدجاج نافع من الدم السايل من اغشيه الدماغ
فلم اقبل ذلك ولا رأت تجربه و منهم من زعم ان دم الحر فان اذا شرب نفع من الصرع
والادويه النافعه من هذه العله ينبغى ان يكون لطيفه القوى و دم الحر فان على صفة
ذلك غليظ لزج :: و زعم اسقوفراطيس ان دم الجدى نافع من الصرع و زعم انه ايضا
نافع من قيد قال الدم اذا اخذ منه و هو جامد مقدار نطل و خلط مثله خلا ثقيفا و طبخ
حتى يغلى ثلث غليانا او اكثر ثم قسم عليه ثلثه اجزا و يسقى منه مثله ايام كل يوم
على الريق وقد جرب هذا فنفع و دم الدب هو جار اذا وضع على الاورام اصحبها سريعا
و يفعل و دم التيوس و دم الكبش و دم الثور وقد زعموا ان دم الضفادع الخضر الصغار
اذا انتف الشعر الزايد بى الاجفان و وضع منه على موضع الشعر لم ينبت فوجدت
ذلك كذبا عند ما جربته و كذلك اصبت دم الفردان الكلبيه فانهم قالوا انه ينفع
من ذلك ايضا و اخبرى من جرب به انه لم ينفع به و قال قوم ان دم الحر اذا ريب
حتى البصر و ركت نخوسته لغده و لا ابى اقدر على عزو من الادويه التى قد امتحنتها يفعل
ذلك و لذلك لم اجرب دم الخيل و ذكروا انه نفعز و حرز و لا دم الفار فانهم قالوا
ينفع الثآليل و المسامير من الابدان آ ب دم الاوز و دم الجدا و دم بط الما ينفع
به احلاط الادويه المعجونه و دم عصا فور و الشانين و الحمام فيوخذ
و هو جار فيكتحل به للجراحات العارضه للعين و كسا الدم فيها و العشا و دم
الحمام خاصه يقطع الرعاف الذى من جنب الدماغ و دم التيس و العنز و الارانب
اذا استعمل مقلوا نفع من فتح المعا و قطع الاسهال المزمن و اذا شرب كان صلحا
للسم الذى يقال له طقسيقون و دم الارانب حار انه اذا الطخ على الكلف و البثر اللبنى
ابراها و دم الكلاب اذا شرب و انقا من عضه الكلب و من شرب السم الذى يقال له
طسيغون و دم السلحفاه البريه اذا شرب بشراب و انفحة ارنب و كمون و افق

دَمٌ حَتَّى الَّذِي يَخُصُّ ذِكْرَهُ مَا مَنَامَ مِنَ الدَّمِ هُوَ الطَّبِيعِيُّ الَّذِي قَدْ سَلِمَ لِصَاحِبِهِ وَكَانَ
بَرِيًّا مِنَ الأَسْقَامِ وَلَمَّا قَاتَ عَيْرَ مَذْمُومٍ لِلخَوَالِجِ وَهَذَا الدَّمُ الطَّبِيعِيُّ هُوَ مُخْتَلِفٌ فِي
الحَيَوَانِ وَذَلِكَ أَنَّ مِنَ الحَيَوَانِ مَا دَمُهُ نَطْبُ وَمِنْهُ مَا دَمُهُ بَابِسٌ وَمِنْهُ مَا دَمُهُ إِمَّا أَحَدٌ
وَإِمَّا أَبْرَدُ فَإِنْ غَلَبَ عَلَيْهِ بَعْضُ الأَخْلَاطِ فَمَالَ إِلَيْهِ أَوْ عَفَنَ فَهُوَ دَمٌ فَاسِدٌ وَلَيْسَ بِصَحِيحٍ
طَبِيعِيٍّ وَدَمُ الخِنْزِيرِ جَاتَ مَثَلَ دَمِ الإِنْسَانِ لِذَلِكَ جُمَّ شَبَّهَ بِلَحْمِ الإِنْسَانِ حَتَّى
إِنْ قَوْمًا كَانُوا فِي بِلَادِ الرُّومِ كَانُوا يَقْتُلُونَ النَّاسَ وَيُطْعِمُونَ لُحُومَهُمْ لِغَيْرِهِمْ عَلَى أَنَّهُ لَحْمُ
خِنْزِيرٍ فَلَا يَتَبَيَّنُ مَنْ يَأْكُلُهُ أَنَّهُ لَحْمُ خِنْزِيرٍ وَأَمَّا دَمُ الحَمَامِ فَقَدِ اسْتَعْمَلَهُ كَثِيرٌ مِنْ قُدَمَاءِ
الأَطِبَّاءِ بِنَفَضِ الرَّأْسِ إِذَا انْصَدَعَ بِأَنْ يَصِيرَ بِهِ الشَّقُّ الَّذِي أَصَابَ الْعَظْمَ وَكَانُوا إِذَا لَمْ يَجِدُوا
دَمَ الحَمَامِ اسْتَعْمَلُوا مَكَانَهُ دَمَ الوَرَشَانِ أَوْ دَمَ الْمَوَاخِتِ أَوْ دَمَ الْيَمَامِ وَالشَّفَاءُ بَيْنَ
أَيْدِيهَا كَانَ حَاضِرًا . وَأَمَّا أَنَا فَقَدْ حَضَرْتُ عِدَّةً مَمَّنْ شَوَّسَ أَنْفُهُ وَفُطِرَ فِيهِ بَدَلَ هَذَا
الدَّمَاءِ دُهْنَ وَرْدٍ وَقَرْ وَلَمْ يَضُرَّهُمْ ذَلِكَ عَيْرَ أَنَّ الدُّهْنَ الَّذِي يَنْبَغِي أَنْ يَنْصَبَّ وَهُوَ تَخْزِينٌ عَلَى
نَحْوِ تَخْوِينِهِ الدَّمَ فَعَلِمْتُ بِذَلِكَ أَنَّ مَنْفَعَةَ ذَلِكَ لِلدَّمِ إِنَّمَا كَانَ لِتَخْزِينِهِ لَا لِشَيْءٍ أَنْفَعُ
فِيهِ عَيْرَ ذَلِكَ التَّخْوِينِ وَاعْتَبَرْتُ مِزَاجَهُ وَقَدْ بَانَ مِنْ هَذَا أَنَّ دُهْنَ الوَرْدِ أَفْضَلُ مَا عُولِجَ
بِهِ الشَّوْيُ الَّذِي يَعْرِضُ لِلرَّأْسِ إِذَا كَانَ هَذَا الدُّهْنُ مُعْتَدِلَ الْمِزَاجِ وَكَانَ فِيهِ شَيْءٌ مِنَ الْقَبْضِ
وَبَعْضُ الأَطِبَّاءِ كَانُوا يَبْتَعِرُونَ دَمَ الحَمَامِ وَهُوَ حَارٌ بَلْ يَعَبُّ إِلَى الْعَيْنِ إِذَا أَصَابَهَا طَرْفٌ فَجَمِيعٌ
فِيهَا الدَّمُ فَيَشْفِيهَا بِذَلِكَ وَمِنْهُمْ مَنْ يَأْخُذُ رَئِيسَ فَرْخِ الحَمَامِ النَّاعِمِ مِنْهَا الرَّخْصَةِ الْمَلْوَةِ دَمَّا
دَمًا فَيَعْصِرُ مِنْهَا فِي الْعَيْنِ وَمِنَ النَّاسِ مَنْ يَسْقِي دَمَ عُلْوِسٍ وَهُوَ الحَبَارَى لِلرَّبْوِ وَعُسْرِ
النَّفَسِ وَمِنْهُمْ مَنْ يَطْبُخُ لَحْمَهَا فَيُعْطِيهَا الْمَرِيضَ وَيَحْتَبِيَهُ مِنْ مَرَقِهِ وَمِنَ النَّاسِ مَنْ نَظَرَ عَلَى
دَمِ شَيْءٍ مِنَ الحَمَامِ وَيَسْقِيهِ لِلْعَلِيلِ وَقَدْ رَأَيْتُ طَبِيبًا قَدْ سَقَاهُ عَلِيلًا بِشَرَابٍ وَمِنْهُمْ مَنْ
أَثْنَى فِي لَحْمِ إِذْ دَمَ الحَنَاسِ لَهُ مَنَافِعُ كَثِيرَةٌ وَأَنَّهُ إِذَا طُلِيَ عَلَى ثَدْيٍ لَا بِكْرٍ رَجَّعَهَا بِكْرًا
بِأَنْ يَمْنَعَهَا عَنْ أَنْ تَعْظُمَ زَمَانًا طَوِيلًا وَحَيْثُ أَنَاهُ هَذِهِ فَوَجَدْتُهُ بَاطِلًا وَكَذَلِكَ
وَجَدْتُهُ فِي طِلَاءِ الْبَطْنِ مِنْهُ إِذْ كَانُوا أَيْضًا قَدْ زَعَمُوا أَنَّهُ إِذَا فُعِلَ ذَلِكَ مَنَعَ مِنْ نَبَاتِ الشَّعْرِ
وَنَحْنُ نَقُولُ إِنَّ الْعُضْوَ إِذَا بَرَدَ بَرْدًا شَدِيدًا حَتَّى لَا يَنْبُتَ فِيهِ الشَّعْرُ وَهُوَ حَارٌّ وَمِنْ

آخرَ كأنّه عكس النحاس الذي يصفّى و علطه و ذلك أنّه بعد صبّ الماء عليه على الحجار و خرجه
من البواطي يوجد في أسفلها هذا الصنف و فيه قوّة الحجار و طعمه و منه صنف آخر
يعمل على هذه الصفة ۞ يوحنا الحجر الذي ينال له فوزبطس و هو المرقشيثا
و يصيّر في أتون و يطبخ عدّة أيّام كما يطبخ الكلس فإذا صار لونه شبيها بالون المغرة
أخرج من الأتون و رفع و من الناس من زعم أنّه يعمل صنف آخر أبيض من الحجان يعمل
منها الحجان إذا شويت هذه الحجار في المواضع التي ينال لها البياذ و في الأرجان و صيّر
في آناء و طبخت فإنّه يوجد حول الآناء شي و إذا أخرجت هذه الحجان أصيب بعضه منها
شي كثير و ينبغي أن يختار من الديفرجن ما كان منه في طعمه شي من طعم النحاس و طعم
الزنجار و لا أن بعضاً جفّف للنار جفيفاً شديداً و هذا البير يوجد في الجوهر الذي
ينال له اجر المجزوي و قد حزق الأجر و سلاخ جنب الديفرن و حن د ط قوّة هذا
و طعمه قوّة طعم مرّكب و ذلك أنّ فيه شي يقبض و شي حاذ قليل و هو لذلك دواء نافع
للجراحات الخبيثة الردية به نافع جدّا في علاج الفروج الحادثة في الفم أن يستعمل وحده
مفرداً و أن يستعمل مع العسل المنزوع الرغوة و ينفع أيضا مداواة الخوانيق
أن استعمل بعد ما قد منع و قطع أو لا ما أن يجري و ينصبّ إلى تلك الأعضاء و قد استعمله
أيضا لما قطعت لهاة و ذاء أو بها بسلعة قطعها ثمّ أحدث مرآرا كثيرة إلى أن
أدملتُ لأنّه دواء يدمل و يجمل أدما الأورام في هذا العضو خاصّه في جميع الأعضاء
الذي يحدث فيها الجراحات و لذلك أيضا هو نافع للنزوج الحادثة في العانة و في
الدبر و استعماله في هذه الأعضاء يكون مثل استعماله في الفم لأنّ هذه الأعضاء تستحيج
إلى مثل هذه الأدوية بأعيانها و تنفع بها و السبب في ذلك أنّها أعضاء جاتّ رطبة على
مثال واحد د و قوّة الديفرن و حن قابضه محفّفه منقّيه تنقيه قوّة جلوا و تقلع
اللحم الزائد ابنية الفروج و تدمل الفروج الحبيثة المنتشر في البدن و إذا أخلط بصمغ
البطم او بنبيز وطي على الدبيلات ۞ غنيزه يبشف فروج النائب الرطبه و إذا
نحوه اكتل و طلبت به الحكه أبراً كما و إذا انحني و نثر على الشعر الغلط رقّقه و لينه ۞

وجده أو مع الآس غضاً قبض أو رام البلغم و إذا ضمد به مع الآس على البطن
والمعده شدها ومنع عنهما سيلان الرطوبات و إذا ضمد به على اسفل البطن
وعلى الفروج قطع نزف الطمث الدايم وقد جلل الجراحات غير المفتوحة و أورام
الثدي بالها أنو جبلا وقد ينكر أو رام الثدي وأما الردي المحترق فانه إذا خلط
بالزاينج قلع الآثا ثاث البيض العارضه في الأظافير وإذا خلط بدهن المصطكي والزاينج
ولخ به الشعر وترك ليله حمره وقد يغسل ويستعمل في أدويه العين كما يغسل
التوتيا وجلوا اثار الدمامل والفروج العارضه فيها ويذهب بالغشاوة من البصر
دهنج كتاب الاحجار هو حجر يكون في معادن النحاس اخضر اللون والزبرجد
ولا يكون الا في معادن النحاس كما لا يصاب الزمرد الا في معادن الذهب وهو
الوان كثيره فمنه الاخضر الشديد الخضره ومنه الموشى لا نه الوشى ومنه على لون
ريش الطاووس ومنه الكمد ومنه بين ذلك في الحسن واللون وربما اصيب هذه
الالوان في حجر واحد بحر خطه اخرى فيخرج منه الوان كثيره من حجر واحد وهو
حجر فيه رخاوه وإذا ضع منه شي ومرت به شهور غاب لونه وذهب و إذا حك
احكاً شريعاً لرخاوته ولذلك ان نقش عليه انحت سريعاً واند رس وان
شع من محكة شارب السم نفعه بعض النفع وان شرب منه ان ال لبن به ثم اكاه
والهب بدنه ولا يكاد يبرئ سريعاً ومن امسكه في قبه او مصه كان زردياً وان مسح
على موضع لتع العقارب سكنه وان نجن منه شي ودبف بالخل وذلك به الغوال الحاد
في الجسد من المره السوداء اذهب بها ويفع من السعفه في الرأس و في جمع الجند
و هو حجر يصفر مع صفا الجو وينكد تنع كدرته وقال البعض ان ماء الدهنج
إذا ينجي نفو أجود ما يكون مداف إذا امسك للذي يصرع ولا يعرف حاله سعط منه
ثلث مرات ويحر به فيبرأ ديم وخس دّه هو ثلثه اصناف
فصنف منه معدني يكون في قبرس فقط ووجوه من جنس الطين يخرج في بربر
تلك الحجرين ثم يجفف في الشمس وبحد ان يحف يوضع حوله الدغل ويحرق ويحرز ومنه صنف

الآن هذه اليقينه يسيّر وأمّا جوهر الدخان نحوهنّ أرضيّ لطيف وقد تختلف
أصنافه الجزيه بحسب أصناف المواد التي عزاحترق فإنّها تولّد المادّه التي يجز وبعد
يتولد عنها دخان على حسب ذلك والمادّه التي يبرأ بالجلاوه ولذ عنها دخان يسيّر
يتولّد عنها دخان الكندر تستعمله الأطبّاء في أخلاط الأدويه التي تصلح للعين الوازمه
التي فيها قرحه فإن خروج العين تنتفع بهذا الدخان وكذلك يستعملونه في
الأجال التي يقال لها محسفه الاشفاز ودخان البطم أيضاً ودخان المرّ كلّ واحد
منها بعينه عزلا ذا الدخان الكندر فأمّا دخان المبيعه فهو أقوى من هذا ودخان
الزفت الرطب أيضاً أقوى من هذا ودخان القطران أقوى من دخان الزفت واللي
يستعملون من الدخان ماهو أحدّ الأدويه للإشفاز إذا نبت بها العلّه المعر وفه
بالسلاق وهوأن تنتثر الإشفان مع غلط وصلابه وجمره من الاجفان في مداواة الناكل
والحكه التي يكون ما في العينين وفي مداواة العين الرطبه التي لا ورم فيها ويستعمل
الأنواع التي نسمّيه بعدفي مداواة سائرالعلل التي قلت إنّهم يستعملون فيها دخان الكندر

دردى ينبغي أن يستعمل منه ماكان من عتيق خمر البلاد التي يقال لها
انطاليا وما كان من خمر أخرى يشاكل خمر انطاليا ودردى الخلّ شديد القوه جدّا
وينبغي أن يحزق ثمّ ما يحزق ربّ بعد أن يجفّف تجفيفاً بالغاً ومن النّاس من
يأخذه ويصيره في آناءٍ يخارجديد ويلهب تحته ناراً قويّه وبعضهم علّه الى أن يصلح
عمله الى باطنه ومن الناس من يكبله ويطوّق يجمر ويبعد عليه الى أن توقيه كلّه
النّار وينبغي أن يعلم أمارة جودةاحتراقه الى أن يستحيل لونه الى البياض والى
لون الهواء وأن يكون منه قرب من اللسان السه احتراقه الدردى الذي من الخلّ
على هذه الصفه يحزق أيضاً والدردى المحزق وله قوّه مجزّبه شديده الاحتراق
جدّاً يجلو ويبلغ اللحم الزايد من الفروج وقبض ويعفن تعفناً شديداً ويسخن ويجفّف
وينبغي أن يستعمل وهو حديث فإن قوّته تحلّ سريعاً ولذلك لا ينبغي أن يخزن في غير
اناءٍ ولا يترك مكشوفاً وقدبغسل مثل ما ينغسل التوتياء والدردى الذي يحزق إذا

طركس

أصلح من الشجري عيسى ابن علي وطعمه شبه طعم اللوز المر ونواه داخله لسان
شبه لسان العصفور وهو المهم. أبو جريج واعلم انه على طول الازمان لا يرى البه
الذي في جوفه مثل السار يصغر حتى ينعقد وخاصه في غير بلاده واما في بلاده فهو
ابقى واقوى حبيش والدنك كله جارحاد والعجب من حدته مع الدهنته التي
فيه وهو يجلو لخام والبلغم الذي ينصب الى المفاصل السوداء واهل الهند خلطونه
بادويتهم الكبار المعجونه والاصطماخيونات وغيرها من الادوية المسهله لان بلدهم
اعدل الاقاليم السبعه وحمل فيه الرند فاما البلدان الشديده الحر فلا يحتمل شراب
الدندو لكن يصلح بالبلاد الباردة واذا اردت انسانا شربه فلو طب عليه الخلفه
والكرب وهو ود ولم يحترس منه قلل باريه من ان ادشربه فليجتحن منه الصيني الكبير
الجت والهندي الذي دونه في القدر فاما السحري الصغير الجت فلا ارى سقيه البته
ولتشر عنه قشره الاعلى وليشر بعد بدر لا يميز بالفر ان قشره الاعلى اذا اصاب
الفم والشفتين واجل عليه ذهب جعلوا واحدث فيها بياضا شديدا يشبها بالبرص
واذا قشر جرج من اجل لسان رقوق شبه لسان العصفور قريبا من نصف الحبه
وليطرح فانه سم وكذلك يطرح البشراكا رج و يوحد الب فيدق مع شي من
الشاشنج والورد الاحمر المطحون المنقى من اقاعه وشي من الزعفران فان زعفران
وان كان نجانا فيه لطافه ودم قه منهب رق بهما يكثر شدته وبلغ به
الى اقاصي البدن فان اردت ان تمزجه بشي من الادوية المسهله فامز جه بالزبيد وعصان
الغافت وعصار الافسنتين وما اشبه ذلك الادوية التي هي مراجيه واذا خلط
بالادوية التي وصفنا كانت زوائد كبيرا او نفع من اوجاع المره السوداء والبلغم واهل
لخام وجلا اوجاع المفاصل ومسك الشعر كما كان على حاله ومنعه ان ينجلي الى البياض وشيب
شريعا ومقدار الشربه منه بعد اصلاحه للاقويا الذين يخلط اطبائهم لا دوية
الشديده من دانس الى نصف درهم. دخان حـ كـ دخان فهو
مجفف لان اجزه من جوهر ارضي وفيه بعد بقيه من النار التي اجرفت تلك المادة

الصلبة وقد يستخرج عصارته وخلط بالدقيق ويستعمل اربا ساس يذهب
بداء الثعلب ❊ **درويطارس** هو المعروف بالغار د د هو نبات
ينبت في الاحراج التي يكون الاشه فيها بعض من ثمر البلوط وهو شبيه بالنبات المسمى
بطارس غير انه اصغر منه بكثير وتشريفه ايضا اصغر من تشريفه وله عروق
مشتبكة بعضها ببعض وعضه الطعم مع جلاوة وقوة هذا النبات قوة مركبه
ومن ذلك انه وجد كذلك فان فيه جلاوة ومرارة فاما اصله ففيه مع منا
الطعم اللذة عنوصه وقوة تغفر فهو لذلك يحلق الشعر د وهذا النبات
اذا انجق مع عزقه وضمد به جلب الشعر د وينبغي بعد ازبد البدن ان ينجح
يصبر عليه منه وجد منه شي اخر ❊ **ابن سينا** زعم انه ينفع من الفالج واللوى

دند زعم **ابن جلجل**
و**ابن الهيثم** انه الماموذانه
وغلطا في ذلك وعلى هذا
الراي اطباء زماننا الدهر
وقد ذكر **ابو جريج**
الزاهب وحبيش ابن
الحسن ومحمد بن زكريا **الرازي**
وغيرهم الدند والماموذانه
جميعا بصنفين مختلفين
ابو جريج الدند لثه
اصلاف كبير الجت اشبه
شي بالسنو وتجري يشبه

درويطارس قال الباطس الماموذنه رجل البط

حب الخروع الا انه منقط بنقط سود صغار وهيئته متوسط القدرين الصينى والجزرى
ولونه اسود يضرب الى الصفرة والصينى اجود الثلثه واقواها في الاسهال والهندى

دوا وقد قاتله للكلاب والخنزير والبغال وعامة المواشي واذا شرب بالشراب
خص الناس من نهش ذوات السموم وخاصة ان خلط بها الشراب :: واما الصنف
من الحيوان مثل الضان والمعز فانه ان شرب من ماء قد استنقع فيه هذا النبات
قتله ** ماسرجويه ** ازطبخ وذقه ووضع مثل المرهم على الاورام الصلبة حللها
واذابها ** وقد ينفع عصيره وذقه من الحكة والجرب اذا طلي عليه من خارج البدن
وفاق جدا معطش ** ابن مانه ** وزده صالح للاوجاع الكائنة في الرحم ** الرازي **
جيد لوجع الركبة والظهر المزمن العسر اذا ضمد به ** ابن عمران ** اذا اخذ انبوب
قصب وقصب دقت فوضع طرف القصب في يا زحم والطرف الاخر في الانبوب
ووضع طرف الانبوب الاخر على الضرس الذي يكون فيه الدودة حتى يرتفع الدخان اليه
فانه نافع ** غيره ** اذا رش البيت بطبيخها سل البراغيث واذا طبخ وذقه وزهره
بالزيت نفع الجرب نفعا بليغا واذا ذق وزنه بابل ورش على الفروج جففها ه

** دوسر ** هو عشبة لها ورق شبيه بورق السنبل الا انه ازين منه
وفي طرف ثمره سيف علافين أو ملسه وطهر جوف الغلف شيء
دقيق البعر ** ح ** وقوه
محلله كما قد يدل على ذلك
طعمه وذلك ان فيه حرافة
يسير وقد يستدل على ذلك
منه بانه يشفي الاورام التي
ينبغي ان تصلب والواطيه
التي تحدث في العينين ويعرف
بالعرب ** ح ** هذا النبات
اذا اضمد به مع الدقيق
العرب المنخر وحلل الاورام

الزيتون الا انه اطول منه وارق وهو خشن جدا وله زهر ابيض وفي اطرافه غلف
كثيفه كانها غلف الحمص فيها ثمر مستدير فيها خمر اوثنت فاذا رجب الكرشنه
الصغار ملمس صلبه مختلفه اللون وله اصل غلظ اصبع وطول ذراع وثبت ب
صخور ليست بعيده من البحر وهذا النبات شبيه بمزاج الخشخاش ومزاج البنج
وغيرهما من الادويه التي تبرد مثل هذا التبريد وذلك ان فيه مقدارا كثيرا
من برودته ماييه قويه جدا ومن اجل ذلك من يناول منه انسان اشي اليسير احد
شيا ومن يناول منه الكثير قتله. **دفلى** هو منتشر عظيم معروف
شبيه بورق اللوزا الا انه اطول واخشن واغلظ وزهره شبيه بورق الوزد احمر
وحمله شبيه بالخرنوب الشامي منبج في جوفه شي شبيه بالصوف ما يظهر في زهر
النبات المزمن واقيش
واصل هذا ظاهر ف
طويل المذاق الطعم وينب
ت في البساتين وفي
السواحل وهو
النبات يعرفه
الناس واذا وضع ع
البدن من خارج فقو
ته تجلل تحليلا بليغا
واذا شرب وله انسان
جف برد الى داخل
البدن فهو قتال وليس
ينقل الناس فقط بل قتل كثيرا من الانعام فامتراجه تسخن في الدرجه
الثالثه عند مبدها ومن التجفيف في الدرجه الاولى وقوه زهر هذا النبات

نماه ماجاريون ثمى هذا النبات بهذا الاسم لمشاكلة وزقه للسوسن وورق هذا النبات يشبه ورق الصنف من السوسن الذي يقال له ارسا الا انه اصغر منه وادق وهو دقيق الطرف مثل طرف السيف وله ساق نحو من ذراع عليه زهر مصفف منفرق بعضه يبعض لونه لون الغربر وثمر مستدير وله اصلان احدهما مركب على الآخر كانهما بصلتان صغيرتان اذا وجدنا الاصلين اسفل والثاني والاصل منهما ضامر والاخر مثمر والثمر ما ينبت في الارض في العام ه ‏ اصل هذا قوته جاذبة لطيفة محلله واذا كانت كذلك فمعلوم انها ايضا محففه وخاصته على منهما
ح الاصل الاعلى اذا ضمد به مع الكندر والشراب اخرج من اللحم الارجه والثلى وما اشبه ذلك واذا خلط بدقيق الشيلم والشراب الذي يقال له اذر ومالى ومضدت به الاورام التي ينال لها وحلاجلها ولذلك ينفع خلاط المرأ هم المحلله هذا الوز مروا واذا احتملته المرأه ادر الطمث ويقال انه اذا اشرب الشراب جرك شهوه الجمع ويقال ان الاصل الاسفلى اذا اشرب قطع شهوه جماع النسا ويقال ان الاصل الا على اذا استف منه الصبيان الذين عرض لهم قتله الامعا استعوا به **الزهراوى** اذا اخذ اصله وانتقع النبيذ وشرب من ذلك البنيذ كل يوم قدر رطل او نحوه حقف ارواح المعدده والبواسير وهذا فعله مجرب وقد جفف ويخذ منه كل يوم وزن درهم بماء العسل فنفعل ذلك

دورقنيون ددد فراطش

فراطش
يسميه الدفقا ويسميه ايضا قلا لاؤ وهو نبات يشبه شجر الزيتون واول ما يغرست وله اغصان طوالها اقل من ذراع وورق لونه شبيه بلون ورق

الناس من يعمله بأن يمضغ الثمر و قد يكون ثمره من شجر الفالج و شجر الكمثرى و شجر
آخر و قد وجد عند أصول بعض الشجر الصغار ٦ ح و جوهر هذا جوهر مركب من
جوهر هوائي و جوهر مائي و حار كلاهما كبير أن فيه جدّ و من جوهر أرضي موقبه
قليل جدا و بذلك صار ثابت الحدة فيه اكثر من المرارة و افعاله ايضا تشهد
لجوهره و ذلك انه ليس يجذب الرطوبه اللطيفه من عمق البدن اجذابا قويا فقط
ولكن يجذب ايضا الرطوبه الغليظه و يخلطها و يلطفها و يجلوها و يحللها و هو مثل الاشياء التي
يحتاج ساعه توضع ان يمكث من بعد ما يوضع من طويله و تنخر كما يلعله
الأفتيمون البنتور و هذه خصله موجوده في الأدويه التي فوه منها كانت مع
اتخانها فيها رطوبة فضلا عن غير نضجة ٥ ح ة فوه محلله ملطفه جاذبه و اذا اخلط برأ
ومومٍ من كل واحد منها جزء و بنا و له الشح للجراحات و الاورام الظاهره في اصول
الآذان و الاورام شائر الاورام و اذا انضمد به و اذا اخلط بالكندس ابرئ القروح المزمنه
و اذا اخلط بالنون او بالجبن الذي ينال به عاطرا او بالجبن الذي ينال له استموس
وطبخ معها و وضع على الاورام الخبيثه او على الطحال الجاسي جلا الاورام و الجنس
و اذا اخلط به الزنج الاصفر و الجمر و وضع على اثار الاظفار قلعها و اذا اخلط
بالنون و عصير العنب قواها ✦ **دلبوث** هو المعروف بسيف
الغراب و الثيانه المزارع
و له بصله بيضاء مصممه
عليها لیف و ليس لها
طاقات تطبخ باللبن و يوكل
و هي اذا كانت ثمره من
عنصه ٥ ح كسيفون
و من الناس من يسميه
سعر غانيون و منهم من

امرة النرى

كسيفون و هو الدلبوث

الكزبرة وله زهر ابيض ورائحة
وثمرة مثل ثمرة الشبث وثمرة
اكليل شبيهة باكليل
الجزر مملوء بزرا طويلا لا شبيهة
بالكمون حريف وزنه خ و
جار شديد يخرج ادرار البول
وهو اذا ادرار البول قوي
الادوية وصلح لادرار الطمث
واذا وضع من خارج جلا عابة
الجلد الورق من الرطوبة
المائية التي يبتدي ابتداء جازه

المزاج خ وزن هذه الاصناف كلها اذا شربت انخرت وادرت الطمث والبول اجود
الجنين وتكرير المغص والسعال المزمن واذا شرب بالشراب نفع
من نهش الرسلا واذا انضمد به جلا لا ورام البلغمية ومن اصناف لدفوثا انما
يستعمل البزر ما خلا الصنف منه الذي يقال له مرطيقوس فان اصله ايضا يستعمل وقد
يشرب اصله ايضا بالخمر لضرر الهوام. غبن جار بابيس الثالثة يخرج المعدة
ويحلل النفخ والا باج ويعين على الاستمراء وينفع من لذع العقارب اذا طبخ وشرب
ماؤه أو صب على موضع اللذعه ويغني الرحم ويعين على الحمل لذلك ويذهب شهوة
الجماع وطبيخه يبني الصدر ويحلل المواد الغلظة من الامعاء وينفع من المغص واذا
خلط ببزر الكرفس في فعله. دبق خ أجوده ما كان حديثا
ولون باطنه شبيهة بلون الكراث ولون ظاهره الى الحمرة ليس فيه حشوه ولا
خلاه وانما يجعل من ثمرة مستديرة تكون في شجرة البلوط التي وذهبها شبيهه
بورق الشجر التي يقال لها موسن وهو الثمار باز تذوذ وحتى يثخن بطبخ بماء ومن

ومن الحقنان مع لذع ولذع العقارب وقال في الجامع انه ينفع من وجع الحلق والقم والمرة التي قابض لطيف مفتح للقلب جداً مفرح ينفع من الرياح الغليظة في المعدة والامعاء والارحام ويلطفها ويحللها وينفع من لسع العقارب و ملاصر وضمادا باللبن واجوده الخمر انثى ثم الشامي ذا الحبروح ويقال داج ابروح وما الجبلي يعرفه الصياد عندنا بالنقل الابيض وموضع معروف بالمشرق بهذا الاسم المجوسي هو يجب يوخذ به من جبال كذا زيتا اكل جا زئى الاولى معتدك في الرطوبة واليبس يزيد في المنى وحرك شهوة الجماع والله اعلم دوقوا دج منه ما

غاريس
دوقس

بقال قرطيغون ورقه شبيه بورق الراز بالج الا انه اصغر منه واذق طولها نحو من شبر واكليل شبيه باكليل الكرين وزهر ابيض فيه ثم ابيض حريف عليه زغب اذا مضغ كان طيبا لانه اجوده عطره حريف فيه مرارة ويدي اللسان والاول اجوده الذي بقال له قرطيغون ومنه صنف ثالث ورقه شبيه بورق

مزازه يبين وبستاك نحشبها فينفع اللثه وتحلل الرطوبه من اللهاه وريحها كريجه البهل لكنها اضعف وهي تحرج العرق وتنفع اصحاب الفالج واللقوه والفرش وربما اكلت باللبن **دواعريا** **اللاحه** هو قصب ينبت بين الصخور وفي الارض الصلبه اخشبه تعلوا شبرا مصمت الداخل خضر ثوبه صفرى يسيره وعليه زغب من اسفله الى الاعلاه ولون زغبه الى الصفره وله في راسه اربع ورقات مربعه الشكل تضرب الى البياض في خضره وزهرها في شي نابت كوز بعيد ورائحه طيبه وهو جيد للمعده مدر للبول يخرج فيه رطوبات غليظه وربما اسهل اذا اكل ناييا لا مطبوخا مطيب للجشاء

دروبج هوالخمس **ابن عمران** هوعروق بيض في نحوغلظ قضبان العصا يؤتى بها من الصين يدخل في الادويه الكباز المعجونه **ابن سينا** الدروبج اصول خشبيه مقدار العقد واصغر ابيض الى طرف اغبر الخارج الى الصلابه والرزانه جار بابين في الثالثه لي هذه صفه الدروبج المستعمل عندنا وينبت عندنا كثيرا وهو صلب للكسر ومر الطعم فيه عطريه يسيره واما الصفه التي ذكرها ابن عمران فلم ارها **مسيح** جار بابس في الثالثه ينفع من الترياج النافجه ومن لسع الهوام المسموم **ماسرجويه** ينفع الترياج الداخله وخاصه الريح العارض وينفع من اوجاع الارحام **الرازي** ينفع من وجع الارحام الباذه

الموسر

فأنه إن وضع ترد وجفف (كذا) هو اينا من الحبوب التي يعمل منها الخبز ويشبه الجاورس ويعمل منه الخـ.... يعمل من الجاورس فانقـ.. اريد ان يدي العذا بطي الانضام وتبقيه يقطع يقطع الاسهال واليـ.. العارضتين من الصفراء

دلاع وهو البطيخ السكي والبطيخ الهندي يقوبا بازد رطب غليظ بطي الاستمرا جيد مطفي حران المعدة يولد دما غليظا ما ساايا وبلغمانيا :: **دسدازما** النلاحه هي بقله جريفه هنديه

نبوت على ساق خشني غير غض وبطلع على الساق شبها بالأغصان طبه تعلو ذرا أعـ.. شبيهه بورق الهاد شديده الخضره ويخرج في الربيع جوز الكوز القطن من عرون يندمه فيها برز مدور اغبر يستعل في الطبيخ واسا قل اغصانها مكون طبا ويطعه جرافه مع

الشكل خمري اللون وزعم قوم ان هذه الشجره هي الدادى الذى يختم به الانبذه بي
العراق يجمع زهره ويجعل فى الشراب فيشتد سكره ويؤكل زهره ايضا وسفل
عليه ما دام غضّا وزعم آخرون ان الدادى هو الذى يجعل فى النبيذ انما هو الشعير
الّا انه اردأ وأطول اللون إلى السواد ما هو مرّ الطعم يجعل فى نبيذ التمر بي
بغداد فيشتد ويقوى سكره ويمنع من الحموضه وذكر هذا ابن سينا وغيره وقد
تقدم ذكره وزعم بعضهم ان الدادى هو الشجر المسمى بلوبانه العراق وقد تقدّم
ذكره وقال بعضهم هو اقحص الأسود ٠ واما جالينوس ذكر ان الهوفاريون
هو الدادى الرومى ٠ ابن ماسويه الدادى أردأ ه الثالثه بابس قابض ٠ عبيره
الدادى جارما يابس يحزن نفرح يحران واحمران فى الوجبين وسدم من عربه مع شربه
المحوس ٠ اجود الدادى ما كان احمر حديث طيب الرائحه ومزاجه بارد يابس لا
اثنيه مزاحمه من ان يوجب بعض اخراقه ونبه قبض اذا شرب منه وزن درهمن مع
السكر نفع من البواسير وكذلك اذا طبخ وجلس فى ماه جفقها وان كان
المتعذه أو الرحم بارزه فانه يقبضها ويبردها واذا عجن بالعسل ولعق قتل الدود
والحيات التى فى الجوف ٠ عبيره يلين الصلابات جدّا وبسدد الزارش ينفع
من السموم ٠ اخضر الدادى يعرض لمن شربه دوار وهذيان ويهيج الأمعاء ويقطع
الرعفه ٠

دوم ابو حنيفه هو المقل وهى يخرج تسلو وينمو لها خوص
كخوص النخل ويخرج أقناء كأنها فيها المقل ويقال لخرصها الطفى والابلم وهو فوي متين
يسنيه حبس يعمل ازدم المقلو هو الرقل ويطبخ المهش وييسه الخشى وهو نوعه
وهو آخر ايات ٠ عيسى بن ماسه ٠ عصر ثمار البطن وهو مخشن بطى النجح وجمانه بارد
يابس بعيد واغذى راعتبر الأنضام مقو للمعده مسكن لحدة الدم والصد ث
والدار ويشدى لطف جوهره وقلح ضرره ٠

دخن ح هذا
حنس ثمر الجروب ومنظر شبيه بنظر الجاورش وفيه شبيه بقوته وغذاءه
تيشير بجفف فهو لذلك يجنس البطن كما يفعل الجاورش فاما من خارج

بطالانا

من كثرة اصابها [د] و زرق هذه الشجرة و اغصانها و قشرها قابضة و اذا انضمد بالورق منها مخلوطا بخل كان نافعا للجرب المتفرح و الزرق للجراحات و نشر الشجرة و الزرق للجراحات من اوزن اذا ربطت به الجراحة كما ترتبط بالبرء و ما كان من نشر هذه الشجرة غليظا و شرب منه مقدار درهم او بما بارد اسهل بلغما و اذا استبر على العظام المنكسرة طبخ الاصل او طبيخ الورق لحمها سريعا و الرطوبة الموجودة ب غلف الثمر عند ظهورها اذا لطخت على الوجه جلته و اذا اجفت هذه الرطوبة تولد منها جور شبيه بالبن و قد يؤكل ما كان من ورق هذه الشجرة رخصا اذا هو طبخ • غبير • اذا اخذ ورق من هذه الشجرة فجعلت النار حتى تيبس و اخذت الرطوبة التي تقطر منه و قطرت في الاذان ايرات من الصمم العارض من طول المرض و عصارة الورق اذا قطرت في الاذن فاتره نفعت من وجعها و اذا خلطت بعسل و اكتحل بها ايرات غشاوة البصر و هو بارد في الاولى و اما قشر هذه الشجرة فانه اذا اعجن بخل و طلي على البرص اذهبه ۞ داذي و يقال داذي هذا الشجر معروف عندنا بهذا الاسم و هو شجر معروف عظيم له و ورق مستدير الشكل و ورق الخاري الا انه امتن و اصلب و اشد ملاسة و له زهر احمر لكي اللون و تظهر في الربيع قبل خروج الورق و كاين على الاغصان حتى لا يكاد يبدو منها شي و له حروب صغار على قدر اصبع لاطبة فيها حب عدسي

داذين

اذا وقع في الآذان وينفع العين اذا اكتحل بها غيره اذا النقط ثمره وجففت
شيء خشن واحد الزبيب الذي طلي عليه و ينفع ايضا تنفع من الرعاف حبا وورقه وثمره
بعد ان كحل ... انه يذرر به ... جوف ... السحج صماد للنهش والعض
درد ... اهل الشام يسمون هذه الشجره دردار واهل الاندلس يسمونه النشم
واهل العراق يسمونه ... الشجر النش ابنا ... وثخ يخرج فيها اقماع منخنه

خرج البق البعيد
اهل العراق هو البعوض
واما الذي يسمى عندنا
البق فانهم يسمونه الاخل
هذه الشجره تعرف عندنا
بالنشم الاسود وهي شجره
عظيمه وورقها مستند بر
اخضر يضرب الى السواد جعد
الجوانب موشرها وهي متوازن
على القضبان وخشبه اجم
الى السواد ... فاذا حملنا ورق هذه الشجره وبعض اوقات جراحات طريته
لنا تأرقنا بما حده ... هذا الورق غيا ثامن فيه القبض والجلا معا والجاهد الشجره
اشد برروده ... ويبس ثامن ورقها ولذلك صار بخارها الى ... يبس الجلد
اذا وعولجن به باكل ... فاما ما دام هذا الاخضر ... قريب العهد فانه ان لف على موضع
الضربه ... يلثم ... يابطن ... ان يندمل واصل هذه الشجره فيه هذه القوه بعينها
ولذلك قد ... يبقوم ما ... الذي يطبخ فيه على جميع العظام المحاجه الى ان يندمل

جيد احسن اصغر بالـ
الحمرة والغبن يجب
الخروع والثرى مما
ينبت في الشعاري
الغامضة وفي بطون
الأودية ٦ ج ٥ ده
رطب للبس
الاشياء المعتدلة
ولذلك صار وضعه
الطري اذا نـجـ ووضع
كالـيـ على الاورام
الحادة في الركبتين

سكنها استكنا ظاهرا او اما لهذا السجر و في زها قوته بجفف حتى
ان لحاها اذا طبخ بالخل ينفع من وجع الاسنان واماجوزها فان استعمل مع السجم نفع الجراحات
الحادثه عن حرق النار وذلك ان الناس قوم يحرقون لحا الدلب فيتخذون منها دقاق مجففا
جلا اذا اعوج به منفع من العيـ التي تدكه وسخنها وعققت بيبب رطوبه كبير
تصب الها وقد ينبغي للانسان ان يحذر ويتوق العبار التي تعلو ولصق بهذا
الوزن فانه ضار جدا للقصبة الريه اذا استنشق وذلك لان يجفف كثيرا ويحدث
فيها خشونته وبضرر بالصوت والكلام وكذلك بضر بالبصر والسمع وان وقع في العين
والاذان ٥ ٦ اذا طبخ الطري من ورفه نخم وضمدت به العين نفع الرطوبات
ويمنعها من ان تنبل الى العين وينشر الاورام البلغمية والاورام الخارجه وقشر
الدلب اذا طبخ بالخل ومضمض به نفع من وجع الاسنان وثمر الدلب اذا كان طريا
وشرب نخم نفع من نهش الهوام واذا استعمل السجم ابا جرق النار وعبارا الثمر والورن

وذلك بأنّ أجزاءه الحادّة الحرّيفة تجفّف وأجزاءه القابضة تبرّد وكليهما يجفّف ولذلك ينفع من أوجاع المعقفه ومن أوجاع المتجلبه ؟ وقوّه هذا

الـاذرشيشقان وهو الذار شيشقا

رجل البستان الاربستان

الـاذرشيشقان مسخنه مع قبض ولذلك ينفع الملاع اذا طبخ بشراب ويمضمض به والفروج والبخه التي في الفم والفروج الخبيثه التي تستري في البدن اذا احتقن به ولنتن الانف وخرج الجبراد وقع في اخلاط الدرجات وطبيخه اذا اشرب عقل البطن وقطع الدم و ينفع من عسر البول والنفخ . غيّر جارء الاولى بابن آخر الثانيه منشف للرطوبات لخلطه نافع من اسنرخا العصب ينفع الانسان وينفع جدًا اعضاء الصدر وينفع من وجع المثانه ..

دلب

ابن سمجون هو الصنار با لفا رسيّه معرّب واصله جار وهو شجر عظيم من شجر الجبال له ورق مشرف مثل ورق الكرم وعوده ابيض اليى الجمرة رخو مشربه فيه عفوصة شديدة وبه تدبغ الجلود ترطبه ويموته بالاشراسا بعلمها له دون غيره

ابن عمران وقشره غليظ احمر وله نوّار صغير محلل خفيف اصغر اذا اسقط اخلف

لطافه جوهر و اما ارفه الدارصینی فکانها دارصینی ضعیف و بعض الناس یسمیه دارصینی
زور وقوه کل دارصینی مختنه مدر للبول ملینه منضجه و مدر الطمث و تقطع الجنین اذا
شرب و احتمل مع مر و وافق السموم و من نهشه الهوام و الادویه القتاله و یجلو ظلمه البصر و یبلغ
الرطوبه اللبنیه و الکلف اذا لطح به و ینفع من السعال و النزلات و الجنب و وجع
الکلی و عسر البول و قد ینفع من اخلاط اطیب الرایحه و بالجمله هو کثیر المنفعه و قد
ینحی و ینجب بشراب لبعضی زمانا طویلا و یجفف فی الظل و یجیز و قد یوخذ اخر
یقال له کما مومیسر و بیمت بعض الناس ایضا اسود و ناموم و خشن الشعب جدا و اخشن
عیدا ناما من الدارصینی و دون الدارصینی بکثیر فی الرایحه الطعم **ابن ماسویه** جاء
فی الدرجه الثالثه بایبس فی اخر الثانیه مطیب للمعده منهب للبرد منها مقوی للسدد
مجفف للرطوبه العارضه فی الراس و المعده و یحد البصر الضعیف من الرطوبه اذا
اکتحل به **مسیح** نافع من وجع الارحام خلط فی الادویه النافعه من العفونه و البله
و ینفع من النافض و الارعاش **الرازی** للاغذیه ینحی و یلطف الاغذیه الغلیظه و ینفع
الاثر و یحلع المعده العسر البارده و لذلک ینبغی ان یکثر منه فی الطعام الذی للمعودین
و فی طعام من به دبوو و اخلاط غلیظه فی صدرت و لیس ینفع من کثره الریاح ما یبلغ البلیله
بل ینفع قلیلا و لذلک یعین علی الانعاظ **الاسرائیلی** ینفع من النوازل المنحدره من الراس
الی الصدر و الرئه و من ضعف البصر العارض من رطوبه اذا اکتحل به او اکل او شرب
و ان طبخ مع المصطکی و شرب ما و ازال النوازن و اذهبه ۝ **دارشیشعان**
هو نوع من الجو یلو ینسج طیب الرایحه ینبت فی ارض السواحل یسمی السندول و بالبربریه ازدرک
اصلا ناس مرج جرم ذات غلظ یدخل بغلظها فیما ینشج ختبا فیها شوک کثیر یکون فی
البلاد التی یقال لها وزریا و یستعملها العطارون فی بعض الادهان و الجید منه ما کان رزینا
و اذا افرک یرمی لونه الی لون الادم ما هو او الی لون الفرفیر کثیفا طیب الرایحه فی طعمه شی من
المزازه و منه صنف اخر ابیض و غلط حتی لیس له رایحه او وهو و و زن الصنف الاول **طعم**
هذا الدوا و طعم حریف قابض و قوته ایضا حنیب ما یعلم من طعمه مرکبه من اجزا غیر متشابهه

ما كان زجديثا اسودا الى لون الرماد ما هو مع ان ان الخمر عبدانه دفاق ملس اغصانه كبير
بعضها على بعض طيب الرائحة جدا واجود ما يمتحن به الجيد منه هو الذي طيب الرائحة
خالص فقد يوجد في بعضه مع طيب رائحة شي من رائحة السذاب ورائحة الفودنا
فيه جرافه ويلذع اللسان شي من ملوحة مع مرارة واذا اك لاشفت سريعا
واذا اكسرته رأيت فيها بين اغصانه شبيها بالتراب دقيق واذا اردت ان تمتحنه
تأخذ العنصر من اصل واحد وامتحانه هكذا هين وذلك ان النبات اعني
هو خلط فيه واجوده ملا الخناشيم رائحة في ابتداء الامتحان فيمنع عن معرفته
ما كان ازدونه ومنه ما كان ازدونه ومنه ما يكون جبليا غليظا قصيرا قويا ومنه
صنف ثالث زبيب من الصنف الذي يقال له موسولون اسود املس مشظ وليس
بكثير المعقد ومنه صنف رابع ابيض رخو خشن النبات له اصل هين الانفراك
كثير ومنه خامس لا جنة شبيهه برائحة ساطع الرائحة بافوني اللون وقشره
شبيه بشر التلخية اجزا لبن منشظ حدا غليظ الاصل قوا كان من هذه الاصناف
رائحة شبيهه برائحة الكندر او كان عطر الرائحة مع زهومة فانه يكون
دون الجيد وانتق ما كان منه ابيض راخوا وما كان زجوف وما كان منكسر العيدان
وما كان املس خشنا والاصل فانه لا ينتفع به وقد يوجد شي اخر شبيه
بالدارصيني يقال له سوريقيا موم حسن النبات لبير بنوى الرائحة ضعيف
القوة ومن قبر فه الدارصيني مانبى نحو وفيه شبه من الدارصيني في المنظر الا
انه يفرق بينهما برهومه الرائحة واما المعروف بالغربه فانه شبيه الدارصيني
في اصله وكثيرة عقده وهو دارصيني خشبي عيدان طوال شديد وطيب
رائحة اول كثيرا من طيب رائحة الدارصيني ومن الناس من زعم ان الفربه
هي جنس اخر غير الدارصيني وانها من طبيعة اخرى عند طبيعة الدارصيني
هذا الدواء في الغاية من اللطافة ولكنه ليس في غاية الحرارة بل هو من الحرارة
في اول الدرجة وليس في الادوية المسخنة شي اخر يجفف. شل يجفف بسبب

أميل وبها أشبه لأن جمرته أقوى من سوداه وأظهر وأما لون شظجته فيقرب من لون شظج السليخة الجمراء وأما طعمه فإن زاد أو لماسود ولجانه منه الجزا فه مع يسير من قبض مع حلاوه سعد ذلك ثم من ان زعفران أنه مع دهنية خفية وأما أجنة فمشاكلة لرائحة القرفه على الحقيقه واذا مضغته ظهر منه شي من لحم الزعفران مع يسير من رائحة النيلوفر وأما الدارصيني الدون فجسمه يقرب من جسم القرفه على الحقيقة بخفته وحله وتخلخله وحمرة لونه الا ان حمرته أقوى ولونه اشرف وجسمه ارق وأصلب واعواد ملتفه فان مفضضه شبيهه بانابيب قضبان الج الا انها مشفوفة طولا لاغير ملتحمة ولا منفصلة وأجنته وطعمه مشاكل لرائحة القرفه على الحقيقة وطعمها في ذكائها وعطريتها وجزائتها الا ان الدارصيني أقوى جزاً وأقل حلاوه وعفوصه وأما القرفه الحقيقية فمنها غليظ ومنها دقيق وكلاهما أجمر املس مائل الى الحلوقية تتلذذا وظاهره اجمر خشن اللون الى البياض وليس علاوة على قشر السليخه ورائحتها ذكية عطرية وطعمها حريف وجزاته مع حلاوه يسيرة وأما المعروف بقرفة الغرنفل فى طبيعه صلبه الى السواد ما هى ليس فيها شي من الخلل أصلا وأجنتها وطعمها كالقرنفل وقوتها كقوته الا ان

فا مومن وضع

القرنفل اقوى وقليلا

الدارصيني اصناف كثيرة لها اسماء عند أهل الامان التي تكون فيها اجود الصنف الذي يقال له موسولون لبن فناينه وبين السليخه التي يقال لها مومولبطس مشاكله يسيرة واجود هذا الصنف

قنا مومن وهما الباقين

الخليل بن أحمد الجلجلان بزر الكرزن وزعم بعضهم ان الكرز يسمى بالهند به جلجلان جلجي لان الحبشه هو الحشائش الأبيض ۞ جليل هو الثمام ۞ جلدا و يا هو القسط من الحاوي ۞ جلفت هو الفجل الحامض ۞ جلما ثا هو الخامي من الحاوي ۞ جلهم قال بعضهم هو عجيج اسود العود والثمره وزفه شبه وزن الآس وله زهر صغير يضرب الى الصفره ۞ حلوجا هو الجاوشير ۞ جلوصطفا هو الصندل ۞ جمار هو لب النخله الابيض وهو قلبها وكذلك لب الدوم ۞ جماع الادويه موضي الدب وهو نوع من النبات ويسمى ايضا حصى الكلب جميري وقد تقدم ذكره ۞ جمر هو كعر اليهود ۞ جودره هو الحضض ۞ جوز هو العنب بالفارسيه ۞ جوز روم يكنى ادخل كثير من الاطباء هذا الاسم في كتبهم وهو خطأ وانما جوز دوم بالدال ۞ جوز سودار فيل هو الخولنجان ۞ جوز الاترج زعم بعض اصحاب التراجم ان جوز الفتى يعرف بهذا الاسم ۞ جوز الرمع قيل هو جوز الفتى ۞ جوز الطيب قيل هو جوز بوا ۞ جوز الهند هو النارجيل ۞ جوزجنا هو فجاح الاذخر ۞ جوز جنس هو جب السمنه ۞ جو قيس بري هي الجعده هو الكا ثم من الحاوي وذكرت في باب اللام لوله من الحاوي ۞

باب حرف الدال

دارصيني تأويله بالفارسيه شجر الصين ۞ اسحق بن عمران الدارصيني على ضربين منه لان منه الدارصيني على الحقيقه المعروف بدارصيني المبزر ومنه الدارصيني الدون وهو الدارصوص ومنه المعروف بالقرفه وفي القرفه على الحقيقه ومنه المعروف بقرفه القرنفل فاما الدارصيني على الحقيقه فجثه اجم من الكل واخشن واكثر حكا كا ثم جثم القرفه على الحقيقه ثم قرفه القرنفل الا انه الى القرفه

جرجى هوالجعده :: جرموده هوالاجاص :: جرمون هوالبربور جرو فيل انه نبت مثل الاصبع اخضر اطب وتسميه اهل الحجاز مشط الذيب له خراشا الفا :: جعدا هوالراوس جعره فيل هوالخد زون وقال ابوحنيفه هوضرب من الشعرابيض كبازغلط القصب عظيم السنابل طيب الخبز :: جفا هوالحاج :: جفر هوالمر زنجوش جفرى هوالكمتري :: جفر هوتسر الطلع ايضا وهوالكفري :: جفن هواصل الكرم قال ابوحنيفه والحفن ايضا ضرب طيب الرنج والجفته ايضا له نبت مسطحه واذا ليست تنقض ولهاحب كحلبه اصفر ولها عيدان صلاب دقاف نضار ونرن اخضر اغبر وهي اسرع البقل نباتا اذا امطرت واسرع هيجا واكثر نباتها الاجام :: جلسنا هو البك من الحاوى :: جسبير هوالحز دوع من الحاوى :: جنباد هو الزعفران :: جسيمول هواصل السوس الهندى من الحاوى :: جسمى بالسرباتيه هو مثل سبه الصعتر وتسمى ايضا الحك :: جل هو الورد بالفارسيه :: جلنار معناه بالفارسيه ورد الرمان :: جلسا هوالنودرى بالسرباتيه من الحاوى وفي موضع منه اخرجلنا هوالحبه :: جلنجوبيه هوصيعنا الفرس وهوالنوديج البرى الذى يسمى بابى تابته على :: جليدما هو المازريون من الحاوى :: جليدوماس وتسمى ايضا بولابون وقد مضى ذكره في حرف الباء :: جليف هوالبرالمعروف بالعجمه بالشيب وتسميه الزوان ايضا وقال ابوحنيفه هونبت شبيه بالربع منه :: عنبر وله في روسه سنفه كالبلوط مملوه حبا كحبه الارز وتنا من السهل :: خلنسرن هونوع من النسرين كبيرله شوك كشوك العليق ويعرف عندنا بالورد الذكر :: جلبهنك رأيت في بعض الكتب انه الكنكر زد وهوخطا وانما هوجلبهنك فوقع فيه تصحيف ثم غلط بمعرفه فقيل انه الكنكر زد وهوصنع الحشف من مثل انه من ادوية التى كما هوالكنكر زد :: جلجلان هوالسمسم وقال

جمد الزمان هو عقد الرمان في أول طلوعه الذي يسمى من الشجرة ۞
جنبهر هو النبت بالهندية من الحاوي ۞ جنني زعم بعض الناس انه بالجيم
وهو الجني الا انا ذكرناه في الجاء كما وجدناه في اكثر الكتب ولم يصح عندنا
انه بالجيم ۞ جحجاث زعم قوم انه النبات المسمى بالبرزبه لمر هلان وفي
الطاقة التي يستعملها اكثر الاطباء بدل العافث وقال ابو حنيفه الجحجاث صحه
ومنابتها التيعان لها زهرة صفراء تنبت على هيئة العصفر وزهر الفرخ طيب الرايحه
وهو اخضر ينبت بالبط ۞ جنجدبون هو الشاهنزج بالبونانيه ۞
جنحم قيل هو الحنا الاحمر ۞ جندبادستر تاويله بالفارسيه خصيه
البحر وهو خصي السمور وقد مضى ذكره ۞ جندك هو الصندل ۞
جندوه هو الحلتيت بالهندية من الحاوي ۞ جنير هو السبطرج من
الحاوي ۞ جبرى هو الجبنى هكذا بلفظه به اهل مصر بالجيم والزاء ۞
جنطبانا قد تقدم ذكرها قال ومن الناس من يسميه اصل السوس
جنطبانى ۞ جنفا هو المر الابيض من الحاوي ۞ جبس قال ابو حنيفه
يسمى بالفارسيه شلم وهو من الاعشاب له قضبان طوال خضر وله سنفة شبين طوال
مملوءة حبا صغارا ۞ جرب هو الجار ۞ جرار هو الحلتيت من الحاوي
جراج هو جب الثمنة من الحاوي ۞ جراسما هو القراسما ۞
جرباً هو السنا اليوش بالهندية من الحاوي ۞ جربوبايا قيل هو
البلاذر من الحاوي ۞ جرجاز في عشبه لها زهرة صفرا جنا عرف
وزعم قوم انه ترمس برى ۞ جرجير يسمى بالعجميه اروقه وهو معروف
وقد تقدم القول عليه ۞ جرجيرالكلاب هو الخردل الابيض ۞
جرجير الماء هو الزواش ۞ جرجج هو الباقلى ۞ جرجم مصري
هو الترمس ۞ جرجبا هو الحندقوقا ۞ جرجس هو
الطين الذي يطبع به على ما ذكر في بعض التراجم ۞ جرجور هو الزرايج

واللواء العصب ووجع الكبد والمعدة واذا احتمل فرزجه من الاصل اخرج
الجنين واذا وضع على الجراحات مثل الحضض كان صالحا لها ويبرئ النزوح المآكلة
وعصارته ابلغ في ذلك وقد هيأ منه لطوخ للعين الوارمة ودماجل وقد يقع
في اخلاط الشيافات الحارة مكان عصارة الحضض الاسود والاصل اجود منه وقد
يستخرج عصارته بان يدق وينزل ويطبخ بالما حتى ينضج ثم يصفى في ذلك الما الى ان
ينظر الاصول ويخلص عنها واذا احمر عنها ترك حتى ينعقد فاذا زاد وصفى حرقته طبخ قليلا
ان يصير مثل العسل وخزن في اناء خزف . **جدوار** *ابن سينا*
هو قطع شبيه بالمزو اودة منه فوة وينبت مع البيش وفى ترياق للسموم
كلها من الافاعى والبيش وغير ذلك *ابن الكتبى* وغيره من المحدثين قالوا
ان الاشلة والبيش الذى ينبت معها هى الطوايه وهى اصول كالبلوط الصغير ينفع من
السموم ويطلق البولنج وينبت معها الطوايه وهى شجر فازلج وسعانب نبات هما حتى
ان راهما الانسان ظن انهما من اصل واحد لشدة تشابهما وهذه الحشيشة
طعمه حلوه والاشلة مرة وهى دزباق تقوم مقام دزباق الفاروق
ولايثما في اوجاع الصلب واوجاع الارحام وربما زعمت بعض الاعنام من الحشيشة
التميمة فاذا اجتنت بها اسرعت فزعت من الاشلة فخلصت منها ۔ لى والاشلة
عندنا اليوم ضربان ضرب يعرف بالاشلة السوداء وهى التى ذكرها انها الحدوار
والاخرى هى البيضاء ويسميها بعض التجار بين النهرين وسنذكرها في حرف اللام فاما
السوداء فهى كانت مدورة ولونها خارجا اسود وداخلا ابيض الى الصفرة ووزن
هذه نحو من زوج كرزة الثعلب وينبت معها الطوايه وهى شبيه به الا انها
اميل الى الشهبة . **جاوشير** ح كثيرا ما ينبت فى البلاد التى *فما نقله ابن خالويه*
يقال لها شوطبا والمدينه التى يقال لها فونيس رمن البلاد التى يقال لها ارغاديا
وقد اخترع البناتير لتله صمغه الشجره ولها ورق خشن قريب من الارض
شديد الخضره شبيه بورق التبن مستدير ممدود ومشرف ذو خمس شرف ولها

من الصنف الآخر وأقوى
فعلا ويقال ان هذا
الصنف الجنطيانا
الغارسي التي تسمى بالغارنبه
كوشاد ينمى الروم بلنعان
وتسمى بالعجمية الاندلسية
بلشكه واما ان واقد
فزعم ان البلشكه هي
الجنطيانا التي ذكرها
واخطى في ذلك

هذا الدواء جنطين ملك لامه التي يقال لها اللوريون وان اسم الدواء اشتق من
اسم هذا الملك وهو نبات له ورق فيما يلي اصله يشبه ورق الجوز او ورق لسان
الحمل ولونه الى الحمرة الذي يلي الوسط والطرف بين الوقصة مشرف نشر بغا
يسيرا وخاصة فيما يلي الطرف وله ساق نحو ملء ساعد غلظ الاصبع في طول
ذراعين ذات عقد والورق متساعد عليها بعضه من بعض كثير او نحو
اقلع عريض خفيف مثل ثمر النبات الذي يقال له سغند ولون له اصل
طويل غليظ مر وينبت في رؤوس الجبال الشاهقة وفي الآجام وفي الاماكن التي فيها
المياه اصل هذا النبات قوى قوة يبلغه في المواضع التي يحتاج فيها
الى التلطيف والتنفيذ والجلاء يفتح السدد وليس منه يعجب ان يكون يفعل
هذه الافعال اذا كان في غاية المرارة قوة اصله فاذا بضه مستخرجه اذا قوى
مقدار درخمي مع فلفل وسذاب نفع من نهش الهوام واذا شرب من عصارته
مقدار درخمي بماء وافق وجع الجنب والنقطة وهن العضل خلا اطرافها

جنس ثاني من الجند بادستر

في البر والبحر والكثر ما
يكون في البحر مع الحيتان
والثعابين وخصاه ينفع
من نهش الهوام ويهيج
العطاس ويصلح لاشياء
كثيرة واذا شرب
منه وزن مثقالين مع
فودنج بري ادر الطمث
واخرج الجنين والمشيمه
وقد يشرب بالخل للنفخ

جنس ثالث منه

والمغص والفواق والادويه النافعه وخاصه الدواء الامثال التي ينال له افا واذ ا
طط به دهن وزد وخل ومسح به الراس ايمن به لينزعز او ي بات كا و اذا اخره
فعل ذلك واذا شرب او مسح به وافي الارتعاش الوجه المسمى اصيموصوس وجميع
اوجاع الاعصاب وبالجله تو نذ سخنه واخرج منه ابد المزد وجه التي يخرج جمل
من اصل واحد والتي ن ح داخلها شبه اللوم كريه الرايحه زها جار لذا اعاهبر الانفراك
منعما محبب كثيره طبيعه يغشه قوم باشو ياخذ وبه او يعجنونه بيم وجبد بادس
دعنه ونمر شان وجفف ه وباطل ن امثال ن هذا الحيوان اذ الطرد وطلب
يبلغ خصاه وينطرحها لانه قال ن برله البهاء وذلك لانها لا صفه سلخصي الخنزير
وينبغي ان يشق الجلد الذي ع اخصي وان يخرج الخصى مع الحجاب التي حوبه وطوبه
شبه العذره وجفف ه وينبغي منها ٠٠ الجند بادستر دوا مجود ينفع من اشياء
كثيره وهو دوا يسخن وجفف وهو لطيف لطا فه بليغه فهو لذلك اقوى من
الادويه الاخرى التي سخن وتجفف وينفع من امراض العصب والشيخ والرعشه
والنواع احدث عن الرطوبه والا سلا ان ضرب به دا بث بدنا رطبا جاح الى

بسلخ فوضع على موضع الضرب ممن جلد نفعه اكثر من كل شي حتى انه يبرى الضرب
في يوم وليلة وذلك انه منضج وجلد مواضع الضرب المثلية دما والجلود العتيقة
التي تسقط من نعال الخفاف اذا احرقت نفعت من النج العارض للرجل من الخفّ
وكل ذلك ضربا من المضاده لهذا النج بالطبع ولكنه ان كان ينفع مع النج ورم
ينفعه فاذا سكن ورمهما استعمل الحفن اذا احرق وهذا الرماد ايضا يشوى الجراحات
الحادثه من حرق النار والنج ايضا الحادث في الخذين **دب** القنفذ البري اذا احرق
جلده وخلط بزفت رطب ولطخ به داء الثعلب وافقه وافى وينفع وهو جيد للحزى الصغير
صغير اذا احرق جلده وخلط رماده بزفت رطب وتحمر غير عنيف او دهن الاخوان
ولطخ على داء الثعلب انبت الشعر فيه ٠ **غيره** ان اخذت قطعه من جلد الماعز
والجلد ساعة يسلخ ووضعت على لسعة الحيّه اخرج السم ويقال ان جلد الذئب ينفع
من الصرع العارض للصبيان خاصة اذا اعلم واشد به البطن اطلق لقولنج وجلد
المهر اذا احرق وطلى به على البثور بردها وزعم بعضهم ان المضروع ان لبس جبّه
جلد حمار قد شبر نفعه ولكن يجرّدها كل عام وخاصة جلد الماعز اذا جعلت على
سيلان اللدم جنبته وجلد الافعى اذا احرق كان طلاء لداء الثعلب وجلد الشاه
ساعة ما تسلخ صالح للمضروب بالسياط وغيرها وللنروح لحبيّه والجرب
والحكه وجلد ارنب اوى اذا اعلى على من عضه الكلب الكلب لم يجن من الماء
دب هو التمون وهو جيوان يصلح ان يحيى فى
الماء وخارج الماء واكث
ذلك يكون فى الماء
ويغتنى فيه بالسمك
والنز اطبر وخصاه هو
الجند بادستر ويصلح
هذا الجيوان ان يكون

قسطريون

قبل نفسه وسأل منه صديد ماتى وخف به وجعه ثم أمر بأستعماله حتى يرى
من وجعه وصفه لعدة من المرضى ممن كان بهم وجع المفاصل فعل الخواص مثل
علاجه فبرؤا برؤا تاما ۞ فأما الجبن الحديث لقوته مخالفة لقوة الجبن العتيق
وقد استعمله أناس في بعض القرى بأن وضعت منه على جرح بعضهم بعد أن سخنه
وعلوته بورق البقله التي ينال الهاجر السواى فبرى به لانه لم يكن خبيثا وإنما جعلت
وزر ذلك البقله لحضورها ذلك الوقت وأما ان استعملت بدلها ورق
الكرم أو ورق السلق والدلب أجزاك وقال في الأغذيه الجبن يكتسب من
الانفحه حدةً ويذهب ما به اللبن عنه وإذا أعنوا ك راحاد وا ولذلك يعطش و هو
مولد للحصى وما لم يكن معه عنبيا فهو اقل اذاءً من غيره وأفضل الجبن الحديث
وخاصه المتخذ من لبن حامض والذي من غيره وأجوده للمعده وأقلها عسر
انهضام وربط نفوذ وليس برديا الخلط لكنه غليظ وهذا امر يم من كل خلط
د ب ‌ الجبن الرطب الاكل بلا ملح إذا أغذى بأطباء الرائحة والطعم جيد للمعده
هين السلوك إلى الأعضاء ويز يد في اللحم ويلين البطن تليينا معدلا وإذا طبخ وعصر
وشوى عقل البطن وإذا اضمدت به العين والجبن الحديث المملوح أقل غذا من الجبن
الرطب والجبن العتيق يعقل البطن وماء الجبن يعد وال‍كلاب جدا والذي ينال له أنا في
وهو جبن يعمل من لبن الخيل وهو زهم كثير الغذاء بشبه فيغد بنه بجبن البقر
ومن الناس من يسمى انفحه الخيل أنافي ۞ غيره الجبن المتخذ بالطبخ بالنار خبر من
المتخذ من الانفحة لانه يكتسب من الانفحة حده ولا حفظ وهو الجبن المتخذ من
الزايب خاصةً وإذا طبخ الجبن الطرى مثله من الطلا في قشر رمان حتى
يذهب الطلا أدلى كد والطرفة وإذا طبخ في الماء
وسقيته المرى يافع شرح الامعاء وخصوصا المشوى
ومنع الاسهال وقد ينجق المشوى وجفر به مع ده نورد وزيت نفع من قيام
الاعراس ۞ جلود ح ى جلد الكبش إذا احذى من ساعته جبن

أجمع أنه ممتنع بينهما وقال بعضهم إنما الجص يعينه ٦٠ ط للجبسين مع القوّه
العاميه الموجوده في جميع الجبّ امر الارض وابدال وهي القوه المجففه قوه
اخرى تعزى ويشتد ويجمع ولذلك ايضا لبسه بعض ينزعه وجمد يصلب
اذا هو انفع بالمادّ اصاب رجله احد ادويه المابته التي تنفع من انفجار الدم
لانه ان استعمل وحده مفردا عند ما جمد صلبا حجرا وبهذا السبب رأيت
انا ان اخلطه مع بعض ادن المزن الذي يستعمل بمداوه او جاع الغز وخلطت
معه اصور غارا لرحى المحنم ومن ابي الحنطه على جدار الرحى وينبغي ان يوخذ
الضماد المتخذ على هذه الصفه في ما الارنب او في اللبن او في شى اخر ليس على ذلك المثال
واذا اجزى الجبسين ليس يكون نسر من اللذ وجهه على مثال ما كان عليه ولكن يكون في
اللطافه والتجفيف اكثر منه اذا المحزوز ويكون ايضا مانعا قامعا ولاسيما
اذا عجن بخل ٥ ة له قوه قابضه معتره يقطع نزف الدم ومنع من الغز وق واذا
شرب قل الحوث
جبن ٦ ح اما الجبن فهو لبن يعقد فيصير
جبنا ولبن جميع الالبان جمد ونقبل التجبين وابن انجبن من اللبن مازل الغلظ
عليه اغلب فيسهل عندذلك انعقاده ومفارقته للماء عند صنعه والزبد به
بن لبن البقر اغلب فيسهل عندذلك انعقاده ومفارقته فاذا اجمل اللبن من غير ان
يمر عنه صار زبنا تما وقد رايت من جبن البقر شيا يسيل منه الدسم من كثره
فيه واذا عتق هذا الجبن صار شديد الحزافه ويشتد لعلا ذلك بطعمه ورائحته زبده
قال وانوع بعض النات ان قوم ما جأؤوا وابعليك به وجع المفاصل يحول لاعل
حقه لا يستطيع النقل ولا يقدر على الحركه ولا زين يديه من هذا الجبن
العتيق الحريف فلا ان انه امر من بعض الخدم رقاق بنات خنزير ثم امر منهم بطبخه
فطبخ تما واطبخ بليغا وصفى ذلك المرق وجاوبى به فامرت بذلك الجبن فقطع قطعا
كبارا وجعلت صلابه وذلك المرق عليه ونحو نحفانا حتى صارا بمنزله المدهم
ووضعته على مفاصل ذلك الرجل فاشفع به منفعه عجيبه وذلك رجل شقوى من

الدبق عليها قشر رقيق كما على الثأ هلوط وهذا النبات لا يصلح لغير الأكل ث

جوزجندم ويقال الجوز كندم وجوز عندم وهي تربة العسل وزهر الجمرو من الألبا ن من بنتها اخو الحمام

هي تربه حبيبة بيضاء إلى الصفرة ويؤتى بها من بره وخراسان وليست ترب برقة كما زعم بعض الناس قال زوفس هو مبرد جفف قليلا و عند جار ن طبه وقال بن سينا فيها قوة منفثه وذلك انها تبرى الثوبا و نطفى حرّ ان النزف والدرد وينهج الباه ويخصب الجسم ويمنع من شهوة الطيز وقال بعضهم انما يغثى وينقى ويسرف بها العسل وذلك بان يطرح منها ربع كلجه في عشرة ارطال من عسل وأ ربعين رطلا من ماء جاز ويضرب ناعما و بغلى قصير شربا من شاعته

جزع حجر معروف وهو صنفان ما بي وصيني يقال ان من نخم بالجزع كثرت همومه وأحلامه أ ذ به منفرده وكثر وقوع الكلام فيه بينه وبين الناس وان علق على طفل كثر نسيلا ن لعا ب من فيه ومن أكل او شرب في انا مصنوع منه قل نومه و إذا انحي هذا الحجر جلا اليا قوت وحسن لونه ولذلك يجلو الأسنان وان علق على المرأة التي تلد سهل ولادنها و الله اعلم

جمست هو صنف من الجان منه ما لونه لو ن الشراب ومنه ما يشبه لون اليا قوت الاحمر من شرب في أنا ء منه لم ينكر بعد ان يكون الآنا ء عطيما

جبسين هو حجر يوجد في معاد ن الجص صفاحي منه أبيض مشف ومنه

الغٰنی وحبه يشبه حب اللفاح وقشره خشن وطعمه عذب دسم باردب فى الدرجه الرابعه ان شرب منه نراط البيد اسكر سكرا شديدا وان شرب منه مثقال قتل من حينه: **الرازى** يخدر وينام قتل وسكر وبغتى وبغتى **جوز القطاه** هونبات ينبت فى الكثبان له ورق مثل ورق البقله الحمقاء الا اليں واعرض عليها زغب وله قضبان كثيره خارجه من اصل واحل منبطه على الارض لينه معقد وله اخبه كاخده الكاليج جوز كلحاعلان صغير الا الطول

جوفه حبان اصغر من الحلبان يوكل ويقال ان ماهذا النبات نفع من القولنج **جفت فرند** ابن سينا هو ثمره صنوبرى الشكل يشبه اللوز الا انه كالشوكى ورنما انشق وانفتح وهو مربى للباه جدا

جبرس قنطابرلوقنا هوالفستق وهو شى ينبت فى مواضع كثيره بالمياه الناببه التى لا يجرى لها ولهذا النبات ساق حوفه مجوف على طراشه شكله وابن الفدج لونه بين الخضره والسواد فيه ثقب بين الاشياء

الزلابج وبنده اذا انط به الرا و دعلیه لا ان له خاصه نضر بالعصب اضرارا
كبيرا شديدا وقد تاب من طعامه مشبه لم يعد صحيحا : **الرازي الجلبان**
باردا ما ترطب للغدا زاير الدا السودا وا بالعصب : **الفلاحه** اذا اجعل
من خارج شد وقوي و نفع من السدر و لا سيما ان عجن بعض الما به
و اذا شرب طبيخه بعد طراحه الطمث و بدرا الطمث و حلل ورم البنين
فضول الصدر و اذا اعلنته البقر هما قربا من منفعه الكرسنه و اذا بخر به
دار جلب لها النمل : و من الجلبان صنف كبير لا و كل الامطبوخا و يسمى
البسله والبونائه فاسلبوسر ومنه و زن اكبر من وزن الجلبان البستانى
نمل حفظنا الى الاباعر قضا به من نفسه ور قه ملصقه عن جانبى
القضلا سوارا ورقه وطرفه كل ورقه ثلاث بطوط ملتفه كخوط الكرم الا
انها ارد و قلب ما قر بها من النبات و زهره ابيض ادا احمر و له حراب فيها حب اصغر
من اللاترمس و الاكل و له اللبن : **جوزلقى** من الناس من يسميه جوز
الرفع بوزن يومنا و نعم وم بشرب من الجاس و هو اكبر من البندق
فليلا لونه بين السفر والبياض فيه تحرير و اذا شرب منه وزن درهمين
فنا و هوحار ابرده الثانيه مع الرطوبه والبلغم وينفع من الفالج واللقوه
جوزالكابل وينبى ايضا اقراص الملك و من الناس من يسميه جوز
الفى و هو دوا ينى به من الهند و هو يشبه الشاهلوط الصغير بجرمه
و لونه و هو يسهل و ينقى مثل ما يسهل اهليلج الاسود و الشربه منه نصف درهم و هو من المهلات
غير المامونه : **جوزمائل** ويقال الجوزمائز وجوزمائا و هو المعروف
عندنا بثجره المرقد و هو ثمر شى يعلو حوفعد الرجل و رقه صغار كورق البادنجار الا
انها اسرا و اشد ملاسه و له زهر كبير ابيض طوله اقل من شبر يشبه افواه الابواق
الشاميه و هو عراعم الخضر طويل المعاليق و له ثمره كالجوز خشنه البشره
كانها مشوكه و اخلاها حب الفتاح : **عيسى بن على** جوزمائا يشبه جوز

الناس كلهم يأكلونه لأنه البطن وإن أحب إنسان حدته بأن يضمد به وجدا فرقه تحلل تحليلا نافعا بليغا وكلا الصنفين إذا طبخا وأكلا أسهلا البطن وإذا سلقا بالماء وشرب ماؤها أسهل مرة ونطوف قد يظن قوم أن ورق الصنف المسمى الأنثى إذا أنخ وأحمله الحامل وهي بعد أن تطهر نصيرها أن نخبل بأنثى وإن ورق الصنف الذي المسمى الذكر إذا أعلقه مثل ذلك الصنف الحامل بذكر

جلبان بن طجل الجلبان من النظائر الماكولة وهو نبات له قضب مربعة شائلة تسطح على الأرض وله ورق حوالي ورق القضبان إلى الطول مجنبة على القضب وله نوار إلى الحمرة غلفة مر وفيها حب ممتد ورق إلى البياض وليس يصح الند وبر حلو يولد شيئا في الربيع ثم يجف فيطبخ وهو حب كثير

مفرط قل أحب... من ناس من يسمى هذا النبات جلنك
ميقونودس ومعنى هذا الاسم الحمامل الزبد والماتين هذا الاتم دلك شبيهه
بالزبد في بياضه
الناس سماه ارفليا
وله ساق طولها من
شبر وورقه صغير
جدا شبيه بورق اك
عندلوزق متراييض
وهذا النبات كله ابيض
وساقه وورقه وثمره
شبيه بالزبد في بياضه
وله اصل دنيئ وقد
يجمع ورقه اذا اشتكل
العظم وذلك يكون في
الدب واذا جمع جفف وخزن واذا اخذ منه مقدار كوتانين بالشراب الذي
يقال له ما لترا طري نبايلي وهذه السقية توافق الموضع وغيرها خاصة
بذر البذم ع غبرن هو قريب القوة والطبع من طلبك والشربه منه نصف درهم
جلبو د هو الحاتيون الاسود د د ليبورسطن ومن الناس من يسميه
بزثاغون ومنهم من يسميه ارطانوس وهو نبات له ورق شبيه بورق
البزوج الا انه اصغر منه وايل لا ورق النبات المسمى الفسي واغصان ذات
عقد وفيها سعف كثير والاكبر من هذا النبات منها شبيه بالعنافيد كثيفه
واما الثمرة فانه ورقد صغار وثمرته صغير مستدير مركبه بعضه على
بعض جزجز شبيه بالخص وطول النبات نحو من شبر ع د زهر هذا النبات يستعمله

الغرق فيزنبه وسطها ابيض فيها بزر يشبه التمر لونه احمر بلون الياقوت وله اصل دقيق د بزر هذا النبات في طعمه شيء من الحدة وهو شديد المرارة فهو لذلك يطحن ويفجر الخراجات د واذا اخذ من بزر هذا النبات مدقوقا فانه ما نصف الكنونا فرن وشرب بالشراب الذي ينال به ما البزر اطن اهل لعما ومرة واذا ضمد به مع الماء برد الخراجات والاورام البلغمية وينبت في اماكن خشنة أبو جريج

سطامونداس الكبير
وهو الجلمنك

الجلمنك صنفان احمر واصفر وهو بزر يشبه السمسم وهو جار في قوة شديدة مجهول وقد يكون نبات آخر يسمى الجلمنك ينبت في آجام ويشبه البردي وقشر اصل هذا النبات هو الشريد الاسود وينبت بالصعيد ولكن الجيد منه هو الهندي وقد كان بعض الاطباء يسقى منه المفلوج الى وزن درهم معاني وهو نى وينهل من نصف درم وفيه خطر والشربه منه نصف درهم والدرهم خطر. الرازى في المنصوري جلمنك جار في قوة شديدة وربما قتل ثلاثة من شدته في وقال في الاغذيه قد وجدت عزا كل السمك الذي يكون ماواه الآجام التي ينبت فيها الجلينك في عسف

الشراب الذي ينال الجلة نجوم اربع اصابع وبنت هذا النبات في تلال
قوة هذا الدواء تجفف مع انها قابضه وكذلك بقي منها ما اصابه فتح العضل
واذا طبخ الاصل من هذا النبات مع اللحم الرخو عضه بعض وقد يسقي الشراب للشدخ
وبطا موعيط وشط العضل **جاز النهر** وانما سمي جاز النهر لانه يكون

وبطا موعطى فى موضان الفم

في المواضع التي بها المياه
والاجام وهو وزن
يشبه وزن النيلوطا هرا
على الماء طهورا وعليه
زغب هذا يبرد
ويقبض على مثال ما يفعل
عصا الراعي الا انه اغلظ
جوهرا من عصا الراعي
وهو يبرد ويقبض ويوافق
الحكه والخروج
الحبته والقروح العفنه
جلبهنك

سيساموىدرس الكبير وهو الذي يسميه الذين يطبعون خرىثاىن كل
عامر ويشبه النبات المسمى اوريغارن والسذاب وله ورق طويله وزهر ابيض
واصل لا ينفع به ووزن يشبيه بالتمتم مر الطعم هذا شبيه بالخروب
وهذا البزر اذا اخذ منه بملئه ثلثه اصابع مع اوبولس ونصف من خمر
ابيض مع الشراب المسمى المقرا طن فنا بلغما ومره واناسيضا مو بدارس الصغير
فهو نبات له قضبان طوله نحو من شبر ووزن يشبيه بوزن النبات الذي ىقال
فوروس الا انه اخشن منه واصغر في اطراف القضبان وورقه نحو الوى

النوع الأكبر من أنواع الجعده واذا جففت الجعده شفت لفز وج الرديه أذا
أذا اشرت عليها وأكثر ما يفعل ذلك الجعده الصغيره التي تستعمل في أخلاط
الأدويه المعجونه وذلك لأن هذا النوع منها فيه من ميزان الطعم والحده أكثر
مما في النوع الأكبر حتى انه قد صار في الدرجه الثالثه من درجات الأشياء المجففه
وفي الدرجه الثانيه بأواخرها من درجات الأشياء المسخنه ٮ وقوه طبخ
النوع عبرٍ جميعًا اذا اشربا نفع من نهش الهوام والاستسقا واليرقان واذا اشرب بالخل نفع
من ورم الطحال وهو يصدع ويضر بالمعده ويسهل الطبيعه ويدر الطمث واذا ادرن
دخن طرد الهوام واذا اضمد به الصنف الجراحات ۞ غيره الجعده تدبر بالدهن
ونفع من الشبان ونفع من رجل المزع ومن الاستسقا واليرقان الاسود ونهش الهوام
والعقارب ۞ جمسبرم ذكروا انه صنف من الذاجين شبه
الفيصوم ابن سينا قوته شبيهه بقوه الشيح مع عطر الخلط منه مسكن للنفخ
والرياح خاصه ويحلل الرطوبات اللزجه في المعده وينفع مع الصبيان ونفع من
رياح الارحام ۞ جبره يسمي بالعجميه انه بيشا اي جامع البضع د
اوسطيون هوم النبات
المصناف كونه في كل
سنه طوله مقدار ثلثه
اصابع او اربع وله ورق
وقضبان شبيه بورق
وقضبان النبات الذي يقال
له قونرلس او النبات الذي
يقال له المنا. فاضنه
واصله دقيق دخانا شبه النبع
ابيض رايحه شبيه برايحه

الاسطيون همى لنبات

والحمز والشوصه ونهش الهوام ولسعها وزعم قوم ان من تقدم في شربه لم يعمل فيه
ضرر الهوام وقد يعين في الحبل واصل هذا النبات يدر البول وجزك ثمره الجماع
واذا احتملته المراه اخرج الجنين وزر هذا النبات اذا دق وخلط بالعسل
ووضع على القروح المتاكله شفاها وبوافق كل ما يوافقه البري . **الفلاحه**
الجزر غير موافق للعصب مضر بالحلق والصدر وقد يتخذ منه شراب يسكن سكرا
جيدا وهو مخن واذا اكثر منه مشده يوخذ بالحلق وربما نكا الدماغ ويكرب
وحمر الوجه واصل الجزر البري يوكل مطبوخا وان اكل نياض بالمعده . **غيره**
خاصه بزره ، من وجع السافين الشربه منه درهم والجزر البري اذا علق في
المنازل طرد الهوام : **جعده** د ح منه ما هو جبلي ويسمى بوتوبن
وهو الذي يستعمله الاطبا وهو ثمر صغير ابيض دقوطوله نجو من شبر وهو ملان من
البزر وعلى راسه
طرف صغير بالـ
الاستدار ما هو
شبيه بالشعره
البيضا وهو نبات
ثقيل الرائحه ح
د من طب وسه
صنف ثانو هو
اصغر من هذ
وسمي رابحه
د ح ذاق
الجعد وجدنهما مرا وحرا يسيرا ولذلك صارت تفتح سدد جميع الاعضا
الباطنه ويدر البول والطمث مادا شربت طبختها مع شراب تنفع الصربات للكبار وخاصه

سطا والسوس

د ذلك عليظ قليل وهو يشبه البستاني د ح هو نبات له ورق شبيه بورق الشهترج الا انه اعرض منه وطعمه الى المرارة ما هو وله ساق مستوية وعليه اكليل شبيه باكليل الشبث فيه زهر ابيض وفي وسط الزهر شي صغير شبه الزعفران لونه وفي بزرى وله اصل غليظ طول اصبع شبيه بالنجوم طيب الرائحة

نوع اخر منه

سطا فالبستني وهو اجود البرى

و يوكل مطبوخا ح و الذي ينبت من الجزر في البرى وكلما بزر زرع منه في البساتين وهو اقوى من البستاني جميعا واما البستاني فيوكل امه وهو اضعف من البرى وقوتهما جميعا قوة حارة تسخن فيها اذا لك مطلقا واصلها به معا وصفة قوته ناقصة يحرك شهوة الجماع واما بزر البستاني ففيه ايضا تحريك شهوة الجماع واما بزر البرى فبالغ اصلا ولذلك صار يدر البول ويجد الطمث وقال قينيس

ح وفيه مع هذا جلاء ولذلك بعض الناس يعمد الى ورقه وهو طرى فيتخذ منه ضمادا ويضعه على القروح التي صارت فيها الاكله ليبقيها و بزره اذا شربته المراة او احتملته ادر الطمث واذا شرب انفع عسر البول

اكل

الدرجة الثالثة واما اصل نبات الجاوشير فهو دواء يجفف وينضج ولكنه
ليس ذلك كل قبل من الجاوشير نفسه وفي اللحم ايضا شي من قوة الجلاء ونحن نستعمله
في مداواة العظام العاربة ومداواة الجراحات الخبيثة لان ما كان هذا
سبيله من الادوية فشانه ان يبري الجراحات بنا لا يبلغا وذلك انه يجلو
ويجفف ولا ينحي اخنا ثوبا وهذه خصال كل يحتاج اليها الدواء المنبت
للحم واما ثمرة هذا النبات فهي لك بذرا اطم ..د ..قوة
الصمغة مست.. .. بلطفه انه ... شعى بما يقر اطن اوشرا يوا فق
للنافض واكثر ان الدابر دا طرو اضها من الضرب وايضا ما واوجاع
الجنب والعصب والني بوسطة البول وجرب المثانة واذا ..رب بالعسل
اخرج ما اذا اللحمة .. واللخبر وحلل النفخ العارضه في الرحم وصلابت
وقد يبط ...عرق النساوي ..ن اخلاط ادهان الاعيا وادوية الصداع
وعله خفت اذا العا زنبه واذا نضماعم الزيت وانوا المقرسين واذا جعل
ما لل لاد ان يبن وجعها واذا كطر بيه يحدد البصر واذا خلط منه بزفت
كان منه مزهم ا نفع جدا للعضة الكلب واصله اذا جك واحمله المراه
احدر الجنبر وهو صالح للتروج المزمنة واذا استحق وتضمد به معجونا بعسل كان
صالحا للعظام العار به وثمن اذا اشرب مع المفتير ادر الطمث واذا اشرب
مع الرزاوند وابوليعه الهوام واذا اشرب بالشراب نفع من وجع الارحام الذي
يحدث منه الاختناق **غيره** الجاوشير منها للعصب وينفع للصرع وام الصبا
وتقطير البول وحكة المثانة والقولنج وبسهل البلغم والشرب به منه نصف درهم
الى مثقال واذا اشرب منه ثلثه درا هم مذابا بطبيخ مرزنجوش ثلثة ايام نفع
من الرعدة الحادثه بعقب جلح : **الفلاحه** **جزر** الجزر
البستاني منه احمر وهو رطب واطيب طعما والاخر يضرب الى الصفره وهو
اغلظ واخشن ما ثم الجزر البرى فانه نبت يقرب الى الماء وربما ينبت في الغيا..

ساق شبيه بالقثاء طويله
وعليها زغب شبيه
بالغار ابيض وورق
صغار جدا وبزر طيب
الرايحة حاد وله عروق
كثيره مشعبه من
اصل واحد يضرب ثعلبه
الرايحة عليها قشر غليظ
مر الطعم وقد ينبت بعضا
في المكان الذي ينال
له موقا من البلاد التي ينال
لها ما قد ينا وقد يستخرج
صمغ هذا النبات بان يشقق الاصل احدا ثار طهو الساق ولون الصمغه ابيض
فاذا جفف كان لونه ظاهرا كالون الزعفران ويجمع ما يسيل من الصمغه في وزن
مفروش وفي حفاير في الارض فاذا جفت اخذت وقد يشق ايضا الساق في
ايام الحصاد ويجمع ما يسيل من الصمغه على ما وصفنا واجود ما يكون من الاصول
البعض منها الحاده المشوبه التي ليست بنشبه ولا ما اكله حطي اللسان عند
الذوق وعطر الرايحة واجود ما يكون من ثمره ما كان منه على الساق فان الموجود
منه على العشب هو عبر واجود ما يكون من صمغه هذا النبات اشد ما رأى ابيض
الباطن ولون ظاهرا كالون الزعفران يبين الايدين من الاغراك واذا اديف
انحل يسرع اينا ئل الرايحه واما ما كان منه اسود فردي ايضا لانه بغش يوشق
ويختبر ذلك بالاصابع في الماء فان الخالص منه يزايد يصير بمنزله اللبن
ح منافع لبن الجاوشير كثيره لانه يسخن ويلين ويحل ويضعه من الاعضار في

الجهتى اذا جلس فيه من به قرحة الأمعاء فى ابتدائ العلة وافنت جذبه المواد الى ظاهر البدن وكذلك اذا دخنت به المقعده واذا احتفر به ابرئ من عرق النسا

جراد دبّ اذا اجترت بها النساء نفعت من عسر البول **عنبره** تحوها

البواسير ونبات ويقال ان رجلها فلع الثواليل واذا اكل الجراد وهو يابس محرز للدم مولد للمره السوداء ويقال انه اذا اخذ من الجراد المستندير اثنى عشر فقطعت رؤوسها واطراف وجعل معها قليل آنيسون يابس وشرب كما هى نفعت من الاستسقا واما الجراد الطويل العنق فانه اذا علق على من به حمى الربع نفعه :: **جلب**
اذا احرق فى قدر وذر رماده على الاكلة نفعها ::

شرح الأسماء الواقعة فى هذا الباب

جارما هو المازريون :: جادى هو الزعفران :: جازلون هو البسانه من الجاوى :: جاطير هو المز من الجاوى :: جاشى قيل هو الخطمى :: جاسيما قيل هو وطين سامس المعروف بالكوكب :: جالدو بوف معناه الخطمى وهو المعروف قال **ح** قيل انه انما سمى بهذا الاسم لانبت اذا ظهرت وجف عند عينيه وقيل انه انما سمى بهذا الاسم لا تذبل فاذا اعنت افراخ الخطاطيف جائت لام هذا النبات وردت به نظرها وقد يسمى ايضا الكربه البيضاء بهذا الاسم :: جاليذ ونون طوبيقرن هذا الصنف الصغير من العروق وهو المميز :: جاليذ وبيو ظوماغا هو الصنف الاكبر من العروق وهو الكركم :: جاهليون حاء فى الحاوى انه الباذنج وفيه تصحيف والصحيح طبليون :: جاورس هندى هو الذره :: جناحمر هو ثمر القطلب :: جناج هو الراسن :: جنار هو الدلب بالفارسية ::
جنافاتر هو الجوز الرومى من الحاوى :: جاسمينوس هو البشنى

التجفيف أو بدأنا بأن إذا احتاج إلى اليبوسة وجزاره بينت له منفعة عظيمة وليس
نبين له مضرة أصلا في شي من الأعضاء ولا سيما كان الانسان غير مجموم أو كانت حماه
فانرة كالحمى التي تكون مع السبات وعلة النسيان فقد شفيت كثيرا من هؤلاء من
الجند بادستر مع الفلفل الأبيض من كل واحد منهما مثل أن ملعقة بالعسل فلم
يتبين أحدهم مضرة. وإذا احتبس طمث المراة فبعد أن تنفرغ بدنها بقطعها استنفراغا
معتدلا سقيتها الجند بادستر مع ودج بري ونهرى فانه يدر الطمث من غير أن
يفتر المراة شامل المنابر ويشرب بماء العسل وأما ما كانت به نفخة عن النخيل ومغص
أو هواء ومرارة الابدان يشربه يلطفه أو ريح غلظه به فهو ينفع به إذا شربه ينفع منها
بأعيانها واذا وضع من خارج على الجلد مع الزيت العتيق أو مع الزيت المستى سعزا وسيون
فان ما كان ببدنه محتاجا بالحزاره كثير ينبغي أن يلطخ بدنه به وقد ينفع
أيضا اذا وضع على النخم حتى يحلل واستنشقه الانسان وخاصة في جميع العلل
البارده الرطبة التى تحدث في الرئة وفي الدماغ وأما في علل النسيان والسبات
الكائنة مع حمى فليخلط بدهن ورد ويوضع على الرأس والعنق ث **جرى**
وبالجرت والسلاح وقال بعضهم للجريب هو التنور بلغة أهل الشام وهو النور
وهو الانقليس **سلورس وهو جرى**
ويسمى بالفارسية
ما زماهى وأما
ابن جلجل فقال
الجريب حوط بل
له خرطوم طويل املس بلا قشر يكون في النيل مصر كثيرا وقيل فيه أنه السباح وذلك
خطاجى لحم الجرى فيه جاذبية واذا اقتدد ودق ووضع من خارج أخرج السلا
د سلورس وهو الجرى اذا اكل وهو طرى كأنه معذى كأنه يلين البطن ويفي الرئه
وجودة الصوت واذا انضمد بلحم الملج منه اخرج الشلا من عمق البدن وأما المطبخ

الشراب الريحاني كان رادعه الا شفة موغلا وقد تضمد بالجرجير مع مرارة البقر لآثار الغروج ويطلى بزر اماوس بحسل على النمش والبهق الاسود والكلف وكذلك الا فرسا اصل المعولة اذا طلى بمداقته بما بجلا وشى من خل وان شرب بوزن بكبخين وما جاوز فيه بانها **جعيفل** يسمى خشبة الاسد واسل العدس وخانق النمر الكرسنه لانه اذا انبت بين العدس خنقه وقد يفعل ذلك بالكرسنه **دب** وهو

اوريغنى

قضيب صغير ضارب الى الحمرة طوله نحو من شبرين وربما بلغ الطول من هذا القدر وله ورق فيه زوجة وعليه زغب غض وله زهر لونه الى الياس ما هو والى الصفرة وله اصل غلظه مثل غلظ الاصبع ينبت

الصيف

فى اوليبرز واذا انبت ما بين الحبوب افسد ما قاربه وقد

يبلى ويؤكل مثل الهليون يؤكل ايضا نيا ويطبخ به انه اذا القى مع الحبوب الطبخ اسرع نضجا **ح** توة هذا الدواء بارد ويجفف فى الدرجة الثانيه

خنطانا انحن عمران الخطانا صنفان صنف ينبت فى الجبال وفى المواضع البارده اللجنه وهو لزومى والصنف الاخر هو يشبه حاض البقر وعزقه اسود فيه شى من مرارة وينبت فى المواضع الدنية **ي** الخطانا التى ذكرها **ك** هى الصنف الذى من هذين الصنفين والصنف الاول التى تستعمل عندنا بالاندلس اكبر من الاخر ولكون بحلشم وفى جمة مستفسطة وهو اصل شجرى ذات اغصان ورزق فارق اصلها شديد المرار وهى اشد مراره

عليه شيء من اللبن ثم اعلبه بجنون يزنه ثم وخلطه حتى ينعجن وعملت منه أقراص وجففت في الظل فإن هذه الأقراص تخزن ويستعمل في الطعام فيكون طيبة جدا وأما البري فهو صنفان

أحدهما يشبه ورقه ورق الخردل شديد الجزء إلا أنه يجمع في جيران: عُشَيْرة

نوع آخر من الجرجير آخر

الجرجير البري وهو الأيهقان وهو صنفان أحدهما يشبه الحرشاء ويسميه بعض الناس خردلا بريا وهي شجرة تقوم على ساق خضراء لها ورق كورق البقل جزء ونور صغير أصفر يجمع مختلف

أبو حنيفة الأيهقان هو الهيو وهو الجرجير البري وهو عشبة تطول في الشتاء ولها ورق أخضر ورقه عريض والناس يأكلونه وفيه مرارة ديس الجرجير إذا أدمن أكله محرك شهوة الجماع ويزيد في المني ويدر البول ويهضم الطعام وبلين البطن وقد يستعمل يزن أيضا إذا أريد الطبخ وقد يعجنه قوم بلبن ويعملونه أقراصا ليبقى زمانا طويلا وقد يحرقونه وقد يكون أن بطاجر بري في بعض بلاد الحر يستعمل أهلها بزنه كما زل الخردل وهو أشد إذا ارام اللول وأشد جزأة من البستانى في كثير عشيرة الجرجير جله يصدع يتقل الرأس وبطل البصر ويرى أحلاما رديئة ويسدر وينخ تخما ثقيلة ويهيج الورم ويهيج المواد إلى المواضع المنتهية إلى ذلك ويدر البول ويحن وإذا أكل جدا وشرب عليه

في التطول أورسيون

ان يكن غاية النفع بجفف من غير ان يلدع واذا اضمد به ايضا فرشانه ان يجفف الالتهاب وسغر الاضاد المحدثه وعر ابا بلزم ذرنجوس هو اقل غذا من سار الحبوب التي يعمل منها الخبر فاذا عمل منه خبز وهي منه ما يشبه الحنطه عقل البطن وادر البول واذا اقلي وتكمد به حا انفع من المغص وغير ما من الاوجاع :: جرجير الفاكهه الجرجير صنفان بستاني وبري وكل واحد منهما صفان فاجنس البستاني عريض البستاني فشي اللون واقبض الخزافه رخص طيب والثاني ورقه ذواق فيها شريف ودخول جوابها اشد شد الجرجير لا يستعمل يؤن في الطبخ واذا الجنس البستاني والبري ادار ودفا جميعا في هاون وبسط على صحاف حتى تجف ثم يرد الى الهاون وتصب

هذِهِ الشجرةُ لبنٌ قبلَ أنْ يثمرَ بانَ تصدقَتهُ الخارجةَ بجرحِهِ فانَّهُ انْ نخاوَزَ الرضّ البشر
الخارجُ الى ما داخلُ الخرجُ منهُ شيٌ وقد يجمعُ اللبنَ باشبيةَ او بصوفٍ و يجففُ ويقرصُ ويُخزنُ
فى آنيةٍ من خزفٍ و قوتهُ مملسةٌ ملينةٌ مفرَقه للجراحاتِ محلِلةٌ للاورامِ العسرِ النضجِ وقد يشربُ
ويُمسحُ به لنشِ الهوامِ و جسا الطحالِ و وجعِ المعدةِ و الامعاءِ و قد ينفعُ اليها الناكلُ و قد
نبتَ بالجزيرةِ التى يقالُ لها فبرين و هى صنفٌ من الشجرةِ التى يقالُ لها طاطا وَ ورَقها يُشبهُ الحجم
وَ عظمُ ثمرِها لا عظمُ الاجاصِ و هو لحمى منهُ و هو يُشبهُ ثمرُ الجمنير ثابِرُ الاشياءَ

جَوذَرْ ابنُ جلجل: هى شجرةٌ ليس لها ارتفاعٌ لها اغصانٌ حمرٌ وهى غليظةُ الاصلِ وَرقُها
يُشبهُ وَرَقَ الكمثرى
البرى وَلها ثمرٌ مدورٌ وزغبٌ
اللونِ و يكادُ يضربُ على الطينِ
و يعملُ منهُ شىءٌ يكونُ كالجلّاسِ
الابيضِ و يُشربُ ليُبَلّانِ
. . . و هذا النباتُ كثيرٌ
بِلادِ و ناحيةِ الغربانِ
لى هذِهِ الشجرةُ معروفةٌ
بلادِ البربرِ و بها الاسمِ و يعملونَ
فشرخُ . . . دباغ الجلودِ:
ابنُ جلجل: انهُ العبيزا
وَلبنيةٌ: **جَاوَرسْ** ابنُ واقدٍ: الجاورسُ صنفٌ من الدخنِ صغيرُ الحبّ
شديدُ البَياضِ اغبرُ اللونِ . . . هذا باردٌ يابسٌ الدرجةِ الاولى و يجففُ امانى آلاثة فى اولها
و امانى الثانيةِ و اخرها و فيهِ مع هذا لطافةٌ سيرةٌ فلما كان رقوَمَهُ و مزاجِهِ هذا التوامُ و المزاج
صارَ متى تناوَلَهُ الانسانُ على انهُ طعامٌ هذا البدنِ غذاءً يسيرًا اقلَ من غذاءِ و جميعُ انواعِ الحبوبِ
و يُيبسُ البطنَ و متى يعالِجُ بهِ انسانٌ من خارجٍ بانْ يجعلَهُ فى كيرٍ . . . و نكبدِهِ نفعَ من الجناحِ

بنطبعنا

الجوز الكبار ٢٥ هو زدي صار للمعده واذا اتخذ وشرب بماء وعسل اری من
السعال المزمن واذا قلی واکل مع شی یسیر من ملح انفح النزله واذا اخرق کما هو
یفشره ویسحی وخلط به بخمر عتیق وبحم الذیب ولطخ به داء النعلب انبت الشعر فیه
وزعم قوم ان البندق المحرق واذا اسقی مع الزیت وضمد به افواخات الصبیان
الزرق ثم ود جلدتهم وشعورهم ۞ عنبر ۞ یغدو الدماغ ویزید فیه ویولد الرباح
فی البطن الاستعلا ویهیج القی و قشره یعقل البطن و قد ینفع من نهش الهوام وخصوص
العقارب لانها اذا لمع نبز سذاب ۞ جمیر ۞ ویقال الجمبرک

سیقومری

وینمی البری الذکر وینبی به ایضا صنف اخر من النیز وهو الرغو وهو النیر ذکر
٢٥ الجمبز ثم بالیونانیه
سفوموزی بمعناه
النبر اد عتو واسمی سذا
الاسم لانه صنف الطم
وهی شجره شبه شجره الانین
لها البر کبیر جدا وزنها شبه
وزن النوت وتم تلث
مرات و ارباعا ولیس یخرج
تمرها من فروح الاعصان
کما یخرجه شجر النبن ولکن
سوقها و تمرها شبیه بالنبن
البری و هو اخلا من النبر البلح ولیس فیه عظم نز زن سفحه و ان سفحه دون ان یشرط
بخلب من طیب وسلب کثیرا فی البلاد الذی یقال لها فادبا و المواضع التی یقال
لها زود وترغ الامامان الکبیر و قد ینفع بثمره فی سنی الجدب لوجوده فی کل
وقت و هو یسهل البطن قلیل الغذاء ردی للمعده و قد یستخرج فی ایام الربیع من

وقد يميل أن يخرج الإنسان منه دهنه إذا اغتوتُ ذلك الوقت قوى الناصور
في ماقي العين ويوم آخرون يستعملونه أيضًا في الجراحات الواقعة في العصب
فأما الجوز الطري الذي لم يستحكم بعد ولم يجف فكان فيه مثل الخلط في سائر
الثمار الطرية كلها مملوءة رطوبة أنما نضجت نصف نضوجها وقشر الجوز اليابس
إذا أحرق صار دواءً لطيفًا يجفف من غير أن يلذع الجوز إذا أكل عسر
الهضم ردي للمعدة يولد المزاج الأصفر مصدع مضر للسعال فإذا أكل على
الريق هون القي وإذا أخذ مع البزر اليابس والسذاب قبل أن يوجد الأدوية التي
كانت بازهرالها وإن أخذ أيضًا بعد أن يؤخذ ذلك فعل ذلك وإن أكثر منه أخرج
حبًا للفزع وقد خلط به شيء يسيرٌ من عسل ويضمد به البدن يحلو التوا العصب
وإذا خلط به عسل وخل وبصل كان صالحًا لعضة الكلب وعضة الإنسان وإذا حرق
كهو يقشره ووضع على المرأة سكّن المغص وقشر إذا أحرق وعجن بشراب وزيت
وطلي به يوس الصبيان حسّن شعورهم ولين الشعر يبرئ داء الثعلب وداخله أيضًا
إذا حرق وعجن وخلط بشراب واحتملته المرأة منع الطمث وداخل الجوز
العتيق إذا مضغ ووضع على الوزع والعقبول ينفع له أعلو ش رق الثعلب برأه
ودهن بخرج منه أيضًا إذا دق وعصر والجوز الرطب أقل ضررًا للمعدة من غير من الجوز
وإجلاء لذلك خلط بالثوم ليكثر جرأته وإذا انضمد به قلع اثار الضرب
غبن الجوز ينفع الكلف ويزيل شنج الوجه وينفع من كدر البصر وكلاله وهو
يبسر الفم ويثقل اللسان ويبطن المغص ويخشن البطن وخاصته أنقى والمرأ باسه بالفنل
يسخن الكلى حار ويطلى البطن حبد المعدة الباردة منافرة للجان العتيق منه يحدث
وجع الحلق وما أدق قشر الجوز يمنع الطمث مشروبًا ومعجونًا وعصيرٌ ورقه إذا أقطر في
الأذن ينفع من الألدة. جلوز وهو البندق ح ر موجيس من الجوز صغار
وفيه من الجوهر الأرضي البارد أكثر مما في الجوز الكبار فهو لذلك أشد عفوصة
منه عند المذاق وذلك موجود في ثمرة وقشره وأما في الحمل الآخر فهو يشبه

بئ المعاوة وغيره اذا شرب منه وزنه درهمان مع كثيرا نفع من النائب الجرب وهو يضر بالناس **جوز الرنج** هو ثمر يقرب التفاح الى الطول قليلا مرو استخن و داخله حب صغير كلفاقه الصغير مدحرج اصهب اللون حريف الطعم يخول الى مذاق الخولنجان طيب الرائحة يجلب من صحارى بلاد البربر واذا نحو وشرب منه قدر دانقان مع ماء حار نفع من الخولنجان الريحى وهو جيد للمعده وبنع فى الجوارشنات المتخنه **جوز الشرك** وهو جوز الحبشه وهو ثمر يقرب من جوز الاكل الا انه اطول وطرفاه محدد ان ذلك له شكل ما صغير من اصول الخنثى ولونه اجمر الى السواد قليلا وطعمه كطعم الزنجبل هو اشد حرافه منه وتأجنه طيبه يوتى من بلاد السواد ويستعمل فى الجوارشنات المتخنه وقد يوتى به من بلاد البربر يبقى منه دون هذا **جوز جرز** هذه الشجره

ايضا وزنهاد اطرفه اشى من النبى وهو فى القشر الخارج من قشور الجوز اذا طرى ابيض ولذلك صار الصباغون يستعملون هذا القشر ماد ام طريا كما يعتمر التوت وثمرة العليق ويطبخ عصارته مع العسل فيتخذ منها دواء نافع جدا من الادواء الحادثه فى الغم و فى المنخر وينفع ايضا جمع الادواء التى ينتفع منها بلك العصارات التى ذكرناها، واما الجوز نفسه فالذى يؤكل منه فهو دهنى لطيف فهو بهذا السبب يسرع الاستحاله الى المزاج وخاصه ما عتق منه يكون من جاله

فارود بابا سلتيقا وهو جوز

المزروجات ومنع القى وأما السبابه فهى من فتح جوزتوا الدقيق الذى فوق
الثرى الغليظ وجودها الحمراء وأدناها السوداء وهى تشور زمتها زقاق معضته
بابسه الى الحمره وصفره تحذما النار لكبابه حار بابسه فى الثانيه فابضه
مجلله للنفح ودحل الصلابات الغليظه اذا وقعت فى الخبز وطبخ بطيب لكهه
واذا استعط بها مع دهن بنفسج نفعت من الصداع الكاين من رياح عليطه فى
الراس ومن الثقبه وهى بقوى الكبد والمعده وتعقل البطن وتنفع من النفح

جلّنار

وهو الرمان الذكر وتسمى بالفارسيه وتسمى بالعربيه المظ بالوسطنيون
هو أصناف كثيره لأن منه
أبيض وموزد أحمر وطبه
مخالطه وزد الرمان يستخرج
عصاره مثلما يستخرج
عصاره الحبوب فنطبدره وهو
فابض يصلح لكل ما يصلح
له الحبوب فنطبدره وروز الرمان
والجلنار هو زهر الرمان
البري كما أن جلد الرمان
زهره الرمان وطعم الجلنار
طعم قوى القبض وقوته
تجفف وتبرد وهو غليظ

وكذلك ان نبت منه شى على موضع قد انسبح أو على موضع فيه قرحه ألصق
الأخر وجدته يبلها سريعا وكذلك ايضا ضماده يدواء من ينفث الدم من قرحه
الأمعاء ومن يحلب الى بطنه تخرج الأنبال والنساء اللواتى يحلب الى ارحامهن شى يخرج
بالنزف وليس من أحد لا وهو يستعمل هذا الدواء من الأطباء الذين وضعوا الكتب

الشحم عروبين بن نعيم :: بوسنون قلوا النعنع :: بوقسيليس
هو البعيث :: بول الحمارة هو نبات ينبت بهذا الاسم ويسمى باللطينية عوذبوله
وفي بقلة نبت في الربيع لها ورق ينبسط على الارض خشن وزغب اصفانج مشقق
وله قضبان عليها زرو وتر صغار مدورة صلبة لونها اخضر موشى بالسواد وعليها
زهرة كالشعر احمر اللون وله اصل اسود واكثر نباته في المزارع والكروم وقوم
يظنون انه الشلاع ومنه صنف اخر اصغر من الاول وثمره واخشن وقضبانه مربعة
خشنة وله زروش وزهر من موضع واحد ومنابته الرمل وبقرب البحر ويزعم قوم ان
اصول هذا الصنف هو الـ ريذان ويزعمون انه نوع شبيه بنوعه :: بولان
قل انه العرطنيثا :: بولامونون هو بولوبيون وقد تقدم ذكره ::
بولوبودين نا وبله با بوناته كثير الارطه هو السبح ::
بولرنون هو الخربق الاسود :: بولوطريخون نا وبله كثير الشعر
وهو البرشاوشان :: بولوغالن مكثر اللبن :: بولوغانا طن
كثر الزكام :: بولوفيمون كثير الزروش :: بولوس اسم
هندي وهو الزاوند الصيني ::

حرف الجيم

جوزبوا وهو جوز الطيب :: ابن سينا هو جوزبنى قدر العفص ثقيل المكسر
رقيق القشر طيب الرائحة :: اسحق ابن عمران يؤتى به من بلاد الهند واجوده مالان
منه ثقيلا رزينا دسما احمر وامّا ما كان منه اسود خفيف يابس فهو ردي عبرة
طعمه كطعم القرنفل وهو جار في بئر اخر الدرجة الثانية قابض ينفع البشرة ويطيب
النكهة وينفع من السبل ويقوى البصر ويذهب البخر ويهضم الطعام ويحلل الرياح ويقوى
الكبد والطحال والمعدة ويعقل البطن ويدر البول وينفع عسر البول ويذهب
الطحال ويلين ويبرى ومه الجاني واذا وقع في الادهان نفع من الاوجاع وكذلك في

بوت قيل انه حب الملوك بعينه يكون منه بستاني وجبلي وقال أبو حنيفه البرت من شجر الجبال نبات نباتات لازعزور وكذلك ثمرته الا انها اذا أينعت اسودت وحلت جلاوة شديدة ولها عجمة صغيرة مدورة وهي تسوّد فم آكلها ومجتنيها وثمرها عناقيد هذا قيد الكتاب الناس ياكلونها ۰ بوت والبرت ايضا على ما ذكر بعض المفسرين هو الكرمة البيضاء ۰ بوت دارىبدك وهو الذي يقال له ايضا دوشرداىدى وسنذكره في حرف الميم ۰ بوبازل اسم هندي وهو بالفارسية سكسوة وبالعربية سنبنان من الجاوي ۰ بوبيه هو الاسنينس من الجاوي ۰ بولوين في الجعدة الجبلية من كتاب بوت هي المحطا على قول اصحاب الزاجم ۰ بونبون معناه الخالي وهو اسطر اطيفن ۰ بودا البون قيل تاويله بالبونانية رجل الاسد وهو مثل اليهود وقال ومن الناس من يكتب العرطبيثا بهذا الاسم ۰ بودران هو التودرى من بعض التراجم واظنه تصحيفا ۰ بودرج هو التودرج وهو تصحيف ۰ بوزيد قال انه عنب الثعلب ۰ بوزيدان اسم فارسي والناس يقولون ابو زيدان ويزعمون انه خصى الثعلب وهو خطا وقيل هو البهج وقال ابن رضوان انه ضرب منه وقد تقدم ذكره ۰ بوزثون هو العاقر فرحا بالبونانية ۰ بوريطس هو بالبونانية هو الما رفشثا بورسمى الحنطه بالبونانية ۰ بورس اجى هو الما زريون بالبونانية وقد يسمون المشازا ايضا بهذا الاسم ۰ بوطانية هي الكرمة السوداء وزعم ابن وافد انه الكرمة البرية وهو خطا ۰ بوطا موحيطن وبوطا موعزطن مواريس هو جاز البهر ۰ بوطريون هو الذي يسمى بالبونانية ۰ بوفاداس وبوفاداىون هو الاندراسبون ۰ بوفارن معناه بالبونانية من البقر وهي الجلبه ۰ بوفصا هو شجر البق وهو الشم ۰ بوفاىنيون هي شجرة الحضض اليماني ۰ بوفسليس هو النفس ۰ بوساد وهو

بلج هو الثلج على ما ذكر الرازي في بعض كتبه ۞ بلحيه فيل انه الباذنجوه
وهو الترنجان ۞ بلجشول وقع في بعض النقا سير بالباء وصوابه بالتا
لجشوك وهو الطرجشوق ۞ بلجون هو الترجش من كتاب د ۞ بلجني
هو البهرابج ۞ بلس هو النبت ۞ بلسانج هو الحاج وهو الجنوا النبطي
بلسامن هو البلنان بالبونانية ۞ بلسلي هو مصفي الزارعي وايضا اذن
العزال فقد تقدم ذكرها ۞ بلسسم هو البلسان ۞ بلسن هو العدس
بلك اثبته كثير من الناس في تسانيفهم بالباء وهو خطا وصوابه بالنون وهو
الزعرور ۞ بلوا احن هو مثل البهود بالبونانية ۞ بلون بخ
الجعده بالبونانية ۞ بلوط الأرض هو الكماذريوس وذكرين
الجزا رتين اساغير الكماذريوس سماه بلوطا وزعم انه الكماذريوس واخطا فيه
وقد تقدم ذكره ۞ بلوط ذهبي هو البتر الاصفر الذهبي وزعم قوم انه
الهليلج الاصفر والناس يعرفون عندنا بهذا الاسم على الكلب ۞ بلوط الخن
تاويله كثير الشعر وهو برسياوشان ۞ بلوغا باطن تاويله كثير الرطب
وكثير العقد ويسمى بالسريانية سكلذن وقد تقدم ذكره في هذا الباب وهو
بالعجمية الفيلوزا وقد سمي ايضا بهذا الاسم نبات اخر يقال له لو قافنا ويذكر في
حرف اللام ۞ بلوغالن و بلوغا اكمكته اللبن وقد تقدم ذكره ۞
بلوعوا بدواس تاويله البنه بالطباط وهو صنف من لماطس ۞
بلوعويز هو عصا الراعي بالبونانية ۞ بلوسطيون هو الجلنار
بهازكي هو الكبير من الكاوي ۞ بهرمر وبهرمانه هو العصفر عن
ابي حنيفه ۞ بهط هو طعام يتخذ من الارز وهي كلمة سندية ۞ بهش
هو صنف من البلوط يشبه البلوط ويشبه العفص وليس بعفص ولا بلوط ويسمى
بالعجمية الشوبهر وثمره غليظا اسود وقصير مدور ويسمى الدلح وبالبونانية بريس
ويعلف ثمره البقر والدواب والبهش ايضا عن ابي حنيفه رطب لمتل ۞

والطعم يأكله الناس والماشيه تذكر به اذا اكلته ريح الجزر وطعمه
بسيله هو الجلبان الذكر المر وابضا الترمس واصله من الساله و في
المزاره وكل مر يبرل ؛ بسيموسون هو الاسفيذاج باليونانيه ؛ في
بسبسه هو السرمق ؛ بسيون زعم قوم انه المصطكي ؛ بسيون
زعم قوم انه الاشيمون ؛ بسر هو ثمر النخل عند استحكامه وقيل انه ينضج
فاذا انضج فهو الرطب ؛ بسرا هي الكرمه البيضاء ؛ بسطافيا
هو الفستن باليونانيه ؛ بسطرنبط هو المزمر ؛ بسعرا هو الزرجون
من الحاوي ؛ بسكدان هو الاعضل الاسود وقد تقدم ذكره ؛ بسل
فيل هو لبن الكبز من الحاوي ؛ بسليون هو البزرقطونا من اليونانيه
و نا وا سليون باليونانيه البرغوث ويتني ؛ ابضا الكرمه البيضاء بسليون
بسلسفن في التلسكه وهي الحنطا بالاندلسيه ؛ بسودوسون
وسوطونوسون قد تقدم ذكره مع ذكر يوسن ؛ بسيوس هو الحرمل
بقسلس هو البقس وهو المشارك الحاوي ؛ بلسيس خشب
كثير تعمل منه صاديو تعرف بالشام به ؛ بلابيس هو الحزمل من بعض الترا جم
بي فان ابو حنيفه البكا مثل الشامه لاذرو بينها الاعند العالم بها وكثيرا
ما ببنا زمعا واذا اقطعت البكا هرقت لبنا ابيض ؛ بلاطابيس هو الدلب
بالالا هو الخطمي الابيض من الحاوي ؛ بلب هو الخطلا بالهنديه من
الحاوي ؛ ؛ بلنجمليس هو اجا شار على ما زعم بعضم ؛ بلجمشك و
وفرنجمشك هو الحبق النرنفلي ذكره في حرف أ ؛ بلمبيطر يحوا هو
البريسا واشار وبنيره كثير الشعر ؛ بلبطش هو البرزيون ؛ بلبيش
هو الحزمل من الزهراوي ؛ بلسابلنك هو الجار شبر على قول
بلبوس بيلوزون هو الشيهان وهوشوك زعم ابن جلجل انه السندر ؛ بلبوس
بيزى هو السوزجان ؛ بلج هو ثمر النخل اذا اعظم واستد قبل ان يصير بسرا

موجود كثيرًا وكذلك عوده وقد ذكر كثير من الأطباء شجرة البلسان التي بمصر بعين شمس ووصفوها بأن كثيرهم بأنها شجرة البلسان يعلو على الأرض قدر ذراع أو أكثر ولها أغصان رقضبان شبه قضبان الشبرم ولها ورق أحمر دقيق صغير يشبه ورق الحلاف أو ورق الينوع ولها بين رأس أغصانها أشد فيها حب عناقد
فذا الفلفل إلا أنه أكبر سوادًا منه وعند ناس نبات وزعم قوم أنه البشام يعلو نحو القامة وله ورق طويل أخضر يضرب إلى الصفرة وغبرة أصغر من ورق اللوز وعوده خوار في داخله شيء أصفر كالقطن فيه عطريه وله حب في قضيب الصنور وهو عطر الرائحة وقد يباع ويستعمل عوض حب البلسان بأنه بنت أهل الجبال وآخرون يزعمون أنه نوع من الأراك وقد يمكن أن يغتر حب البلسان بحب أصناف الصنور وإن فيها ما يشبهه جدًا : **بشاما** قيل إنه البشام بالرأيته :: **بسنابرور**
نبات قد تقدم القول عليه زعم قوم أنه الشرقة الحلوة وزعم بعضهم أنه النبات الذي يسمى عندنا طرطوزًا حاجب وهذا أخو عنبي وأماجنين فقال لا أن بينار ابرور هو البرزبابه بطاطيئي :: **بسماسه** هي ثمرة جوزبوا الرقيقة وسنذكر مع جوزبوا في الباب الذي يأتي هذا : **بسناور** وجدت هذا الاسم على هذه الصفة في كثير من التراجم وزعموا أنه السنباج بالبربرية والاسم مصحف وإنما هو بستناوون :: **بستناج** هو نبات معروف يعبد في أصناف الجزر البرى وهو صنف منه صغير طيب الرائحة له بذر دقيق كالناخواه وينمى الغر برا ومنه كبير خشن الرائحة خشن البزر كبير وهذا الصنف هو شجرة الفنة والفنة هي الباردى لينة وكلاهما ينمى بالعجمية شنافدة ولها زهر أبيض يخرج من الجل العسل ويستعمل الناس أكلهما في خل الأشنان لصلابتها ورقتها والكبير يغطي به السقوف وهي شبه الكلج وقد يكون من السنباج صنف آخر صغير وله سن ناخث **بسماس** وهو الزانباج وزعم يحيى بن عمران أنه غير الزانباج ولكنه شبيه به ذو نال بوحيفه البنات طيب الرائحة

تسمى الفرصعنه بهذا الاسم واذا رايت في الجامع الفلة اليهودية فانما يزيد بها الفرصعنه ۞ بقلة حمقاء هي الرجلة ۞ بقلة حمقاء برية تسمى بهذا الاسم النبات التي بالفارسية مشار و باليونانية طلافيون و ايضا بان تسمى باليونانية طلافيون و قد ذكرت اصناف في العلم و ايضا بان اخر من جنس النبوعات هو الحلبسا ۞ بقلة خراسانية هي السانا و ايضا صنف من الريان يقال له الكبريت الخراساني ۞ بقلة ذهبية هي القطف ۞ بقلة عربية هي الزربون ۞ بقلة لبنة هي الرجلة ۞ بقلة مباركة الهندبا وعند قوم هي الجمجما ۞ بشاسا هي الحرمل السرابنة ۞ بشام قال ابو حنيفة هو شجر دوسار و افنان نكعه يغبر شبطه و روق صغار اكبر من ورق الصعتر و لا ثمر له و اذا قطعت و رقة او نصف غصنه خرج لبن ابيض و هو تجري طيب الرايحة و الطعم يشاك بعصا به و ورقة تسود الشعر قال ابن جلجل وعين ان الحب المعروف بحب البلسان هو حب البشام و ان شجر البلسان التي تسمى عودها عود البلسان و يسمى دهنها دهن البلسان لبس لها ثمر و منبتها بمصر بعين شمس فقط واما البشام فينبت بمواضع كثيرة وهو الذي يجمع حبة فيطلبه الصياد له وبيعونه و بتمونه حب البلسان قال المولف لبت ان هذا القول صحيحا على كثرة نواته و على ان جميع التجار يجمعون على ان حب البلسان هو حب البشام و قد نجد كثيرا من حب البلسان الذي يجلب ننا شاما عود البلسان و نجد عود البلسان الذي يجلب لنا شاما من حبة فهذا يدل على انهما تجرة واحد واما دهن البلسان فقد رايت قوما يخبرون ان شجرته بمصر من داخل مصر ونعم انه ناي شجر بعين الثمن فقط جان لحمها السلطان فلا يخرج منها الي البلاد شي بلا مرد زع و بعضهم يرعم ان دهن البلسان انما يخرج من عوده بالتصعيد و هذا خلاف لما ذكر القدماء و قد يمكن ان يكون هذا المعروف اليوم عندنا ليس دهن البلسان الذي ذكرته القدماء مع انه على غاية الغلة و العدم و جهه ليس كذلك بل هو

خراساني موبتل ينال له الموسانا وقد يمكن ايضا ان يسمى هذا الاسم الكرب الخراساني. **بقلة سنى** البقول الدستيه هى البقول البزيه كلها بهذا كالاسفانخ والطرجشقوق والعضد والتفاف الا ان المقاء خاصه خص بهذا الاسم دون نظايرها. **بقل دمشقى** هذا صحيف وانما موبقل دنى وهو النفاق وكما ذكرنا كثير من الناس يصحفونه بالكتب فيكتبون بقل دمشقى وبعضهم يكتب بقلارشى. **بقل رشى** هذا صحيف وخطا معا. **بقلة** انزجه هو الكراث وايضا الباذرنجبويه وهما بقلتان يشبه ناحتهما رايحة الاترج. **بقلة الانصار** هو الكرب. **بقلة الخطاطيف** هى العروق باليونانيه جالدونيه ويون مشتق من خاليدون وهو خطاف قال ح قيل انه انما سمى هذا الاسم لانه بنت اذا ظهرت الخطاطيف وجف عند غيوبها وقيل انه انما سمى هذا الاسم ان فرخ الخطاف اذا عمى ردت الام بصره بهذا النبات. **بقلة الرماه** هو من النبات المنثاف لكونى لها ورقه يشبه ورقى الثور او ورق النبات النبى بقال له لسان الذيب الا انه اميل الى غبر وله اصول دقاق وذات شعب خارجها اسود وداخلها ابيض جعفر عنها فى شهر حزيران وجمع قشره ويخد لحاؤها فيدق ويعجن ويخد عصارته ويطبخ حتى يصير كازفت الرطب ويرفع هذا الدواء فيطلى به الشاب ويرمى به الصيد فيقتل اذا اخلط الدم فلا وحلا وانما الاصول التى فشرعنها فبيعها الصاده عندما كان الكندس وينمو بها الكندس الكدس على الجيفه غيرها وهى حارة جدا تقى ينوه نوته وسعبها خطروهى محركه للعطاس ويبى هذا النبات بالعجميه سرتلة. **بقلة الضب** قيل انه الترنجان البرى الذى يسمى باليونانيه بلوطى وقد تقدم ذكره **بقلة يمانيه** هى اليربوز. **بقلة يهوديه** هى العصيد على الحقيقه وقد يسمى ايضا الطرجشقوق هذا الاسم وايضا التفاف ومن الناس من

اكلّه فيها زهر بزرى اصغر وثمر كالدارقلى لطيف بذنى بالغنوبا والفروج وهو نم وحى لا يلبث ومنه انواع احد منهما ما هو شديد الشبه بالكرفس الثنائى وله عروق طوال كالخرنوب الابيض تخرج من موضع واحد فى غلظ السبابة غيره فى الارض زخوه وزهر ابيض وربما مال الى الفرفيرية وهو صنف اخرشبيه وزنه قدره الاصبع فى اول طلوعه فاذا شب تهذب وزاد وطال وساق رقيقه جوفا يعلو نحو من شبر وزهر ابيض دقيق وثمره لا و كلّه ينبت بالقرب من المياه والانهار وهى حشيشه فتاله لكل حجوار ويكون منه جلّة اصل كاصيل الاخدران جاد جدا و رائحه جدا وزهره ذهبى لا يكبر وهو اضاف قتال وقد بعدم اضافه . **بصل الزير** هو الملبوس وقد تقدم القول عليه وينفاك انه البصل الذى ينال له بالعجمه طرفنيه وهذه بصله بيضا مدوَّر الى الصفره وساق رقيق يعلو نحو من شبر مدور واملس فى اعلاه زهر فرفيرى واصله بوكل وفيه مرازه وفبض وزنه كورق الكراث ومنه نوع آخر مدرج ايضا دو لنايف كثره قشره الى الحمره وله ورق اتق اطول مر ورق الاول وساق شبيهه بساقه وزهره ارق دقيق وقال قوم ان اللبوس بصل لا طاقات له وقد مضى ذكره . ومنه نوع اخر وهو العقيل ونوع اخر وهو الذى يسمى الدروز بالعجمه فنسبوله . **بصل الفار** وهو العنصل . **بعقوبيل** هو حب الغار . **بعلسن** هولسان الثور . **بقلمن** تابيله بالبونانيه عن البقره وهو البهار وله . ومن الناس من يسمى جنى العالم بهذا الاسم . **بعخازش** نبات ينبنى بالعربية الزهر من الحادى وقد ذكرناه بحرف زاى . **بعطى** هو سفوط الاكبر . **بقلين** وبنلبوز وتوفل هو الجلبنا . **بقولون** ادخل الزارى هذا الاسم فى الحاوى على هذه الحاله من العريف والعنبار وانما هو بيلون . **بقل الزل** هو صنف الثقا قاطس . **بقل الروم** هو القطف . **بقل

باليونانية . **برسما** هو جب فازخ خفيف وحدى النلنل . **برم**
هو نور العصا يعنى النجم الكبير العظام . **برعوم** هو غلف النور
قيل انه ضرب من الحمص وهو نبت دقيق . **برمك** هو خشب الشرومن
الكاوى . **برهفاى** قيل انه المروى لجى الرهماى صنفان احدهما
طيب للراحة وهو المرماخور . **برهليا** هو انزاباج بالسريانيه .
برونيا هى الكرمه السوداء . **بروبولس** هو وسخ الكور
بوزق شجرة ضعيفة تنبت فى اول البقل لها نضه كالسياط وبينها
ضعف ياعمر زبار واذا غامت السماء اخضرت ولها خطوط دقاق زووبها
اذا اجتمعت عليها الثمر ذبلت ولها جب اسود صغار وبو كل اسطوقه و ازالت
وجدها او رثت جرب وهو مما يخرج فى الجدب ويقلع الحمض واذا اصاب بها
المطر الغزير يهلكت . ل هذا نبات معروف وليبرى باختى كما زعم قوم
لكن فيه منه شبه يسر . **برومس** هو الخرطال وهو الفرطان بالفارسيه
برفن يعنى الاشنه . **بروز الحجرى** هى الاشنه الجبريه فطاربن
هو الرخن . **بطاريقى** هو السعاط . **بطالا** يا موتجده
البق وهو الشم . **بطباط** هو عصا الراعى . **بطيح** يذكر مع الماء
نجزن ق . **بطيح برى** هو الحنظل . **بطيح** فلسطينى وشامى
وسنبلى وهندى هوالدلاع تاويله باليونانيه الصفدعى وهو
الكبج . **بطراساليون** معناه باليونانيه كرفس برى وهوالمعروف
عنداللطبا بالبطراسليون ويذكر مع اضاف الكرفس . **بطربيعى**
هو السعاط باليونانيه . **بطمون** ويسمى ايضا وارس وسنذكره
نجز النون . **بطولاون** تسمى باليونانيه دهن الجزر وهو النفط
بطل هو نبات يشبه الكرفس ينبت على المياه وقال رنه نشبه
ورق كرفس الماء المعروف بقره العين الا ان فيه شبنه وساقا وعليه

هو الشهترج من الحاوي: **برق** هو المشار بالفارسية ويسمى باليونانية
طلاقيون: **بريون** هي الأشنة باليونانية: **بريون بحري**
هو الطحلب البحري: **بزرمتي** بل مطلقا إنما يراد به بزر الكتان:
برشه بالمعجمة هو الوصرا الذي يعرف بالبكران الأصفر ويسميه
بعض الناس السلق البري: **برنونيا** هي الكرمة البيضاء باليونانية:
برهى هي الرجلة بالفارسية: **برحنوا** هي الشمونيا بالسريانية
من الحاوي: **برخليا** هو الزاراوج بالسريانية: **بردا النحاس**
هو قاتل الكلب وقاتل الذيب: **برديقون** هو العتبا وهي حشيشة الحاج
بردكلفا هو النماش من الحاوي: **بردون** و**برددن** باللطيني
هي شوكة يقال لها العناة بالعربية: **بردوسلام** هو لسان الحمل:
بزر البراعيث هو بزر قطونا: **برعا** هو الهو فاربقون
بالسريانية من الحاوي: **برعاوي** هو عصا الراعي على ما زعم بعضهم:
برعه حفلا هو الشيح بالسريانية من الحاوي: **برعشت**
بالفارسية هو الفايزي باللطينة وهو بالفارسية العمللوك: **برعوث**
هو البزر قطونا: **برفي** هو الفطوريون الكبير من كتاب
برفافيثا هي الكروان وهي النملة الانجفة:
برفاكرشبنا
هو المرماجوز: **برقاطال** هو الكهاذا: **برقامصرا** اهى
الحراكة: **برفقش** هو البلك باليونانية: **برقلبان** هو
الأنكسوه وهو بزر السبان من الحاوي: **برقوق** هو المشمش
برس هو العظن: **برسا** أو برشا وبرسون هي الفارسية وهي
اللبخ: **برشياد أزو** وهي عصا الراعي بالفارسية: **برشنا**
وهو الجعفل باليونانية: **برسيقي** هو الأرج: **برسيقي ميلا**
هو الخوخ: **برسينا** وهو الجعيل باليونانية: **برسيقي** هو الرأس

بنطس هو الصنوبر الصغير باليونانية. بنطا هو العروق الصفر.
بنطونياس هو ثمرة الصنوبر الصغير. بنع مشراب مسكر
يتخذ باليمن من العلة. بطاس هو السذاب باليونانية.
بنقر اطيون هو صنف من الفنجل. بنفرطش هو الحمّاس
الاسود باليونانية. بلش هو الشراب الذي يسمى الفقاع وهو شراب يتخذ من
الشعير. بلسيون هو النبات المسمى بحيون وقد تقدم القول عليه.
بلص ويلس هو الولك. بيلق زبل هو المودج الجلي. نخبج
ما و بلة بالفارسية مطبوخ. بنوله هو الماء. فطوس بالعجمية.
نخزيه هو الجزر البري بالعجمية. خزيه هو البقل بالعجمية. خوز
الاكراد هو الجاما. خوز البزر وخوز مورشكه هو القطوم
برزاح هو الزبيب. برزيون هو الحنا الاحمر وهو ثمر العطب
بسم هو الحنطة. بر ايبون دبانون هو الاهل. براحا
هو الشيح. براطانقى هو برطانقى وقد تقدم ذكره. براسيون
هو الاهل باللطنى. براسين و براسيون هو الفراسيون. بر وانيا
هو الكرمة البيضاء باليونانية. بوبارس اصل هذه الكلمة امربارس
وقد تقدم ذكره في حرف الالف. برباحملا هو الشيح بالسريانية
من الجاوى. بوبارس هو عصا الراعى وهو المسرج من كتاب اهرن.
برسان هو الاذخر بالهندية من الجاوى. برتبلس صنف من البلوط
ويقال بالعجمية الشوبرو وهو البلش وقد تقدم القول عليه وهو اسم فارسى ويقال له بالعجمية الشويلا. برنخمشك
هو الجبن السرنجلى وهو فرنج مشك وافرنج مشك وسيذكر في حرف الباء.
برنخاسف وبرنخاسب هو البلنخاسف
برجوس هو عنب الثعلب. بوير هو ثمر الاراك. بربتر
هو الثلث من كتاب الاعذية لجالينوس ويسمى باليونانية طبى. برنطوا

بُقَرْفَره هي عشبة تعرف بالضابطه والرافعه وبغلط بها اطبّاؤنا
فيستعملونها بدل الخربق الأسود ۞ بِنْتَرفِه قيل انه القسط ان لم يصح
وزعم قوم انه الكماد ذبون ولين يصح اذا هي عشبه مره وثمرتها ولها ورق
رعب خمر نحوى وزهر الصنوبر ان یعلى وأجدهُ وسعه متقفله لونها الى الحمرة
ولها اصل اسود اكبر من اصل الحنى وتسمى ذنب المرة ۞ بَنِيلَ هوالدارنلفل
من الحاوى ۞ نَقْشَلَمْ معناه باليونانيه عين القرة ويسمون بهذا الاسم
الباذاورد ايضا الصنف الكبير منه جا العالم ۞ بَنُوحِلِنْ هو السروح
باليونانيه من كتاب د ۞ بَلْبُوا هو الخرزه السريانيه من الحاوى
بنج اسودان وعکر ان لسان العصافير بالفارسيه ۞ بَنْد هو العروق
الصفر من الحاوى ۞ بِدْدْزُوَا هو الملاء الهنديه من الحاوى
بَنْدَو هوالحلور بالفارسيه ۞ بُنْدُقْ هِنْدِى قيل انه الفوفل
والصحيح انه ثمره اخرى هنديه يقال لها الزته ۞ بَنْدَقَيْرَوْن
السرابايون يسمى بهذا الاسم شجره الغاز ۞ بَنْدْسَوَا هى البناء بالهنديه
من الحاوى ۞ بَنْدَب هو اصل الرطبه من الحاوى ۞ بَيْرُدَوَمْنْ
هى ثمرة الكلب من الحاوى ۞ بَيْرَم وبیرمافيل هو النودج وقال
الرازى هو الصغير الطويل الورق ۞ بِيرَوْطَانَا هو صنف من العنصل
وهو المثنى باليونانيه ما القرطيون ۞ بَنْطا هى العروق الصفر
بَنْطَابَاطِسْ تفسيره ذوخمسة اجنحه البطافلون ۞ بَنْطَادَقَطُون
تفسيرُه ذوخمسة اصابع وهى البطافلون ايضا ۞ بَنْطَازَنْسْ هو
الرخن باليونانيه تفسيره باليونانيه ذوخمسة اقسام
وهو البطاڭلن ايضا ۞ بَنْطَافْلُنْ تفسيره ذوخمس ورقات ۞
بَنْطِيفِقَا هو الحلور باليونانيه ۞ بَنْطِيفُوس هو كانت الذى
يسمى باقلى فنطى ۞ بَنْطَيغٖى زمَرا هو اصل التوس من كتاب د

اباز اوطان ومعنى باز نسطاز بيون بالبونانية الحمى :: **بازهر** اصل هذا الاسم
بالفارسية باذ زهر ومعناه دافع الضرر وهو اسم يستعمل على معنيين احدهما
عام والآخر خاص فاما العام فهو كل دواء عامّ نافع من السموم كان من المفرده
او من المركبة وكذلك كل دواء كان منفعا وملائما من السموم فهو يقال فيه
انه بازهر لذلك السم واما تحجّر يكون بالمشرق ويُنفع من جميع السموم وقد
الخاص
تقدم القول عليه :: **بارزو** موجز الحادثة بالسريانية :: **باروق**
هو الاسبيداج :: **بازون** هو العاقر قرحا :: **باطاسيطس**
نبات قد تقدم القول عليه نعم فوم ان تاويله المنين وهو دو الورقه
الواحده :: **باطس** وأطوس بالبونانية هو العليق :: **باطرايدي**
تاويله عليق ايدى وايدى جانب اليه وهو الورد البرى يعرف بالورد البرى
الذكر ويسمى بالعجميّة طوبه لوبه قال د ومن الناس من يسمى لزاس
باطرايدى :: **باطوبيغى** فى الحشيشة المسماة قنطريون :: **بافيل**
هو القسط من الجاوى وفى موضع اخر منه بافا خطى اسود :: **بافج** هو
الستاليوس بالهنديّة من الجاوى :: **بالس** هو مشكطر امشير ه
باسبلوا وباسلوس قيل انه اللوبيا الابيض والصحيح انه اجنار المز
وهو السنبلة :: **باسليغون** هو الكاخواه :: **باسبلقنا**
هو الجوز :: **باسلسقان** هى مشلشكه وهى اجبلى بالاندلسيّة
بالانس هو باسيغى موجب البان بالبونانية :: **باكور** هو كل
ما اسرع ادراكه من النبات والاثمار :: **باليا** هو الغار بالاسكندرانى
بالبطرون هكذى دخل الرازى فى الجاوى هذا الاسم فى حرف الباء
وهو جز ت تصحيف والصواب البطرون بالتاء :: **بالبورص** هو
السبه وهو ضرب من الشوك :: **بالوسطيون** هو الجنار بالبونانية
بلينه قيل هو الشاهترج :: بنرمه هو الكمّاذريون بالعجميّة

بابُلْيُون هو نَبْتٌ الحِمَّاز عَلى ما زَعَم قوم من اصحاب الترا جم ؟
بابُوناق قيل انه الشجر المعروف بالبابُونج ويقال بابُونك ؟ بابُوس
قيل هو الشاهَنج وقيل هو لَبَنُ بَرِّيّ يُسَمَّى الحرَزلى ؟ باذامك قيل انه
الشجر المعروف عندنا بالشفقين وهو صنف من الخِلاف ومن القوم من يُسَمِّيه قَضْبانه
السَّلال الاطْبا ؟ باذاوَرْد صِنْفٌ من الشَّوْك قد تقدَّم القولُ
عَلَيه وَزَعَم بعضُهم انَّ تأويلَه بالفارسية الوَرد وكَذب في قوله واسمُ الورد
بالفارسية كُلْ وقيل انه القُرْطُم البَرِّي وهو خطأ وقيل انه المُسَمَّى فُسْطُوره بالطَّبَى
وقيل انه المُسَمَّى اشْنه البَّه أى شَوْكه بيضاء وقيل هو الطُّوب وهذا كلُّه خطأ
وهو شوك يشبه الطُّوب وليس به ؟ باذِنجَان اسمٌ فارسيٌّ ويسمَّى بالعربيَّة
الانبَ والمَغد والحَذْف والوَغد ؟ باذرَنْجُويه هو الترنْجان وقد يكون
بَقْلةٌ اخرى تسمى باذرَنْجُويه واسمها ايضاً كَرْوان ؟ باذرِنكاهُ
هو المازَده ؟ باذْرَه هو وَجَدّ الورس واحِدتُه نَبَاتاً ؟ باذرُوج
هو حَبَقٌ عَرِيض الورَقِ طَيِّبُ الرائحة يُوجَد في البَسَاتين ويُسَمِّيه بَعضُ النّاس
الحَبَق القرنفُليّ على الجنْبَتَه ؟ عَنْبَرَه ومن زَعَم انَّ الباذرُوج هو النَّبات
المعروف عند ناس بِطَرْطُور الحاجب فقد أخطأ ؟ باذرُوجِي هو
النَّبات المُسَمَّى قَلَطاريُون ؟ بازادعبا هو البَلَسْكا بالسُّرْيانية وقد تقدَّم
ذِكْرُها ؟ بازافُونا هو البَيُوع النَّواحلي ؟ بارَح هو البارحَل
بازِمَر ويقال بازْيُون وهو الابْهَل ؟ باريقليماني ويقال
باريقُولُومايَن بصرَمْيَه الجَدَرى ؟ بازْمَل هو القُسْطُ بالسُّرْيانية من
الحاوى ؟ باروجا هو السيرج ؟ بازْرَد هو اللفْتَه بالفارسية
بَازْفاسْبَر شجرةٌ فتَّاح يسمى بارَسَك من الحاوى ؟ بازْقُلومايَن
هى صرمَيه الجدى ؟ بازِى هى البَمَكة المحَدَّره وهى الاعاد ؟ بازشا
هو البَنج ؟ بازسْطاريُون هو وَعى الحَمام وأيضاً النَّبَات المسَمَّى

الإنسان بول الجمل يافع أن من الاستسقا وطلي بها الطحال وبول الإنسان طبوخ
مع الكرات ينفع من وجع الأرحام وإذا جلس فيه حمته أيام من كل يوم أحد
بول الكلب وتركه حتى ينعقد ثم عمل به الشعر سوده وكل ما يحل من الخضاب
وزعم بعضهم أن أنكر ان إذا اشرب بول جمل أفاق من ساعته وقال ابن سينا
أن رجلا مطحولا رأى في النوم انه امر يشرب بوله ثلث مرات كل يوم ففعل ذلك
يعني في حرب في غيره فوجد عجبا ٠ **بول الإبل** هي أراضي دنى بها
من اليمن وسلع بمكة بالموسم يعالج بها الجراحات الطرية بدها إذا انحنى منها
قرضة على رجل جرح طرى دمه لصق به ولم يسلع حتى يبرى وهو معروف عند هم
مشهور ونكرا أهل اليمن أن أبلهم ترعى في فصل من السنة حشيشا يكون هناك خاصة
في ذلك الوقت فيأخذون البان ها عند ذلك فيجففونها ويقرصونها وإنما يكون هذا
باليمن فقط ٠ **بنت وردان** هي الصراصر من الحاوي تجو فيها
إذا انحنى ترنب أو اجفف برنب وقطرته في الأذن تنكر وجعها ٠ عبرة بنات
وردان ينفع من وجع الأرحام والكلى إذا استعمل مع ترنب وموم وبيض بيض
وهي تؤبة الحليل ويدر الطمث وينقط الأجنة وينفع من النافض وسموم الهوام
والبواسير يرفع ترد ٠ ساسا

وهذا شرح ما وقع في هذا الباب من الأسماء

باباري هو الفلفل باليونانية ٠ باباقس يسمى باليونانية بهذا الإسم
شجر الجا وشير وأيضا الزوفرا وهي نوعان أحدهما كبير يسمى باباقس اسفليوتس
والأخر صغير يسمى باباقس خردنيون ويقال حرسوس وأيضا باباقس نوع من
الصغير ٠ بابفرا طبيون ومنوع من العسل ٠ بابلس يسمى
باسم لغار ٠ بابلس ويقال بالبص هو الولب وهو نوع من البقولات

وآلحكة فجلوها والبول العتيق فهو أشد جلاءً من البول الجديد للفروج الرطبة العارضة في الرأس والنخالة وهي الحزاز والقروح التي تنمى أوماً وهي الجدري وينفع القروح الخبيثة من أن تنمي في البدن واذا حقنت به القروح منع الفروج العارضة فيها من النمي ويقطع سيلان القيح من الآذان وإذا غتربه نثر الزمان وقطرت في الآذان اخرج الدود المتولد فيها وبول الصبي الذي لم يحتلم اذا اخرجته وأفق عمر البول الذي يحتاج معه إلى الأنصاب وإذا طبخ بإناء من نحاس جلا البياض العارض في العين من اندمال الفروج والقروح التي ينال لها رامد والتي ينال لها احليوس وينفع من الرمد وجلو ظلمة البصر وقد يعمل منه ومن النحاس القبرسي لزأن يلزق به الذهب بعضه ببعض وعكر البول الرأسب في اسفله اذا أمكنت به ما يطلع على الجمرة سكنها وإذا عجن مع دهن الحنا وعمل سكن وجع الأرجام وخفف الوجع العارض من الاحتاق وجلو الجفون في البياض العارض للعين من اندمال القروح وبول الثور اذا عجن بالمر وقطر في الأذن سكن وجعها وبول الخنزير البري له قوة بول الثور غير ان لخاصة اذا اشربت ان بقيت الحماء المتولدة بين المثانة ويبوبها وبول العنز اذا اشرب بشيء الطيب منه لأيام مقدار قوقيس يحط الحين الحمي وخرجه باسهال البطن وأدار البول وإذا قطر في الآذان ابرا من وجعها وبول الحيوان التي ينال لها المكر وبوله يبقي بعد ودون ينال انته اذا ابيل يحرى على المكان هذا باطل وأما هو الذي ينميه بعض الناس ينبى للفطرون بطارعون بوزون وإذا اشرب بالماء وأنقى رأس المعدة والبطن الذي يسيل الفضول الله

وبول العجار يقال انه ابرا من وجع الكلى غيره البول ينفع من التغشير اريب
والحكة والبرص ولاشيما مع بوروحاصى الأترج وينفع من الأوجاع العصبية وخصوصا بول الماعز ولاشيما للفشج والاستذاد سعوطا بول ابن شد يدا ينفع من الخشم ويفتح شد المصفى يقوي شد يده واذا انعقد البول في اناء يحجر ويخصوصا بول الصبيان نفع من البياض والجرب في العين وكذلك ان طبخ مع الكراث وبول

وما كان من الحيوان اشد حرارة نجران بوله اشد من حرارته واقوى منه وما
كان منه باردا دنا بوله اقل حدة وبول الانسان اضعف من ابوال الحيوان وما خلا
بول الخنزير الذي فدحي فانه في ضعفه مثل بول الانسان بسب ما راى الاطباء
من جلا البول على جوابه الفروح العميقه والجرب والوسخ والفروج الوسخه لكثرة
الرطوبه ويسعطون به الاذان ويغسلون به الراس ينفعه من الحشفه الرحبه
ويذهب بآجرار المتولد فيه وينفي النعفه ان كانت فيه واذا استعمل بالضروب
لعد مردوا غيره مثل العلوج والاكره شغفت به قروحهم بان يوخذ مثلا فه
تلف على الجرح والفروحه التي يحدث في اصبع القدم من غيره ويربط ربطا ينفا
ويومر المريض ان يبول على ما كل ليلة جاه البول ويقدم اليه لاجل الرباط حتى يبرا
بروا تاما فينفع بذلك فاما الدواء الذي يتخذ بول الصبيان الغلمان وهو المعروف
بلصاق الذهب ان الصاغه يستعملونه فيه فلحمون به الذهب وهوداء قوى
المنفعه جدا ان الفروج الخبثه البطية البرء واذا ارادوا صنعة هذا الدواء عمدوا
الى مهارس محدد من النحاس وكذلك دنجه فصيره في بعض المواضع وبول الصبيان
الذين لم يراهقوا ابا يبولوا فيه ويبقى بذلك النبج اياما كثيرة عند الشمس او في
بيت دي لهب اع من حرم النحاس بنجر ذلك البول حراره الشمس يكثر ويكون
البغ في المنفعه ولهذا الدواء هذه الفروج التي وصفنا منفعه عجيبه واما
النجابه التي تكون في جوف البول فاتها غليظه بعضا دفيل اتها نافعه من الجمرة واما
بول الاطفال وابوال الرجال فقد شربها قوم ممن كان بهم مرض من فؤاد الهواء
وتغيره وهواء ولما فظنوا انهم يجوا من ذلك الامراض عند شربهم هذه الابوال
واما ابوال الدواب فانها تخلط بالادويه التي تتخذ لوجع المفاصل ينفع من ذلك
هب بول الانسان اذا شربه صاحبه دافنوا بشه الافعى والادويه القتاله
وابدا الخبز اذا اصب على بشه الافعى فعزب البج وتبن البج ينفع منها والبول
ممن كان من الناس قد تخلط بطرون ويصب على عضه الكلب الكلب والجرب

نفع من النذر لذة واذا اخلط بدهن ورد و الشراب المثلى او مالى و بإذنه الصوف
و وضع على العين سكّن الاورام الحادثة للعين و اذا احتقى البيض نفع
من نهشة الافعى التى يقال لها الولتن و اذا امترخى و افوه جزه فيه المثانه
و نزوح الكلى و خشونه الصدد و نفث الدم و النزله و الصدا اذا سيل اليه

غيره قشر البيض نفع من الحكة و الجرب و الباس الحادث فى العين اذا احرق
و سحق و اكتحل به و اذا احتقى و نفخ فيه الاذن قطع الرعاف و اذا ذر على الجرح
قطع الدم و اصلى بعض الدجاج بيض الطير الذى يجرى مجراه كالدرج و الدراج البيض
و الفنج و الطهوج و اتابيض البط و جوه ردى الخلط و ايس البيض بيض النعام و الاوز
و صفرة البيض اذا شويت و جففت كانت طلا للكلف و السواد و تلبن العصب
و ينفع من أوجاع المفاصل و من الاكل و ومن وجع البيض يديج الباه لاسيما بيض
العصافير و هو مكثير الغذا و خاصة بيض الحمام و هوى سريعا و بيض الحجاز يقال
انه خضاب جيد للشعر و يحرب وقت صلاحه لذلك خيط صوف بفتلفيه
و يترك حتى ينظرفيه هل ينود و يقال ان بيض الاوز اذا اخلط بزيت و قطر فاتر
فى الرحم ادرا الطمث بحذار بعة ايام و بيض السلحفاه البرتيه يقال نفع جدا
لسعال الصبيان و ينفع ايضا من الصرع و بيض الحجا يقال انه سم قاتل
ه
بصاق خى بصاق المتلى من الطعام ضعيف و بصاق الجايع
قوى جدا و هو يبرى قوبا الاطفال بان يدلك به كل يوم و اذا صعفت الحنطه
على الصومر و وضعت على الاورام اى انضحجتها و طلتها و خاصه فى الابدان الرخصه
فقد يستعمل فيها وجل او مع الخبز فيكون اسرع لنضجه و تحليله و هو نافع من
الدم الذى ينصب الى العين و يحلل اثار الكمدة من الوجه و ساير الابدان
و البصاق و كله عامة ضد كوانا من ايا ئله للاكل بلحمها و نهشاعامه و هو
يقتل العقرب بول خى قوة البول جادة جانة و فيه جلاء كثير
و لذلك يستعمله العصا رزون و يعملون به الثياب الللدنة و يقلعون به اوساخها

وضعت الصفرة مع الباضِ وذلك لأنها تبرد تبريدا معتدلا وتجفف تجفيفا
لا لذع معه فلما كانت البيضة على هذا من الحال صرنا نستعملها في الأضمدة التي توضع
على الجبهة المعروفة بالبزوق ولتذر وأثبنا بها الشعر الذي ينبت مع الأشفار
وتدخل إلى العين بعد أن يخلط معها شيء يصلحها بمنزلة الكندر ولا سيما
إذا كان الكندر مما لبس بعتيق ولا يابس الا أن الذي ينتفع به في هذه المواضع
من البيضة إنما هو لون وجه بياضها فقط اللهم إلا أن نقول إن المزاج ها هنا من قبل
أنه لبن بعضه لاعناف للدواء الذي تداويه هذه العلة أخرى أيضا نفعها
ولأن كثيرا من الأشياء اللزجة التي بها مضادة مخالفة لهذه العلة بمنزلة
اللبن الذي هو موجود جدا ومن قبل أنها إذا شويت أو طحنت كنها خلطا
للبن بالبس صارت من هذه الوجوه كثيرة المنافع وذلك لأنها لا تخلط مع
الأدوية التي تجفف لطوخ بعد ما تسلق وتشوى أو تقلى أو تخلط مع الأدوية
التي يقطع ما بين الصدر وبين الرية وهي تنمبرنث أي ن حد ما تنخي وهي التي تطبخ
بالماء حتى تنضج نضجا وبها المنا ولها بسبب طعمها وجوهرها
يسكون خشونة بين حجرته أصابته بسبب صلاح صاحبة أو من خلط حاد انصب
إلى حجرته وقصبة رئته لأن البيضة تلطخ ذلك المواضع العليلة وتنقي ألا فيها
بمنزلة الضماد وسميا على هذا الطريق تثنى الخشونة بين المري وبين المعدة
وبين الأمعاء وبين المثانة تـدر اليمبرنث وصفرة البيض المسلوق إذا خلطت
بزعفران ودهن ورد كان تأفعل من الضر يأن العارض للعين وإذا خلط بها
إكليل الملك نفعت من الأورام المتعقدة والأورام البواسير وإذا اثبتت بالاثمام
أو العفص عقلت البطن وإذا الكنت بيضا وجدها فعلت ذلك وباطن البيض
التي إذا قطرت في الأذن الوارمة وزماجا أبرده وعدى شكن الوجع وإذا
لطخ بحرق البادئة أولها يعرض لم يدعه أن ينفط وإذا لطخ به الوجه نفع
من الاحتراق العارض من الشمس وإذا خلط بالكندر ولطخ على الوجه والجبهة

فهى تبرد نشرىدا معدلا وتجفف تجفيفا لا يلذع ويجب ان يستعمل منها الاطربة لان العنبه قد نالها آفه فاما بياض البيض فينبغى ان يستعمل فى جميع الاوجاع التى تحتاج الى دواء لا يلذع اصلا بمنزلة وجع العين والجراحات التى فى المعده والعانه وفى جميع الجروح الحبينه الرديه وخلط الادويه التى تقطع الدم المحترق من اغشيه الدماغ يكون من وقعها منها موقعا حسنا نافعا وهذه الادويه يلح و يقبض من غير ان يلذع كالموميا المغسوله وجح البيض فى منحوم شبه جوهر لعارضها ولذلك صار خلط مع العين وطى على التى لا تلذع معها بعد ان ينلى البيضه و يشوا والامرين ان بينهما بينا اخلا فاىسىرا امرين و ذلك ان الذى يىوى هو يحفف فضلا قليلا و بحسب ما يكسب من هذه الفوه قلك لذلك يخرج عنداعندا له وهو الذى يخلط ايضا فى الاضمده التى تحذ من اكليل الملك النافحه لغير المعده واماجمله البيضه فانه يستعملها بعد ان يخلط معها دهن ورد فى مداواة الورم الحادث فى اليدين وفى الاجفان وفى الاذنين اذا كان قد اصاب واحدة منها ضرر به او نوزم بوجه من الوجوه ويستعملها ايضا فى مداواة الاعضاء العصبيه بمنزلة المرفق والوزات التى فى الاصابع ومفاصل اليدين والرجلين فاذا طبحنا البيضه كما هى باجلَّ و اكلت نفعت من المواذ التى تسلو تصب الى الامعاء وان انت ايضا خلطت معها من الادويه التى ينفع ان اطلاق البطن ووجع البطن ثم شويتها وطبختها على نار لا دخان لها بمنزلة نار الفحم والطعمتها للعليل نفعه بذلك منفعه لبست بالبسيره وانفع ما خلط معها فى هذه المواضع عصاره الجسم وانمار نفسه وعصارته والعفصر ايضا وقشورالرمان وزماد الحؤت المحترق معجنه وكذلك عجم العىب وجلانرق وى من هذه الحار وهوشطىان وجنذ الرمان وان انت وضعت على الحرق الماء الحاز بيضه نفعه جدا وان انت اخذت بياضها وحدا فوضعته عليه بصوفه نفعته جدا وان انت

خط يسمى هذا الحجر اسبيوس وليس هو صلبا كالصخر لأنه يشبه في لونه وقوامه إجازه
المتولدة في قدور الحمامات وهو رخو نبت بسهوله ويكون عليه
شيء شبيه بغبار الرجل الذي يرتفع ويلصق بالحيطان إذا أخل الدوم وهذا الدواء
يسمى زهر الحجر المجلوب من اسيوس وهو الصخره التي منها يتولد هذه الزهره شبهه
بنوه الزهره الآن فعل الصخره أقل من فعل الزهره وذلك أن فعل الزهره يفوق فعل
الصخره لأن في هذه الحله فقط فإنها أكثر أدله وتحليلا وتجفيفا منها الكن في أنها
تفعل هذه الأشياء أيضا من غير تلذيع شديد وفيها مع هذا شيء ماج الطعم
أعني في هذه الزهره وفي ذلك ما ندل باجدس ران يتولد هذه الزهره إنما هو
من الطل الذي يقع على تلك الصخره من البحر ثم يجففه الشمس د وقوة هذا الحجر
وزهرته معينه تعفينا سيرا احلله للخراجات إذا خلط بكل واحد منهما
صمغ البطم والزفت وينبغي ان يعلم ان الزهره اقوى من الحجر وبفضل على الحجر
بانه اذا كان نابتا ابرى ان يروح العنه عنه الابدال وقلع اللحم الزائد
في الفروج الخبيثه وقد يملا اثر روح العميقه لحما وشفها اذا خلط بالعسل
واذا خلط بقير وطلى منع الفروج الخبيثه من الانتشار في البدن واذا خلط
بدقيق الباقلي وضمد به النفرش نفعه منه وقد ينفع من ورم الطحال اذا خلط
بالكتان والخل واذا لعق بالعسل نفع من الفرجه العارضه في الريه وقد يتخذ
جزو ان من هذا الحجر يبضع فيه المنفرسون أو لحم فينتفعون به انتفاعا كليا
ويتحذ منه أيضا اسرع باكل اللحم واذا در الزهره بحمام على الابدار الكبيره
اللحم السمينه مكان النطرون أضمرها واذا أرادا أجد ان يعتل هذا الحجر وزهر
فيعملها مثل ما يعمل الأقليميا ابن رضوان يقوي البصر وجلو ويقطع البياض
من العين ولعمر احنا بيض ح الذي قد فناه من البيض ونهل علينا
وجوده اكثر هو بيض الدجاج فلستا نحتاج معه المغيره على ان طبع هذا
البيض وذلك طبع واحد ومزاج البيضه ابرد قليلا من البدن المعتدل و الوسط

موضع لدغ العقرب والهوام والطبازات ذوات السموم نفع منها نفعا بينا
وان سحق ونثر على موضع لسع الهوام حين يلسع جذب السم بالنجح وان عفن الموضع
قبل ان يتدارك بالدواء ثم نثر عليه منه هذا الحجر وهو يجوز ابرأه وان
جعل الحجر على حمة العقرب بطل لسعها وان سحق منه شعيرا وذيف بالماء
وصب في أفواه الأفاعي والحيات ماتت ث ابن جلجل هو حجر إلى الصفرة
فيه خطوط بيض واخبرني ابن الصقلي انه رآه في جبال فرطبة باطنه وهو بالشرق
مشهور عند الملوك كحلة ث الرازي حجر اصفر رخو لاطعم له ذائب منه
مقاومة عجيبة في دفع ضرر البيض وكل الحجر الذي يضربه إلى الصفرة والبياض
في لون الخمرة كأن مع ذلك نشطا كظاهر الشب اليماني ث عطارد بن محمد
حجر بابلي زهري وضع فيه الآلة التي يعرق بها لمنة الماء وهو نافع من لهب الحمى
الشديدة والرمد إذا امتصح عرقه ث عنبرة الوأنة كبيره فمنه الأغبر
والأصفر والمشرب بني من الخضرة والمشرب بياضا من المكن واجوده الاصفر
الصافي لاغبر ث برادي وهو الجادي ايضا الاحجار معادنه بلاد
المشرق وإذا اخرج من معدنه كان مظلما لا يرى له شعاع وإذا قطعه اصابع
خرج جنسه وانار وصار له بريق ومن تحتم به ووزن عشرين حبة من شعيرة
لم يرى في منامه احلاما رديئة مفزعة وهذه خصوصيته ومن استقبل شعاع
الشمس وادمن النظر في هذا الحجر نقص نور عينه واجود ما يكون منه ما
اشتدت حمرته وكثر بريقه وإذا سحق شعرا لعظم الراس من الارض الصفا
والنين الصغار ث بارود وهو حجر ابيض وتسميه اهل مصر ثلج الصين
د ه وهو بعض الحجارة ينبغي ان يختار منه ما كان لونه شبيها بلون القيشور لينوشراسيوس
وكان رخوا خفيفا سريع التفتت وفيه عروق وغايرة صفرا اما زهر هذا الحجر
فهو ملح ينكون عليه دقيق ومنه ما لونه ابيض ومنه ما لونه شبيه بلون
القيشور وما يليه الصفرة وإذا قرب منه اللسان لذعه لذعا يسيرا

من الذرايح التي ينال لها نو قرطس واذا شرب مع الاحمال نفع من عضة ذوهر وقد
نعمل منه ضمادا ينفع الهزال وتخلط بفرطى وقد يضمد به للفالج الذى
يعرض فيه ميل الى قبة يحلف فى اعطاط العلة والتوآء العصب وقد خلط
بالعجين وخبز لمن عرض له استرخاء فى المثانة ومن الناس من جرنه
مثل ماجرو غبره من الادوية بان يصبره فى آناء من خرار ويصعه على جمر
ويتركه الى ان يحى تم يرفعه من على النار **غبره** يرذ الشعر اذا انثر عليه
وحس اللون الجزيبه الددو وينفع من الجرا فى الراس وقد يشرب مع بعض
الادوية الغنا له للدود فى الجوف ويعين فى قتلها واخراجها وقد يمسح به
السره وجلس الفرب من النار فيقتلها :: **بصاق القمر**

وقد يسمى ايضا زعوة القمر وزبد القمر **دة** انما سمى هذا الاسم لانه يوجد
بالليل فى زيادة القمر وهو حجر لطيف شفاف خفيف ويكون ببلاد العرب ليونرسالنيطس
وتدبك هذا الحجر ويغنى محكه الذى ينطل منه لمن به صرع وقد يلبسه ابيض
النساء مكان المعوبذ وقد ينال ايضا انه اذا اعلق على الشجر ولد فيها الثمر
حط قد وثق الناس به انه ينفع من الصرع واما انى لم يمتحنه ولم اجربه ::
بادزهر :: معناه بالفازسيه مقاوم السم وهو معروف والبازهر
كتاب الاحجار الباذهر ينفع من السموم الحارة والبارده اذا شرب واذا
علق ومعادنه ببلاد الصين وبلاد الهند والمشرق وله فى شبهه احجار كثيره
ليست لها خصوصيه ولا تشابه فى شى فعله من ذلك الفروى والمرمر وحجر مس
الخطاطيف شيا وقد نعالط به كثيرا ومن تبين المحنه لينا غبر
مفرط ذتبى المذاهب فى غاية النفع من السموم الحيوانيه والنبانيه ومن
عض الهوام ولذعها ونهشها اذا اشرب منه مسحوقا منخولا وزن اثنى عشر
شعيره خلص من الموت واخرج السم بالعرق والتى وان يلد منه انسان شيا
او ختم به ثم وضع ذلك الخاتم فى فم شارب السم ومصه نفعه وان وضع على

وهذه القوّة التي هي للبورق بينها الا ان جوهرها الطف وارق وقوة البورق
ونط بين قوة البورق الافريقي وبين قوة الملح وذلك ان البورق الافريقي انما فيه
قوّة تجلوا فقط والملح فيه قوّة تقبض واما البورق ففيه قوّة ان جميعا الا ان القوّة
القابضة فيه ليّنة جدا وقوّته الجلافيّة كثيرة والبورق اذا اجزى صابّا
قريبا من البورق الافريقي وذلك لانه بلطف فهو بهذا السبب يجفّف ويحلل
وازلق زد البدن منه شيّ نطع ولطف الاخلاط الغلظة اللزجة اكثر مما يفعل
الملح جدا واما البورق الافريقي فانّا لم نضطرنا اليه امر شديد فليس يعطاه الانسان فمى
بردّه لانه يغثّى ويهيج الغثى ولو ذلك لكن يقطعه الاخلاط الغلظه اكثر
من يقطيع البورق وقد كان ان انسان يستعمل هذا البورق الافريقي مداواه وامّن
اكل فطرا اختنف فكان يستفى به في كل وقت واما البورق المحرّق ق
ولا سيما زاد فيخنّ قد نستعمله ايضا مداواه هذا الاختناق ح قوّه النطرون
وقوّه الدواء الذي ينال له افروطرون ويشبهان بقوّه الملح الا ان كل النطرون
يفضل عليه بانه يسكن المغص اذا انخى مع الكمّون شرب مع ادروماليّ والشراب
الذي ينال له اسمانا او بعض الادويه التي لا ياج مثل طبيخ الزوفا وما
اشبه ذلك مثل السذاب والشبت وقد تخلط بعض الادهان يشيج به لبعض
الحمّات الاخذه بادوات وقت اخذها ويكون بالقرب من نار و قد يقع
اخلاط بعض المراهم المجلّله والمراهم الجاذبه والمراهم المتّخذه للجرب المنفتح
والحكّة والبرص واذا خلط بالماء او الخمر وقطر في الاذن ابراها من
اوجاعها وسدّ الريح العارضه فيها ومن الدواء والرطوبه السائله منها وان
خلط بالخل وقطر فيها نفا وخّتها واذا خلط بلحم الكرام مع خل ولحم الخنزير
ابرى من عضّه الكلب واذا اخلط بصمغ البطم فتح افواه الدمامبل وقد يضمد به
مع التين نفع من الاستسقا واذا اكحل به مع العسل احدّ البصر واذا شرب بالخل
مع الماء نفع من مضرّه الفطر القتّال واذا اشرب مع الماء نفع من مضرّه الشراب

والمصري هو هذا البورق الذي يجلب الينا وبكثر عندنا وهو صنفان صنف
يسمى النطرون وهو ملح حجري يضرب الى الحمرة وطعمه الى الملوحة مع مرارة يسيرة
تدل على شدة احتمار قده وضرب بورق الخبز لان الحبارين يصيرونه حلوه بالماء ويغسلون
ظاهر الحنطة قبل طحنه فيكسبها بزيغا ورونقا والبورق المصنوع هو هذا الذي ينبخ
عندنا النطرون وهو ملح حجري قطاع جلا يتولد من مادة الزجاج و طوبه
الرصاص والقلى واذا اخلط الزجاحون بعضه ببعض ادخلوا الى زد وهو يسبح
ايضا ما الزجاج ۞ **الرازي** اصناف البورق بورق الصاغة وهو الابيض السجى
ومنه البورق الزبدي وهو اجودها كلها ولون ترابى اعفر منه بورق العرب و هو
يكون في شجر العرب ۞ فينبغى ان يخاذ منه ما كان خفيفا مجوفا لونه موزد
مثل لون الوزد او ابيض اللون مثقب كانه اسفنجة والذي يجلب من فروم ومن
بلاد فور ربما هو على هذه الصفه فاما الدوا الذي يقال له افرن ونطرن ومعنى
اسمه زبد النطرون هو الذي زعم الناس انه البورق الارمنى فاجوده ما يكون
خفيفا جدا اسفاج سريع التفتت فى لونه مثل لون الفرفيرى يشبها بالبلد
اذا اعام ثل الذي يوتى به من المدينة التى يقال لها بلادلسا وبعد هذا الصنف
فى الجودة المصرى وقد يكون ايضا بالموضع الذي يقال له مغسام البلاد التي
يقال لها فاوريا ۞ بين البورق الابيض الارمنى المعروف بالبورق الزبدى
ومن زبد البورق الزبدى او مجفف ومنظره شبيه بمنظر دقيق الحنطة وذلك
انه ابيض ولينه هو مثل هزة الحجر المجلوب من اسون زمادى اللون واما البورق
الزبدى فلين مثل الدبى نحلا لج جامد مجمع وهو الذي يستعمله الناس بكل
يوم ولغسلوا به ابدانهم في الحمام لانه قوة تجلو فمو هذه الفوة لين يغسل الوسخ
فقط بل يشفى ايضا الحكه وذلك لانه محلل للك الرطوبات الرطبة التى يحدث
عنها تلك الحكه واذا كان الامر على ما وصف فقد اصاب اطبا القاهم
فى اخلاط الادويه المحلله واما زبد البورق فطبيعنه وقوته هذه الطبيعه

وقد يوجد كثيراً في الجبل الذي يقال له باجولس الذي عند المدينة التي يقال
لها اسورافوسا. واجوده ما نه الاحمر الشبيه بالجوهر الذي يقال له استربيس وفيها
زعم الناس الاسج او المشبع اللون من الجوهر الذي يقال له صفيدس وفيهما بن عمر
بعض الناس الزنجفر يرتفع الانفراد جمع اجزائه مساوى الاجزاء اجنه شبيهه
بذلك الطل البحري كثيرة الاغصان شبيهه في كله شجرة السليخة واما ما كان من
شجر يا رخوا رديا وقوة ها من الانوار فابضه ابرد باعتدال وقد تقلع الحم
الزايد وتحلوا انا ينز وج العارض بد العبر وقد ملا الفروج العميقة لحماً
وينفع نفعا بينا من نفث الدم ووافق من ربعه عسر البول واذا اشرب بالماء احلل
ورم الطحال. ومنه صنف اخر اسود اللون شبيه به بالشجرة وهو اكثر
اغصاناً من الاول ورائحته اشد من رائحة وقوته مثل قوته يقطع نفث الدم من
جشا خصوصاً اذا اجزو ويشرب منه مقدار ثلثة دوانيق مع وزن دانق
ونصف صمغا عربيا معجون ببياض البيض وردا اجزائه ان يكون ان يوضع في
كوز فخار جديد ويطين ويوضع في تنور يخبز الصباح وهو يجلو البصر
ويقطع الدمعه ويجفف الجراحات والفروج تجفيفا شديدا وينفع من فروج
الامعاء والحقنان ويفرح القلب ويقويه ويقال انه انجى وقطر به في
الاذن منها فابد من بلسان نفع من الطرش: **ابن اسحق** **بورق**

البورق الارمني يؤتى
من ارمينية وسنه ص
يقال له ٥

البورق صنوف كثيرة فمنه صنف يقال له النطرون ويؤتى بهم الواحات وهو
ضرب ان احمر وابيض وشبيه بالملح المعدني ومذاقته بين الحموضة والملوحة :
ابن وافد انواع البورق كثيرة ومعادنه كثيرة كمعادن الملح فيه ما
يكون خزازا ثم ينجمد ومنه ما يكون في معدنه حجرا ومنه ما يكون احمر ومنه
ما يكون ابيض واغبر والوانا كثيرة والنطرون وان كان من جنس البورق
فان له افاعيل غير افاعيل البورق **غبره** البورق صنفان مخلوق ومصنوع
فالمخلوق هو المعدني وهو صنفان ارمني ومصري والارمني اجوده ولسره عند بـ

بومنا انه الجزوث وزرقه بنودا الثعبان **بيش** قيل انه المسمى بالعجمية بماله وبالبربرية طشفون وقال بعضهم انه ينبت ببلاد الصين بلاد نيبال لها هلاها قرب بلاد

بيش

وهو نبات يعلو نحو الذراع وعلية وزرف كزرف الهندبا باكها اهل بلد هلاهل غضا ويابسا فاذا بعد عن السند ما به ذراع قتالا اكله وهو يقتل جميع الحيوان الا الفانر والسانفى **ابن سينا**

البيش حادث الغاية من الحرارة واليبوسة يذهب البرص طلاء وكذلك اذا

شرب معجونه الذي ينبغ نبه وكذلك ينفع من الجذام والشربة منه مقدار نصف درهم واقلها منها يغسل وتزاد فانه فان البيش وهى تغذى به والسماني ايضا عذدك به وذوا المنك ايضا بتاومه ٥ **المسعودى** اصناف البيش ثلثة اولها يسمى ديشيني ازل من البيش والثانى القرون وينبت هو والبرهموا بين يفسح على المكان والقرون يوحد ني سنبل الطيب عوده دفيق كفدر نصف اصبع علمه فنط ببض غاز كانها نجبون الطلق اوالكا فور نصاصه ٥ والثالث ليعبه يصاب فى سنبل الطيب ايضا طوله عقد اصبع كانه اصل النبات الفارسى عفد معقد وهو خبث ويسفى منه كل ليسعة العقرب قدر رسسمة

بسد هو العرزان وهو المرجان ٥٥ هو ميعقد من الحجر وهو النجرى الجحرى ويقال انه نبات بحرى ينبت فى جوف البحر وانه اذا اخرج من البحر ولفيه الهوا اشتد وتصلب

واصلاً وشعباً كثيرة دقاق الوانها إلى البياض ما هي منه الراعية تنبت بين
الزرع وهي تقلع الثواليل إذا انضمد بها ٠ بــربلنه ويقال مرانة وتسمى
بالبربرية ايموث ومن الناس من يسميها الجوز وقال إنه العظيم هو نبات
له ورق طوال مشرف صغير
فيه خشونة شديد الخضرة
يضرب إلى السواد والغبرة
وله قضبان مربعة دقاق
تعلو نحو الذراع من أطرافها
زهر رقيق يشبه زهر الكزبرة
على طول النضار وبينه
صنف آخر شبيه بهذا إلا
أنه أكبر ورقاً وأقوى وأعطر
نفساً يفرش على الأرض بساطه
وهو مائل إلى الغبرة

ولا الصنفين إذا دق اجمعها وشرب ماوها فنا بلغم الرجاء وكان من اجود
الأدوية للبلغمه لذلك وهو ينوم وكحل من النعج ينفع من الغشي وقد يشرب طبيخه
لتسكين حزان الدم وعصارته تطلى على الخنازير تحلها ٠ بسّــام ٠

أبو حنيفه شجر ذو ناق
وأصل شعبه تعني كن غير
بسيطة ودرق صغار
أكبر من الصعتر ولا ثمر
لها وله لبن أبيض وهو شجر
طيب الرائحة والطعم تتأكل

بسام

برسنه نوعان

بلخيه

أغصانها بعضها بعض وتنتشر
دائرة في الارض ولها نورة
بيضاء فيها حمرة واذا تعرعر
بها هذا النبات نقط العاني

بشمه

دقيق له أغصان كبار وثان
يخرج من أصل واحد يفترش
على الأصل وهي مبانيه طولها
طول اصبع معقدة شانبات
الثمرة وخضرتها مثل لبا
الصفرة والبياض وله ورق
دقيق مدور كأن عليه زغبا
دقيقا وعليه دعيه كبير
كأنا عشرين عقدا وله زهر
دقيق جدا ابيض خلفه بزر
شبيه جدا الكزبرة دقيق
في غلف صغار ونعم مذاق
هذا النبات مذان وقبض يتبزه وشرب طبيخه اذا ذهب اللبخ والزلج وفيج
الندود و عسر البول ينفع من حبس الطحال

بده

مغشيه
لها ورق كورق الكزبرة
مشققة واغصان كثيرة
خارجة من اصل واحد
مابلة الى الحمرة قليلة

أدثمان وينبت في مواضع العمان وعلى الإسطحه الجلیدة النطبین واذا اشرب هذا النبات بشراب قابض قطع الاسهال ونزف الدم ویقطع كثرة البول زعم قوم انه اذا شد فی صوف مصبوغ بحمرة فانه وعلق علی الانسان الذی به نزف الدم من ای عضو كان قطع نزف الدم

بلوط الارض ابن عمران عروق شبه البلوط یكون تحت الارض مثل البلوطه طالع علاوه الارض وزن عرق نبت اخضر شبیه بورق السرس الصغیر وینبت فی الاكثر ما یكون نبت عروق السناء وطعمه مر بحلاوة مر طعم البلوط وفیه حران وهو یقطع النضول وینظم الطمای من ظاهر ویفتح سدد الاعضاء الباطنه ویدر الطمث والبول

بلخیه هی عشبه تنبت وتنبسط علی الارض ولا یعلو شیا اغصانها دقاق وزرها غبر دقاق لاشبه للعضل كانها دود یضل

بلوط الارض

ابو وائد

برنج هو صغير الحب على رجبة الماش مزرقط ببياض وسواد عديم الرائحة
يؤتي به من الصين وهو مار ازبابن في الثالثة سهل البطن ويغص فضول البلغم من
الامعاء ويسهل الديدان وحب القرع بقوة الشربة منه درهمان

بوزد كابلي ابن سينا هو حب هندي وهو نوعان صغار غير مشققة
وكبار مشققة وافضلها الصغار ينفع البلغم من المفاصل ويسهل البلغم والديدان
وحب القرع وهو جيد جدا اظنه البرنج المذكور قبل هذا

شجرة

باجروجي النعامة هي ترتفع مقدار ملئة اذرع ونبت في الاراضي اليابسة
الصلبة وورقها كورق الكاكنج وتورد ورد احمر خفيف الحمرة اذا اسقط عقد

باجروجي

جافي قد يحمر واصغر اسود
لبن وثمرها اذا دق وغلي
بالزيت وتحن قلع الداء الناري
وضمد به لسع العقارب
ينفع منه واذا دق ثمرها
نفع مع ورقها مع الخل وضمد
به السلع والثواليل برات
وادهم ذلك عليها ملعها واذا
استنشق ورق أنف اليد وشرب
نفع نفث الدم من الصدر ولا
ينبغي ان يشرب منه احد
فقط لا زيادة عليها هذه الشجرة تقبض ببرد وتلين الصدر ويغني ثمرها وتبقى وبذر
بقبضة الربو ولا ينبغي ان يؤكل وليس من اذا ويذا القي فيستعمل لذلك

بهمن دد هو نبات له ورق شبيه بورق الشعير الا انها اقصر منه واذا
له كنبل السلم وقضبان طولها نحو ستة اصابع نابتة حول الاصل وسبع نبتات

اوقان

منه و قد يعطى منه مطبوخا مع بعض الطيور والسمك والسلق والملوخيا واذا
جفف ونحن ووذر على الشراب المسمى ليقراطن اسهل مرة وبلغما واذا انضمد به
كان نافعا لالتواء العصب والشقاق العارض فيما بين الاصابع ∴ **ابن ماسويه**
خاصته اسهال المرة السوداء والبلغم من غير ان يلذع او يمغص او يؤذي والمختار منه ما
اصفر وقرب في طعمه من العفوصه والحلاوه البسيره وكان غلظه كغلظ الخنصر
من احد فليطبخ بما والشعبر وما السلو المطبوخ ثم يشربه فان اردت خلطه
بافاويه لينجح الى الاصلاح اكثر من ده والشربه مطبوخا او منقعا ما بين درهم
الى خمسه دراهم ∴ **حبيش** خاصته اسهال المرة السوداء في رفق اذا شرب
مفردا مع السكر وخلط بعض المطبوخات والمعجونات ومقدار الشربه منه
مفردا درهمين ∴ **ابن سرابيون** يسهل الخلط اللزج المحاطي من المعده والمفاصل
ويحبس الغثيان ويجب ان يسحق من اصله مقدار مثقالين ويشرب مع ما العسل
اوما الشعير المجوى حار يابس في الدرجه الاولى معتدل في الرطوبه واليبس يسهل المره
السوداء ينقي ويجلو ويدفق وجيده ما كان حديثا غليظ العود ظاهر الحمره قليلا
اخضر المكسر والشربه
منه مفردا من مثله
درهما او اربعه مدقوقا
ناعما مع السكر غيره
ان سقى منه كل يوم
درهمان ونصف مع
مقدار سكر جبه ما
خياشنبر سبعه ايام
منه البابه نفع من
المالنخوليا والجذام ش

بولوبوذيون
وهو البسباج

شبهه بزراجة الشراب ونبت في مواضع صخرية خ خ اصل هذا النبات وثمرته
وورقه فوتها قوة تحلل وتجذب وطعم هذا الطعم حريف فورقه تجلل الخراجات
والثواليل المنكوسه وثمرته
اقوى من ورقه ويمكنه ان
يفعل هذه الافعال اذا هو
خلط مع الاضمده المحلله
بمنزلة الضماد المتخذ من ورق ليبوذيوم
الشعير وشانه ان يجذب
السلا وكل ما سله يسل لا
ويخرجه الى ظاهر الجلد واما
واما اصله فيفعل تلك
الخصال الاخرى التي ذكرنا ها
بتميز ولكنه يخرج مرة صفرا

بالاسهال واذا اشرب من ثمره مقدار زنحمي احدث احلاما كثيرة فيها تخليط
وتشويش واذا انضمد به مع سويق الشعير جلبت الاورام البلغميه واخرجت الارجه
السلامن اللحم وقلعت الثواليل واذا انضمد بالورق حلل الخراجات والجفون
واصله ينهل البطن وينبغي ان يعطى منه دخمان والشراب الذي يغال له ما لم يغرطن

بسفاج د د وهو نبات ينبت في الصخور التي عليها خضر وفي
سوق الشجر البلوط العتيقه على الاشنه طولها نحو من شبر وشبه النبات
المسمى بطاريس وله اصل عليه شي من زعب وله شعب وهو شبيه بالجوار والزعب على
مشرف ولين ليس ثمه بذي قضي مشاركة من المسمى بطاريس المنمى للحيوان الذي شبهه هو المسمى ازبعه
وازبعين وعلظه شلع لظه الخضر واذا كسر ما داخله ظهر لون ما داخله اخضر وطعمه عفص
ما يميل الى الحلاوه خ خ قوته قوة تجفف بليغا من عير ان تلذع وقوة هذا الاصل

ودجع الطحال وعسر البول وقد نبتت الحجارة ويعقل البطن واذا اشرب بالشراب
نفع من نهش الهوام ومن سيلان الفضول الى المعده وقد مدر البول ويقطع سيلان
الدم وقد ضمد بهذا النبات النزوح الخبيثه المفرطه الرداه وقد نبت الشعر
بداء الثعلب ويبرى الاوارم التي يقال لها الخنازير واذا اخلط بالاذن ودهن
الآس او دهن التوت والزوفا والشرا بمثل الشعر المنتاقط وطبخه اذا اخلط
بالشراب وما الرماد وغسل به الراس واذا فعل ذلك واذا اخلط بعلف الدبوك والجانات
واعلفته فواها على المراس وقد نسب في خطاير الغنم لمنفعتها به رد السم النازى
وغير ان قوته تذهب سريعا ابن ماسويه اذا اشرب منه من ثمه دراهم
الى سبعه اسهل المره الصفرا عن المعده الزهراوى قيل انه اذا دق وهو
اخضر وحمل على الجبهه الاخرى حتى خرج بولوعالن دد نبات له
ساق طولها نحو من شبر ووزق
شبيه بورق العدتر وب
طعمه مقبوضه وقد بطر ان
هذا النبات اذا اشرب
اللبن ح ج هذا نبات له
ورق قابض معبد وقد نظر
به الناس انه اذا اشرب
ولد اللبن واذا اكل لذلك
فالغالب عليه الحرار والرطو
بوينوقومن د د
هو نبات له ورق شبيه بالجرجير خشن حزيف وهو اغلط من
الجرجير وله ساق مربعه وزهره شبيه بزهر الباذرى وثمره شبيهه ببزر
الكرات واصل اسود وفيه صفره مستديره مثل تفاحه صغيره ذا لحنه

يستعمل الشراب الذي يقال له القراطن وانا سطوبون وقد يتخذ طولة نحو
من ثلثة اشبار وينبت في الخزرة التي يقال لها قرنطي وله ورق شبيه بورق
البان الذي يقال له بوبون ح د وكذلك بسوط وسوك لبوبون ح د واذا
شرب منه نحو اربع طاقات بالماء ابرا المغص وقطع البول ودفع الجنب واذا
خلط به ملح وشراب وضمد به فاتر احلل الخنازير ح د واما الشراب المتخذ
بالدواء الذي يقال له بوبون من هذه صفته يوخذ من الدواء مثقال دق ذلك
ويجعل في اربع قوطوات من عصير وترك فيه ثلثة اشهر ثم يروق وهذا الشراب
ينفع المعده ومن به اعيا ومن جذاب او وثب الخل

برشاوشان

هي شعر الجبار وكذرتن البير ح د هو نبات له وورق شبيه بورق الكذبره
مشقق الاطراف واعضان
سود صلبه دقاق طولها نحو
من شبر وليس لها ساق ولا
زهر ولا ثمر وله اصل لا
ينفع به وينبت في اماكن
ظليله وحيطان المغاير
النديه وعند المياه المجتمعه
من بلاد العيون ح د
هذا الدواء يجفف ويلطف
ويحلل فهولذلك ينبت الشعر

اسخانه

اذا بارطون

اذا بالبطون اسبيلاواسا

في داء الثعلب ويحلل الخنازير والدبيلات وينقي الحصاه اذا شرب ويعين على
نفث اخلاط اللزجه التي تخرج من الصدر ومن الرزبو ويحبس البطن وليس بين
له جزآن معلومه ولا برود معلومه بل هو من المزاج الحادث عن هاتين الكيفيتين
المتضادتين في الدرجه الوسطى ح د وطبخ هذا النبات اذا شرب نفع الرزبو والبزبان

له الذكر فقد يعلم منه ضماد الجزء الثاني وينفع به وقد زعم قوم ان وزق
الصنف من قلوس الذي يقال له الانثى اذا اشترب مع التين منع عنه السوس

باطاسيطس ذ

هو نبات له قضيب نحو من ذراع واكبر غلظ
الابهام وعليه ورقه كبيره باطامس موضوعه في اعلا القضب كانها فطره اذا ديفت
دوفا ناعما وتضمد بها كانت صالحه للخروج الخبيثه والقروح الماكله
هذا الدوا في الدرجه الثانيه من درجات الاشياء المجففه ولذلك صار يستعملونه
في مداواه الخراجات والقروج الخبيثه والاكله

بونيون ذ

ومن
الناس من يسميه انطوون هو
نبات له ساق مربعه صالحه
الطول غليظ اصبع وزق مثل
الكرفس الا انه الطف منه
بكثير مثل وزق الكرزبر وله
زهر شبيه بزهر الشبت وبزر
طيب الرائحه اصغر من بزر البنج
هذا النبات حار ومبلغ
حرارته انه بدر الطمت
والبول والبزر هو منجن مدر
للبول يخرج المشيمه ويصلح لوجع
الطحال والكلي والمثانه واذا استعمل
يابسا او رطبا او اخرج عصاره
مع القضبان والاصول فانه انما

طولها نحو من ذراع او اكثر بيضآ وعليها زغب وزهرا ابيض مائلا الى الصفرة وبزر
اسود واصل طويل اغبر في غلظ اصبع وينبت في الصحارى والصنف الذي يقال
له الذكر وله ورق اخضر ايضا وهو اقل ما هو ادق من ورق الانثى وله ساق
ادق من ساق الانثى واما الصنف الاسود الورق فانه بخلاف الابيض فانه اشد سوادا
منه واعرض ورقا وهو مما ينوع انواع اخر الا جلالات ومن النبات صنف اخر يقال له
فلوس برى وله قضبان طوال الاجنحة بكبرها بقضبان الشجر وورق شبيه بورق
النبات الذي يقال له الاسفاقس وعلى القضبان اشياء مستديرة كالفلك مثل ما
للقثر استون وغيره ازهار من الى الذهب ومن النبات نوع اخر يقال له فلوس وهو
ثلثة اصناف منها صدر لهما غب وهما الاذنان لا ارض ولها ورق مستند بن
والصنف الثاني يقال له فلوس وهو ثلثة اصناف منها صغار عليها زغب
لحيطس ومن الناس من يشبهه بوالس وله ملك وزفات او اربع واكثر قليلا
غلاظ عليها زغب وفيها رطوبة يدبق بالبد فعلمانة قابل السراج ح و اصل الوعين
الاول من انواع البوصير حد له امر يذوقه فضلا وهو لذلك نافع للعلل السلانية
ومن الناس قوم يتمضمضون به لوجع الاسنان وورق هذا الانواع قوة مجلله
وكذلك قوة الانواع الاخر ولا سيما ورق النوع الذهبي الزهر وهو الذي جمم به
الشعر وقوة جمع اصناف انواعه وربع مجفف دخلوا جلا معدلا د واصول الصقعين
الاول بن اذا كانت قابضه فكذلك اذا اخذ منها مثل ازكعب وشنى بالشراب
نفع من الاسهال وطبخها ينفع من شدح العضلة والاشنم والسعال المزمن واذا انضمد به
سكن من وجع الاسنان واما النبات الذي يقال له فلوس برى فان زهرة وهو الاصفر
الشربسم من لون الذهب يصبغ الشعر وحيث ما وضع جمع العناصر وقد يطبخ
ورقه بالماء ويضمد به للاورام البلغميه والاورام العارضة للعين وقد يضمد
به مع العسل والشراب للفروج التي يعرض لها قانون وانضمد به ايضا مع الخل
للجراحات فذبها وينفع من لسعة العقرب واما الصنف من فلوس الذي يقال

قيل الامعاء الجارضه للصبيان والمرار النابه ابرأها واذا الجبح ان يتخد منه هذا اكسوبا فرسراق ويفع
الضماد اعنى الذى ليتنل للصبيان وسرزهم فينبغى ان يوخد منه قوطولين من ماء
فاذا جمد الما اضمد به وهو يبرد تبريدا قويا غيره اجوده الكبير المثل الذى
يرسب فى الماء والمغلول منه فابض يعقل البطن وينفع من النج وخصوصا للصبيان
والشربه منه وزن درهمين صحيحا وليحفظ من نجعه والاكتار من شربه
وزن افضل واذا اضمد به مددا فو قال اكتر تبريدا ولعابه مع دهن البنفج بطلق
البطن وبذلك يسبب لجمات الجان وينفع العطس الشديد الصفراوى وبلن خشونه
الفم والصدر والامعاء وبتلن لذع المعده وينفع الاورام الجان نفع يبيا وينفع ما
من شانه ان نفح واذا غسل الراس بلعا به تين الشعر واذهب تثقيله وتففهه
بوصير هو الجوتران والطسون برماسكه دد هوساتس بغير على قلوس

صنفين احدها ابيض الورق والاخر اسود والابيض الورق وصف يقال له الانثى
ومنه صنف اخر يقال له الذكر الا ان الصنف النى يقال له الانثى ورقه يشبه
ورق الكرنب الا ان عليه زغبا وهو اعرض من ورق الكرنب وهو ابيض وله ساق من

طرى يكن الرجع واذا اشرب منه مقدار ثلث ورقات او اربع بالشراب
ابرا الحمى التي يقال لها القيالس وكل حمى يعرض منها للانسان برد واذا طبخ الورق
كما يطبخ سائر البقول واكل منه مقدار ارطل ممن افتدا العقل في ذلك الوقت
وزعم قوم انه ان كان لا يجد فرحه المعا التي يقال لها قولون واحقن به فعل ذلك
واصل هذا النبات اذا طبخ بالخل وتمضمض به نفع من وجع الاسنان غيره البح الابيض
قد يستعمل هذا الادوية السمينه لعقده الدم وان شرب منها اولوبس نفع
من نفث الدم المفرط وينما وقمح الادويه المسكنه للسعال وعصار وزقه
يطلى على اورام الثديين العارضه لجهال بينهما وان شرب منه زرقه ثلث او
اربع وطلا ابرا اكله العظام واذا اخذ بزر البح الضرير الرجع انبوب شكله

سيليون

بزر قطونا هو الاسفيوس بالنازسيه د د نبات له ورق شبيه
بورق النبات الذي يقال له فونيوس وعليه زغب وقضبان طولها
نحو من شبر وانداحته من
وسط الساق في اعلاه
زاسار ان ثلثه مستديرين
فيها بزر شبيه بالبراغيث
اسود صلب وهو المستعمل
وينبت في الارض المحروثه
د ح افعال هذا النبات
بزرن وهو بارد في الدرجه
الثانيه وسط ما بين الرطوبه
واليبوسه د له قوه مبرده
واذا ضمد به مع الخل ودهن الورد والماء نفع من وجع المفاصل والاورام الظاهره
في اصول الاذان والخراجات والاورام البلغميه والتواء العصب واذا اضمد به

الطب وهو ألينها قوة واسلسها وهو لين المجزوزه زطوبه بدبوق ألبد وعليه
شيء فيما بين العناد والرعب وله زهر ابيض وخرز واسع وينبت الغيث من الشجر
وفي الخرابات فان لم يحضر احدها الصنف فليستعمل بدله الصنف الذي بزره
احمر واما الصنف الذي بزره اسود فينبغي ان يفض شربا وقد يبدل الثمر مع الورق لانه
والغصان كلها رطبه وخرج عصارتها وجفف في الثمر وانما يستعمل خوفا من
سنه فقط لسرعه العقوبه اليها وقد يؤخذ البزر على جدته وهو يابس ويستعمل
بدوق ينث عليه ما اجل ريح الدق وخرج عصارته وعصارة هذا النبات هي اجود
من صمغه ويستعمل ينكبها للوجع وقد يبدؤ هذا النبات ويخلط بدقيق الحنطه
ويعمل منه اقراص وتخزن جج اما البنج الذي بزره اسود وهو محرك جنونا وتبيانا
والبنج الذي بزره احمر جمه معتدله هو قريب من هذه القوه وكذلك ينبغي
للانسان ان يتنوق فانما جميعا وحذرها وكل بنهما جانبه ما لا ينفع به وهو
قتال واما البنج الابيض البزر والزهر منه من انفع الاشياء في علاج الطبيب
وكانه في الدرجه الثالثه من درجات الاشياء التي تبرد د وقد يخلط عصاره
الورق والغصان والبزر وعصاره البزر وحده بالشياف يستكنه لاوجاع
العين فينفع بها وقد يبدؤ فان شيئا لا رطوبه الجاده انا يله اليها واوجاع
الاذن واوجاع الازحام واذا خلط بالدبق او السويق او فقا الاورام العارضه
في العين والرجل وسائر الاورام كلها ت وقد يفعل بعضا البزر مثل ذلك
للسعال والنزله والسيلان الى العين وضربا بها واذا شرب منه مقدار دولس
مع بزر الخشخاش والشراب الذي يعال له ما البشر اطر وانقى نزف الدم من الرحم
ومن سائر الاعضاء واذا ادق دقا ناعما وتضمد به مع الشراب وافق النقرس
والحصى الوارمه والثدى الوارمه في النفاس وقد يخلط بسائر الضمادات
المسكنه للوجع فينفع بها والاقراص المعمول منه من وزن النبات هي نافعه في
تسكين الوجع اذا خلطت بالسويق او وجد هاضمادا واذا ادق الورق هو

اشقواتمز وهو الیج وهو ثلثة انواع

القضبان واحد بعد واحد
كل واحد منها مطبق
بشي شبيه بالزين وهذا
المثنى ملايين يرتد شبيه
ببزر الحنطان وهو ثلثة
أصناف منه ماله زهر
لونه بالغرغرة وورق
شبيه بورق لبنات الذي
ينال له سمىلقو وبزر اسود
وزهر شبيه بالحلازصلب

ومنه ماله زهر لونه بلون الفالج وزنه وزهر وزهرة الصنف
الاول وزين نبي الاجمرة شبيه ببزر النبات الذي ينال له ازيمن وهذه الصنفان
يحفان وينشان وهاذا زدبار لا منفعة في اعمال الطب اما الثالث ما ندبه اعمال

خوص البردي ونباته ملتفت في طرف ساقه حمل أصل عليها وزر مثل هدب الصنوبر
إلا أنه أقل وقشر ساقه قوي صلب ويصنع منه أرسان وحبال قوية ويتخذ الناس
هذا القشر محل الصابون الخوف وغيره ومن العامة من يتخذ القراطيس ومن الناس
من يقول كـمد ناموريس وهو البردي وهو معروف ومنه تعمل القراطيس
حد وهذا نبات ينتفع به الطب وحده ولكن منه انفع وأجزؤه صار أ نفع وذلك
إذا أنه انفع بالخل والماء والشراب دمل الجراحات الطرية إذا لف عليها كما يلف
على الساق الا أنه في هذا الموضع إنما يقوم مقام مادة من المواد العاملة للأدوية
الناشفة وأما إذا أحرق فإنه يصير بذواتا مجففا على مثال الرماد والقرطاس
المحرق إنما الفرق بينه وبين القرطاس المحرق أن البردي والحرق أضعف
من القرطاس المحرق د وقد يستعمله الأطباء إذا أرادوا فتح أفواه البواصير إذا
أرادوا استعماله بلزودا بالماء ثم لغوا عليه وهو رطب كتانا وتركوه حتى
يجف ثم أدخلوه في البواصير فإذا أدخلوه اسلا رطوبة وانفتح فتحه وأصله
يعقد وإذا طبخ يسيرا وقد يمصه أهل مصر ويطرحون ثفله وقد يستعملونه بدل
القصب والبردي إذا أحرق الا أن يصير رمادا أو يستعمل مع الفروج الخبيثه
التي في الفم وفي ساير الأعضاء منهما من أن ينفع فيها والقرطاس المحرق قوي فعلا
من البردي المحرق عنبره رماد القرطاس ينفع من نفث الدم من الصدر وإذا أشرب
منه كل يوم وزن درهمين بخل حلل ورم الطحال وقد ينتفع في الكحل النافعة لفروج
المعا وينفع من فروج الزبية إذا استعمل في أدوبها وإذا استنشق نفع من الزكام
وقد يفعل ذلك رماد البردي الا أنه أضعف وأقل وقد بين وزنو زق البردي
العفض وينفي عصير الطحال فينفع نفعا بينا بنج هو الشيكران
المعروف عند الناس بهذا الاسم والشيكران على الحقيقه د سقمواس
هو نبات له قضبان غلاظ وأوراق عراض شبيه الاطراف إلى السواد
عليها زغب وعلى القضبان شبيه بالجنار في شكله منفرق في طول

الورق والشراب الذي يبال له ادرّ وماليٰ وشراب ممزوج مع شيء من ليل حمى
الربع وزق أربع غصون وحتى العنب وزقلته اعصار وللحمى الابيٰ ماخذ كل يوم
وزق غصن واحد واذا اشرب الورق يوم لشبين يوم منوا ايه نفع من الصرع
وعصارته اذا اشرب منها عدة ايام في كل يوم ثلث قوا ابات ابران البرقان
واذا ضمد بالورق مع الملح والعسل ابرى الجراحات والنواصير والداحس وقد ينفع
من قبله الامعاء واذا اشرب من هذا النبات وضمد به ينفع نزف الدم وقطعه وقد يستعمل
هذا النبات في الهياكل للنظر وغير ذلك ممّا يستعمل في الهياكلة **غيره** اصله
بلصق الجراحات الطريّة بدنها ويفعل منها افعال ادم الاخوين وزقه اذا افرش وزقد عليه
نفع من الاحلام واذا أدقَّ زقه واعصر ماؤه وسعط به الفرس المجدور ابراه من
الجدري وينبغي ان يسعط الفرس اذا استنعط به بالجدري حتى يعرف

بردى ابن جلجل هو الخوص ويعرفه اهل مصر بالغافور وهو نبات ينبت
في المياه وله ساق طويل
اخضر الى البياض عليه
قنعلة كبيرة وعند من هذا
النبات كغد ابيض بمصر
ويقال له القراطيس
فمنى قبله الطب فرطاس
محرق فانما ازاد به الفرطاس
الذي يكون من البردى **في**
البردى صنفان منه ذكر
لا يخرج له ساق ومنثى

وله ساق وقطن يقال له الطوط واما الغافور فزعم قوم انه غير هذا البردى المعروف
عندنا ولكنه صنف منه وذكروا ان الغافور اغلظ ساقا من البردى وله خوص

وقيل هو البردى

بنطافلون

شا واذا مضغ هذا الاصل سكّن وجع الاسنان ۞ بنطافلون

معناه ذو خمس ورقات وبعضه الناس يكنّى مريم د د هو نبات له قضبان

طولها نحو من شبر وله ورق

شبيه بورق النعنع وخمس

على كلّ قضيب وعشر إمّا وجل

أكثر من ذلك والورق

مشرف من كلّ جانب مشا

بتشريف المنشار وله زهر

لونه إلى البياض والصفرة

وينبت في اماكن رطبة وقريبًا

من الأنهار وله اصل لونه إلى

الحمرة وهو مستطيل وهو اغلظ

من الخربق الاسود وهو كثير

المنافع د ج اصل هذا النبات

يجفّف تجفيفًا شديدًا وليس له حدّة ولا حرافة فلذلك هو يجد نافع كنفع

جميع الاشيا التي جوهرها لطيف مجفّف من غير لذع وكنفعه تجفيف كا

في الدرجة الثالثة وليس فيه حرارة د وطبخ الاصل اذا طبخ بالماء حتّى ينقص الثلث

وامسك في الفم سكّن وجع الاسنان واذا امضمض به منع القروح الخبيثة من ان تنبسط

في الفم واذا تغرغر به نفع من خشونة الحلق واذا شرب منع من اسهال البطن وقرحة

الامعا ووجع المفاصل وعرق النسا واذا دقّ ناعمًا وطبخ بالخلّ منع الملة ان

تسعى في البدن وقد جلا الخنازير واورام البلغمية وثمرة السريان عند النصل

والبثرات والحمرة والداحس والبواسير النابتة في المقعدة وبرى الجرب وعصارة

الاصل اذا شرب اصلح لوجع الكبد ووجع الربو والادوية القتّالة وقد يشرب

بمنزلة الراجه ن غلظ اصبع اذا انضمد به کان صالحا للجراحات وقد ينقلع الآثار التي تكون في الوجه مثل الكلف وما اشبهه ح ح قوة هذا الدوا وطعمه قوة وطعم مركب وذلك لان فيه شيا من القبض ومن الحرافه وشيا من الكراهه والبشاعه ليرخط بهما الصفه وبولذلك ينبغى ان نفع في اشياء كثيره خلا ان قوما يستعملون اصله کاضماد في مواضع الضرب وفي الناس قوم يستعملونه في جلا الكلف الحادث في الوجه :: بولامونيون د د ومن الناس من يسميه فيلاطاريون ومنهم من يسميه حلبد وناس هو نبات له اغصان صغار دقاق متشعبه وورق اطولُ واكبر من ورق السّذاب بنى تىبر شبيه بورق برشيازد اذا فودح الماء وهو الذي يقال له بالبونانيه فلاشى وعلى اطراف الاغصان شئ شبيه بالرؤس المستنديره فيها بزر اسود اللون ولهذا النبات اصل طوله نجو من ذراع لونه الى البياض ما هو شبيه باصل النبات المسمى اسطرو بىز والكبر من نبت هذا في جبال ومواضع خشنه ح ح هذا نبات قوته لطيفة مجففه ومن اجل ذلك صار بعض الناس يسقون من اصوله بالشراب لمن به وجع الورك ولمن به قرحه الامعاء وقد يشرب بالماء لعسر البول وعرق النسا ويشرب منه مقدار درخمى بالخل لوجع الطحال وقد يجعلون هذا الاصل على الانسان للسعه العقرب ويقال ان من كان هذا الاصل معلقا عليه لا ينزر به عقرب وان قرب به ولسعه فان اللسعه لا نضر

الشجره وقد ينبت أيضا في شجر الكمثرى وله قضبان طوال معقده خضر أقصر من ورق الزيتون وأعرض وأصلب وله ثمر أحمر لبج في داخله بزر من أنا د زراعته شق في ساق شجره الزيتون والبلوط أو جوها من الشجر وجعل في جوف حبة الشوى وحين يعلو ذلك في أول الربيع فإنه ينبت ورق هذا النبات إذا شرب مع الطين الأرمني جبر كسر العظام ورض العضل وبها وخصوصا عضل الصدر وينفع من نفث الدم فإذا لج مع السمن وشرب بطبيخه نفع السعال وطعمه قابض وفيه شيء من المرارة

بلوغاناطن يعرف بالفلوره هو نبت ينبت في الجبال وطوله أكثر من ذراع وله ورق شبيه بورق الغار الا أنه أعرض منه وأشد ملاسة وفي كل موضع نبت منه الورق زهر أبيض كثير جدا متشعب من موضع واحد وله أصل أبيض طويل كثير العقد عليه زغب

زغب ويقبض اللسان وله ساق ملس عظيم وقد قيل قصير واصل وقد تخرج عصارته هذا النبات اما من الثمر او النارجو وزو هذا النبات فايض بدل الجراحات والاورام ايضا التي تكون منه يقبض مثل قبض الورق ومن اجل ذلك قد طبخ وجد ماؤه مجفظ من طريق نافع جدا للقروح الغمر وهو مع هذا ينفى البثور ايضا ودنفس وله قوه ما بضه تصلح خاصه للاوجاع العارضه نية ... الورز الذي يقال له اللوزبان واللزوج الخبثه العارضه للغم وساير ما ج اخرجه الى اللثه ..

بستان ابرور

جنس والرازي هو برطانيثى ابن جلجل هو نبات يعلوك قد اكثر من ذراع له قضبان طوال عليها ورق كورق الفشا الى الطول وفى اطراف اذرعه وسايع لونها فرفيرى مليح المنظر وليس له رايحه عطرته واول من عرف هذا الدواء الاندلسيون الحراى وماوه اذا اشرب معصورا نفع من الدواء القتال الذي يشاك له انفس يطرن وهو الناي المجوسيه والبسا ... ما زد بابرىشكن لجرازه التى تكون في المعده والكبد اذا اشرب من ماء المطبوخ فيه باجلا ب والنجيبين

بلوومه هنا نبات يعرف عندنا بهذا الاسم ويعرف ايضا بالرقعه الفارسيه وذراق الطيز وزعم قوم انه يسمى الحوطان وانه ينمى بالسريانيه ما زاقونا هو نبات ينبت فى نجر الاسنور يخرج من بين

من ورق الياسمين البرى وقضبانه مربعة بيض لونها ورقيزه تمتد جبالاً على الأرض
ومعلق بالشجر وله زهر اصغر من الياسمين ابيض فى عناقيد فى داخله هدب
وهو طيب الرايحه جدا يظهر فى الصيف وله عروق فى غلظ الخنصر ومنه صنف
اخر دقيق الورق جدا وقضبانه شديدة الجلفاء وكلا الصنفين جيد الطعم جدا
يفرح النفس كثير يستعمل اصل هذا النبات بدل السيطرج ومنهم من يستعمله بدل
الحربق والصنف الصغير من هذا الذى ذكره خاصة ٥ وسنماه فليماطن
وورقه يبى
ووزن لهرا حج بنهل البطن ويضمد به عرق النسا فيقوم مقام الكى وعرقه
ونهل وسبع مطبوخا بالخل مزوجا للاسنان وزهره ينفع من الصداع البارد والزياج
الغلظه ع الرأس اذا شم ويتخذ دهن جار لطيف جاذبى الجلى ينفع من
اللقوة والفالج وعرق النسا والرعشة والسقيته الباردة وشبها من الامراض
البلغميه الباردة ٥ فلماطن هو نبات يخرج اغصانا لونها الى الحمرة دقا قا
بالجلفاء وورقا
شبيه جرفاحدا يفرج الانسان ويلقى على الخمر مثلا يلقى لبنات المنى ثم يلقى
النبات ويعطس بشينا
٥ وورق هذا قوته قوة مجرفه جنية مكشطه عن الجلد فلذلك فى الدرجه
الرابعة من درجات الاشياء التى يسخن عند ابتداء الدرجة الرابعه هذا النبات اذا
شرب بالماء والشراب المنى ادر ومالى وهو سم ومرة واورقه اذا
يضمد به قلع الجرب وقد يتخذ بالملح مع السيطرج للاكل والله اعلم

برطانيقى الرعفه الكون
جنين هو الذى يسمى
بالاناشيه سنان ايرو
٥ ٥ هو من النبات المنابت
كونه بى كل سنه وله ورق
شبيه بورق الخاض البرى
الا انه اشد سوادا منه وعليه

زهرا لونه لون الفضة من طيب رائحة جدا وينبت في مواضع طبلة خشنة خ د
ورز هذا النبات جوهره جوهر مآء اذ قليلا ولذلك صار متى وضع ورقه
كلضماد ما وجده واما مع دقيق الشعير يسكن الاورام الحارة وقد يوضع ايضا على
فم المعدة اذ كان فيه لهيب وعلى العين ايضا د ورز هذا النبات اذا انضمد به
وحده او مع السويق يبرد وينفع من التهاب المعدة والاورام الحارة العارضة
في العين وسائر الاورام الحارة ونتو المقعدة وقد يقال ان زهره اذا اشرب
بالماء نفع من الخناق والصرع العارض للصبيان وهو المسمى ام الصبيان عصيره
رهره اذا اشرب باسانبيل آمرة الصفراء من المعدة والامعاء والشربة منه
من ثلثة دراهم الى السبعة يندق ويحل مع سكر مثله ويشرب بماء حار وهو
يقوي المعدة واذا ضمد به الراس وهو طري نوم واذا ربي ما السكر نفع السعال
الحار واذا اشم سكن الصداع الدموي وشرابه صالح لذات الجنب وآلتي به
وجع الكلى وبذر البول.

بَهْرَامَج أبو حنيفة هو الرنف
وهو الخلاف البلخي وهو ضربان منه مشرب شعرنون بحمرة ومنه احضر
هادب النور وكلاهما طيب الرائحة لي هذا هو الياسمين البري ورقه اكبر

بَهْرَامَج

فارن

وينبت في الدمن ح د ورده اكبر من ورد البابونج جداً وله من الحدة
والجزاءة اكثر مما للبابونج ولذلك هو اكثر تحليلاً حتى انه يشفي الاورام
الصلبة اذا اخلط بشمع مذاب

ودهن د دهنه اذا تحنى
به وطلى حلل الادرام اللغمة
والحساو زعم قوم ان من
كان به بوار فان شرب به
الحام بعد خروجه من الآبرن
جز لونه وقتاه ما اصفر

ابن سينا هو شيء
بالفارسية كاوحمى عين
البقر ورده اللوز احمر
الوسط اصفر من ورد البابوج
جرنته الثانية ياسع الاويا بشع شمه من الرياج العليظة في الرأس ٠

بنفسج د د هو نبات له ورق اصغر من النبات الذي يقال له قنوس
وادق منه واشد
سواداً وليس بعيد الشبه
منه الجزار هو شبيه
بورق الجنازي اخضر
وقضبانه تفترش على
الارض د هو نبات له
ورق اصغر من الجنزير وله
ساق يخرج من الاصل عليها

اصفرً او وَرْدِيّة او نِبرّيّاً وَهوَ بَرد قد درَ هنَ السَّذاب ونبتَ فى اماكنِ خشنة وبالقربِ من الطُّرقِ وَبَلغ فى الربيع وجمع ح د بُطحنُ فى الدرجة الاولى وجوهره لطيف وبهذه الاسباب صارَت قوَّتهُ جَلىلة وينفعُ متألم البدن ح وقوَّة هَذا النَّباتِ وعروقِهِ وزهرَتِه تخنهُ ملطفة واذا اشرِبَ وطبخَ وجلسَ فى مائها ادرَّ الطَّمث واحدرت الجنينَ عند الولادَه وادَرَّت البول وابا النَّخامه وقدْ يدعى ايضاً المنخ والغوليسَ الذى يُقالُ لهُ ايلاوس وَيذهبُ البَرقان وبَرْى من وجعِ الكبدِ وقدْ ينفعُ اطبحا فى تحكمِ الْمثانة والصنفُ الذى زَهرَه فَرْبَرى من الْبابُونجِ اشَدّ فعلاً احتى الصنفَين الاخرَين وَهو اكثرُ منهما ويقى حامَه ومَن واما الصنفُ الذى زَهرَه ابيضُ والصنفُ الذى زَهرَه اصفرُ مَنهُمَا اشْدادِرَارا للبول وجميع هذه الاصناف اذا انضمدَ بها ابرات الجربَ المنفرجِ واذ مضغت ابرات الفلاح وقد يسحقُ بالدهن وتمرخُ به الحميات الداءرةَ وينبغى ان الحزر اللحمَ والوزنَ وقد يسحقُ بالدهنِ بعد وتمرخُ به الحميات الدايرةِ بعداَ ان يُدَقَّ كل واحدٍ منها على حدةٍ ويعملُ منه اقراصاً واما الاصلُ فينبغى ان يجفف ويُخزن الى وقت الحاجَة اليه وينبغى ان يشربَ بالشراب الذى يقال له اومالى
عنبره وَهومفتحُ ملطف ممين للبس حال للاحدبِ وهذه خاصة من بَين الادويةِ مرخٌ للنسا ومقوى للاعضاءِ والعصب كلها ويقَوى الدماغ وهو ينفعُ الادويةِ للاعياء وينفعُ من الصداع البارد وينفرعُ مواد الزايد وبَرى العرقِ المنفجرِ ضمادا ويسهلُ النفسَ ويذهبُ البرقان ويشربُ للحميات العقَّبه فى اخِرها وهو اشدّ الاشياءِ تسكينا والها مداواه الاجشا الذى من وزامرا والبطن
بهار هو الانجوان الاصفرُ الذى يعرفُهُ بعضُ الناس بالنارجه وبعضُهم سمَّنه خبرَ الغراب والبها عندَ العامَّه هو النرجس د ح تفتلن تفسير عبز البغر وهو نبات له ساقٌ رَخصه ورَقُ يشبه ورق الزّا زيا لح وزَهرً اصفرُ اكبرُ من زَهر البابُونجِ شبيه بالعبرِ ولذلك يسمى بهذا الاسم

من سدد الزكام والأنف واذا أجر في شرب رماده على فرج الفرح
حقنا واذا شرب مع ماء الاسلانتل الدود حب القرع
بابونج دحح هو ثلثة أصناف والفرق فيها انما هو في لون الذهب

انثمس وهو البابنج

فقط وله أغصان طولها نحو
من ذراع يشبه بأغصان النش
و فيها وفي ما يشعب دقاق ورؤوس
مستديره صغار شبه بأطن
بعضها دهر ابر وفي بعضها
دهر لونه الى اللون الذهب
و الذي يظهر عنه من الذهب
على الرؤوس يظهر باسنان
حولها ولونه يكون ابيض و

انطاميسا وهو البنجاسف

وفيه رطوبة تدبق باليد
ومنه صنف آخر وأنضر
أغصانا وأعظم ورقا من
باقيه وباقيه أدق ورقا
منه وله زهر صغار دقاق
بيض يشبه الرائحة وزهرها
يظهر في الصيف ومن الناس
من يسمى بعض النبات المتاني
اللون في كلتا الباب
جزوفيلا فرجه انطاشايا

وهو نبات دقيق العيدان نادج النبات صغير جدا ملان زهر تجتمع اللون يسمى
باسم البنجاسف وهو اطاميسا جنسين كلاهما اجنخان اجنخان باسية وجفقان
جفنقا أبيز منه فلوضعه على هذا القياس من الاجنخان من الدرجة الثانيه
ومن التجفيف في الدرجة الأولى في ممتده وفي الثانيه مستحجه ولها اضاف لطاف نبره
ولذلك ماز اموادتين قليلا للحصاة المتولده في الكليتين ولتفرح الارحام

وكل هذه الاضاف نخن ولطف واذا اطحن بالماء وحبل النساء فيها
واقهن لادرار الطمث واخراج المشيمه والجنين وانضمام فم الرحم ودم الرحم
ونفيت الحصاه ونفع لاحتباس البول واذا اخدمن هذا النبات شي كثير
فضمد به اسفل البطن اذا لطخ وعصارتها اذا دقت وتحفق مع الممر
واحتمله المرآه احدرمن الرحم واخرج ما جد ذى طبخه اذا اخذ فيه الشناء
وقد يسقى من جرمه هذا النبات وزن ثلاث درحمان لاحداثما ذكرناه
واخراجه عين الاصفر الزهر اقوى فعلا من الابيض الزهر واذا اسبطح
البنجاسف على الراس نفع من الصداع الكابر عزيز دوا السدد والدوار وينفع

اصفر ويسقط زهره وساقه
سريعا ولذلك ظن قوم ان
هذا النبات لازهر له ولا
ساق وله اصل دقيق ونبت
في مروج ومواضع مائيه
وهذا النبات انما
يسمى ابونابته بهذا الاسم
لان الناس كلهم قد وثقوا به
لانه انفع للنعال ولنفس
الانصاب من اخذ الانسان

منه ورقه واصله يابسا فيجبنه وانكبت عليه حتى ينشو البخار المتصاعد وهو حاد
جدا ضيف باغدال ومن اجل ذلك صار ينفع الدبيلات والحراجات التي تكون في الصدر
لغير اعتبر مودا واما ورقه فهو ينفع ما ورط با للاعضاء التي تحدث فيها اورام
غير نضيجه اذا وضع عليها من خارج كالضماد ان ورق هذا النبات المتى نحخون اذا
جف فقوته اشد حده وجزا وحتى لا نفع الاعضاء الوازمه ۵ وورقه اذا انضمد
به مسحوقا مع العسل نافع الحرم وكل انذرجا زوما كان رنع نعال يابسا اوعن النفس
الذي يحتاج معه الى الانصاب فانه اذا انخ به ورقه يابسا واخذت ارجاف
نفسه الى جوفه ابرا وقد ينفج الدبيله التي تكون في الصدر وقد يفعل ذلك
اصل النبات اذا انخ زبه واذا طبخ ايضا بالشراب الذي ببا له ادروما الى اخرج
الحبر المبت ۰ ابن سینا يعمل ودا به المخذه للعرى والطرى منه يفلح الجرب
المتقرح ۰ **بلنجاسف** ونبال توج جاسف وهو السوبلا
۵ ارطاميا زهر البلنجاسف كثر نبا نه من السواحل وهو نبات شنا ف
الكبنوه في كل سنه وهو حتى نبت الاقتين وله ورقا عظم من ورق الاقتين

الرائحة مع جده ‌ ح هذا ينضج ويجفف في الدرجة الثانية فهو لذلك يحلل مواضع الضرب د واذا انضمد به طريّا او يابسًا بماكان صالحًا للجراحات لاصقة اياها وينبغي ان يحل ضماده بالنوم راحا وقد يشرب بالشراب لتعطير البول ويشدخ او ساط الاصل بلمسكى يعرف ببعض الراعى والودود ويحمل اصبانا‌ ه افاريني ومن الناس من يسميه امفالوقرن ومنهم من يسميه تيلفرن هو نبات ذو اغصان كثيرة طوال مربعة خشنة عليها ورقيات بأسنان متفرق بعضه من بعض مثل ورق النوة وزهر ابيض وبزر صلب مستدير وسطه الى الجوف بما هو مثل الزو وقد يستعمل هذا النبات بالثياب وقد يستعمله الرعاة مكان المصفى اذا ارادوا تصفية اللبن من الشعر الذى يسقط فيه ه وهذه الحشيشة تجلو قليلا وتجفف ولها ايضا لطافة د واذا اخرجت عصان ثمرة وعصارته وورقه ويشرب بالشراب نفعت من نهش الزيلة ونهش الافعى واذا قطرت فى الاذان ابرات من وجعها واذا انضمد به مع لحم عنبر حلل الخنازير بحيون وهى حشيشة السعال له ورق شبيه بورق البنى يقال له فسوس الا انه اعظم منه وعدد الورق سبعا وسبعاء ومبنه في اصل النبات والورق الى الاسفل ابيض ما الى اعلاه اخضر وى الورق ذو اكتينه وله ساق طوله اكثر من شبر يطرح في الربيع زهر

افاريني وموبلكى فى ذعلى الصعى الراعى

النبات يكون

وينفع المعدة البارده الرطبه وينفع الكابوس وحدث النفس ح ز قوّة هذا
قوّة شبيهه بقوّة الفرانسيون الاانه دونه كبرا والله اعلم بالصواب
بلوطيني ومن الناس من يسميه المرو البرى ومنهم من يسميه ترجانا بريا
ومن الناس من سماه مالفرانسيون وهو نبات له قضبان مربعه لونها
اسود عليها زغب وحجر جاس
اصل احمر كبير شبيهه بورق
... الا انه اكبر منه
واذا ... بان وعليه يعنى
وعلى القضبان ... وبعضه
من ازانجه وزنه السوسن
الرايحه والملك شما
الناس ما ليه على قلن الزهر
على القضبان على استدار واذا
تضمد به مع الملح كان زجل العضة
الكلب واذا دق ... ر ما د
حارحتى يدبل ذهب بالبواسير اليابسه واذا خلط بالعسل نقى الفروج القبحه
قوّة هذا شبيهه بقوّة الفرانسيون الاانه دونه لثرا بولوقنس
هو شجيره صغيره تستعمل فى
وقود النار وله ورق شبيه
بورق او زبغاث وثمر
كبير الفلك مثل ثمر
... ليس عليه اكليل كبر
له زوون مغار طيبه

بَاذَرَنْجُوَيْه ويُقال باذرنجيه وهو اللاعبة الحلبة وهو الترخان وهو عشبة
ما وإنما تثبت بهذين الاسمين لانبساطه النخل الحلو فيها ورقها وقضبانها بشبهان
ورق لوطي وقضبانه الا ان ورقها اكبر من ذلك ورق لينه علته زغب مثل
ما علته ورائحته مثل رائحة الاترج واذا شرب ورقها بالشراب او ضمد به وافق
لسعة العقرب ونهشة الزنابير
وعضة الكلب وطينه لواصب
على هذه المواضع نفع ذلك
واذا جلب فيه الماء كان
صالحا لادرار الطمت واذا
تضمض به كان صالحا للاثة
واذا شرب ورقه بالنطرون
نفع من قرحة الامعاء ومن
الاختناق العارض من الفطر
وينفع من المغص ويشربه لعوك
عسر البول والذي يحتاج اليه
الى الانتصاب واذا اضمد به ينفع مع الملح لجلا الخنازير ونقى الفروج واذا انضمد به
ايضا سكن وجع المفاصل. غيره حار معتدل الحرارة لطيف ينفع من جميع
العلل السوداوية والبلغمية والجرب السوداوي وطيب النكهة ويذهب سدد
الدماغ ويفرح القلب ويقويه ويعين على الهضم ويسكن النواصر والخفقان وقد
يشرب من مائها ورقها ورقها وزن عشرة وزن درهما مما ذكرناه وقد يؤكل نيا ومطبوخا
يفعل ذلك واذا طلي بمائها الخله والنار الفارسية ازالهما وان اتخذ من
بزرها نصف مثقال وطلي بها ورقها في البيت لا وسطني من اخرام الاقتعار
الشديد والحمى والنافض واكله يقوى الدماغ والقلب وفم المعدة والكبد

واذا ضمد به مع السويق ودهن الورد والخل نفع من الاورام الحارة واذا ضمد به وحده مع اسفيداج العجين والتين الجفني واذا ضمد به مع الشراب الذي من الجزر الذي يقال له الهاخيوش ينفع من ضربان الاذن وماؤه جلا طلمة العين وجفف الرطوبات السايلة الى العين بوزن اذا شرب وافي من يولد في بدنه المرة السوداء والضرع ومنه عشر البول والطمث اذا شرب وافي في بكاء مرة سوداء واذا استنشق احدث عطاسا كثيرا والبادزج ايضا يفعل ذلك ان يعض العين غمضا شديدا

في الوقت الذي يعرض فيه العطاس وقد يقوم اكله لانه اذا مضغ ووضع في الشمر يولد منه دودا واهل البلاد التي يقال لها السوى يزعمون انه اذا اكله لحد لدغته عقرب لم يالم اللدغة

الرازي بول الصغير والاكبر منه يظلم البصر وهو جيد للمعدة والقلب والخفقان ما ينفع من العطشان

ابن سينا فيه قوة مضادة فانه يقبض وان صادف خلطا اسهله وعصارته قطون نافع للرعاف لاشتمامه بالخمر وكافور ويذهب الطرش وهو مما يسكن العطاش ينحس مزاج وجرم كبده في مزاج والسكر به من مائه ينفع من ضيق النفس ونفث الدم وهو مما يدبغ الطمث ويبس المقعده

غيره هو عسير الهضم رديج القبول للعفونة مولد للدود في الجوف ردي اللعاب والدم المتولد عنه سوداوي ردي مذموم وعاقبته غير محمودة وهو مما ينقض الذهن حقا ويظلم البصر يعسر ردها ويجفف الرية والصدر

شبيه بزر النفنف الجبلي الا انه اصغر منه مستطيل ولـه زهر لونـه لون الفرفير وبزر شبيه ببزر القرطم الا انه اشد استدارة منه

ح و اصل هذا النبات جفف ففيـه قبضا معتدلا ولذلك صار ينفع من استطلاق البطن ومن ضعف المعدة ويقطع نفث الدم وان وضع من خارج كالضماد

اصلها ورمها الرخوه وينفع ايضا من وجع الاسنان متى مضمض بالماء الذي يطبخ به وبزر قوة انفاقوه لطيف. وان من اجل ذلك صار نافعا لاصحاب الشيخ اذا شربوه

د اصله اذا شرب كان صالحا لنفث الدم ووجع المعدة والاسهال المزمن ويدر البول ويضمد به الاورام والبلغمه واذا طبخ ومضمض بما به كان صالحا لوجع الاسنان واذا شرب بوزن نوع الصبيان الذين يعرض لهم الكزاز او المنهوشين للهوام

وقد يقال انـه علق طرد الهوام التي يعلق بها ۞ المجوسى اصله اقوى من ورقة من المواضع دهو نافع من الحميات الصعبة واذا وضع على نهش العقارب مضمونا نفعه

بادروج هذا الحب الرجاني ابن جلجل هو الحبق العريض الورق والعلامة هو مشبع الخضر. ويوجد في السايس والحن القرمط نوع منه غيرة هو بالمشرق معروف وهو عندهم من بنو المابرة ح ح هذا احار زى الدرجه الثانيه وفيه رطوبة فضلية وزطو بنافع للبن اذا اورد المدن واما من خارج فهو ينفع

اوغنين اذا اتخذ منه ضمادا للنمل والانضاج ب ب اذا اكثر من اكله احدث في العين ظلمه ولين البطن ويهيج الباء ويولد الا ياح وبذره للبول واللبن وهو عسر الانهضام

مثل ما نفع السوزنجان في تسكين أوجاع المفاصل والنفع من القرحة ما نذكر جوبه
جاز بزيدنى المنى وخاصته إنها الماء الأصفر والإضراس ويصلح بالخردل
وخبز الجاورس والشربه منه درهمان **المجوسی** ينفع من الأخلاط الباردة والبلغمية
ولطفها وينفي العصب منها **ابن سينا** ينفع من السموم **بهج** هو المستعمل
وهو دوا معروف وبوني به من المشرق وقوم يزعمون أنه المغاث وقوم
يزعمون أنه الانوريان وهي عروق بيض لها صلابة وفيها لزوجة تستعمل النساء
للسمنه ويخدم مع الحشا وى اللبن ليسمن وحمرة الوجه جدا وقد يزعمون أنه أصول الماغيث
وهو خطا وقد ينفض به وأصول أخر يشبه به ويزعم قوم أنه أصل نبات يشبه ورقه
ورق الطرخشقوق إلا أنه جلو الطعم
وله أصل أحمر له دمعة جمرا
كالدم إذا قشر خرج داخله أبيض
ويجمعه التجار ون فيبيعونه على البهج
بدسكان وقال اللله بأدسقان
وبرسغان وبأسكان **ابن سرابيون**
قيل إنه دواء مسوس يجلب من آذربيجان
الرازي وهي الحشيشة التي يتخذ
منها النط الاسوره **ابن سينا**
حشيشة يتخذ منها الزنج أسوره
وهي خشبية المجوسی جار بن الى ملطف محلل ينفع أصحاب البلغم والرطوبة
باذاورد اقشاوقا ومعرفه بالاسم لبوئا انه الشوكة البيضاء
نبت بجبال وعناصره له ورق شبيه بورق الخام اللون الابيض غير أنه أدق
وأشد بياضا وعليه شي يشبه الزغب وله شوك والمناشع لها اكتر من ذراعين
في غلظ أصبع الإبهام وأكبر لها من حوله أربعة بطن على طريقة ازار منوك

بهج

نبات

ما هي وأصول خشبية لونها ما بين السواد والصفرة وداخلها إلى الحمرة وقد يكون ينبت الجزء الأصلي البلح لأنه أغبر يلي الحمرة هش خفيف رخو ينتشر منها شبيه الأصابع اثنان أو ثلثة ولهذا النبات ساق مربعة لونها أخضر فيرى عليها زهر فوق فيرى كزهر النبات الذي يسمى حصى الكلب وكأنه صنف منه وينبت في رمال قريبة من البحر ويستعمل أصله بدلاً للبهمن الأحمر ولونه لونه وقد ينبت بعروق سبط طوال مغتولة رخوة لزجة وهي البهمن الصحيح وقد نظر ابن قنه كفوته وهذا النبات نبات له ورق طوال ذراع وأكثر وعرضه دون الشبر وهو مشقق جعد أملس أخضر إلى السواد له بزور وهو كثيرا ما ينبت من الأصل وأطرافه بمنزلة ما بلغه إلى الأرض وله ساق خارجة من بين الورق وزوج غلظ الإبهام طويلة جداً مدورة عليها ورق صغار من بعضها إلى أعلاها إلى الطول ما هي منها شويك وفيما بينها غلف كبر بعضها فوق بعض في شكل منافير البط عليها زهر فيرى ما يلي البياض واحلة ثمرة كالبلوط مملوءة رطوبة لزجة وله أصل طويل معقب رخو يشبه أصل الخطمي مما لوء رطوبة لزجة غائبة في الأرض فيه شيء من حلاوة مع حرارة قوته قوة البهمن يزيد في الباه ويردي الرحم إذا أناوه ويبرأ من نهش العضل ويخصب البدن ويدر البول وينفع من وجع الخاصرة والمثانة وبعض الناس يسمى هذا الدواء وهو النبات مطرشانة وبعضهم ينمة عشبة البحر وينبت في المواضع الرطبة من الجبال والخنادق وقد نحن بعض الناس يسمى الباتيس والمنازل :: **بوزيدان** و عامة الصادلة يقولون أبو زيدان ويزعمون أنه حصى الثعلب وهو فيه غلط وبعض الناس يزعمون انه البهج والصحيح انه البهج أو صنف من البهج :: **ابن جلجل** البوزيدان أصوله بعض يشبه البهمن الأبيض وهو دواء هندي قليل التصرف وقد جلب أيناً وزاد في مرار :: **ابن رضوان** هو ضرب من المستحجلة جاء باسرخ الثالثة وينفع من الآم أصل البارد ويدبب الأخلاط الغليظة :: **ابن ما سويه** لجودة ما أبيض لونه وغلظ عوده وكثرة خطوطه والدقيق العود الشديد الملاسة القليل البياض ردي قليل المنفعة :: **حبيش** مأدبه

دويس اصفر كأنه شعبه من اكليل الشث وبزرکبیر واصل هذا النبات اذا علّق
على المرأة منع الحبل • **بهمن** ارضوان هو اصل جزر بری ومنه

بهمن لحم وابیض

ابیض ومنه احمر غبین البهمن ضربان لحمر وابیض وهو عروق سنه قد یر
الجزر الصغار کثیرا ما یکون مفتولا ومعوجه منتبه طیبه الرایحه والطعم وفیها
لزوجه وهو دواء جزری الدرجه الثانیه قابض لطیف منج نفع من الخفقان ویقوی
القلب جدا وسمن ونفع من التفزز ویحلل شهوه الجماع المولد هذه اقاویل جمیع
الاطباء المتاخرین فی البهمن وهم متفقون نصفحه وقوته الاان البهمن عندنا فی
الیوم مجهول والاختلاف فیه کثیر والمجلوب منه غیر شبیه بما وضعوا المجلوب
ایضا اختلاف کثیرا وقد یوتی باصول کالجزر وداخلها ابیض وظاهرها لکی اللون
ویقال انه البهمن الاحمر وقد یوتی باصول شبیهه الکما زخوه لزوجه ویستعمل علی
انها بهمن احمر وقد یوتی بقطع کالجبیل طیبه الرایحه کالندرور علیه اللون فیها لزوجه
ویقال انها بهمن ابیض وقد یستعمل بیانبه بعض التجاربن نفذ ادم ویزعمون انه
البهمن الاحمر وهو نبات لسانه یعلوا نحوا من ذراع ورق الاول اطرافها کالتذور بیز

اسْهَلَ بَلْغَمًا كَثِيرًا وَكَيْمُوسًا ابْيَضَا وَاذَا اشْرِبَ وَاجْتُمِلَ ادَرَّ الطَمْثَ وَقَدْ زَعَمَ بَعْضُ
النَاسِ انَهُ انْ تَخَطَاتْهُ امْرَاهُ حَامِلُ اسْقَطَتْ وَاذَا اشْتَدْتْ الرَّفْنَهُ اوِ العَضَدُ مَنَعَ الحَمْلَ
وَقَدْ يَشْرَبُ بِالشَرَابِ لِلادْوِيَهِ القَتَالَهِ وَالسَمُومِ وَخَاصَهٌ لِسَمِ الارْنَبِ البَحَرِي وَاذَا انْضَمَدَ
بِهِ كَانَ زَنَادَ زَهَرَ السُّمُومِ الهَوَامِ وَاذَا اخْلَطَ بِالشَرَابِ اسْكَرَ وَاذَا اشْرَبَ مِنْهُ وَزْنُ ثَلَثَهِ
مَثَاقِيلَ بِطَلًا وَبَالمَقْرَاطِنِ مَمْرُوجًا بِالمَاءِ الفَرَاجَ رَقِيقًا اجْرَى مِنَ البَرْقَانِ وَيَنْبَغِي
اذَا اشْفَى مِنْهُ مَنْ بِهِ البَرْقَانُ انْ يَضْجَعَ فِي بَيْتٍ حَارٍ وَيَغْطَى بِثِيَابٍ كَثِيرَةٍ لِيَعْرَقَ
وَلَوْنَ ذَلِكَ يُشْبِهُ المَّ الصَفْرَاءَ وَقَدْ يُخْلَطُ مَاوَهُ بِالعَسَلِ وَيُسْعَطُ بِهِ لِنَفْثَهِ
الزَانِبِ وَيَصِيرَ عَلاصُوفِ يُحْمَلُ المَقْعَدَهِ لَا سَهَالِ البَطْنِ وَاذَا لَطَخَ السَرَّهَ وَالمَزَانِ
وَالخَاصِرَتَيْنِ لَيَّنَ البَطْنِ وَطَرْحَ الجَنِينَ وَاذَا اخْلِطَمَا فِي بِالعَسَلِ وَالكَحَلِ بِهِ وَافَقَ الِمَا العَارِضِ
فِي العَيْنِ وَضَعَفَ البَصَرَ وَقَدْ يَنْفَعُ مَنْ اخْلَاطِ الادْوِيَهِ القَتَالَهِ لِلجَنِينِ وَاذَا اخْلَطَ مَاوَهِ
بِالخَلِ وَلُطِخَ عَلَى المَقْعَدَهِ النَاتِيَهِ رَدَّهَا اذَا اخْلِي الا وَقَدْ يُقَشَرُ وَيُدَقُ وَيَعْصَرُ وَيُوضَعَ مَا
وَيُطْبَخُ الَى انْ يَصِيرَ مِثْلَ العَسَلِ وَخَرْزَ لِلاصَلِ ايَضَ انْفِي البَشَرَ وَيَذْهَبُ بِالبَثَرِ وَاذَا اخْلَطَ
بِالخَلِ وَالعَسَلِ اوْكَانَ وَحَدَهَ ابْرَى الجَرَاحَاتِ وَاذَا اضْمَدَ بِهِ خَلِلَ وَرَمَ الجَرَاحَاتِ وَالطَحَالِ
وَيَنْقِي الكَلَفَ وَالثَعْلَبَ وَيُوَافِقَ الالْوَاءَ العَصَبَ وَالنَقْرَسَ وَطَبِيخَهُ اذَا صَبَّ عَلَى الرَاسِ
وَافَقَ القُرُوحَ العَارِضَهُ وَالشَفَا العَارِضَهُ مَنَ البَرْدِ اذَا اخَنَ مَعَ الزَيْتِ العَتِيقِ
وَادَهَنَ بِهِ فَعَلَ ذَلِكَ وَاسْخَانَهُ عَلَى هَذِهِ الجَهَهِ بِكَوْنُ بِالفَقُورَ اصْلَهُ وَيَمْلَاءُ زَيْتًا وَيُوضَعَ عَلَى
رَمَادٍ حَارٍ وَيُمَاصَبَرْ مَعَ هَذَا الزَيْتِ شَيْئٌ يَسِيرٌ مِنَ المُومِ الذِي يَسِيرُ مِنَ البِلَادِ الَتِي يَنَالُ لَهَا

طَرَى : **نحو مريم**

ابو الهيثم هو نبات لَهُ وَرَقٌ
دَقِيقٌ نِصْفَهُ وَرَقَ النِيلِ
وَعَشَلُوجَ ارْتِفَاعُ الذِرَاعِ
دَقِيقٌ نَصْلُ كَلِ وَرَقَةٍ
عَشَلُوجٌ صَغِيرٌ شَيْءٌ طَرٌ فِيهِ

ولونه فرفيرية وله أصل أسود مثل بصل النار ونبت في مواضع ظليلة وآبار وخاصه
ظلال الشجر ⸢ج⸣ قوة هذا الدواء قوة منقية ودلك لأنه حلو ونفج ويجدب
ويحلل والدليل على ذلك أفعاله الجزء التي يفعلها أولاً أولاً وأما أن
عصارته تفتح أفواه العروق التي في المقعدة وتحث على الغايط
جاعفا منى عنت فيه صوفه
وادخلت في المقعدة وهو يخلط
أيضا مع الأدوية التي تحلل الخراجات
والخنازير وسائر الصلابات
واذا اكتحل به مع العسل نفع الماء
النازل في العين وهو منفع مدارع
الدماغ اذا استعط به وله من

شدة القوة ما بلغ انه اذا طلي على مراق البطن اطلق البطن وافسد الجنين ودلك انه
من غير هذا الوجه ان احمل من اسفل كان أقوى في الأدوية في فساد الأجنة وحمله أيضا
أضعف من عصارته الا انه اقوى أيضا فهو لذلك بدأ الطمث اذا شرب واذا الحمل
ونفع لأصحاب اليرقان لأنه ليس انما ينفع الكبد وتفتح سددها فقط بل يفضض ايضا
المزاج المنتشر في جميع البدن ويخرجه بالعرق لذلك صار من بعد ما يشربه الشارب
له وقد ينبغي لمن اراد ان يحل احلاب ان العرق وينبغي ان يكون مقدار ما يشرب
منه للاجاده لشمه مثل قبل ان يشرب بشراب حلو وماء وبزن العسل وايضا حلو ولذلك
صار نافعا من داء الثعلب والكلف وجميع النمش وسائر ما هدا سبيله من العلل
وهذا الدواء نافع للطحال الصلب اذا اضمد به وطرح اذا اناسا ويرب الناس ثم ياخدون
من أصله اذا يبس فيسقونه اصحاب الربو ⸢ج⸣ اذا شرب الاصل مع الشراب المثنى ادر مالى

لالتواء العصب وسحاح الاذان التي يرض اللحم ووهن العظم ولاكسر ويسمى باليونانية
السلا بلبثا ولاخراج وما اشبه ذلك من باطن الجسد ووجع المفاصل والنقرس واضماد
به اضمامع المعتل كان صالح الدهان العارض من المجموز وعضه الكلب الكلب ويحبس
العرق واذا ضمد به ... نكز ووجع المعدة واذا اخلط بقطرون
يشوى فى الحالة ... بزر الآس والفروج الرطبة العارضة في الرأس واذا
خلط بصفرة البيض استعمل وجد ... ذهبه جميعه الداء العارضة تحت العين والمآلى
التي يقال لها اساوا واذا اخلط بكعبين قلع البثور اللينة واذا اخلط بسوى
من يخرج الاذان وشخ الاطفال اذا شوى فى رماد حار واخلط ببزر وتمر التمك الصغار
التي يقال لها الصير يعذبان حرق ووضع على الفروج العارضة ... الوذن الذى
يسمى شيرون قلعها واذا اخلط بالدواء المسمى السوسن ولطخ به بنى الثمن قلع الكلف والآثار
السود العارضة ... اندمال القروج ولطخ به بالخل كان صالحا لعدن
العصل اخلاط لغاها وينبغى ان يسوى فى الاكثار منه لانه يضر بالعصب

بصل الفار د ب
ورقه ادق واطول كثيرا من البلبوس المأول وله اصل
شبيه بالبلبوس عليه قشر
اسود وهو الاصل اذا اكل رطب
او طبخ وشرب طبيخه هيج البراءة
مزاج هذا اسخن من مزاج
الذى ذكرته من قبله

نخور مريم د ب
قلاميوس شبيه بورق شوس
دقيق الورق ثلاثة الوانها البا
البياض وطول لسانها اربع اصابع
عليها زهر شبيه بالورد الاحمر

الزجاج ينفع من النسج العارض في الطين من الحقف واذا قطر وحده في الاذن نفع من
ثقل السمع وطين الاذنين وسيلان القيح منها واذا نفع منها واذا دلك به على أ
الثعلب انبت الشعر فيه اسرع من الغيره ويصدع اذا اكثر من اللعق من الامراض
التي يقال لها الشقر واذا طبخ كان اشد ادرارا للبول ۞ **عنبن** يولد خلطا زدا
ويضر بالعقل وينبت ويكثر اللعاب ولا يبعد اذا عزب منه غدا بعد به واذا طبخ
اصلح حدته ويزيد في الباه وما وه يدر الطمث والبول ويلين
البطن واذا اكثر به جفف الدمعة القوية ومن شأنه اذا كل ينفع يضر المباء
واخلاطها ۞ **بلبوس** ويسمى بصل البر **الفاجه** وموصل للطاقات

له ورقه كاصل البستاني
وانما الفرق بينه وبين البصل
في طعمه ولذلك الطاقات
له وقد يكبر ويعظم اصله
بكثرة المطر وله طعم من ان
وقبض وهو خشن ياخذ بالحلق
والرى اذا اكل يولد خلطا
غليظا باردا للرجال لانه عسر
الانهضام نافع مهيج للشهوة الجماع
واذا وضع من خارج كالضماد

ويذيب ما فيه من المزمن والقبض معا جلوا ويدمل ويجفف ۞ **بلبوس** وزعم
قوم من اهل الجزيرة ان اسمه عندهم بلسا هوينات يوكل والاحمر منه من البلاد
التي يقال لها سوس جيد للمعدة والمزمنه يشبه الشقل اجود للمعدة ويهضم الطعام
وكل اصناف البلبوس حربف مسخن مهيج لشهوة الطعام والجماع محمر اللسان وطابي
الحلى كثير الغذاء كثير اللحم ويولد نفخا واذا ضمد بوميغ العسل وحده كان ناجحا

وادرّ البول منها واذا طلي بالخل المثمن على موضع البهق الابيض اذهبه واذا ذلك ه داء
الثعلب انبت فيه الشعر اشرع منابته زبدايج واذا رض انسان البصل وغزعصاره
كان النخم الذي يغ منه بعد نه عصابت ممكون ما به جاده ومن اجل ذلك صارت
نافعه من الماء النازل في العين ومن الظلمة في البصر اذا كانت من اخلاط ذي غلظه
اذا البحل بامثل

قرومیان و هو البصل

مزاج هذا الجرم
بهذه العصاره
صار البصل اذا
اكل كما هو يولد
ريحاً و نفخاً و ذلك
صار البصل مزاجه
الا الست اكثر
يولد الرياح والنفخ
الآذب والطويل
منه اشد حرافه
من المشوي و من

المعول بالخل والمج وكل البصل هو لذاع مولد للرياح فانه لنهوه الطعام ملطف
معطش مغث مغث مغني مفج للبطن منهج فواه العروق والبواسير واذا الجج البو فيها
قشر و غمر و زيت واحتملت المعده وما البطل اذا اكتحل به مع العسل نفع من ضعف
البصر ومن القروح العارضه في العين النتي نبات لها ازغان والتي يقال لها ماتالون
واستدا الماء واذا احتك نفع من الخنان وقد يدرّ الطمث واذا استعط به الرانس وقد
يعلم مما به و ضماد لعضه الكلب اذا اخلط مثله من النوبنا سكن حدة العين
واذا اخلط بالمج وضع على الثاليل التي يقال لها الثواذهب بها واذا اخلط بشحم

جدا وبوله يعز ادمانه الأمراض السوداوية وينفح شدد الكبد والطحال والخل والدهن يصلحانه وانما ينبغى الجدة والجراءة شى المشوى منه بلا دهن وشرما يؤكل منه المشوى التى غيره اذا شوى ملئ بالملح حتى يأؤه وتذهب مرارته لمستين له ضرر فإن أكل على هذه الصفه الحل اطفى الصفرا ونفع من اليرقان ولم يضر بالعين ولا بالرأس البته واذا لم يعمل به ذلك كان منعا لشدد الكبد والطحال وخاصه اذا اكل الخل لأنه ردى الغذا مولد للسدد مسود للبشرة ومغير اللون وبقيل يورث ادمانه الكلف والسرطانات والبواسير والصلابات والجذام ويصدع الراس وبئر الغم ابن سينا الغثوم منه زدى والجد يشاكلهم وعندا بن ماشر حوبه انه بارد والصحيح انه حار زياين فى الثانيه وهو يولد فساد الكبد والطحال الا انه اذا طبخ بالخل منها فتحها ولين يعقل البطن ولا يطلقه ويجوز اقاعه المحففه فى الظل طلاء نافع للبواسير واذا اخذ من جوف الباد نجان السلوق اوقيه ومزج فى الشراب مرنا وسقى ادر اللبن غيره اذا غلى بالزيت واذيب فيه شمع كان منه قيروطى نافع من شفاق الأطراف من البرد واذا احرق وعجز ماؤه بالخل قلع الثوالل

بصل ح هذا النوع الرابعة من درجات الأشياء التى تسخن وجوهر غليظ ومولدها النيئ اذا ادخل المعدة فتح افواه العروق

من وبر الحشائش وذلك من الرأس منه بزر يشبه بالسقرحله ويؤكل مطبوخا ونبأ وطعمه مطبوخا يشبه طعم صفرة البيض حـ بزر بحـ بزر يتخذ منه خبز ۞ بسرور قسطانى لوفا هو نبات ينبت فى مواضع فيها مياه قايمه ويكشف عنها ويكون اذا كشف عنها الماء قربا منه وهو يشبه الكماه ويؤكل ويسلو قال ابن رضوان بسرو الاصل اليشنين النابت فى النيل وقد ذكرنا د دب افاعى بقيه ينبت فى الحروث وفى اول

من نبات العدس دقيقه الورق وهى اعظم قضبانا وغلف ثمرها اكبر منه ف غلف ثمر العدس ويؤكل ابقل كمثل ما يؤكل العدس حـ قوه هذه الجله قابضه كقوه العدس ويؤكل كما يؤكل العدس وهى اعسر انهضاما من العدس واقوى تجفيفا وجرارتــه معـتدله وقال فى الاغذيه انه عسر الانهضام عاقل البطن دى الخلط سوداوى مثل العدس الا ان للعدس قضايا ليست له د قوه حبه قابضه وكذلك اذا قلى وطبخ وطبخ مثل ما يطبخ العدس قطع جلت لموذا للمعده والامعاء وفرجه الامعاء والله اعلم بخره عشبه تشبه نبات الكث والحب

تسمى بالعجميه ارقليوله ابو حنيفه شلجم الكرم بزعم العامه الماشيه فتسمى بنبانها السعان النيل الرازى دجان اسم فارسي يسمى بالعربيه الارنب والمغد والحدق والوغد موحد للمعده التي تنقي الطعام دايا ذدى للنائب والعين يولد دما سوداويا ويسر الندا

وَسُقِيَ مِنْهُ مِقْدَارَ ثَلَاثِ قَوَانِوسَاتٍ وَالشَّيْءُ الْأَخْضَرُ الَّذِي فِي وَسَطِهِ الَّذِي طَعْمُهُ مَنْ
إِذَا طُبِخَ وَخُلِطَ بِدُهْنِ وَرْدٍ وَنُطِّرَ بِهِ الْأَذَانُ كَانَ صَالِحًا لِوَجَعِهَا **الْفُلَاحِهْ**

عَالُوطَا نَبْتٌ فِي الْمِيَاهِ الثَّابِ‍
‍ـتَةِ بِمَصْرَ وَأَوْرَاقُهُ أَنْعَمُ مِنْ
وَرَقِ الْأُتْرُجِّ قَلِيلًا وَعَلَيْهَا
ضَعَفٌ فِيهَا تَقْوِيجٌ وَعُقَدٌ
كَثِيرَةٌ وَذَكَرَ أَنَّ فِي صِفَتِهِ
مِثْلَ فُولٍ سَوَاءً أَكْبَرَ
وَدَقِيقَةٌ بَطْءٌ الْخِلْفَةُ
الصُّفْرَاوِيَّةُ وَأُصُولُهُ بِيضٌ
أَكْبَرُ وَأَشَدُّ تَدْوِيرًا مِنْ
أُصُولِ الْقَصَبِ وَكُلُّ فَغَذَوْا
غِذَاءً كَثِيرًا مَحْمُودًا وَيُوَلِّدُ
عَنْهَا أَخْلَاطَةً زَجَاحًا قَلِيلًا وَدَمًا صَالِحًا لِلْأَمْزِجَةِ وَالْأَوْزَانِ

لِشْنِين ❊ صِنْفٌ مِنَ الْهِنْدِ فَوْقًا بِمَصْرَ يَنْبُتُ فِي الْمَاءِ إِذَا طَبَنَ
عَلَى الْأَرْضِ يَفْتَرِشُ وَلَهُ نَبَاتٌ
لَهُ سَاقٌ شَبِيهٌ بِسَاقِ الْبَاقِلِّي
وَهُوَ أَبْيَضُ شَبِيهٌ بِالشَّعْرِ
وَيُقَالُ إِنَّهُ يَنْبَسِطُ إِذَا طَلَعَتِ
الشَّمْسُ وَيَنْقَبِضُ إِذَا غَرَبَتْ
وَأَوْرَاقُهُ إِذَا غَرَبَتِ الشَّمْسُ
يَغُوصُ فِي الْمَاءِ وَإِذَا طَلَعَتْ
يَطْلُعُ عَلَى الْمَاءِ يُشْبِهُ الْعَظْمَ

اعنى النوع الذى ينال لمستخلفين واورام العين الحارة وقد يعشر ويمضغ ويوضع على
الخبر لعطع سيلان الفضول الى العين واذا طبخ بالشراب اينى من اورام الخصى واذا
ضمدت به عالت ابيانا ثم عن الاكرم وجلوا من على الوجه الهنوا واذا
ضمد يقشره المواضع البرديه ومنا يعجرنا الشعر النابت فيها دقيقا ضعيفا
واذا خلط بدقيق الباقلى مع يو سبانى وريت عتبق وصمد به حلل الخنازير وما
طبخ الباقلى بصنع الصوف واذ كرشو نصغير و وضع اصل قه على المواضع التى عليه
عليها العلو قطع نزن الدرهم بعد داخل العلو **عبره** الخلط المتولد من الباقلى
لبن ردى ولا يورث السدد لا نه جلو جلاجينا والمطبوخ منه فى قشره اوفى
نعما وادما نه يسهل الزارن ويولد نكسا فى البدن وهر الفكر ويورث هما
واجزاما واحلاما رديه ويعع من رويه الاحلام الصادقه وحدت الحكه
وخصوصا طربه ويعطع بيض الدحاج وهو جيد للصدر وتفث الدم والسعال
وقد يضع نه دقيقه جنا يهن اللوز نافع للسعال وذاب الجنب

باقلى قبطى دت هو بنت كثير يمصر وقد ينبت بعضا البلاد التى ياك ناس القبطى
لها اسم والبلاد التى ينال ها اقلينا ويوجد فى المياه القائمه وله وزن
كبار مثل وزن فاطاسون ولها ساق طوها ذراع به غلظ اصبع ولون زهرن
شبيه بزهر الورد ولونه الاحمر وهو فى طعمه ضعف زهر الخشخاش واذا اورد
عقد شباشيبها باخراب وفيه الباقلى صغار وعلو موضعه على الموضع الذى بنبت
فيه حب كا به نفلحه الماء وينال له قسور يون وقتوليون وهو الموضوع نور
الطرلان الذى يزبد ورن زراعته بان يصبر وفيه من كل مبطر يلبونه بين
الماء وله اصل مثل القضب و كل مطبوخا نيا ويقال له قلقاس وقد وكل هذا
الباقلى طريا واذا جف اسود وهذا اضعر من الباقلى المعروف ونوته قابضه
جيده للمعده ودقيقه اذا اشرب مثل السويق و علم منه جنو فانه بوافق من به
انها لمن وفتح الامعاء ويدز انقى فعلا اذا طبخ بالشراب المثى ابو مالى

الرطوبة من الصدر والربو وأما إذا استعمل على سبيل الدواء ووضع من خارج
فإنه يجفف تجفيفًا لا إذاعة له وقد استعملته مرارًا كثيرة في أصحاب الفرس
بعد أن طبخته بالماء وخلطت معه شحم الخنزير واستعملته بمداواة الفتوخ
والفزوج الحادثة في العصب بعد أن طبخت دقيقه بالخل والعسل ووضعته
عليها ووضعت بضاد قبيحه على الأعضاء التي ورمت بسبب ضربة أصابتها مع
دقيق الشعير وهو ضماد نافع بليغ لمزيه وورم حار ان الثديين وفي الثديين
وذلك لأن هذه الأعضاء تشتاق إلى الأشياء المبردة بعد الأذى تؤذى
ولا سيما إذا كان ورم الثدي إنما حادث من قبل لبن يجبن فيه فإن هذا الضماد
يقطع اللبن ولكذلك أيضًا إذا ضمدت به عانة من الصبيان من دقيق الباقلى
ناجح ولا ينفك عن النفخة بالطبع كما ينفك الشعير وحدث في البدن مدد من
ريح نافخة وجوهر تجفيف وفيه بعض إجلاء ولذلك لا يطبخ الأجذار
والرطب منه مولد الفضول في الأعضاء لنهاية الغذاء وكذلك ما هذا

فابش اليوناني **دب** تولد الرياح والنفخ وهو عسر الإنهضام ويعرض
سبيله من الثمانية إلى أربعين لرضخ أحلام رديئة للسعال يزيد في لحم البدن وإذا طبخ بالخل والماء
بنشره قطع الإسهال العارض من قرحة الأمعاء والإسهال المزمن الذي لبن معه
فرج وإذا طبخ على أو على به وهو ينفذ لك لما عنه وصب عليه ما آخر وطبخ كان
أقل لنفخه والباقلى الحديث ردي للمعدة من العتيق وأكثر نفخًا ودقيق
الباقلى إذا طبخ وضمد به وحده أو مع السويق سكن الورم الحار العارض
من ضربة ونفع من أورام الثدي التي ينعقد فيها اللبن وقطع إدرار البول
وإذا خلط بدقيق الحلبة وعلاج الدمامل والأورام العارضة في أصول
الآذان وما يعرض من العين من كمودة اللون الموضع ويسمى باليونانية
أبوقلا وإذا خلط بالورد والكندر وبياض البيض نفع من الجدة خاصة
ومن نتو العين جملة وإذا عجن بشراب وافق من أنفع ثم الجدة خاصة

العسل أسود اللون زبينا :: **ابن سينا** لبته مثل لب اللوز جلو لامضره فيه
وعله لنجٔ دؤذٔ واجه مفرح مؤزّر وجز ءُ الدٔم والاخلاط وبلغم ويذهب
الثاليل والبرص وبرى من داء الثعلب البلغمى واذا اتخن به جفف البواسير
واذا اشرب نفع من يبز داٰ العصب واسترخايه ومن الفالج واللقوة وفؤاد الذكر
ولكنه بهيج السوس والملخوليا والاورام الحاره فى البطن وهو من حملة
السموم :: **ابن ماسويه** جيد لفساد الذهن وجميع الاعراض الحادثه فى الدماغ
من البرد والرطوبه :: **ابو جريج** جاره جدا يهيج السوس والبرص والجذام
والاورام فى الجوف وربما قتل ولا ينفره الشبان ولا من مزاجه حاره وهو جيد
للفالج ولمن خاف عليه منه :: **غيره** يقال ان لبته باذر جهر له يرفع ضرره وكذلك
دهن الجوز ويخص البقر ومن الناس من يقضمه وينضره وخصوصا مع الجوز
والكٔز والله اعلم :: **باقلى** موت كيفيته قريب من المزاج
الوسط جدا اعنى من انه جفف
وفى انه جلو وجز م الباقلى
نفسه فيه رقه الجلاثى واما
قشره فقوته قوة تعبض و جلو
وبهذا السبب صار قوم من
الاطبا يطحنون الباقلى ويطعمونه
لمن به قرحه الامعاء ومن به
استلاق او ثْى والباقلى عٓ
سبيل الطعام اشدّ بغخه من
كل الطعام واعسر انهضاما
الآ انه يعين من نفث لرطوبه من الصدر والريه واما اذا استعمل على سبيل
الطعام كان اشدّ بغخه من كل طعام واغزر انهضاما الآ انه يعين من نفث

الغروج، ابن جلجل: يقال
أنه اذا اشرب من أصله مسحوقا
قدر مثقال
بلح، ابن عمران: ثمرة
خضراء ورق ويجفف يخرج
يؤتى به من الهند وطعمه مر
عفص. غيره: وهو يشبه
الهليلج الاسفر الشرقي فيه
دهانة وفي طعمه عفوصة
لذيذة ومرارة وفيه أيضا
قوة تسهل السوداء انهاء لطيفا. ابن سينا: قابض ملطف يقوي المعدة
والأمعاء أدبغ لهامتها وربما عقل عن الاعتدال البطن وفي الأكثر فهو ملين وهو
نافع للمعا المستقيم والمتفقدة. الجويني: يشبه القوة بالابلج الا أنه أضعف
منه قليلا والله أعلم. بل الخوزي: هو فتاه ندي وهو مثل ثناثا الكبر
مرجان يا بن في الثالثة قابض يقوي الاحشا نافع من صلابة البدن وتطوّية
وامزاضه الباردة كالفالج واللقوة وتوقد نا را المعدة وينفع من القي ويعقل
البطن ونبس الرياح ويدخل في الجوارشنات. ابن عمران: حبّة سود مجردة
شبه الدن السرا منها مجردة لزائر وفي داخلها شحمة دسمة وهي المستعملة
يؤتى بها من الهند وهو حار يابسه في الدرجة الثالثة ينفع من استرخاء العصب
والغريزة ومثل الابلج الواسم وتزيد في الباه. بلادر. ابن جلجل:
ينبت بأرض الهند والسند وهو حبّ فيما بين الفستق واللوز أسود في داخله
حبّة كاللّوز بيضاء عليها قشره له عسل أسود إلى الحمرة وهو عسل البلادر
غيره: يؤتى به من الصبر وقد ينبت بصقلية بجبل الناد وأجوده ما كان كثير

قسطا نام بلدة بعثه
فوطا وبه
لونا وسيته
دوسيلا
الشاه بلوطا
أيضا فعله
البلوط
الباطن
الذي فيها بين ذلك الغلـ
ولحمه ولحم الشاه بلوط
الباطن نوافق الدم والفتا الذي يقال له اقمارون بقس سمه
أهل الشام الثمار وهو باليونانية بنلس ابن جلجل مجره
ورقها الآس وعوده أصفر صلب ولحاجب أسود كالآس قابض بعض
البطن اذا شرب وينشف بلة
الأمعاء والله أعلم
بقم وهو جنس
شجر عظام ورقه مثل ورق
اللوز أخضر وساقه وأغصانه
حمر وبانه بأرض
الهند والزنج ويضع بطبيخه ابن رضوان للجراحات
ويقطع الدم المنبعث من
أي عضو كان ويجفف

وهو طري فشأنه ان يحفف تجفيفا قويا واما ورق شجره البلوط الآخر فهو اول
تجفيفا من ورق هاتين بحسب ما هو اقل قبضا منه وانى لا اعلم انى ادمنت جراحه
اصابت انسان من نجل بورق ذلك البلوط وجده عندما لم اجد دواء اخر
وذلك انى اخذت الورق ودفعته وتحفقه على صحزه ملسا ووضعته على الجراحه
وعلى جميع ما حولها وقوه ثمره البلوط شبيهه بقوه ورقه وقوم من الاطباء يستعملون
ثمر البلوط فى مداواه الاورام الحاره عندابتدايها وفى وقت تزيدها وبالجمله
فهو يجفف ويقبض له يزيد ليس كاد ان يكون زيده دون الاشياء الوسط فى
درجه الادويه التى هى فى المثل فان وقال فى الاغذيه البلوط كثيرا الغذاء
مثل الحبوب المتخذ منها الخبر وقد كان الناس فى سالف الدهر انما يغتذون

درس ٦

بالبلوط وحده وغذاوه ثقيل غليظ عسر الانهضام واجوده من الشاه بلوط
هذه الشجره كلها يقبض شد قبضا واشد ما فيها قبضا القشر الزقيق فيما بين
الناذق والساق واما القشر الباطن من البلوط كذلك وقد يعطى من طبيخها من
كان به استهال مزمن او قرحه الامعاء ونفث الدم وقد ينع منه فروج وحمله النساء
سيلان الرطوبه المزمنه من الرحم والبلوط ايضا يفعل ذلك ويغزر البول
ويصلع وسخ البطن ويوافق وذات السموم من الهوام وطبيخه وطبخ القشر اذا
شربا بلبن البقر نفع من الدواء القتال المنى طوفسفون واذا انضمد بالبلوط
سكن الاورام الحاره واذا انضمد به مع شحم مملوج من شحم الخنزير وافق الدم الجارى
الصلب والفروج الخبيثه والنوع من البلوط الذى يقال له بريس وهو السويس
اقوى فعلا من غيرها والشجره التى يقال لها سغوس والشجره التى يقال
لها بريس هما من اصناف شجر البلوط وقشر اصل بريس اذا طبخ بما حتى يلين ووضع
على الشعر وترك الليل كله بعد ان يقدم بغسله بطين كيمى فمولياى صبغ الشعر
اسود وورق اصناف شجره البلوط اذا دق ناعما وافق الاورام البلغميه
وقوى الاعضاء الضعيفه واما ما يقال له صردا بالاثو ويسميه بعض الناس

نجمعها شىء قابض مجفف ايضا الا انها ما دامت طريه رطبه بعد تجفيفها اقل حتى اذا هى يبست صارت نحو الدرجه الثالثه من الاشياء وبلغ من جزازتها ان من صفتها يعلم جزازتها من سماعته ولذلك صارت ندر البول وتفع الطحال د ثومتها قابضه مثل ذلك مثل ما يوافق ما يوافق شجره المصطكى وصمغها مثل صمغها واستعمالها مثل استعمالها واثمرتها فانها توكل وهى ردّيه للمعده مسخنه مدرّه للبول محرّك شهوه الجماع واذا شرب بالخمر وافقت نهش الزنبار. عيره احود ما يكون منه جيّد للحديث الزبر ويُنقط شهوه الطعام ومزاجها يبست في حا(ره) الثعلب وورق البطم اذا جفف ونحى ونحل وعلف به الراس طوّل جمّ الشعر وابنته وحسنه د وكما يصنع دهن الغار كذلك يصنع دهن الحبه الخضراء وله يزيد وقبض يابس كالذى لدم من الورد. عيره دهن الحبه الخضراء جاز نافع للفالج واللقوه د ه وشراب شجر الحبه الخضراء وصنعته مثل شراب الآس وذلك بان يوخذ اطراف هذه الشجره مع الثمر الذى فيها وبفعل به كما يفعل بالآس وهو شبيه بشراب الآس فى قوته وهو قابض مسخن للمعده ويقطع نزف الدم ويمنع سيلان الرطوبات الى المعده والامعاء والمثانه واذا صبّ على النروج الرطبه جفّفها واذا جلست فى ما به قطع سيلان المواد الى الرحم وييبس المنعده

بلّوط د جمع اجزاء هذه الشجره وفى هذا قوه تقبض واما الذى هو شبيه بالغاسا المسمط فقشرته ثمرته اعنى ما يختفى قشره البلوط ملفوفا على نفس جرم البلوطه وهو جفف البلوطه يبغى ينزل العارض للنساء ونفث الدم وخروج الامعاء ولاستطلاق البطن واكثر ما يستعمل مطبوخا واقوى من هذا فى القبض لبنا ثمار الاخرّان اللذان يقال لاحدهما فاغس والاخير نيس وهما نوعان ان شاء انسان يقول انهما من انواع البلّوط وان شاء يقول انهما مخالفان له فى الحبنر كذلك جاءنا ورقّ هاتين الشجرين جميعا اذا دلك فى الضماد

بنك د آ هذا يؤتى به من بلاد الهند وهو شبيه بالكثور كأنه قشر شجر النبوت بشقفتن
يدخن به لطيب رائحته ويقع في أخلاط الدخن المركبة واذا ادخن به نفع من الزكام
قير الرحم الذي عرض له الجفاف

ابن رضوان هو دواء طيب
الرائحة يقال انه ينبت من أصل
شجر أم غيلان باليمن **ابن سينا**
أجوده الأصفر الخفيف العذب
الرائحة والأبيض الرزين رديء حار
يابس في الدرجة الأولى وجيد
للمعدة **ابن رضوان** قابض بارد
يابس يقوي الأعضاء اذا ضمدها
ويمنع العرق ويطيب رائحة البدن
ابن سينا يقوي الجلد وينشف ما تحته من الرطوبات ويقطع رائحته النورة
الجويني ملطف يقوي المعدة والكبد البارد يبرد اذا انضمد به من خارج واستعمل
من داخل **بطم** في
شجره الجبة الخضراء بشقفتن وهو البطم
الغلاجه ينبت في الجبال
وعلى الحجازة والصخر وعيدانها
خضر الى السواد وحبه
الخضر د آ طرمنبس ثمره
الجبة الخضراء هي شجرة
معروفة ح ح ج اجزاء هذه
الشجرة وثمرتها وزفتها طاليبس وهو البطم

وهو الصلب الأرضي فالمزاج فيه اكثر وخلط مزاجه قبض ايضا ولذلك
صار فعله فعلا قطاعا نافعا كما نرى وبهذا السبب صار ينفع من الكلب
والنمش والبرش الكائن في الوجه ومن الجرب والحكة والعلة التي تنتشر معها
الجلد ويلطف صلابة الكبد والطحال وان شرب انسان من عصارته وزن
مثقال باعلى المآء وامزج الفرك كبيرا وسهل من اسفل ايضا اسهالا
ليس بدون ذلك متى استعملناه وجزء زيد نفعه بعض الاحشاء وخاصة الكبد
والطحال نقاه مع خلوا واذا استعملناه ايضا في الاشياء التي تستعمل فيها من خارج
خلطناه بخل فانه اذا صار مع الخل كان اكثر جلاء به حتى جلوا الجرب والعلة الى
نفس الجلد وجلوا ايضا اكثر من جلاء به لهذا الكلف والبهق وتشعفه والنمش
والبثور المفرجه وجميع الادوا المفرجه المتولدة عن الاخلاط الغليظة وتتلوا اثار
الخروج فاما العشر الخارج من حيث لبان نقبضه اكثر بخ ولذلك يمكن
الانسان ان يستعمله في المواضع التي يحتاج فيها الى القبض الكثير اذا شرب
من عصيره مجفوا قام مقام ادوحنى خل ممزوج بما اذا ابت الطحال وقد يضمد بها
للطحال ايضا مع دقيق الشيلم والشراب المتنى بالقراطيس ويضمد بها المغربن واذا
استعمل خل اذهب الجرب المفرج والذي ليس بمفرج والبهق الا اثر السود
العارضه من استعمال الخروج واذا استعملت بالبول قلعت بثور اللبنه والثواليل
التي يقال لها انشور والكلف والبثور العارضه في الوجه واذا شرب بالشراب الذي
يسمى ادرسالوهحي النى واسهل البطن ايضا فشرها اشد قبضا والخمر الذي يكون بها
اذا اعتصرت ينفع في اخلاط الادويه الموافقه للحشوبه والحكة وقد
يصنع الانسان ان يصنع كما يصنع دهن الخروزة وله قوة جلوا ما في الوجه من الامرا العارضه
من استعمال الخروج ويسهل البطن وهو يردي للمعده ويوافق وجع الاذان ودوى بالخطا
اذا خلط بشحم البط وقطر فيها :: غبيره جب البار يشد اللثه وينفع الرعاف
ودهنه يلين العصب الجاسى جدا والشيخ طبخ اصله اذا تمضمض به نفع وجع الاسنان

حلا
كان

غير انها اضعف واذا طبخ بماء وشرب نفع من سوء الهضم ومن نهشة شى من الهوام ومن به تشنج الاعصب وبدر البول ويوافق الفروح العارضه به اذا اخلط مع النوع من السوس المنبى اربعا اذا اخذ يابسا ويخرج فتوت العظام وقد يفع باخلاط شى من الطيب

بان ابو حنيفه البان شجر ينمو وبطوله استوا امثال بنات الانل وورقه ايضا يشاهد كذلك الاثل وخشبه خوار رخو خفيف وقضبانه شجره خضر وهدبه يبت في القضب وهو طوال اخضر شديد الخضر تمره تشبه قرون اللوبيا الا ان خضرها شديده وفيها حب فاذا فتق واستخرجه اعتبرتح الفستق ومنه يستخرج دهن البان ويقال لثمره الشوع وهو مربع ويكثر على الحدب واذا اراد طبخه دقه على الصلاية وغسله حتى ينعز لقشره ثم يطحن ويعصر وهو كثير الدهن

حب البان ثمره بحجم تشبه الطرفا وهذه الثمره تشبه البندق وقد يعصر ما داخلها مثل ما يعصر اللوز المر فيخرج منه زيت وبه فيستعمل في الطيب المرتفع مكان الدهن وقد تنبت هذه الشجره ببلاد الحبشه ومصر وبلاد الغرب وبالموضع من فلسطين المسمى بطرا واجود هذا الثمر ما كان حديثا ممتلئا سهل القشره وهذا دواء يجلب الناس من بلاد الغرب والعطارون يستعملون عصاره لبه وجوفه وجوهره جوهر جارٍ فاما الثمر الذى يستخرج العصار منه

واعلم من بعد والمغشوش فانه يطفوا مثل الزبد ويجمع او يتفرق فيصير بمنزلة
الكواكب والخالص منه على طول الزمان يخرج وبعد وقد يغلط من يظن ان الخالص
اذا قطر على الماء يغوص ولا ينغمقه ثم انه يطفوا عليه وهو غير مخيل واما
العود الذي يقال له عود البلسان فان اجوده ما اخذ ثم دقنوا لعيدان
احمر طيب الرائحة حشا منه رائحة دهن البلسان اخذ مزجه عقد
الجاجدالنه ما كان ممتليا كبيرا يصلح للدغ اللسان ويوجد به جدا يسيرا وفوج
منه رائحة دهن البلسان وقد ينحت من البلاد التي يقال لها اطراسون شبيه
بالافاريقون يغش حب البلسان يستدل عليه من انه اصغر قارح ضعيف القوة
طعمه شبيه بطعم الفلفل ۞ ۞ البلسان يخفف ويحر في الدرجة الثانية
وهو مع ذلك لطف وللطافته صارت لطافته رائحته طيبه واما دهنه
فهو الطف قوه من البان نفسه ولبزله من الاخبار وقد ما طبه به قوم غلطا
منهم بنبت لطافته واما ثمرته وهو حب البلسان فوتهما من جنس هذه القوة
بعينها الا انها اقل لطافة من دهنه ۞ قوة دهن البلسان شديد جدا اذا
اجتمع مع ثمر ودهن وزاد ابرا من طبله البصر وبرودة الرحم وهو جار من فرط
الحران واخرج المشيمه والجنين واذاكه اطلا الناض ونقى القروح واذا اشرب
ادر البول وكان موافقا لمن به عسر النفس لانضاجه للفضول واذا اشرب بلبن
كان موافقا لمن شرب السم الذي يقال له افوقيطون و لمن نهشه شي من الهوام وقد
ينتفع اخلاط بعض الادهان النخل للاعياء واخلاط بعض المراهم والمعجونات
وبالجمله اقوى ما به البلسان دهنه وبعد دهنه حبه وبعد حبه عوده موافقا
اذا اشرب لمن به شوصه او ورم جانبيه او زنبه او من به سعال او عرق النسا أو
صرع او سدد ومن لا يمكنه النفر دون ان ينصب او من به مغص او عسر بول
او من به نهشه من الهوام وهو موافق في اخلاط الدهن الذي ينفع من وجع الاذخار
واذا طبخ وجلس في ما به البسان فتح قرا الرحم وجرى منه رطوبه وللعود قوة الحت

عصان فثا الحمار، أو ما طار حس هو الحوت المعروف وفي التركاب

حرف الباء

بلسان

بلسان د: وعظم شجرة مثل شجرة الحنة الخضراء أو مثل شجرة يوافس له ورق شبيه بورق السذاب غير أنه أشد بياضا كبيرا وأطول وأدق وزكا ويكون في بلاد اليهود فقط في غورها وقد تختلف بالخشونة والطول والرقة وقد يسمى ذلك الزيتون الذي شبه الشعر الموجود في شجر البلسان أرسطوز ولعله يسمى مكني له نحضر إذا كان دبيقا. وأما دهن البلسان فإنه يخرج بعد طلوع الكلب بأن يشرط الشجرة بمشرط حديد والذي يسل منه شيء يسير والذي يجتمع منه في العام ما بين الحمسين إلى السبعين رطلا يبلغ في مكانه بضعف وزنه فضة والجيد منه حديثا قوي الرائحة خالصا ليس فيه شيء من أجل الحموضة سريع الإنحلال إذا قبضا بلدغ اللسان لذاعا مسيرا وقد نغش على ضرب فإن من الناس من يخلط به بعض الأدهان مثل دهن الحنة الخضراء ودهن الحنا ودهن شجرة المصطكى ودهن السوسن ودهن البان والدهن الذي يقال له طرييون وبعض الناس يخلط به عسلا أو شمعا قد خلط بدهن الآس أو دهن الحاجة روحيا والسبيل إلى معرفة هذا منه وذلك أن الخالص منه إذا قطر منه على صوفه

أوبله خانق الكرشنه وهو الجعيل ∴ اورسيبى الكرشنه باليونانية ∴ اوزيرا ∴ هو الارزباليونانيه ∴ اورطينوس هو افيثوس فسرجنين كتاب المامرجالينوس وبقال ايضا اورسطيوس اوربغانس هو النودج الجبلى ∴ اوربغانس راع باضرب منه برى ∴ اورسيما هو السوسن الابيض البرى على ما جاء فى بعض التراجم ∴ اورليسيم هو التودرى ∴ اورساليون صنف من الكرم الجبلى ∴ اوربغانس هو افيثوس ∴ اوريحى هو خانق الكرشنه وهو الجعيل ∴ اوعبرا هو الفنخ كشت اوفاطلن بذكر الغاز ∴ اوفاطوريوس هو الغافث اوفمواياس هو نطاريون ومعنى اوفمواباداش شبيه الباذروج وقد يسمى ايضا الاسخيص الاسود بهذا الاسم اعنى افوياداس ويسمى ايضا النبات المنمى فيلبويوديون ∴ اوفمون هو الباذروج باليونانية ∴ اوفواسطافل معناه باليونانيه عنب الحيه وهو الكرمه البيضاء من كتاب د ف ك ومن الناس من يسمى الكبر بهذا الاسم ∴ اوفوسفردن هو الثور البرى ومعناه باليونانيه ثوم الحيه ومنهم من يسمى الكبر ايضا بهذا الاسم ه اوفريبون هو الفرسيون ∴ اوبطربون هو قاتل النمر اوساليون هو الكرفس الاجمن كتاب د ∴ اوسيرس هو الثعلى ∴ اوسقاميس هو البنج ∴ اوكسوم سينى هو الخيزران ∴ اولاما مى يجرج الغاذ بالريانيه ∴ اولاسانون هو الكرفس الثمرمن كتاب د ∴ اوليا هو البحغ ∴ اولينا هو الكيث ∴ اوسطيون هو الجبح ∴ اولواجين هو مثل البهود من د ∴ اولودا هو الكيث ∴ اولوفطس هو الكبر ∴ اولوفون هو الاشخيص الاسود ∴ اوما هو فتاج الكرمه ∴ اوماذا هى

امعطا لبطس هوالنوع النكر ∴ امسوسين موجر الحنطه
من الجاوى ∴ املق هوالامج ∴ املوك قيل هوالمازريون املى
هوالنشابج ∴ اموسافن هوالاشق بالبونانيه ∴ امولن هو
النشابج ∴ امومن هوالكما ∴ امى هى الناخواه ∴ اوا
هى العبرا بالبونانيه ∴ اوافسش نبات قد تقدم القول عليه
نماه الرازى بجداول الجاوى الحرى ∴ اوبطالن نوبع من
النبات المسمى باسم الغاز وسندكره مع الغاز ∴ اوما طوربوس هوالغافت
بالبونانيه ∴ اوناعرن نبات يسمى انغرا وقد تقدم القول عليه
اويسلا هوالجلنار من الجاوى ∴ اوبطس صنف من النوبج
الجبلى ∴ اوقفنوون قد تقدم ذكره وزعم قوم انه نبات ربيعيه
الشماى ينبت بين الزرع ويسمى بالمجمسه البلوك ∴ اوبدون هوالطرخشون
من الجاوى ∴ اونكس هوجر المزمر ∴ اوبعلص نبات قد
تقدم القول عليه وقد يسمى نبات اخر بهذا الاسم وهوالغار الاسكندرانى
اويقس هى اظفار الطيب ∴ اونفس هوالمزمر ∴ اوشنوف
هوالاشنين بالبونانيه ∴ اونونيا هوالكما طوس ∴ اوعبرا
هوا وافسش ∴ اوبحلوس هوصنف من السحار ∴ اوبوعلوس
هوا وبعلص ∴ اوبوقليا صنف من السحار وينال ايضا انقليا ∴
اوبيوس هوالشريس ∴ اوبولس هوانوما ∴ اوجيلوس
هوصنع الخطمى من الجاوى ∴ اوحروس هوصنف من الجلبان
اودربا فارى معناه بالبونانيه فلفل الماء وفى جداول الجاوى
باره هذا الاسم بتله يسمى القاتلاه وهذا الخط واظنه اراد بالناقل هنا البتله
التى يسمى بها بعض الناس السلام وهوالوارس ∴ اودرحورس هوالزبون
من كتاب د ∴ اوارا س هوالحرجير بالبونانيه ∴ اوزالحى

اصفر ايضا فى خلقته و زق الخلاف يشبها الناظر اليها حركتها فاجن لك
ياتن زايجه واختها ٠ **امر وجع الكبد** قيل انه النبات المسمى بالبولى
ولم نجتهد و قد ذكرنا فى قول ابى حنيفه فى هذا النبات و تذكر بعض
الناس انه المسمى باليونانيه اقسقطس ٠ **اما ناطن** واما ناطون هو الطلق
من الحاوى ٠ **اما بكه** قيل انه العقعقه ٠ **اما زاقن** هو
الاخوان باليونانيه ٠ **اما زيطون** و **اما زبطرن** قد تقدم القول
عليه وهو من المنش مريشبه الخوان اصغر وقد سمتاه بعض البلغا كمونا
هنديا ٠ **اما در اقفطس** سودا الاخوين على ما زعم ابن اخوان
عمران قال وتاويله دم النبتين ٠ **اما زنفن** واما ريفون سود
الاخوان ٠ **اماطنيطس** هو حجر الدم وهو الشاذنه ٠ **امتد**
وهو الخروع من الحاوى ٠ **امند** ما جى الحاوى و امند ريان هو اسند ايا النبا
وهى سفندا سفند ٠ **اميرمبس** هو المازريون من الحاوى ٠
امبروسيا سمى بهذا الاسم نوعا من النبات يسميه الناس البلجاسف
وقد ذكرناه ومن الناس من يسمى الشواصير امبروستيا ومنهم من يسمى
الثويلا وهى البلجاسف هذا الاسم ومنهم من يسمى جرجم العالم الكبير امبروستا
اميزون هو الطرخشقوق باللطنى ٠ **امبلون** هو الشاسح
باليونانيه ٠ **امزاقن** هو المزدجوش باليونانيه ٠ **امزاقون**
هو الآبنوس ٠ **اميرطابل** هو الملح ٠ **اموغا** وامرتا هو عكر الزيت
امرسنا هو اللبلاب الصغير من كتاب د ٠ **امزكها**
هو الهليلج من الحاوى ٠ **امزون** هو المازريون من الحاوى ٠
امطوطو ليثو هو حجر الدم ٠ **امعا قطس** هو العفص الاخضر
امعا فوقرين وامغا لوقرين هو البلسكى ٠ **امعداني** هو اللون
باليونانيه ٠ **امفافيون** هو الزيت المعتصر من الزيتون ٠

الصغير من اخبات الحطينا هو اجلنا زمن الحاوى الص هو الملج
باليونانى العما انبات تسمى مزمارا الراعى القناريوس
هو صنف من السحار كبر وايضا قدتسمى اجنون بهذا الاسم الفرانيون
هو زبد البحر باليونانيه ويقال لغرايست لقنس هو صنف من على
العنوش القسبنى من الاسم بغع ناير احدهما يقال له البرطال وهو
نبات يشبه شاهسفرم وتجلى به الزجاج والاخر هو الللاب الصغير
ويكتب ايضا الكستى بالكاف وهو ايم يوناني فيه من نفس الاسم
غير رايدتس التعريف واتما قلنا هذا لان كتبرا من الناس يغلطون
فى هذا الدوا فيكتبونه فى حرف الكاف والثاف المروالمرة
هو زنيج اصفر من الجاوى الموس هو الدخن باليونانيه
المى هو الملج باليونانيه اله هو الراتى باللطينيه ومعناه الجناج
شبه وزنه جناج الطاير وقد فجه للطيبران الوان والوين هو الصنوبر
باليونانيه الوين نبات قد تقدم ذكره ونعم قوم انه النريد
ولمربح وقد وقع استم هذا الدواى فى بعض الذب الوين فى بعض الوبنات
وراينه ايضا الوطق فى كتاب بولس اماصرون فى كتاب ابن سبنا
يوومون الوفودن هو صنف من الكما فطوس الراسا جنى
تاويله عبارا الملح وهو السروح وقد تسمى ايضا بهذا الاسم صنف من زبد البحر
الوسن قاك البطريق تاويله منهب الكلب ويكت ايضا الوسن ولس
وقد تقدم ذكره وبعض الناس يزعم انه خامى اعطى وهو كذب الوة
هو عود الجور من اللغة الوى هو الصبر ام السعا
هى الصزمه ام عملان قيل انه القرظ ولمربح وقيل هو الطلح
وقيل هو الثمر ام كلب قيل انه بلعودرس وقيل انه البطا فه
الجلية فاك ابوجنيغه هى تجره جليته جلدته لها نوار اصفر ورق

معادن أخرج آبيض يستعمله الصاغة في الجلاء و في كتاب ما فرط سطرس الأحجار الانباط سطرس حجر يوجد في أرض دمشق و الشام أبيض اللون فيه خطوط شبه مناطق و في بعض الكتب أنه صنف من الرخام رفيع بني المرمر و سنذكره في حرف ميم و زعموا أنه الجزع بعينه و ليس يصح ث **الابوزيني** ويسمى أيضا أبيفطن و قد تقدم ذكر هذا النبات ٠٠ **الابورس كو فوس** هو الحربوا الابيض **الابورس مالس** هو الحربوا الاسود ٠٠ **الاطريون** هو عصبان قتا الحمار ٠٠ **الاطي** شجر له صمغ مثل صمع الصنوبر و قال حنين في كتاب تدبير الأصحا بالجالينوس قيل انه شجر بمنزلة الدلب و زاد مثل و في الفلاحه الروميه و منه انه من جنس الصنوبر له ثمر كالجوز و اللوز و أخبرني رجل خبر أنه رأى شجر الاطي ببلاد الأفرنج و داخل بلاد الروم معروف عند جميعهم بهذا و وصفه بهذه الصفات المذكوره قبل قال و حشه هو الفندق الذي يوتي به من بلاد الروم و يعمل منه دقيق السروج ٠٠ **الاطي** أيضا في كتاب ك هكذا حقيقه هذا الاسم باليونانيه و اختصر فقال اسافن و هو السالفن و قد تقدم ذكره و قد يقال باللون الاسعافن ٠٠ **الاومالي** تاويله باليونانيه دهن العسل و يسميه أهل الشام عسل داوود ٠٠ **النشا** هو الخطمي من كتاب ك ث **البنيس** هو نوع من النبيخ من الأدوية المقابله للأدواء ث **البثما** هو مزمار الراعي ث **الجبني** هو الخيزران ث **الحرس** هو أما بطون ٠ **البيح** و البجوج هو عود الجوز ٠٠ **المقاين** هو الكاكنج و أيضا عنب الثعلب المنوم و أيضا فنيون و قد يقال لينا فانون ث **البسيني** نوع من اذان الفأر و قد تقدم ذكره ٠٠ **البهن** هو الملوخ اليه بالفارسيه هو السفرجل ٠٠ **البوجيو** باريميسه هو الخبني و يقول العامه الحشه **البورن** موصنف من الكما فطوش ٠ **البوس** قطي هو الصنف

هو البزر قطونا على ما وجدت في بعض الكتب وانما في كتب سيلون
اسمافور صنف من الجراد بلا جرجول وانجحه برونه :: اسم العدوس
هو السنبت اشمس اسمر مثل هو الفرخشك ويقال اسمر
ستيرم :: اسوا هو منزل ابيض السنبانته من الحاوي اسوفن
هو الزوفا :: اسوس هو الشيطرج وجدت في بعض الكتب اسوس
هو العويج وهذا خطا فاحش وانما صحفه من راسيون اسورن قبل
هو السخباء :: اكباه هو بزر الجزجير على ما جاء في بعض الكتب
والصواب كله :: السوطا هو عزل السمك :: ارد هو عود الجوز من
الحاوي :: اكسنا هو الاخضر الاسود :: اكسوفيلن
ما وله اجاد الورز وهو الحزمانه :: السولافاتن مرحماض السوائي
اكسوموسني هو الخيزران وهو الذي يسمى بكتاب الآن
البري :: اكا زعم قوم من المفسرين ان الا هو الدفلي وزعم بعض الناس
انها الطباقة وقال ابو حنيفه الا من شجر الرمل ذا برالحضم وزقه
هوحب وهو من طيب الريح يريغ به :: الا باليونانيه هو الزيبون من
كتاب د ورسالة الترياق المنسوبه الى جالينوس الايون وا يكون
في بلاد امه توعا الماطريا باحن اهل تلك البلاد فيقلعونه على ارجه
نسابهم فاذا اصاب ذلك الناب الانسان وادمى يده مات من ساعته
واذا اكل انج الانسان من الموت ولابضر اكله شيا وزعم ازنوا الاكل
بنهم من هذه النهام فيموت فان اكل احد منه لمحف ضرر ام ذلك وهذ
صفة البقلة المعز وقد عندنا بقلة الزماه وهي التي يستعملها الطباونا عم
الكندس الاخطوس هكنى ادخل الرازي هذا الاسم في الجاوي
وهو خطا والماهو فالاخطوس وهي الرلبلة :: الاسطرطس هو
الحجر الفوايرى وقد يسمى ابضا او لكس ورايت في بعض الكتب انه رخام بوجد في

أبي حنيفة وأما الجزر الآخر العربي فهو معروف بالعراق غير معروف بالأندلس وهو المسمى باليونانية مولي يسمى بالفارسية مدلدراع وحدث في بعض التفاسير اسفندار هو الجزر الأبيض وأظنه تصحيفاً ٠ اسفند اسفيد هو نبات يسمى باليونانية لوفايرس وسماه الطبري حرقاً أبيض وفسره الرازي نحو الجادولى كاوى اسفيناج اجص هو الجنين ٠ اسفمطا واسقيطا هو الجنسين من كاوى ٠ اسفنضار هو حب الخروع اسفنور هو السفنور بنكر وحرف آن ٠ اشفيل هو العضل ٠ اسفس قال بعض المفسرين هو اليمسوت عند العرب وهو الذي يقال له الفوبه بالعجمية ٠ اسفيوس هو البزرقطونا بالفارسية ٠ اسفعو هو الاسنج البحري ٠ اسفعو هو القط ٠ اسعس هو الخطمى اسفسنت هي الفصفصه وهي الرطبة وهي اتم فارسي اسفلت اسم رومي يقال للنفر اليهود مزفت البحر ٠ اسقلسناس نبات قد تقدم ذكره والقول عليه وسماه جنس في كتاب جالينوس في الادوية المفرده القنابرى والقنابري غير هذا ورايت في بعض الكتب قنابرى واظن ان القنابرى وقعت فيه تصحيف فان الموصوف بالقنابرى بعيد من صفة اسقلسناس جداً ٠ اسفلطون واسفلطن هو قفر اليهود باليونانية كذلك يسمون دمع البحر والموميا والقط ٠ اسقلطس هو الحومانة التي بهذا الاسم من قبل ان زائحته شبيهه برائحة قفر اليهود اسفودالس وهو الخنثى ٠ اسفوريدائس موصف من الهو فارسي عيون ٠ اسفولاوه هو القط البابلي ٠ اسكندرانى
الغار
يذكر اشك بردين رق انه العوسج قال ابن جلجل وتاويله بالفارسية شوك الحظاير ٠ اسكحدا اسم سريانى ويسمى بالفارسية طرسفلس وهو الجرمانه ٠ اشكله هو العضل بالعجمية ٠ اسليون

فلم يبرز في جمال المنسرين بن حام الا ما بين حام الاون وظنوا انهما واحد

اسد العدس هو الجعيل بهذا الاسم لانه ينبت بين العدس فيفسده ويسمى ايضا خاتم الكرسنه ٠ **اسدوهي** هو الجاميث ٠ **اسميس** واشراس وهو اصل الحنثى ٠ **اسرب** هو الرصاص الاسود ٠ اسرعند واسرعند يسمى خورا البربر وهو اليقطوم ٠ **اشروا** هو الاسارون اللطيبه ٠ **اسطارمى** زعم بعض المفسرين انه الزبد ٠ **اسطاخس** قيل هو الدارصينى ٠ **اسطام** هو الحديد الذكر وهو الفولاذ ٠ **اسطيوياس** هو الشب باليونانيه ٠ **اصطربوس** معناه باليونانيه الزكى وهو صنف من حجر الشب ٠ **اسطروق** زعم فوم ان الماميثا يسمى بهذا الاسم **اسطردوس** هو فثا الحمار من بعض النراجم وفى بعضها اسطربدوس قيل انه دباق لازبغ ٠ **اصطرخون** هو عنب الثعلب ٠ **اصطرويون** هو الكندس باليونانيه ٠ **اسطرون** مكنى وقع فى الاسماء بعض الكتب وهو تصحيف وانما اسطرويون هو الكندس المذكور قيل هذا **اصطزيقون** هو التلى ٠ **اشغالايس** هو الفنه علما زعم ايحنن عمران ولمى بها بهذا الاسم ٠ **اسعرانى** الحادى انه اصل اللوف ٠ **اسعبرون** هو نوع من الهوفا زبقون **اسفراح** وانفاراج هو الهليون بلسان اهل الاندلس واصله بالرومية اسفاراغش ٠ **اسفالانوطش** هو السكر منجد ولى الحاوى وفى موضع احرمنه اسفالانوطش سام ابرص وهو السمربص **اسفاليتيا** هو العلس ٠ **اسقناطا** نبات يسمى ايضا انوما وقد تقدم القول عليه اسفند هو الحرمل العرى ابن حجلا وهو البات المسمى باليونانية مولى سنذكره اذا ذكرنا الحرمل وذكر غيره ان الاسفند هو الحرمل الفارسى وهو المعروف عند جميع الناس بالحرمل وهذا القول اصح وهو ابو انقول

انارومانه اسلا بوطيس هو العقاب ٠٠ امّا اسفار اعس
بطراوس معناه باليونانيه الملبون الصخري قال د ٠٠ وقد تسمّى ايضاً ثمر
اللوسا اسفار اغث استاڢور هو الشادنج من الجاوي ٠٠ اسلا ابون
دازبشغان ٠٠ اشنان هو العتول وهو الحرض وقد تقدّم ذكره ٠٠
اشنان داود هو الزوفا ٠٠ اسفند بازهي الكرمه السودا
بالفارسيه ٠٠ اسبزان في الخلاف ٠٠ اسفيس هو السفنور
وهي باللطيني اسكه وقد يسمّون ايضاً خي الثعلب اسكه ٠٠ اسرابكه
واسمحر هو الاصطرك ٠٠ اسّرغاز قيل هو اصل الابجدان واصل
الابجدان هو المحروث وقد تقدّم ذكره والفولس علي الاسّرغاز وزعم قوم
ان اصل الاسّرغاز هو اصل الكاشم ٠٠ اسرعاره قيل انه العوسج ٠٠
اسبرعي هو السوزنجان ٠٠ اسه وحبه هو الزراوند
الطويل ٠٠ اسطر بلبس قيل انه صنف من الخامر يوجد في معادن
الجزع ٠٠ استنفير هو الزوفا الرطب باليونانيه وهو العلج ٠٠
اسبوس هو حجر اسوس الحجاز ٠٠ اسوس هو الشطرنج باليونانيه
اسبولي واسبولس هو السواد وهو مداد يستعمله المصوّرون من كتاب
اشبح واسوهو الوشي ٠٠ اسجار قيل هو النودرى الذي
يسمّى ازوسمن وسمى بالحبشيه تسداله ٠٠ استخيص صنف من الثوم
يسمّى باليونانيه خاما لاون وقد تقدّم ذكره والاستخيص ايضاً ضرب من النمّ
اسحل زعم قوم انّه المعرّ وف عندنا بالخلج ولبز يصحرف الانجل
شبه الاثل ويغلط كما يغلط ولا يكاد يفرق بينهما من لا يعرفهما ومنابته
السهول وقضبانه تمر وسناك به ٠٠ اسد الارض اكثر المفسّرين
يزعمون انّه المازريون باليونانيه وهو خطا وائل الارض باليونانيه هو خاما الارض
وسبب غلطهم ان اسم المازريون باليونانيه خاما لا ومعناه زيتون الارض

علّيق الكلب بهذا الاسم قال اسحٰق بن معنى اسنا الحاد ومعنى ابن الشوك فمعنى هذا الاسم الشوك الحادة ويقال انها الشجرة التي تحمل الحب المسمى زرشك وهو الامبرباريس يؤتى به من خراسان :: افسنتين لحرى هو الشيح :: اقسيني هو اللبلاب الصغير :: افسيوس هو العفي :: افشرج او بله بالفارسية ربّ جمّا وقد منه البعل افشرج وهو ربّ السفرجل ومورد افشرج وهو ربّ الاس وانما الافشرج وهو ربّ الرمان وكذلك ما اشبهه ::

اقسطافرقطس هو العنصل من الحاوي :: افسرالي هو البلح من الحاوي :: افسرا فلس وهي الشوكة الحادة وهي الفيلزهرج وقد يسمى ايضاً علّيق الكلب بهذا الاسم :: افشنوحز هو القلب :: افسوس هو الدبق وايضاً الانخيس الاسود وايضاً اقسوس دواء من التمور ذكره ذ فالك ابن الجرار اقسوس يشبه الباذنجان فى عظمه ولونه :: اقل هو الّبلو فرن من الحاوى :: افلنحه ولحمه مذكر في حرف فا :: افونات هو صنف من السلج صغار جمّ ذكره من الفلاحة وهو اسم نبطى :: افوسناس صنف من السلج صغار ذكره ذ وهو المذكور قبل هذا :: افوبطن وابوبطن فابوسطى هو قال ابن الذيب وقائل النمر :: افوزون هو الوج :: افوزرن هو ذنب الخل :: افوقاميس وافوميسجان لحرى نعم ابن جلجل انه البلدى مرس واخطا فى قوله وصحف اسمه ايضا وفسد وزعم غيره انه الحوت المعروف بالكلب وهو اشبه والبله من هذا المسمى باليونانية فوقا افونس ونوفنون هو قاتل الكلب :: افوسا من ذكر بعض المفسرين فالك هو كرذس برّى والاسم هو مصحف واما هو انوسالبيز وهو الكرنب المشترى به :: افولا فاتن هو حماض التواى الكبير ومعنى هذا الاسم حماض الخل :: افومازثون وانومازث هو الزاباج العزيز ومعناه ايضاً ازباج الخل :: اسازوم هو الانارون وهو بالنبطية

هو ذنب الخيل ٠ اقومطس هو جزر المنث ٠ افريون و افربيون هو
الفوربيون ذكر في حرف فاء ٠ افريطون هكذى وقع هذا الاسم
في كثير من الزاجر وهو تصحيف وفسروا بانه الشيح والصحيح انما هو افرطبون
وهو القيصوم ٠ افربوس هو بقلة معروفة وهو الزواتر ويعرفه
الناس بالعلام ٠ اودغارن هو الادربون من الحاوى ٠ افرنطرون
هو زبد البحر ٠ افروح وهو صنف من الجازه بذكر في حرف حا ٠
اقربطوس هو الشيح من الحاوى والصحيح انه القيصوم وهو قرطبون
افروسالنون تأويله النمر وهو زبد الجمان ويسمى ايضا صاق الغنم
يذكر في حرف ب ٠ اقطوعون هو سيبون ٠ اقطربون هو
السكبينج من الحاوى ٠ اقطفا هو الافسنتين ٠ اقطن هو الماش
بلغة اهل اليمن ٠ اقطوم هو الخربق الاسود من كتاب
اقطى هو الحامل بذكر في حرف حا ٠ وهو شجر معروف منه كبير يسمى بالجبه
شبوقه ومنه صغير يسمى برقة وقد ذكرها بصفنها وجلبها وما ارى
احدا حمل من المفسرين الذين كتبوا في شهر افطى شجرة هندية وهى صنفان
اجدهما هو البلو والاخر هو البسلو وهذا القول هذيان وهم يقولونه عن
الرازى بانه ذكره في الكتاب الذى تماه بالكافى وقد وجدت للرازى نفاسير
كثيره كاد به هذا احدها فان كان ذا نجرب للبلو والبسلو كما نعم الرازى انه
افطى فان افطى عبر هذا النبات الذى تماه بالبونانيه افطى وقد بلغ الجهل
ببعض المفسرين الى ان قالوا ان افطى هو البلو والبسلو ان البيقه والبنوفه
انما يسميان بالبونانيه حاما افطى وهذا كذب واثنى ٠ حاما افطى الصغير
منها وهو البذقه خاصة ويسمى السفنج جميعا افطى ٠ اقصلين هو حماض
برى من كتاب ٠ افسيما هو الديو بالبونانيه وقد يسمون بهذا
الاسم الانجبين الابيض ٠ افسياقس هو شجرة الفيل دهره وقد يسمى

هو الفنجنكشت ۞ اغرس هو الجوز الرومي بالحا والراغ معجمتين لا بالحيم والراي كما يصححه الجهال ونال ان صنعته في الكهبا ۞ اعيسن تاوبله بالبونانيه الطاهر وهو الفنجنكشت ۞ اعليص هو الدوتم بالبونانيه اعمالا هو ريتون اعرياقانش هو فستري ۞ اغرياميفن هو خخاشي اعريو ساليين موكرنزبري ۞ اغربولن هو الكرفس البري ايضا وهو الكرمه المعروف بالمشرق ۞ اغرسطس هو النبل ومن البونانيين من يسمي الكرمه البيضاء اغرسطس ۞ اعلاوفرطس هو الفا وانيا ۞ اعلبني هو المحتج ۞ اعلوفرطس هو الطلق من الحاوي ۞ اعروجن هو التتبع ۞ افانش هو افنون ايضا وهو صنف من الشوك وقد تقدم ما المول عليه ۞ افانس وهو صنف من الشوك ايضا وهو الهيشر ۞ افادي وهو الكما ذبوش ۞ افاربني وهو البسلي ۞ افارون هو اروج بالبونانيه ۞ افايا من رب القرط بلذرن حرف القاف ۞ افاقلس هو الاثل ۞ افاقي هو البيقيه ۞ اثالبغي هي الاجنره بالبونانيه ۞ افاوانبا هي الفا وانبا بنكرن حرف فا ۞ افسيني ارانقي تاوبله بالبونانيه الشوكه العربيه وهو النكاع ۞ افشالوفي تاوبله بالبونانيه الشوكه البيضاء وهو الباذاورد ۞ افنبا الجلار من الحاوي ۞ افسس هو فرجمك ۞ افيمبلس هو الزغزوز ۞ افندوطون هو وازنس ۞ افندوفطس هو العضل من الحاوي ۞ افنط هو المازريون بالبونانيه ۞ افيمارون هو الرودرجان وايضا السوسن الاصفر ۞ افيمو ايراس هو الاخيص الاسود وايضا البان المني فلطاريون ۞ افين هو اغرورس وايضا الكرنبي بهذا الاسم ۞ افيون يذكر في باب الخشاش اقورن

هو اللوز الدقيق ۞ ارونيا الزعرور باليونانيه ۞ ازيمون فازيمون هو الثمام ۞ اريوداس هو القوة ۞ اروسيمون واروسيمون وارونيم النودري اططا هو العوسج الأسود ۞ اطراخابا الباذرنجويه ۞ اطرون هو الجزر اليهودي ۞ اطماط واطبط واطموط هو البندق الهندي وقيل انه الموز وقيل لبن صحيح واظنه الزنة ۞ اطموس هو البنج من الحاوي ۞ اطهنا هو الجستين من الحاوي ۞ اطهورس هو السكران من ح ۞ اطوليوس موجب لشان ۞ اصابع العذارى هو صنف العنب طوال كالبلوط وسمى البقري ۞ اصابع الفتيات قال ابو حنيفه هو الرحانه التي يسمى بالفارسية فرنجمشك وهو قاص ارض العرب كثيرى لا يرعاه شي ۞ اصابع صفر يعرفه الناس عندنا بقنطريوم وقد عايشه وقد نقدم القول عليه وقد زعم قوم ان الاصابع الصفر هو الماميران ان ذلك خطا ۞ اطباطيس هو نيل الصباعين ۞ اصاص موجب المشان يا برنبه ويقال زاز ۞ اصالا وفا هو صنف من الجدفر قا اصبالاوس مودا ۞ شعنان اصابع هرمس هو فتاج النورنجان ۞ اصحيان هو النحو ان الاصفر ۞ اضراس الكلب قيل هو البساج ۞ اسططاليس هو الشليم اصطراك هو الميعه اليابسه ۞ اصطفلين هو الجزر بلغه اهل الشام واصله باليونانيه سطافاليوس ۞ اصف لغه في اللصف وهو الكبر ۞ اصوفورن هو السحورز وقد ذكر ۞ اغافت هو الغافث ۞ اغاسوليس مرتم الوشق وهي اللخ ۞ اعالوجش هو عود الجوز ۞ اغا هو القسط بالهندبه ۞ اعناس قال بعض المفسرين موجب للعفل وهذا كذب وخطا ۞ اعيش ولوعش

هو النبات المسمى باليونانية نواريس ايضا وسيذكر في باب النون **ارفطاون**
هو لفت برى من الجاوى واظنه اراد به النبات المسمى ارفطوز وقد مضى
القول عليه ‹ **ارفطورن** هو ارفطون ايضا من كتاب د وفدطن
قوم انه المسمى بالحجة الطوله وهو خطا والطوله هو سفلد وليون ‹
ارقليا اليونانيون يعنون بهذا الاسم الثآليل وايضا خشيشة الزجاج وهى
الدطال وايضا الخشاش الردى وهو الجاسوس ‹ **ارفلس** هو النمام
البستانى ‹ **ارفلس اغريا** هو نمام برى ‹ **ارفوسيدا** هوجب
العزعر باليونانى ‹ **ارفوس وارفوسيدس** هو العرعر ‹ **ارفوده**
هو الجار شبير من الجاوى ‹ **ارفوس** هو النمام باليونانيه ‹
ارساسيقون وهو الزريخ الاصفر باليونانية ‹ **ارساس**
قيل هو الحنطى والاسم مصحف وانما هو اشرس وقد صحفه قوم فى تراجمهم
فقالوا الاشراس الحنطى ‹ **ارسليس خطرن وارينين وارسيسفطرن**
هو الدارشيشعان باليونانية فاك د ومن الناس من يسمى السعد بهذا
الاسم ارسططيون هو الراس باليونانية ‹ **ارسططالوحما** هو الزاوند
باليونانيه ويسميه الروم ارسطولوجيه ‹ **ارسعوا** هى السباعة من
الجاوى ‹ **ارسليس خطرن** هو دارشيشعان ايضا سعد وقد تقدم
ارسوس عالا نبات ذكر د رأيت عليه مكتوبا فى بعض الكتب بالعربيه
صاصلى وسندرى فحرف ص ‹ **اركسى** صغ الخطمى من الجاوى ‹
اركوما هو الراس من الجاوى ‹ **ارقانيا** هو المشمش ‹
ارمالا هو الجمل باليونانية ‹ **ارمالى** هو شوكة الحاج من الجاوى
ارميافون هو الجزر الازمنى ‹ **ارميس** هو النلنل ‹ **ارمون**
بوطانيون هو الحلبوب ‹ **ارمودافون** هو النجل البرى ‹
ارمى هو الحاج من الجاوى ‹ **ارن** هو اللوف الجعد ‹ **ارن صارن**

نقلم وهو النهار :: ازسميومس هو الحمر النباتية :: ارسلوش
هو الحمض من الحاوى :: ارغالس واريغلس هو لسان الحمل اليونانية
ازيعى شجر يعرف عندنا بالخلنج وسنذكره فى حرف الخاء وزعم
قوم انه العاقول وهو خطا :: ارساون هو اللوف الصغير
المعروف بالصرين ارووكه هى الخزوع من الحاوى :: ازخا هو الثمان
من الحاوى :: ارجان هو لوز البربر :: ارخارسطنس هو الكهربا
البيضاء من كتاب د :: ارحيقن هو ملح اسود من الحاوى ::
ارحيص هو خصى الكلب وخصى الذيب :: ارحل هو السرنس
ارجلا :: هو النبات المسمى باليونانية دورقنيون ارحمولى هو
صنف من شقايق النعمان ويقال ارغامونى :: ارحون فى الفضة
باليونانى اردشيران هو صنف من المروبس بعد الاثم من الغاسه
ازرر هو شجر النطرار وهو الصنير وهو الذى يسمى عندنا الارز والارز ايضا
ذكر الصنوبر وهو الذى يسمى باليونانية قونا وزعم بعض الناس ان الارز
هو السرو :: ارطا هذا النبت بعضنا من اصل واحد يطول يحرم
قامة وورقه هدب حم ولا شوك له ولا نور مثل نور الخلاف الى انه
اصغر رطب الرائحة وله ثمر كالعناب مرة عزوته شديد الحمرة يصبغ
بها :: ارطاماسيا هو البلنجاس وايضا النبات المسمى امبرونيا
وقد ذكرناه وايضا الشواصير :: ارطدطوش هو اصل اللتاج
من الحاوى :: ارطمسيا هو الاطاماسيا :: ارغامولى
صنف من الشقايق ارعنى هو البرطال وهو حشيشه الزجاج :
ازغبس هو اصل الشجرة المسماه بامبزارس :: ارعمونى
وارعمونس صنف من شقايق النعمان وقد مضى ذكر :: ارفاقلموس
هو شجر الجزع من الحاوى :: ارفان هو الحا :: ارفيذوطون

اذ اماس هو البنج من كتاب د ۞ ادمانطون هو البرشیاوشان
بالیونانیه والنبات المسمی داروح بالفارسیه ۞ ادریره هو الخروع
ادرودایرهی القثوهی بالیونانیه من كتاب د ۞ دازانی
هو قنل الصقالبه ۞ ادراحه قیل انه الجبسن ۞ ادرفنه
بالعجمیه هو اللون الكبیر ۞ ادریره هو رجل الحمامه الذی یصبغ به
الثمر وقد ذكرناه مع اصناف الثمر ۞ ادرس هو البنون بالبربریه
ادریس هو بالیونانیه هو اصل السوس ۞ ادریون نبات یسمیه
بعض الناس بالذهبی معروف عند الناس باسمه وهذا هو الصحیح ومن الناس من
زعم انه جوز مرمر ومنهم من زعم انه العرطنیثا ۞ ارزقطوس هو
القرطم البری ۞ ادروفا فاری هو فلفل الماء بالیونانیه
ادرومالی هو ماء العسل ۞ ادلا هو الشبطرج اذاكمار
هو وزن عرضه مثل الشبر وله اصل كل اعظم من الجزره مثل الساعد
وفیه حلاوه ۞ اذن الفیل هو القلقاس وقیل هو اللوف الكبیر
اذن الشاه هو لسان الحمل الصغیر ۞ ارسیفوس نأویله
الاعرابی وهو حجر یشبه العاج النقی ۞ اباعورن هو صنف من
النبات المسمی قیلون ۞ ارافنیون ح انه جل لبك علی ما زعم
قوم ۞ ارامونی هو مشقانق النعمان بالیونانیه ۞ اراونه هو الخربق
ارباش هو فقاح الكرم ۞ ارباطین هو البرشیاوشان وایضا
طرخوماش ۞ ارباقه هو الزبیب ۞ ارسیا هو الصنف الكرم
عرق الصناعین ۞ ارسا ۞ وارساوس هو البیزلنج وهو الذكار ومن
الناس من یسمیه الحمیر ۞ ازبان هو الجراد وقیل هو الجراد البحری
ویقال ایضا زوبار وقال بعض المفسرین الاربان بلغه اهل الشام نبات
یسمی رجل الجراد وهو ضرب من الاخوان یوكل نیا ومطبوخا ویسمی بالیونانیه

اخراطن وبنال غراطن نبات قد تقدم القول عليه ∴ أخشنه هو
هو بالعجمه اللسان ∴ أحلوس صنف من النبات المسمى بالبوناينه سيذكر
ويقال انه ادم الاخوين ∴ احلس هو الدوسر ∴ اخيون مواتم
الافعى الذكر بالبونانيه وهو الادعوان بالعربيه وقد تقدم ذكر النبات
المسمى بالبونانيه اخيون وهو بالعجمه ريه شان فلجهوله وزعم قوم انه المسمى به شأنه
وغلطوا و زعم احزانه العودبوله وهو خطأ ايضا وقديسمى اخيون ايضا نبات
آخر غير المذكور وهو المسمى بلطاون ∴ احداق المرضى هو
الهائى بالسريانيه عراعل ∴ اجد ارم وهو الحجر المعروف بالاركن و قد
ذكرناه ∴ احزاو هو فلفل الصنابه ∴ اخراس هو اللمرى
البرى بالبونانيه ∴ اخريض هو القرطم ∴ احرسطوس
هو كبريت برى ∴ اخروس هو امارطرو وقد ذكرناه ∴
اخزبط هو نبات ينبت بين طرانى الماء يستدل به على ما بها
قال بعض المحدثين هو نبات بالعجمه سمى ونبقه يعلو بعلو بعل ساق واحد
نحو الشبر دقيقه معقد وله ورق كبرم و رق الاس واطول ورق
عليها زغب كالعباز وهى مثوازنه مزدوجه ولون ساقه الى الحمره وله زهر
أصفر الى البياض ∴ اوطناماس فوراليون هو نوع من
البسد وينال الاطيا ابن موزال البر ∴ احسسمى هو الطلق من
الحاوى ∴ احلاما واحلاما هو السحار ∴ احلوش
هو سيد لطش احمر وهو الناخواه من الحاوى ∴ احمد هو صنف
من السوس ∴ اذا بفور هو المثل الابيض ∴ اداد بالبربربه
هو الاتحيض وقد ذكرناه ∴ ادارى وادرقس وادافيون وهو ثى
شو لذى الحيرات جول القصب من نوع الملح وسمى زبد ابحره وغلط من زعم
انه ملح البلى ∴ ادامس هو الحجر الماس بالبونانيه وتقول الوزر اذا مسس

ذكره ورأيت في بعض الكتب منسوبا الى ابن ماسويه انه نبتي بالعبرّ بيه
العرب وهو مذهب الطبّال ٭ ابهير هو الطلبون ٭ انهفان
هو الخجيز البرّي واصله بالسرّيانية انهنائي ٭ ابهل هو العرعر المذّور
وقد تقدم ذكره ٭ انهما هلبج ٭ ابوا ٭ صنف من الطيور زعم بن
جلجل انه الطائر المعروف بالثعل أنونيا هو الكافطون ٭ ابونرا هو اغفرا
ابو نولس هو انوما وقد مضى ذكره ٭ ابوجار هو الباذنجبويه
ابوجيدرة هو الاذريون من الجاوي ٭ ابوجلس صنف من
السّحار ابوحرما هو القيد الذي يقدّ به السفن من الجاوي ٭ ابوخطرما
هو الماهودانة من الجاوي ٭ ابوذران هو التوذري ٭ ابور هو الجبري
من الجاوي ٭ افورس مودب الجلمن ٭ ابوزيدان
ابوزيدان وهو دواء هندي ومن زعم انه خصى الثعلب فقد اخطى وزعم قوم
انه البج ٭ ابورعنا هو مزمار الراعي ٭ ابورق هو عنب الثعلب لجن
من كناب ٭ انبورن هو انعا ٭ ابوقارن هو الكلبه ٭ ابو فاس
وابو فاوتن هو الاشنان باليونانية ٭ ابوقسطن هو الاشنان ايضا ٭
ابوقسطداس وهو قسطريس نبات ينبت عند اصل لحية التيس ويعرف
بالشملال وهو الطراثيث الذي يستعمل في الطب وقد ذكر مع لحية التيس
ابوقرين هو وقائل الكلاب باليونانية ٭ ابوس هو الرجا باليونانية
ابوس سندر وهو صدا الحديد ٭ انوساليون معناه
كرفس الخل وهو الكرفس المشرقي ٭ انوساما وهو البلسان
ابولاباش هو الحامض الكبير ٭ ابوليون هو التنام المنتي باليونانية
ازفلوش من الجاوي ٭ انوما هو انوما وقد مضى ذكره ٭ احسا هو
البزدي ٭ اجاجي هو الكمّون من ٭ اجاص شتوي فألف
ابوانجى هو ثمر شجر الدب وهو الزعرور ٭ اجير اطس هو مجر الأسالغة

انصوزين هو المزماجور ∴ انصوفوزن هو اسوفوزن نبات قد تقدم القول عليه ∴ انعرا نبات قد تقدم ذكره ∴ انفاق هو الزيت المعتصر من الزيتون واصله باليونانية انعافيون ∴ انفلجل قد تقدم ذكر هذا النبات وتذكر نبات الخرنبى زائد العجل معروف عند التجار بزيت اللبن بالذى ذكره ∴ انخه هو البتع ∴ انفوخوليا هو صمغ الخطمى من الحاوى ∴ انفزديا هو البلاذر بالزنوتية ومعناه لا قلب ∴ انفسيما هو مثل الما باليونانية ∴ انفسلس هو جماض رزى باليونانية ∴ انقليما هو نوع من السحار ∴ ايشقواميس هو البنج باليونانية ∴ اسفون هو الزوفا باليونانية ∴ ابقوريس زعم قوم انه الطرانيث وغلطوا وانما انفوزين ذنب الخل ∴ ايسطاطس هو نبل الصباغين وهو العظم ويعرف عندنا بالساوى ∴ ايسفس هو الخطمى باليونانية ∴ السهولى هو مهزار جشان هو الكزمة البيضا ∴ اكسنيا هى الفضة باليونانية ∴ اكنسى هو صمغ الخطمى من الحاوى ∴ انكرسنا هو السحار ∴ افلى هو صنف من الطرفا وليس هو الطرفا كما زعم قوم ∴ ايل سنبل البوس بالهندى من الحاوى ∴ ابلاما روذون نحده المزمون من الحاوى ∴ اللبارون هو البنج ∴ ابلقرا نوع من المشار وبسميه بعض الناس جى العالم وقد ذكر مع الجى العالم ∴ اكلسفونون وبله ناط الثمن وهو صنف من النوع ∴ ابلوطر وبيون المقبر والمنقلع الثمن ويسمى بالعجمية طرشوبا وبالسرنانية صاميوما وقد ذكرناه فى حرف صاد ∴ اللقطن قبل هو الخار شنبر ∴ اماروفالاس وابارو فاطقطر سنوس بزى اصفر وهو الذى يعرف بالنرجن المنتن ∴ اىمونطيس وقد تقدم

الفَوا علیه ۞ اِبرِ قلی هو صنف من الفُودنج الجبلی وهو الصغیر ۞ اِبرِفس هو الیاقُوت الفائق الذی یُضئ باللیل من الحاوی ۞ اِبرقلا و بطقی هو الفُودنج الجبلی وهو الصغیر ۞ اِبرِ قِلا هو الفُودنج الجبلی وایضاً صنف من سید بطیس ۞ اِبرقلیون هو الثُیُّوم ۞ اِبرِس هو العَرعَر بالفارسیه ۞ اِبرِسنا هو السوس الاَنماجُی مذکور مع السوس ۞ اِبرساعِزا ای اِبرِسازی وهذا ایضاً صنف من السوس ۞ اِبرساً هو اللبلاب ۞ اِبرکِست ویقال کِنت بِرکِنت وهو دواء مجهول وسیذکر فی حَرف الکاف ۞ اِبرةُ الراعِی وابن الراهب نُسمی بهذا الاسم نبات یُقال له الجبلی وهو نُوع من النبط وایضاً النبط البات المنسی بالیونانیه نوفالس وصنف من النبات الذی نباه ۞ غاراثیون وهذا الصنف الثانی منه و کل واحد من هذاثیر المذکوَن قبل ولیس منها ۞ اِبرواری هو الحنظل بالهندیه من الحاوی ۞ اِبرو نودبا هو لَبَنک بالرومیه ۞ اِبرُوبیَه هو البحنویه و هو بِزر السبّتان من الحاوی ۞ اِبرُور هو السلحفاه علی ما زَعم بعضهم ۞ اِبرُوا هو الخریف ۞ اِبروطین و اِبریطیون هو البَصوم بالیونانیه و اِبروطین وهو بالطیبیه اِبروطنه ۞ اِبرُون هو النمام من کتاب ۞ اِبرُون هو جی العالم من کتاب ۞ وقد یُسمی بهذا الاسم نبات آخر یسمی بالفارسیه مِشار ویقال له ایضاً اِبرون اعنی جی العالم البری ۞ اِبرِی زدی هو السَلوفَر بالسریانیه من الحاوی ۞ اِنطَا واِنطَا اَس هو الاکلا بالیونانیه ۞ اِنطیدوطس هو الزباد ۞ اِنطیلس قیل هو ضرب من التُوبا ۞ اِنطمیَن هو البَرُوج من کتاب ۞ اِنطرِتین هو ناس العجل ۞ اِنطُوقلون هو لِسان الحمل من ۞ اِنطوفیا و اِنطُوعیا هی الهندبا من الحاوی ۞

اندرياسمن هو النبع باليونانية :: اندزيقون معنى هذا الكلام
فال د منه ما يشبه القصب الهندي ومنه ما يستعمل في الصبغ وهو
شي يظهر على صدف الفر فير وجمعه الصاغون وعجنينه وهذا الفر فير
وسيذكر في حرف الفاء واما الاورفوم فزعم قوم انه الطباشير ::
اندراسيون هو البرطوزى بالعجمية وقد تقدم ذكره واطن الاسم
فارسيا واسمه باليونانية بوفادامن :: اندرخى هو البقله اجفا باليونانيه
اندخا اغريا معناه بقله حمقاريه وهو المشار واينا الكناس هذا
الاسم :: اندرحوا هو لسان العصافير :: اندرففا هو الماهوذانه
اندروطاملاس
اندروصا فاس تقدم القول عليه وبعضهم زعم انه النعام وزعم ابن جلجل
انه الكبرى وموحطا :: اندروسامن تسمى هذا الاسم صنفان من النبات
وكلاهما من اصناف الهبو فارسيون وسيذكر ان معه :: اندروس
واندرون هو عنب الثعلب البحنى :: اندمما هى الفرد مانا
ابدع قيل انه قشر الكندلا وقيل هو البقم والاول الواضح وقال ابو حنيفه
وقال الجوز الخبرني اعرابى ان الابدع صمغ احمر بوتنيه والابدع عند الرواه هو دم الاخوين
وينفع من قروح
اللام ومن الحبن وترصعنه
وتنفع قروح الامعاء
ابرا يعقون هو صنف من خصى الثعلب ذكره :: انزار
هو الانبربارس بالعربيه عن ابى حنيفه :: ابرافيطوس قيل انه
حجر هندى :: ابرافلسا هى الجبيثه المنايسد بطين :: ابراميون
موشقاينث النعمان :: ابراوس هو الابرسا :: ابرج وبغاك برج
وسيذكر في حرف ب :: ابريحان ابريقاره وهو نبات قد تقدم
ذكره قيل انه البنان الازرق تسمى اشكيزه وقيل غير :: ابرنو هو البرج
ابرجى وابريجون في الرصعنه وتسمى خبز نكث :: ج اليهوديه ::
ابزنيسم هو الجزير الخام :: انرج قد تقدم القول عليه :: انرج
هندك هو النارنج :: انزروت هو العزروت وقد تقدم

السترابنو الثلث هو انئلة يسمى عندنا بهذا الاسم ضربان من النبات احدها هو الاثلة السودا وقد ذكرناما نقول فيها حيث ذكرنا الجدوار والاخر هو الاثلة البيضاء وهو نبات يسميه بعض الحجازين النبوق وبعض الناس لغلطه فيه فجعله خربنا ابيض وسنذكره في حرف الخاء ٠ انثمش هو البابوج باليونانيه ٠ انبوب الراعي هو عصا الراعي وقال مسيح هو صنف من جمر العالم وقد تقدم ذكره ٠ انوشرا هو شجر يسمي الغرا ٠ اسوسعني الا هو الزيتون البري باليونانيه ٠ انبو نيفون هو الكمون الكرماني باليونانيه وقد يسمون ايضا صنفا من السنا اليوناني ابو نيفون انبولسس قد تقدم قولنا على هذا النبات وابن جلجل يزعم انه المسمى بالعجميه لاميرود وذلك خطاء ٠ انثولة هي الاثلة ٠ الحبار هو طين معروف يستعمل يبل الطين الازمني وايضا حشيشه قد تقدم القول عليها تعرف بهذا وايضا حشيشه اخرى وهي الحرة وايضا حشيشه النسومه وتسمى من هذه الحشاىش بهذا الاسم لانها تجبر العظام المكسوره ٠ الحبوا هو المغرز من الحاوي الجدان هو المحروت وهو شجر الحلتيث وقد تقدم ذكره ٠ الجدان رومي هو السنا اليوني من كتاب د ٠ الجدان برخسى هو الطيب الماكول وهو الابيض والاسود ٠ اكرل قيل هو المرزنجوش الحرير هو الخربق الخنا هو الستحار باليونانيه ٠ الجزه زعم اصطفن قوم من اهل الحجاز ين يسمون الغافت انجره ٠ اجونيس هو البهي ٠ ابزا هو الغار الاسكندراني وهو الرند قد ذكر في حرف الراء ٠ ابزا ريدا تا ويله باليونانيه اصل ايزا وابزا اسم جبل بلاد الروم وريدا هو اصل ونسب الى هذا الجبل لانه نبت فيه كثيرا وهذا النبات نبت بالاندلس في جبال الجزيره الخضراء ومن زعم انه اصل الابجار فقد اخطا نقدم القول على ابزاريزا

والناس يصحفونه ويقولون أبا عنزان ٠ **انا سيس** هو حجر السيف
الاكبر قال ابن جنبر انا غالب يسمى بالنبطية أبا كبر ٠ **انا منطفر**
مؤتومن كتاب ط ٠ **انت** هو الباذنجان عن ابى حنيفة ٠
انانيون هو سلفش ايضا وهى شجرة قتاله ٠ **انا ريقن**
اليونانيون يسمون بهذا الاسم ساق الخنثى وزهرها ٠ **انا لقراس**
هو كرات الكرم وهو الكراث البرى من كتاب ط ٠ **انا لس**
هو الكرم ايضا ٠ **انا لس** ابو فورس تاويله كرم الشراب
وهو الكرم السنانى ٠ **انا لس اعريال** هو الكرم البرى ٠
انا لس لو قا هى الكرمة البيضاء ٠ **انطس قلا** نه
الطلق وليس بصحيح وانما هو حجر يعبا بالنار وهو الذى يتمه الناس
بالمندل ويزعمون انه جبوان ٠ **انثليس** نبات تقدم القول عليه
قال البطريق انه يسمى بالعربيه الزهر والزهر عدد خرن هذا النبات
المسمى باليونانيه نخماس ٠ **انثلى** ويسمى ضاطيغى هو الصليان
فيما يزعم قوم ٠ **ايسوس** هو الشربس ٠ **ايثون** هو الينبت
باليونانيه ٠ **ابج** هو انجاب ٠ وفى كتاب العن الابج حمل شجره
بالهند يشرب بالعسل ومنه يسمى الانجان المرئيات بالعسل من ج ابج وغيره
وقد تقدم قول ابى حنيفة فى الابج ٠ **ايبد** ق هو نبات مثل
زرع الشعير ينبوا وله سنبل مثل سنبلة الدخن فيها حب صغير اصغر من
الخردل اصفر يسمن الابل ٠ **ايش الوص** معناه باليونانيه زهر
الملح ٠ **افيون** هو المرقد وهو لبن وذكرة بأى ن ف باب الخنفاس
اقيفالس ج هو المارزيون ٠ **انيسون** هى الحبه الحلوه
وقد تقدم ذكره ٠ **انيش** هو باليونانيه الانيسون ايضا
يسمى ايضا طيفى وهو نبات ذكرنا فى باب جرر ط ٠ **اثيلا**

لصغار الشوك ∴ الحملتس هو الدوسر باليونانيه ∴ الامون
هو شقايق النعمن ∴ الارن هو صنف من اللوف وهو الصاذن بالعجميه
الارنصاذن هو اللوف الصغير الذي يقال له الصريث ∴ الطا
هو العرب ∴ اغنس هو البخنكست وهو شجرة الرهبان باليونانيه
الغلنص هو الدوسر باليونانيه ∴ افنفطس قد تقدم ذكره
و نبي الابورن قال ابن جلجل هو نبات يسمى باللطيني اسطوا ∴ القيشس
هو الهيشر فيما زعم قوم وهو ضرب من الشوك ∴ افتش هو الفرجمك
وهو الجوز الفرنلى ∴ افسيني هو اللبلاب وتسمى ايضا هذا
الاسم نبات اخر ويعرف بالطال وهو حشيشه الزجاج ∴ النثا وهو
الخطمي باليونانيه ∴ النشا هو من مار الزراعى ∴ اللهون هو الملوح
باليونانيه ∴ الغما هو من مار الزراعى ∴ اللوب هو الصبر
باليونانيه ∴ القسيني هو صنف من لفسوس ∴ مغطا لطس
هو البوع الذكر ∴ ملون هو الشاسبح ∴ امى هو الاناخاه
أث هو المزعى فى اللغه ∴ اباً هو النصب من اللغه ايضا ∴ اناب
قال ابو حنيفه ويقال انبت وهو شجر عظيم جدا ينبت نبات الجوز وورقها
كورقته ولها ثمر مثل التين الابيض الصغا رطبه كرامته وقد قيل وفيه
جب يخ لاينبت في الجبال ∴ انانسيون ذنب الخيل من كتاب
د ∴ ابار الرصاص الاسود ∴ ابا زابوطاني هو نوع من
زعم الحام ونه الجاوى العكرش ∴ ابا راحس بل هو زبد الحيره ∴
ابا زني هو البلسكي وايضا انات المنى كسنيون يسمى ايضا هذا الاسم
ابا زسن هو اننف البعل ∴ انا غالس حشيشه معروفه وصنفان
احدها يعرف بالشنله والردله بالعجميه ويعرف بالعرا ق بالانبات ∴
انا عورين هو خردب الحنزير ∴ انا عبر ان هو اناعورين

وَشَرِبَ نَفَعَ زَعَمُوا اصْحَابُ الضَرْعِ بِسَبَبِ هَذِهِ القُوَّةِ المُحَلِّلَةِ وَقَوْمٌ آخَرُونَ يَقُولُونَ
إِنَّ أَبْعَرَتِهِ وَخَاصَّةَ العُضْوِ الَّذِي يَقُومُ لَهُ مَقَامَ المَعِدَةِ إِنَّهُ دَوَاءٌ نَافِعٌ يُقَاوِمُ
وَيَدْفَعُ كَلَّ سُمٍ مِنَ الحَوَامِّ أَيَّ هَا كَانَ. **أَرْنَبْ** فَقَالَ بَعْضُ الأَطِبَّاءِ الأَرْنَبُ
نَفْعٌ جُمْلَةً مِنَ الجُبْنِ إِذَا شُوِيَ وَأُكِلَ وَإِذَا طُبِخَ
أَوْ عُمِلَ قَدْ يَنْفَعُ مِنْ قُرُوحِ الأَمْعَاءِ وَقَدْ جَرَّبَ
الأَرْنَبُ كَمَا هُوَ صَحِيحًا وَيُسْتَعْمَلُ لِلْحَصَى المُتَوَلِّدِ فِي
الكُلَيْتَيْنِ وَإِذَا أُخِذَ بَطْنُ الأَرْنَبِ كَمَا هُوَ بِأَحْشَائِهِ
وَأُحْرِقَ مَثَلًا كَانَ دَوَاءً مُنْبِتًا لِلشَّعْرِ عَلَى الرَّأْسِ إِذَا أُحْرِقَ وَاسْتُعْمِلَ هَذِهِ
أَرْنَبُ البَحْرِ فَقَالَ بَعْضُ الأَطِبَّاءِ وَهُوَ **ابْنُ سِينَا** هُوَ حَيَوَانٌ بَحْرِيٌّ
صَغِيرُ الصَّدَفَةِ حَمْرَةٌ يَلِي الحُمْرَةَ مَا هُوَ فِيمَا بَيْنَ
أَجْزَائِهِ أَشْيَاءٌ كَأَنَّهَا وَرَقُ الأُشْنَانِ غَيْرُهُ
هُوَ حَيَوَانٌ بَحْرِيٌّ صَغِيرٌ رَأْسُهُ حَجَرٌ **دَبٌّ** هُوَ
حَيَوَانٌ بَحْرِيٌّ يُسَمَّى بِاسْمِ الأَرْنَبِ وَهُوَ شَبِيهٌ بِالصَّغِيرِ
مِنَ الحَيَوَانِ الَّذِي يُقَالُ لَهُ لُوسُ وَإِذَا انْضُمِدَ بِهِ وَجَعٌ أَوْ وَجَعٌ قُرْبِيصٌ حَلْقَ الشَّعْرِ
الرَّنْتُ الَّذِي يُطْبَخُ ثُمَّ يُسْتَعْمَلُ فِي حَلْقِ الشَّعْرِ غَيْرُهُ رَمَادُ رَأْسِهِ
جَيِّدٌ لِدَاءِ الثَّعْلَبِ وَهُوَ يَجْلُو البَصَرَ وَهَذَا الحَيَوَانُ نَافِعٌ مِنَ السُّمُومِ إِذَا شُرِبَ
مِنْهُ شَيْئًا قَتَلَ يُفْرِحُ الرِّيَّةَ

وَهَذَا شَرْحُ مَا وَقَعَ فِي هَذَا

البَابِ مِنَ الأَسْمَاءِ بِاليُونَانِيَّةِ

الْسَرَحْ **الابْنُسْ** هُوَ الأَبْنُسُ بِاليُونَانِيَّةِ **الثُرُونْ**
هُوَ الثُمَامُ بِاليُونَانِيَّةِ **الونِيسْ** هُوَ الأَشْرَاسُ وَهُوَ ضَرْبٌ مِنْ

التي تصير إلى الجلد ما هو منها غليظ أرضي ومنها ما يكون للجرب والعلة التي يقشر معها الجلد والجذام **دب** لحم الأفاعي إذا أطبخ وأكل جدد البصر ويوافق أوجاع العصب ويمنع الخناريز ينبغي وقت زيادتها من الزيادة وينبغي أن تسلخ وتقطع رؤوسها وأذنابها لأنها حلول أن من اللحم فأما ما ينال من أن يقطع أطرافها على بعض التقدير فإنه باطل وينبغي أن يؤخذ الباقي ويغسل ويطبخ بزيت وشراب وملح يسير وشبث وقد يقال إن من أكله نعمل ذلك باطل وقوم يقولون إن الذين يأكلونه يطول أعمارهم وقد يعمل ملح من لحوم الأفاعي ينعمل فعل الأفاعي غير أنه أنقص فعلا منه قليلا بأن يؤخذ أفعى بالحياة ويصير في قدر جديدة ومعها من الملح والشبث والتين من كل واحد مدقوق ممحو أرطال ونصف مع نبع أو أنجاع ويطبخ ثم يفتح القدر ويشوى في تنور حتى يلتهب الملح ويصير كالجمر من بعد ذلك يسحق ويحرز وربما خلط به سنبل الطيب أو شيء بزر سناج ابطيب طعمه **يجهل** من أكثر من لحم الأفاعي قرح به وأفسد مزاجه وإن دقت أفعى تنبه وضمد بها موضع نهشها ينفعها

ابن عرس **دب** هو بعض الحيوان ذا ملح وجفف في الظل وشرب منه وزن مثقال كان ذا نوى علاج يكون للهوام كلها وإذا استعمل كان بإذن الله عقال الدواء الذي فيه يقال له طقسيقون وجوفه إذا أحشي ببزره وجفف في الظل نفع من نهش الهوام والصرع وإذا أحرق كما هو ينفع قدر وخلط بزماورد ولطخ به نفع من النقرس **دب** أنا الجرة فقط وقد ذكر قوم من أصحاب الكتب أن رماده إذا عجن بالخل وطلي على النقرس ووجع المفاصل نفع من طريق أنه يحلل تحليلا شديدا وإن جفف ابن عرس

غالا وهو ابن عرس

التي يقال لها أبو ثائية و في قوتها قوة الجندبادستر د وانفحة الحيوان
الذي يقال لها قوما قوتها شبيهة بقوة الجندبادستر و توافق اذا شربت
من به صرع و اوجاع الناس التي يعرض من الاخناق و الحة التي يعلم بها ان كانت
الانفحة لهذا الحيوان صحيحة له امر لا ان ياخذ انفحة حيوان ما و خاصة انفحة
خروف و يصب عليها ماء و دعها قليلا و خذ ذلك الماء الذي صببته على
انفحة الخروف و نصبه على انفحة الغوفا فانها ان كانت بحقيقته انفحة هذا
الحيوان ذابت و صارت ما سريعا و ان لم يكن له بقيت كما هي و اما توجد
انفحة الغوفا اذا كانت جريانها لا تنوي على الساحة بعد و باجلة كل انفحة
فهي تجمد ما لم ذابا و تذنب ما كان جامدا ۰ **أفعى**

لحم الأفاعي
يجفف و نحن و يجعل خلا لوبيا اذا ماطبخ بالزيت و الملح و الشبت
و الكرات بمقدار نصف و نقى و خلال من جميع البدن شيئا و يخرجه من

اخبرو عن الأفعى

الجلد و قد صح بالتجربة ان الأفعى اذا سقطت حية في تراب و ماتت فيه وترمه
مجذوم غلظ جلده كله و سقط و صار ما ابتني من لحمه متميز له الجزء الجلدو
ن اللين و برء على هذا الوجه و ذكر ذلك حكايات و قعت في زمانه
نركناها قال فلحم الأفاعي يجفف تجففا خفيفا و تحليلا لويبا مع انه
يجذب قليلا و يشبه ان يكون قوة هذا اللحم قوة ادوية بادرزايا الصعود الى الجلد
فينقض و يدفع عنه جميع ما في البدن من الفضل و لذلك صار نفوذ منه الى
البدن و ما زال كثيرا متى ما اكله قد اجتمعت في بدنه اخلاط ردية و يخرج
ايضا من الجلد و يسقط منه شبيه بالعشن التي فيها خاصة تخبر و يلج من الاخلاط

والتحليل وذلك ضد ما يحتاج اليه لعلاج نفث الدم من الصدر د ت انفحة
الارنب اذا شرب منها مقدار ملث انولسات بشراب و افنت نهش الهوام
والاسهال المزمن و وجع البطن و قرحة الامعاء والنسا اللواتى يسيل من
ارحامهن رطوبات سيلا مزمنا و جمود الدم تزيب الاوصال ونفث الدم اذا
كان و اذا احتملها المراه بالزبد بعد طهرها اعانت فى الحبل و اذا
طهرت منعت الحبل و تمنك سيلان الرطوبات الى الرحم و يعقل البطن
و اذا شرب نخل نفعت من الصرع و كانت باذا هزل الاشياء القتاله و خاصة اللبن
المنجمد المعدة و نهش الافاعى الطبرى ان شربت المراه من انفحة الارنب
الذكر مدبر ثلث خصيته مع الشراب الممزوج ولدت ذكرا اذا حملت وان
شربت من انفحة ارنب انثى ولدت انثى وان شربت من انفحة نبدر بافاله مع
شراب صلب نفعت من حمى الربع وان خلطت انفحتها بالخطمى والزبد ووضعت
على البدن اخرجت الفضول والعقب وان شرب الصبيان منها امنوا من الصرع
والالنح كلها ولاستما انفحة الارنب ان علقت من ابهام المحموم اذ هنالكما و اذا
عجنت بالماء و وضعت على المخزين قطعت الرعاف ۞ الاسرائيلى و اذا شرب
منها وزن قيراط بالطلا المطبوخ نفعت من لسع الحيات والعقارب وسائر
الهوام ح و ذكر بعضهم ان انفحة الفزر اذا شربت جبنت فى سنطلان البطن
و منعت من اختلاف اخراطه والدكبة د و انفحة الحمل ابو خا صة
الاسهال المزمن و قرحة الامعاء و وجع الامعاء الاسرائيلى ۞ انفحة الحمر والظبا
والجدى اذا شربت بالخل نفعت من الخبز وانفحة الجدى والحروف والخشف
وهو ولد الايل والجبوان الذى بنال له ملاطفا والحيوان الذى ينال له دوش
والجمل مشابهة ﺑ ﻣﻮت و يوافق اذا شرب ليشرب السم الذى ينال له اقى بطون
و اذا شرب بالخل و افنت جمود اللبن ﺑ ﻣﻌﺪﻩ وانفحة ولد الايل خاصة اذا احتملها
المراه ثلثة ايام بعد الطهر منعت من الحبل وذكر انهم ايضا يدخرون الدبابه الحجرية

اونفس شيء من العطر اسود يشبه بالطفر يجعل الدجن ولا تفرد منه الواحد ح ب هو
عظام صنف منذ وات الصدف وهو يشبه بصدف الفرفير يوجد في بلاد الهند
في المياه الغائمة المبتنة الماذنة وزاحته عطره لان هذ الحيوان يرعى النادين
وحمى اذا جفت المياه في الصيف وقد يوتى بشي منه يوجد
على ناجه بابل فان لونه اسود وهو اصغر منه وكلاهما
طيب الرائحه اذا اجرت بها النساء اللواتي عرض لهن اختناق
من وجع الارحام نفعهن وللذين يصرعون واذا اخذ بها واذا كان
اذا لحمها شيء من رائحه الجند با دستر وهذا الحيوان
اذا اجزى كما هو نفعل كلما يفعله مفورا والغربوس
مسح حار يابس في الثانيه لكن يبوسها اكثر
من حرارتها وفيها قبض يسير ملطفه للكيموسات
الغليظه نافعه من الخفقان و وجع المعده و الكبد و الدماغ الرازي
ثقل الزائر ويصدع ابن عمران اذا اشرب منها وزن درهمين بما اجاد اخرج
الدم المنعقد في الكلى و المثانه و اذا انتحرت المراه بها انزل حيضها و الله اعلم
أنفحه وهو الينوح آي الانافح كلها جار لطيفه محلله بابسه
في قوتها و هي لذلك نافعه من هذه الاشياء التي يذكرها اضطرارا فقد
ذكر بعض الاطباء انه نعم من انفحه الارنب مداف فيه بخل بعض من به الصرع
نفعه وزعم انه ينفع من نزف النساء و يحلل الدم و اللبن اذا جمد في المعده
وقد جربت بالحن وجدناه نافعا وليس انفحه الارنب فقط ولكن نوافح سائر
الحيوان عير ان انفحه الارنب في ذلك قوى و افضل من غيرها وقد ذكر بعض
الاطباء ان انفحه الارنب ينفع من نفث الدم الكائن من الصدر و اما انا لم
اجربه ولا رايت احدا فعله و رايت ترك ذلك العلاج باصلح لذلك العارض
اذ كان النافع له من الادويه ما كان في انه قبض و هذا دواء قوى ليجذه

الثمر واجوده ما يعمل بالجزيرة والبلاد التي يقال لها فورسوس والبلاد التي
يقال لها الساذاش وبعده ما يعمل في البلاد التي يقال لها دسارحا :: وقد يتخذ
الاسفيذاج على هذه الصفه يوخذ خزف وخاصته ازا كان من البلاد التي يقال
لها الطي وصبر على جمر ويذر عليه الاسفيذاج وهو مسحوق ويحرك حركة دايمة
فاذا ابكون الرماد احمر من النار وبرد واستعمل وقد يعمل اسفيذاج الرصاص
مثل ما يعمل القليميا وقوته مرخيه محلله مغبره بملته ملا الفرج حجما
مطلقا ويلع اللحم في الزايد في الفروج قلعا زيفا ويدلها اذا قرع الفروطي
والمراهم التي يقال لها ليارا وهي الاقراص وهو ايضا من الادويه الشاله ح ط
هذا ايضا يشهد على قوه الاسرب لانه انما يكون من لاسرب اذا اجل كل تفيف
جدا ولكنه ليس حارا ولا لذاع بل هو مبرد خلاف قوه الزجاج على ان الزجاج
انما يكون اذا احل النحاس بكل جمره غيره بارد في الدرجة الثانية صالح للبياض
الحادث في عيون الجواز لنفر وجها اذا اخلط بغيره من الادويه وسقع من
حرق النار اذا اطلي عليه بعض الادهان ولا يكاد موضع احرق وسيجيل سا
البياض اجوده ما يكون ربنا شديدا بالبياض ث اسرنج ويقال
سرنج وهو السيلقون وهو الرزقون ويسمى باليونانية سندوقس الرازي هو
اسرب يحرق ويشد عليه النارجي يحمر ويجعل عليه شي من الملح وقد يكون من
الاسفيذاج اذا احرق ح ة وقد يحرق الاسفيذاج على هذه الصفه يوخذ
ويجعل في طجن برعين ومسحوق ويوضع ذلك الطي يرع الجمر ويحرك بعود حتى
يلون بلون الزربج الاحمر ثم يوخذ عن النار ويستعمل وما اعلم منه هل ذي
اسمه عند بعض الناس سيدونس ح ط واذا احرق الاسفيذاج واستحال
صار منه الاسرنج وهو دواء الطف منه ولكنه ليس هو ايضا مما يبنخ ث
غيره بارد يابس في الثانيه لطيف ينقي الفروج ويلزق الجراحات ويذهب
اللحم المتعفن والله اعلم :: **اظفار الطيب** الخليل الاظفار

انطأكيه الموجود على السواحل فإنه يشبه الرمل وهو أبيض مدوّر والنوع يحمله إلى
أو كارها ثم قبل لغرّا خها ولذلك يسمى الطيطن ونفس بين السرى وخاصته أنه
نافع بهل الولادة يعلق في جلد ابل ويشد على الساق اليسرى وينجى أيضاً يبرك
في لبن النساء ويعصر فيه صوفه وتحملها المرأة التي لا تحبل يحبل بإذن الله تعالى
ويربط أيضاً بخيط أحمر ويعلق على الحوامل فينفعهن ومع ذلك فإنه يمنع الإسقاط
وخشونة خروج الأجنّة فلك كما لها ويجعل في جلد خروف ذبيحة ذكيّة ويلزم
على العانة والجفون في وقت الولادة فإذا كان في وقت الطلق يحمل على
المرأة فإنه إن تُرك حالها تصدع عن المرأة في الولادة وكذلك سائر
الحيوانات

اسفيداج يعمل على هذه الصفة يؤخذ خفيف
يصب في خابيه واسعة الفم أو في إناء خزف ويوضع على قراطيسه قطعه
من بار به وعليها بنه من رصاص ويغطى اللبنه وبين نوّ نوّ من يغطيها بالأسن
نكاد فإذا ذاب اللبنه ونسافظت في الخلّ أحد ما كان زنج الخلّ صافياً وعزل
ناجيه وما كان من تجبّناً صيّر ناجيه في إناء وجفّف في الشمس ثم طحن أوذنت
أجزاؤه على جهة أخرى ثم خلط ثانيه ويفعل ذلك ثالثه ورابعه وأجوده
ما خلط أول وهله وهو المستعمل في أدوية العين وبعد ما جل من المرة
الثالثه وهكذى الصفه في المقدّم والثاني من الباقي ومن الناس من يأخذ
الباريه فيصيّرها في وسط الإناء فلا يكون مماسه للخلّ ويغطى ثم الإناء بالرصاص
ويغطى الرصاص بغطاء آخر ويطين عليه ويدعه أياماً ويكشف الغطاء الأول
وينظر إلى الرصاص فإذا رآه قد تخلل فعل ما وصفناه آنفاً وإن أحبّ أن
يجعل منه أقراصاً فليعجنه بالخلّ ويعمل منه أقراصاً ويجفّفها في الشمس
وليفعل هذه الأشياء في الصيف فإن الاسفيداج يجيد فيه تعلًا يفعلًا فوياً
ويكون بياضه قويّاً ونجس وقد يعمل أيضاً في الشتاء بأن يؤخذ الأواني
فيصير على سطح حمام أو سطح أتون فإن فعل حرارة الحمام والأتون فيها شبيه بفعل

ابن وافد قد ذربى
هذا العلاج عندنا وجرب
وصحت التجربه فيه

من النفث ولكن من البلاد التي بها الاطبا وقد يجز و يغسل كما يغسل
الاقليميا وله قوة قابضة وقوة تعفن بها و يبرد الاورام الحارة والجراحات و يبلغ
الحجم الزائد في الفروج واذا خلط بعجين وطلى ملاها لحما وقد نبتت الحجارة التي نبال
لها وزن ب **اكمكث** هو حجر الولادة و يسمى حجر العقاب وحجر النسر
لانه يوجد في ادكارها ونومر يقولون حجر النسر لانه بهل الولادة و يسمى باليونانية
الطيطنس **ابن جلجل** هو حجر الحمر كل حجرة كأنه يسمع طنينا سمع الجلجل
فاذا كسرته وجدت داخله شياء وهو حجر البسر بهل الولادة على النفسا اذا علق
على فخذها **الرازى** في كتابه بدل الادوية اكمكث دواء هندي يشبه
البندق الا ان فيه نقرطا قليلا الى الغبرة واذا حركته سمعت له كانه
اخرى كنى في جوفه واذا كسرته انفلق عن شئ كأنه حب البندق الا لونه
يميل الى الباصر قليلا ووجدت في بعض الكتب الهند به انه ان جعل في صرة
وشد على فخذ الحامل اسرعت الولادة وقد جربه فوجد نه صحيحا وقال
ابن كتاب الخواص موسى يشبه بيضة العصفور وشبه حجرا في جوفه يحرك
وقد اجمع الناس انه حجر نافع لعسر الولادة اذا علق على فخذ المرأة فال
واصبت في الجامع انه يصلح لدلام الفاوونيا وقال في الحاوي اكمكث
دواء هندي يعمل عمل الفاوونيا اذا امسك بها وطلى على العضو الذى يعم منه نجار
المرة السوداء **كسوفراطس** ان الحجر المسمى الطيطنس اربعة اجدها اليمانى
والثانى القبرتى وهو الذكر منها والثالث من لوسه والرابع من انطاكيه
فاما اليمانى فاته شبيه في عظمه بالعضضة اسود لونه خفيف حملته داخله
حجرا جاسيا والقبرتى شبيه باليمانى الا انه اعرض الى الطول البل ماهو وربما
وجد ايضا كهيه البلوط وهو ايضا يحمل حجرا داخله وربما حمل زملا او جسى
وهو جيد لبن جدا يفرك بالاصابع واما الجلوب من لوسه فانه صغير ليز لونه
كلون الزمل يحمل داخله حجرا ابيض لطيفا نفث سريعا ∴ واما الذى فى

الجانب

جدًا بأن يبلغ بلا الوساجي ويوضع بين الثمن في الصيف ويغلب العيون يولا
فوق الجانب الآخر إلى الأسفل وإن كانت الليلة فإنه يبلى بالشراجي أو بما يجز
ويوضع أضاء الغمر فيشتد بياضه والله أعلم ❊ **اثمد** وهو الكحل
أجود ما يكون منه رافوه إذا أفتت سُفل له بريق ولمع وكان ذا صفائح
وكان نديّ داخل الملمس ولا يكون فيه شيء من الأوساخ وكان يتبع النفث ❊ هذا
الدواء القوة الغالبة التي تحقف انه يقبض ولذلك صار يخلط في الشيافات
وفي الأدوية الاخر اليابسة التي ينفع العين وهي للبرودات ❊ وقوة الاثمد
معربه قابضه مبردة تذهب باللحم الزائد في القروح وتندملها وتشفي ارساخها
واوساخ القروح العارضة في العين وتقطع الرعاف العارض من الجبهة
فوق الدماغ وبالجمله فقوته شبيهة بقوة الرصاص المحرق والا ان الاثمد خاصة
اذا اخلط بعض الشحوم الطرية ولطخ على حرق النار لم يعرض فيه الحكرة به
واذا خلط بالشحم وشيء يسير من اسفيداج الرصاص اذا ما عرضت فيه
حكر به شبهه من القروح العارضة من جرم النار غبره ينفع من الحرارة
والطروبه العارضة للعين ويحفظ صحتها ويقطع نزف الدم من الرحم ان
احتمل أو شرب ❊ وقد يشوى الاثمد بأن يعجن بشحم ويصير في خبز
ويترك على النار إلى ان يلتهب ثم يؤخذ الشحم ويطفى ببيض امراة ولدت ذكرًا وبول
عليه الصبيان أو حمز عنب وقد يحرق الاثمد على جواب بأن يؤخذ ويوضع
الجمر ويوقد عليه الى ان يلتهب ثم يؤخذ من الجمر فانه ان احترق اكثر
من هذا صار في حد الرصاص وقد يغسل كما يغسل التوتيا أو مثل النحاس المحرق
ومن الناس من ينزله بحيث الرصاص ٮ قوله الا المحرق والله أعلم ❊
ارتكان ❊ ويقال الارتكن واسمه باليونانيه احرا **ارا كرا** الارتكجان
صغار صفر وحمر إذا أحمرت ❊ ينبغي ان يختار منه لخفته وما كان لونه
أصفر والصنف الشامله لأجزائه كلها وان لم يتشبع اللون ولكن يكون فيه حجان وكان

الموضع الذي فيه يبل الدم والنار فيه مشتعلة ليقوم مقام الكي ويصير شبيهاً بالغطاء والسداد للجرح أعني جرم الإسفنج الذي لحرق أعني جمعاً فأما الإسفنج الحديثة إذا أخذت وحدها على الإنفراد فليس هي بمنزلة الصوف أو الخرقة المنشفة تقوم مقام آلة النافلة للرطوبة التي تعتريها بل يجب جففت أيضاً جفافاً بيناً وأنت تعرف ذلك بأن تستعملها وحدها على الإنفراد فليس هي بمنزلة الصوف في مداواة الجراحات بعد أن تبلها بالماء والخل الممزوج أو بالشراب على حسب اختلاف الأبدان فإنك تستعمل الجراحة بهذا الإسفنج كما تدملها بالمراهم المعروفة وفيه ما لها الجراحات الطرية بدمها فإن لم يكن الإسفنجة طرية لكن إسفنجة قد استعملت علمت علاوتها بعضها عن الإسفنجة الجديدة إذا وضعت على الجراحة بالماء كانت مبلولة أو بالشراب أم بالخل الممزوج ولكن يجب أن تكون فيها الإسفنجة التي اكتسبتها من البحر قائمة محفوظة جففت باعتدال وإنما يكون فيها أن تفعل ذلك ما دام الجرح قائمة بها فيها إلا أنه إذا طالت بها المدة ذهبت عنها قوة الراجحة وكل ما تستعملها أحد وجنيد ليس ممكن أن تجفف على ما كانت تفعل وما كان من الإسفنج جديد لين يرسم فإنه يصلح للجراحات ولأن نفث الأورام البلغمية وقد يلصق الجراحات في أولها بعض ما يستعمل بالماء والخل وأن لحم الفروج العتيقة إذا استعمل بعسل مطبوخ وقد يستعمل بالماء فقط وأما ما كان من الإسفنج خلقاً فإنه ليس ينتفع به وإذا استعمل الحديد غير مبلول لامع كتان غير مبلول وأما وجد وشكل شكل فيلة أفواه العروق والمضمومة الخاسئة وإذا وضع وهو جاف في الفروج الرطبة التي لها غور في الأعضاء جففها ونشف الرطوبة منها وإذا استعمل بالخل قطع النزف وأما الإسفنج المحرق فإنه يصلح للمبدا اليابس وللجلاء والقبض وإذا جعل بعد جزئه كان يصلح لأدوية العين منه إذا لم يغسل وإذا أحرق مع الزفت قطع نزف الدم وقد يصير منه ما كان دنساً

للسباع فلا يلتبس ان اكله وان شمه وان لم ناكل منه عميت وصمت واخبث
الالب خوض وهو جل من السرا انشو نهامة :: **اتقون** الرازي
هو الورد المنتن وهو جاب ابن واصله جرف مثل عاقر قرح: **ابرناماش**
الرازي هو شتم فارسى وفر حجره على اغصانها مثل الصوف فابضه الطعم جدا
نشدا البطن وتماه في موضع اخر ابرامبرواك. وفي موضع اخر ابو مان دوا
كرماني بد عورش ينبع جدا من الاسطلاق خاصية فيه :: **ابرزاقون**
ابن سينا دواء فارسى يقال له البرجة والحرم جيد للحفظ **الرازي** كلنا
نستعمله للحفظ جيد للعقل :: **ابوزفال** **ابن سينا** دواء فارسى
جار لطيف بدكى الذهن والعقل وقال في موضع اخر دوا فارسى
جيد للحفظ والعقل واظنه المذكور قبل :: **اطموط** **ابن سينا** جار
الثالثة رطب في الاولى جلو البهق بقوة وقال في موضع اخر اطاط
دواء شنبى قوته كقوه البوربدان زيد في الباه وانا اظنه هو الرنة ::
اوسيد **الرازي** ضرب من النيلوفر الهندى جا بابن والله اعلم
اربديد **الرازي** دواء فارسى جلب من سجستان يشبه البصل المشوى
نافع من الباسير :: الموبف. اظنه الدلبوث :: **اسفنج** يقال له
الغيم والغام **ابن سينا** هو جسم بحرى وهو مخلخل كاللبد وقال انه حيوان
يتحرك فيما لمصوته لا بارحه 55 منه ما تسميه اليونانيون الذكر وهو صنف
دقيق الثقب كثيف ويسوا جلما لا يمثل هذا الصنف المنتن ومنه ما يسمو نه
الانثى وهو صنف جاله خلاف حال الذكر وقد نحرق الاسفنجه مثل ما يحرق
زبد البحر ج لى اما الاسفنج المحرق فقوته جادة محلله وقد كان زجل
من معلمنا يستعمله في مداوا انفجار الدم العارض عند القطع والبط وكان
يعد ليكون مهيا في وقت جاجنه وهو يابس لا يداوى به وينمسه
اكثر ذلك في الفقر فان لم ينله الفقر غمسه في الزيت الرطب وكان يضعه على

اسافطرون

إنما يصلح للاسهال به فقط
ويخرج البلغم والمرار
وطعمه مالح ومن اجل
ذلك قد يمكن الانسان
استعماله في اشياء اخر
من الاشياء التي يحتاج فيه
الى القوة المحللة والله اعلم

اسحقال ابو حنيفه
هو نبات ممتد جدا على
الارض وزركو زقي
الخطر الا انه ادق وله قرون اقصر من قرون اللوبيا فيها حب مدور احمر
يتداوى به من عرق النسا :: **ام وجع الكبد** ابو حنيفه
هي مثله من ادق المنابخها الصان لها زهر عبر ان في برعة مدور لها
قرون صغير جاعر وتنبت بهذا الاسم لانها تنفع من وجع الكبد والصفرا
اذا عصر بالشرسوف بني عصرها :: **ام غيلان** ح هي شوكة
الفناد **عنر** هي شوكة القرظ ابو حنيفه هي الطلح ابن سينا ام غيلان ب
شجر من عصان البادية معروف وفيه يا بسته بنفع لقبضها سيلان الرطوبات
جيده لنفث الدم :: **الهلا فسط** موصف معروف من الزياحين
وهو جاد الرايحة متحن يرزع في المنا كريا لونه بين الخضره والبياض اذا استعمل
فيما ببتعمل البادرنجبويه كان اتوى فعلا واكثر منفعه والله اعلم

الب ابو حنيفه في جمره شاكة لا ثمر لها الاترج ومنابتها في
الجبال وهي قليله حدا لا يقوم مقامها شي من الصماع والصماع كلبجر ينبت بها
السباع اجي تسيم واحنها الالب بدو اطرافها الرطبه وينقش بها اللحم وبطرح

الوبون

لبوں خفيف واصل يشبه اصل
السلق ملان دمعه
جريف وبزره يشبه
الافثيمون ونبت
كثيرا في بعض
السواحل وخاصة في
اماكن لوى وينبت
ايضا في مواضع اخر
وبزره اذا اخذ منه
ومن الحلو والملح
المقدار المتساوى

لما يوخذ من الافثيمون اسهل البطن كيموسا اسود ونح الامعا نجحا خفيفا
البطرس ترجمة الكتاب الونياس ينبت في الرمال والسواحل طبعه
حار يسهل وغسل الجوف والمختار منه الذى اذا قلعت اصوله نشرت وربى
ولا ياخذ ما يشبه الليف وزعم انه النربد وهذه الصفه نوم ذلك وهو
خطا ونذكر هذا الدوا بولس ولم يذكر اصله انما ذكر بزره كما ذكر
واما ابن وافد فظن ان هذا هو طريفوليون واصناف هذا القول الى
في طربعولون وزعم ان طريفوليون هذا النربد والله اعلم بالصواب
اسطرون
وقد يسمى ايضا الشبيه بالكراث هو
نبات ينبت في مواضع جبليه وفي صخور وفي سواحل البحر مالح الطعم وما كان
منه ابعد من البحر اوعر في البرد اشد مرارة واذا اعطى منه نمر زنه
الشراب اثنى ادر ومالى اسهل بلغما ومر طوبه مايه هذا دوا

بلغماً ومرة سوداء ووافق خاصةً أصحاب المرة السوداء والنفخ وقد ينبت كثيراً
بالبلاد التي يقال لها فاداقيا والتي تسمى ليدونيا **أبو جريج** أجوده ما أحمر
لونه وأجدّت زاجته وجلب من ارمطيس **جربح** قوته شديدة في قلع المرة
السوداء من الأبدان وإذا استقى منه أصحاب المرة الصفراء أغلظ على طباعهم وأصابهم
عرش شعيّة كرب وربما فناهم وهو صالح للمشايخ والمنهلبين وقد يؤخذ ما
كثيراً من الماليخوليا إذا أخلط بالأفسنتين وشرب مفرداً **ابن الجزار** إذا أخذ
منه حبّة يحوّ فأعشر دراهم يصيّر في خرقة صفيقة وانقع ليلة في مقدار
ثلث أرطال من الشراب الجيّد وترك إلى الصباح نحاجت النما ثم عصرت الخرقة
الصرم من الشراب ورمى بها والقى في الشراب أوقيه من شراب جلاب والبنفسج
والقرطان ودهن لوز حلو وشرب نفع أصحاب الماليخوليا وأسهل منهم
المرة السوداء يسّه ووجب أن يصلح قبل أخذه بأن تلتّ بدهن لوز ولا يشفى
دقة لتخلص لبابه **بولس** يعطى منه وزن ستّه دراهم يجوّ فأنفع تنفع أوقيه من
اللبن **جالينوس** ينفع من الصرع والنشج والماليخوليا ويسهل البلغم أيضاً ويخرج الدود
الطوال وإذا النفخ المطبوخ فليلقى فيه جبن معتّق يبرّش ويصفّى فإنه إذا طبخ
بطلت قوته والشّدة منه في المطبوخ من جنبه در اهم إلى عشر **بولس** وأما
الأنيثون وميثى نكون على الأصغر ويسهل وربما أمرأ أسهال الأنيثمون إلا أنه
أضعف منه في هذا هو الأنيثمون الذي يستعمله أطباء زماننا كلهم وأما الأفيثمون
الحقيقي فلا يعرف قوته وهذا النبات يجلب من بلاد البربر وينبت أيضاً عند نا
وهو من جنس الكشوث وأكثر ما يطلع على الصّغر في خيوط دقاق جنبه لون
العتيق لا أصل لها ولا ورق لا ذوات صغار لونها إلى البياض أصغر من زرّ
الأكشوث زغبه عليها زهر ضعيف يظهر في الربيع وينفد لأنّات باشتباكه
عليه وقوته كقوة الأفيثمون إلا أنه أضعف قليلاً **د د** **الوبيون**
وهي حشيشه تستعمل ونؤذ النار ينفع لونها إلى الحمرة دقيقة العيدان لها زهر

وله ورق شبيه بورق السذاب لانه اطول من ورق السذاب اخضر وثمرته
صغيرة وله اصل شبيه بالبات المنمى مخنى الا اشد ان منه ما يميل
الى شكل الكمثرى ملآن
من دمعه وله قشر اسود
وداخله ابيض وهذا الاصل
اذا اخذ منه الجزء الاعلى
قيّاً ومرّة وبلغماً واذا اخذ
منه الجزء الاسفل اسهل
البطن واذا اخذ كله
قيّاً واسهل واذا اردت
ان تستخرج دمعة الاصل
فخذ وددّه وصيّره فى
اجانة وصبّ عليه ما
وحركه وما طفى من اللمعة فخذه برّيشه وجففه واذا اخذ من هذه اللمعه
ثلثة اضعاف اولوريا واسهل. **أقيمون** د ذفر الصنف
من النبات الصلب الشبيه بالصعتر وهو ذو رؤوس دقاق وخفاف لها اذناب شبيهة
بالشعر ح وفوته شبيهة
بالفوة الجانا الا انه اقوى
منه فى كلّيّة وهو يطبخ
ويجفف فى الدرجة الثالثة
د واذا اشرب منه مقدار
اربع درخمات بعسل وملح
وشى يسير من الخل اسهل البطن

باذاب العقارب ويستعمله بعض الطباخ بدل النافل وصنف آخر يسمى الطروح
ورقه كورقه العالم الا انها دون منها كانه اذن الميل الفرس به
في لونها وله بزر دقيق ونباته
يأخذ عرضا ويعلو نحو من
ذراعين وخشبه ابيض صلب
ويسمى الرعل والاشنان
النارني وصنف
يعرف بالغاسول يعلو نحو
من شبر اغصانه فيه
الابزرية ونزر دقيق كأنه
بزر من دقه وله زهر
ابيض دقيق جدا مائل الى الحمرة
قليلا واغصانه كثيرة
شطب على الارض ونباته في
الارض المالحة في زمن
النبط وبه نحل اللك ويسمى
بالعجمية شراهه واذا شرب
منه درهمين ادر البول
ومنه اصناف اخر والنافلي
من اصنافه وكلها جيدة الطعم **افيوس** د د ومن الناس من
يسميه اشخاص ومن الناس من يسميه حاملا سر ومنهم من يسميه راس اغرنا
ومعناه نجليزي ومنهم من يسميه دراسطن هو نبات يخرج من الارض عود بين
أو ثلثة شبيه بعيدان الاذخر ذقا فاجم ام نتعه من الارض ان نفاعا يسيرا

اذا اخذ منها مقدار اولوس اسهل البطن مرارا وبلغما ورطوبه ما ايه واما المخلوط
بالكزبرته فانه يوخذ منه مقدار اربع اولوس بالشراب المثنى ما يقراطس وقد يوخذ من
هذا النبات كما ما اصله فيحفف وينق ويعطى منه مدقوقا مع نصف قوطولي من التراب
المحى ما يقراطس وقد يسخرج ايضا عصار هذا اصل النبات مثل ما يسخرج من الثافسيا
ويسقى منه بلابها مقدار درحم واما اوقمط الذي يقصر به الثياب وهو ينبات لط
مع الارض له روق ونرخوه وزق صغار فقط وليس له زهر ولا ساق وله اصل غليظ لبن
يعذ ورق هذا النبات وزهر اعنى نوره واصله ثم يسخرج منه عصان ثم جعلها
واعطى منها بمكيال ثلث اودنيات مع الشراب الذي يقال له ما يقراطس من ارد ان يسهل
منه رطوبه ما ايه وبلغمه والاهلبحا يا وابو خاصه من كان به عسر النفس الذي يحتاج
فيه الى الاذسات والفتق واوجاع الاعصاب غير واما البلى وهو سبع العصفر
فانه يخد على هذه الصفه يحفر في الارض حفره كبيره ويشعل فيها
النار ويرمى فيها من اطراف الاشنان الرطبه من اي اصنافها كار حاضر حتى
اذا اخرت جعلت غير فلا يرم يعمل هذا حتى يمتلى الحفره رمادا ثم يترك
حتى يبرد فان الرماد ينحجر ويصير فلكا ما ثم يكسر قطعا ويستعمل واللطاف انواع
البلى الابيض هو الذي يسميه بعض الناس نجو العصافير واحدها الاخضر
وهو دوا يا ن با ايسر الدرجه الثالثه شبيه قوته بالملح الا انه انوى منه
واشد بيا جلا ح اخضر وان كار الجمر الراديد منو يعيى ينفع من اللهو والجرب
واذا شرب منه نصف درحم الى درحم بذرا لطم ووزن تلته
دراهم بنهل بنه ما ايشته المستسقا ووزن خمسه درا هم يسقط الولد حيا
وميا ووزن عشره دراهم يقتل ودحار الاخضر منه يطرد الهوام وعصير
وذق الاشنان الرطب اذا اغتنر به ينفع من وجع الورك بن اصناف
الاشنان كثيره جدا واشهرن عندنا هو الصنف الموصوف اولا يسميه بعض
الناس نجل الغزوج من شكل وزقه ويسمونه ايضا العثرن لان وزقه شبيه

الثياب ويغسلونها به وربما طبخوه بالماء وغسلوا الثياب بطبيخه. غُبَيْر هو
الغسول الذي تغسل به الثياب وتجلى به اللك حتى يكن فيه الكتابة وهو نبات أو رق
له وله اغصان وشعب فيها شبه العقد رخصة كثيرة الماء ويعظم حتى يكون له
خشب غليظ يوقد وطعمه الى الملوحة وناره جاذة جداً واذا وجد دخانه كره به وله
اصناف كثيرة دد انفافسطون ومن الناس من يسميه اتوفابس وهو شيء ينفض

نوعٌ ماني من الاشنان

انفافسطون
ومولا شنان

به الثياب وهو نبات ينبت في سواحل البحر ومواضع رملية مش يستعمل في وقود النار
وهو نبات مخصب له وورق صغار شبه بورق الزيتون الا انها ادق من ورق الزيتون والبن
وفيما بين الورق شوك كأن لونه الى البياض ممأ ومنفرد وبعضه من بعض وهو شبه بزروس
النبات الذي يسمى فسوس كأنه عناقيد شرا كم بعضه على بعض الا انه اصغر ولا يزيد لونه
شيء من الحمرة مع البياض اصل غليظ لبن لماء ودمعه مر الطعم يستخرج دمعه مثل ما يستخرج دمعه
ثافبها وقد يخزن الدمعه وجدها وخزن مخلوطه مع دقيق الكرسنه ويجفف والدمعه وجدها

قريبه من نوع الحشيشة المسماه يوسن ولكنها دونها كثيرا في القوه
وقد يزعم بعض الناس ان هذا النبات اذا أمن شرب بعض النموم بإذا أزهر له
واذا اعتصرن دهن السوسن وادهن به صبر على اوجه المدهين به للنبول

اخيوس ج د هو اخسر هو نبات ينبت بقرب الانهار ومنابع
الماء المجتمعه من العيون وله ورق يشبه الباذروج الا انه أصغر منه
مشوهو وله عيدان رخمه هكذا
اوبشبه طولها نحو من ذراع
او نحوه من شبر وزهر أبيض
وثمر أسود صغير في رءس
عيدان هذا النبات وورقه
مملو رطوبه جدا وثمر هذا
النبات وابرزه منه ولذلك
يمنع المواد المتحلبه وجفنى
والاطباء يستعملونه في
مداواة العين اذا نـ
نصب لها ماده ج د واذا
احد من ثمر هذا النبات
منداز درخمى وخط بمقدار
اربع درخمات من عسل
وخلط به قطع سيلان الرطوبات من العين واذا وضع من الأذن ندرجما

اشنان ابو حنيفه أجناس الاشنان كثيره وكلها من الحمض
والاشنان هو الحرض وهو الذي يغتل به الثاب ابن حاج الاشنان بي
حشيشته القلي والقصارون يدقونها للثياب يابسا ويخلوها ويبذرون بها

بسبب ان قوته مركبة فقد ظن الناس انه موافق لعلل مضاده ويزرع هذا النبات اذا اشرب بالشراب الذي يقال له الميبختاطن في اوجاع الصدر والسعال واوجاع الكبد ونفث الدم والله اعلم ☼

اوغلصن

ثمرش صغير له وزر شبيه بزر الآس البري الذي يوزنه دقه والجهة مشوكه وفي طرفه عند الوزن شيء نابت شبيه بالآس صغير اصله وعصارته قوتهما من قوه الملينه وقد ظن بعض هذا النبات انها اذا طليت على زابس منه صداع نفعت منه وقد ينفع في اخلاط المزاج الملينه

انف العجل

انطيين ومن الناس من يسميه اباريس ومنهم من يسميه لخيزاعزيا هو من النبات المثنى فانه كذلك وشبيه النبات الذي يقال له اناغالس في ورقه وقضبانه وله زهر شبيه بالجبري الا انه اصغر منه ولونه ارفيري وله ثمر شبيه بمنخري عجل وثمر هذا النبات ليس ينتفع به في الطب والحشيشه ينتفع بها فقوتها

طرباأعضاً ايضاً وفيه ايضاً قوةً تبردّ داُفعة فهولذلك مركبٌ من قوّى مختلفة كمثل الورد الاّ انّه للبرد ياًبضٌ ‎ دّ‎ وورق هذا النبات ينفعُ من النهاب المعده والاورام العارضه في العين وساير الاورام الحارّه ونزفِ احدِه وزعم قومٌ انّ زهر هذا النبات الذي لونهُ يضربُ الي الفرفوريه اذا شُربَ بالماء نفعَ من الخناق والصرع العارض للصبيان وهو اذا اضمّد به رطباً بوافياً وأوَرام الحارّه العارضه للاذنيه وهو اذا اضمد به وزعم قومٌ انّ من عصر اوَراقه وزمانِ سناوله هذا الزهر وهو بابن يُرِدهُ البُرِك ثم رشّه علي الوَرم فانّه يُسكن الضرب ان العارض فيه والله اعلم واحكم ‎ ه‎

اَصوفورون ‎ دد‎ ومن الناس مَن يسمّيه فاسيليون لانّه نبات
يشبه الفاسيليس وهذا
الفاسيليس كما زعم قومٌ
هو اللوبيا الابيض وانبايشه
ايه تخرج منه عند موضع
الوَرق زَهر ابيض شبيهة
بالحبوط ملتفٌّ مثلَ الحرح
نبات اللوبيا الابيض وعلي
طرفِ النبات زَهر وبُرُدُقانٌ
مملوءَ بزر طعمه يشبه طعم
الابسون ‎ دد‎ وهذا
النبات له بزر وَرقه عفوصه
يسيره فهولذلك جلواد ينفضُ الاخلاط الغليظ مع انّه يشدّ الاعضاء وبِزرهُ والشب صاز ينفعُ من النفث من الصدور وينقّي الكبد ولابِزرِ من به نفث الدم بل وَرقُ الناس به قد وثقَ الناس بانّه نافعٌ لمن به نفثِ الدم وذلك

وزهرَ شبيهٌ بالجُلَّنار عظيم واصل صغير أبيض اذا جفَّ فاجتف منه رايحة
نشبه رايحة الشَّراب ونبت في مواضع جبليه ٦٦ اصل هذا النبات
اذا جفَّف صارَت رايحته كرايحة الخمرَ د وطبيخ الاصل اذا شربَ به
الجُوارشن الوحَشي انَّه واذا اشتم بهذا النبات سكن اسباط الفُرُوج الخبيثه
في البدن ديوسقُريدوس المانخوليا هو النبات الذي يبال ان الارض انه له
يوسيس يوبس به السباع وذلك ان فيه قوة تطيب النفس الا انها ضعيفه
لان الذي فيها ممَّا يشبه الشَّراب يسير والله اعلم بالصَّواب

اسطُراطيقوس نعم ابنُ وافد انه الحانه فانطه وهي الفرصعنه
واخلط في ذلك واما النبات
الذي يسمى بالعجمَّة قطيله
٦٦ ومن الناس من يسميه
بوسون هو نبات له ساق
صلبه خشنه على طرفها زهر
اصفر شبيه بزهر البابوبج
وبعضه ما يضرب لونه الى
الغبره فيربه وله زوذُن مشقَّقه
شبيه في شكلها بالكواكب
فاما الورق الذي على الساق
فانَّه الى الطول ما هو عليه
زغَب ٦٦ هذا النبات يسمَّى باليونانيه بويون وهو يسمى من اسمَ
الحالب لانه دواء وقد وثق الناس منه بانه يبسر الورم الحادث في الحالب
اذا وضع عليه كالضماد واذا اُعلَى ايضا على ضلعا وقوته تحَلَّل قليلا لان
جرمها يضَ يسيره ونحيَبه لبن الشديد الغلظ لبن المهر ولاسيما اذا كان

وله ساق دقيقه وعليها زغب ابيض مثل زغب ساق الكبر من الهندبا طوله نحو مشبه اصابع او اربع وله قضبان ذوات طولها اصبع متفرقه من نصف الساق الى اعلاه وبزر مثل بزر الشونيز ربما كان احمر وربما كان اسود وقل ما يوجد ابيض وهو في غلف فيه غلف بزر البحلبا الطول ما هي وزهر هذا النبات يكون على لون ثمره اي الالوان اي ان كان وقد يشرب هذا النبات باسره مدقوقا للادويه القتاله واوجاع الكبد والورم العارض له وقد ينضج شده الكبد والطحال جميعا ويذهب بالاورام الحاره وحللها ويذهب بالمغص والزاج الغليظه من سائر الاعضاء ويشرب بشراب بازدحلو لما وصفناه مقدار نصف مثقال ثلثه ايام متواليه وهذا النبات ينبت في مواضع يصل اليها الماء ويحسر عنها وفي ما اصبع قريبه من البحر وقد ينبت ايضا مع كثير من العطاني وفي مايها قربا منها وبين الشعير والحنطه والاقراط معروف عند كثير من الناس يعالجون به لما وصفنا وقد زعم قوم انه ينبت ارض رمال وارض فيها احجار ويوجد كثيرا بالسواحل وخاصه سواحل الشام والاسكندريه ومصر ونواحيها ورايحه هذا النبات اقرب الاشياء من رايحه الترج وله اصل عطر مثل الكماه واملس لا عروق فيه وعصاره الاصل في النضج وصفناه البلغم ولكنه ليس يكاد يوجد فيه رطوبه الا في ايام الربع

البغزاد

ومن الناس من يسميه انوبيدا ومنهم من يسميه انورس هو مش شبيه بالشجر صالح العظم وله ورق شبيه بورق اللوز الا انه اعرض منه وزهره ابيض شبيه بورق السوسن

ن الفم يسكن وجع الأسنان واذا صب علي از وب على الشقاق العارض
من البرد نفع منها وقد يشرب ل عرق النسا والله اعلم ك

ارقطيون اخر د د ومن الناس من يسميه فروسس ومنهم من
يسميه فروسس وهو نبات ورقه شبيه بورق اليقطين الا انه اكبر منه واصلب
واقرب الى السواد وعليه زغب وله سناق وله اصل كبير ابيض اذا
شرب منه مقدار درخمى جـ ح من اللسع الاكرب الصدر واذا
دق دقا ناعما وضمد به يسكن
الوجع في المفاصل العارض
عن الحكة المتلهبه وقد
يضمد بورق هذا النبات
للخروج المزمنه فينفع
د ق وهو مجفف يحلل وفيه
شي من القبض وبهذا السبب
صار ورقه يشفي الخروج
العفنه والله اعلم ك

افنقطس د د
ومن الناس من يسميه
الافوري هو همش صغير وله
ورق صغار ويشرب للادويه
القتاله ولوجع الكبد قطي
ن اصلاحيه هو همش صغير له
ورق صغار شبيه
السذاب فيه لشرف خفي

نسأل الله المداواة وعرفوا
هذا النبات إذا شربت
وشرب طبيخها نفع من
عرق النسا والنقرس
ونفث الدم من الصدر
وخشونة الحلق وينفع
منه أيضا إذا أخلط بالعسل
لعرق ولهذه الأوجاع
فينفع منها جدا والله أعلم

أرقطيون

ومن الناس من سمى أرقطوز هو نبات ورقه
أيضا يشبه بورق وليس غير إلا أنه أكثر زغبا منه وأشد استدارة وله أصل
حلو أبيض وساق نحو طويل وثمر يشبه بالكمون الصغير الحب [ح] قوة
هذا النوع قوة لطيفة في غاية اللطافة من أجل ذلك يغرى ويجفف أيضا وفيه
من الجلاء شيء يسير ومن أجل ذلك متى طبخ أصله وثمرته بالشراب سكن أوجاع
الأسنان وأوراجه في النار

أرقطيون

والقروح التي تحدث في
أصول الأظفار من اليدين
والرجلين والماء الذي يطبخ
فيه هذا إذا نفع إذا صب
على الموضع وكذلك أغصان
هذا النبات [د] وأصل
هذا النبات وثمره إذا طبخا
بالشراب وأمسك بطبيخهما

ايرِيغارُن د ح هو نبات له ساق طولها نحو من ذراع ولونها
يميل الى الحمرة ملاسٍ براء وله مشرف شبيه بورق الخرنوب الا انه اصغر
منه يكثير وزهر شبيه بأجنحة شبيه باجنحة التفاح شرح وظهر في وسطه
شى أبرد قنو شبيه بدقه
الشعر اذا كان المرعى
ابيض ومعنى اسمه الشيخ
الراعى وله ايضا اصلا
شبيه الطب وينبت كثير
ذلك فى الساحات وفى
المدن ح وقوة هذا
مركبة تبرد وتحلل تحليلا
يسيرا د ولورق هذا
النبات وزهره قوة مبرد
ولذلك اذا ضمد بهما
وحدهما أو ثنى سير مبنح ابرا الاورام العارضه فى الحصى والمعدة واذا اخلطا
بدقيق الكندر ابرا الجراحات العارضه فى الاعصاب وغيرها من الاعضا
والتى الذى يرى الزهر الشبيه بالشعر اذا انضمد به مع الخل فعل ذلك واذا شرب
هذا الثى الشبيه بالشعر وهو طرى عرض منه اختناق اشويس
د ح هو نبات له ورق شبيه بورق قلوقوص وعليه زغب كثير وهو
متراصف حوالى الاصل وله ساق مربع خشن غلظ شبيه بساق النبات الذى
يقال له مالبطا وساق النبات الذى يقال له ارقطبون وينبت منه شعيب
كثيرة يخرج من اصل واحد طوال الغلاظ واذا انودت وصارت فى
صلابة القرن وقد يكون كثيرا بالبلاد التى يقال لها اسنبا وبالجبل الذى

تخرج من الصدر والریه اذا اشرب وكذلك بیعه ما بلغاه من اعضاء البدن واما النخه التی قلنا انه تولدها فانما تولدمنه عندما بنضم فی المعده وذلك انه لیس هو نافعا بالفعل بل هو نانخ بالقوه وهو نطلق البطن اطلاقا معتدلا من طریق انه سهل لبابز الادویه المنهله والذی بعله ایضا من شقا الفروج الماكله بذا العله المعروفه بالاكله وفی السرطانات وفی جمیع ما البه فی التجفیف جمله من غیر بلذیع ولاحده وهو طبق بدا اذ كان فی مزاجه لطیفا بابسا اذا نضمد بهمع الحل ابز المروح العارضه من عض الكلاب والفروج الخبیثه والفروج السرطانیه والفروج الیحه والتوا العصب والجراحات والاعضاء التی ینال لها وحلا والدبیلات وقد یعمل مع الفبیر وطی وبضمد به الطحا الحاسی واذا ادق الوزف وصنع فی المحذ من قطع الرعاف واذا ادق وخلط بالمز واحتمل ادر الطمث واذا اخذ الوزف وهو طری ووضع علی الرحم لتانیه ردها الی حد اخلو وبزر هذا النبات اذا اشرب مع الطلاج حرک شهوه الجماع وفح فم الرحم واذا ادق وخلط بالعسل وعوفمنه ضمغ من عفن الفن الذی یحتاج الی الانضاب ومن الشوصه ومن الورم العارض فی الریه وقد خرج الفضول التی فی الصدر وقد نفع فی اخلاط المراهم التی یاكل واذا طبخ الوزف مع بعض دواب الاصداف لبن البطن وجلا النخ وادر البول واذا طبخ بالشعیر اخرج ما فی الصدر وطبخ الوزف اذا اشرب مع قلیل من المز ادر الطمث وعصارته اذا نفع غرغر بها اصمرت وورم اللها مجهول اذا اشرب من بزر الاجنه وزن درهمین فی شراب اسهل بلغما باعتدال ونقی الصدر والریه من الاخلاط الغلیظه ویحتاج شارب به ان یشرب بعده شیا من دهن ورد لبلا یحذر جلعه وقد نحذن منه شیا من عسل وجعل مسهل وقد نفع اذا اشرب من البلغم اللزج فی المعده ویشرب بلخجبین للطحال ووجع الكلیتین والله اعلم بالصواب

اثاليقا وهو الأخضر نوع ثان من الأخضر

ثلثة اصناف مما يُسمى هذا المذكور قبل وإكبرها بزرا وإكثره في قدره وشكله أخضر اللون يبرق صلب يكون في زوبة ومده وزنه خشنة لها معاليق رقاق طوال والثاني هو الكبير من الصنفين اللذين ذكرهما وساقه أحمر يميل إلى السواد وله ورق كور اكبر اللاته ورقا واشدها خشونة وبزره في قدر الأخرا الا انه فرط ابيض وارق والثالث هو الصغير وهو اضعفها قوة وادقها بزرا ه د هو صنفان احدهما اخشن من الأخر واشد سوادا واعرض ورقا وله بزر رشبيه ببزر الشهدانج الا انه اصغر منه والأخر دقيق البزر وورقه وزنه ليس بخشونه ورق الأخر ح ه ومنهذا النبات وورقه فيهما اللذان يستعملان فيما يحتاج البده من المداواة وفيهما قوة تحلل خلبلا كثيرا اجتى انهما يذهبان بالجراحات والأورام التي تحدث عند الأذنين وفيهما مع هذا نفخة بنسبتها صار استنجاز الشهوة للجاع وخاصتة من شرب البزر من هذا النبات مع عقيد العنب ومما يدل على انه لسخن غاية السخان وانه في غاية اللطافة انه اصعان ما يصعد من الأخلاط الغليظة اللزجة التي

الأولى وتبرد في الدرجة الثانية عند ما يأوي الديك السالمة وقد
مبتداها وادلاك فقد نفع ...ه يحفظ اسلمان مدة طويلة ولا ينبت
لهم الشعر في اليه اذا ... ضمادا على لوضع العاند بشراب واما برده
فانها تجلو جلاء بينا وتقبض ... مك صار ينبت منها اصحاب البرقان بشراب
وهو يحقن في الد... الثالثة واما في الحران والبرد فهو متوسط المزاج
د وقد استعرض الناس انه اذا صب باصل هذا النبات موجعا ابيض
الصبيان بطاهر عن الأحلام واذا شرب الأصل عقل البطن وادر البول ونفع من
نهشه الزنابير ثم هذا النبات اشد قبضا من الأصل واذا شرب بالشراب
قطع الاسهال المزمن ونفع من البرقان والله اعلم

افيون **د** هو نبات ينبت بين زرع
الحنطة وفي الأرضين المجروثة
وله ورق شبيه وزق السذاب
واغصان صغار وقوته شبيهة
بقوة الافيون الذي هو صمغ
الخشخاش **ح** قوة هذا
نبات تبرد تبريدا شديدا كأنها في
الدرجة الثالثة من نبات
الأشياء التي تبرد وبعده
من الخشخاش بعده يسير والله اعلم

انجره هو القريص وهو المعروف بالخرنق **ابن حسان** وله
ورق خشن وله زهر اصفر وشوك دقيق يسوعه البرقان ما سه عضو من البدن
اجزاه والمه وحمره وهو نوعان كبير وصغير فالكبير كبير الورق اصغر
اللون وله بزر كالعدس وهو المستعمل في صناعة الطب ... الانجره على الحقيقه

اسـقراغـالوس

وأغصان شبيهة ورق الحمص وزهر صغار لونه أفبري الأصل مستدير صلاح الطعم شبيه في شكله بالنجلة الياسه يشعب منه شعب عليه شوك شبيه الصلابة الغـدرون مثل كله بعضها في بعض قائمة للساق وينبت في أماكن ريحية وأماكن ظليلة يسقط فيها الثلج وهو
كثير بــالمواضع التي يقال لها فاماوس وفاماني ينال لها رفاديا $ح و$ له أصول قابضة وإذا ذلك من الأدوية التي تجفف تجفيفا ليس بالبتر ولذلك عمل الفروج العنقة ويبس البطن المستطلق بنسب موادجل له مع طبخ الأصول بشراب وشرب هذا الشراب $د$ وأصل هذا النبات إذا شرب بالشراب يقطع إسهال البطن ويدر البول وإذا جفف ودق وسحق وذر على الفروج العنقة كان صالحا وقد يقطع نزف الدم وقد يعتمد به لصلابته والله أعلم

أواقينوس $د د$

هو نبات له ورق شبيه وزن البلبوس وساق طولها نحو من شبر ملساء أديم من الخضر خضر وجمة منجنيه مملوء زهر لونه فرفري وأصل شبيه بأصل اللبوس أصل هذا النبات وهو شبيه بالبير يجفف في الدرجة

اَیارَا بوطَانی

بارسطاریون هو نبات له
قضبان طوطها نحو ذراع
او اكثر عليها مزو له
وعليها ورق منفرق بعضه
من بعض وتشبه ورقه بحر
البلوط الا انه ادق واصغر
منه واطرافه مشرفه وطعم
الى الحلاوه ما هو وله اصل
الى الطول ما هو دقيق واصل
هذا النبات وورقه ايضا

اذا سقى منهما بالشراب وعمل منهما ضماد كان صالحا لنهش الهوام واذا شرب من
الورق مقدار درخمى مع الزبيب مع ثلث اوليسات هند وقوطولى من شراب
عتيق بحر وفعل ذلك اربعه ايام متواليه كان صالحا لليرقان واذا ضمد بالورق
شكن اورام البلغميه المزمنه والاورام الحاره البلغميه و نفى القروح واذا طبخ
هذا النبات بالشراب وتمرغ بطبيخه قلع القروح التى تكون فى جانبى اصل
اللسان ومنع القروح الخبيثه من ان تنبسط فى الفم وقد زعم بعض الناس
ان غليظ هذا النبات اذا رش فى موضع فيه قوم مجتمعون على شرب طيب عشرتهم
وحسن احلامهم وقد شفى من كان به حمى غب لمعتقد الثالثه من قضبان هذا
النبات مع الارض مع الهام من الورق وقد شفى من كان به حمى غب المقعد
الثلثه من قضبان هذا النبات من الارض والهام من الورق وقد شفى من
كان به حمى غب الرابعه مع ما جوا الهام من الورق وسمى بهذا الاسم لانه
ينتفع به فى التطهير اذا اغتلى ومعنى اتيمه اشبه المقدسه والمكرمه

اسطراغالوس

هو نبت ينشب صغير على وجه الارض وله ورق

دُبَيْق في أماكن وعرة من حزون الأرض ۞ قوّة هذه الحشيشة قوّة تلطّف وتقطع الأخلاط الغليظة ولذلك صارت تدرّ الطمث إذا شرب طبخها بشراب وقد وثق الناس منها أيضًا بأنها تحلّل الدم الجامد إذا لبن فعل ذلك بما يجمد منه في المعدة فقط بل يفعله بما يحدث في المثانة وينبغي أن يُشرب في هذا الموضع بشراب العسل ومن شأنها أيضًا أنها جفّفتْ ما يختلب إلى المعدة حمله إذا اشرب وهي زَدْيَةٌ لفم المعدة ۞ إذا شُرب حَمّة هذا النبات نفعت عُسر البول ونهشَ الهوامّ وعرْق النَّسا وشَنَج أوساط العضل وتدرّ الطمث إذا شُرب بالشراب الذي يقال له انومالى إذا أُذيب الدم الجامد والمتعفّن في المثانة والبطن وإذا استُنعم منه على الريق مقدار ملشأ لو لبس ثياب ليست ممروَّج ببعض من كانت به نزله قطعًا وقد يحفظ هذا النبات مع الثياب فيحفظها من الأكل ۞ اغير اطون ۞ هو مَيْشٌ يُستعمل في وقود النار وطوله أكثر من شبرين وهي ساذج وهو قريب الشبه جدًّا من النبات الذي يقال له ابوغانس وعليه إكليل فيه زهر شبيه بنفاخات الماوّة شبيه بلون الذهب وهو أصغر من احدروتى والماشى اغير اطن لطيف نابتٌ عليه نمّا يا طويلًا على جذل واحدٍ لا يسيخ ۞ قوّة هذا النبات فوّة تحلّل وتمنع كون الأورام ۞ وهذا النبات إذا طُبخ ويُكمّد بطبيخه أو نُطخ بالنبات أدّر البول ولبن الحبل والله أعلم ۞ ومن الناس من سمّاه ايا زابوطاني ۞

فصاً واكثر لحماً من الصنفين اللذين ذكرناها ويقال له أو فجوس وهذا النبات ثمر يشبه أطرافه شبيه بثمر الصنفين الأولين وثمر هذا الصنف وثمر احد الصنفين الأولين إذا شُرب بشراب ممزوج عقلا البطن وقطعا نزف الدم من الرحم وادرا البول وقد يعرض منها الصداع وما لى أصل هذا النبات من الزوق الطري إذا انضمد به وافق نهش الريلا وثمر الصنف الثالث إذا اشرب نوم شاربه فينبغى أن يحترز من الاكثار منه فانه مميت ح ح هذا النبات نوعان والنوع الأول ارتر واصلب والنوع الثاني اغلظ واشد رخاوة وثمر هذا النوع يجلب النوم والنوع الأول ايضا هو ايضا نوعان احدها لا ثمر له والآخر له ثمر وهى ايضا يجلب النوم الا انها اقل حملا للنوم من ثمرة ذلك النوع الثانى وهذا النوع يهيج الصداع والنوعان كلاهما إذا غلياً فى النار وشربا بالشراب حبسا البطن وقطعا النزف الحمر العارض للنساء وهذا كله خصال تدل على أن مزاج هذا النبات عنبر مزاج مركب من جوهر أرضى بارد يابس ومن جوهر مائى حار نحو ازيد ما فيه سبره وأنها فيها مقدار ما يحقن ما يحد من المواد إلى الاسفل وأن نصاعد منها إلى الوائح جزأ إلى أن بازده يسيره البرد وفى التى تحدث للنوم والله أعلم

اماريوطن د د هو نبات يستعمل فى الاكاليل التى توضع على رؤوس الاصنام له قضبان فى بعض ورق دقاق شبيهة بورق القيصوم متفرقة بعضها عن بعض مستديرة واثنتى أطراف الجنبة مستديرة لونه شبيه بلون الذهب كانه زووس الصغير اذا ينبت واصلم

اماريوطن

الإحاطي هو نبات ذو صنفين
منه صنف يقال له النحويس
جاد الأطراف وهذا الصنف
ينقسم أيضاً إلى صنفين وذلك
إذ منه صنف ليس له ثمر
ومنه صنف له ثمر أسود يشبه
وقضب هذا الصنف أغلظ
وأكثر لحماً من قضب الصنف
الآخر ومنه صنف ثالث أغلظ

عنصر يقال الأكل

نوع ثالث منه نوع ثاني منه

اخجار

الى السواد وجمع اجزاء هذه
الشجرة تقبض قبضا شديدا
ولها وجه واذا افرشت
اصولها ودخنت بها
واعتفر كانت عصارته
جدا مثل ما الوث واكثر
ما يستعمل من هذا النبات
هذه العصاره ويستعمل رطبه
ويابسه وقد يستعمل لها
الاصل يجفف والشربه من
كل واحد منها قد رمثقال قد نقط العصاره مع السكر والمح ويعمل
منها شراب فيكون الطف تناوله وخاصه هذا الدواء نفع من نزف الدم
من حيث كان من البدن غير ما يثقب من قصبه الريه وجب الصدر وينج
الامعاء والبواسير وانفتاح افواه العروق وقطع الاخلاف المزمن
وتقوى الامعاء ويمنك بطن اسنان كافوبا دون اعمال كانود الى اذى ويبرى
قروح الريه ويقطع البلى وينفع من الوثى والرض وفتح العصر والمنك ويجبر
الكسر والقطع بى اللحم ويلحم الجراحات وقد حدث عنه من يوثق به انه
ابرا اطلام قرحه الريه بعد ثلثه اعوام من العله وقد وقع بى الذبول
وقذف قطر دم مع صديد من كثير وابران اخر من بول الدم والمده بعد
عشر اعوام والله اعلم ٭ اسل ٭ هو الديس ابو خنيه هو
المار وهو بجرج قضبانا دقاقا ليس لها ورق ولا شوك الا ان اطرافها محدده
ولا شعب ولا حشب وينحذ منه الحصر ويدق فيتخذ منه حبال ويتخذ منه
باعرق غير ابل ولا بكادين الا فى موضع ما اقرب من ماء د نجونس

بعضها فوق بعض تشبه علف البنج الا انها اقصر و البزر داخلها بزر دقيق جدا اسود وله عروق في غلظ اصبع لونها بين الصفرة و الحمرة حريفة الطعم جدا و نبت في ارض رملة و في البياضات من الجبال و تنمى بالحجمة الربال اذا دق و شرب نفع من وجع الجوف و يبشر الرياح و ينفع من التوثى الرخى و ينفع من لدغة العقرب و السموم القاتلة ۞ آ اذا ابدا ۞ د د هو نبات له ورق

شبيه بورق الآس البرى و هو
الحيران و عند لورى شى
طويل نابت شبيه بخيوط الكرم
البلقة علي ما كل نبات يقرب
منها و يحيط الحجر و له زهر
هذا النبات حاد و هذا
نبات في طعم حار شديد
جدا و محموه يسير منه
ايضا ان قوته مثل هذه
القوة و ذلك انه ينفى ايجاع
الدبر و استطلاق البطن و خروج
الامعاء و النزف لعارض النفاس و غير ذلك من سائر الاشياء اذا اشرب و اذا
وضع من خارج فعلم ذلك ۞ د و اصل هذا النبات فابض شديد القبض
يصلح للمواضع التي تحتاج الى قبض فيها و قد يشرب لانها الاسهال البطن و لسيلان
الرطوبات المزمن منه ۞ م و قد يقطع نزف الدم من اى عضو كان و الله اعلم ۞

اخيار ه هو نبات كثر ما ينبت على شطوط الانهار بين العلبن
له ورق شبيه باغصان النطة ما يلبه الى الحمرة حوان و تعلو قد ز
القامة و اكثر و يندح و يشبك باغصانه على العلبن و له زهر احمر

نے الصدر ویلین البطن ملائم لاعتدالہ المبرودین والمحرورین ولبرلہ ما اکثر
البقول من الانفاخ وکثرۃ البلغمہ فی الدم: ا**بن سنا** باردرطب فی آخر
الاولی غذاءہ اجود من غذاء السرمق وقوۃ جلاءہ غذاءہ یمنع الصفراء
وینفع من اوجاع الظہر الدموی ۞ **ازاقواح** الاعدیہ انہ بزر صغیر مدور
صلب ینبت بین العدس **الملاحہ** وینبت بین العدس خشبہ یشبہ وجملہا فی شبہ
بالعلف بزرہ اسود وادق من اجت مدور وہو لا شرینات العدس وخالطہ مخالطہ عظیم وقضہ
اشدمن قمع العدس وبزرہ یطبخ وخلط بعسل وکمون وجبن وتمام ترک فی الثمس
ساعات ثم اعید الی الشی یبرء من شاراج وعجز جدا وضمدت بہ الا ولم اجان الصلب
لبہاء واذا زال اوجاعہا ۞ **اسلیح**
ابوجنینہ ہو عشب طوال النفس
لونہ صفرۃ منابتہ الرمل وہو یشبہ الحمر
لی ہو اللبز ل الذی یستعملہ الصباغون
وہو نبات معروف اذا طبخ
وزقہ فی الرصف وضمد بہ
مثل الاورام البلغمیہ ویبدھا
واذا طبخ نبتہ الماء ودقت
بدقیق شعیر وضمد بہ ینفع
من الحمرۃ وہو مجلل منضج
ومسہ بنوی وزقہ اصفر من
ورق الاول ایکثر وساقہ ذات
شعب کثیرہ ومنبت علی
الارض لوینہ الی المغبرۃ ونبی
اطراف الاغصان غلف کثیرہ

ابن رضوان منه ما يشبه اللك فيه خمس أصابع تشبه مخالب الأسد ولونه أصفر وقوته جان لطيفة فوي الجلبة. **ابن سينا** شكله كالكف من صفرة وبياض صلبة فيه قليل حلاوة ومنه أصفر مع غبرة بلا بياض جازٍ في الثانية محلل للفضول الغليظة جداً نافع من الجنون له خاصية بنقي الجلد وينقي الأعضاء العصبية من آفاتها. **المجوسي** ينفع من السموم والهوام واسقاط الأجنة.

البح **ابن رضوان** هي عروق بوني بها من الهند ولونها أبيض وبها نكت سود وأنه بالتجربة ينفع من الشرا نفعاً بيناً وذلك أن يشرب منه أول يوم نصف درهم بشراب سكنجبين ساذج وفي يوم ثاني نصف مثقال وفي ثالث يوم درهماً واحداً فإذا ذهب بالشرى فبطله بالواحد مرة غِبّاً إثمال ويرى منه فعلاً عجيباً بمنزلة السحر وإذا أنعن وخلط بدهن ورد ومرخ به ظاهر البدن اذهب الشرا أيضاً من أي خلط كان يخصوصية جوهر وطعمه مُرّ وقوته حار والله أعلم.

اسفاناخ **الفلاحة** هي نبلة معروفة تعلو شبراً وله ورق وشعب ولينة ولها أنفاخ كـ لسائر البقول ولا تولد بلغماً وهي أول البقول غائلة ومن الأسفاناخ برّيّ وهو شبيه بالبستاني عند اهل الطف منه وأدق أكثر تشريفاً ودخولاً وزنه وأقل انفاعاً من الأرض. **الرازي** الأسفاناخ معتدل جيد الخشونة

اطرماله :: هو نبات له ساق بطول نحو الذراع ليس عليها شعب ولاورق
بني اربعه صفوف والوزن منوازيه والوزن شبيه وزن الشهدانج الا انه اصغر
منه بكثير وله سنبله نحو من شبر منظومه مرصفه بخلف ملتصقه بعضها
فوق بعض من ينبعه والخلف
مدور مفتوحه الافواه يبنى
شكل غلف البندر الا انها
اصغر بكثير وفى داخلها ثم
كالسندقى يبنى فى شكله
وهو فى قد الحمص فى داخله
بزر دقيق جدا احمر اللون الواحد
وعلى هذا النبات لزوجه تبين
كالعسل وله زهر ابيض دقيق
ورنما كان اصفر ونباته فى
الارض الجيده والنضر وبزر
هذا النبات كحماليه فيطع من الجرب ومن انتاء الرمد البارد والله اعلم ⁕
اصابع صفر هو النبات الذى تسميه التجازون بكف عايشه وكف
مريم ورده نحو وزن النبات الذى ينال له خصى الذيب وله ساق ينبع
دقيق عليه زهر وزمبري
من اسفله الى الاعلاه وله
اصل فى قدر كف طفل
رضيع وفى شكله ذو خمس
اصابع مملوه رطوبه ونباته
فى الرمل وقرب البحر

اسلاخنی بلب ونبت فی مواضع حضر وهو مجمع النبات واذا شرب
هذا النبات بشراب ابیض قطع الاسهال وطبیخه یشرب للفتوق والقیله
وینفع من علل الکلی المثانه فینفع الاعضاء الباطنه وینفع من شدخ العضل
واذا شرب طبیخه مع اللبن نفع من السعال وعسر النفس واذا دق مع هذا
النبات وذر علی الجراحات لحمها واذا ضمدت به القیله ضمرها

والصنف الثانی هو اغلظ ساقا واکثر اغصانا واقصر وثمره اجمر فاذا
نضج اسود ویستعمل فیما یستعمل فیه الاول وقد بعد ما قوم من اصناف ذنب الخیل

اذن الارنب ویسمی ایضا اذن الغزال ویسمی الضبی ویسمی اللفن ویسمیه
البربر اذن الشاه وهو نبات
له ورق نے صورہ ورق لسان
الحمل الا انه ادق واخشن ولونه
الی السواد وعلیها وبزر کالغبار
ابیض وفیها ایضا شبه من
لسان الثور وله ساق فی
غلظ بعلو اکثر من ذراع
وزهر ازرق فیه بیاض مثل
زهر الکتان مع جله
اقماعه اربع جهات جنس سلع
یلتزق بالثیاب وله اصل ادق وشبه کالحرب ظاهره اسود وداخله ابیض فاذا
قلع وحک به الوجه طری حمره وحسن لونه وطبیخه یشرب للسعال وخشنه
الصدر وورق هذا النبات اذا دق وضمد به مع دهن ورد نفع من اورام المعا
وسکن ضرباتها واوجاعها ومنه صنف ثانی اصغر من الاول ورق واصغر ورقا وزهره
احمر فرفیریه والله اعلم بالصواب

الظاهر طلي من غير مغلي وكذلك
يفعل بذه الاتجار كعب
الثعلب والكاكنج والهندبا
وغيرها واذا طلبت منه
النجم غصونا ضمدت بها
موضع لسع الزنابير سكن
وجعه وبرد الورم ودفع السم
وقد ما بسقى منه ما مغلي
مصفى او قنبار هو عجيب
للورم الحار والله اعلم مصوخ تسمى بالعجمية يسيلة وهو صنفان
صغير وكبير والصغير له قنبان صلبة رقاق معقد مثل ذنب الدرّ مثله
اذا جذبت انفصلت من مواضع العقد بعضها من بعض وفي كثير مجتمعة
لها ساق صغير خشن غليظ الخضر واورق اعلوا الجوانب صابر وليس له زهر
وله ثمر احمر فاني بسقت هذا النبات نبض مع مزّا من بنين ولها

واللّه اعلم ۞ **ادريون**

ابن عمران هو صنف من الماجوان منه ما يرا اصفر ومنه ما نراه احمر **ابن جناح** نواره يبقى فى وسطه زاىس صغير اسود **ابن بطل** هو نبات بعلو ذراعا وله ورق الى الطول ما هو قدر الاصبع الى البياض عليه زغب وله ادرع كبير وزهر كالبابونج ۞ **الفلاحه البطه**

وزده اصفر لا ذا يحه له وان سطعت منه رايحه كانت شبيهه بالمنتنه وهو نبات مدود وزاد قوم ان الثمر وسطح وزده بالبلك وزعم قوم ان المراه الحامل اذا امسكته بيدها مطبقه اجذاها على الاخرى بالاجبين ضرر شديد وان ادامت امساكه واشتمامه اسقطت ويقال ان دخانه يهرب منه الفاد والوزع وهو نبات جار زدى الكيه واذا شرب من مايه اربعه دراهم قيا بقوه وان جعل هذه فى موضع هرب منه الذباب وان دق وضمد به اسفل الظهر انعظ انعاظا سوطا ۞ **غيره** اذا سعط بعصارته اصل الا دريون نفع من وجع الاسنان ما يحلل من البلغم ويقال ان اصله اذا اعلق نفع من الحاز برو يقال ان المراه العاقر اذا احتملته حملت ۞ **امدزيان حبش**

هى تخرج بنشه وزهرها وزق نبات لبر جاده ارايحه ثقيله ينفع من الا وام الجوف و يفتح السدد ويقوى الكبد المعتله وينفع ررا وارام الظاهر البوره هى او اى من محلل الاورام الظاهره ومن عنب لتعلب والكاكنج ولحب نع غلف له مثل الببشه وهى يغرب من البرد والبس واذا اسفى عصيرا للاورم

أخيون

ومن جانبي كل واحد من
القضبان هو أصغر
يسيرا من سائر الأوراق وعند
الورق زهر لونه لون الأفة
وثمر شبيه بـ
برأس الأفعى ولونه من الزرقة
من أصبع لونه إلى السواد
ما هو إذا شرب أصله بالخمر
أو طبخ في بعض الاحشا
ويجلى سكن وجع الظهر وأدر
اللبن والله أعلم بالصواب

الأطيني هو نبات له ورق شبيه بورق اللبلاب إلا أنه أصغر وأشد استدارة
وعليه زغب وله قضبان دقاق طولها نحو من شبر رخمة أو شبه يخرج من أصل أحد
مملوه من الرز وعفص ونبت بين زرع الحنطة وفي مواضع عامرة ۶ و وهذا
الدواء جلاء
معتدلا ويقضب وورق
هذا النبات إذا ضمد
به مع السويق ووضع على
العين ينفع من الورم الحار
العارض لها ويمنع السيلان
الرطوبات وإذا
طبخ ويحتسى طبيخه
قطع الاسهـ العارض
من قرحة الأمعاء

الأطيني

على البدن من خارج جلد الجراحات واذا اجفف هذا الورق ثم سحق وشرب
بشراب شفى من عسر البول واذا اخلط بالزيت ودهن به البدن ادر العرق
وهذا النبات اذا دق وضمد به جلد الجراحات واذا شرب بالشراب ابر انطيب
البول واذا امتسح به مع الزيت ادر العرق **فمندون** د د هذا
النبات لينبت كثيرا بالساق وله ورق شبيه بورق النبات الذى يقال له
قسوعيدة من عشرة الى اكثر
قليلا له بشر وله عرق
دقاق سود دقيل الرائحة اطعم
لها من وبيتا في ولاصع فيها ما حق
قوة هذا الدواء قوة تبرد تبريدا
يسيرا مع رطوبة مائية فهو
بهذا السبب منسخ الطعم ليست
له مدة انه معلومه ويمكن فيه
اذا وضع على الثديين ان يحفظها
ناهدين وينال فيه انه اذا شرب
جعل الشارب له عقيا د وقد
يصلح ورقه مدقوقا مخلوطا بالزيت ضمادا للثدى ليلا يعظم واذا استعمل عروق
هذا النبات تطعت الجلد وزرقه اذا دق ناعما وشرب منه مقدار خمسه
دنخمات بالشراب الثالث اذا انطرحت المراة فطرح الجنين **اخيون** د د هذا
الافعوان اليونانية وقد كل الافاعى ومن الناس من يسميه دونير وسمى
مربيسمه الفار بوسر وموسيات وورق له وورق خشن منطبل الى الرقه ما هو شبيه
بورق النبات الذي يقال له انخلا الا انه اصغر منه وفيه زطوبه يدق
بالبدنى على الورق شوك اصفار شبيه بالزغب وله قضبان صغار دقاق كثير

اللواني يعصر ولا ذهن واذا ولدت فينبغي ان يوخذ منها على المكان وعصارة هذا اصل النبات جلى ويبيح واذا اكلته اكلت قايا شديدا

املس ثامنطرنى وهو شجر يعلو فوق القامة وله دوح وورق وله ورق يخرج من ورق الانس الاخضر ناعم وله ثمر احمر يشبه حب الصنوبر واذا نضج اسود يثمر الاملس وله خشب صلب اصفر الى البياض يلمع بحمرة يسيره ويجز فيه بعض الناس بالصنبرا واكثر ما يستعمل منه لحا اصله اذا اشرب نقيعه اسهل البطن وقوى الكبد والطحال ويبح ندد ها ويذهب اليرقان اذا طبخ مع اللحم وشرب المرق

اونوبرو خش هو نبات له ورق شبيه بورق العدس الصغير الا انه اطول منه وله ساق طولها نحو من شبر وزهر احمر جمرى فانيه واصل صغير نبت ينبت اما كن رطبه منفطله عن الجبال

ح قوة هذا النبات قوة توسع المسام البدن وتحل ولذلك صار وزفة ما دام طريا اذا وضع

البواسير وينفع من ادراه الماء بعد ان يشرب وينفع من المغص ووجع المثانه
وصلابه الطحال والشرب منه يشدد درا هم واذا بلطيخه صوفه ووضعت
على المفاصل نفعت من الم بها ودهنه ينفع من وجع الاذن ويحلل صلابه الرحم
ويذيب العرق ويفتح افواه العروق ونافع في اوجاع اخلاط الادويه المعفنه
ويوافق في الادويه و يوافق الجراحات وجراحات العصل والتواء الاعصاب

اناغورس هو خرنوب الخنزير ويقال له ايضا اناغيرن والناس يسمونه
يقولون الباعيران ﻋ ﻡ هو منبت شبيه بـ ... وورقه وقضبانه البان الذي يعتاد
له اعتين قريب في عظمه من عظم الشجر مثل الراجه جدا وله زهره شبيهه بزهر
الكرنب وثمره في غلف مستطيله وشكل الثمره شبيهه بشكل الكلي وفي ثمرته
اختلاف في لونه واملسا ... عند نضج العنب ﻡ ﻭ وهذا نبات من جنس
الشجر مثل الراجحه جادا وقوه جاره جلله الا ان ورقه مادام طريا وهو
ينبت ما خالطه من الرطوبه قليل الحدة يضمر الحلا ويلام الرخوه فاذا جف
صارت قوته قد تقطع ويجفف
تجفيفا بليغا وهذه التوه بعينها
موجوده في جميع اصوله واما بزره
فهو يلطف ويصلح ايضا للغي ﺩ
وورق هذا النبات اذا كان
طريا ودق وضمد به حلل الاورام
البلغميه وقد يسقي منه در خمي
بالشراب الذي ينال له غلوا في الربو
واخراج المشيمه والجنين
واذا ازال الطمث ويسقي بالشراب
للصداع وقد يعلق على النساء

في اما كرنخه شامه وهو صالح العظم ∴ ومنه صنف آخر له وزق فضبان تشبه بقضبان ورق
النبات الذي ليس كانه مفطون الا انها اكثر زغبا واقصر وزهره فرفيري اللون نتن الرايحه جدا واصله
شبيه باصل شلاذي اذا شرب منه مقدار اربع درخميات نفع من عسر البول وجع الكلح وكلاهما
جفف نبلا بحتى انها بملا المواضع المقرحه ∴ واما الصنف النوع وهو الشبيه بالفيطون فهو الطف من
الاخر حتى انه ينفع اصحاب الصرع والنوع الآخر الثخين الا من هذا والصنفان جميعا اذا احتفنا وخلطا بدهن
الورد واللبن واحتملا بنا الاورام العارضه في الرحم وقد يبريان الجراحات ∴ واما النوع النتن الذي شبه بالفيطون
فانه مع شبانا بنافعه اذا شرب بالتكحسن كل زوا ادا للصرع ∴ ا**لفوان** فزابيون ولور
شبيه بورق الكزبره وزهره ابيض والذي في وسطه اصفر وله رايحه فيها ثقل وطعم مرا ∴
امتحان هذا الدوا المس بالستر
الا انه ليس يحفف بحففا
شديدا هذا بالقياس من الحرارة في
الدرحه الثالثه ومن البوسه
في الثانيه واذا شرب
بانسا بالتكحسن او بالمحل يشفا
يشرب لاقميون يهل للمعاوم مع
سوداء اد ينفع من كان به زبو
واصحاب المرة السوداء واذا شرب
هذا النبات بلاا يشرب زهر
معه نفع من الحما والزبو وطبخه اذا جلس منه النسا سلابه الرحم والورم الحار العارض
فيها وقد يتضمد به مع زهر للاورام الحارة ∴ **مسيح** ينفح الغلظ وينفج السدد وطيب المعده
ويشفي شهوه الطعام ∴ **ابن ماسة** بيهم ويشبت اذا شيم ونفج اذا شرب ادر البول اذا اطلي به نفع اللانيه
واذا اتخذت منه مرة وزجه للنسا التواتي اسكن عن الطمث ادر الطمث **غيره** يدر
العرف وينفج افواه العروق ونفع الاورام الباطنه وينشر الخثر بشانه و ينفج

خريف لاورق له في اطرافه غلاف فيه البزر واذا شرب من هذا النبات مقدار دخمتين بشراب
بوليو الىبية ومن ثم استفاه وطبخ هذا النبات اذا شرب وزن بعقل ذلك وقد يفعل بالنبات للمغص
وينفع به نفسها وثمرها كان نوعها اذا شرب ادر البول وادرا اكثر الامرين بها ابين ايضا مع هذا اذا خلل ويجفف

اسقلني تأويله مخففه الطحال والحين الخامسة من كتاب جالينوس ذ‍ح لبوسطس ومن الناس
من سماه اسقلني لم وزقه شبيه بورق الضد
المسمى درا يطبون مثل النبات الذي يقال له الوف
وهو في شكل الهلال وله عروق نشبه د فاف
ولبزره ساق لا ثمر ولا زهر وينبت في مواضع
تجربه في مداق هذا النبات قبض واذا شرب
بالخل اطرف ورم الطحال ح قوه هذا النبات
قوه مر فمن اجل ذلك ينفع الطحال اذا شرب بالخل

اثلبيس ذ‍ح هذا النبات صنفان منه
ورقه شبيه بورق العدس ولها قضبان اطولها
نحو من شبر قايمه وورق لين واصل دقيق صغير ونبت

عفوصه فهو لذلك ينفع المعده اذا اشرب ويفتح السدد الحادثه في الاحشا وكذلك تفعل اطراف هذه الشجره ۞ وقد يقع في اخلاط بعض الادويه المجوده ويظن به انه اذا خلط بالعسل واحتملته المراه قبل ان يدنو منها الرجل منع من الحبل وينبت بين الحنطه والشعير والله اعلم ۞

اونوما

۞ ومن الناس من يسميه استفاطا ومن الناس من يسميه ابوبولس وله ورق شبيه بورق النبات الذي يقال له الخنسا مستطيل ليرتبط وله اربع اصابع وعرضه نحو من اصبع منفرش على الارض شبيه جدا بورق انخوسا وليس له ساق وازهره وله اصل دقيق ضعيف طويل فيه جمره يبيس برد وبيه وينبت اماكن خشنه ۞ وهذا الدوا مركب من جوهر حاد حريف من ذلك قد يثق الناس منه بانه يسل لاحه ويخرجها من الارحام اذا شرب وزرقه بالشراب ۞ واذا اشرب ورق هذا النبات بشراب حاد دز الجنين وقت الولاده وزعم قوم ان المراه الحامل اذا احتط هذا النبات اسقطت ۞

ابروطاقاس

۞ الابروطاقاس ۞ هو نبات ينبت في البلاد التي يقال لها اسوريا في السواحل منها وهو من النبات المنانف وفي كل سنه ابيض اللون دقيق العيدان مر الطعم

اﻳﺎﻗﻨﻄﺎﻟﺲ

لە ورق وساق شبيه بورق السوسن وساقه الا ان ورقه وساقه اخضر لون الكراث وله زهر ملك واربع واجل فرع شقيق فيه نجال السوسن ابتدا انفتاحه ولونه اصفر شديد الصفره وله اصل شبيه بالبصل التي يقال لها الوسن الا انه اعظم اذا شرب منجوفا واجتمل بالعسل اصوفه احد من الرحم الرطوبه المايه والدم واذا ضمد بورقه مع جوفا سكن اورام الحاره العارضه للثدي بعد الولاده واورام العين الحاره واصله وورقه يضمد بها الاحراق النار فينفع بها

د و اصل هذا شبيه باصل السوسن في منظره وقوته وفعله مثل منفعه ذلك من حرق النار لان فيه نوه نخلا قليلا مع ان فيه شئ من القوه المانعه النجا ح

انلدروﺻﺎرون د ح وهو الذي يسميه العطارون بالابيس وهو

ﻳﺎﻟاﻧﺪرﺻﺎرون

ممش وله ورق وصغار شبيه بورز الحمص وغلف شبيه بالحرنوب الشامي نشكلها فيها بزر احمر شبيه بالفوس التي لها اثنان من الطعم جيد للمعده اذا شرب ح وكان فيه مرازمه

نى الذكر والنجم د ح لم يجرب هذه الحشيشة ولم نخبرها بعد

أمبروسيا د ح ومن الناس من سماه البنجاسف هو نبت
كبير الاغصان طوله نحو ملىء اشبار وله ورق صغار مثل ورق السذاب
ينبت من مخرج الساق ومن اصله واغصانه مملوءة من بزر شبيه بالعناقيد
قبل ان يزهر ورائحته شبيهة برائحة السذاب
وله اصل دقيق طوله نحو شبر من
اهل ايادو يجعدون منه
اكاليل له قوة قابضة اذا
تضمد به منع المواد ان تنصب
الى العضو د ح واذا وضع
من خارج كالضماد كان فيه
نفع ومنع المواد من البطن

اللبنى د ح هو نبات
له ورق شبيه بورق الجزر وزهر
ابيض وساق غليظ طولها نحو
شبر وثمره شبيهه بثمر السرو ومن اصل
عظيم له عروق كثيرة مستديرة
ويثبت بين الصخور وقد يسقى ثمره
وساقه وورقه بالشراب الذي ينفع
له انبوبا لاخراج المشيمة وقد
يسقى اصله بالشراب لتقطير البول

امارو فالس د ح
من الناس من سماه امار وقاطيفطن

آماوه وسُقي منه المعضوض من كلب كلب قد زد درهمين من لبن حلب نباه وانفع
به جداً وزعم قوم انه يُنقى المعضوض من كلب كلب الذي يرد وقع من الماء واشرف
على الهلاك ۞ وينبغي ان يعصر الماء من ملسه اصول طرى به فان عدم الاصل الرطب
اخذ من اصله يابساً ويسحق وسقي منه من وزن درهمين يجب القوة العلو
وايضا نبات له قضبان شبه قضبان المثان وورق طويل قليل العرض حديد
الاطراف عليط اخضر ناعم كثيف وفي اطرافه زهر يشبه النوافس
لونه بين الغبرة والحمرة ما يراى الاصل وهذا النبات شديد المرارة ومن اهل
البوادي عندما ياخذ من ورقه قليلاً ويشرب بزيت ثمرة وبمزاد دهسه
فنفع فيا شديداً ما نفعاً و ينفع من عضه الكلب الكلب و قال انه ايضا ينفع من
الجزام والامراض السوداوية وهو دواء قوي غير مامون ان لم يحفظ منه واذا
تضمد به ينقي القروح الخبيثة ويبقيء بعض الناس عنبة السبع واجود هذه
واكثرها استعمالاً الحادة وهو ما ينم تجده العافنة و اظن هذا الصنف الثالث
هو الكراث الذي ذكره ابو حنيفة ۞ استقلينياس يسماه حبين

في كتاب ⟨ح⟩ العنابري ⟨دم⟩
هو نبات له اعصان طوال وعلى
الاعصان ورق مستطيل يشبه
في شكله ورق قوس وله
عروق كثيرة دقاق طيبة وزهر
تقيل الرائحة وبزره شبه بزر
الافيس وتنبت في جبال وعروقه
اذا شربت بخمر تنفع من المغص
ونهش الهوام واذا اتضمد بالورق
وافواه القروح الخبيثة العارضه

خاصه جمله جوهره وما كان من هذا اسبيله من النوى فانما يذرك بالجازب فقط واما قوته التى يمكننا استعمالها في اشياء كبيرة فهى قوة يجفف باعتدال وبجلو ايضا جلاء بينا واولاك صار يتبنى الكلبين ومذهب الكلف من الوجه وقال في الادوية المنا بلد للادواء عزد مقرا طير هذا النبت يشبه الفرا سيون الا انه اخشن منه واكثر شوكا كما يذوز ويخرج شوكه وورده تضرب لونها الى الحمرة الكمده وينبغى ان يلقط هذا الدواء في وقت طلوع العبور ويجفف ويدق ويحل ويخزن فاذا كان زبع وقت الحاجة سقيت منه عضه الكلب الكلب مقدار ملعقه بماء العسل اربع اواقى ونصف قد ذكر جالينوس عزد مقرا طير في هذا الكتاب جليه هذا النبات على غير ما ذكرد سقوريدس وقد رأيناه هذا النبات على ما وصفه فاما الذى ذكره د فان الناس يجعلونه عندنا ابنا فنموته ايضا الهاده وبعضهم سميته القارة وليست صفته على ما ذكر د في كتبه وهوينبت يخرج قضبانا كثيرة مدورة من اصل واحد عليها ورق اكبر قليلا من ورق المرنجوش وهى متكاثفة على الاغصان يحثنه الى الخلف من وجه متوازيه ما يله الى المغل ولو نامع الاغصان الى الباصر وعدل ورقه حب قد ذبرز الكزبرة وكانه من دوح واحد ايض عليه زغب في جوفه حبه سوداء قد العنب وهذا النبات يبقى المره السوداء وينفع من الما ليخوليا ويجمع اعراض المره السوداء ويقوى القلب والنفس ويذهب حديث النفس واوجاع جوف الحاد ثه من زنج غليظه او خلط غليط بارد وينفع من عضه الكلب الكلب اذا تبنى له ينفع صلاحيهما من الماء واذا علقت في الرقبه نفع من وجع الاسنان

وايضا فنات اخر يشبه الشبت شبها كثيرا شانه ورده وزنته وذوقه ومنا بته ارض زفته ذات جازه وله اصل طويل كاتنم الطويل والجزر وطعمه حلو وفيه جرا نده كبيرة فاذا اخذ من لحا اصله سبا ودق واستخرج

وليجته اجله واشده بياضا ويشرب منه من نصف درهم الى درهم مطبوخا او
نحو قائم عشره امثاله دهم بجوارا وارززله للشيخ يقدم ما يذيبه بدهن خروع فقط
وان خلط مع الادويه فاصلح ما يخلط به الكنبج والهليلج والتربد والصبر والمقل
ونحوه وان يشرب مفردا دون اصلاح قتلوا هو يورث الصلع حيف ما شرب
وخصوصا للكهول والمشايخ وان اخذت قتله بعسل ولوثت بازر وث منحوق
وادخلت في الاذن التي يخرج منها المده والقيح ابراها في ايام يسيره والله اعلم

الوسن هو نبات يستعمل في وقود النار وهو في المجرى

الحشوه ما هو دوسار وله
وله اصل الورق مجزرية
شكل الرس... وطبقتين فيه
بور... العرض ما هو وينبت
في مواضع جلبته واماكن
وعره واذا شرب طبيه شكل
الغاز واذا كان بلاحمي واذا امسك
بالبد اونظر اليه فعل ذلك
ايضا واذا انخي وخلط بالعسل
ولطخ على البثور اللبنيه والكلف
نفاه وقد نظر انه اذا ذوق صبر

في طعام والكمينه المعضوض من كلب كلب ابراه وقد دنيا انه اذا علق في
بيت حفظ صحته الذى فيه او بهايم واذا اسند بخرقه جرا وعلى بعض المواشي
شكن اوجاعها وانمائي هذا الدواء بهذا الاسم اعرف بانه بنفع من نهش الكلب
الكلب نفعا عجبا وقد دفع ايضا منه مرارا كثيره لمن قد نهش منه الكلب
واستحكم فيه بشربه وجد الا ان فعله ما يفعله من هذا اما هو بسبب

أبطاء المعدة وأقل هضما للطعام من أصل الأجزاز وأصل الأجزاز أجّد منه وخاصّته أن يغثّى ويغنى بلذيعه للمعدة اذا اكثر منه وبنبغى ان يستعمل منه خلّا ولا يعرض لجنمه ث ابن ماسّه خاصّته النفع من حمى الربع الكاينه من عفونه البلغم والّنّوب في قوته وفعله مثل الّنّواني الأجزاز : الرازى الاستغاز المخلّل لأجل من انخان وان عنق فه وهيحى وهيح شهوه الطعام ث

انزروت ث الانزروت جارتيجى الثانيه بابن في الأولى وقبل انه بارد في الأولى ولبس بنفجم

ابن سبنا موضع شجر بند
د موضع شجره سنية
بلاد الغزنت شبيه بكندر
صغير الحصى صمغ قرازه
غيره افضله اشرعه نقسبا
ح قوة قوة مركبه من قوتين احداهما قوة مسدّده لاجه والأخرى قوة فيها بعض المزاره ولذلك صار بجفف تجفيفا لالذع معه ولهذا

السبب يقدر ان بلحم ويدمل الجزاجه الحاده عن الضربه د وله قوة ملزقه للجزاجات تقطع الرطوبه السايله الى العين وبنع اخلاط المزاحم وقد بعض بصمع يخلط معه : غيره ينضج الاورام ويحلّلها واكل الّاج العثم منها ويبر الوثى واذا انحى معى بنب من بطرن بّماء وطلبت به الكاينه في الرقبه الشبيه بالخاز يرحلها وينع من الزمد والزمع وخصوصا المزا بلبن أو بياض بعض ويسهل البلغم اللزج الخليط بقوة وخصوصا في الوزك والمفاصل

جاذبه منتنه محللة للحصاة والخراجات واذا اشرب اسهل البطن وقد جذب بالجبين
واذا اشرب منه مثقال اندرخمي مخللا حللا ورم الطحال وقد يبرى من وجع المفاصل
وعرق النسا اذا اخلط بالعسل ولعق منه او خلط بماء التعبير ويحنى ينفع من الربو
وعسر النفس الذي يحتاج معه الى الانتصاب والصرع والرطوبة التي بنج الصدر
وبذر البول يحدر ويبني فروح العين التي ينبي لئوما ولئن خشونة الجفون واذا
ذيب بالخل ووضع على الطحال والكبد محللا حنانهما واذا اضمد به مع العسل
والزفت حلل الفضول المتحجرة في المفاصل واذا اخلط بالخل والنطرون ودهن
الحناء ومسح به كل زصاحا للعياء وعرق النسا شـ **عبير** يسهل الرطوبات وينفع
من ادجاج المفاصل البلغمية ووجع الورك والخاصرة والشربة منه من مثقال
منقوع في مطبوخ وقد يدخل في اصلاح المسهلات وفيه ملبن وحذب وينفع
بليغا الى ابساخ اللذين من اقواء العروق وهو نافع من الحاجات الرديئة والاكل
الخبيث وبنت اللحم الجيد وجلو بياض العين وجربها وينفع من الخوانيس التي
من البلغم والسوداء وحذب الرطوبة من عمق البدن ويخرج الشوك والنلا الى
الطمث ويخرج الجنين حيا وميتا والله اعلم :: **انتـنرغاز** ::

ابن عبدون هو واصل نبات ينبت
بخراسان يطبخ مع اللحم يجعل له نكهة
وقوته قوة الاجران د ح وقد
يكون اصلا نبات بالبلاد التي ليس
لها سوى ما يشبه اصل شجرة الاجدان
الا انه اذق منه وهو حريف زخم
وليس له صمغ وفعلها ما يفعل سلسيون
مسيح جاء باب نبات الثالثة منافعه
مثل منافع الاجدان **ابن ماسويه** هو

وازجعل في الضرس الماذا لفته وهو شديد الراجحه جدا فانه يبحراره من
البلاد. وزعم قوم انه لا يلدغ من اهل البلد لا به وذلك ان علقه مصرورا
في افواههم فتلد ايجنه يقول لدى من يزارعهم من كلاب الماء والديدان
وان اهل ازبينه اذا اصاب جنهم حرب الحرز رميه متمومه وضعوه على الربيه
فيسلم منها غيره يقوى على الباه وبنفع من الاسهال ويطل بزم العين البارد
وبنفع من حمى الربع جدا ويقلع الرطبات من المفاصل وليس ذلك خاصه
عجيبه ويقتل الدود وجب الفرج: اسق . ويقال السخ و سخ
وسق ح هذا الدوا ابيض وهو صمغ يشبه القنا في شكله نبت في البلاد اموبيامن
التي يقال لها لسوى في مالي الموضع
الذي يقال له فرسي يقال
لشجرته غاسوليس فاخترمنه
ما كان اجز اللون ليس فيه جاره
ولا خشب وقطعه شبه حصا
الكندر نقيا مكا يعا لبسه
وسخ البته وزايحته تشبه
رايحه الجند بادستر وطعمه مر
وينقال لما كان على هذه الصفه
روسيما واما ما كان فيه تراب
او حجاره فانه يقال له ذراما وقد
يوتي به من الموضع الذي يقال له اوسافون وهو عصاره شجره تشبه القتا ايضا
في سهلي ينبت هناك ح وهذه صمغه من صمع الشجر تخرج من عود ينبع على
استقامه وقوته ملينه جدا ولذلك صار طلابا للصلابات الحادثه
في المفاصل ويبرى الطحال الصلب وبحلل دبش المخانير ح وقوه الاشق ملينه

من ضرر الحيوانات ذوات السموم والجراحات العارضة من الثياب المتمرم
وقد يلاف بزيت ويمسح به للسعة العقرب واذا اشرط الاورام الخبيثة
القريبة من الجلث مع الاورام المسمى عانوكراا ووضع الجلث في مواضع المشارط
نفع منها واذا وضع وحده وشرب مع الشراب والظفرون والعسل نفع منها
واذا وضع على المواضع التي قلع منها الثاليل المسمارية والخدد الظاهرة
النابية بعد ان خلط بفين وطي اوجون المن النابت ذهب بها واذا خلط بخل
ابرا العوابي في حد ثان كوى بها واذا خلط بالقلقنت والزنجار وصيّر في المخنين
وفعل ذلك ايما شئ من اللحم الزايد النابت في الانف وينبغي ان ينزع اللحم اذا
اكله هذا الدوا بالكليين التي تسمى سوذانس وقد ينفع من خنونة الجلق المزمنة
واذا اذيب بالماء وتجرع صفاء على المكان الصوت الذي عرضت له الجحة دفعه
واذا خلط بالعسل وجك به جلاء ورم اللهاه وقد ينفع غرغر به مع ما لينزا طن
فينفع من سوحي واذا استعمله اجذب الطعامه حنرلونه واذا جفى بعض وافى السعال
واذا طرح الاجزا وحنّاه من به شوصه وانقنه واذا شرب بالشراب مع الفلفل
والسذاب سكن الكزاز واذا استعمل بالبن ينفع من اليرقان والحين وقد وحد
منه مثدانا ونوعن وخلط مع ثمح ويبلعه من عرض له قالج مع انصاب الوتبه
وميلها الى الخلف واذا تغرغر به مع الحل قلع العلق المعلق في الجلق واذا شرب
بالسكنجبين نفع من حمود اللبن في الجوف ومن الصرع واذا اشرب بالمرّ والفلفل ادرّ
الطمث واذا ادن في حبة عنب نفع من الاسهال المزمن واذا اشرب بما الورد
نفع من تشنج العضل واطرافها وقد يضاف في بلوزمتا وسلاب اوخبرجاز اذا
احتيج الى تشربه الرازي ذاب الخبث بلغار وعلل العصب لايعد لدوش
في الامتحان وجلب الحمى فلم يضع منه العلبل كالباقلا غدوة ومتى اغتسله ينفع يعبيث
بشراب حد قليل فانه يلهب البدن من ساعته :: الخبث حار يابس
في اول الدرجه الرابعه يقرب بفعله من فعل السموم ويضر بالكبد والمعده

أخلاط الصادعات أو خلط بالخل ث جاز بابرى الثالثة ينفع من أنبج مسيح
البول وبرد المعدة وبدأ الطمث ابن ماسويه مجفف لرطوبة المعدة
بطيء فيها يعبر براحة الفم والبول لتسحج الأجفان ويسهل
الطبيعة وينفع الاكلة اذا لُبخ ود علمها محمد بن الحسن
المحروث جار يابس مقو للكبد والمعدة معين على الهضم وقال في الأعذية ابن عمران نافخ بالمثانة الرازى
أنه يحط النفخ ويولد منه ذا ته نفخا يسيرا ويخرج الكلى والمثانة ونواحيها وينفع
مع الخل فكشنا الأعذية للمعدة ومنعها هضم ويكثر من خطة د وقد يجمع من
هذا النبات صمغ وهو الجلبث بارشروط اصلنا قد واجوده ما كان
الى الحمرة ما هو صافيا شبها بالمرقوى الراجحة للكون لا يجده شبيها براحة
الشراب ولا اكثر به المذاق هبا ان نداو واذا ذيب كان به بلى الباص
والجلبث لمعر وف بغوربانس وهو الذى من قوربنا اذا ابنان منه قليلا
فانه على المكان شد بده كله وراحته ليست بكربهة ولذلك اذا اتوى ك
منه لا يكون للفم راحة شديده والجلبث لمعر وف مسدتوب ويتبرج اتقانى
وهو الذى من ماه والجلبث لمعر وف بتوز بايسر وهذا الذى من شوربا همها
اصعف قوه من الفوا مس وازدى راحه وكل اصناف الجلبث بعث نل أن
حث تشكين خلط به اودبق الباقلى واشو ويعرف المغشوش منه بالمذاوى
والراجحه واللون ومن الناس من يسمى شاف هذا النبات سلينون وتنمى اصله
ما عظادن ويسمى ورقه مسنسطر واقوى هذه كلها الصمغ وبعده الورق ولخل
الورق ولساق والصمغ نافع حريف واذا خلط بخل والخبر والبلبل ولطخ عا ارا
الثعلب براه واذا خلط بالعسل ويجلى به احد البصر وذهب ابتدا الماء
من العين وقد يوضع بالماء كالعاز ضرج الأسنان فيسكن وجعها ايضا ويطبخ
مع الزوفا والتين جلا ممزوج بالماء وتمضمض بطبخه فيفعل مثل ذلك واذا وضع
على الفرحه العارضه من عضه الكلب ابراها واذا اشرب ونلخ به نفع

بطحون بعد الجلبت وبالوما ولبست مما يُبنى على الشار :: ابن عبدون هو
نبات كالكشمشت بابل يشبه البقال مع الشار د ح شلبيون وهو شجر
الجلان بنبت في البلاد التي يقال لها سوريا ولا يمنته وهديا وهو ماء ناقع
نبتى قطر قطر سطحٍ شبيه في كلها بالقنا وهو بالج وورقته شبيهة بورق الكرفس وبزره
منبسط شبيه ببزر بنى ما يُعطى ما يُعطى طارس ابن عمران والصنف الثاني هو الاسود
المنتن الذي يخلط ببعض الادوية وصمغ الانجذان هو الجلبت فالطيب منه
يكون من الطيب والمنتن يكون من المنتن وهو اصل غلظ يطلو ورقًا منبسطًا على
الارض جعدًا كالفت في السعة منه كامن وورق صغير وورق الحرز اشبه شيء
بالصفائح المخرمة التي يكون بها حلق الابواب يطلع من بين ذلك لوز وعسلوج في
رأسه كليل كليل البشت الا انه اعظم ثم يحلف في غلف دقاق منفرجه
الى الطول لما هى كربيه الزخ ح ح لبز هذا النبات جرّا جدا ولذلك
ورقه وقضبانه واصوله نتحرر اسخانا شديدا وجوهرها كلها جوهرنفاخ هوائي
ولذلك صارت كلها عنده الانهضام واذا وضعت على البدن من خارج
كان فعلها اكثر والمغها فعلا نفس الصمغه لان هاوه يجذب جذبا بليغا
وفيها سبب هذا المزاج الذي ذكرناه منها يبعض الجمر وذبيه وقال
ج الجلبت كثرا بالن الشجرحرّاره ولطافه ولذلك هو اشد تحليلا
وقال د الجلبت ينفع من ورم اللهاه كنفع الفاووانيا من الصرع
وقال قال جالينوس ان حرازه الجاوشير ينبت عند حرزان الجلبت شيء
واصله نافخ محبس يجتمع عند الانهضام مفرط المثانه واذا اخلط بالسريوطي
ونعوج به اورام الحناريز والحراجات ويضمد به مع الزفت ابزاكمنه الارم
العارضه تحت العين واذا اخلط بصيرة وطى يعمل مزدهن الارتنا وبذمن الخط
ويضمد به وافق عرق النسا واذا طبخ خلّ وشرب زمان ويصمد اذا ذهب اوجس
النبات في المعده واذا اشرب كان زيادة في اللذه القتاله وصمغه اذا وضع

الذي ينال له فرانيطس والسدر والصرع والصداع المزمن والفالج العارض
بطلان حس بعض الاعضاء وحركتها وعرق النسا ومن كان اصمع وبأحلها
اذا مسح بها بالخل والزيت وافتت الاعصاب وقد تستشق راحتها للاختناق العارض
من وجع الارحام والسبات واذا تبخر بها طردت هوام البيت واذا اخلط
بدهن ورد وقطرت في الاذان نفعت وجعها واذا جعلت منها كحل للعارض
للضرس نفعت من وجعها واذا استعملت بالبيض كانت صالحة للنعال وتوافق عسر
البول والمغص وتلين الطبيعة تلينا رفيقا وتليّن اورام الطحال وينفع منفعة عظيمة
من عسر الولادة واذا شرب نفعت من وجع المثانة والكلى والمثدد العارض بها
وقد ينفح من الزكام وقد يصنع بالاصل كل ما ينتفع به من الرطوبة اذا شرب
طبيخه الا انه اضعف فعلا من الرطوبة واذا ادق وهو يابس وعجن جفا ما عمل
وعجلت به الفروج العنيفة وقد تخلط المراهم والفيروطي المخنة وينبغي
ان يختار منها ما كان رخيا ولين ما يوكل صلبا ناطع الرائحة وقد يخلل رطوبته
بلوز مر وسذاب وخبزجان ويستعمل فيما يشرب

ابن عمران هذه الشجرة تسمى **انجدان**
وورقها الانجذان ويسمى صمغها الحلتيت
ويسمى اصلها المحروت وهو صنفان
احدهما الابيض الطيب الماكول والآخر
الذي يسمى النخى يستعمل في الاغذية
والادوية.

والمحروت
هو اصل الانجذان ومنابته في
الرمل الذي بين نسنا وبين بلاد
السغار والجليت مخرج من
اصوله وقد واهل تلك البلاد

فى جبال مظللة بالثلج. وقد يشترط الأصل بالتين وهو طرى ويستخرج الرطوبة التى
فيه ويوضع ذلك الظل لأن ثمرتها تضعف فى الثمن ومن وقت ما يجمع الرطوبة بعرض لمن
يتولى ذلك صداع وظلمة فى البصر الا انه مذا قد ينضج بمزجه بدهن الورد ويضع على
أذنيه ايضا منه فاذا استحج ذلك الرطوبة من الأصل لم ينفع به جنيد وقد يستخرج
ايضا رطوبة من اللسان وتستخرج ايضا عصارة الأصل كما تستخرج رطوبة أصل
البرزوج الا ان فعل العصارة أضعف من فعل الرطوبة التى تستخرج بالشرط وفعلها
فى الأسنان اذا استعملها أسرع حلالا وربما اصيبت صمغه لازقة بالأصل
والأغصان مشبه بالكندر واجودما كان من دمعة هذا النبات ما أوتى منه
من البلاد التى يقال لها ساموار وفى ثقبة الراجحة لونها أحمر لذع اللسان فى
الذوق ح [ج] أكثر ما يستعمل من هذا النبات اصله خاصة وقد يستعمل
ايضا اغصانه وعصارته وجميع هذه نوع واحد بعينه الا ان البنه اكثر قوة من
الجميع وذلك انه يحرز اسخانا عظيما وجلا ومن اجل ذلك صار الناس يتقون منه
انه يصدع من علل العصب وهو نافع ايضا من العلل الحادثة فى الصدر والريح من
قبل الأخلاط الغليظة اللزجة اذا زد بداخل البدن بالشراب واذا انخر العليل
به واستنشق اخته التى تنبع بالنار وذلك انه يقطع ويلطف واذا وضع ايضا
فى الموضع المآكل من الأسنان يذر وجعها مرارا كثيرة من ساعته لتلطيفه
وسخانه وهو ايضا ينقى الطحال الصلب لانه يقطع الأخلاط الغليظة ويلطفها وحلها
وأما أصلى فقد يمكن فيه ان يستعمل فى هذه الوجوه كلها واذا وضع على ورم يريد
ان ينقطع وتربه براهامه واسقطها سريعا وذلك انه يجفف تجفيفا قويا شديدا
الا ان هذا الأصل اقل لينا من لبنه وهو نافع ايضا للشروج الخبيثة الرديه اذا
جفف ويحا ونثر عليها وذلك لانه ينشها ويملؤها مدما يدملها وهو يحر فى الدرجة
الثالثه قريبا من ان منها ويجفف فى الدرجة الثالثه عند بدئها د دمعة
اذا طلى بها الزاين بالخل ودهن الورد وافقت لمرض الذى يقال له البرغر والمرض

للبول ولعرق مذهبه للفضول
يقطع العطش إذا شرب وقد
تداوى من دواء ذوات السموم ومن الهوام
والنفخ ويعقل البطن ويقطع
سيلان الرطوبات التي لونها
أبيض من الرحم ويدر البول
وينهض شهوة الجماع وإذا
استنشق لحون سكن الصداع
وإذا أنضج وخلط بدهن الورد
وقطر في الأذن أبرأ ما يعرض

باطنها من الأضداد للنقطة والعثر به :: **الرازي** في الجامع الكبير أنه ينفع
من الاستسقا ويذهب القرا قر والنفخ :: **ابن ماسويه** ينفع من سدد الكبد والطحال
ابن ماسه يعدل مزاج النفس :: **جالينوس** إذا اكتحل به نفع السبل المزمن مجهول
ينفع من المنتهى في الوجه وورم الأطراف ويفتح سدد الكلى والمثانة والدم
وينفع من الحميات إذا عصف به

اندراسيون هو البرطوزى
بالعجمة ٣ح فوقاذان
هو نبات له ساق
دقيق شبيه بساق النبات
الذي يقال له مارتون وله
جمة وافرة ذات كثافة
عند الأصل وهو لونه اصم
وأصل أسود ثقيل الرائحة
غليظ مملو رطوبة وينبت

وخلط بمسيح وقطرن في الاذن سكنت وجعها واذا صب على الراس مع
الخل ودهن الورد سكن الصداع والله اعلم بالصواب. **الرازي** حار رطب
للاورام الصلبة في المفاصل والحشا. **بولغورس** خاصته اذا به الفضول

اكليل هذا نبات معروف عند الناس وهو من نبات الجبال يعلو
أكثر من ذراع وورقه طويل
دقيق كالهدب متكاثف ولونه
الى السواد وعوده خشن صلب
وله بين اصعاف الورق زهر
دقيق لونه بين الزرقة والبياض
وله ثمر صلب داخنح وسائر
منه يزد دقيق من خرد له ورقه
في طعمه حرافة ومرارة وقبض وهو
طيب الرائحة وهو حار يابس
في الثالثة مدر للبول الطمث
ومحلل للرياح ومنضج سدد الكبد الطحال

ونقي الرية وينفع من الخفقان والربو والسعال والاستسقا الزفر والصيادون
عندنا يجعلونه في جوف الصيد بعد اخراج احشابه فيمنعه من ان يسرع اليه النتن

انيسون ح خ انيسون اجود ما يكون ما كان حديثا كبير الحبة لا
يسفر ويشرا اشبهها بالنخاله قوي الرائحة والذي باجرين الذي يقال لها فريطي
هو اجوده وبعده المصري ح ح وانفع ما في هذا النبات بزره وهو مسخن لطيف
ان في جزو زنه قريب من الادوية المحرقة وهو من اللطيف في الرائحة المالحة
وكذلك ايضا هو في الاعيان ومن بهذا السبب مدر للبول محلل مذهب للنفخ الجامدة
في البطن ح وقوته بالجملة مسخنه ميبسه وهي تقشر عن البدن وتسكن الوجع محلله مدر

ابو عمران هو عندى افضل واحضر من نبات الانواع المستعمله عندنا وهو نبات
طعمه الى المرازه وله رايحه فيها عطريه واكثر ما يستعمل عندنا نبات اخر يعرف
بالقرنوليه وهو عريض الورق فرنبرت من بزر الحلمر وله كلابل منلوبه منعطفه ضخمه
مجرعه بياض وخضره وفرفيريه فيها بزر اصغر من الجلبه وفى هذا النبات لزوجه
ولبن لاطعم ولا رايحه ومن الناس من يستعمل نباتا اخر له قضبان رفاق ممتدة على
الارض عليها ورق كورق الجنك وثمره فرنوز ممدوده كانها اشافل شبه شىء يعرول
البقر تكون جميعه شتا اسباعا فى داخل حب صغير شبه الجلبه وزعم قوم ان
اكلبل الملك المستعمل بالاسكندريه نبات طيب الرايحه جليل المقدار له ورق
كورق القرط ناعم اذا شاحمه النسيم شىء من عطريه وله زهر اصفر دقيق وفى
اطراف قضبانه كلابل صفر ملى شبه الدود الاصفر الذى يوجد تحت الارض فى الربيع

ابن سينا اكلبل الملك هو زهر نبات شبيه باللوز ملا فى الشكل فيه ملوحه مع صلاته ما
ومنه ابيض ومنه اصفر واجوده ما كان منه اصلب ولونه الى البياض قليل الطعم
امر ورائحه اظهر ٥غ قد يكون منه بالبلاد التى ينال لها طيفيون شىء جيد جدا
لونه الى الحمره زعفراى طيب الرايحه وقد ينبت ايضا بالبلاد التى ينال لها قنابا عند
تونس منه شىء يشبه الجلبه قليل طيب الرايحه ٦غ قوه هذا الدوا قوه مركبه
وذلك ان فيه شى قابض وهو مع هذا جلا وينضج وذلك لان الجوهر الحار فيه
اكثر من الجوهر البارد د ٥ اكلبل الملك قابض ملين للاورام الحاره ولا سيما
الاورام الحاره العارضه للعين والرحم والمقعده والانثيين اذا طبخ بالبطيخ وضمد به
وربما خلط ايضا معه صفره بيض او دقيق الجلبه او دقيق بزر الكتان او عبازالخطمى
او خنثا او سارس واذا استعمل وحده بالماء شفى التروح الحديثه التى ينال لها الصدع
واذا خلط به الطين الذى يؤتى به من الجزيره التى ينال لها هاصير اذا خلط به عنصر ودلف
بالشراب ولطخ به النزوح الرطبه فى الراس شفى منها وان استعمل مطبوخا او نيا
بالشراب نفع واحدا مما ذكرنا نكر وجع المعده واذا اخرجت عصاره نيلا

مابى لوطس

بعد الغسل وعليه زغب ولونه الى البياض ما هو طيب لرائحه وفيه ثقل
وله على الاطراف عضاه تشبه ثمره الذي لبر بستاني من النبات الذي
ينال له ازبين وهو الفاصل ونبت في مواضع خشنه **ح د** مزاج هذا الدوا
مزاج حار بحراره بثنه **د بلا ح** ولطبيخ الورق وطبيخ الاغصان اذا شرب به
فوته ندر البول والطمث وخرج الجنين ونفع بوسعه طرغور البحري وهو يسود
الشعر وينفع الجراحات ونفح الدود وينقي الفروح الخبيثه وطبيخ الاغصان وطبيخ
الورق اذا استحى به نفع احلى العارضه الفروح من الذكران واثاث **ابن جبل**
ينفع من حدرا اللسان وتوقف لكلام **غيره** ينفع من الخفقان ومن الاعراض السوداء
وينفع الجراحات الطريه اذا اضمد به **د ٮ** واما الشراب المتخذ باسفارس فبك صنعه
يوخذ من الاسفارس شيون درخمى ولغن فى جرة من عصيره وهذا الشراب ينفع من
وجع الكلى والمثانه والجنين ونفث الدم والسعال وهو من اجناس
الطمث **ث** **اكليل الملك** **ابن عمران** هى حشيشه ذات
ورق مدور مدور وزهر اخضر
وعفر واغصان رقاق جدا
يخالطه الورق والها نوار اصفر
صغير يخلفه مرا ودرقاق
مدور وزن تشبه انون الجبال
الصغار فيها حب صغير مدور
اصغر من حب خردل والمستعمل
منها اكليل الاكليل بما فيها **ي**
فى هذا الدوا اختلاف كثير
حتى لم يثبت له حقيقه الان
هذا الصنف الذي ذكره انطق

بسببه قبض ومن جوهر آخر أرضي
لطيف كبير المقدار بسببه صار
مرا وبسبب تركب هذين الجوهرين
صار يمكن منه أن ينفخ ويلطف وجلا
ويقوى جميع الأعضاء الباطنة والبدن
كله :: ابن ماسه خاصته تنقيه
الدماغ والنفع من المرة السوداء
ويسهل بكثير والشربه منه
خمسة دراهم وقد يسعط منه بوزن درهم معجونا بالعسل فينقي الدماغ تنقية تامة ::
الرازي يسهل السوداء والبلغم ويبرى من الصرع والماليخوليا اذا ادمن الاسهال
غبره أجوده ما كان أغبر اللون حديثا وهو جار في الأولى وابن في الثانية يلطف
ويفتح نفخا جلا وانضاج يقوى البدن الأجشاء ويمنع من العفونه ويبطى بالشيب ويمنعه
شديدة في تقويه القلب وتذكيه الفكر والنفع من السموم المشروبه ولدغ الهوام
ويشرب للاسهال مع شراب صاف وسكنجبين وشيء من ملح وهو يركب اصحاب المره
الصفراء ويميم وبعضهم ٥ ٥ واما شراب الاسطوخودس فصنعته مثل صنعه
شراب الافستين وشراب الورد فانه ينبغي أن يلقى عليه جزاير من العصير منا
من الاسطوخودس وهذا الشراب يحلل الغلظ والنفخ واوجاع الاضلاع واوجاع
العصب والبرودة المفرطة وقد يسقى منه المصروع مع عافر قرحا وسكبينج فينفع به
وقد يتخذ من الاسطوخودس خل ايضا لهذه العلل التي وصفنا وصنعته على مثل صنعه
الشراب الذي يتخذ به ولا فرق بينها الا اي الحشيش ينقع في الخل ويستعمل ٥
اسفاقس وبالسالمه وهي بالعجميه سالبيا ٥ هو مشيط يكثير
الاغصان وله اغصان ذوات اربع زوايا لونها الى البياض ما هي وله ورق شبه ورق
السفرجل الا انه اطول واقل عرضا وهو خشن خشبه شبيه مثل الثياب التي تعرك

شراب الأفسنتين فإنه يتخذ على ضروب مختلفة وذلك أن من الناس من يلقي على ثمنية
وأربعين قسطا من العصير رطلا من الأفسنتين ويطبخونه حتى يبقى منه الثلث ويلقون عليه
من العصير سبعين قسطا ومن الأفسنتين قسطا نصف رطل ويخلطونه ثم ينقلونه إلى الآوانى فإذا
صفى رققوه ثم خزنوه ومن الناس من يلقى على ذلك المقدار بعينه من العصير مثلا من
الأفسنتين ويبيعه فيه ثلث شهور ومن الناس من يأخذ من لحم الأفسنتين منافيه
ويشده في خرقه صفيقه ثم يلقيه فى ذلك المقدار بعينه من العصير ويبيعه شهور ومن
الناس من يأخذ من الأفسنتين ثلث أواق أو أربعا ومن السنبل والدارصينى والسليخه وقصب
الذريره وفقاح الإذخر والأكر وهو فر الطلع من كل واحد أوقيتين فيذر ذلك
ذرا جريشا ثم يلقونه فى ما طرسوس من العصير ويسوسون من ذلك الأوانى ويدعونه
شهرين ثم يرققونه ويفلونه إلى الآوانى ويخزونه ومن الناس من يأخذ من العصير
ماطرسوس ومن شيخ سبعة عشر مثقالا ومن الأفسنتين أربعين مثقالا فشده فى
خرقته ويلقيه فيه وترققه بعد أربعين يوما وتوعيه فى الآوانى وأخروز يأخذون من
العصير عشرين قسطا ويلقون عليه من الأفسنتين رطلا ومن صمغ الصنوبر الياس أو قيتين
ثم يرققونه بعد عشرة أيام ويخزونه وشراب الأفسنتين مقوى للمعدة مدر للبول ينفع
من به علة الكبد والكلى وأصحاب اليرقان ومن يبطئ به انهضام الطعام ومن ضعفت
شهوته ومن به وجع المعدة ومن به تمدد من تحت الشراسيف والنفخ والحيات الذى
فى البطن وإحتباس الطمث وينفع من شرب من ثم الذى يقال له اثيما إذا شرب منه
مقدارا كثيرا المرسله : **أسطوخودوس ط** سنخادس وهو
الأسطوخودوس ينبت فى الجزائر التى بلاد عندها البلاد التى يقال لها ما ليا وإسم تلك
الجزائر سنخادس ونمى هذا العقار باسم الواحدة من هذه الجزائر وهو نبات دقيق
له جمة جمه الصعتر إلا أن هذا أطول وزراقه من الصعتر وموجز يقع الطعم مع مرارة
يسيره وطبخه صالح لأوجاع مثل الصدر مثل الزوفاء وقد ينفع فى أخلاط بعض الأدوية المعجونة
خح طعم هذا النبات طعم مر وكأنه يقبض قليلا ومزاجه مركب من جوهرين أرضى

ورزقه ينفع كما ينفع قشره . **ابن عمران** ورزقه هاضم للطعام مسخن للمعده موسع
للمقر اذا اضاف من البلغم لأن من شأنه فتح السدد البلغميه ۞ **غيره** ورزق الأترج
بين النضج و زهرته الطف من ذلك وهما منقيان للأحشاء وخاصه الورق
۞ شجر الأبنج كبير

أبنج بأرض العرب من نواحي عمان
وهو يغرس عرسا وهو لونان
أحدهما ثمره في قدره اللوز لا يزال
حلوا من أول ما ينه والأخرى
ينه الجامد وجامضا ثم
يحلو اذا اينع ولهما جميعا ريح
طيبه ويكبر الحامض منهما حتى
يخرج حتى يدرك فيكون كأنه
الموز في رائحته وطعمه وبعض
شجره جنى صير كشجر الجوز ورقه

نحو من ورق الجوز فاذا أدرك فحلومنه أصفر والمز أحمر واذا كان عضا طبخت به القدور

أملج **ابن عمران** هي ثمره سوداء تشبه عيون البقر لها نوى مدد ورجاد الطرفين
فاذا نزعت عنه شقّ النوى على ثلاث قطع والمستعمل منه ثمرته التي على نواه وطعمه
مرتعفص يؤتى به من الهند ۞ **حبيش** يقرب فعله من فعل الهليلج الكابلي وقد ينفع في البلك
التي تحلب منها في اللبن الحليب يسمى شير أملج وانما ينفع في اللبن ليخرج منه بعض قبضه ۞
ابن ماسه أجود الأملج المعروف منه بشير أملج ۞ **منح** بارد في الأولى يابس في الثانيه
ماسرجويه بارد في الثانيه قابض يشد أصول الشعر ونوى المعده والمتعده ويدفعها
ويقبضها ۞ **شركه وحده** الأملج يسخن ويلطف ويسهل الأدويه ۞ **ابن غزل**
خاصته تقويه المعده وينفع من السوداء والنفع من النشاد ۞ **ابن ماسه** يقطع العطش

نافع للبحارات الحاره ، ابن عمران عن الخروج زدى الغذا . غيره جب
ان يوكل مفردا ولا يخلط بطعام قبله ولا بعده وهو زدى للمعده منعٌ بطئ الهضم والمربا
منه بالعسل اسلم واقبل للهضم وهو يجبس البطن ويمنع رشح الفوايح مطف جراره المعده
وقد ينفع اكله للبواسير ح واما ماء الاترج فيجفف بما فى قوته ومزاجه
الحده اكثر من اليسير ولذلك صار يجفف فى الدرجه الثانيه ولبن
بذره اما دون الاعدال اشبه يسير وقال فى الاعذيه بشر
الاترج عذر الانضام عطر الرايحه ينفع من الاستمرا كماينفع اشياء اخر مما لها كينيه جاده
جزيبه ولذلك صار اليسير منه يقوى المعده وصار ماوه خلط ما يشرب من
الادويه المنهله ، فشر الاترج جار با بس فى الثانيه نطيب المكه ،
ابن عمران يشهى الطعام ويعطش الاسرائيلى وينفع من الادويه المسمومه :
غيره اذا جعلت الاطعمه كالابازير اعان على الهضم ونفس البشره لصلابته
وله قوه مجلله واذا ضمد به ينفع من نهش الافاعى وقد يشرب بطبيخه لذلك وطبيخه ايضا
بكر الغى واذا القى لقشره الحمير صار حامضا سريعا واذا احرق واستعمل رماده كان
جيدا للبرص ورايحه الاترج يصلح فساد الهواء ودهن الاترج يتخذ من قشره وهو قوى حار
وهو اجود الادهان للامراض الباردة كالفالج واللقوه واستر خا العصب وينفع
من البواسير اذا طلى به وقد يتخذ دهن من زهره لكنه اضعف من المتخذ من قشره
، كتاب ح وبزرا لاترج مر الطعم واذا اكل زكذلك فا لامر فيه بين انه محلل
مجفف فى الدرجه الثانيه ح اذا اشرب بشراب كانت له قوه يضاد بها الادويه
القاتله ويسهل البطن وقد يتمضض بطبيخه وعصارته لتطيب النكهه وقد تشبيه النشاء
الحوامل للشهوه الخارجه عن الطبيعه العارضه له من ذ الحمل وقد بينا انه اذا وضع بين
الثياب حفظها من ان يوكل ، الطبرى اذا اشرب منه مثقال ان ماء فان وطلا
مطبوخ نفع من لدغ العقارب وان دق ووضع على موضع اللدغه نفع . الاسرائيلى
يحلل الاورام ويقوى اللثه ح ووزن هذا الثمره ايضا قوه مجففه مجلله الاسرائيلى

أقنثيون نبات وهو الشوك الذي يعرفه الناس ما لطيب ﺩ ﺡ هو صنف من الشوك
وورقه يشبه ورق الشوك التي ينال لها باليونانية اقنالوني في الماداوود وله زوبر
مشوكة وينال إذا زرع هذا النبات إذا جمع منه شيء يشبه ما ينسج من العطر وأصله
ورقها إذا شرب ينفع من الفالج الذي يعرض فيه ميل الظهر إلى خلف ﺩ ﺡ أصل هذا
النبات وبزر قوتهما حار
لطيفه حتى إنه ينفع من
به تشنج والله أعلم بالصواب

أفسنتين البحري
وورق الأفسنتين هدب يشبه
شبيه في هيئته وزبره جود
وهو لاحق بالأشجار لا بالبقل
وزهرته صفراء مجتمعه وهي
المستعملة ﺩ ﺡ هذا النبات

معروف وقد يكون منه بالبلاد التي ينال لها ماديا وفي الجبل الذي ينال له طورش

مثل الشعر وثمرته شبيه بالقرطم واصله في الارض الجيده التي به غليظ وفي الارض
الحبلية رقيق ولونه داخله ابضر وفيه ياكله شئ من طيب وكراهه وهو جلو اذا شرب
اصله اخرج حب اليرقع ومقدار الشربه منه اثنوا فرا اسوا بشراب قابض مع طبيخ
النودج وقد يسقى منه المحبون مقدار اني بشراب لانه يضم ويشرب طبيخه لعسر
البول واذا شرب نفع من نهش الهوام واذا خلط بنوى وعجن بالماء والزيت نفع الكلاب
والخنازير والفار ح ح ح اصوله يسقى ماءا بحب القرع ومقدار الشربه منه اثنان
واحد من شراب قابض ويسقى منها اصحاب ومزاج هذه الاصول مثل مزاج النوع
الاخر غير الا سود الا انه اشد مرارة منها جاما لا ال تفسيره البر الاسود
هو ات ورقه ايضا يشبه ورق الشوك الذي يقال له من لا انه اصغر منه
واذى وفيه جمره يضرب لاجر نه الدم وله ساق فيه غلظ اصح طوله اشبر لونها شبيه ب
جمرة المدح عليها كالليل وزهر مشوك دقاق لو زهر الناس الذي يبنى بر ابيس
وفيه نفط واصل اسود غليظ كثيف وربما كان مزمنا الا لوزن في الحمره ماهو اذا
مضغ لذع اللسان ينبت في البحارى بابيه والتلال والسواحل د اسله فيه
شئ فتالك لذلك ضايا انما يستعمل وينفع به من خارج وهو ينفع الجرب والقوابي
والبهق وبالجملة يذهب جميع العلل التي يحتاج الى شئ جلو وقد يخلط ادهنه مع الادويه
الملينه والادويه المجلله واذا اخذ منه ضماد شفى الشاكله وذلك لانهفي
الدرجة الثالثه ويسخن في الدرجة الثانيه عند منها م د اذا نحو الاصل واطبخ بنى
من القلفنت وصفوة العطار ويشجم عفو قلع الجرب واذا خلط بكبريت وقذر وطبخ
معها خل ولطخت بها القوابي قلعها واذا اطبخ وتمضمض به سكن وجع الاسنان واذا خلط به
من الفلفل اجزاء ومن الموم كمثله والصوف على الاسنان سكن وجعها وقد يطبخ
بخل ويضمد به الاسنان والمخنر واذا نحو وصير فيه طرف ثمار وصير على السن
الالمه نفتها واذا خلط با الكبريت نقى الكلف والبهق وقد ينفع اخلاط المراهم التي
تاكل ويضمد به القروج الماكله والجيشه فيبريها والله اعلم بالصواب

الفروح
في

ودن مثقال ويقال انه اذا علق على اجل له لمنفعة عقرب واجودها كان منه اخفقه وزنا وكان ابيض حديثا ينزع السقرف واذا غاص اسود وفسد والصلب منه والاسود ردى بالجملة | **شخيص**

موشوكة العلك وهى تصعد فى البربرية اداد وبالنونانية خاما لاون وهذا هواسم الحنزبا عندهم دد يسمى هذا النبات عندهم خاما لاون لاختلاف الورق فانها توجد خضرا جدا والى البياض ما هى والى اللون النماء والحمرة الدم رى قد رى اختلاف الاماكن التى ينبت بها منها ابيض ومنه اسود فالابيض هو النيط بالبربرية وهو الشكاير لا

خاما لاون وقرونشير لوقس الابيض ومن الناس من سمّاه فسقبا لانه لا نبات يوجد عند اصله فى بعض المواضع اقسوس وهو الدبن فى الاصل اقسوس فيقا وثعى اقساوهذا الذى يكون عندا صول هذا النبات تستعمله النساء مكان المصطكى وهذا النبات يشبه وفرق النبات التى يشبهها اهل الشام العلكرب والصنف من الشوك الذى يقال له سفولومن وزعفه اجش واحد اطر افا واصلب من ورق الخاما لاون الاسود وليس له ساق وينبت فى انسطه شوك شبيه كالقنفذ البحرى او شوك النبات الذى يقال له القنابية له زهرة شبيه بلون الغر فريز وهو

بحدله مزاجه وبعد ان مضى لذلك وقت بين لها حرارة وشئ من قبض يسير وهو ايضا يحو
الجزء وهذه اشياء كلها يعلم منها ان هذا الدوا مركب من جواهر مزاجى وجوهر ارضى قد لطفته
الحرارة وانه ليس فيه شئ من المائيه اصلا ومن اجل ذلك فوته مجلله مقطعه للاشيا الغليظه ولهذا
السبب فتاح للسدد الحادثه فى الكبد والكليتين يشفى من اليرقان الحادث عن عدد الكبد
وينفع ايضا اصحاب الصرع بسبب منه القوه فان للكيشئ اصحاب النافض التى تكون بادوار وهى
النافض التى تكون عن الاخلاط الغليظه اللزجه وهو نافع لمن نشئه افعى ولسعه دابه من الهوام
التى ينفض بزوده اعنى شمه اذا وضع من خارج على موضع اللسعه كالصفا اذا اشرب منه ايضا المسلوع
مندار مثقال احد بشراب ممزوج وهو مع هذا دوا اسهل والاغاريقون قابض مسخن وهو صالح
للعصر والكبد بنآت اللحيه ومهز العضل كلما كان فى اطرافها والسقطه اذا اشفى منه مندارا ثلوثين
بالشراب المثنى او مائى من السنت به حمى واما من كانت به حمى فليسقى بما يقراطن واذا اشفى منه مندار
درهمين بمآء نفع من وجع الكبد والرية وعسر النول ووجع الكلى والبرقان ووجع الرحم الذى يعرض
منه الاختناق ومن فساد لون البدن وقد يسقى لمرجعه الرية بالطلا ويبغى لورم الطحال بالنبيذين واذا
مضغ وحده وابتلع بلا شئ يشرب على اثره من الاشياء الرطبه نفع من وجع المعده والجشا الحامض واخذ
واذا اشرب منه مندار ثلثه اولوسيات بالمآء قطع نفث الدم من الصدر وما فيه من الآلات واذا
اخذ منه ايضا مندار ثلث اولوسيات بنبيذين كان اصلح للعسر النسا ووجع المفاصل والصرع وبدل
الطمث واذا اشرب منه المدار الذى ذكرنا نفع من الرياح العارضه فى الارحام واذا اشرب قبل
وقت دور الحمى ابطل نفض النافض وينفع منه احدا دخمين بما يقراطن اذا اشربها اسهل البطن وقد
يوخذ رحمى ويبغى ايشراب ممزوج بلاذوبه اذا انا له واذا اشرب منه مندار ثلث اولوسيات بشراب
نفع منفعه عظيمه من لسع الهوام ونشها ولحلها فانه نافع من جميع الاوجاع العارضه فى باطن البدن
وقد يسقى منه بعض الناس بالمآء وبعضهم بشراب وبعضهم بالنبيذين وبعضهم بالشراب المثنى بما يقراطن
على حسب علته ومندار قوه الانسان غبير خاصته اسهال الاخلاط الجميعه فى الدماغ والعصب
ولذلك صار ينهل اخلاطا مختلفه وهو ينفع اصحاب الصرع والجنان ان اصيفه وفساد اللون وانها له
دوا اخر ولا غايله واذا اخلط بالادويه المسهله فواها وبلغها الى اقاصى من البدن واشرب به منه

انه عصاره نبات ويكون هذا النبات ايضا ببلاد الغرب التي بنواحي مصر وهذا النبات شبيه
بالزوفا منه يوكل للجرب ويرفه كثيرا وينفع الشعر ان السوس اكلته قليل الماء هش
وله زهر لونه يشبه لون الزعفران او ان الزهر كبار ولذلك ظن قوم انه صنف
من اصناف شقايق النعمن ويكون منه عصاره لانه ينفع في اخلاط الادويه وفي
الادويه المشتبه التي تصلح للعين وجلوظله البصر ومن الناس من زعم انه طبخ من
هذا النبات واخذها من النار فغسلوها بنزوعها من التراب والحجار وجمعوا من هذه
الرطوبه فيعلموا منها افراصا نافعة مما ينفع منه العصان ومن الناس من زعم ان ذا هو
حجر يكون بالصعيده لونه كلون النحاس يغبر يلذع اللسان وجذبه ويغضبه

أغاريقون

هو اصل يشبه باصل الاعدان ظاهره لبر يكثف مثل اصل
الاعدان بلا محل لله وهو صنفان
ذكر وانثى واجوده الانثى في داخل
طبقات منتظمه والذكر مشدد
لبر يذي طبقات بل هو شيء واحد وكلاهما
في الطعم متشابهان الا لما بذا قال ان
يوجد في طعمها حلاوه ثم من بعد
يتغير طعمها كانه في فيه من الحلاوه
ثم من بعد يتغير طعمها نظر فيه شيء
من مرار ويكون بالبلاد التي ينال لها
اغاريقون من البلاد التي ينال بها سراطيقي ومن الناس من زعم انه اصل لنبات ومسهم من قال
انه ينكون من العفونه في اشجار تصور كما يكون مثل ما تصوره للعطار والاغاريقون ايضا يكون
في الارض التي ينال بها الاطعام من البلاد التي ينال بها الاباء وفي البلاد التي ينال بها
قبليبا على الشجر الذي ينال له الشرس الا انه شريع النفث ضعيف لغواه
الاغاريقون هو دواء واذا ذاقه الانسان وجد له حلاوه في اول مذاقته ثم انه في اخر

نمرخ بعضاً منه من اعزائها الاعجازها واخذه الشيوخ والذين لا يقدرون على الجماع
فيجامعون وقد تنبت هذه الشجرة بمصر واشد منبتها كبيرة وكثر منبتها في الرمل

اذان الفار اذخر الرازي كتابه الى من لا يحضره طبيب اذان الفار

احد النوعات وهو نبات له
ورق كاذان الفار علية زغب
ابيض لا شوك فيه فان علبنا
ابيض ازغب بعض اللون اذا اقطف
ينسل منه اللبن وسهل وفي قوته
فيا كثيرا **حبش** وفيه
اضعف من قوة الماء هوى زائدة وما
ينبت منه في البر وبعد عن
الماء هو واحد والطف من نابته
ولذلك صار زبحم الجلد الناعم اذا
وضع عليه من زؤفه ۞ فاما ما ينبت منه قريب من الماء والمواضع الرطبة فليس يفعل ذلك

عصره اذان الفار اذا استلق يباً وصفى ذلك الماء وخلط مع لبن وشرب واكل بعد
ذلك تمك ما يج فان الدود الذي في البطن ينزل كله واذا اسعط به نفع من اللثوة ۞

اونيادث من الباس من قال انه عصارة الحشائش الذي ينال له فاذا اعطى

ونهم من قال انه خلط
من عصير الصنف من النبات
الذي ينال انا نائل الذي
ازهره اود اللانورد وعبر
نبات البج وعصير نبات
الحشخاش ومنهم من قال

مجوفه ولها زوج صغار زرقاء طوال الأوساط
ظهورها مائله لونها الى السواد
واطرافها جاده وهى والج ازدلج
بها مواح وتشعب من الاغصان
قضبان صغار عليها ازهار صغار
لونه لازوردى مثل زهر واحد
صنفى اناغالس وللاصل غلظ مثل
غلظ اصبع له شعب كثيره وبالجمله
هذا النبات يشبه النبات البرى
الذى يقال له ستولوفندريون
الا انه اخشونه منه واصغر اصل هذا النبات اذا اضمد به نفع من نوا صير العين
حر هذا النبات يجفف فى الدرجه الثانيه ويبرد جدا ان بينه وبينه اصلا

اذان الفار برى آخر ۞ مجهول ۞ اذان الفار برى شجره تنبت فى الرمل

مغرسها الاغصان على الارض
لها وزج صغار تشبيه باذان
الفار البستانى لاغاد منه
شيا وهذا النبات اذا دق
باسره واستخرجت عصارته وتح
بها الذكر والمراه من السعط
ولاجامع ينعظ ويبيج جماعه واذا
اخذت هذه الشجره يابسه
وانقعت فى الماء وعولج باغصانها
فعلت ذلك وقد بلغ من قوه هذا النبات فيما قيل انه يعالج به الخيل اذا المتنع من الركوب ان

من الماغاليا الذي لون زهره لون اللازورد إذا ضمدت به المنعقده الثانيه ردها
وإذا ضمدت بالصنف الذي لونه أحمر زاد هانوا ح‍ ونوع هذا النبات كلاهما
فيهما جلوا وتسخن قليلا وجذب ولذلك صار كل واحد منهما يخرج الشاء من البدن
وعصارتهما تنقض ما في الدماغ ويخرجه إلى المنخرين فهذا السبب فيهما
قوه يجفف من غير أن تلذع وكذلك صار ملان الجراحات وتفعل في الأعضاء
التي تعفن **داساس** إذا انف من عصير مراجلس السبق والخردل الحريف
أخرج العلوا المبلول في قصبه الجوف والله أعلم **أذان الفار البستاني**
ح‍ ثم إن أذان الفار اللازورد وتشبه أذان الفار وسمى البستي ثابويا اليونانيه
البستاني لأنه ينبت في المواضع
الطلله وفي البسانين وهو نبات
يشبه النسبي إلا أنه أصغر

وذوقا من القسبى واصغر من
النسبى وبرق عليه زغب واذا
ذلك فاحت منه رائحة الغثا
وقوتهما تشبهه بقوه هذه
الحشيشه التى بحلوها الزجاج
لانها تبرد وترطب وذلك إن
جوهرهما مائى بارد ولذلك
صارت تبرد تبريدا لا تنقص منه وبهذا السبب هى نافعه من أو رام الحار المعروفه
بالجمره إذا كانت يسيره ح‍ وله قوه مبرده قابضه وإذا ضمد به مع السويق
وافق أو رام الحارات العارضه للعين وإذا قطرت عصارته فى الأذان الآلمه
وافقها أيضا وبالجمله فإن هذا النبات يفعل ما يفعله النسبى **أذان الفار**
البرى د‍ له قضبان كثيره من أصل واحد لون مائل إلى الحمره وهى

المعدة بقاؤه ۞ الاسرنبلي قبضه يسير وأطهر ما في قشره الأحمر وهو يجلو
وينقي ظاهر البدن ويداوي الجراحات الرطبة ويستعمله من جذا لذعا شديدا في المعدة
والامعاء ومن كان بولهم من فضول كثيرة دون حمى واذا طبخ بماء النخالة أو بماء
اللبن الرايب التي زيادة بينه ۞ اناغالس دد هو نبات

دو صنفين مختلفين في زهرهما الأول زهرة لازوردي ويقال له الأنثى والآخر زهره
احمر قان ويقال له الذكر وهما ينبتان بستان على الأرض ولهما ورق صغير بالاستدان
شبيه بورق النبات الذي يقال له حشيشه الزجاج وهي عروقها على قضبان مربعة
وثمر مستدير وكلا الصنفين من هذا النبات يصلحان للجراحات ويمنعان منها الحمرة
ويجذبان السلاء وما اشبهه ما باطن اللحم ويمسكان انتشار الغروج الخبيثه في البدن
واذا دقا واخرج ما وهما وغرغر به نقي الرأس من البلغم وقد ينتفع به أيضا لذلك
ويسكن وجع الأسنان اذا استعط به من المنخر المخالف للسن الآلمة سكن ألمها واذا
خلط بالعسل الذي من البلاد التي يقال لها اطفنائي ونفع من ضعف البصر واذا شرب
بالشراب نفع من نهش الأفاعي ووجع الكلى والكبد والجبرين وزعم قوم ان الصنف

أخرساج

اغصان هذه الشجرة واصولها
عناقيد صغار فصان مغشاه
بغشا ابيض اذا زلع عنها الغشا
بث فنفر لاجل منها عناقيب
نفوس كثير من الناس تم لها
وطبخ الثمر والورق اذا اصب عليه
البشر من بكرة الشرب ازى وهادها
اذا بل بالخل وطل به الجراحات
والجرب والدمامل الشون
وكبر علعها ابا ايما

أرزّ

من الحبوب التي تعمل منها الحبر بنبت في الحار ومواضع رطبة وهو قليل الغذاء يعقل البطن
الأرز شي من البض من ذلك فهو يجب البطن حبا معتدلا ونال في الأغذية
هو اعسر انهضاما من الخندروس واقل غذاء
ابن ماسويه هو اغذى الحبوب بعد الحنطة
واحمدها خلطا وبسد البطن سدا يسيرا ويقوي
المعدة ولها ابطا فيها وخاصته ان ماه يدفع
المعدة ويعقل الطبيعة وجلا جلا يسيرا
ابن ماسه زعمت الهند انه احمد الاغذية
وانفعها اذا اخذ بلبن البقر الخليف
وزعموا ان من اقتصر على الغذاء به دون ساير
الاغذية طال عمره ولم يشبه في بدنه صفرة
ولا لغير
منيح للبن خلطه حسن فاذا طبخ باللبن اغذك وحسن غذاوه وطال يبنى

نفع من الحمى البلغميه والمره السوداء ويجنب ايام الخريف والربيع فقط ۞

أمير باريس اكثر الناس يصحفون فيقولون أمبر باريس والصواب بالباء
منقوطه بنقطه واحده واشكال
الميم وكسر الباء وقد يجعل الميم
نونا فيقال نبرباريس والاصل ما
ذكرنا ومن ظن ان البرباريس غير
الامير باريس وسواه فانه بالجهل

الفلاحه هي شجره خشنه النبات
خضراء تضرب الى السواد نخلا حبا
مشتبها ۞ **غيره** حبه الى الطول
ولونه الى السواد وله داخله بزر
رزين كالنواه ۞ لي قد ظن قوم
انه العوسج الاحمر وليس بذلك
هو البلز من وسنذكره في بابه وكلاهما يصنع منهما الحضض وكليهما شوك حديد وقريبان
من العوسج ومنابته كثيره عندنا لكنه اضعف من المجلوب والمجلوب ايضا اضاف
منه الرومي واليمني والخراساني وهو اجوده ۞ **ماسرجويه** بازد ما بنى يمنع من
الاوراهم الحاره اذا وضع عليها ۞ **ابن ماسويه** يقوى الكبد والمعده وفيه قوه قابضه
مانعه ۞ **الرازى** عاقل للبطن قاطع للعطش جيد للكبد والمعده الملتهبتين ۞
مجهول اصل شجره البرباريس اذا طبخ بشراب وخلو سقى نفع من وجاع الكبد
منفعه عظيمه وليس دونها ۞ **أخرساج** الفلاحه النطه
هي شجره تنبت في البلدان الحاره والمواضع الشفه اليابسه وهى ترتفع كقامه كالنخل الطويل
وخشبها اخشن التبر تخوا جوف ودهم كورق التين اكبر قليلا له طعم عذب ثفه
املس وليس له نوى له الاتى يمضغ اذا مضغ واذا كانت جشاس وطيبت قعر المعده وسول بع

ويزيد الفؤاد جيّده وذكر: اليهودي: يهيّج الباه ويقطع البزاق وألقى: ابن ماسويه: يطفي حرارة الدم ويعقل البطن يسوّد الشعر والمربّى منه يليّن البطن ينفع البواسير ويزيد في الباه وينقي الطعام. غيره: شراب به ينفع البواسير المزمنة ويقوي الأعضاء الباطنة وخاصة المعدة والأمعاء والمقعد ودهنه يقوّي الشعر ويحسنه ويطوّل ويعظّمه ... والأهليلج الأسود أفضل من البليلج ويمنع ... الطعام. ابو درخت: ابن جلجل

اسمه بلسي معناه حرا البخم؟ع؟م؟ ...
وتوم؟ده البيج: ابن الجزار:
... عظيمة تشبه ...
والشام ولها ثمر كالزعرور في شكله
ولونه في غايته مختلط الحلاوة أحلى
نوى كنوى الزعرور وهو عظيم
الخشب كبير الدوح: ماسرجويه:
أما جيّده الذي يشبه النبق فإنه إذا
أكل ... الرازي: ثمنه رديء
للمعدة مكربة وربما قتلت:

ابن الجزار: من اكثر من اكله عرض
له غثي وقيء وصغر النفس وغشاوة على البصر ودوي في الرأس وعلاجه من شرب
الفريبرين والبلاذر: ماسرجويه: وأما ورقه فقد تستعمله النساء لبطلان به
شعورهن وأطرافه وغصنه إذا اعصرت رطبه وشرب ماءها وبالعسل والخلا المطبخ
نفع من السمّ النابل وعرق النّساء واسترخاء الأنثيين يدرّ البول والطمث ويحل الدم الجامد
من المشاش: ابن ماسه: تفاحة حزازة الثالثة وابنع او وصالح للشائح
والمبرودين فتاح فتائح السدد المتولدة في الدماغ ويشرب اذا طبخ بالهليلج الأسود والشاهترج

ابو درخت

والشم الذي ينال له فربيون ونشه الهوام الذي ينال له وغالي التبن الحري واذا عجن
بالعسل والنطرون وخلك نفع من سنجى واذا عجن بالماء نفع الشرى واذا ذيف بالعسل وافون
الآثار البنفسجيه التي تعرض ختما لعين واغشاوه والاذان التي سيل منها رطوبه وجنار
طبخه يوافق وجع الآذان اذا احترت به واذا طبخ بالمنخي وهي منه ضماد العين التي يعرض
لها ضرب ان تسكن الضربان وقد نضمد به الخاصره والكبد والمعده واذا نشرها اربح
منه بان تسخن ويعجز واذا نضمد به الخاصره والكبد عجن بوم مداف بدهن الحما وحقن
معه واذا ضمدت به المعده عجن بوم مداف بدهن وزدمجو فامعه واذا عجن بالبزر النطرون
وذبل الشيلم وافوى المطحولبن ومزبه الخبز وقد عمل منه شراب سمي الافتيمن خاصه
البلاد التي يقال لها زيد قطس والبلاد التي ينال لها رازي ونستعمله اهل هذه البلدان
الامراض المذكوره اذا مريكل جج ويشربونه ايضا على وجه اخر بان يعقدوا شربه في
الصيف لانهم يظنون انه يورث جعه وقد نظر انه اذا شري الصاديون حفظ الشاب
من السوس واذا ذيف بزيت ومسح به البدن منع التي ان يقربه واذا ابن يمابه المداد
منع الكتب التي كتب به من الغار ان يعرضها ويغل عصارة الافسنتين فيما بظر كعمله
الا انا لسنا نستعمله في الشراب لانها زده للمعده مصدعه وقد نعش عصارة
الافسنتين بعكر الزبب بان يخلط بها ويطبخ رونى الافسنتين يحفف لراير وجلو البصر
وحسن اللون **ابو حرج** ينفع من نفج الوجه وورما الاطراف وبد فنذاذ المزاج
ودآ الثعلب والحزاز العافت في ذلك كله افوى فعلا واسرع نا تبرا والشكاعي يقرب
فعله منه ∴ **جيد** نفعه او طبخه يبري اصحاب المره السوداء وخاصه مع الافثيمون
الرازي جيد جدا للدغ العقارب عجيب في ذلك يقوى المعده والكبد وينفع من
الخفقان لطوبله ∴ **ابن ماسويه** الشربه منه من مثقال الى درهمين ومنفوعا او مطبوخا
مرخسه الى سبعه بان اخذ مفرد افرن مثقال الى مثقال ونصف ∴ **مجهول** ينفع
من البواسير والشقاق والمعده وينفع من علط الجنون وينفع من الصلابات النافذه
الباطنه ضمادا وشرا وطبخه يقتل البراغيث ودخانه يطرد الهوام ۞ ۞ فاما

بو خرج انواع کثیرة یونی یه من بلد فارس و من نحو المشرق و من جبل اللکام و غیرها خلف
و اجوده السوری و الطرطوسی الذی اذا راسه انه زغب و فیه عقد کانها برن الصعتر
الغادیتی و ما لا زمنه شدید المرارة بطرحنه فی السخنو مثل ما یطرح من الصبر السقوطری
و کانت صفرته کانها زغب فرایج اجام ٭ فی جبلة البرة انواع الاطنتین کلها لا یخلو
من کنا نفع فویتن الا ان الاطنتین الجلوب من بطش الکنیسة النابضه فیه اکثر
التاس انواع الاطنتین فوه المزاج فیها فوی کثیرة و اذا انت دققت واحد منها
فاما ان تجده فیه یضرضعف خفی جدا و اما الاخر فیه ینبض اصلا و لهذا لا ینبغی ان
یعان زلا و رم الکبد و المعده و الاطنتین الجلوب من بطش و تؤثر علی غیره و من علامات
هذا الاطنتین ان وزنه و زهنوته و زهرته سایر الاطنتین و زهرته بکثرة
جیدا و ارایحه ... لیس فیها ... یکسره قد وجد فیها عطر به ما و رایحه سایر انواع
الباضه ملبته و قال ٭ ... طعم الاطنتین فیه قبض و مرارة و حرافه و هو
نتحو و یبلو و یجفف بیس و لذلک صار ما فی المعده من الخلط المزاری و خرجه بالاسهال
و یدر البول و ینفی خاصه ... فی العروق من الخلط المزاری و خرجه بالبول و من
اجل ذلک صار متی اخذ و فی المعده بلغم ینبن لم یتفع به و کذلک ایضا ان کان البلغم
فی الصدر او فی الریه لان ما فیه من القبض اقوی مما فیه من المرارة و من قبل ان فیه
جره و جزا فیه ایضا صار ایستخن اکثر مما یبرد و ان کان تبتی لنا ان نقول اجمله کیف
الحال فی مراجعه فی القوی الاولی فان کان اجزاوه منفاوه حدا و انه لا تشبیه بعضها بعضا قلنا
انه حار فی الدرجه الاولی یابس فی الثانیه و عصارته اشد اجزاوه کثیرا من خثیشه
٭ فوته قابضه متخنه منقیه للفضول الرطبیه الحاله فی المعده و البطن و اذا استدم فی
شربه ادر البول و منع الخمار و اذا اشرب مع ... السا او سل و ما زاد ش فلیطی و انقی النفخ و وجع
المعده و البطن و اذا اشرب منها و من ماء عده و ابا کبل یوم مقدار ثلث اوقیة ...
شنی من عدم شربه الطعام و البر فارق و اذا اعجن بالعسل و اجعل ادرا الطمث و اذا اشرب بالخل
و انقی لاختناق العارض من القطر و اذا اشرب بالشراب و انقی السم الذی یقال له اکنیطا

وشجرةٌ تبقى عشرين سنةً تحمل
وحملها مرةً واحدةً في السنة
ورقها نحوٌ من ورق الجوز وهو
طيبُ الرائحة وتفاحها شبيهٌ
بتفاح النرجس إلا أنه ألطف
منه وهو دقيق كثيرُ الشوك حديدٌ

ح أ هو نباتٌ يبقى ثمرُهُ عليه
جميعَ السنة معروفٌ عند جميع
الناس والثمر منه طويل لونه شبيهٌ
بلون الذهب طيبُ الرائحة معه

من كَرَاهية وله بِزرٌ شبيهٌ ببِزر الكُمَّثرى ح ر جوفُ الأُترج وهو الذي فيه البِزر
حامضُ الطعم وقوته تُجفف تجفيفاً كثيراً حتى أنه في الدرجة الثالثة من درجات
الأشياء التي تُبرّد وتجفف • الأَنزَرُوتُ هو على ضربين لأن منه ما حوفه تفه مائلٌ
إلى العذوبة وبه قلبٌ ومنه الحامض القِطاع فما كان زِائداً في حُموضته كان زائداً رُطوبةً في الثانيةِ وما
كان حامضاً كان زائداً يابساً في الثالثةِ • ابن ماسَوَيه حُماضُ الأترنج يُسكن المرةَ الصفراءَ
والقيء والغثيَ العارضين منها عادلٌ للطبيعةِ وإن لطخ الكَلَفَ والقوباء بعصارته أذهبه
خاصةً الثوب فإنه يُذهبُ بلونه وطبيخُه نافعٌ من مزاحمته للطعام مُطفيٌ لحرارةِ
الكبد • الأَنزَرُوتُ والنَفطهُ منه أيضاً بِنكهةٍ الحرارة قاطعٌ للعطش والحامضُ
يَنفعُ من الخبز من الثياب • غيره إذا طُبخ بالخلّ وسُقي منه نصفُ أوقيةٍ فتلَ
العَلقَ المُبتلعةَ وأخرجَها وهو رديءٌ للعصب والصدر وبَعضٌ من البُرفانِ وإذا اكتُحِلَ
به أذ البُرفان العتيقُ والعينُ وعُصارتُه تُسكن غُلمةَ النساء • وحُكمُ الأُترنج بِن قِشرهِ وحُماضهِ
يُولدُ أخلاطاً غليظةً بارده • ابن ماسَوَيه باردٌ رطبٌ في آخر الأولى ويرودُ منه أكثرَ
من رُطوبته عِنزَ الانهِضام مُطفيُ للمعدةِ • مسيح نافعٌ لأصحاب المَرَّة الصفراء

إذا أكل حب البطم الذي ذكرنا قد نجده يطلق البطن إطلاقاً ظاهراً ولكنه أقل إطلاقاً من الإجاص المجلوب من لمبريا وهي أن ميبه الداخلة أشد جلاده والشجرة كل واحد من هذين البلدين على جهة الثمرة فيجئ الإجاص التي تكون ذا أن ميبه الداخلة أقل قبضاً والذي يكون بدمشق أكثر قبضاً وجمله جميع الاتجاه والأصول التي يوجد القبض

ورقها وقضبانها ظاهراً فهي إذا اطبخت صارت نافعة لمن تغرغر بها من ورم اللهاة والنغانغ :: **ابن ماسويه** الإجاص بارد رطب في الثانية يغذو يسيراً ويطيب المعدة ويسهل الصفراء ويطفئ الحرارة وفعل الأسود كما ذكرنا أكثر من فعل الأبيض وما صغر منه كان أقل إطلاقاً :: **الإنزابلي** الأبيض منه يبطئ الإنهضام ردي للمعدة قليل الإسهال لغلظه وقلة رطوبته وجوده ما كان رايع النضج :: **مجهول** ما الإجاص بدل لطمث :: **الفلاحة النبطية** الإجاص الجبلي شجيرة ورقها مدور أصغر من ورق الإجاص وثمرتها لا الإجاص حامضه صادقه الحموضه وهي لا تفلح في البساتين البتة ح ثمرة الإجاص الصغار البرى يقبض قبضاً بيناً ويجبس البطن ح وورق الإجاص إذا طبخ بشراب وتغرغر بطبيخه نفع سيلان المواد إلى اللهاة وعضلتي اللوزتين واللثة وثمرة شجر الإجاص إذا نضج وجفف فعل مثل ذلك وإذا طبخ بطلاء كان طعمه أطيب وكان أمسا كه للبطن أشد وصمغ شجرة الإجاص يلزق الجراحات ويغرى وإذا شرب بشراب فتت الحصاه وإذا اخلط بخل ولطخ به النوى الى العارضه للصبيان برأها ح إن رنج الصمغ يفعل هذا فالأمر فيه بين إنه قطاع ملطف :: **مجهول** هو شبيه في القوة بالصمغ العربى إلا إنه أضعف وإذا انتخل به حد البصر والله أعلم :: **فق** يعز رنج غرسنا ولكن نا **أترج**

من اوجاع الركبه والنعال ومأورقه جبس الأنمال طلاءً واذا شرب مع دهن آخر
والارسد
عصر البلغ فانه له وهو ينكر الحمرة ورماده يدخل في أدوية الظفر وصنعه
دهن الآس يوخذ من ورق الأسود منه مااكان اخضرا ويعصر ويخلط بعصاره جزءا
مساويا له من زيت اسفار وضع هما على جمر ودعهما حتى ينطبخا ثم اجمع الدهن
او يوخذ من ورق الآس ويوضع في زيت ويغمر فوقه فابضه مصلبه ولذلك ينفع
في اخلاط المراهم المدمله التي تختم الجراح وصلح خرق الناذر والفروج الرانس والسبج
والشقاق الذي يكون في المعده والبواسير واسترخا المفاصل وحزة العروق
ولكل شي يحتاج الى قبض واختصاف. وقال في صنعه شراب الآس يوخذ
اطراف الآس الأسود ورقه مع جبه ويدق ثم يوخذ منه عشرة امناء ولقى على ذلك
قوا نس من عصير العنب ويطبخ الى ان يذهب السلت ويبقى اللثان ويرفع بعد الصفيه
وقد ينفع هذا الشراب من الفروج الرطبه العارضه في الرانس والخاله والبثون
ومن استرخاء اللثه ومن زفر النفاغ والاذان التي يخرج منها فيح ونقطع العرق
واما شراب جب الآس فعمل بان يوخذ من جب الآس ما كان اسود نضيجا فيدق ويخرج
عصارته بلولب وتوخذ العصاره وتصبر في أناء ويرفع ومن الناس من يأخذ جب
الآس فيشمسه ويجففه ويدقه ويخلط بالكيل مثله الذي ينال له سوس ثلاث
قوطلات من شراب عنيق ثم يعصره ويأخذ عصارته فترفعها وشراب جب الآس
شديد القبض جيد للمعده يقطع سيلان الرطوبات الى المعده والامعاء وهو طلاء
للفروج العارضه في باطن البدن وسيلان الرطوبه من الرحم سيلاناً دائماً وقد
يصبغ شعر الرانس

اجّاص
هو المعروف عند ابوش

البقر
شجره معروفه ثمرها ابو ولو وهو زدي للمعده مليّن للبطن فاما ثمر
الاجاص الشامي وخاصته ماكان منه يبشو فانه اذا جفف كان رديا للمعده ممزك
ثمره هذه الشجره ينظف البطن وخاصته اذا كانت طريه فاما اذا ايبست
منها البطن اقلا واما دستقى زبدون ولا ادرى من اين فال ان الاجاص الدمشقي

طب واوى

من القوة العناله د‌ والورق اذا دق ونخل وصب عليه ماء وخلط بشي يسير
من زيت انفاق ودهن وزد وخمر ونضمد به وافق لقروح الرطبة والمواضع التي يسيل
اليها الفضول والاسهال لمن من النمله والجمرة والاورام الحارة العارضة للاثنيين
والثرى والبواسير واذا دق ابناه وذر على الداحس نفع منه وقد يجعل في الاباط
والاذنيه المتغيرة الرائحه وبقطع عرق من به خفقان في ثوبه وان دق اوله
بجزه واستعمل موم وزيت عذب ابرا من جزء الداجس والنار وقد يخرج عصارة
الورق بان يدق ويصب عليها في الدق شراب عتيق او ماء المطر ثم يعصر و تما استعمل
عصارته وهي حديثه لانها اذا جفت تخرج وتضعف فوتها وأما المنطبد فاته شي
ينبت في شاطئ بحره الآس مضر هل كان ثبه بلك لونه بشبه نافق الآس و شكله
مشابهه بالكف وفضه اشد من فضل الآس وقد يحرز بعد ان يقدم في دقه ويخلط به
شراب عفص ويعمل منه افراص ويجفف في الظل وهذه الافراص اقوى من ورق
الآس وثمره واذا احتيج الى ان يكون من الثمر وطي عند استعمال ثبق خلط به شي من
هذه الافراص د حتى ما هو هذا السرط ان من ورق الآس وثمرته وعصارته لذلك
يعني يجفف بعضا ويجفف ناوا وا كثر منها ابن ماسه الآس ارد ي الاولى
بالبرد الثانيه ابن ماشويه نافع من الحرارة قاطع للاسهال المتولد من المزة
الصفراء انا نافع للبخار الحار الرطب الحادث والحبه والحبه وحبته صالح للسعال بما فيه من
الحلاوة واستطلاق البطن الحادث من الصفراء ولبن بزه نافر للصدود ولا للربيه
ابن عمران اذا اتخد ورقه يابسا وذر على القروح ذوات الرطوبه والبله نفعها
ونفع من انسلاخ الاعضاء اذا ذر عليها وهو غض وضرب بخل ووضع على الرائز قطع
الرعاف الرازي في الخواص ان اخذت حلقه مثل الخاتم من قضيب الآس وهو
طري وادخل فيها خضر الرحل الذي في ابنيه و رمسكته الاسرائلي اذا طبخ بماء
السلق في الابريه انبي في الراس واذا دق وعجن بماء الباقلى نفع الكلف من الوجه
وحبه دابغ للشعر والفم قليل الغذاء ردي به غيره شراب بحبه يعقل البطن و

أيضا مركب من قوى متضادة و
الأكثر فيه من الجوهر الأرضي
البارد وفيه مع هذا شيء
لطيف فهو لذلك يجفف
تجفيفا قويا وورقه وقضبانه
وثمرته وعصارته ليس في
القبض كبير خلاف و
قوته وقوة ثمرته قابضتان
وقد يؤكل ثمره رطبا ويابسا
وكلاهما ينفث الدم وتحرقه المثانة
وعصارة الثمر وهو رطب جيدة
يفعل أفعال الثمرة وهي
للمعدة مدر للبول موقفة

السرجيدة وأول ما يحدث منه على

إذا خلط بشراب لم ينفع لدغة الزنبور والعقرب وطبخ الثمر يضع الشعر وإذا
طبخ بشراب وتضمد به أبرأ القروح التي في الكتفين والقدمين وإذا
تضمد به بالسيكران سكن الأوجاع الحارة العارضة للعين وقد يتضمد به
للعقرب والأفشرج الذي يعمل من حب الآس بعصر حب الآس ويطبخ
عصيره طبخا يسيرا فإنه أن يفعل به كذلك أحضر ومتى يقدم في شربه قبل
شرب النبيذ منع الخمار وهذا الأفشرج يصلح لكل ما يصلح له الثمر إذا
صيّر في المياه التي يجلس فيها وافق خروج الرحم والمقعدة والنساء النبيل
من أرحامهن رطوبات غزيرة وحلاوة الحال الرأس وقروح الرطبة وثبور
... ومنع الشعر المتقاطر وقد يقع في أخلاط المراهم اللينة مثل ما يقع الدهن
... الذي يعمل من ورق الآس وطبخ الورق يصلح ليجلس فيه ويوافق المفاصل

يخالطها شيء من القوة السهلة وكذا

اجود ومن الناس من يأخذ اعضار خشب بعض اصناف الشوك اوالخشب
الذي يقال له سيسًا ميافتدعه بدلا للآبنوس لانه شبيه به والسبيل الي
معرفة ذلك من انه رخو متشظ وفي لونه شيئ من لون الفرفر ولا يلذع اللسا
البته واذا وضع على النار لم ينفح منه رايحة هذا الخشب من الاشيا
التي اذا حكت بالماء انحلت كما ينحل بالحك بعض الاحجار وصار عطرًا
وقوتها قوة مسخنة لطيفة تجلو ولذلك قد يشق بعض الناس منه انه
يجلوما كان قدام الحدقة فينجيها عن النظر ويخلط ايضًا مع ادوية اخر
من الادوية التي ينفع من القروح العتيقة من قروح العين والمواد المنحلبة
اذا عتقت والبثور الذي تحدث في لعين من جنس نفاخات وقوة
الآبنوس خاليه لظلمة البصر جلاء قوباً ويصلح لسيلان لرطوبات
العين سيلانًا مزمنا ولقرحة العين التي يقال لها قلوقطيس وانعمل منه
ميل وحكت عليه السياقات كان فعلها اقوى واجود واذا اردنا ان بجلخ
اخذنا برادته ونشارته اذا خرط بالشهر وانقعناها في شراب من اشراب البلاد الذي
يقال له اخيوش يومًا وليلة ثم سحقناه اولًا سحقًا ناعمًا ثم عملنا منها اسياقًا
ومن الناس من يسحقها اولًا ثم ينحلها ثم يفعل مثل ما وصفنا ومن الناس
من يستعمل الماء بدل الخمر وقد يحرق في قدر من طين حتى تصير فحمًا ثم يغسل
كما يغسل الرصاص المحرق فيوافق الرمد اليابس وحكة العين ينفع
من النفخة العارضة في المعدة ونشارته ينبت شعر الاشفار اذا اشرب فتت
حصا الكليه ويطفى حران الدم وهو كثير بعرض العرب في السهل والجبل
وخضرته دائمه يموحتى تصير شجرًا عظيمًا ولم يبرة بيضاء طيبة الريح وثمرة سوداء
اذا انعمت وحلوا وفيها مع ذلك علقم ويسمى لقطس من يسير الاباريس وهؤلا
البستاني الذي استدت خضرته منه حتى مال الى السواد انفع في العلاج مما مال الى
البياض وخاصة ما كان منه جبليًا وثمر الاسود اضعف من ثمر الابيض هذا

الرتحم ورما هذه الشجرة قوته قوة غسالة وان طبخ اصلها بشراب او بخل و
شرب نفع من وجع الكبد منفعة عظيمة ويلين ورمها هو افضل
ما استيك باصله وفرعه من الشجر واطيب ما رعته الماشية رايحته لبن به
كبيره ذو شايكه وثمر في عناقيد منه البري وهو اعظم حبا او اصغر عنقودا
وله عجم صغيرة مدورة صلبة وثمر اكبر من الحمص وعنقوده يملو الكف كبره
والكتان فوق حب الكزبره وليس له عجم وعنقوده يملو الكفنين وكلا هما ابيدا
اخضر ثم يحمر ويحلو وفيه حرافة ثم يسود فيزيد حلاوة وفيه بعد حرافة ويباع
كما يباع العنب ونباته في بطون الاودية ورما ينبت في الجبل وذلك قليل
وشوكة قليل متفرقة اذا اشرب طبيخه ادر البول ونقى المثانة حبه
يقوى المعدة ويمسك الطبيعة ابا نوس اقوى ما يكون منه
الحبشي وهو اسود ليس فيه طبقا
يشبه في ملاسته قرنا مخلوكا واذا
كسر كان كبيره كثيفا يلذع اللسان
ويقبضه واذا وضع على جمر بخر
بخارا طيب الرايحه ولم يقتر وانما
ما كان منه حديثا فلما فيه من الدهن
يلتهب اذا قرب من النار واذا
حك على مسن صار لونه الى
لون الياقوت وقد يكون منه
ايضا بلد الهند صنف فيه
عروق لونها ابيض وعروق
لونها يا قوتى واثار وهو كثيف
ايضا الا ان الجنس الاول

سعى القروح الخبيثة ويسكن الاورام الحارة واذا انضمد به بقى سواد الجلد واوساخه التى تعرض من فضول البدن وتقشر خشكريشة الجرح واذا اشرب بالدم واسقط الجنين واذا ادخن به واحتمل فعل ذلك وقد يقع فى اخلاط الادهان المسخنة وخاصة فى دهن عصير العنب ثمرة الابهل تشبه الزعرور الا انها اشد سوادا حادة الرائحة طيبتها اذا غليت فى دهن الحل فى معرفة حد يحتى يسود ويقطر فى الاذن نفع من الصمم جدًا ديدار من جنس الابهل يشبه اطرافا واغصانه وورقه خشنه

ديودار صنف من الابهل يقال له الصنوبر الهندى تشبه عيدانه عيدان الزرنبا دفيه حدة يسيرة وشى ديودار هو لبنه حاد حريف يحرق معطش وفى جوهره قبض ويبسه فى الثالثة اكثر من حره والانثى افضل منه لاسترخاء العصب والفالج واللقوة والصرع والامراض الباردة فى الدماغ ويفتت حصاة الكلى والمثانة ويحبس الطبيعة ويزيل استرخاء المقعد ه
قعودًا فى طبيخه يسهل البطن ويقتل الدود وحب العرعر اذا اخذ من الابهل وزن عشرة دراهم وجعل فى قدر ويصب عليه ما يغمر من سمن البقر ووضع على النار حتى ينشف ذلك السمن ثم رفق وجعل منه وزن عشرة دراهم من الفانيذ ويشرب منه كل يوم وزن درهمين على الريق بالماء الفاتر فانه نافع لوجع اسفل البطن العارض من البواسير ابن عمران بوشجر عظيم متدوح وله خشب وقضبان خضر ململخ حمرة وله ورق اخضر يشبه ورق الطرفا فى طعمه عفوصة ولسر له ازهر ويثمر على عقد اغصانه حبا كالحمص غير انه الضفرة وفى داخله حب صغير ملصق بعضه الى بعض حب الاثل العذب دو يجمع فى الاخر الخريزان اثاليس وهو الاثل هو ثمر شجر يكون بمصر مثل التمر الطوى ء فى اخلاط اشياما فات العين الموافقة لضعف البصر المقوية له الاثل ليستعمل فى دباغ الجلود وهو نافع من تاكل الاسنان ويدع من انجلاب البلة

السرو والصنف الرابع ينشر عرضًا ولا يطول ولا يحمل شيئًا البته
الابهل صنف من العرعر كبير يشبه بورق الطرفا وله ثمر حمل يسمه
شبه النبق في لونها وقدرها داخلها مصوف ولها نوا ولونه احمر اذا نضج
كان حلو المذاق وفيه طعم القطران يجمع في وقت قطاف العنب الابهل
صنفان وذلك ان منه ما ورقه شبيه بورق السرو وهو اكثر شوكًا من غيره
من الابهل كريه الرايحة وهذه الشجرة مستديرة وهي تذهب بالعرض اكثر
منها في الطول ومن الناس من يستعمل ورقها بدلا من اللحور ومنه ما ورقه
شبه بورق الطرفا وهذا نبات قوي التجفيف في كيفيته اثلثها الموجود
في طعمه على مثال ما في الشربن الا احد من الشربن وكانه في المثل طيب
وله ايضا حرارة وقبض اقل مما للشربن وهذا مما يدل على انه احد من الشربن فهو
لذلك يحلل اكثر منه ومن اجل ذلك صار لا يقدر ان يملا الجراحات لشدة حره
ويبوسته وذلك ان فيه من الحرارة واليبوسة جميعا مقدار ما يخرج بها الى ان
يكون بهج ويلهب واما القروح التي يحدث فيها العفونة هو نافع فيها
كالشربن وخاصته للعفونة الرديئة الخبيثة التي قد استحكمت وتمكنت منه
زمان طويل فان العفونة اذا كانت بمثل هذا من الحال احتملت قوة هذا الاكل
من غير اذى وهو ايضا ينقي القروح المستودعة الوسخة اذا وضع عليها مع
العسل ويقلع الجرب وبسبب لطافته بلغ اللطف بلد اكثر من كل دواء و
بول الله ويفسد الاجنة للاحياء ويخرج الاجنة الموتى وليوضع هذا
الدواء من اليبوسة والحرارة في الدرجة الثالثة على انه ايضا من الادوية
التي هي لطيفة جدًا ولذلك صار تخلط في الادهان الطيبة وخاصة في الاخلا
الدهن المسمى غلوس ويقع ايضا في كثير من المعجونات وغيرها من الادوية التي
يشرب ومن الناس قوم يكون منه مكان الداراصيني ضعف وزن الداراصيني
لانه اذا شرب كانت قوته تلطف وتحلل وورق كلا الصنفين يمنع

قابضه وتصلح لاوجاع الرحم اذا اطبخت وجلست فی مائها وقد یقع فی اخلاط
دهن البان وسایر الادهان من اجل القبض الذی فیها وهی نافعه اذا وقعت
فی اخلاط الدخن والادهان التی تحلل الاعیاء قوة الاشنه
تختلف بحسب الاختلاف قوة الشجر التی تعلو علیه اذا سحقت مع الماء
ووضعت علی المواضع التی هی ضعیفة قوتها مثل الاربتین والابطین
والخالبَین والکفین واصول الاذنین تجفف البله وینفع من جرب
العین وحمرتها وطبیخها یشرب فیقوی القلب ویدخل فی الغوالی والخالج
وادویة المسک والاکحال وان نقعت فی شراب قابض وشرب ذلک
قوی المعدة واذهب نفخ البطن وانام الصبیان نوماً مستغرقاً
بحبس القی ویقوی المعدة یفتح السدد ویطلی علی الاورام الحار
فیدکنها ویحلل صلابة المفاصل ونفتت الحصا واذا جلس فی طبیخها
ادر الطمث واذا اطبخت نخل وکمد بها الطحا ل نفعته وینفع من الصبیان

ابن ماسویه ودواء هندی یشبه قرفة القرنفل
خشب لیشبه القرفة طیب الریح یجلب من الیمن هو نبات یشبه عیدان
عیدان الثبت سمعت ان الرمال الخشب خفیف شج یتحلل منه حفو
وقال مرة اخری فالجمع الاطباء فی هذا الدواء انه جید لاوجاع الفم
یطیب النکهة ویشد اللثوم ویقوی الاحشا کلها وعقل البطن و
ضماده ینفع من الاورام وخصوصاً الحارة ویمنع انتشار القروح ویدملها
لانه یجفف بلا لذع ویمنع یعفن الاعضاء ویقوی الدماغ والاکل منه
ینفع من الرعد الفلاحه اصناقه اربعة منها الابهل الهندی الذی
یسمیه الهند سیدارید وسمیه الفرس سیداریه وهو شجر یرتفع نبات وبیش
اغصاناً وثمره کالبند وصنفان اخران احدهما ورق کورق الطرفاء والا
کورق السرو ولهما شوک کثیر وله رائحه کریهه حاده وحامه اصغر من جوز

بالاصول　　　زهر هذا النبات يسخن اسخانا يسيرا ويقبض فيه اليسير مه
ليست بعيده من الجوهر اللطيف ولذلك هو دواء يدر البول ويحلله الطشـ
اذا استعمل على جهة التكميد اذا اشرب واذا انضمد به وهو نافع ايضا للاورام
الحادثه في الكبد والمعده وفي المعده واصل هذا النبات اشد قبضا من زهرته
وزهرته اكثر اسخانا من اصله والقبض موجود في جميع اجزائه من ذلك الا
ان ذلك في بعضها اكثر وفي بعضها اقل وبسبب هذا القبض صار يخلط مع الاد
التي يبقى فعلها مما ينفث به ‍ الدم　　وقوة قابضه مسخنه اسخانا يسيرا ملينه منضجه
مفتته للحصاة مفتحة لافواه العروق ومدره للبول ولطشـ محلله للنفخ
يورث الراس ثقلا يسيرا وفقاحه نافع مما ينفث الدم واوجاع المعده والرية
والكبد والكلى ويقع في اخلاط بعض الادوية المعجونة واصله اشد قبضا
ولذلك يسقى منه وزرقا مع مسل فلفل من كانت معدته تغشيه ومرة
جبن ومن به شلخ في عضله وطبيخ موافق للاورام الحاره الحادثه في الرحم
اذا جلست فيه النساء　　خاريابس في الثالثه　　　جيد للورم الصلب
في الكبد والمعده اذا انضمد به　　خاريابس في الاولى لا يكن الاوجاع
الباطنه خصوصا في الارحام وينفع الفضل ويقوي العمود وينشف
رطوبتها وفقاحه ينقي الراس واذا ادهن شمه اثقل الراس وانام ودهنه
ينفع من جميع انواع الحكه حتى في البهائم ويذهب الاعيا وهو جيد للمرض
واذا امسك فائرا في الفم ينفع من بثورها جدا وينبت اللحيه اذا ابطأت في الخروج
هو المعروف بــدب لجوز النابت على البلوط وغيره من الشجر　الجيد منها
ما كانت على الشربن وكانت جبليه وبعد ما يوخذ عن الجوز واجوده من هذا كا
اطيب را يحة وكانت بيضاء وما كان لونه منها الى السواد ما هو فانه ردي
قوة قابضه باعتدال وذلك لان ليست بارده برودة قوية بل هو قريب من الفتور و
فيه مع هذا قوة محلله ملينه وخاصه فيما يوجد منها على شجر الصنوبر وتــ

ورق دقيق اصغر من ورق نهش جميع الحيات ثمّ وبزره واصوله
الزراوندلنيه اغصان صغار يمتد على الارض وزهره وثمره مثل الذى ذكرنا
قبله الا انه اصغر واصوله لنيه غير معقدة لونها اصفر تخرج من اصل واحد
مثل الخربق الاسود وذرة عطرة الطعم عطرة الرايحة مثل رايحة الاسارون والثير
نباته فى التربة البيضاء من الجبال وقد يظنّ ان قوته كقوة الاسارون ويستعمل
بدل الاسارون وقوم يظنون انه نوع من الماميران
له اصل مندفن
وقضبان دقاق ذفر الريح ومثل الاسل الكولان الا انه اعرض منه وضعّ
كعوبا واوله ثمرة كانها مكانس القصبا الا انها ادق واصغر يطحن فيدخل فى
الطيب وقلما ينبت الا ويخرج منفردا
متى رايت واحدة ثمّ نظرت وجدت
غيرها وربّما استسلست منه الارض
وهو ينبت فى السهول والحزون واذا
جفّ ابيض ما ينبت منه
بالحجاز وهو الحرج وما ينبت
منه يقفصه وساحله اذ بقيه فهو
ادناه منه ما يكون بالبلاد
التى يقال لها لينوا ومنه ما يكون فى
البلاد التى يقال لها انطاليا وهو
اجودها وبعده ماكان من بلاد العرب
ويسميه بعض الناس البابلى وبعض
طوسيطين واما الذى سوى فليس نفع بفاخر ومنه كان حلذا وفيه حمرة كثير
الزهر واذا ايش كان فى لونه فرفيه دقاق وطيب رايحة شى يشبه برايحة الورد اذا
دلك بالايدى يلذع اللسان ويحد دحد رايبر والمنفعة هى فى الزهر وقصب

منه قوتها مدرة للبول مسخنة صالحة لمن به جرب ومن به عرق النسا
ويدّر الطمث واذا اشرب منه وزن اربعة مثاقيل بماء العسل اسهلت
مثل الخرء بقوة الابيض وقد يقع في اخلاط الطيب وقال في ويتخذ بلا رقى
شراب على هذه الصفة ٠ يؤخذ من الاسارون ثلثة مثاقيل ويلقى
في اثنى عشر قوطولي من عصير ويروق بعد شهرين وهذا الشراب يدّر
البول وينفع المستسقين ومن به اليرقان ومن به علة في الكبد ولوجع
الاسارون نافع من صلابة الطحال ويقوى المثانة والكلية ويدّر
في المني ويلطف الاخلاط الغليظه واذا اكتحل به نفع من غلظ القرنيه
اجود الاسارون الصبيو والاندلسي واجود الاندلسي ما يؤتى من جزيرة الخضراء
هو مقو للكبد وللمعده نافع من اوجاعها المتقادمه الذى يستعمل بالاندلس
ليس اسارونا بالحقيقة وان كان شبيه الاسارون في منظره ويظن ان قوته كقوته
وخاصه الجزيرى منه والاسارون الصحيح يجلب من بلاد الروم واما هذا الجزيرى
فهو نبات لدساق خوان مدورة تعلوا نحو من ذراع متباعد العقد وورق كورق
الفطور يون الصغير اخضر يضرب الى السواد في اعلاه جمه من شعب بعضها فوق
بعض في اطرافها رؤس صغار في قد رحب المحطه داخلها زغب ابيض ولها اصل
ادّق من الخضر يتشعب منه شعب دقاق في طول الانملة طيبة الريح والطعم لذيذ
فهذا هو الذى يجلب من جزيرة الخضراء وهو اشبه بالاسارون الصحيح من غيره من الاندلسى
وان كان نباته غير شبيه بما وصف واما غيره من الاسارون فهو مر الطعم في رائحته
كراهيّه وقوم يجعلونه من اصناف الزراوند الطويل وهو نبات له ورق اصغر من ورق
السوسن واصلب يضرب الى السواد والغبرة وله اغصان رقاق وصلبة ذوات عقد يتعلق بما
قرب منها ويرتقى في الشجر وله زهر فرفيرى كثير مثل زهر الزراوند يخالف ثم اصل الكبر فيه
بزر كبزر الحلتى وله اصل كثير متعقد تدبّ تحت الارض في لونها غبره وصفره الى السواد
قوته الرائحة مرة الطعم تلذع اللسان قليلا وخاصية هذا النبات النفع من السموم و

ولا يتولى شيئاً مما عمل ذلك بيد هو طبيب فقط وليس بصيدلاني و الذي يتولى عمل الادوية وتركيبها هو صيدلاني فرق قال من اطبائنا ان معرفة الادوية المفرده ليس بواجب على فانما لا يجب عليه ذلك من حيث هو طبيب فاما من حيث هو صيدلاني فذلك واجب عليه حتى لا يشئ او كد عليه او كان لا شئ اضر في الصناعة من ان يسقي دواء بدل دواء ولا اجهل ممن يفعل ذلك من الاطباء اذا تولى ذلك بنفسه فاما اذا اسلم الامر لغيره فالخطا عليه فالطبيب ومعرفة الادوية واختيارها يتقدم صناعة الصيدلة وهو كالاساس لهما فاما معرفة قواها وافعالها فهو جزء من اجزاء صناعة الطب ولنبتدي الان بما شرطناه في كتابنا بالله التوفيق

بعض الناس يسميه تاردينابواله ورقوشبيه بورق قسوس غير انه اصغر بكثير واشد استداره وله زهر فيما بين الورق وبين اصله لونه فوفيري شبيه بزهر البنج فيها بزر شبه بالقرطم وله اصول كثيرة ذوا عقد دقيقة معوجه مثل اصول التين غير انه ادق وبكثير طيبة الرائحة يسخن ويلذع اللسان جداً وينبت في جبال كثيرة الشجر وهو كثير في البلاد يقال لها فرغواء والبلاد التي يقال لها اللورس والمدينة التي يقال لها ابوسطا التي من انطاليا الذي ينفع من هذه الحشيشه انما هو اصل وقوة هذه الاصول شبيهه بقوة الوج الا انها اقوى

التي لم يستعملها أحد قبله لكن يستعمل ما قد عرفت قواه بالتجارب فأما معرفة قوى الأدوية وتقسيمها وإن كان يظن به أنه أمر نافع والصناعة فأقول إنه من أمور الطب الكلية التي ينبغي أن يوضع في الكتب التي هي أصول في علم الطب لا أعني الكلام على قوة دواء دواء إذ هو مجرى قد تركنا القول فيها في هذا الكتاب مع أن أهل الكتب قد كثروا فيها من الكلام فأما حلى الأدوية واختيارها ومعرفة الجيد منها من الردي فهو خاص بغرض هذا الكتاب مما ذكرنا وإن كان أكثر أطبائنا يرون أن ذلك فضل خارج عن صناعة الطب وأن الطبيب ليس عليه علم بشيء من ذلك بل تقليد في ذلك التجارين والصيادلة وأنا أقول في جواب ذلك ما قولهم أن ذلك من غير صناعة الطب فصدق واوذلك أن معرفة الأدوية واختيارها إنما هو من صناعة الصيدلة لا من صناعة الطب لكن أطباءنا هؤلاء كلهم صيادلة فمن قال منهم إنه ليس عليه معرفة الأدوية فهو منه جهل فاحش قبيح لأن أطباءنا هؤلاء كلهم يتولون بأنفسهم عمل الأدوية المركبة وجميع أعمال الصيدلة ولا في بأحدهم لو عقلوا أن يطب أدوية مفردة لتركيب دواء فيؤتى بأدوية لا يعلم هل هي التي أراد أم غيرها فيركبها ويسقيها عليله ويقلد فيها التجارين ولقاطي الحشائش وقوماً لا يقرون الكتب ولا يعرفون من الأدوية لا أقلها ولا أكثرهم أمانتوا والذي يعرفونه من الأدوية فهم في معرفتها مقلدون لغيرهم بغير علم هذا إلى ما نشاهد من اختلافهم فيها وقلة انفاقهم وأنا أقول إن أطباءنا هؤلاء كلهم إنما هم صيادلة ومثلهم ولا تكب بهم ولا معايش الا من الصيدلة وهم لا يعلمون أن ذلك نقص في ذلك كمثل رجل نجار ولم يكن له كسب إلا من النجارة وهو يجهل أنه نجار ويظن أن صناعته غير ذلك ومن جهل نفسه هذا الجهل فليس ينبغي أن يتعلم أصلاً فأما الطبيب الذي يحكم بما يجب للمريض من غذاء ودواء وتدبير وغير ذلك

اراد تي ابكلام نضاف في كل واحد من الادوية التي ذكرها استوفى في ذلك المتقدم وكان كلامه يحتوي على الحلية والاختيار والافعال وازيد عليه كلام مستوفى في الغرض والمنفعة وربما حرف منه فضل ان كان فيه ترك لحق بعد ذلك زياده ان كانت لاحد المتاخرين على قولهما والحقت في هذا الكتاب ما لم يذكراه من الادوية المفرده وذكرها من كان بعدهما من الاطباء والحقت على ذلك ايضا بعض الحشايش الموجودة عندنا التي يستعملها اهل بلادنا مما لم يذكرها احد ممن تقدمنا ورتبت ابواب الكتاب على حروف ليكون ايسر لوجود ما يطلب منها واخر كل باب بشرح ما وقع في الكتاب من الاسماء التي على ذلك الحرف فصار كل باب ينقسم الى قسمين قسم في الكلام على الادوية وقسم في شرح الاسماء فما كان من هذه الشروحات مما ذكره الرازي في كتابه الحاوي علمنا عليه وما كان مما ذكره ابن جنيفه عن الاعراب علمنا عليه وسقنا اسماء غيرهما اذا كان اكثر تكرارا للاسماء ان كل باب الذي فيه شرح الاسماء تكثر فيه الاسماء ويحتاج من يطلب فيه اسما ان يقرا الباب كله تحيلنا لترتيب الاسماء فيه على حروف المعجم له من فهمها امكن ان يستخرج من اي باب شاء اي اسم شاء من غير ان يقرا سطرا واحدا من الباب فما فوقه وهذا اشي لم يستو اليه احد غيري ونحونا في هذه التي نخوصد ورد الحروف لانو الحروف بالحقيقة اذا كانت اكثر هذا لاسماء عليها التصحيف والتغير فلا يبقى منها صحيح الاصول الحروف فكان غرضنا في كل ما فعلناه التقريب والتسهيل واما الكلام على الطعوم والارايح وتقسيم قوى الادوية الاولى والثواني والثوالث فمع انه خارج عن غرض هذا الكتاب فقد استوفاه جالينوس ثم من جاء بعده القول فيه وانما قصدنا للغرض الذي اغفل وليستوفه احد مع ان هذا الغرض قليل المنفعة في صناعة الطب اذا كان الطبيب لا يلتمس ان يجرب الادوية

كتاب

السبب الذي دعاني الى وضع مجموع من اقاويل القدماء والمحدثين لمعنى استغني به عن النظر في غيره من الكتب الموضوعة في هذا الفن الناقصة المحطاة واني اتوكل على الله فقد قصدت في ذلك ما امكنني حسب علمي ومبلغ طاقتي وتحرزت من الغلط الذي وقع فيه جهدي ولم اطلب به الذكر ولا الفخار لكن منفعة نفسي فقط واثبت فيه ذكر جميع الادوية التي ذكرها جالينوس وديسقوريدس التي لم يستوف الجمع بينهما احد ممن تقدمنا والحقنا بعد قولهما في دواء دواء مما ذكراه قول من جاء بعدهما ممن اصاب القول واهملنا ما كان من اقاويل المتاخرين غلطا قد تبين لنا خطاوه وسقنا على كل قول اسم صاحبه الا من جهلناه وفعلنا ذلك لكي يعلم صاحب كل قول فلا يتبع الانسان من اقاويل وبقين الا ما ذكره ديسقوريدس وجالينوس فقط فاما ما قاله المحدثون فليكن منه على ربية وفوق اذا كان دكى منهم بغلط ويتمى الادوية بغير اسمائها فليسمي اسم دواء وهو يتكلم في غيره وهو لا يعلم او يكذب كما ذكرنا وينقل عن القدماء فمنى النقل ويصحفه ويفسد وكلهم ببث ما لا يتحققه ولا يجرب فلهذا كان لابنا يجب علينا ان يسند كل قول الى قائله وما كان من اقاويلهم متشابها وموفقا لاقاويل القدماء لمزات به واستغنينا عنه باقاويل المتقدمين وان كل قوم يظنون ان ذلك جميلا لان ذا عندهم بمنزلة كثير المؤامد ونحن نقول لو كان كل واحد منهم انما يذكر في الادوية ما جرب من افعالها لكان ما ظنه هولاء صحيحا وليس الامر كذلك بل كل واحد منهم انما ينسخ من قول متقدم الا في اليسير فليس لذكر لا قاويل المنفعة جرا الانكبر الكلام واطالته فقط ولطلبنا الاختصار والابجاز جعلنا بدل اسم ديسقوريدس وجالينوس والحقنا بعد الحرف الذي يدل لكل واحد منهما على اسمه حرفا يدل على مقالته التي وقع فيها ذكر ذلك الدواء من كتابه ليكون اليسر لطلب ذلك القول في كتاب كل واحد منهما لمن اراد ذلك وقصدت

وهذان الغرضان قد تقدم في الوضع فيهما خلق كثير الا انهم لم يتم واحد منهم
غرضه ولا استوفاه ولا تقصى البحث عن حقيقة ما وضعه ومن نظر في
كتبهم وجد فيها من الاختلاف ما لا مزيد عليه حتى يتحير ولا يعرف الحق
من الباطل ويرى اكثرهم متبعين بعضهم بعضا مقلدين في غلطهم لا قائم
اذا غلط واحد منهم رأيت جماعة يتبعون غلطه ويخطى بخطائه وهذا الدليل
على انهم لم يكتبوا في كتبهم ما كتبوه بجث وطلب ولكن انتسخ بعضهم ممن تقدمه
من كتابه نسخا فما اخطا فيه تابعه على خطائه وما اصاب وافقه فيه معه
فليس ينبغى ان يلام احدهم اذا اخطاء ولا يحمد ان اصاب بل ينبغي ان يلام الكل
منهم لو ما واحدا على توانيهم في البحث وقلة فحصهم على الحقائق ومبحث
منهم عن شئ فلم يستوف البحث عن كل شئ فلا يستقص على ما ذكره الاستقصا
التام فاصاب فى بعض وغلط فى بعض ولو لا كراهة التطويل لابينت غلط
كل واحد منهم وشرحته وبينته حتى يعلم القارى لهذا الكتاب قد بحثنا
وطلبنا على حقائق الاشياء المختلف فيها حتى وقف بنا الفحص على الحق من
الباطل فى اكثرها الا اليسير اليسير منها مما لم نجد الى حقيقتها سبيل رشد
لكن يقضينا الامر فيه بحسب الطاقة والامكان ومنهم من غلط فى الجمع
الا اما وبالكما فعل ابن وافد حيث يجمع بين كلامه ويقول ليس فى دواء
ويضيفه الى كلام جالينوس فى دواء اخر وهو يظن انهما واحد وهذا
ما حرف من كلام جالينوس وافسده واخرجه عن معناه واسا العبارة عنه
صحّف عليه مما يطول ذكره ومنهم من يكذب كما فعل ابن سينا فى موا
كثيرة من ادويته حيث حكى عن وعن ما لم يقول ولا وبالجملة ما من احد
تكلم فى احد هذين الغرضين المذكورين فى صدر هذا الكتاب الا وقد
غلط الغلط الفاحش من الرازى الذى كان اولهم الى زماننا هذا ومع
الغلط والخطا فما استوفى احد منهم غرضه ولا اكمل فى كتابه وهذا

بسم الله الرحمن الرحيم

قال أبو جعفر أحمد بن محمد بن سيد أبي الغافقي رحمه الله فقي رحمه الله قد كنت عشت في كتاب في الأدوية المفردة اتخذه تذكرة لنفسي وأحب إذا ذاعته في أيدي الناس ومنعني عن ذلك ما رأيته من قلة أهل البصر بما يوضع على صواب وعلى غير صواب وقلة معرفتهم بالفرق بين من استخرج شيئاً صحيحاً قل وقع فيه الغلط قبله وبين من غلط في شيء قد كان صحيحاً فأفسده على بعده بل كان نفوسهم مغطوة على الميل نحو القول السقيم والنفور عن الصحيح وإنما يؤثرون الكتاب الذي بين أيديهم ويقدمونه ويفضلونه على غيره أما لأن واضعه زوجاه ومنزلة عند السلطان وأما لأنه كان رجلاً كثير المال وبالجملة أن رجلاً قد انتشر له ذكر وصيت بسبب من الأسباب الدنيا ويريد فأما نصر الكتاب فلا يفهمون منه ولا تفضل به على غيره ولا ما يفضل به غيره عليه فلذلك لم أحب أن أنشر لي كتاباً في أيدي الناس لما ذكرناه من قلة بصرهم ولا أن يكون لإنسان قد صير نفسه به غرضاً لأقاويل الناس من ذوي الحسد وإن من الجهلة مضغة إليهم ودون البصرة والمعرفة والإنصاف أقل من القليل فلما ألححني على أخذ هذا الكتاب بعض الإخوان أردت أن أقدم فيه فاذكر غرضه ومذهبي في وضعه والسبب الداعي الذي كان بي إليه فأقول إن غرضي كان فيه شيئان أحدهما أن أجمع فيه بين أقاويل القدماء والمحدثين من أهل البصر من الأطباء في دواء دواء من الأدوية المفردة حتى يكون الناظر في دواء منها قد عرف كل ما قيل فيه وأفعاله من الأقاويل من غير تطويل ولا إكثار ولا ذكر إفاوال متشابهة بل لغاية ما يكون من الإيجاز والاختصار مع الجمع والاشتمال والثاني شرح ما وقع في كتب الأطباء من أسماء الأدوية المجهولة

2a

[These notes apply to the other MS., Dioscorides, no. 346, given to Bodleian. W.W.F.]

Title is: Al-maqālāta-th-thalitha iii(ult.)
min al Ḥashāish
"Third discourse - concerning herbs"

Plate: Ṣūratul ḥakīm Dioscorides
alazū dawwana Khwāṣṣu-l-mufradāt
"Picture of Dioscorides the Physician who composed the 'Khawāṣṣu-l mufradāt' = 'Properties of Simples'"

Colophon. Here ends the "Discourses of Dioscorides the Physician. — — — This is the end of the book. It is written by the slave who stands in need of the mercy of God — Hasan bin Ahmad bin Muhammad on the 25ᵗʰ of Zi Hijjah, in the Nizāmīyya College — — — — — — in the year 637 H. (A.D. 1239)"

["Baghdad Sir Thos"]

504 (so dated)

Refers to no. 346 (Dioscorides)
Writer

Written by?

22 × 25 Sir Denison Ross interpreted the difficult date of this MS. as 654 A.H = A.D. 1256. I took it to him to the Oriental School in London. W.W.F.

AL-GHĀFIKĪ [Abū Ja'far Ahmad ibn Muḥam-
 mad al-Ghāfikī] –1165.
7508. In Arabic, on paper: written A.H. 654,
 i.e. A.D. 1256: 10×7 in., iii +284 leaves:
 illustrated: in oriental binding.
On Simples, al-adwiya al-mufrada; by
al-Ghāfikī, a Spanish physician; arranged
alphabetically. Vol. I (A–K) only. With
about 367 coloured drawings of plants and
6 of animals.
 MS. Hunt 421 (1) in the Bodleian Library appears
to be abridged from this work. Inserted: copies
of the letters referred to in the note to the Arabic
Dioscorides, no. 346, with which this MS. was pur-
chased from a Persian in 1912.

FROM
THE LIBRARY
OF
SIR WILLIAM OSLER, BART.
OXFORD

Front outside cover